VASES &
VOLCANOES

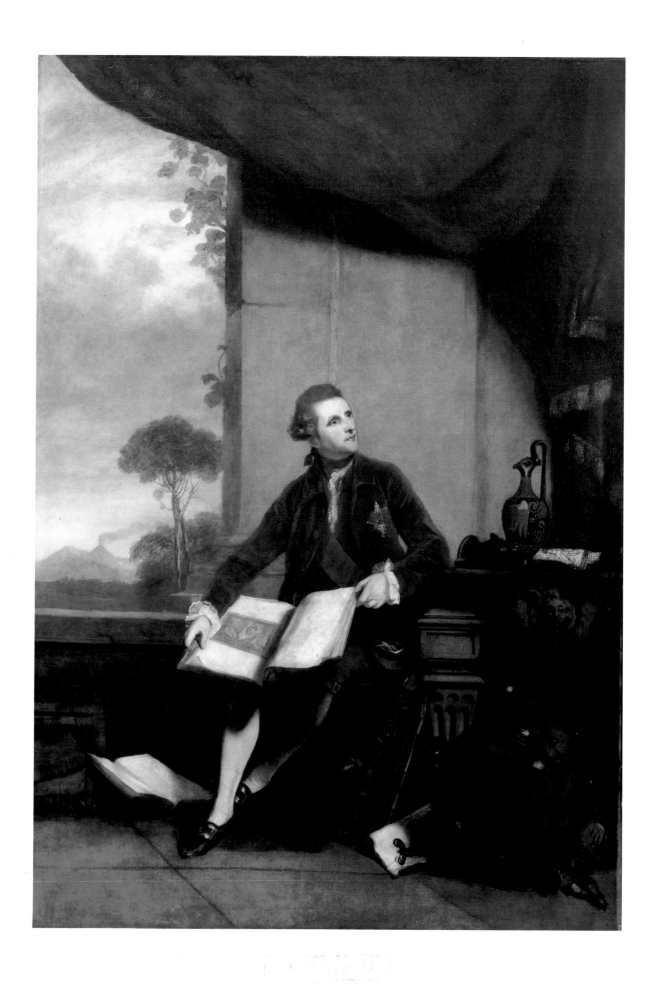

VASES & VOLCANOES

SIR WILLIAM HAMILTON
AND HIS COLLECTION

IAN JENKINS AND KIM SLOAN

PUBLISHED FOR THE
TRUSTEES OF THE BRITISH MUSEUM
BY BRITISH MUSEUM PRESS

© 1996 The Trustees of the British Museum
Published by British Museum Press
A division of The British Museum Company Ltd
46 Bloomsbury Street, London WC1B 3QQ

First published 1996

A catalogue record for this book is available from
the British Library
ISBN 0-7141-1766-8

Designed by Harry Green

Typeset in Bembo by Southern Positives and
Negatives (SPAN), Lingfield, Surrey
Printed in Great Britain by Balding+Mansell

FRONTISPIECE *Sir William Hamilton*, painted by
Sir Joshua Reynolds in 1777–82 (cat. no. 51)

PHOTOGRAPHIC ACKNOWLEDGEMENTS
Photographic acknowledgement is to the owner, as given in caption
 or catalogue entry, with the exception of the following:
Trustees of the British Museum: figs 15, 16
Christies's: fig. 28
Lord Patrick Douglas-Hamilton: cat. no. 146
The Government Art Collection of the United Kingdom and
 Antonello Idini, Rome: fig. 11 (cat. no. 7)
By courtesy of the National Portrait Gallery, London: fig. 97
The Natural History Museum, London: fig. 31 (cat. no. 38)
Photographic Survey of Private Collections, Courtauld Institute of Art:
 fig. 42 (cat. no. 176), fig. 98 (cat. no. 169)
Antonia Reeve Photography: fig. 2 (cat. no. 129), cat. nos 47, 48, 147,
 153, 164
Science Museum, Science and Society Picture Library: fig. 32
Scottish National Portrait Gallery: figs 8, 9
K. Sloan: figs 3, 6, 103
Whitfield Fine Art, London: cat. no. 23

Contents

AMERICAN FRIENDS OF THE BRITISH MUSEUM

THE PUBLICATION OF THIS CATALOGUE HAS BEEN

FUNDED BY A GENEROUS GRANT FROM

AN AMERICAN FRIEND OF THE BRITISH MUSEUM

Preface

Sir William Hamilton's collections were formed in Naples, where he was ambassador during a period in the eighteenth century when the city was experiencing a golden age. The exhibition has brought together many objects which were of fascination to him, and which he found in abundance in southern Italy. These included objects from the ancient past – Greek vases, especially – and from the natural world, the slopes of Vesuvius providing a lavish source of specimens. The exhibition is being shown at a time when Naples itself is undertaking an extensive programme of renovation in order to restore its past splendours.

Sir William loved Naples, its people and its surroundings, and they provided rich material for his inquiring mind. Vesuvius was then more active than at any time since antiquity, and Hamilton observed and recorded its pyrotechnics with scientific acumen. Coincidentally, the Roman city of Pompeii, engulfed in the ash of a previous eruption in AD 79, was being rediscovered. Sir William's collection of antiquities included objects from these early excavations. In 1772 he offered them to Parliament for sale, and they entered the collections of the British Museum for the considerable sum of £8,400. This large acquisition made a significant impact on the character of the British Museum's collections which has lasted to this day. Beforehand the Museum had been primarily a repository for books, manuscripts and natural history. Hamilton continued to make substantial gifts of antiquities, including several fine sculptures, and he also served as a Trustee of the Museum from 1783 to 1803. He was an influential figure in the history of the British Museum, and his collections were important in the development of English classical taste.

All who work with the collections of the British Museum are constantly reminded of the debt they owe to the Museum's many founders and benefactors. It is fitting, therefore, that the life and collections of Sir William Hamilton, one of the most gifted and versatile of that remarkable group, should be celebrated in *Vases and Volcanoes*.

The exhibition would not have been possible without the generous participation of the lenders listed overleaf, all of whom have loaned important exhibits.

Dr R. G. W. Anderson
Director of the British Museum

List of Lenders

Catalogue numbers are given in brackets

The Warden and Fellows of All Souls College, Oxford (174)

His Grace the Duke of Atholl (129)

The British Library (62, 43, 150)

The Earl of Elgin and Kincardine, K.T. (47, 48, 153)

The Elton Hall Collection (178)

Glasgow Museums: Art Gallery and Museum, Kelvingrove (144)

Government Art Collection of the United Kingdom, on loan to the British Embassy, Rome (7)

Collection of the J. Paul Getty Museum, Malibu, California (4)

James Holloway, Esq. (147, 164)

His Grace the Duke of Hamilton (146, 162, 163)

Dott. Carlo Knight (43, 151, 152, 183 and ex. cat.)

The Mostyn-Owen Family (5)

The Natural History Museum, London (38)

Bibliothèque Centrale, Muséum National d'Histoire Naturelle, Paris (ex. cat.)

Board of Trustees, National Gallery of Art, Washington (8, 159)

Trustees of the National Portrait Gallery, London (1, 9, 13, 51)

The President and Council of the Royal Society (44 and ex. cat.)

Scottish National Portrait Gallery, Edinburgh (16)

The Science Museum, London (ex. cat.)

Fundación Colección Thyssen-Bornemisza, Madrid (182)

The Board of Trustees of the Victoria and Albert Museum, London (20, 21)

Yale Center for British Art, New Haven, Conn. (193)

Private collections (6, 23, 46, 68–71, 73, 110, 112, 114, 148, 166, 167, 169, 175, 176, 181)

Foreword

The history of museums is a rewarding field of enquiry for understanding the many different ways that objects have been seen and valued in the past. Not least, it can provide fresh insight into our own way of seeing. Sir William Hamilton's first collection of antiquities is one of many private collections that have been absorbed into the British Museum. During its Museum life, some parts have become separated from others. No longer is it displayed as a single entity, new ideas of classification having supplanted the old method of arrangement by collection.

In Sir William's day antiquities and specimens of natural history alike went together in the Department of Natural and Artificial Productions. Hamilton himself would have found nothing strange in this, it being traditional for private cabinets to be made up of 'natural and artificial rarities'. Nowadays natural history is not even kept in the same building as the British Museum's collection of antiquities, let alone in the same department. Unwittingly, Sir William contributed to the modern division, for it was he, more than any of his contemporaries, who saw the Museum's potential for serving antiquary and artist as a source of instruction and improvement. All his life he endeavoured to raise public consciousness of the beneficial influence that classical antiquity in particular could provide as a model for contemporary artists and manufacturers to follow.

Vases and Volcanoes reunites many objects long separated and in so doing revives ways of interpreting them that were current during Sir William's lifetime. In presenting the opinions of such antiquaries as Baron d'Hancarville and the Abbé Winckelmann, we have made few value judgements. Rather, our aim has been to rediscover as far as possible an eighteenth-century way of seeing.

The scope of the exhibition and this book ranges far beyond the limits of the British Museum's own collection: only Sir William's first collection of antiquities was acquired *en bloc* in 1772, while the second collection was dispersed piecemeal, and although the bronzes, some of the sculpture and a few of the vases eventually came to the Museum, much else did not. Extensive detective work, therefore, has brought together parts of the second collection, in particular that of engraved gems. Still more elusive are Hamilton's collections of paintings, ranging from old masters to works commissioned by him from contemporary artists. Better known for his interest in antiquity and volcanoes, Hamilton was all his life an avid collector of paintings and drawings, and this book provides the fullest account to date of his activities in this important area.

In making the selection for this exhibition, the primary aim has been to focus upon objects that were owned by Sir William. In addition to objects themselves, the exhibition includes pictures of people and places that he knew during his thirty-six years of residence in Italy. Whenever possible, these images too have been selected from his own collection. This practice has applied necessary limits to the biographical and topographical scope. Nevertheless, the exhibition and its catalogue, with the assistance of two guest contributors, Carlo Knight and John Thackray, aim to give a broad view of the man, his life, scholarly interests, ambitious publishing projects and diplomatic career. The result is the fullest account of the subject so far and, indeed, the most comprehensive of any eighteenth-century collector of the period described by Adolph Michaelis as 'the Golden Age of Classic dilettantism'.

Such a claim could not be made without the many people and institutions who have generously assisted us. The late Brian Fothergill must be credited with the revival of modern interest in Sir William and the first major attempt to rescue his reputation from the tarnish of his second wife's affair with Lord Nelson. Fothergill's charming biography has been an inspiration to all those with an interest in the subject. Chief among these is Carlo Knight, to whose scholarship and great knowledge of Naples and its history we owe a personal debt.

Thanks also go to Professor Francis Haskell for his encouragement at the outset and to Antony Griffiths and Dyfri Williams, Keepers of the Departments of Prints and Drawings and Greek and Roman Antiquities respectively, for their support throughout the project.

In the compiling of this catalogue a great many colleagues in archives, libraries, universities, museums and galleries all over the world have assisted our research. It would be impos-

sible to mention them all individually by name, but particular thanks go to Mary Beal, Susan Bennett, Ilaria Bignamini, Iain G. Brown, Keith Christiansen, Fintan Cullen, Elisabeth Fairman, Kate Fielden, Burton Fredericksen, Peter Funnell, Jasper Gaunt, Mme P. Heurtel, James Holloway, Ulrike Ittershagen, Alastair Laing, Stephen Lloyd, David Mannings, Hermann Mildenberger, Renata Müller-Krumbach, Jane Munro, Nicholas Penny, Uwe Quilitzsch, Jeremy Rex-Parkes, Aileen Ribero, Christopher Ridgway, Ruth Rubinstein, Francis Russell, Peter Schatborn, Jacob Simon, Helen Smailes, Jo Trippa, Clovis Whitfield, Julia Lloyd Williams and Sarah Wimbush.

Sir Brinsley Ford's Archive of material on the Grand Tour, the result of over thirty years' work, is now deposited in the Paul Mellon Centre for Studies in British Art and will be published in the form of a Dictionary of Grand Tourists in 1996. Sir Brinsley has supported this exhibition from the beginning and made several valuable suggestions. His research has enriched this catalogue throughout, and our debt and that of others working on the Grand Tour cannot be repaid. John Ingamells, who is preparing the Dictionary for publication, has patiently permitted us to interrupt his own tight schedule and plunder the files. Also at the Paul Mellon Centre, Brian Allen, Evelyn Newby and particularly Elizabeth Powis have patiently dealt with innumerable queries and requests for assistance.

Our debt to the institutions and staff from whom we have borrowed objects is enormous, and their patience has been greatly appreciated. Our debt to the private lenders, however, is even greater. Unassisted by registrars, they have dealt with reams of paperwork, in addition to welcoming us to their homes and agreeing to part with paintings and objects which leave large gaps on their walls, particularly during a time of year when they will be greatly missed. Their names are listed on page 8, but we would like to add our personal gratitude and appreciation, especially to those who prefer to remain anonymous.

The entire responsibility for incoming loans to this exhibition has fallen on the shoulders of Janice Reading in the Department of Prints and Drawings. She has performed the miracle of dealing with all the loans in addition to her regular responsibilities and we cannot thank her enough. Special thanks are due also to Charles Collinson for undertaking to hang the oil-paintings borrowed from collections outside the Museum.

Other Museum colleagues who have helped us include Maurice Bierbrier, David Buckton, Christopher Date, Aileen Dawson, Michael Downing, Peter Higgs, Susan Hills, Judith Swaddling, Luke Syson, John Taylor and Susan Walker. The descriptions of scarabs in the Department of Egyptian Antiquities and of sealstones in the Department of Western Asiatic Antiquities were provided by Drs Stephen Quirke and Dominique Collon respectively.

Parts of the catalogue text have been read and improved by the following: Lucilla Burn, Hugo Chapman, Lesley Fitton, Antony Griffiths, Ellen Macnamara, William Mostyn-Owen, Judy Rudoe, Gertrud Seidmann, Dyfri Williams and Susan Woodford. Any remaining faults are our own.

For many of the photographs in the catalogue we are indebted to the patience and skill of the British Museum's own photographers, notably Philip (Nick) Nicholls, Stephen Dodd, Ivor Kerslake, John Williams and Graham Javes.

Special thanks go to our editor, Teresa Francis, for sharing all the agony and none of the ecstasy of the making of this catalogue, and for turning it into a very much better book than it would have been without her diligence and determination. Other staff of the British Museum Press who should be thanked include Emma Way, Julie Young and the designer, Harry Green.

On the exhibition side, we are very grateful to Graham Simpson, Teresa Rumble, Paul Goodhead and Gill Hughes of the Museum's Design Office; also to the technical staff of all the British Museum antiquities departments involved in the exhibition, chiefly those of the Departments of Prints and Drawings and Greek and Roman Antiquities, and to the staff of the various sections of the Department of Conservation.

The entire undertaking of exhibition and catalogue could not have been achieved within the time permitted without the tireless assistance of two people in particular, who generously served as special assistants assigned to the project. They are Madeleine Gisler-Huwiler and Carol Blackett-Ord.

Finally, we should like to thank Frances, Paul and Morwenna for making Sir William a welcome, if demanding, guest in our homes and lives over the past twelve months and Sir William Hamilton for being so charming and fascinating a companion.

IAN JENKINS AND KIM SLOAN
January 1996

William Hamilton
and the
'art of going through life'

CARLO KNIGHT

To travellers on the Grand Tour no other city could offer an array of attractions to compete with Naples. The harmonious natural beauty of the splendid Bay remained unspoiled, its loveliness only enriched by other, man-made allurements (see cat. nos 6, 23). The galleries containing frescoes unearthed at Herculaneum allowed the visitor to discover for the first time the marvellous extent of Classical painting. The ruins of Pompeii – which inspired Goethe to exclaim: 'Many disasters have befallen the world, but few have brought posterity so much joy' – similarly appealed to the reigning taste for Classical art and, at the same time, provided models for decoration in the fashionable 'à la grecque' style. And over all this, literally, loomed Vesuvius, whose frequent eruptions offered a spectacle at once splendid and terrifying, a perfect combination of the ideals of the picturesque and the sublime. Further, Naples' 350,000 inhabitants made it the third largest capital in Europe, after London and Paris. In the past they had caused the city to be defined as 'a paradise inhabited by devils', but now they seemed tamer, less dangerous; and the estimated 40,000 devilish, tattered *lazzaroni*, who survived chiefly on alms and often slept in doorways, were now considered more a tourist attraction than a menace.

On 17 November 1764, however, the date of William Hamilton's arrival there, Naples did not show its usual jaunty face. A severe famine followed by an equally terrible pestilence had brought the capital to its knees. In its wake there was a grim atmosphere of mourning and desolation. The poor were visibly dying of hunger; bakeries and other shops were regularly looted and emptied, and robbery and other crimes were rife. This was the picture painted later by the historian Pietro Colletta in his *History of the Kingdom of Naples 1734–1825* (1848; 1st English edn 1858). Hamilton himself, writing to the Earl of Halifax shortly after arriving, explained that the king, as the emergency persisted, chose to postpone his return to the city. Plague victims still crammed the lazarets: 'there are near two thousand in one Hospital crowded together, with no other covering than a shirt which they have worn for months'.[1]

But in southern Italy neither inclement weather nor the dejection inspired by a disaster can last long. And, like the sky over Naples, the city's mood can pass in a few hours from dire grey storm-clouds to a habitual, carefree brightness. As both plague and famine came to an end, the city quickly resumed its customary tone, noisy and full of life. And the tourists returned in throngs, fascinated as before by the natural beauty and the many curiosities: historical, archaeological and artistic.

For about a year, while the threat to public health remained, foreigners had kept well away from Naples. Even Sir James Gray, since 1753 His British Majesty's Envoy Extraordinary to the Kingdom of the Two Sicilies, first went home on leave, then, still afraid of contagion, adduced ill health as an excuse to postpone his return to his duties. Finally, on still more flimsy pretexts, he asked to be replaced. His successor was a young Scottish nobleman, William Hamilton (unafraid, the new envoy had actually insistently requested this assignment). Son of Lord Archibald Hamilton, seventh son of the 3rd Duke of Hamilton, William was born at Park Place, near Henley, on 13 December 1730. There is little to note about Lord Archibald, beyond listing his various offices, from Lord of the Admiralty to Governor of Jamaica; but, as Brian Fothergill has written: 'If Hamilton's father passes as a sort of a cipher, the same cannot be said of his mother'.[2] Lady Jane Hamilton, daughter of the 6th Earl of Abercorn, was regarded, rightly or wrongly, as the mistress of Frederick, Prince of Wales; and this gossip actually carried with it both prestige in society and influence at court. Her appointment

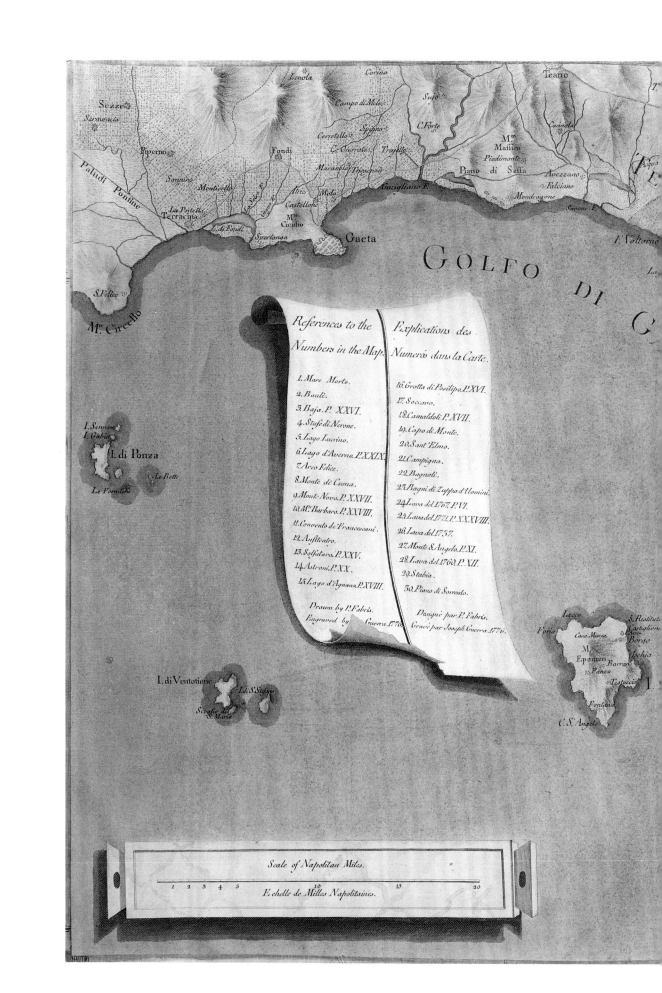

Lenola · Corino · Teano

Sezze · Campo di Mela · Sufo · T.

Sirmoneta · C. Forte · Carinola

Piperno · Cerretells · Spigno · M.^{te} Massico

Fondi · C. Onorata · Trajetto · Piedimonte

Paludi Pontine · Maranola / Triennza · Piano di Sefla · Avezzano

Sonnino · Monticello · Falciano

Atrio · Mola · Guigliano F. · Mondragone

La Portella · Castellone · Savone F.

Terracina · M.^{te} · I. di Fondi · Spuerlanga · Cicubo · Gaeta · F. Volturno

S. Felice · GOLFO · DI · G · Lag

M.^{te} Circello

I. Sennone
I. Gabia · Le Botte

I. di Ponza

Le Formiche

References to the
Numbers in the Map.

Explications des
Numeros dans la Carte.

1. Mare Morto.
2. Bauli.
3. Baja. P. XXVI.
4. Stufe di Nerone.
5. Lago Lucrino.
6. Lago d'Averno. P. XXXIX.
7. Arco Felice.
8. Monte di Cuma.
9. Mont: Novo. P. XXVII.
10. M.^{te} Barbaro. P. XXVIII.
11. Convento de Francescani.
12. Anfiteatro.
13. Solfatara. P. XXV.
14. Astroni. P. XX.
15. Lago d'Agnano. P. XVIII.

16. Grotta di Posilipo. P. XVI.
17. Soccavo.
18. Camaldoli. P. XVII.
19. Capo di Monte.
20. Sant'Elmo.
21. Campigna.
22. Bagnoli.
23. Bagni di Zuppa d'Uomini.
24. Lava del 1767. P. VI.
25. Lava del 1771. P. XXXVIII.
26. Lava del 1757.
27. Monte S. Angelo. P. XI.
28. Lava del 1760. P. XII.
29. Stabia.
30. Piano di Sorrento.

Drawn by P. Fabris.
Engraved by ... Guerra 1776.

Designé par P. Fabris.
Gravé par Joseph Guerra 1776.

Iacco · S. Restituta
Foria · Castiglione
Casa Miccia · Borgo
M.^{te} · Ischia
Epomeo · Barrano
Panza · Testaccio

I. di Ventotiene
I. de S. Stefano

Scoglio di
S. Maria

C. S. Angelo

Scale of Napolitan Miles.

1 2 3 4 5 10 15 20

Echelle de Milles Napolitaines.

FIG. 1 Map of the area around Naples. Hand-coloured engraving by J. Guerra after Pietro Fabris, from *Campi Phlegraei*, 1776, frontispiece. Hamilton's residences were located just below numbers 20 (Palazzo Sessa), 16 (*casino* at Posillipo, later Villa Emma), 27 (Villa Angelica) and near Caserta (upper right).

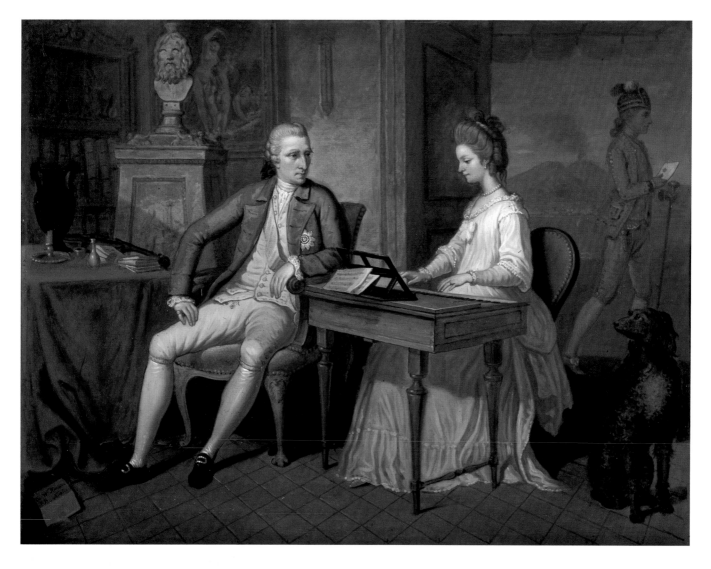

as Mistress of the Robes in the royal household ensured that her son was brought up as another 'foster brother' to the future George III.

At the conclusion of his studies at Westminster School, following the rule that decreed a military career for younger sons, William joined the 3rd Regiment of Foot Guards, but after ten years of army life realised that he had taken the wrong road. Later, recalling that period in conversation with the painter Wilhelm Tischbein, he told how he had participated as a cadet in the war in Flanders. At that time officers still carried the halberd, a kind of short pike, as a symbol of command. 'Once, as he was marching in line', reported Tischbein, 'a bullet carried away the tip of his halberd. It was then that he became aware of his greater aptitude for civilian life than for the military.'[3] In fact, young William preferred the company of artists and literary men to that of his comrades in arms, and instead of fencing lessons, he received instruction on the violin. Leaving his army career, he decided to go

into politics, and to improve his economic situation he thought to follow the customary course of aristocratic younger sons – a marriage of interest.

In 1758, therefore, he married the heiress Catherine Barlow (see fig. 2), an attractive but frail young woman. After six years he realised that his wife's delicate lungs could not support the cold, damp English climate; the doctors warned him that, without an immediate change of air, Catherine's days were numbered. Although William's choice of wife had surely been dictated by economic considerations, he developed a sincere fondness for her, not least because she proved a devoted companion. Consequently, for Catherine's sake, he had no hesitation in giving up the seat he had won in parliament and, having learned that the diplomatic post in Naples was available, he hastened to apply for it. Reports of

famine and plague did not greatly disturb him. Only one thing mattered: Catherine had to breathe the warm, balmy Mediterranean air and recover her health and strength.

When the Neapolitan prime minister Marchese Tanucci communicated the arrival of the new British diplomatic representative to Charles III of Spain, father of the King of Naples, he mentioned that Hamilton had already won a 'deserved and universal respect' in Naples. And this was true: Hamilton not only appreciated Neapolitan high society, but also enjoyed the sharp wit and somewhat impertinent cordiality of the populace. The Envoy Extraordinary leased an official residence, Palazzo Sessa, in the most elegant quarter of the capital, the Villa Angelica near Portici, and also a *casino* ('little house') by the sea, on the beach of Posillipo (after Catherine's death in 1782, he named the latter Villa Emma after his second wife). In Palazzo Sessa the young diplomat

FIG. 3 The Palazzo Sessa, Sir William's residence at Naples.

immediately felt at home, as if he foresaw a long stay there; in the bedroom he had an emblematic Latin motto affixed: 'Ubi bene, ibi patria' (where I am at my ease, there is my homeland).[4] The Palazzo Sessa was both home and museum to Sir William. He kept the most important of his extensive collection of paintings there, and twice filled it with a collection of antiquities. The Posillipo *casino* (see cat. no. 23) which, unlike Palazzo Sessa, enjoyed an exceptional view of Vesuvius, served him for observing the behaviour of the volcano and, above all, for sea-bathing. In 1780, writing to his nephew Charles Greville, Hamilton described his pleasant *train de vie*: 'I roll luxuriously in the sea every morning and we dine at our Casino at Pausilipo every day, where it is as cool as in England. Spring and autumn we inhabit our sweet house at Portici, which you remember, and in winter I follow the King to Caserta and the Apennines after wild

boars, etc.'[5] Sea-bathing at that time was among the favourite pastimes of the English in Naples, and the traveller Patrick Brydone, writing in May of 1770, was no exception to the rule:

> Sea-bathing we have found to be the best antidote against the effects of the sirocco; and this we certainly enjoy in great perfection. Lord Fortrose, who is the soul of our colony here, has provided a large commodious boat for this purpose. We meet every morning at eight o'clock, and row about half a mile out to sea, where we strip and plunge into the water … My lord has ten watermen, who are in reality a sort of amphibious animals [*sic*], as they live one-half of the summer in the sea. Three or four of these generally go in with us, to pick up stragglers, and secure us from accidents. They dive with ease to the depth of forty, and sometimes of fifty feet, and bring up quantities of excellent shell-fish … After bathing we have an English breakfast at his lordship's, and after breakfast a delightful little concert, which lasts for an hour and a half.[6]

Hamilton also had his watermen, ready to perform for him and his guests like 'amphibious animals'. Tischbein, writing to Goethe in July 1787, said:

> Day before yesterday I went with Cavaliere Hamilton to Posillipo, to his villa. It is impossible to see anything more splendid. After dinner a dozen boys flung themselves into the sea: a very beautiful spectacle, with the many groups and various positions they assume in play among themselves. The Cavaliere pays them specially, to provide his entertainment every afternoon.[7]

The 'sweet house at Portici' or Villa Angelica, which Hamilton leased at the foot of Vesuvius, was his vulcanological observatory (see cat. nos 20–21). The musicologist Charles Burney, who visited this Vesuvian dwelling with Captain Forbes in October 1770, discovered it to be 'a small house' with a 'large garden, or rather vineyard, with most excellent grapes'.[8] The evening that Burney and Forbes spent in Hamilton's company proved exceptionally pleasant:

> After dinner we had Music. … As soon as it was dark, the Musical entertainment was mixed with the sight and observation of Mount Vesuvius, then very busy. Mr. Hamilton had glasses of all sorts, and every convenience of situation etc., for these observations, with which he is much occupied. … Though at three miles distance from the mouth of the mountain, we heard the reports of the several explosions before we saw the stones and red-hot matter thrown up by them … . The sight was awful and magnificent, resembling on a great scale the most ingenious and splendid fireworks I ever saw … . After supper we had a long dish of musical talk … . Music was not wanting, as Mr. Hamilton has two pages of his household who are excellent performers, one on the violin, and the other on the violoncello.[9]

FIG. 4 *The Hon. Charles Francis Greville*. Mezzotint, 1810, by Henry Meyer after George Romney (cat. no. 49).

Music represented more than a simple pastime for Hamilton, who had learned to play the violin in London under the composer-performer Felice Giardini, and who kept a box at the Teatro San Carlo (for which he paid 77 ducats annually). Catherine, too, was a fine harpsichord player. Lady Anne Miller, after attending a musical evening in Palazzo Sessa, had noted: 'Mrs. Hamilton's musical assembly, which she gives once a week, is rendered perfect by her elegant taste and fine performance; it is called an *Accademia di Musica*, and I suppose no country can produce a more complete band of excellent performers.'[10] Other members of Hamilton's 'Accademia' (whose payment chits have survived in the British Library, Add. MS 40,714), included the violinist and composer Emanuele Barbella and a certain Gennaro Alessandro. Once Hamilton confided to his nephew: 'I supped in private *en famille* with the King and Queen of Naples lately, after having accompanied His Sicilian Majesty's singing, and charming harmony we made. The Queen laughed, for she really sings well.'[11] A painting by Pietro Fabris (cat. no. 16) portrays such a scene: in the Neapolitan residence of Lord Fortrose a chamber concert is in progress – the host, standing with his back to us, is listening to William Hamilton and the musician Gaetano Pugnani, both playing the violin, while Leopold

Mozart and his very young son Wolfgang (visiting Naples in May 1770) accompany the two gentlemen on the harpsichord.[12]

Hamilton's *casino* in Caserta, not far from the royal palace, was devoted, on the other hand, to the ambassador's favourite sport: shooting. The mountainous Tifatina area nearby offered an abundance of game, and from there it was relatively easy to reach the wild forests of the Abruzzi. Thus Caserta represented an ideal base for what was also Ferdinand IV's main pastime (see cat. no. 7). The diplomat, who possessed excellent guns imported from England, was a fine shot and soon became a frequent companion of the sovereign. In 1775 Sir William (made Knight of the Order of the Bath three years previously) wrote to Greville: 'Tomorrow we go to Caserta, for the King has invited me to all his shooting parties which are going to begin; and then I am to go to Persano for the same purpose. In short, my favour is very great.'[13] The royal hunts were always exciting. Hamilton wrote to Greville:

> I believe I formerly gave you a description of the life we led at Persano when I was with His Sicilian Majesty at a boar shooting there. We are just returned from such another party at Venafro on the Apennines, where we have been these three weeks, and where we have been from morning to night without intermission persecuting boars, wolves, chevreuil, and foxes (of which we have slain above 1000); 613 wild boars, some most enormous and very fierce, which made it necessary for us to be entrenched, for, if they do not fall, upon being wounded they usually come directly upon you. We have had two men wounded and numberless dogs killed.[14]

These expeditions at times assumed great dimensions, comparable to a military campaign: 'Some days we had no less than 1000 men and 800 dogs in the woods, with drums, cowhorns, grenades, etc. to drive the boars out of their impenetrable cover.'[15] Hamilton had become such an accomplished sportsman that he received official recognition from 'His Highness the Prince of Dietrichstein Proskau, Grand Master of the Noble Society of Diana the Huntress in Vienna'. The prince had sent him a diploma, in Italian, declaring himself happy, 'in view of his revealed skill', to consider him 'enrolled among the ranks of his fellow members'.[16] But nothing gave Sir William greater satisfaction than Ferdinand IV's compliments on his unerring aim. 'The king told me *Senza adulazione, avete sparato come un angelo* [without flattery, you shot like an angel]', he once proudly informed Greville, adding: 'which I suppose is the greatest compliment he could possibly pay me, for when we talk of great men it is always understood in the sporting sense. A good shot is a great man with us; in short, we do nothing else nor talk of anything else.'[17]

In February 1782 the future Tsar Paul I and his wife arrived in Naples, and among the various festivities arranged, a hunting party was organised in their honour. The Grand Duke, however, declined the invitation for reasons of health, leaving Ferdinand IV much put-out: 'The King was greatly disappointed that the Grand Duke would not accept of his invitation to a shooting party at Persano, fifty miles from Naples, and which he had been preparing for two months at the expense of 14,000 Neapolitan ducats.'[18] The expense was enormous, the equivalent of a high official salary for twenty years. Thousands of men had been employed for over two months, successfully collecting within a restricted area over 500 boars and 1,500 stags, as well as a huge quantity of foxes and hares. The king could not swallow this refusal, and sought Hamilton's help, so that the investment would not be wasted: '[The King] was determined not to lose his labour & cost, so he left his Imperial guests to the care of the Queen, and staid a week, shooting every day, before he could demolish the game he had shut up.'[19] Hamilton, however, could keep him company only for one day, since their Imperial Highnesses had expressed a wish to make an excursion to Vesuvius. Naturally the guide's role fell to the diplomat, who was Vesuvius's great expert, but he was unable to take the guests all the way to the crater: 'Their Imperial Highness[es] were quite knocked up on Mount Vesuvius, without being able to get up the mountain. The Duke's lungs are very weak, and his body ill formed and not strong, and the Duchess is rather corpulent. However, the novelty pleased them. The Duchess' feet came through her shoes, but I had luckily desired her to take a second pair.'[20]

A few weeks later, in April 1782, the state of Catherine's health, still fragile despite the move to Naples, began to cause serious concern. Since the beginning of the year she had suffered a mysterious feverish condition that the doctors had declared of 'bilious' origin. Some respiratory trouble made matters worse and led Hamilton, who for seven years had occupied only the first and second floors of Palazzo Sessa, to make use also of the attic. Thus his wife would have a more airy bedroom, with a spacious view (see fig. 3). For permission to create windows, which would overlook the garden of the Nunziatella military academy, a request had to be forwarded to the administration of the Royal Household. The petition was presented by the Marchese Sessa, who explained that 'the state of Milady Hamilton's health required a comfortable apartment and a high and airy bed chamber'.[21] However, before the improvements could be made, Catherine's condition grew still worse; so, at the beginning of summer, to allow her to breathe pure air, Sir William decided to take her to the country, to Villa Angelica.

On 8 July Catherine seemed to feel better. Her dear friend William Beckford, who had been the Hamiltons' guest two years earlier in Caserta and had now accepted their invitation to spend a few weeks at the Villa Angelica, proposed to her a drive in the carriage: 'The morning, refreshing and pleasant, invited us at an early hour into the open air.'[22] The coach proceeded at a trot to the 'royal Bosquetto [sic]', in an area reserved exclusively for the king's shooting, 'no other unroyal carriage except for Sir William's being allowed to enter its alleys'. There the coachmen slowed the horse to a walk 'amidst wild bushes of ilex and myrtle', to allow the passengers to admire 'a rude knoll where the rabbits sit undisturbed, contemplating the blue glittering bay'.[23] This was probably Catherine Hamilton's last outing: she died a month later, on 25 August 1782. On 20 September Sir William wrote to the Marchese della Sambuca for a sad authorisation: 'As a Swedish vessel is about to sail for Ostend and will convey there the corpse of the late Milady Hamilton, to be interred in the tomb of her ancestors, the Cavaliere Hamilton requests ... that a Royal permit be granted so that there will be no impediment from the Customs to this shipment.'[24]

Sir William mourned Catherine's death far more than might have been foreseen. Fothergill has written that 'what Hamilton missed and missed deeply, was the presence of a dear friend and companion in whose company his life had been spent for the past quarter of a century'.[25] In his official engagements, he could find no source of distraction: Naples, as a diplomatic post, remained secondary to Paris, Vienna or Madrid (nor could he have imagined that the Napoleonic wars would soon greatly increase its strategic importance). In the spring of 1783 Hamilton visited Calabria in order to report to the Royal Society on the effects of an earthquake. Shortly afterwards he left for England to see to his wife's interment and to organise her estates in Wales. After his return to Naples at the end of 1784 some new diversion had to be found, an antidote to his ennui, something to help him shake off the burden of solitude. And it was these considerations that led him, in 1785, to try to convince Queen Maria Carolina to create in Caserta the first Italian 'landscape garden'. If he were to succeed in having the supervision of that garden assigned to himself, Sir William would have a pleasant occupation against the day when he wearied of collecting Greek vases and works of art, and when old age would prevent him from continuing his arduous ascents of Vesuvius.

At that time the art of the 'informal' garden had spread from England, its country of origin, to other parts of Europe, though it was slow to take root in Italy. The resistance was not difficult to understand: it was hardly to be expected that the home of the 'classic' garden would readily welcome a novelty opposed to its own tradition. For this reason Sir William was relying on Maria Carolina, as a cosmopolitan

member of the Neapolitan court who was receptive to foreign cultures. As Hamilton had foreseen, the idea of a garden 'à l'anglaise' immediately appealed to her. First of all, she liked to compete with her sister, the Queen of France, who had already created such a garden at the Petit Trianon at Versailles. Furthermore, Maria Carolina eagerly looked forward to the pleasure 'of surprising the King some day with a plate of fruit out of her Garden much superior to his'.[26]

Writing to his friend Sir Joseph Banks (see cat. no. 40), the illustrious botanist and President of the Royal Society (to which Hamilton himself had long been sending papers on the activity of Vesuvius), the envoy explained the reasons for his interest: 'I promise myself great pleasure in this new occupation. As one passion begins to fail, it is necessary to form another; for the whole art of going through life tollerably in my opinion is to keep oneself eager about anything. The moment one is indifferent *on s'ennuie*, and that is a misery to which I perceive even Kings are often subject.'[27]

After agreeing to collaborate on the project as a consultant, Sir Joseph Banks was delighted when, on 20 February 1785, Hamilton wrote to him to confirm that finally all was ready. Now they had only to begin: 'The Queen of Naples has adopted my project, and has given me the commission to send for a British Gardiner and Nurseryman, ... a man of sense and high in his profession.'[28] Fundamental was the queen's willingness to assume the financial burden of the undertaking: 'she told me she would allot out of her privy purse about 100£ Sterling a month for her garden; all this to be done without the King's interference'.[29] Sir Joseph was to choose the right man, supply him with everything he needed, and send him to Naples as soon as possible: 'I should think he would do well to bring a young man also as foreman Also a set of implements for gardening (by way of Models at least) should be brought Seeds, plants, etc. should also be brought, to lose no time.'[30]

Banks replied promptly. A short time later Hamilton learned that Sir Joseph had found an excellent gardener, a disciple of William Kent, one John Andrew Graefer, who was prepared to move to Naples immediately. He had splendid references. A pupil of the celebrated Philip Miller, Graefer had worked first as a gardener to the Earl of Coventry, then for the rich merchant James Vere. Further, he had expanded his botanical knowledge by collaborating with the nurserymen Thompson and Gordon of London. Everything was proceeding as planned, except Graefer's departure for Naples, which was not as prompt as Hamilton would have wished. Banks intended to send Graefer on a certain ship, which then ran into a series of difficulties. The sailing was constantly postponed, the captain producing new excuses every time.

Thus the gardener did not reach Naples until 18 April 1786, but the next day he was already at Caserta with Sir William, looking over the chosen terrain. Describing the land to Banks five months later, Hamilton said (with some exaggeration): 'Our piece of Ground is upwards of 50 Acres, and has every capability, the richest soil imaginable, and command of the purest water.'[31] In reality, as Graefer was quick to see, it was a strip 1 kilometre long and only 300 metres wide, its shape anything but ideal; and its southern portion, being absolutely flat, allowed very little opportunity for picturesque results. Nevertheless, the gardener accepted the challenge. By shifting some earth, a few small hills could be created; and the land's most impressive resource, a monumental aqueduct providing abundant water, would allow a brook to run through the garden, with a series of little cascades and even an enchanting lake. The final result would astonish everyone.

A week after Graefer's arrival, on 26 April 1786, Sir William Hamilton received at Palazzo Sessa a young woman who had just come from England; she was destined to bring him much joy but also much bitterness. An extraordinary beauty, she went by the name of Emma Hart.[32] Hamilton had met her in London three years previously, during his stay there following his wife's death. At that period Emma was the mistress of Charles Greville, Hamilton's nephew and, despite their difference in age, also probably his closest friend (see cat. nos 49, 50). An enthusiastic amateur of art and of natural history, Charles accompanied his uncle on visits to London's antiquaries and booksellers, to the sales at Christie's, and to the British Museum. Above all, Charles knew how to cheer his uncle's spirits, on occasion inviting Sir William to take tea at a little house in Edgware Row, where he had established his charming nineteen-year-old mistress. On these visits the middle-aged diplomat seemed particularly pleased to sip the invigorating beverage prepared by Emma with her own fair hands. To be sure, the girl's background was humble, and despite her eagerness to learn she was unable to conceal her ignorance. But besides beauty she possessed other qualities: she was straightforward, sweet and full of gaiety.

Sir William enjoyed himself, flirting playfully with 'the fair teamaker', as he dubbed Emma, while she responded by calling him 'uncle'. But, though the situation did not allow anything further, Emma's classic beauty, recalling that of an ancient statue, could not leave Hamilton indifferent. Even after his return to Naples, Sir William was unable to dispel Emma's features from his mind, suggesting to him as they did the profile of a Greek goddess carved on a cameo (see fig. 5). Finally, in January 1785, he received a letter from Greville in which he hinted at certain economic difficulties: 'I am not quite of an age to retire from bustle, and to retire to distress

and poverty is worse.'[33] The obvious solution would be a suitable marriage 'to a lady of at least £30,000',[34] even if the idea of losing his freedom did not greatly attract him: 'If I was independent I should think so little of any other connexion that I never would marry.'[35] In this event the problem would be 'how to fix Emma to her satisfaction'; even if, assured Charles: 'on the least slight or expression of my being tired or burthened by her, I am sure she would not only give up

the connexion but would not even accept a farthing for future assistance'.[36]

In March Greville made the plan clearer, adding that it would be greatly facilitated if his uncle would take Emma off his hands, making her his mistress: 'If you did not chuse a wife, I wish the tea-maker of Edgware Row was yours.'[37] After all, 'at your age a clean and comfortable woman is not superfluous'.[38] A few simple precautions, such as living at

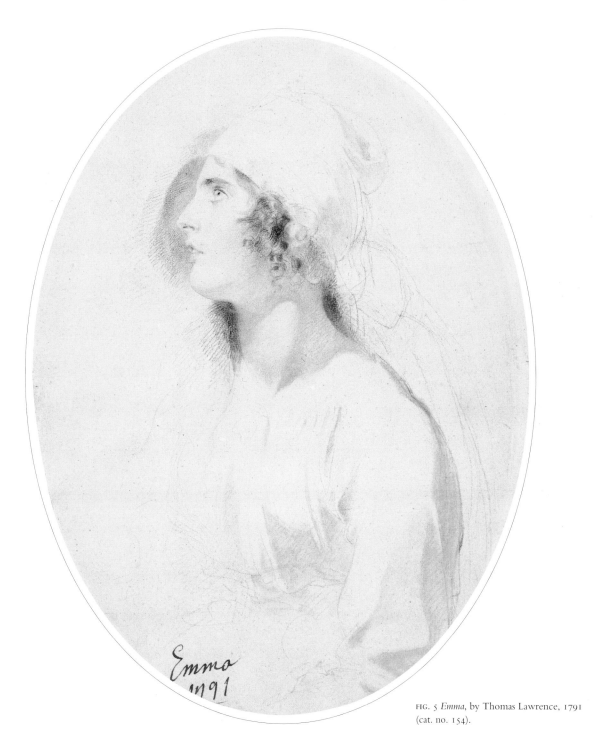

FIG. 5 *Emma*, by Thomas Lawrence, 1791 (cat. no. 154).

separate addresses, would suffice to avoid scandal: 'If you had given her any of your villas, only making it a decided part that she had a home distinct from your house, whether her visits were frequent or rare was immaterial, her home would be distinct.'[39]

Hamilton's first reaction was negative, not so much because of the immorality of the plan as for the risk it involved: 'Tho' a great City, Naples has every defect of a Province and nothing you do is secret. It would be fine fun for the young English Travellers to endeavour to cuckold the old Gentleman their Ambassador, and whether they succeeded or not would surely give me uneasiness.'[40] But Greville was able to convince him: 'What you say of Naples is true. As I told you in my former letter, every inconvenience must be of your own making. Give her one of your villas, or rather take a small retired house on the Hill at Naples, very small; she will not want to go about. . . . As to Englishmen, there is nothing to fear; left to herself, she would conform to your ideas.'[41]

In November 1785 Greville explained to his uncle that 'I did not increase Emma's uneasiness by any hint of the subject of our last correspondence. At any rate, it cannot take place before the spring.'[42] But still the moment of decision was approaching: 'I can assure you she would not have a scarcity of offers.'[43] At this point, abandoning any resistance, Hamilton gave his consent; and a month later Greville sent him the particulars of the plan: 'The absolute necessity of reducing every expence . . . and to pay the interest of my debt without parting with my collection of minerals . . . occasion'd my telling Emma that I should be obliged on business to absent myself for some months in Scotland.'[44] The young woman, though saddened by the news, was consoled when he suggested to her a Neapolitan visit, to last six to eight months, in the company of her mother: 'She naturally said that . . . she should be very miserable during my absence',[45] but at the same time she agreed that 'my absence would be more tolerable if she had you to comfort her'.[46] Emma and her mother, accompanied by the artist and antiquarian Gavin Hamilton, would travel by diligence (public stage-coach) to Geneva. There they would hire a two-wheeled chaise, and thus they would arrive comfortably in Rome. The expense of the journey to Geneva, a total of 30 guineas, would be assumed by Charles, as a token of his fondness for his uncle. Further, he would take care of shipping Emma's baggage to Naples, after he had filled any gaps in her wardrobe: 'she has a good stock of everything, and I shall add some linnen which is rather wanted'.[47] Greville once again reassured his uncle: 'You will be able to have an experiment without any risque. If it should not turn out as I expect, she will have profited by seeing a little of foreign parts.'[48] In any case, it would be a pleasant experiment for Sir William: 'She is the only woman I ever

slept with without having ever had any of my senses offended, and a cleanlier, sweeter bedfellow does not exist.'[49] On 26 April 1786, her twenty-first birthday, ignorant of Greville's plot, Emma arrived in Naples.

Hamilton announced her arrival to Sir Joseph Banks in botanical terms: 'A beautiful plant called *Emma* has been transplanted here from England, and at least has not lost any of its beauty.'[50] In fact, two important events in Sir William's life – the birth of the Caserta garden and Emma's arrival – were taking place at the same time; and this simultaneity can appear symbolic. It is possible to see the romantic garden as destined to become an ideal setting for an exciting amorous adventure – only the intervention of fate, indeed, could explain the miraculous rapidity of the garden's development. By the beginning of September 1786 eighty gardeners were working under Graefer. The winding stream was already beginning to flow, apparently rising from an underground source beneath the roots of a yew (fig. 103). The stream was to be traversed by a pair of delightful little bridges, then, after being displayed in a picturesque cascade, to flow into a small lake with two decorative islands. The irrigation system was intended to exploit the terrain's slope, remaining virtually invisible. Hamilton later described its mechanism to Banks: '[The ground lies] on a gently inclined plain, with plenty of water from the great aqueduct at the upper part, so that it can be conducted to the foot of any tree or plant, and the turf can be overflowed at pleasure, so that it is not burnt up even in the month of August.'[51]

Matters with Emma went less well, however. She realised that she had been duped and wrote to Greville, expressing herself in her own ungrammatical manner and trying in vain to move him: 'I am poor, helpless and forlon. I have lived with you 5 years, and you have sent me to a strange place, and no one prospect, but thinking you was coming to me. Instead of which, I was told to live, you know how, with Sir William. . . . I have been from you going of six months, and you have wrote one letter to me – enstead of which I have sent fourteen to you. So pray, let me beg of you, my much-loved Greville, only one line from your dear, dear hands.'[52] Seeing that her pleas achieved nothing, Emma tried anger and outrage. In a subsequent letter she expressed all her fury to her former lover: 'Nothing can express my rage! I am all madness! Greville, to advise me! – you, that used to envy my smiles! How, with cool indifference, to advise me to go to bed to him, Sir William!'[53]

But her desperation could not last forever. And when resignation followed it, Hamilton – who until then had displayed philosophical understanding – remarked on the change in a letter to Banks: 'My *visitor*, for you must know I have one, is as handsome as ever, and in tolerable spirit

considering all. It is a bad job to come from the nephew to the uncle; but we must make the best of it.'[54] In fact, Hamilton saw in Emma not so much a mistress as a masterpiece of nature, a precious object added to his collections. Goethe, when he visited the cellar storerooms of Palazzo Sessa, noted 'a chest, standing upright, its front removed, the interior painted black, set inside a splendid gilt frame'. There Emma would strike poses, with the talent of an actress, and 'dressed in various colours against this black background, enclosed in the gold frame, she would imitate the antique paintings of Pompeii or even more recent masterpieces' (see cat. nos 158–61).[55]

In the meanwhile the Caserta garden, though work continued, came up against some difficulties. Already in 1788, after only two years and despite Graefer's splendid achievements, Queen Maria Carolina made it clear that she had tired of her costly toy. Consequently, Hamilton was dismissed, and Graefer pensioned off: 'The Queen dismissed me and Graefer in form, by a letter to me under her own hand.'[56] Just when it seemed that the venture was miserably dying, however, a providential and unexpected *deus ex machina* intervened: King Ferdinand himself, to general surprise, reimbursed his wife the 40,000 ducats already spent and declared that from then on the garden would be his concern. Unfortunately, however, for all Graefer's skill (typically, in only three months, as Hamilton informed Banks, he had caused a camphor tree to grow almost two metres), the king continued to doubt the value of an informal garden. To derive some sort of profit from his money, he demanded that Graefer replace the perfect lawns (the result of enormous efforts) with fields of maize. And, to the gardener's dismay, he ordered a horribly jarring note to be added: 'The first improvement the King of Naples is going to make in the English Garden is to make a Labyrinth, that he may have the fun of bewildering his Courtiers therein. Graefer is at a loss for a plan of one, and I can only help him by shewing one on an antique medal.'[57]

Fortunately, however, even if in 1788 the signs of political storms coming from France might have suggested an increased military expenditure in the Kingdom of the Two Sicilies, the king would not economise on his English Garden (see cat. nos 182–3). In that year, in fact, Graefer made frequent expeditions into the provinces of the realm, climbing into the Lattari and other mountains in the Matese area, and combing the coastal areas of Baia, Capri and Gaeta in search of plants for Caserta. And throughout 1789, though echoes of the grim events of that Parisian summer also reached Naples, work on the English Garden proceeded apace. Then in 1791 – the year Sir William married Emma – the labyrinth was enhanced by the addition of a little circular temple, and an apiary (to produce honey for the royal table)

FIG. 6 'Diana's Grotto', also known as the 'Bath of Venus', in the English Garden at Caserta.

was established in a vast basin that was to 'supply the gardens and the royal apartments if work had to be done on the Acquedotto Carolino'. Finally, with the *Criptoportico* and the 'Bath of Venus', Graefer created an area rich in light and shade, where the visitor, emerging from a dark gallery bedecked with ancient statues, was plunged into dazzling sunlight, reflected by the surface of a pool surrounded by luxuriant vegetation (see fig. 6 and cat. no. 183). The groundbreaking necessary for the creation of the Swan Pond was carried out after 1792, while the *casino* designed to be Graefer's house was finished in 1793, the year in which Queen Marie Antoinette, sister of Maria Carolina, was guillotined in Paris.

All were now convinced that the bloody events in Paris would soon affect Italy. The monarchies of Europe had declared war on republican France, and Naples became a clear military objective. In 1793, fearing a possible French naval bombardment, the Neapolitan court moved to Caserta, where they sought in the serene charm of the locality and the gaiety of social life to stifle the din of arms. Never before had the palace of Caserta seen so many balls, banquets and receptions. In 1794, however, even an optimist like the Neapolitan king could no longer ignore the imminent threat, and he decided to improve the defences of the kingdom. The increased military expenditure made drastic economies necessary in every area, and the English Garden was suddenly deprived of funds. Only a couple of years' neglect sufficed to cause immense

damage, and in 1797 Hamilton wrote to Banks about the disastrous situation:

> I am now in Graefer's house at the English Garden, which is on an elevation and in much better air than my house at Caserta. For two years past the King of Naples had put a stop to every thing here, all money being required to raise an army, and did not even leave enough to keep up the part of the Garden that was finished. Poor Graefer, seeing all going to ruin, was so affected that he took to his bed, and was really in a desperate situation.[58]

Fortunately, to mitigate the disaster, the queen stepped in, drawing on her private funds to give Graefer the equivalent of a hundred pounds. Not enough to continue the work, but sufficient to arrest a deterioration that otherwise would have become irreversible.

Like the other Neapolitan royal properties, the English Garden also suffered the consequences of the Neapolitan revolution of 1799, after Sir William and Emma had embarked on Nelson's flagship and, like the royal family, sought refuge in Sicily. Graefer, fleeing with them, had been appointed by Nelson overseer of the Duchy of Bronte.[59] Graefer's three sons (Giovanni, Carlo and Giorgio) remained in Caserta, and did their best to save the garden during the tumultuous events that followed. The three youths witnessed the French invasion and the ill-fated Neapolitan Republic, fearing for their lives during the bloody time of the restoration. They somehow survived the long 'French decade' until, in 1815, the Bourbon rulers could finally return to Naples.

In the meanwhile, in 1800, after the nightmarish events in the Bay of Naples and the explosion of the scandal provoked by Emma's liaison with Nelson, Hamilton gave up his diplomatic career. In Palermo Emma was to be seen always 'at a table of *trente et quarante*, her cheeks flushed, as she staked gold with both hands', while Nelson 'was constantly seated behind her, his one hand resting on the back of her chair, not taking part in the game or addressing a word to anyone'.[60] Hamilton then had to return for good to London, where his residence at no. 23 Piccadilly, while quite comfortable, was hardly comparable with the luxury of Palazzo Sessa or the villas in Caserta and Posillipo that had enhanced his leisurely Neapolitan life. Now old and ill, he was content with such activities as visiting the British Museum, an occasional auction, the meetings of the Royal Society, and fishing on the Thames. In short, it would have sufficed if his wife had left him in peace. But Emma was enjoying her moment of glory, and had no thought of renouncing anything. She gave continuous receptions, gambled, made absurd purchases. In consequence, money ran out and debts mounted. Sir William tried to make her see reason – a touching note reads: 'I am arrived at the age when some repose is really necessary, and I promised myself a quiet home, altho' I was sensible . . . that I shou'd be superannuated when my wife wou'd be in her full beauty and vigour of youth. That time is arrived, and we must make the best of it for the comfort of both parties.'[61] His age, to be sure, did not grant him time to waste ('as I cannot expect to live many years, every moment to me is precious'), but that meant also 'the probability of my not troubling any party long in this world'. Emma had only to be patient a little: 'let us bear and forbear for God's sake'.[62] But the sweet 'tea-maker of Edgware Row', now ambitious and calculating, would not hear this reasonable proposal. A year before, after the secret birth of their daughter in January 1801, Nelson had written to her (calling her 'Mrs. Thomson' and referring to himself in the third person, to confuse any reader if the letters were intercepted): 'If your uncle [Sir William] would die, he [Nelson] would instantly come and marry you.'[63]

The lovers, perhaps unconsciously, missed no opportunity to let Sir William know what an obstacle his presence was. And given his natural discretion, we may legitimately suppose that he offered little resistance when, on 6 April 1803, he felt death approaching. Nelson, who was present with Emma at the end, informed his friend Alexander Davison that Sir William died 'without a sigh or a struggle'.[64] Even the hour of his exit, 'ten minutes past ten, this morning', was convenient for all, as if it had been discreetly arranged by the aged diplomat.

TRANSLATED FROM THE ITALIAN BY WILLIAM WEAVER

NOTES

1 British Library, Egerton MS 2634, ff. 4–5. Letter of 4 December 1764.
2 B. Fothergill, *Sir William Hamilton Envoy Extraordinary*, London, 1969, p. 22. This excellent biography has greatly helped to foster recent study of Hamilton.
3 Schiller, II, p. 102 ff.
4 Schiller, op. cit.
5 Morrison, no. 92.
6 P. Brydone, *A Tour through Sicily and Malta*, London, 1776, pp. 10–12.
7 J. W. Goethe, *Italienische Reise*, Berlin, 1988, p. 359. English-language version by W. H. Auden and Elizabeth Mayer, London, 1962.
8 Scholes, *Burney*, I, p. 260.
9 Ibid.
10 A. Miller, *Letters from Italy*, London, 1775, II, p. 226.
11 Morrison, no. 58.
12 D. A. D'Alessandro, *Mozart a Napoli: una testimonianza iconografica?*, Naples, 1991.
13 Morrison, no. 58.
14 Morrison, no. 101.
15 Ibid.
16 British Library, Add. MS 42,069, f. 116.
17 Morrison, no. 101.
18 Morrison, no. 115.
19 Ibid.
20 Ibid.
21 Letter from Hamilton to the Marchese della Sambuca, 24 April 1782, with attached memorandum from the Marchese Sessa. Archivio di stato, Napoli [ASN], Esteri 683.
22 W. Beckford, *Italy, Spain, and Portugal*, London, 1840, pp. 144–5.
23 Ibid.
24 ASN, Esteri 683.
25 Fothergill, p. 182.
26 British Library, Add. MS 34,048, ff. 22–3. Letter to Sir Joseph Banks of 20 February 1785.
27 British Library, Add. MS 34,048, ff. 24–5. Letter of 3 May 1785.
28 British Library, Add. MS 34,048, ff. 22–3. Letter to Sir Joseph Banks of 20 February 1785.
29 Ibid.
30 Ibid.
31 British Library, Add. MS 34,048, ff. 31–3.
32 Partly because her real name, Emy Lyons, was associated with past scandals she preferred to forget; and partly because 'Emma' sounded better and more elegant (her mother, on the other hand, probably for similar reasons, went by the name of Mrs Cadogan).
33 Morrison, no. 134.
34 Morrison, no. 137.
35 Morrison, no. 134.
36 Ibid.
37 Morrison, no. 136.
38 Morrison, no. 137.
39 Ibid.
40 British Library, Add. MS 42,071, f. 4.
41 Morrison, no. 138.
42 Morrison, no. 139.
43 Ibid.
44 Morrison, no. 142.
45 Ibid.
46 Ibid.
47 Ibid.
48 Ibid.
49 Ibid.
50 British Library, Add. MS 34,048, f. 30.
51 British Library, Add. MS 34,048, ff. 86–91.
52 Morrison, no. 152.
53 Morrison, no. 153.
54 British Library, Add. MS 34,048, ff. 31–3.
55 Goethe, op. cit., p. 331.
56 British Library, Add. MS 34,048, ff. 48–9.
57 British Library, Add. MS 34,048, ff. 57–9.
58 British Library, Add. MS 34,048, ff. 86–91.
59 Where he died in 1802.
60 M. Palmieri De Micciché, *Moeurs de la Cour et des Peuples des Deux Siciles*, Paris, 1837, p. 40.
61 Morrison, no. 684.
62 Ibid.
63 Morrison, no. 513.
64 N. Harris Nicolas, *The Dispatches and Letters of Vice Admiral Lord Viscount Nelson*, London, 1845, V, p. 56.

'Observations on the Kingdom of Naples'
William Hamilton's
Diplomatic Career

KIM SLOAN

William Hamilton was British envoy to the court of King Ferdinand IV for some thirty-seven years.[1] While in terms of British foreign policy Naples was never considered among the most prestigious or important postings, Hamilton's official position was far from a sinecure, and his other activities – as a collector, connoisseur and scientific amateur – must be seen in the context of an active and often demanding diplomatic career. In time Hamilton became the most senior foreign diplomat at the Neapolitan court, and his close personal contacts with the king and queen placed him at the centre of political and cultural developments in the Kingdom of the Two Sicilies during this period.

During the eighteenth century Italy and its ports were of some economic importance to Britain, both as markets for British wool and manufactured products and as the conduits for goods coming from the Middle East. Culturally, Italy was even more significant, not only as the well-spring of the Classical and Renaissance periods on which so much of British culture and learning was still based, but also because many members of Britain's ruling classes spent some part of their education 'on Tour' in Italy. Politically, however, apart from the Pope's support of the Scottish Pretenders to the British throne in the first half of the century, the Italian peninsula's various kingdoms and duchies were not directly of great consequence to Britain. Until the 1790s, when France began to invade Italy and Britain joined Austria and Spain in treating the various kingdoms as pawns in a larger European game, the Kingdom of the Two Sicilies was only of concern to Britain for its status as a satellite of the greater power of Spain, for its trade and commercial benefits, and, in particular, as one of the most magnificent sights on the Grand Tour.

During the first half of the eighteenth century, the Spanish Bourbons under Philip V, his queen Elisabetta Farnese and their son Charles, and the Austrian Habsburgs under Charles VI and then his daughter Empress Maria Theresa, fought for control of the most important states in Italy, with France fluctuating in its support of both powers. In 1748 the Peace of Aix-la-Chapelle settled matters more finally, leaving the Grand Duchy of Tuscany to Austria and the Spanish in control of the Duchy of Parma. The treaty confirmed the younger son of the King of Spain on the throne of Naples, which he had occupied since 1734 as Charles III, King of the Two Sicilies. This latter kingdom consisted of Sicily, Naples and the entire southern half of the Italian peninsula, and the empty title King of Jerusalem gave him, though in name only, control of Malta as well.[2]

With peace and settled relationships with the rest of Europe came a growing hope among the intellectuals in Italy that they might finally begin to leave behind the formalities and the rigidly stratified control of government by the nobility and move towards the advances of the European Enlightenment.[3] In the first half of the eighteenth century France was viewed as the centre of new ideas of reform, but, as the century drew on, the French and the Germans increasingly came to admire many British institutions, philosophers and 'scientists'; ruled by a parliament under a monarchy of very limited power, Britain began to be looked upon as a model of a progressive society, which permitted social mobility and economic viability in both town and country.[4] However, apart from the availability of a few translations of Locke and Newton, and the constant invasion of certain cities by English *milordi*, whose beneficial impact on local culture was minimal (although through *conversazioni* some managed to meet a few of the local nobility), the opportunities in the middle of the century for the Neapolitan aristocracy and intelligentsia to

learn of England's 'model progressive society' were few. Gradually, the presence of an English diplomat at the Neapolitan court, improvements in communications, press and transport, and the increase in numbers of travellers, both of British to Italy and Italians to Britain, resulted in greater exposure to all things British, and indeed European. This manifested itself in Naples in a variety of ways – in writings on antiquity, politics and science; in painting, gardening and, most visibly, in fashion.

One of the first steps in the process of building relations with northern Europe was the establishment of diplomatic representatives at the respective courts. Britain had maintained the lion's share of Neapolitan trade with Europe since a treaty signed with Madrid in 1667 gave British merchants and ships an advantage over the French. A consul, the lowest of diplomatic posts and mainly responsible for overseeing trade within ports, had represented British interests in Naples from that time. In 1753, however, Sir James Gray was sent to Naples as the king's envoy to the court of Charles III. The immediate reasons for upgrading diplomatic relations that year are not known, but it must have been clear for some time that Charles III intended to create his own court at Naples and would be less dependent on Spain than previously. Peace had brought some new prosperity and development, and Britain was anxious to strengthen economic ties and put them on a higher level, particularly as it was also becoming clear that the new Spanish court was willing to give French traders increasing privileges. Economic reform was foremost among the political priorities of the new regime, and if this meant selling cheaply and more to the French and cutting duties on their imports in return, then Charles was willing to bend the rules of the 1667 treaty. Keeping an eye on infringement of this treaty was one of Gray's, and subsequently Hamilton's, most important duties.[5]

In the early eighteenth century the Kingdom of the Two Sicilies had been governed by a viceroy from Spain, but by the time Gray arrived in Naples in 1753 the new court and the beginnings of economic reform had already made enormous changes. Although he was crowned in Palermo as tradition dictated, the eighteen-year-old Don Carlo of Spain chose Naples for his capital and entered that city as its new King Charles III in 1734. His mother, Elisabetta Farnese, was heiress to the Duchy of Parma and Piacenza, which she had been forced to cede to Austria in 1737. She had had the treasures of the Farnese family removed to their palaces at Rome, and, although the following year Spain regained the Duchy of Parma, the Farnese treasures from Parma remained in Rome. As the property of Charles III and then of his son, Ferdinand IV, they were gradually brought to Naples as the ambitious royal and public building programmes progressed.

Charles III tore down the old city walls, laid out new, wider streets, enlarged the former viceroy's palace (now the Palazzo Reale), built the adjoining San Carlo opera house, and began the construction of an immense new hospital for the poor. In 1737 he had begun building a palace at Capodimonte, originally intended as a hunting lodge but continually enlarged, although without being completed, through the century. The king had the paintings from the Farnese collection brought to this palace, which, despite commanding a magnificent view of the city and the bay, had proved too far from the centre of Naples to be a viable royal residence. The paintings, gems and cameos, comprising one of the finest collections in Italy, were displayed haphazardly through twenty-four unfinished rooms. They were one of the major reasons for a visit to the city by artists and Grand Tourists alike, although the treasures of the Farnese library, also dumped in the palace at Capodimonte, had to wait half a century to be unpacked.

In 1751 Charles III brought the architect Luigi Vanvitelli from Rome to Naples (where he had been born in 1700 the son of the Dutch landscape painter Gaspar Van Wittel), to build for him a palace at Caserta, sixteen miles north-east of the city. The buildings and the gardens were on a scale intended to compete with Versailles. When Charles III left for Madrid in 1759, having unexpectedly inherited the Spanish crown on the death of his brother, the palace at Caserta was not even structurally complete and only the chapel was finished at the time of Vanvitelli's death in 1771. Construction carried on through the century; the royal family moved into residence in the 1770s and the palace was eventually completed by Vanvitelli's son, Carlo.

Although Charles III was more interested in architecture than painting,[6] his new palaces and public buildings ensured there was much work for decorative and portrait painters. Francesco Solimena had dominated painting during the half-century before Charles's arrival in Naples in 1734, when the artist was nearly eighty, and his pupils continued to attract the majority of the new royal commissions. Drawings by Solimena and earlier artists in Naples, such as Luca Giordano and Mattia Preti, had been collected by European visitors, such as the English consul John Fleetwood and the Parisians Pierre Crozat and Pierre-Jean Mariette, but not much by Neapolitans themselves. Nevertheless, no Italian city could be a complete cultural centre without an academy of art (British artists through the century sought membership of those at Rome, Parma, Bologna and Florence), and Charles III founded the Accademia del Disegno in 1752. At this period, however, Neapolitan artists had begun to rely more on coloured sketches than drawings as preparation for paintings, and in 1789, when Wilhelm Tischbein became director of

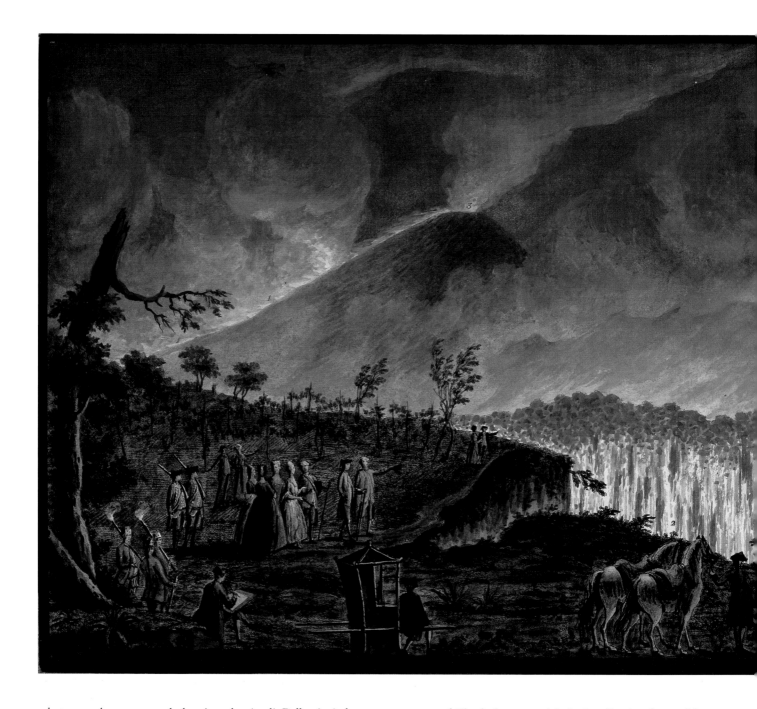

what was then renamed the Accademia di Belle Arti, he complained that the young artists had lost the ability to draw well.[7] One of the rooms displaying the Farnese collection in Capodimonte was hung with nothing but oil sketches, and this makes Hamilton's fondness for them in his own collection more understandable. The collections in Naples were not rich in works by Dutch or Flemish artists, and this too explains Hamilton's importation of a number of them from London to the Palazzo Sessa in the 1790s in a deliberate effort to broaden and improve local taste.

A new style of painting was introduced through the patronage of Charles's queen, Maria Amalia, daughter of the Elector of Saxony and King of Poland, who brought Anton Raffael Mengs to Naples. She had been brought up at the court in Dresden and was probably responsible for setting up the royal porcelain manufactory at Capodimonte on the model of Meissen shortly after her arrival in 1742. Antonio Joli, originally from Modena, trained in Venice and came to Naples via the court at Madrid to work on the decoration of the Teatro San Carlo in the 1750s. In the middle of the century Joli and the Milanese-born artist Pietro Antoniani were responsible for numerous magnificent panoramic views

FIG. 7 Sir William Hamilton conducting their Sicilian Majesties to see the current of lava from Vesuvius in May 1771. Hand-coloured engraving by Pietro Fabris from *Campi Phlegraei*, 1776, pl. XXXVIII. British Library.

it is not surprising to find the names of these artists occurring in the lists of paintings brought back to British country houses by Grand Tourists. A number of their works appear in the collection assembled by William Hamilton during his years in Naples (cat. nos 5, 6, 183).

The portraits of the royal family by Mengs and Anton Maron, and the paintings of the court by Joli, Antoniani, Pietro Fabris and others, glorifying and celebrating the new palaces, public streets and buildings which had changed the appearance of Naples, did not merely serve as decorations within the palaces. Multiple copies were made by the artists to be sent as gifts to other European rulers in order to promote and advertise the cultural achievements of the Bourbon kings in Naples.[8] In addition to views of members of the royal court on the terraces of their palaces, there were paintings of them visiting great sites of antiquity within their kingdoms, such as the temples at Paestum, or transporting antiquities from Herculaneum and Pompeii into their museum; in others they stand imperviously next to flaming lava, watching an eruption of Vesuvius (fig. 7), or slaughtering game in vast numbers during a royal hunt. Such images served to display to visitors from courts all over Europe (and, in the form of prints, to enlightened collectors everywhere) the power of the Bourbons not only over their kingdom, but over antiquity and even over nature itself.

Gradually the new Bourbon regime attracted the nobility from their feudal bases in outlying areas of the country to participate in the new cultural, intellectual and social life in the city. They were encouraged by example to rebuild and redecorate their Neapolitan palaces. The nobility had long collected ancient South Italian pottery, which decorated their private residences. Three of the finest collections were that which ornamented the library of the Duca di Noia (Giovanni Carafa, a professor of mathematics at the University of Naples); the group of 300 figured vases from Nola which belonged to the artist Mengs by 1759; and the collection belonging to the Marquis Mastrilli, which contained 400 vases from Nola displayed along with sculpture, bronzes and gems in his private museum (this was dispersed in 1766, two years after Hamilton's arrival; see cat. no. 24 and pp. 51–2).[9] The painting collections most frequented by visitors to the city were those of the Duca della Torre and the wealthy Prince of Francavilla, whose lavish *conversazioni* were famous. His painting by Veronese of Mary Magdalen was recommended by Joshua Reynolds to Hamilton, who did not manage to purchase that particular work but bought several others from the collections of the Dukes of Baranello and Laurenzano.[10] The most spectacular act of artistic patronage by a Neapolitan noble in the eighteenth century was the private chapel built for the Prince of Sansevero, for which he

of the court and palaces shown against a background of the city and Bay of Naples. This reliance on foreign artists for view paintings continued through the century with the employment of C. J. Vernet, P. J. Volaire, and especially Philipp Hackert, who became the official painter to Ferdinand IV. British visitors to the city saw their work there, and

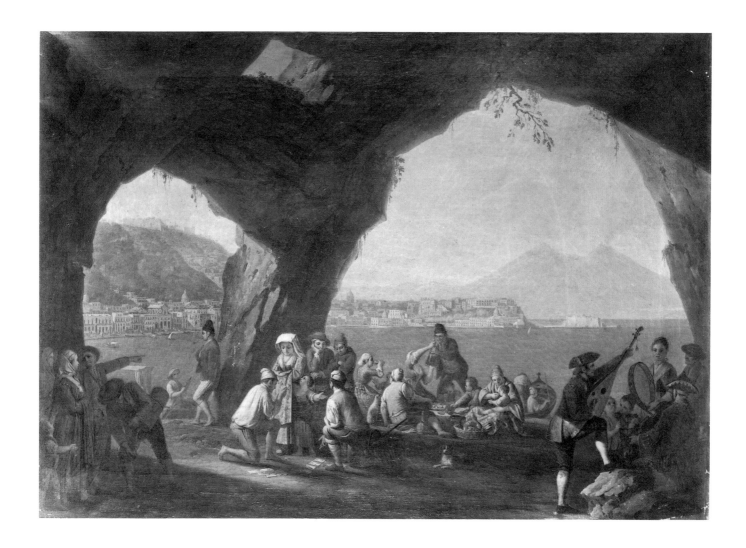

commissioned a series of sculptural monuments to members of his family. These included figures of *Modesty* and *Enlightenment* designed by Antonio Corradini, and a figure of a shrouded *Dead Christ*, the work of the Neapolitan Giuseppe Sanmartino (1753). The chapel and its sculpture are still one of the tourist sights of Naples.

The great building programmes of the court and nobility were part of a concerted attempt to give Naples a cultural status appropriate to the third largest city in Europe. Its private and public architecture had previously been dismissed in the same breath with which European commentators mentioned its streets teeming with poor, and the economic reforms and building of the great hospitals and granary were the first attempts to alleviate this other overwhelming impression of the city.

In 1738 Charles III began construction of the Villa Reale, facing the sea at Portici at the base of Vesuvius. Excavations at Herculaneum began in earnest after Charles III's marriage to Maria Amalia, who in the sophisticated Saxon court at

Dresden had already been aware of the importance of the discoveries earlier in the century. The site at Portici was chosen so that the king and queen could follow the excavations closely as they were directed by the royal antiquary Marchese Marcello Venuti, and the finds were displayed in a museum they created within the palace itself.[11]

When Charles III's elder brother died in 1759, he inherited the throne of Spain and left his younger son, Ferdinand IV, then aged eight, on the throne of Naples under a regency headed by the Tuscan Bernardo Tanucci. Tanucci had been Charles III's chief adviser and Minister of Foreign Affairs. A classicist, he encouraged the foundation of the Royal Herculaneum Academy in 1755; this oversaw the publication of the eight volumes of *Le Antichità di Ercolano esposte* (1757–92) which 'was to influence taste from St Petersburg to Edinburgh for the next half century'.[12] Shortly after Hamilton's

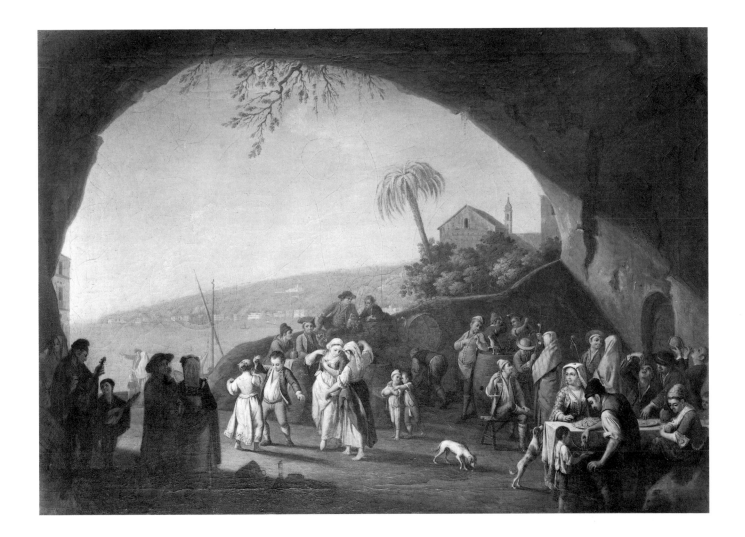

arrival Tanucci had ordered excavations to concentrate on Pompeii, and Hamilton was present during the unearthing of the Temple of Isis (fig. 14).[13]

Ferdinand was to carry on his father's building programme, seeing to completion a number of the grander projects discussed above, including the palace at Portici. He took a particular interest in two which were on a less grand scale but architecturally more inventive: the Hunting Pavilion on the Lago di Fusaro and the smaller royal palace at Carditello, both built largely by the younger Vanvitelli. Ferdinand also oversaw the completion of the building and decoration of the enormous palace at Caserta and the creation of its gardens. In 1787 he sent his Keeper of Antiquities, Domenico Venuti, and his Court Painter, Philipp Hackert, to Rome to supervise the removal from that city of the famous Farnese Hercules which was to grace the grand staircase at Caserta, and the large sculptural group known as the Farnese Bull intended to be placed on a great fountain in the walk of one of the royal villas.[14] By removing them from Rome, much to

the outrage of the Papacy and the artistic community, and displaying his ownership of these statues, known throughout Europe, so publicly in his own royal palaces in Naples, the king was demonstrating his nation's new superiority as a centre of culture and reinforcing its direct descent from the Classical civilisations being unearthed at Pompeii and Herculaneum.

Charles III and his son Ferdinand IV were also great patrons of music. Although he was not as fond of opera as of hunting, Charles recognised the importance of musical patronage to the reputation of his court and brought Italy's greatest musicians and singers to the spectacular new San Carlo opera theatre. Carlo Knight has discussed some of the musical guests at the court, including Leopold and Wolfgang Amadeus Mozart, and how Hamilton and his first wife, who shared a passion for music, entertained both of these visitors at their own musical assemblies (see p. 16). At the University of Naples the sciences and humanities flourished along with the study of antiquity at Herculaneum and Pompeii, and

Charles III's patronage of the arts and Neapolitan culture in general was so munificent that this period of Bourbon rule, continuing through the reign of his son, has been described as 'the Golden Age of Naples'.[15]

This then was the cultural context of Naples in which first James Gray and then Hamilton found themselves in their postings as envoys to the court. Charles III was concerned most of all with creating a new royal capital and with promoting the impression in Europe of an enlightened monarchy. Enjoying a period of peace, the king was not very active politically. He relied heavily on his lawyers for administration and his ministers, particularly Tanucci, for bringing about economic viability and reform. In 1767, when Ferdinand IV came of age and Tanucci became Prime Minister, Tanucci was the founder, president and secretary of the Giunta del Sollievo, designed to reanimate the Neapolitan economy.[16] These efforts at reform were the result of pressure from intellectuals like Antonio Genovesi and Ferdinando Galiani after the great famine of 1763–4. They were among the numbers of intellectuals attracted to Naples from the provinces during the great cultural changes of the Bourbon reign.[17] The difficulty of Tanucci's task, however, was exacerbated by the fact that the attractions of Naples under the new regime were not only emptying the provinces of the wealthy nobility and the new intellectuals, but were also a magnet for the poor, who left the countryside for the promise of a better life in the city. The publicly active and resplendent royal and noble presence in the city contrasted sharply with that of the Neapolitan *lazzaroni*, whose numbers were now swelled by the influx of a new group of poor.

To the vast majority of visitors the overwhelming impression of the Neapolitan population was of a lazy, unemployed, dirty mass of humanity. But the impression of laziness was deceptive: more perceptive visitors like Goethe, and long-term residents like Hamilton, were able to recognise and even respect the underlying philosophy of this way of life. Regarding the *lazzaroni* from a humanist's point of view, they saw that many of the men apparently just standing around were porters waiting to be hired, or fishermen between catches; that many of the 'beggars' were actually selling sawdust, sweets or lemonade, and that the items of food being sold had been carefully nurtured and grown by the vendors. Goethe quickly realised that this was a subsistence economy, not one devoted to saving for the future, and that the 'watchword was enjoyable consumption: "they want to be merry even when at work"'. As a northerner he found it 'a strange sensation for me to keep the company only of people who live for pleasure' (see figs 8–9).[18]

It was a way of life which Ferdinand IV not only respected but admired and imitated. This brought limitless criticism and concern first from his regents, then from his wife, representatives from other courts and visitors from other countries. The fear of inherited insanity had caused him to be brought up to lead an active outdoor life, concentrating on riding and hunting rather than an academic education, and Ferdinand terrified his court with his passions for the first and ignorance in the latter. Before his marriage and during its early years, he spent more time with the *lazzaroni* and fishermen from the Lipari islands than he did attending to matters of government. This was the situation Hamilton found when he arrived at Naples during the last years of the regency, and it was one which affected his own life immeasurably during his years as envoy at this king's court. When the Emperor of Austria visited Naples a few years after Hamilton's arrival, he too noted that the king

> has never reflected in his life either about himself or his physical or moral existence, his situation, his interests, or his country. He is quite ignorant of the past and present and has never thought about the future; in fact he vegetates from day to day, merely engaged in killing time.[19]

When Ferdinand's wife, Queen Maria Carolina, the daughter of Maria Theresa, arrived from Austria, she soon became aware of the situation. She blamed Tanucci for it completely, and manoeuvred his removal from power as quickly as possible, replacing him first with a malleable prime minister, Marchese della Sambuca, then with John Acton, a British admiral from her brother's court in Tuscany. She was unable to cure the king of his passion for hunting, but with his energies channelled thus, rather than in gambling and gambolling with the *lazzaroni*, she was able to take the reins of government largely into her own hands. The *lazzaroni* remained loyal to the king, however, and their blind faith in his right as monarch was his greatest advantage during the republic set up by some of his nobles and intellectuals when the French took over the city in 1799.

All these attempted economic reforms, political manoeuvrings in the government, the king's passion for hunting, and, above all, the Bourbon cultural ambitions which led them not only to excavate ancient sites but also to build new palaces, directly affected Hamilton's duties as envoy. When the king and his court moved from one palace to another to enjoy different sports at different times of the year, Hamilton could not attend as his duties demanded if he remained in the Palazzo Sessa near the Palazzo Reale, the one royal palace in which the family spent as little time as possible. When they stayed for weeks at Portici, which was several hours away by road and was awkward to reach by boat because of contrary winds, Hamilton found it advantageous to hire the Villa Angelica a few miles further along the slopes of Vesuvius. Caserta was sixteen miles from the centre of Naples, so a villa

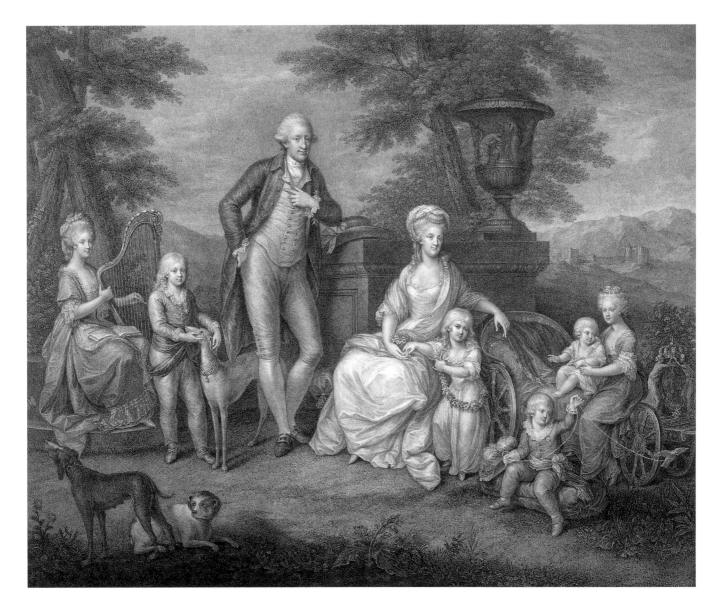

FIG. 10 *Ferdinand IV, King of the Two Sicilies, with his Family*. Stipple engraving by Mariano Bovi after a painting by Angelica Kauffman (cat. no. 12).

in the small town nearby served as the envoy's residence there. The king had a dozen other villas and palaces, one of which was a small palace which served as a fishing lodge at Mergellina, near Posillipo, where the air along the cliffs, caves and beaches was clearer and fresher than in the crowded streets of the city's centre. Here Hamilton maintained a *casino* ('small house'), later called the Villa Emma, built on a natural rock arch on the beach; from his balcony he could watch royal parties picnicking and fishing in the bay. Since each of these residences was rented and required permanent furnishing and staff even when he was absent, the expense was substantial. He entertained and accommodated guests at each of them (see map, fig. 1, and cat. nos 17–23).

In the scale of British diplomatic representatives at Italian courts, Naples was not the most important post, and the envoy was not intended to expend as much, for example, as the full ambassador to the Kingdom of Savoy and Sardinia which controlled access to the vital port of Genoa. Venice, Leghorn (Livorno) and Parma had consuls and occasionally residents representing British trade interests, while Florence and Naples had envoys, mainly because of their courts' connections with the greater powers of Austria and Spain. There was no British representation in Rome because of the Pope's recognition of the Stuart claims to the British throne. The important British ambassadorial appointments were Paris, Vienna, St Petersburg, Madrid and Constantinople. Diplomatic postings were at the disposal of the king, on the advice of the prime minister at the time and, until 1782, when the post of Secretary of State for Foreign Affairs was created, that

of the Secretary of State for the Southern Department (who was also responsible for home affairs). It was the king, the prime minister and these secretaries of state who formed British foreign policy; and these secretaries passed on instructions to the diplomats and received their reports.

Two other facts about eighteenth-century British diplomatic postings are essential for an understanding of Hamilton's position, both in Naples and at home: first the financial and political undesirability of a diplomatic post abroad, and second the fact that the diplomat must always act as a conduit of information and instructions and never as an instigator. The second of these is easily understood, as the diplomat was not expected to play any role in the formation of foreign policy, but instead to provide the best information he could obtain on matters requested, and to carry out meticulously and promptly any orders he received. His was an executive not a consultative role. In his *Letters* Lord Chesterfield had advised that the best way to obtain secrets was for the diplomat to make himself pleasing to the most important families of the place and, by gaining their confidence, to accustom them to looking at him as one of themselves; they would then be more open with him and he would be informed of all that went on. A minister who went only to formal court functions would put the local people on their guard, and he noted that the French always insinuated themselves into favour while the British were reluctant to do so.[20]

The undesirability of a diplomatic post abroad is less understandable to us today, but in the eighteenth century the diplomatic service was unpopular, rarely lucrative and not a good route to high office: once removed from England, a diplomat often found himself forgotten at home. An envoy extraordinary received £5 per day, and an additional £3 per day if promoted to plenipotentiary, which Hamilton achieved in 1767. They were given a service of plate for their embassy – one of the only perquisites – and sometimes money for equipage; otherwise they received a regular fixed extraordinary allowance for postage, intelligence, stationery, etc. (£400 per annum in Naples in 1789), and were permitted to apply for extra extraordinary expenses for court funerals, weddings, etc. These were paid for out of their own pockets and the diplomat applied for reimbursement, which often did not come for years, if at all. If the Civil List was frozen, as it frequently was during the second half of the century, salaries, allowances and repayments were suspended and the diplomat was forced to borrow against the eventual arrival of funds. One of the first duties of the minister was to do honour to his king by keeping an open table and entertaining members of the court, as well as British and other foreign visitors. It is not surprising, then, that expenses usually exceeded income. Sir Robert Murray Keith wrote home in 1774 from his post in Vienna, 'I find myself unavoidably verging into beggary', and the 3rd Earl of Marchmont refused a diplomatic post, commenting 'I would not ruin myself and my family ... to come home here forgotten, to walk about soliciting a Scots pension.'[21]

The unavoidable debts of the diplomatic service were not widely known, and the extra expenses specific to the court at Naples were not yet clear when William Hamilton wrote to Charles Jenkinson, secretary to George Grenville, in April 1763 asking for the embassy at Naples in case of a vacancy (Gray had just applied for leave) 'on account of Mrs Hamilton's ill-health and my own situation'.[22] By the following April it was accomplished: Lady Temple wrote to her husband that month that 'Mr Hamilton is going to Naples ... Mr Grenville had done it for him at his own request ... as he says; his wife has a terrible state of health, and he thinks the climate will do her good.'[23] Catherine Hamilton's health improved immediately on arrival in Naples and she was able to survive another twenty years. However, faced with the ceremonies of Ferdinand's coming of age and wedding, Hamilton found himself within only two years of his arrival writing for advancement to the post of plenipotentiary and for extra extraordinary expenses. Fothergill records that when Hamilton received his Order of the Bath in 1772, the traditional recognition for diplomatic services, the ceremonies cost him £350.[24] Hamilton's accounts, which survive among his papers in the British Library, indicate that the jewels which were part of the regalia cost an additional £1,000.[25]

Hamilton had prepared for his post at Naples carefully and conscientiously by reading through Gray's dispatches for the past ten years, paying particular attention to, and making detailed notes on, the Neapolitan challenge of aspects of the 1667 Madrid trade treaty with Britain. Gray's secret instructions on his arrival had been to find out the favours of the Austrian government, to report on factions of all sorts and to enquire after the 'Pretenders' to the English throne (James Stuart, 1688–1768, son of James II, and his son Charles Edward Stuart, 1720–88, who lived in exile in Italy). After Gray had left Naples on 5 April 1763, leaving matters with the chargé d'affaires, and before Hamilton's arrival in November the following year, the Neapolitans had tried to take advantage of the absence of an envoy by presenting a new treaty of commerce. Gray learnt of it and managed to stop it proceeding, since the British always contended that the terms of the 1667 treaty were still valid.[26] Naples persisted in denying the validity of the 1667 treaty and breaking its terms, and Hamilton's diplomatic correspondence during the first few years of his envoyship indicate that his diplomatic responsibilities were substantial. The difficulties over the treaty continued well into the 1770s, and Hamilton's duties

were complicated by the presence of an obstructive and difficult British consul in Naples, Isaac Jemineau.[27]

Hamilton was instructed to collect information about the present state of defence of Naples, with regard to forts and land and sea forces, as well as details about the Neapolitan economy and state of trade. He took these standard instructions seriously, procuring maps, lists of forces, accounts and manufactures, and suggesting means of improving trade with Britain.[28] His 'Observations on the Kingdom of Naples of 1774' circulated in manuscript and won a reputation for the author (for transcription see p. 39). It is not entirely true, therefore, to suggest that Hamilton's diplomatic duties were light and that this enabled him to devote his time to collecting. During these early years, however, his actual presence at court was not required as constantly as it was to be later, and Catherine Hamilton disliked court life and avoided it as much as possible. It was during the leisure hours thus created that Sir William was able to turn to 'the study of the natural history of this country or to antiquity'.[29]

Sir William's standard diplomatic instructions also included maintaining a correspondence with his predecessor, Gray, who was now at Madrid, and with other British diplomats throughout Europe. If some of this correspondence was less officially diplomatic than usual, this was due to the fact that Hamilton was a personal friend of some of the secretaries to whom he reported, such as Henry Seymour Conway and James Bland Burges, and he was directly related to several of the ambassadors at other courts: his sister was married to Lord Cathcart at St Petersburg, and her daughter, his niece, became the second wife of his old friend Lord Stormont at Vienna and then Paris. Sir Horace Mann, British envoy at Florence from 1738 to 1786, was a regular correspondent, and as a fellow connoisseur received interesting reports about the progress of Hamilton's collection of antiquities and its publication, particularly when its author, the French antiquarian Baron d'Hancarville, was expelled from Naples and took refuge in Mann's diplomatic territory of Florence. Mann and Hamilton exchanged news and warnings of notorious, difficult and important British visitors, such as John Wilkes, who stayed several months in Naples in 1765, and Lord Bute, the ex-prime minister travelling incognito as Sir John Stuart in 1769.

It was also to Mann that Hamilton reported the constant increase in the numbers of their countrymen visiting Naples: in February 1771 he wrote that the 'English tide', moving through the country with the seasons, was 'falling with me and rising with you ... I never had such a numerous family as this year, Entre nous the management of our Own Countrymen is not the least difficult part of our business.'[30] Hamilton's letters on Vesuvius, published by the Royal Society, were well known by January 1774 when British visitors flocked to Naples on hearing news of an eruption. In fact the numbers of visitors were so great that year that Hamilton reported that the English merchants in Naples believed that the money the English were spending might considerably diminish the British balance of trade with Naples;[31] in 1778, during the carnival celebrations on which the king spent the equivalent of £14,000, the bankers to the British in Naples reported providing them with a total of over £50,000.[32]

One of Gray's main duties had been to reassure the Secretary of State about the decline of any threat from the Young Pretender, Charles Edward Stuart, in Rome. In 1734, as 'Bonnie Prince Charlie', he had sailed into Naples in company with Charles III, and the British were wary of Spanish and Neapolitan support for the Pretenders. In 1767 Hamilton was commended for news he had sent of the Young Pretender from an anonymous English lady who had reported visiting him in Rome, where he was 'absorbed in melancholy thoughts', was distracted in his conversation and suffered from 'frequent brown studys'.[33] On his return from England in 1773, Hamilton himself made certain of the Pretender's status and reported immediately to the Secretary that he was 'universally looked upon as in a great degree out of his senses and would be deserted if a few people did not go to him out of compassion for his wife'. Hamilton also paid a private visit to the Pope on the latter's request: Clement XIV had heard of the envoy's great reputation as a collector of antiquities and was anxious to hear his opinion of the collection Thomas Jenkins had formed for him. Hamilton reported that it had been created largely 'to curb prodigious exportation of valuable monuments of antiquity'.[34] Both these visits were unprecedented by a minister of the British court in the eighteenth century, but appear to have been made with the Secretary of State's knowledge and blessing, which, if not given before the fact, was certainly given afterwards when Consul Jemineau maliciously reported the visits, believing Hamilton had made them in secret and accusing him of being a closet Jacobite and papist.[35]

By this time, Hamilton was the senior diplomat at the Neapolitan court, not by rank but through having been there longer than the representatives of any other country, and by the fact that he was growing closer to the king and queen. The queen was a Habsburg and violently anti-French, bent on withdrawing her husband and his ministers from the direct influence of the King of Spain. In 1771, when Spain, supported by the French, came close to declaring war on Britain over the Falkland Islands, Hamilton succeeded in persuading Naples to remain neutral. Later in that decade, when Spain joined France in the fight against Britain in North America,

Hamilton was again successful in persuading Ferdinand IV to remain neutral under increasing pressure from his father, Charles III, in Spain. This was in 1779, when Maria Carolina had already managed to have Tanucci dismissed and replaced with a less powerful minister, and after her brother in Tuscany had sent his best general, John Acton (see cat. no. 13), to revitalise the Neapolitan navy. A year later Acton, whose father had been British but who lived all his life on the Continent and the last twenty years in Italy, was in the full confidence of the queen and had been made Minister of War as well as of the Marine. Acton quickly gained a reputation for being able to cut through the corruption that surrounded the court and actually get things done, and he and the queen between them put the country on a different footing as an individual power in the 1780s. The French chargé d'affaires Vivant Denon (cat. no. 14) was one of the first to feel the effects of the combined efforts of Acton and the queen, who had him banned from court in 1782, making his diplomatic mission almost impossible until he was finally relieved by the presence of an ambassador and sent home in 1785.[36]

The anti-French and pro-British bias of the Neapolitan court affected Hamilton's ability to carry out his normal duties as a British diplomat. Being in such favour, his presence was called upon increasingly at court and in attendance on the king during his incessant hunting, especially at Caserta. In 1781 Lady Hamilton suffered recurring bouts of melancholy during his lengthening absences,[37] and the ever-growing numbers of British visitors complained of his lack of attention to them. The artist Thomas Jones (see cat. no. 19) mentioned that although Hamilton was courteous, he had not visited his studio, and in May 1782, when Lady Hamilton was growing worse while Hamilton danced attendance on the king, a tourist, Thomas Clarke, intending a visit to Naples, wrote that he hoped Sir William 'will do me the honour to pay some little attention to me, a thing he is not very apt to do. This is a universal Complaint.'[38] The French ambassador to the court, Charles-Maurice de Talleyrand, was able to take advantage of the situation. In 1788 when another tourist, Thomas Watkins, and his friends, in spite of letters of introduction to Hamilton, found themselves not being introduced into Neapolitan society because of his insufficient attendance on them (he had presented them at court and had them to dine twice in Naples and once in Caserta), they were introduced to M. Talleyrand, 'at whose house we met, and made acquaintance with the first company in Naples. His excellency keeps a superb table, from which he insisted that our *mauvaise honte Anglaise* should not deter us, and indeed we are obliged to dine there seldom less than three times a week.'[39]

In fact, if a British tourist was keeping company with the

French, it would de diplomatically difficult for Hamilton to show him much attention, such was the bias of the court against the French by this date. In 1784 Denon had reported to Paris that the queen was pushing her brother, the Emperor of Austria, into armed conflict with Spain and France, and that she was saying to anyone who would listen, 'J'y perdrai la couronne, j'y perdrai jusqu'à la dernière goutte de mon sang, mais je sortirai de la dépendance de la maison de Bourbon.'[40] Negotiations had begun for an important mutually beneficial commercial treaty between Naples and Britain in 1786, but the Foreign Office acted slowly and it was not ratified before the French Revolution.[41]

Before Lady Hamilton's death, Sir William had begun to add a new storey to the Palazzo Sessa. He continued with the work after her death, spending over £3,000 on the decorating and furnishing of the new apartment through the 1780s, by which time Emma Hart, the future second Lady Hamilton, was well established at the Palazzo and could assist in entertaining, although she could not officially be recognised by royal visitors or the court. Her position was altered, however, when she returned from England at the end of 1791 as Lady Hamilton, and the queen took her into her close circle. Her new position at court was useful to Hamilton, who wrote to Walpole:

> Since my return here I have been in one perpetual hurry, and the Holy Week having carried off most of the foreign travellers to Rome, it is now only that I begin to breathe. Having resided at Naples upwards of 27 years, foreigners of every denomination contrive to bring letters of recommendation, and as your countrymen can without much difficulties, *paying 2 Guineas at the Secretary's office*, get a letter, they now all bring me such letters, & think themselves entitled to get that Penny's worth out of me, and after all it is most difficult to content them. It appears to me that education in England does not improve, for of upwards of 100 British travellers that have been here this winter I can scarcely name those who can have reaped the least profit, for they have lived together and led exactly the same life they wou'd have done in London.[42]

Meanwhile the king still spent most of his time hunting, with Hamilton and British visitors in attendance, as shown so vividly in the large painting of the *Boar Hunt at Persano* by Tischbein (cat. no. 7; fig. 11). When it was commissioned in 1792, the king and queen had recently returned from Vienna, where they had successfully married two of their daughters to Habsburg princes.[43] All the loyal Neapolitan nobility, as well as the British and Habsburg diplomatic and royal connections, are depicted prominently in the carefully delineated portraits. Prince Augustus (cat. no. 9), the son of George III, who spent much of the decade in Naples because of his delicate health, is given a prominent place, along with Sir

William and Emma, the latter pointedly wearing a red *lazzarone* cap. Court dress and insignia are depicted with great care in this hunting scene, which shows a group of loyal subjects, including *lazzaroni*, to the right and apparently also includes careful portraits of the king's favourite horses and dogs.[44]

Such a strong visual political statement was necessary for the Neapolitan royal family after their return from Vienna in 1791: France declared war on Austria on 20 April 1792, Sardinia was under threat of French invasion through the summer, and the French sent a new ambassador whom the king and queen of Naples refused to recognise until the end of November, when they heard that the French proposed to invade Naples. In December the French fleet anchored in the bay in a show of force for twenty-four hours and then left. When they returned after a storm, the officers landed and were fêted by young Neapolitan Jacobins wearing Phrygian caps. Maria Carolina's brother-in-law, Louis XVI of France, was executed in Paris in January 1793; her sister, Marie Antoinette, followed him ten months later.

This was also a period of shortage of corn in the kingdom, increasing debt in the effort to raise forces, and the rise of Jacobinism in the freemason lodges that the queen herself had encouraged in the interests of enlightenment and reform in the 1780s. The Kingdom of the Two Sicilies could not afford to cease trade with France and was forced to negotiate an uneasy truce. However, increasingly through the decade the queen and Acton, still Prime Minister and now proudly also a British baronet by inheritance, 'dropped all pretence of reform and adopted a policy of blind repression',[45] especially towards the intellectuals and young members of the Neapolitan nobility, whose recently 'enlightened' sympathies were with the new government in France and their army of liberators now making its way through the north of Italy.

At this point the actors in Neapolitan history, like their modern historians, diverge into two streams. On one side are the liberators, Jacobins and members of the Neapolitan Enlightenment, such as Gaetano Filangieri, Francesco Maria Pagano and the Sicilian viceroy and reformer Marquis Domenico Caracciolo, the supporters of the new republics of Italy who became the martyrs of the brief Parthenopian republic of Naples of 1799. On the other are the supporters of the *ancien régime*, the monarchies in Naples, Britain, Austria and Spain, who saw the end of reasonable government as they knew it, which, with all its faults, was preferable to the anarchy and rapacity displayed by the French liberators. As events progressed, Sir William Hamilton was overwhelmed by English visitors fleeing other parts of Italy; he found himself getting deeper into personal debt and being thrust into war's increasingly complicated and delicate diplomatic negotiations. Meanwhile, Acton was gradually ostracised by the queen and

pushed into the hands of the king, who was forced to act and used Acton as his instrument. By 1797 both Acton and Hamilton were worn out and ill and desperately needed to attend to their affairs in Britain, but they were obliged by events and loyalty to their respective kings to remain through the shocking events that unfolded in Rome, Palermo and Naples between 1798 and 1800.

In November 1798 Ferdinand IV marched into Rome, but was driven out only days later by the returning French. Nelson managed to evacuate the royal family and the Hamiltons to Palermo in December 1798 and the French entered Naples, where they were welcomed by the pro-Jacobin inhabitants and set up a new Parthenopian republic. The *lazzaroni*, however, remained faithful to King Ferdinand and assisted Cardinal Ruffo in recapturing the city for the king. Ruffo's terms with the rebels were considered too lenient by the king and queen, who sent Acton as their representative to deal with them. Acton was transported to the Bay of Naples by Nelson; he was also accompanied by the Hamiltons, who were to act as interpreters. The reprisals carried out by Acton and Nelson in the name of the King of Naples were judged excessively harsh by Ruffo, by many of the loyal Neapolitans and by Sir William, who saw many of his old Neapolitan friends and acquaintances ruined. He returned to Palermo in the summer of 1799, sick at heart.[46] In June 1800 Hamilton was finally able to return home, but had remained long enough to have been caught not only in a three-way diplomatic struggle between the Foreign Office, Nelson and the King of Naples, but also in a three-way personal relationship.

In 1799 the newly appointed British Consul to Naples, Charles Lock, wrote to his family from Palermo:

> Sir William has ever showed a forwardness to give me an insight into the politicks of this Court, and of the mode of conducting business, but the unbounded power her Ladyship possesses over him … has easily prevented his intention. The extravagant love of the latter [Nelson] has made him the laughing stock of the whole fleet and the total dereliction of power and the dignity of his diplomatic character, has made the friends of the former [Hamilton] regret that he retains the title of a situation, of which he has resigned the functions.[47]

Lord Elgin passed through Palermo later that year, and respected Hamilton's reputation as a connoisseur enough to seek his advice on the appointment of an artist to accompany him on his ambassadorial mission to Constantinople, from where he hoped to record monuments of Greek antiquity in Athens. On Hamilton's advice he contracted G. B. Lusieri (see cat. nos 4, 46–8). However, he also quickly realised the minister's ill-health and the submission of his will to Nelson, and wrote to England recommending 'the necessity of a

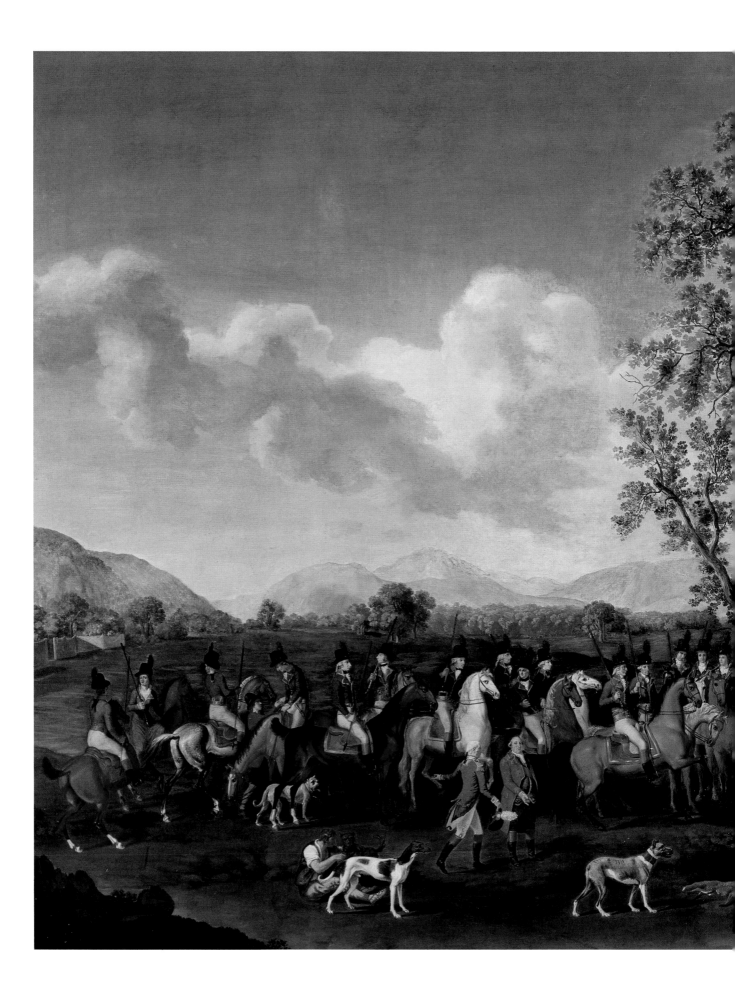

FIG. 11 Wilhelm Tischbein, *A Boar Hunt at Persano under Ferdinand IV.* Oil on canvas, *c.* 1792–3 (cat. no. 7). Queen Maria Carolina and Emma Lady Hamilton are shown in the left-hand cart; among those standing below them are Prince Augustus and Sir William Hamilton. King Ferdinand IV is shown on his horse in the centre of the picture.

change in our representative at Naples and in our conduct there'.[48]

Hamilton was officially commended by the Foreign Office immediately after reporting the events in the Bay of Naples in 1799, but Charles James Fox, possibly acting on information received from his first cousin, Mrs Charles Lock, fanned disapproval of Nelson's violent repression of the rebels through a vigorous speech in the House of Commons in January 1800. Thus, although his diplomatic role in the events in Naples had been approved by the Foreign Office, before he even arrived back in England Hamilton had become a pawn in the wider political debate between Whigs and Tories, Foxites and Pittites, even Jacobins and Monarchists, who were not necessarily worried about the fate of fellow republicans or royalists in Naples but anxious to make a political point at home (see cat. no. 188).

Gossip concerning two such individually renowned figures as Nelson and Emma Hamilton was rife, and news of their relationship in Sicily and stately progress through Europe preceded their arrival in Britain. After carefully cultivating his reputation as a diplomat, antiquarian, natural scientist and connoisseur during his thirty-six-year absence from Britain, Hamilton arrived back to find this reputation submerged beneath the public persona of a failure who could not curb Nelson's excesses, not only in the Bay of Naples but even in his own home.

NOTES

1 The main sources for Hamilton's diplomatic activities are his letters transcribed by Morrison, the summary and discussion provided by Fothergill, and the actual letters themselves and copies of them in the British Library and various repositories of the papers of his addressees. His dispatches were sent to the Secretary of State for the Southern Department until 1782 when the Department of Foreign Affairs was created. The Secretary responsible changed with each change of ministry, but the post was held by Lord Carmarthen from 1783 to 1791, then Lord Grenville from 1791 to 1801. Hamilton himself stated he had been envoy for thirty-seven years (Fothergill, p. 400), so there is some doubt about the date his appointment officially ended. When he left Palermo in 1800, he still thought there was a possibility of his return. He had arrived in Naples in November 1764 and returned to London in November 1800, so he was actually abroad for thirty-six years.

2 For the details of Charles III's ascent to and consolidation of the throne of the Kingdom of the Two Sicilies, see H. Acton, *The Bourbons of Naples (1734–1825)*, London, 1957, ch. I–IV.

3 See S. J. Woolf, *A History of Italy 1700–1860*, London, 1979, pp. 26–8.

4 J. Black, *Convergence or Divergence? Britain and the Continent*, London, 1994, p. 144.

5 See D. B. Horn, *Great Britain and Europe in the Eighteenth Century*, Oxford, 1967, pp. 346–7.

6 F. Haskell, 'Patronage and collecting in Bourbon Naples in the 18th century', pp. 15–22, in *Golden Age of Naples*, exh. cat., Detroit and Chicago, 1981–2, p. 15.

7 Marina Causa-Picone, 'Drawing in Naples: background and overview', in exh. cat., *Golden Age of Naples*, pp. 243–50.

8 For example see Joli's view of *Ferdinand IV and the Court at Capodimonte*, c.1761, a copy of which was sent to the Austrian court at Vienna; reproduced in exh. cat. *Golden Age of Naples*, p. 121, no. 28.

9 Lyons, 1992, pp. 3–5. Mengs's collection may have been moved to Rome by the time Hamilton arrived in Naples, but many items from his collection were published by Winckelmann (Lyons, n. 19) and Hamilton would have been able to see the collection when he visited Rome in 1768.

10 For Reynolds's letter to Hamilton see Hilles, pp. 21–2; for various collections, see Haskell, op. cit., p. 17, where he states that many of the Francavilla paintings did not actually belong to the prince but to the owners of the palace he was renting.

11 Essay by Michael Grant, 'Bourbon patronage and foreign involvement at Pompeii and Herculaneum', in Chaney and Ritchie, pp. 163–5.

12 Acton, p. 144, cited in Chaney and Ritchie, p. 165.

13 See pp. 42–4 and see also Ramage, 1992b, pp. 654–5.

14 T. Martyn, *Tour through Italy*, 1791, p. 266.

15 Two exhibitions: *Civiltà del '700 a Napoli*, Naples, Dec. 1979–Dec. 1980; and *The Golden Age of Naples: Art and Civilization under the Bourbons 1734–1805*, Detroit Institute of Arts (Aug.–Nov. 1981) and Art Institute of Chicago (Jan.–March 1982).

16 M. Grant, op. cit., p. 166.

17 See R. Burr Litchfield's essay in exh. cat., *Golden Age of Naples*, pp. 11–12. For an excellent summary of the ideas and leaders of the economical and intellectual reforms of Naples in the second half of the eighteenth century, see D. Carpanetto and G. Ricuperati, *Italy in the Age of Reason 1685–1789*, London, 1987, pp. 236–58.

18 Boyle, p. 462.

19 Acton, p. 145.

20 Summarised in D. B. Horn, *The British Diplomatic Services*, Oxford, 1961, pp. 182–3.

21 Ibid., pp. 63–5; see also pp. 47–53, 105.

22 Namier and Brooke, p. 572.

23 *Wal. Corr.*, XXII, p. 243, n. 10.

24 Fothergill, p. 120.

25 British Library, Add. MS 40,714, f. 117, bill from George Robertson, Sept. 1772.

26 These notes are now in Hamilton's papers in the Bodleian – Eng. hist. g.5: 'Extracts from Sr James Gray's correspondence to the Secretary of State during his Envoyship to the Court of Naples & from their answers'.

27 Ibid., g. 13, f. 6, 22. Gray had also experienced difficulties with the consul: see ibid., g.5, letters of 5 and 12 March 1754. Copies of Hamilton's dispatches in the Egerton MSS in the British Library cover 430 folio pages, two sides each in the first volume alone (Eg 2634), beginning with the speech he delivered to the King of Naples on 25 November 1764 at Portici and ending with a dispatch of June 1768.

28 Ibid., g.15, ff. 1–13.

29 Uncalendared letter, Krafft Bequest, Bibliothèque Centrale du Muséum National d'Histoire Naturelle, Paris, 18 June 1765, from Hamilton to Lord Palmerston: 'You know that politics in this country are at a very low ebb indeed and *cisisbe* nonsense is not worth writing about ... besides that it would not have been very agreeable to Mrs. H.'

30 Public Record Office, SP 105/321, f. 34 (from note in Sir Brinsley Ford Archive, Paul Mellon Centre).

31 'This fashionable rage and spirit of emigrations seems to merit (at least in this point of view) some serious reflection' (PRO 93, f. 29, WH to Rochford, 22 March 1774, notes from BF Archive, PMC).

32 PRO 93/21, 3 Feb. 1778 (from note in BF Archive, PMC). About this time Hamilton found himself forced to attend and act as peacemaker at card parties given by Ferdinand IV at which the king regularly won sums of £2,000 nightly from English visitors; he also found himself dispensing Dr James's Powders ('that justly celebrated medicine') to numbers of English suffering from sore heads and stomachs (PRO 93/30, 7 March 1775, WH to Rochford, notes from BF Archive, PMC).

33 PRO 93/20, 12 Mar. 1767.

34 PRO 93/28, 12 and 19 Jan. 1773.

35 Fothergill, pp. 127–9.

36 See G. Chevallier, 'Denon chargé d'affaires à Naples 1782–1785', Mémoires de la Société d'Histoire de Chalon-sur-Saône, 2nd ser., XXXVIII, 1964, pp. 104–21.

37 See British Library Add. MS 40,714, ff. 193–4, letter of 19 April 1781 from Dr Drummond to Lady Catherine: 'As it is you are but too much a prey to ennui and it is this which is the parent of your low spirits, mingles with your constitutional ailments, and is mistaken for them sometimes; and always aggravates them'.

38 BF Archive, PMC, notes on British Library, Egerton MS 1970, f. 86.

39 Watkins, Letters, I, p. 434 from note in BF Archive, PMC.

40 Chevallier, op. cit., p. 115.

41 Horn, 1967, p. 348.

42 Morrison, no. 208, WH to Earl of Orford (Walpole), Naples, 17 April 1792.

43 One of those daughters, Maria Luisa, who had become the Grand Duchess of Tuscany, is included in the painting, while the other had become Empress of Austria in March 1792 when Queen Maria Carolina's brother, Emperor Leopold II, had died. The Queen of Sardinia is included in the group on the right.

44 Von Alten, p. 59.

45 Woolf, p. 158.

46 There is evidence that Hamilton did attempt to abide by the terms of the armistice Cardinal Ruffo had contracted with the rebels in Naples and to curb Nelson's rejection of them and his enthusiasm for reprisals. He also requested the king to come himself immediately and oversee the reprisals he and the queen had insisted upon, so that it would be clear that they were being carried out under the king's and not British command. See Fothergill, pp. 356–63. After his return to London, Hamilton showed Henry Swinburne a list of people executed, telling him of petitions for clemency that were deliberately held back until too late, and commenting that 'almost every man of worth and learning is destroyed or fled from Naples' (Swinburne, Letters from the Courts of Europe, II, London, 1841, pp. 242–4).

47 Sermonetta, Locks of Norbury, p. 165 ; Charles Lock was the brother of William Lock who drew Emma dancing the tarantella (cat. no. 156) and son of the connoisseur whom Hamilton so admired. He managed to get himself ostracised from the Neapolitan court in Palermo by attending a costume ball as a Thames fisherman, which the king and queen interpreted as a sans-culotte. He also antagonised Nelson, whose fleet he was to provision, and found himself £4,000 in debt before he even set foot in Naples. Ibid, pp. 194–9.

48 Ibid., p. 156.

Appendix

'Observations relative to the Kingdom of Naples given to me by Sr W. Hamilton Minister Pen'ry. at that Court 1774' (British Library, Stowe MS 307, ff. 230–31 [hologram])

1774
The Kingdom of Naples is said to contain 419,267 Inhabitants of which the City of Naples contains 353163, according to the last computations which are not I believe very exact; The number of Priests Monks & Nuns in the Kingdom of Naples amounts to 96547. The whole number of Troops (& which are not included in the above numeration) amounts to 30 Thousand – The pay of the Army amounts to about 350 Thousand Pound Sterling per Ann'm exclusive of castles & forts – No castles of force except St Elmo, Gaëta, Pescara, & Siracusa – 500 brass Cannon were cast during the reign of the K. of Spain & very few have been cast since His catholick Majesty left Naples.

The Annual Sum raised upon /f. 230v/ the Kingdom of Naples is Ten Millions of Ducats, Four Millions only go into the Kings Coffers, the rest is apportioned to the discharge of the large National Debt which is about 19 Millions Sterling, contracted by large donations to Charles the 5th Philip the 2d and their Successors to assist them in their many expensive Wars & Enterprizes. – Massaniello's Insurrection occasion'd by the burthensome Impositions of Taxes, the greatest part of the present Revenues are Duties & Customs, three other Articles also, the Dogana di Foggia the Adoa & and the Fuochi. The first is a Tax upon Sheep, at so much a herd when they pass from the Mountains to the plains of Apulia & produces 250 Thousand Ducats per Ann'm it was practised by the Romans. The Adoa /f. 231/ is a sum paid by those who hold Fiefs of the Crown in lieu of personal service; the Fuschi is hearth money and produces about One Million Ducats. The Maintenance of the Fleet & Army amounts to Two Million Ducats – the Fleet consists at present of Two Men of War of Seventy Guns. Two Frigates of Forty – The Guns of the Men of War are 18 Pounders and their compliment of Sailors 432. Of the Frigates they are 12 Pounders & their compliment of men 210. There are besides 8 Zebecques 2 Galleys & 6 Galliots – The Zebecques have 20 Guns 6 Pounders & are excellent vessels. The Officers & Sailors of the Fleet amount to 2409 – the Marines 1274 – & the Slaves for the Galleys 1200.

The Ballance of our Trade with this Kingdom is greatly /f. 231v/ in our favor – by the last exact valuation of our Imports from the 1st of Septr 1771 to the 31st Augu't 1772 amounted to £398216 and the Neapolitan Products exported by us within the same term, amounted only to £61728 – so that the Ballance in favor of Great Britain was £336488. Woollens of all sorts is the chief Article of Importation it amounted in 1771 to 221600£. Tann'd Hides amounted to 50922£. Baccalaw 44175£, Hardware 31800£ – These are the chief Articles. The smaller articles are Lead, Tin, Pepper, Iron, pitch allum. &c. Pilchards is a great article amounting in 1771 to 12694£ – the chief articles of Exportation are Galipoly oils & silk – in 1771 the first amounted to £22947 the latter to 29400£ the smaller articles are Raisins Fiddle strings Drugs – Argol & Rags --.

[A similar manuscript, quoted in part by Fothergill, pp. 42–3, is also in the British Library, Add. MS 42,096, ff. 35–6.]

'Contemporary minds'
Sir William Hamilton's
Affair with Antiquity

IAN JENKINS

A ntiquity', wrote the self-styled Baron d'Hancarville, 'is a vast country separated from our own by a long interval of time.'[1] To readers of L. P. Hartley's *The Go-Between* this calls to mind that book's opening phrase, 'The past is a foreign country'.[2] D'Hancarville elsewhere explains how that country could be reached: 'Writing', he says, 'has caused in the Moral world revolutions like those which navigation has produced in the Physical ... Every

FIG. 12 Baron d'Hancarville. Glass cast by James Tassie of an engraved intaglio. Scottish National Portrait Gallery (Tassie, no. 14219).

mind is in some measure become contemporary; and times, stopped as it were in their progression, seem to be reunited.'[3]

We hear the voice of d'Hancarville, celebrated for his silver tongue, thrilling to its own sound as he sets out on the great voyage of discovery that was to be his monumental publication of Sir William's first vase collection. The idea of the past

made present is central to d'Hancarville's necromancy, conjuring up the ghosts of antiquity, some of whom he had encountered in their very tombs (cat. no. 25). But he also had a reverse role to play, whereby he himself would travel back in time. For d'Hancarville, vases and other objects in Sir William's collection were, on the one hand, the means of exposing to contemporary eyes the life, art, religion and customs of the ancients, while on the other they presented the vehicle for going back in time oneself to chart the coasts of the land called Antiquity. Not content, moreover, merely to follow the course signposted by those who had sailed before him, d'Hancarville sought to discover the hitherto uncharted territory of what today would be called 'prehistory'.[4] D'Hancarville did not know it by that name, but the author of *Antiquités Etrusques, Grecques et Romaines (AEGR)* exhibits the unmistakable instinct of a modern prehistorian, seeking to push back the limits of our knowledge of antiquity beyond Homer and the first Classical literature, to a time altogether more remote. 'Some travellers', he wrote, 'have discovered its coast almost waste, others have dared to push on to its very heart ... My first volumes may be looked upon as attempts to discover unknown lands.'[5]

D'Hancarville was writing in an age captivated by accounts of actual voyages of discovery, notably those of Captain Cook, revealing previously unsuspected worlds inhabited by so-called primitive cultures. Sir William seems not to have collected ethnographic material himself but he was responsible for the King of Naples' own purchase of a number of Polynesian artefacts, souvenirs of one of Cook's voyages.[6] D'Hancarville, too, was interested in such things and, as well as the proto-prehistorian, we encounter d'Hancarville the would-be social anthropologist, fascinated by comparisons to be drawn between Stone Age cultures of the present and those of the past.[7] The past and the present, in the fertile

imagination of d'Hancarville, were intrinsically mixed. Cook's South-Sea islanders were one instance of the past existing in the present; but for d'Hancarville the time traveller it was equally possible for the present to be projected back into the past. With brilliant and characteristic conceit, in the third volume of Hamilton's first vase collection he contrived to set himself among the ghosts of the past by inscribing his own epitaph upon a funerary altar (fig. 13). 'The Publick', he writes, 'does not forget that a right has been given me to look upon myself as an author that does not exist for some years past; not being at a loss, if needs must, to name the places where I have been buried.'[8]

FIG. 13 D'Hancarville's 'tomb', engraved in volume III of *AEGR*.

A new Pliny

We shall return to Sir William's fascinating hireling-scholar. But first, what of Hamilton's own view of that foreign country, present as well as past, in which he arrived with his first wife Catherine in November 1764? In the person of Hamilton we find an epitome of the idea of an eighteenth-century *amateur*, interested in all around him. To call Hamilton an archaeologist is to diminish his role as someone who would not have recognised the modern division of the arts and the sciences as discrete fields of intellectual enquiry. Hamilton loved art and nature as one, and shared the universal interests of the antiquaries of the past. Indeed, his very life on the Bay of Naples seems to imitate those ancient noble Romans who had their summer homes along the Neapolitan coastline, before it was spoiled by the eruption of Vesuvius in AD 79.[9] Moving around his town and country residences according to the season, Hamilton's life was a blend of *otium* and

negotium, of private leisure and public duty. Like the ancients, he sought the tranquillity of solitude as the precondition for the enjoyment of fine things[10] and, just as Seneca's stoic reserve gave him strength to 'refrain and endure' at the court of the emperor Nero, so Hamilton must have bitten his tongue a thousand times in the company of Ferdinand IV, the boorish King of Naples. Of all the ancients, however, whose lives could provide an inspiration for Hamilton's own, none could compare with that of the inveterate scribbler on all matters natural and artificial, Cnaeus Plinius Secundus.

In Hamilton's day Pliny's *Natural History*, a lengthy discourse upon the world as he found it in the first century AD, was the indispensable companion of a gentleman with scholarly interests. Sir William kept two copies in his library, one for use, the other for show.[11] Pliny's was an encyclopaedic mind which, like that of Hamilton, did not share the modern concept of knowledge as a series of narrowly compartmentalised fields for specialists. Modern divisions between arts and sciences would have been alien to Pliny and Hamilton alike. *Scientia* in Latin simply means 'knowledge', and Pliny's aim was to shine a light on any dark corner of human enquiry – to report, and, where possible, to explain natural phenomena and their causes. He was no philosopher, however, and Hamilton would have found sympathy with Pliny's statement, 'What is important for us is to demonstrate what is clear and manifest in Nature, and not to discern doubtful causes'.[12]

The sad story of how Pliny's curiosity led to his own death in the eruption of Mount Vesuvius is told in the letters of his nephew, the younger Pliny, to the Roman historian Tacitus.[13] Hamilton also had a nephew, Charles Greville, with whom he shared both his interests and the credit of being labelled 'the two Plinys' by the wits of contemporary London society.[14] Hamilton, whose eyebrows were singed more than once by the lure of the mountain, was lucky to have escaped the fate that befell his ancient predecessor who died on that day in August AD 79, when whole townships succumbed to the volcanic catastrophe. In Hamilton's own day, what died with Pliny was to be rediscovered and partially resurrected and Sir William, whose Villa Angelica was conveniently situated on the road between ancient Pompeii and Herculaneum, followed the excavations with interest.[15] The villa also provided an excellent vantage point for watching the pyrotechnics of Vesuvius. All this, as Sir William was to remark in a letter written shortly after his arrival in Naples, made up for the lack of interest he found in the dull and corrupt politics of the place.[16] In this same letter he reports the discovery of one of the now celebrated finds from Pompeii, namely 'a Venus of white marble coming out of a bath and wringing her wet hair. What I thought most remarkable was that all

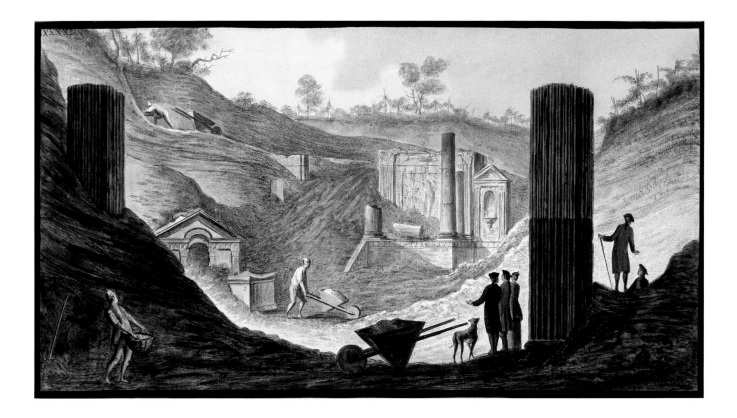

her *tit-bits* such as *bubbies*, *mons veneris* etc. are double gilt and the gold very well preserved, the rest of the marble is in its natural state.'[17]

'Glorious discoveries'

Already before Hamilton's arrival in Naples, the laborious process of disinterment had begun, first at Herculaneum and then at Pompeii.[18] The secrecy surrounding the excavations gave rise to accusations of malpractice and neglect.[19] Among those to make their objections known was Johann Joachim Winckelmann, whose critical *Open Letter on the Discoveries of Herculaneum* was published in German in 1762. A French translation appeared two years later, a copy of which Sir William kept in his library. Sir William's diplomatic position prevented his voicing similar public criticism, but he vented his indignation in private correspondence, and also in person to Bernardo Tanucci, the Neapolitan prime minister. The problems are outlined in a previously unpublished letter to Henry Temple, Lord Palmerston.[20]

> The arts here are at the lowest ebb, and the little progress made in the searches at Herculaneum and Pompeii proceeds solely from vanity. I ventured to tell the Marquis Tanucci, who has the direction of these antiquities, my sentiments upon their manner of proceeding and have had the satisfaction of seeing that in some things they have been attended to.
>
> Could one think it possible that, after the principal gate into

FIG. 14 Excavation of the Temple of Isis at Pompeii. Engraving after a drawing by Pietro Fabris for *Campi Phlegraei*, 1776, pl. XLI.

> Pompeii has been discovered at least five years, that instead of entering there and going on clearing the streets they have been dipping here and there in search of antiquities and by that means destroyed many curious monuments and clogged up others with the rubbish. Now they are going to begin at the gate.
>
> The Temple of Isis is certainly extremely curious, it is now entirely cleared, the very bones of the victims were upon the altars, and the paintings and stuccos as fresh as if they had been just executed. They will have relation to the Egyptian cults. By the inscription over the gate of the temple, which is perfectly preserved, this temple was rebuilt at the sole expense of N. Pupidius, the ancient one having been thrown down by an earthquake, so that it must have been executed some time between the year 63, when the great earthquake happened and the year 79, when Pompeii and Herculaneum were destroyed by the fatal effects of Mt. Vesuvius. Glorious discoveries might still be made, if they would pursue the excavations with vigour.

Hamilton later complained in his letter to the Revd Dr William Robertson, former tutor to his nephew Charles Greville, of the Temple of Isis being left open and unprotected after excavation, the only remedial action being to cut

the paintings out of the walls, and then to mix them with others in the royal museum at Portici. 'I could have wished', he says, 'that, before they were removed, an exact drawing of the Temple had been taken and the position of the paintings expressed therein, as they all related to the cult of Isis, and would have been much more interesting published together than at random, which will I fear be their fate.'[21]

In recent years there has been an attempt to make amends and a full study has now been undertaken of the finds from the Temple of Isis.[22] Although too late to prevent the rape of the shrine, Sir William at least had the satisfaction of knowing that his intervention had effect in inhibiting further malpractice. In a letter addressed to Henry Seymour Conway, he writes, 'The Marquis Tannucci ... has lately shown his good taste by ordering that for the future the workmen employed in the search of Pompeii should not remove any inscriptions or paintings from the walls, nor fill up after they have searched, so that travellers will soon have the opportunity of walking the streets and seeing the houses of the ancient city (which is infinitely more considerable than Herculaneum) as commodiously as Naples itself.'[23] Here we see how close in Hamilton's mind was the comparison between the Naples of the past and that of the present.

One of Sir William's duties as British representative at Naples was to assist his countrymen, and others, in gaining admission to the finds from the excavations housed in the royal museum at Portici. Limited access was possible up until 1770, but was all but stopped in that year by a row between an English visitor and the royal antiquary, Camillo Paderni.[24] One reason for this secrecy was the Neapolitan court's own jealously guarded plans for publishing the antiquities. In 1755 Ferdinand's Bourbon predecessor, Charles III, had set up the Reale Accademia Ercolanese for this purpose. This would eventually result in eight richly engraved folio volumes entitled *Le Antichità di Ercolano*, published between 1757 and 1792. This work was to have considerable impact upon eighteenth-century art and design,[25] even though initially, at least, its circulation was limited to those privileged few who were honoured by its presentation in the royal name. Hamilton was dubious of the virtue of this and made his views known to Tanucci.[26]

> I ventured to say that His Sicilian Majesty would do more service to the arts by allowing the books of Herculaneum to be sold than by giving the few copies in the manner they are given, and as the public are so eager to possess this work, it would no doubt bring in a great sum into the country, which would be a fund to go on with vigour in the searches at Herculaneum, Stabia and Pompeii, which searches are almost at a stand for want of money, and a false pride will not suffer them to think of selling these books. If my scheme took place,

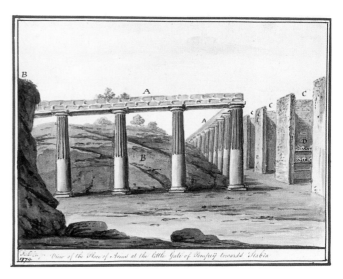

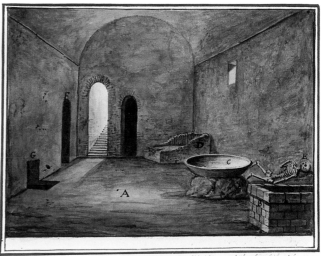

FIGS 15–16 Two views of Pompeii by Pietro Fabris, the first signed and dated 1774. Pen, ink and watercolour, later engraved in *Archaeologia*, IV. Society of Antiquaries of London.

how much the arts would profit by it, but nothing is more difficult to conquer than pride and ignorance.

By 1775 some further progress had been made at Pompeii, and in that year Sir William communicated an account of recent excavations, which was read at a series of meetings of the London Society of Antiquaries. This was subsequently published with engraved illustrations in the Society's journal.[27] The original drawings that Sir William sent to the Antiquaries to illustrate his report still survive. They have both colour and a charm not conveyed in the austerity of the black-and-white engravings. It seems not to have been noted before that, as well as the date 1774, a signature appears *pars pro toto* on the first drawing in the series: 'Fabris p[inxit]'. Pietro Fabris is well known as the artist of Hamilton's books on volcanoes, and it is not surprising that, while that project

was in hand, Hamilton should have sent his draughtsman into Pompeii to record the excavations.

'A favourite child'

Sir William had in mind for the Society of Antiquaries more than one publication on the excavations. Until the very end of his life he cherished the idea of a treatise on Herculaneum, which never in fact materialised. The first we hear of it is a letter to his nephew, dated October 1781:

> I have collected much curious information relative to the early excavations at Herculaneum, and shall one of these days be at liberty to communicate them to the public, which I think of doing by the means of the Society of Antiquaries, as it will answer my purpose without expense, and what I have collected is from such good authority and of so curious a nature that the public will be much obliged to me. I have also employed a person who lives at Portici and draws well, who has made observations on the smoke on Mount Vesuvius every day since the last eruption, and made daily drawings of it.[28]

In fact, the source of Hamilton's information about Herculaneum and the person he paid to watch the mountain – from the eruption of 1779 to that of 1794 – were one and the same, Father Antonio Piaggio. Sir William was to present Piaggio's eight-volume *Diario Vesuviano* to the Royal Society through its President, Sir Joseph Banks. A letter from Sir William dated 14 June 1801 is inserted into the first volume in the series. 'The Padre Antonio', we are told, 'lived in a house at the Madonna Pugliano near Resina at the foot of Vesuvius and with a full view of the volcano from his window. He always rose at daybreak and took his observations several times a day.'[29]

Padre Piaggio is best known to papyrologists as the man who invented the machine for unrolling the carbonised papyrus rolls that were found interred in the ruins of the so-called Villa of the Papyri, situated just outside the town of Herculaneum. In spring 1750 Colonel Roque Joachim de Alcubierre, who had been entrusted with the excavation of ancient Herculaneum, first became aware that the digging of a well near the modern village of Resina had penetrated the ruins of what would soon become known as the Villa of the Papyri.[30] In 1752 the remains of a library were found, consisting of a great quantity of papyrus rolls. At the instigation of Camillo Paderni the first attempts at reading them resorted to the drastic action of slicing the roll in two lengthways. By this means a portion only of the ghostly text was exposed and it was possible to make out the author, an obscure Epicurean philosopher named Philodemus of Gadara. Padre Antonio, formerly employed in the Vatican Library, developed a less destructive way of reading the texts using a gadget which unrolled the papyrus at the rate of a millimetre a day.[31]

In 1907 Domenico Bassi published a quantity of autograph memoirs of Padre Antonio relating to the antiquities and papyri of Herculaneum. The memoirs were incomplete, and Bassi was aware of but could not find the manuscript Piaggio had left with Hamilton. In fact this was more than a mere text, for there were also drawings, as William Beckford informs us in a letter written from Paris and dated 27 February 1792: 'Will your man ever be able to complete the Herculaneum drawings, a volume of which he showed me last summer? If he could I might treat with him.'[32] It seems not. Piaggio's last services to Sir William were all of a volcanic nature, especially after the great eruption of June 1794. What is possibly Piaggio's last letter to Hamilton, dated 15 November 1795, is written from Resina, the modern town above Herculaneum, but makes no mention of the antiquities. Instead it encloses two samples of volcanic ash (still preserved in tightly folded packets) and a good deal of self-pity besides. Piaggio spoke of himself 'standing with both feet in the grave' and was preparing to retreat into a monastery and there to meet his redeemer. 'He cannot', he says, 'think of papyri any more, nor of any of the things of this world.'[33]

Piaggio died in the following year aged eighty-two, and Sir William was left to cope alone with the planned publication of the Herculaneum manuscript. Following his return to England at the end of his residence in Naples, he made one last effort to see it into press, this time through the Society of Dilettanti. The papers of Charles Townley contain the fullest account both of the contents of Piaggio's work and of Sir William's intentions. A remarkable letter from Sir William written to Townley from Piccadilly and dated 22 January 1803 reads as follows:

> I send you according to my promise a small specimen of the numerous fragments of important remarks made by Padre Antonio, whilst the excavations were carrying on at Herculaneum under the direction of that wicked and ignorant rascal Camillo Paderni. I have ten times as many fragments of drawings and remarks mostly in cypher in my possession, but I must own the idea of the labour of decyphering them has discouraged me. I send you, however, the Padre's cypher, not that I think you will attempt the difficult task – nor indeed should you in your present state of health – of decyphering. You will I dare say, as I have, be much amused with even the rough sketches of Padre Antonio from the antique monuments, as they came out of the Earth, and before the barbarian spoiling altered most part of them. You will see truth in every stroke of the Padre's pencil. You may look over them at your leisure and when you send them back, I will send you another parcel.[34]

A week or so later Sir William left a note with Townley to say that a Signor Cassano, 'one of the partners of the Italian

Library near Earl's in Albemarle Street', had undertaken, as Townley put it, 'to fag at Padre Antonio's cypher'. Sir William requested Townley to send him the key and one of the manuscripts. The Italian bookseller succeeded in deciphering Piaggio's code, but Sir William died in the following April, leaving Charles Townley in charge. The latter wrote in his diary as follows.

> Sir William left in my hands all the manuscripts of the Padre Antonio, chiefly relative to the discoveries in Herculaneum, Pompeii and Stabia, from the first excavations made there about the year 1751. They contained many sketches by the Padre from various antiquities, particularly a plan of the town of Herculaneum as far as excavations were made, all of which are filled up, except a few avenues around the theatre, left for public view. Padre Antonio was employed from the first discoveries of the ancient rolled manuscripts in the house of Philodemus, to unroll and decipher them. All that are published of them are the work of this Padre. He was ungratefully used by the Court of Naples, scarcely paying him a very miserable pension. He, therefore, having very many obligations to Sir William, gave all his papers on antiquities. Many of them, however, are frivolous.[35]

Although Hamilton had left the Piaggio papers with Townley, he had personally offered them to the Dilettanti Society before he died and the offer was accepted.[36] The decision on whether or not to publish them was deferred until Sunday, 27 March 1803. Sir William was himself prevented through ill health from attending the meeting that would decide 'the fate of a favourite child of mine'.[37] It was decided in his favour, however, and news of that decision will have reached Sir William before he died on 6 April. Unfortunately, that is the last we hear of Piaggio's papers, which are not now among the remnants of the archive of the Dilettanti Society and have yet to be located elsewhere. A few fragments only have found their way into the manuscripts collection of the British Library. These bear Sir William's annotations and clearly were once part of the set.[38] They date to the 1760s and all relate to the papyri.

D'Hancarville and the publication of Hamilton's first vase collection

Fortunately Sir William's other 'children', his books on vases and his writings on volcanoes all grew to maturity. Little did he know, however, what a cuckoo he nurtured, when he admitted the so-called Baron d'Hancarville into his home to manage the publication of his first vase collection. The man chosen by Sir William arrived in Naples in October 1763 already preceded by a reputation as, at best, an adventurer, and at worst a swindler.[39] Hamilton would discover d'Hancarville's dark side all too painfully in 1769, when he

fled his creditors in Naples, taking the plates of Sir William's unfinished book with him.[40] It was d'Hancarville's other side, however, that attracted the genial and trusting Hamilton. He was not the first, nor would he be the last to fall under the spell of d'Hancarville's magic. His brilliant mind, the intoxicating way he spoke of art and antiquity and, not least, his indisputable talent as a book-designer, were all ways to both the connoisseur's heart and his pocket.[41]

Born at Nancy in 1719, the son of a bankrupt cloth-merchant, d'Hancarville's real name was Pierre François Hugues. His prodigious memory enabled him to excel at school, and he quickly became proficient in a number of languages, ancient and modern. D'Hancarville also had a natural talent for mathematics, and demonstrated his lifelong passion for 'systems' in his first known publication, entitled *Essai de politique et de morale calculée* (1753), in which he attempted to subject moral philosophy to mathematical principles.[42] In the publication of Sir William's vases there is copious evidence of d'Hancarville's love of numbers in his exceptional willingness to use hard dates in working out the chronological development of the arts in antiquity.[43] Bernard de Montfaucon (1655–1741), the Comte de Caylus (1692–1765) and Johann Joachim Winckelmann (1717–68), foremost antiquaries of their own day, all preferred to deal in relative chronologies constructed out of periods – Egyptian, Phoenician, Etruscan, Early Greek, etc. D'Hancarville, by contrast, emulated the polymath chronologers of the past who, from Eratosthenes (c.275–194 BC) to Joseph Scaliger (1540–1609), had all sought to demonstrate their virtuosity for applying mathematics to history by calculating fixed dates for important events, even in remotest antiquity.[44] There is a panache about d'Hancarville's calculations, reminiscent of the preface to Isaac Newton's *Chronology* (1728), which declares Newton's achievement to be no less remarkable for having been compiled in his spare time, during relaxation from matters of greater gravity.[45]

In an age that put a high value upon 'virtu' and connoisseurship, d'Hancarville was all too aware – sometimes painfully so – of the prestige to be gained from personal involvement in a great publishing project.[46] He was determined that there should be no doubt about the authorship, and frequently refers to 'mon livre', making a great show of having to stand in for his patron, who was too preoccupied to undertake the work himself. Even in correspondence with Hamilton, d'Hancarville's initial impersonal reference to 'l'ouvrage' soon becomes 'mon ouvrage'.[47] Not for him the self-effacing anonymity with which Ennio Quirino Visconti undertook the text of Richard Worsley's *Museum Worsleyanum* (see pp. 101–2).[48] Just as well for Hamilton, perhaps, who would later distance himself from d'Hancarville's higher

flights of fancy.[49] For his part, d'Hancarville saw the work as a vehicle for his own apotheosis into the pantheon of celebrated antiquaries, including Caylus and Winckelmann. We have seen how he had his own tomb engraved; this was a deliberate conceit designed to accompany the imaginary sepulchres of Winckelmann (cat. no. 31) and Caylus that were part of the introductory pages to the second and third volumes of the book.[50] Throughout his work he makes copious reference to their published opinions. Often, however, his purpose is to contradict or to go one better.[51]

By the mid-1760s Winckelmann had become the foremost antiquary of his generation.[52] He was established in Rome, first as secretary to the art-loving Cardinal Alessandro Albani, and then as Papal antiquary commanding the collections of the Vatican. His *History of Ancient Art*, published in Dresden over the winter of 1763–4, set out his ideas about the rise of Greek art in antiquity in clear elegant prose. It established his reputation as the leading authority on ancient art and assured his role as the principal *cicerone* of visitors wishing to see the antiquities of Rome. From February to April 1768 Hamilton himself and his wife were in Rome to be taken around the sights by Winckelmann. The party included Lord Stormont, British Resident at Vienna – recently bereaved and in need of distraction – and James Byres, the architect, antiquary and antiquities dealer.[53] Upon his return to Naples, Sir William wrote to d'Hancarville saying how much he had profited from seeing the statues with Winckelmann.[54] Hamilton had already made Winckelmann's acquaintance the previous autumn, when the German scholar was himself in Naples on his fourth and what was to be his final visit.[55] On this occasion Winckelmann shared lodgings with d'Hancarville, where the walls were lined with Hamilton's vases.[56] Sir William had courted Winckelmann in an exchange of letters in which the collector attempted to interest the scholar in compiling descriptions for his vases.[57] Winckelmann was certainly flattered by these approaches and Hamilton tried to tempt him further with presents of the proof plates of the first volume. On 7 April 1767 Winckelmann wrote an acknowledgement from Rome, flattering Hamilton but without making any firm commitment to participate in the publication.[58] He was apparently wary at this time of risking his reputation through entanglement with the unpredictable d'Hancarville, and was besides preoccupied with the follow-up publication to his own *History*, an anthology of ancient objects in various collections entitled *Monumenti inediti*. Hamilton himself received a gift of the first two instalments of this work.[59] A third was planned, but never appeared, for on 8 June 1768 Winckelmann was brutally murdered at Trieste by the low-life Francesco Archangeli. The two had become 'friends' in a boarding-house where Winckelmann lodged on the return leg of a journey he had made across the Alps to his native Germany.[60]

Another of d'Hancarville's heroes was the ancient author of the *Roman Antiquities*, Dionysius of Halicarnassus, whose biographical preface to his own work is quoted at length by d'Hancarville.[61] By reading all existing authorities, Dionysius set out to reconstruct the early history of Italy. His long reach into what – even for Dionysius, living in the first century BC – was remotest antiquity, became a model for d'Hancarville's own prehistoric speculation, sifting the sands of time for clues to the very origins of human art.[62] D'Hancarville mixed his blend of myth and history, based upon the writings of Dionysius, with borrowings from the *Geography* of Strabo and the art histories of Pliny and Pausanias. From these he compiled his own narrative of the rise of Greek art, into which he slotted not only Hamilton's vases,[63] but also numerous other ancient artefacts, including engraved sealstones – of which he once had a small collection himself[64] – sculptures and paintings, some preserved, others described only in the pages of the ancient authors.[65] D'Hancarville's main text on ancient sculpture appears in the fourth volume and, as a letter written to Hamilton from Florence dated 20 June 1773 shows, was clearly intended to rival Winckelmann.[66]

D'Hancarville's narrative is not a continuous one: his voyage to the past tacks back and forth, seeming often to drift on a sea of words. Ideas pour forth in fits and starts, spilling over from one chapter into another, and on into further volumes and even future editions of the work. D'Hancarville's writing is the very antithesis of Winckelmann's *History*, where the reader is led in clear, progressive episodes through the various phases of ancient art, culminating in a magisterial analysis of the unique beauty of that of the Greeks.[67] D'Hancarville's art history, by contrast, is not so much to be read by his audience, as inferred or reconstructed, almost, from the 'ruins' of his own text. Winckelmann's book is a literary analogue of that beauty he admired in an ancient sculpture, a balanced whole constructed out of a measured blending of parts. D'Hancarville's book has pictorial beauty and great literary energy, but all this is belied by the chaos of the text.

One major difficulty the reader faces in d'Hancarville's work is its apparent indifference to the principal subject, Hamilton's vases. Leaving aside the confusion in the numbering and sequence of the plates, there are no explanations to the engravings bound as volume I, issued late in 1767. A selection only of these vases is described in the second volume, published in 1770, but this lacks descriptions of the

FIG. 17 A page from *AEGR* (I, p. 112).

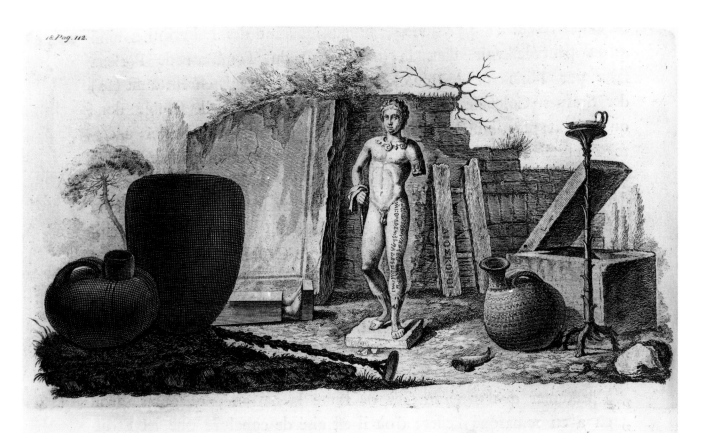

SECTION II.

Of Sculpture and Painting.

19. Pag. 112.

Orn to numberless wants which his imagination also encreases, Man who exists in the present moments that are ever flying from him, holds by his hopes to a futurity, and by his remembrance to a time which is past and is no more. Desirous of enjoying, he would extend his existance to all times, and seems in his Ambition which knows no other bounds than those of his desires, that has been or will be. He to wish to be the Cotemporary of all has invented Speech, Writing, Sculpture and design which serve to re-

call

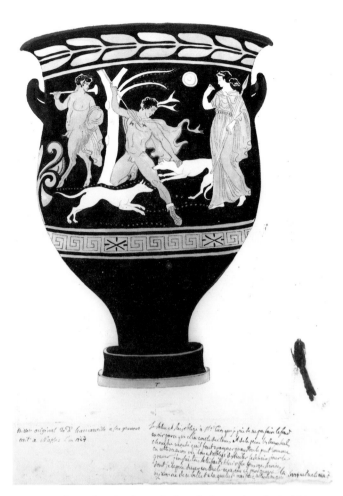

FIG. 18 Drawing perhaps by George Redmund of a vase (now lost) which seems to have been intended for *AEGR* but which was probably never in Hamilton's collection. It shows a South Italian red-figured bell-krater painted with a scene of the death of Actaeon. The inscription, written below the vase in d'Hancarville's own hand, carries instructions to the engraver. British Museum, Department of Greek and Roman Antiquities, Townley Drawings.

vases it illustrates. For these the reader must turn to the fourth volume, not printed until 1776, which lists a selection only of some of the descriptions in all four volumes.[68] Hamilton was party to the decision not to swell the first volume, already bloated by d'Hancarville's preliminary essays, with further text matter.[69] Besides, there was the hope that the book would receive the imprimatur of Winckelmann's descriptions. Whether or not some of the published descriptions of the vases are by Winckelmann is a question that has previously been discussed without conclusion. With one exception (see cat. no. 54), it is generally assumed that the entire work is d'Hancarville's own. It seems, however, to have passed without comment that in a letter to Hamilton dated 8 March 1768, d'Hancarville explicitly says that Winckelmann had furnished him with several explanations for the

second volume.[70] While this does not represent the full and formal participation Hamilton was hoping for, it does mean that the descriptions included in the second volume must be regarded in part at least as Winckelmann's.

A further source of confusion is the fact that the work includes engravings of vases that were never in Hamilton's collection. D'Hancarville seems to have persuaded Sir William that the book would have more universal appeal and provide a more authoritative account if it encompassed a broader field than that of a single collection.[71] In addition, therefore, to Hamilton's own vases, we find engravings of subjects drawn from vases in other collections, that never entered the British Museum. Hamilton seems to have agreed relatively early to his book expanding from the initial plan of two volumes to four, and d'Hancarville attributes to Catherine Hamilton the suggestion at the planning stage for the addition of a fourth.[72] Nevertheless, Sir William must have begun to feel uneasy as costs of production began to increase in the rising tide of d'Hancarville's learned digressions, which soon filled a second volume, with no end in sight. D'Hancarville took care to make a show of keeping his patron abreast of the planning of the work, giving at least a version of his various financial transactions with the printer and the team of artists who carried out the drawings and engravings. His letters to Hamilton are preserved in the Bibliothèque Nationale in Paris and are testimony to the energy with which d'Hancarville pursued his patron's commission. We may wonder, however, what Hamilton's response was to these impenetrable 'explanations', head-spinning calculations and spiralling costs.[73]

Hamilton was by nature trusting, some might say gullible, and even when news reached him in December 1769 of d'Hancarville's expulsion from Naples and flight to Florence, he refused to think the worse of him. In a letter to Horace Mann, his diplomatic counterpart in Florence, Hamilton expressed his belief that d'Hancarville's only crime had been to outshine the Accademia Ercolanese in knowledge of antiquity and in the brilliance of his vase book.[74] The real reason, however, seems to have been debt and an attempt to raise money by publishing pornography.[75] Hamilton continued to support d'Hancarville in Florence, while the latter, having first found a new patron in the Grand Duke of Tuscany, then proceeded to run up new debts. Even as tales of d'Hancarville's latest misdeeds began to reach him, Hamilton was performing further kindnesses, arranging for an escort to accompany the miscreant's wife to Florence. That escort was to be provided by one, 'to whom we owe the best part of the execution of the Etruscan work: he drew all the figures; his name is Redmund [George]. He is a good sober creature, as well as a charming designer, or I would not venture to recommend him.'[76] The involvement of this artist,

seemingly substantial, in the preparation of drawings from Hamilton's vases has not previously been recorded.

Eventually, Sir William was himself obliged to pursue d'Hancarville to Florence. There, as he wrote to Josiah Wedgwood on 2 March 1773, he found a stand-off between d'Hancarville, who was in prison, and his creditors, who were in possession of the engraved plates but with little prospect of recuperating their losses. Hamilton therefore organised them into a syndicate, each member contributing towards the publication of the rest of the book, whereby both their losses and his own would be recovered.[77] The two volumes were completed by 1776, but even then the way was not clear for their publication. Insufficient subscriptions had come in to satisfy all d'Hancarville's creditors, who refused to release the printed volumes until Hamilton paid a lump sum. Sir Horace Mann was brought in to act on Hamilton's behalf, and the long-drawn-out process is documented in his letters to Horace Walpole[78] and in hitherto unpublished correspondence between Hamilton and his bookseller, Thomas Cadell, who had his London premises opposite Catherine Street in the Strand. On 24 October 1779 Hamilton wrote to the latter:

> I have at last had an offer of one hundred copies of the third and fourth volumes of the Etruscan work for the sum of four hundred and twenty pounds. Before they are delivered at Florence, I must deposit a bill on a creditable House in London for the said sum. It may be payable three months after date … The case is that we have to do with a court of justice, and before they deliver the books will have the money down, or such a bill for it as is known to be as good as money itself – I own that I wish at any rate to be rid of this business, both for your sake and for mine, but I flatter myself that even those that have subscribed to you will not scruple paying something more for the last two volumes, than the agreement, when they are informed of the true state of the case, and what they cost me. As to the supplying those that subscribed to Mr d'Hancarville, who is in London to answer for himself, and who had all the subscription money, I do not think myself by any means bound to it.[79]

It seems a hundred copies of each volume were printed and sent to London in two consignments of fifty each. As late as August 1781, Hamilton had not received confirmation that all the books had been delivered to Cadell.[80] Although, therefore, the date of publication of the third and fourth volumes is usually put at 1776, few copies actually reached the hands of subscribers until the early 1780s. Little wonder that Josiah Wedgwood, writing to Hamilton in 1779 about the pictorial source for his jasperware plaque entitled the *Apotheosis of Homer* (cat. no. 60), considered the original vase, upon which he had based his design, unpublished.[81]

FIG. 19 Engraved title page of volume III of *AEGR*, dated 1767 but not printed before 1776.

The story of the publication of Hamilton's first vase collection is as extraordinary as the man he hired to carry it out. Given the circumstances, it is remarkable that it was published at all, and it is a credit both to Hamilton's own determination to see it through and to d'Hancarville's energy and imagination. Nor was the quality of the illustrations of the final volumes, or the length and complexity of the texts lessened by their frenetic production.[82] Rather the contrary: colour was added in the fourth volume even to the supplementary illustrations, and in his copious text d'Hancarville reworked and expanded many of the subjects he had raised earlier. The striking aspect of d'Hancarville's later writing is an increasing tendency towards a metaphysical interpretation of antiquity, which has been called his 'theory of signs'.[83] The mature working out of his theories is to be found in the three-volume treatise he published in London, but in French, in 1785–6.[84] His ideas, however, were already sufficiently developed by 1767 to fill large tracts of the vase publication. These are discussed in detail elsewhere in this book,[85] and suffice it to say here that whatever his subject – whether it be vase-painting, sculpture or gem-engraving – d'Hancarville tended towards a symbolic rather than an empirical view.

For d'Hancarville every image must signify something, and every part of that image must contribute to the overall message. Art is a language: 'écriture figurée' is the memorable metaphor he used to explain his idea of art as a form of hieroglyphics, a writing in pictures, where even apparently decorative elements have meaning.[86] The impulse to communicate through visual signs was a primitive urge that d'Hancarville recognised both in the art of contemporary 'Stone Age' cultures and in that of early antiquity. At its most elementary, art that was purely symbolic had a clear and abstract message, only later compromised by figurative expression. 'The spirit of sculpture and of engraving of the time of Daedalus was not to express, but to signify much. The clarity absolutely necessary to this genre of composition, does not admit anything which is not serving its purpose, to which everything is subordinated − even form.'[87] For d'Hancarville, art was ever faced by a dilemma created by the tension between intellect on the one hand, and physical sensibility on the other. He believed the former to have pre-existed the latter, and that even post-primitive art carried reminders of its origins. A well-known marble group of two youths, now in Madrid, was thought to represent Castor and his twin brother Pollux. Here one figure is compositionally linked to the other in a design intended to evoke a primitive image of these two gods, which Pausanias described as two planks of wood bolted together, a sign of the inseparability of the divine twins.[88] Nor were these echoes of primitive sign language restricted to Classical art. In one miraculous leap, d'Hancarville connects the earliest art of Greece with that of the sixteenth and seventeenth centuries of the modern era: in the first trials of the artistic circle of Daedalus are sown the seeds of that 'exactitude with which Poussin marks the scene of his learned paintings, the care that Raphael has taken to show the place, the time, the circumstance, where he made the meeting between Attila and the Pope.'[89] D'Hancarville included in the second volume of *AEGR* a line-engraving of Raphael's painting of *Attila before the Pope*,[90] and a fleshed-out version of the Meidias Hydria (cat. no. 55) to show what a vase-painting would have looked like if it had been painted by Raphael.

D'Hancarville's positive view of primitive art seems peculiarly contemporary to modern readers, seeming to anticipate Sir Ernst Gombrich's distinction between conceptualism and realism, between the *what* and the *how* of Greek art, as he expresses it in an influential essay.[91] D'Hancarville wanted to be considered an innovative thinker who had gone beyond the limits of Winckelmann's art history, which ostensibly followed a conventional line, whereby civilisation was seen as a rise from crude beginnings in the art of Egypt or Etruria to the summit of perfection with the Classical Greeks. Instead, d'Hancarville shared a Rousseauesque idea of early

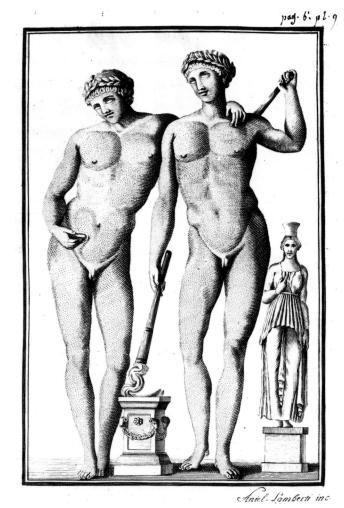

FIG. 20 'Castor and Pollux', statue group in the Prado, Madrid, engraved for volume IV of *AEGR*.

man as savage − but noble − before the Fall, or, given his apparent atheism, *without* it. His history breaks off, as he himself explains, where Winckelmann's begins. 'Winckelmann', says d'Hancarville in the fourth volume of *AEGR* − the initial letter of the name drawn to an enormous scale and elaborately illuminated − 'says nothing about sculpture before the time of Daedalus, nor of his pupil Endoeus or Endochus, he goes straight instead to the eighteenth Olympiad [*c.*700 BC], some five centuries later.'[92] That d'Hancarville had it in mind to rival the reputation of the great Winckelmann there can be no doubt, and in a letter to Hamilton written from Florence to announce the completion of a draft of what would become the third and fourth volumes, we read, 'The most brilliant part is that which talks of the statues. It could make two volumes in *octavo*, like Winckelmann's art history, and could serve infinitely those who travel to Italy.'[93]

D'Hancarville was to confess to Hamilton that his natural tendency was towards a metaphysical view of his subject.[94]

What he does not remark upon, and what has only recently been discovered by Pascal Griener, is the great debt that view owed to the work of another scholar, Octavian Guasco. Griener thinks d'Hancarville guilty of deliberate plagiarism where Guasco's ideas are concerned, even to the point of falsifying the dates on the title pages of *AEGR*, which are 1766 for the first volume and 1767 for volumes two to four.[95] If these dates were real, then Guasco's book published in 1768 would appear to have been written after d'Hancarville's. D'Hancarville's debt to Guasco is, again, a topic discussed in detail elsewhere in this book.[96]

How, therefore, to sum up here the part played by this talented, complex and certainly flawed personality in the production of the publication of Sir William's first vase collection? Perhaps the last word may be borrowed from a judgement of d'Hancarville's later *Recherches* made by Paul Henry Maty, writing in the *New Review*. What that book needed, according to its reviewer, was 'less tautology, more order, more clearness, less mixture of old and known things with the new, and a smaller torrent of erudition'.[97] These are standards for all scholars to aim at; nor is d'Hancarville's book itself without apology. In the preface to the first volume he recalls how he was humbled by the arrival of the letters for printing it. These were cast specially for the purpose in Venice, and d'Hancarville explains in a memorable and typically stylish soliloquy how he 'was frightened to think of the few good things and the immense quantity of bad ones, which these characters might bring to light'.[98] Contemplating the very letters themselves, d'Hancarville threw himself upon the mercy of his readers. The fact that they have not always been quick to forgive him is due, no doubt, to the monumentality of the work and the scale of its solecisms.

Etruscan or Greek?

When Hamilton was putting his first collection together, ancient painted vases were in plentiful supply. He was by no means the first to form such a collection. Already before he left for Naples, a number of painted vases, which can be traced back to the cabinet of the Neapolitan lawyer Giuseppe Valletta (1636–1714), had entered the British Museum through the founding collection of Sir Hans Sloane.[99] In addition to acquisitions made direct from excavations at Nola, Capua, Trebbia and Sant' Agata dei Goti, Sir William also bought from old Neapolitan collections, notably that of Felice Maria Mastrilli, who died around 1755 (see cat. no. 24).[100] Mastrilli was one of an important group of Neapolitan intellectuals, including A. S. Mazzocchi and Giacomo Martorelli, who pioneered the growth of interest in and understanding of vases.[101] Their most important contribution, based principally upon the evidence of Greek inscriptions, was to identify

the origin of vases as Greek rather than Etruscan. The notion that Greek vases found in Italy were Etruscan can be attributed to the nationalism of another group of scholars from northern Italy. Filippo Buonarroti and Francesco Gori had adopted the idea as part of a nationalist movement, embracing the culture of the ancient Etruscans in the dukedom of Tuscany.[102] Cultural patriotism in the various states of Italy, still independent before unification in the nineteenth century, acted as a powerful incentive to exploration of the antiquities of a given region.[103] The origin of modern Etruscology is often traced back to a treatise compiled between 1616 and 1619 by Thomas Dempster, a Scottish Catholic, who wrote it in Pisa partly as a means of flattering the contemporary Tuscan ruling aristocracy.[104] The manuscript was discovered a century later and published in Florence by Filippo Buonarroti between 1720 and 1726. Assertion of the Etruscan origin of vases was to have a long history, and, colloquially at least, the term 'Etruscan vases' is still in use today. Contemporary with Sir William's publishing project was the production of another book on vases, by G. B. Passeri, who was one of those to insist upon their being Etruscan. But, as the German painter Wilhelm Tischbein was later to point out, Passeri omitted to state that even the vases in Florence were acquired in Naples.[105] Against this background we begin to understand the national importance to the Kingdom of the Two Sicilies of the discovery of the buried cities of Pompeii and Herculaneum and the reasons for royal interest in the Accademia Ercolanese. For some Neapolitan luminaries it was Greek rather than Roman antiquities that moved their national pride, but here there was no royal interest nor understanding, and the hellenist Martorelli wrote to a friend of how he wondered what a king whose stupidity was '24 carat' would make of Hamilton's present to him of the first volume of his vase collection.[106]

Hamilton would have come to Italy with the view, common in the antiquarian literature of his day, that vases were Etruscan. Later he was to explain how the 'Hunt Krater' (cat. no. 33) with its Greek inscriptions made him realise their true origin.[107] Already, however, in a letter to Lord Palmerston dated 18 June 1765, he had expressed a different view. 'I now and then pick up a good little bronze, and have also collected a great number of Etruscan vases … my opinion is that few are really Etruscan, but made by Greek and Roman artists.'[108] Later Sir William was to drop the erroneous notion that painted vases could be Roman, correctly inferring that, as they were not found at Pompeii or Herculaneum, they must date from before the Roman era.[109] In this same letter Sir William gives the first hint of what is to come: 'I think one day or other of publishing my collection, as I am sure it would be a very valuable present to antiquarians. There is a taste and

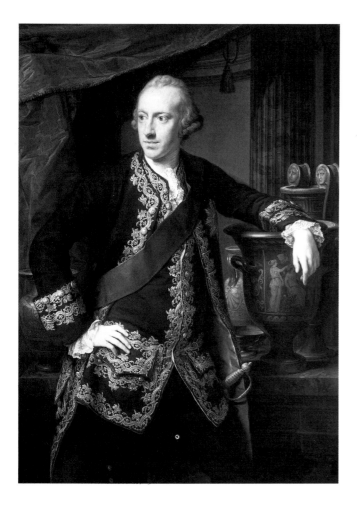

FIG. 21 *Prince Karl Wilhelm Ferdinand, later Duke of Brunswick and Lüneburg*, by Pompeo Batoni, 1767. Brunswick, Herzog Anton Ulrich-Museum.

ber 1766 the young prince arrived in Rome, where he was to be shown the sights by Winckelmann himself and have his portrait painted by the best available Grand Tour artist, Pompeo Batoni.[114] Mengs, who would otherwise undoubtedly have been chosen to carry out this royal commission, was then in Madrid, but his presence is nonetheless felt in the portrait, which shows some of his vases, to which Batoni seems to have gained access through Winckelmann. These take the place of sculpture, which is the usual adjunct in such portraits. Vases provide a set of new paradigms of the beauty of ancient art, and thereby indicate the sitter's initiation into the select group of individuals who have learned to recognise the true status of an artwork as Greek rather than Etruscan.[115] This portrait was to have a great influence on the formulation of Sir William's own self-image: he twice had his picture painted with vases, in a similar manner (cat. nos 1, 51), and commissioned a copy of Batoni's portrait of Karl Wilhelm to hang in the Palazzo Sessa.[116]

Neapolitan gold

By the time d'Hancarville's book was finally issued, the sources from which Sir William had built his first collection of vases had dried up. Already in 1773 he was writing to Wedgwood: 'You cannot conceive how very scarce the true ancient Etruscan [i.e. Greek] vases are now, but one has come to my hands since I returned here, and that of no consequence. My collection at the Museum, I am sure can never be rivalled.'[117] Through the 1780s vases became a rare collectors' commodity, and this, combined with the great boost given to their status and popularity by the sumptuous publication of the first collection, pushed prices to new heights. In spring 1789, Hamilton went with Emma on a thirty-two day tour through southern Italy. He hoped to pick up antiquities along the way but found only a couple of intaglio gems (cat. no. 110) and a single Greek vase from Bari. In a letter to Greville reporting these events, Sir William reflected upon how things had changed:

> The value of my collection in the British Museum is immense, if you was to value it at the present price of antiquities in this country; and be assured that never such another collection will be made, considering the variety of the subjects and the beauty of the forms. I have two or three very extraordinary, indeed, but the Museum shall not have them till I can see no more, for they beautify my new apartment. Emma often asks me, do you love me? ay, but as well as your new apartment?[118]

That same year this situation was unexpectedly reversed by the discovery of new caches of vases which reawakened in Sir William the old passion for collecting them. 'One day', explains Tischbein in his memoirs, 'he [Hamilton] came to me full of joy, and declared that he could resist no longer and

elegance in their shapes and though the figures are not always correct, yet there is a choice in the attitude, and a je ne scais [*sic*] quoi.' In the eighteenth century this last remark was more than the casual expression of the loss for words that it has become today – Hamilton is here using the aesthetic language of contemporary art theory, which was usually reserved for sculpture.[110]

Neapolitan assertion of the Greekness of Greek vases found support in Rome, notably from the painter Anton Raffael Mengs and his friend Johann Joachim Winckelmann. The former had acquired a collection of some 300 vases in 1759, most of them from Nola.[111] Winckelmann's growing conviction can be traced through his various writings,[112] but perhaps the most eloquent document of the realisation of the Greekness of Greek vases, and one which Sir William knew well, was Pompeo Batoni's portrait of the man Winckelmann hailed as the new Achilles, Prince Karl Wilhelm Ferdinand, later Duke of Brunswick and Lüneburg (fig. 21).[113] In Octo-

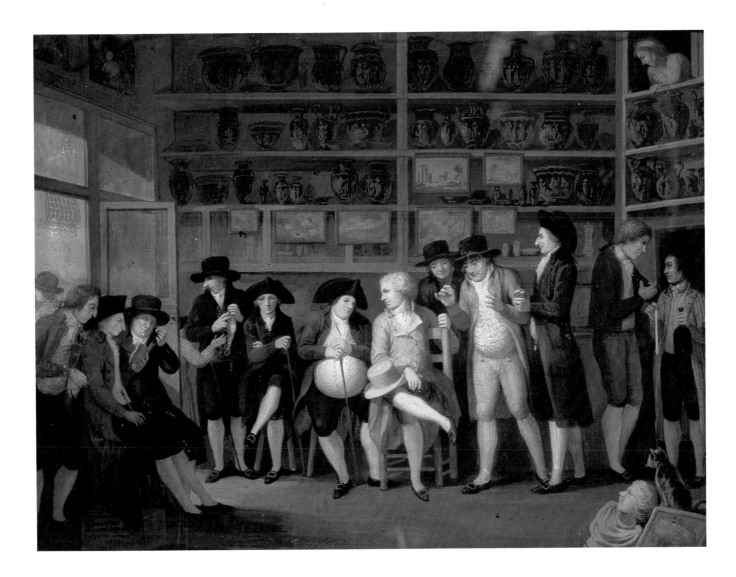

FIG. 22 An antique shop in Naples provides the gathering place for a group of antiquaries, probably including Sir William Hamilton, who is perhaps to be identified with the figure seen in profile, third from the right. Vases and framed watercolours line the walls, while other smaller objects are undergoing close examination. Antiquity is not the only preoccupation, and a fish-seller appears at the left of the picture, while the quality of a bottle of oil is being discussed on the right. The proprietor's cat sits by an antique bust in the bottom right hand corner, and in the bottom left the anonymous artist has cryptically signed his picture 'painted by the owner of this hat, Naples, 1798'. Rome, private collection.

had started to buy vases all over again.'[119] The German painter Wilhelm Tischbein had arrived in Naples in spring 1787, accompanying Johann Wolfgang Goethe on the southern leg of his Italian journey. The two companions were to have travelled on together, but so taken was Tischbein with the place, its people and the beauty of the landscape, not to mention prospects of gainful employment, that he stayed on there. In 1789 his change of plan was justified when he was appointed Director of the Neapolitan Academy of Fine Arts.[120] On 2 March 1790, Hamilton had himself explained the new developments to his nephew:

> A treasure of Greek, commonly called Etruscan, vases have been found within these twelve months, the choice of which are in my possession, tho' at a considerable expense. I do not mean to be such a fool as to give or leave them to the British Museum, but I will contrive to have them published without any expense to myself, and artists and antiquarians will have the greatest obligation to me. The drawings on these vases are most excellent and many of the subjects from Homer. In short, it will show that such monuments of high antiquity are not so insignificant as has been thought by many, and if I choose afterwards to dispose of the collection (of more than 70 capital vases) I may get my own price.[121]

By June of that same year Sir William was thinking seriously how best to dispose of his collection, which he now considered far superior to that in the British Museum. The incentive to sell was not to make money but to reduce his

FIG. 23 Bellerophon and the Chimaera, from Tischbein, I, pl. I.

growing overdraft. His plans did not include the Museum, with which he was disenchanted following the Trustees' refusal to buy the Warwick Vase for what it cost him. 'I certainly will make no more presents there', he wrote to Charles Greville. He goes on, 'I am sure that the mine of these vases lately discovered must fail soon, and therefore I have not let one essential vase escape me, tho' the price is much higher than it was formerly. The King of Naples has now begun to purchase them, but my harvest luckily was in first.'[122] These were not the first vases to enter the king's cabinet, for already the collection of the Duca di Noia had gone to the palace at Capodimonte upon the duke's death in 1768.[123] Whereas before, however, royal interest had lagged behind that of others, the king was now eager to acquire as many as he could. Nor was he ultimately disappointed. On 11 December 1790 Tischbein wrote to the Duchess Amalia in Weimar of the king's successes. Not content with the rich finds of his own excavations, he sought to stem the tide of vases into other collections by commanding that wherever they were discovered they should be shown first to him.[124]

Goethe explained how he himself was hard-pressed not to succumb to vase madness.[125] In Hamilton, however, the irresistible urge had been reawakened with renewed vigour. In his memoirs Tischbein records how he had once encountered the British minister returning from the palace in full court dress, assisted by a ragged *lazzarone*, each taking one handle of a basket full of vases.[126] Tischbein's Neapolitan memoirs are an inspired account, full of southern light and warmth, combined with a melancholy nostalgia for life in the city before the French invasion brought the eighteenth century to its catastrophic close. He gives vivid glimpses of the circumstances in which Sir William's second collection was compiled. There was, it seems, a simultaneous series of lucky strikes by 'people who dig for such vases': one included a 'great vault' where two vases stood side by side, together telling the story of Bellerophon and the Chimaera (fig. 23);[127] while in Puglia a priest sold Sir William a whole collection of vases.[128] Tischbein is in general vague as to precise find-places but, to judge from his account and the publication of Hamilton's vases itself, these seem to have been Nola, where Kniep's engraving shows Emma and Sir William at the opening of a tomb (cat. no. 26), Sant' Agata dei Goti, Trebbia, S. Maria di Capua, Locri and sites in Puglia and Sicily. At Nola the finds were mainly intact, while those from Locri,

where Cavaliere Venuti had conducted excavations, were found in fragments, which fact Tischbein attributed to earthquake.[129] Tischbein wondered at the numbers of vases that must have been interred daily with the dead. In Apulia it was said that the roads were paved with vase sherds.[130] Tischbein thought it remarkable how the style of the vase-paintings differed according to the region in which they were found. The differences were so striking as to incite him to draw a

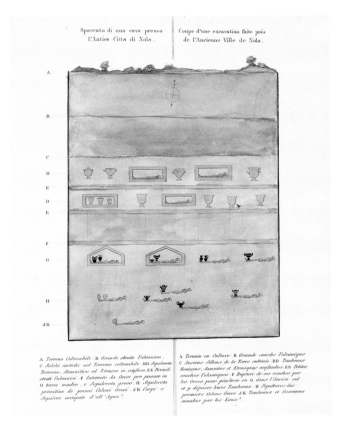

FIG. 24 'Section through an excavation near Nola' on the estate of Nicola Vivenzio. The various layers represent different phases of occupation and volcanic destruction: 'B' is the thick layer of volcanic matter deposited in the eruption of AD 79. It overlies the Roman tombs marked 'D'. Below this are the Greek tombs, 'G', and the tombs of the first Greek colonists are shown in the lowest register, 'H–K'. From Dubois-Maisonneuve, p. 101.

comparison between the stylistic separation of Venetian and Roman schools of Italian old masters.[131] In this he seems to have anticipated the work carried out in the twentieth century by Professor A. D. Trendall, distinguishing the regional styles of South Italian vase-painting, and ultimately the hands of individual artists.[132]

In the great Neapolitan vase-rush of 1789–90 the British minister had a rival in the person of the Marchese Nicola Vivenzio, president of the Neapolitan Tribunal. Vivenzio's father owned land in the vicinity of Nola, and Tischbein was

taken there. Passing a great vase on the veranda of the house, he went inside to view the rest of the collection. The tour culminated when a green silk curtain was drawn back to reveal the single piece for which Vivenzio's collection was famous.[133] Tischbein was to look back upon the day he saw that vase with its tragic scene of the plight of Priam as one of the saddest of his life.[134] In a letter to Duchess Amalia, dated 16 December 1794, he explains it was found 'some weeks ago' in perfect condition full of ashes and bones.[135]

Tischbein and the publication of Hamilton's second vase collection

Tischbein's interest in Vivenzio's vase stemmed from his involvement in a particular project, which consisted of a compilation of all known images from antiquity relating to the works of Homer – a 'Homer in pictures', as he called it. This was later published in Germany (see p. 103). He is better known, however, for his editing of the publication of Sir William's second vase collection, which was already under way in June 1790. 'At present', wrote Hamilton to his nephew, 'I am only superintending the publication of about 50 or 60 prints of the vases, which are most interesting in point of subjects and elegance of design. I will send you a specimen in my next letter for about a dozen are already engraved.'[136] That initial volume was to grow into four. Tischbein's own letters and memoirs give valuable insight into how the work was done. At first he employed his best pupils, who traced the subjects on oiled paper and then transferred the outline to make a proper drawing. Fear of French invasion and loss of the drawings, however, incited him to employ a skilled engraver, who could engrave the outlines, taking them directly from the vases.[137] Tischbein explained that one of the chief merits of Hamilton's collection was its richness in scenes of mythology. This he attributed to the collector's own acumen in recognising particular scenes, and for choosing these out of the many he had been offered. Some of the first proofs were sent to Duchess Amalia, which she received with descriptions in a letter from Tischbein dated 11 December 1790. They included the two 'Bellerophon' vases mentioned above, which comprised the first two plates in volume I of the eventual publication.[138] Further proofs were sent by Tischbein to Weimar in March 1791, shortly after Sir William and Emma had departed for England with the secret intention of marriage. These included the engraving of pygmies fighting cranes from a vase that had cost Sir William 300 ducats. In the letter reporting this fact, Tischbein recalls how, on the day before his departure for England, Sir William had purchased a vase painted with a scene of Oedipus and the Sphinx; earlier that same day, by coincidence, Tischbein had read Sophocles' *Oedipus Rex*.[139]

The history of the publication of Sir William's second collection of vases is not as complicated as that of his first, but nor is it as straightforward as is commonly supposed. The advertisement for subscribers promised three volumes of sixty engravings in each, the first to appear in October 1791.[140] That date appears on the title page of the first volume, and it is usually assumed to be the year in which it appeared. In fact it was not published until much later. On 10 September 1793 Hamilton wrote a letter, probably to Thomas Cadell in London, although the addressee is not identified. The text, previously unpublished, reads as follows:

You will find enclosed a bill for four cases directed to you, they contain each fifty copies of my new publication of Greek vases that have been dug up in this neighbourhood within these last five years, and which I flatter myself will be found very curious. Two more volumes will speedily follow, for all the prints are ready. Considering the little knowledge of language and the imperfection of printing here, I hope the work will please.

I have advanced the money to Mr Tischbein the editor and he pays me in books at four *ounces* a volume, which is something more than two guineas. So that I may not be a loser paying carriage duty and your profit for selling, I believe the price must be in England two guineas and a half the volume. You may advertise that you expect some copies of this first volume speedily. The work is in French and English. I enclose the French title, not having one proof in English, but it will inform you enough for advertisement.

Before any are sold I would wish two copies to be plainly but neatly bound and presented, one to the president, Lord Leicester, and one to the Society of Antiquaries. Also two copies for the Royal Society: one for Sir Joseph and the other for the Society's library; and one, to be sure, finely bound for the King. I can afford to give no more, and if people do not buy, I am [rewarded?] in endeavouring to serve. As soon as the cases arrive, be so good as to let me know, and when you sell, as the money comes in, be so good as to pay it to my account with Mr Ross and Ogilvie.

You may inform the Public that various accidents of war have retarded the publication, which you see was intended to have appeared in 1791.[141]

The French text was no doubt the work of Count Italinsky (d. Rome, 1827), the Russian consul, who is credited with compiling most of the descriptions of the vases. Sir Charles Blagden, resident in Naples in spring 1793, saw the book long before most people, and remarked upon how in matters of interpretation Hamilton had given up his own judgement to the Russian.[142]

The real reason for the delay in publishing the first volume was, in fact, Sir William's absence from Naples during the greater part of 1791,[143] when he travelled to England with Emma, partly to seek the king's permission to marry her, and partly to sell his gems and bronzes in order to raise money against his mounting debts.[144] It is clear that the first volume is unlikely to have reached the hands of subscribers before early 1794.

There were also difficulties with the press. For assistance with the printing of the second volume, Hamilton had recourse to a Dr Thomson, to whom he sent his thanks in a letter written from Caserta and dated 17 December 1794: 'I am sure we are much obliged to you for the assistance you have given Tischbein and me in the printing of the second volume. Printing at Naples in a foreign language is but a bungling business, and as you see in the first volume remains very imperfect. However, if I had not printed here, I am sure I never should have published the work.'[145] The day before, Sir William had written to Joseph Banks, 'I shall send you another volume of my vases, which is just made from the abominable Neapolitan press.'[146]

The date on the title page of the second volume is 1795 and the same date appears at the front of volume III. The actual dates by which the books reached subscribers, however, are indicated in the minutes of the meetings of the Society of Antiquaries. The Society and its president were dedicatees, and it can therefore be assumed that they were among the first to receive the work. Their receipt of the publication was acknowledged on the following dates (the dates on the title pages are given in brackets): volume I (1791) 3 April 1794; II (1795) 10 November 1796; III (1795) 18 December 1800. The Society did not receive a copy of the fourth volume, which appeared later, probably after Hamilton's death. Tischbein seems to have planned further volumes, for which copies of the engraved plates survive in various collections.[147] In the library, for example, of the Greek and Roman Department at the British Museum, a fifth volume labelled 'Supplement' is bound with a series of miscellaneous plates, many of which do not appear in the other four volumes. A note written in French, apparently by a Mr Steuart, who was offering the five volumes for sale, explains part of the later history of Tischbein's book:

One knows that this work was never completed because of the troubles at Naples in 1798. The fourth volume was even published without text, but it is not generally known that Mr Tischbein also prepared a large number of plates for other volumes. These plates were dispersed and lost, and it is no longer known what became of them.

Mr Tischbein, in leaving Naples, left a mass of work, among which were more than ninety plates which have never seen the light and of which the existence has been unknown up till now. His pupil Mon. A. Cléner took with him to France the

drawings of several compositions; they are published in the work of Mon. Dubois-Maisonneuve and are explained by Mon. A. L. Millin (Paris 1808–10) without any indication of the source.[148]

Cléner was the engraver of the frontispiece of volume 1 and possibly of the entire series. The author goes on to explain that a number of plates in the supplementary volume can be matched through his own annotations to plates in the volumes of Dubois-Maisonneuve. What this source does not mention is that, in addition to further volumes of Hamilton's vases, Tischbein was also planning a volume of his own collection. On 25 March 1797 he wrote to Duchess Amalia, sending her a set of ten engravings after his own vases, which were intended as the first of a total of sixty plates.[149] It is now unclear to what extent Tischbein's own vase collection can be reconstructed from the extraneous plates in the British Museum's supplementary volume and in other collections.[150]

The publication of Sir William's second vase collection was a great success and went into several foreign editions.[151] By comparison with d'Hancarville's, it is a restrained work of measured intention. The primary aim was that which had been at the front of Hamilton's own mind when he conceived of the publication of his first collection, namely to provide a model for contemporary artists and manufacturers. He realised this could not be done at an affordable price unless – d'Hancarville's extravagances apart – the cost of production was greatly reduced. The choice of simple outline, in place of the elaborate coloured engravings of the first publication, was therefore a matter of economy. It also happened to coincide with and in its way promote the taste of the day.[152]

Another purpose of the book was to provide a set of images relating to the life, religious beliefs and mythology of the ancients. Hamilton's second collection of vases was especially strong in scenes of myth, although not every assignment of a vase-painting to a particular story from Greek mythology would be accepted today. The circumstances in which the book was brought out prevented descriptions from being included in the fourth volume, but a summary list of the subjects represented by the plates of all four volumes survives, apparently drawn up by Sir William himself.[153] The list of the fourth volume is particularly important as representing the only known record of Sir William's identifications for the vases illustrated there.[154]

Greek, not Etruscan: a controversy resolved

A third remarkable aspect of the publication of the second vase collection is the extent to which it reflects Hamilton's growing conviction that vases formerly called Etruscan were in fact Greek, as the title page itself proclaims. As we have

FIG. 25 Engravings to show the similarity of the decoration of two vases, one found in Italy, the other on Melos. Both vases belong to the group of late Attic vase-painters identified by Sir John Beazley as the 'Fat Boy Group'. Tischbein, II, pls 61–2.

seen, even as the publication of the first collection of vases was going through the press, Hamilton had realised that many of the vases must be of Greek rather than Etruscan manufacture. What was lacking, however, was clear proof by way of comparable discoveries of vases in Greece itself. This was forthcoming as early as 1772, when Sir William was still in England after selling his first collection to the British Museum. The painter William Pars went there with Hamilton to see his collection,[155] and was able to provide parallels from vase sherds found in Athens. Pars had been employed by the Society of Dilettanti in the 1760s to record archaeological remains in the eastern Mediterranean for their publication *Antiquities of Ionia*.[156] At Athens he had picked up several fragments of pottery which he showed to Hamilton; they compared very closely with the finds made in Italy. Sir William persuaded Pars to deposit these fragments in the Museum.[157]

Further corroboration would come in time for Sir William to include a postscript in the first volume of the second vase

publication. The original letter, on which the published text is based, survives and is dated 10 August 1792. It is written from Palermo by one George Graves, recently returned from travel in Greece accompanied by two others, Messrs Tilson and Berners.[158] Hamilton had charged them with finding out whether it was really true that painted vases of the kind found in Italy could also be found in Greece. The answer came back that they were to be found there, and the travellers had seen such vases at Athens, Megara and on the island of Melos, where they themselves had opened tombs in which they had found vases.

Hamilton himself acquired two of the Melian vases, one in black figure, the other red. He had the red-figured vase engraved in the second volume of his book, juxtaposing this image with one very like it on another vase found at Sant' Agata dei Goti (fig. 25). Blagden was impressed by the telling comparison of the objects themselves when he saw them at the Palazzo Sessa in spring 1793.[159] This was the proof Sir William had been seeking for establishing that vases found in Italy were made by Greeks.[160]

The fate of the second collection of vases

From the outset Sir William seems to have regarded his second vase collection as an investment. In two years, between 1789 and 1791, Tischbein tells us he had laid out 20,000 ducats (about £3,800),[161] and he was looking to turn his expenditure into a healthy profit. At first he preferred not to see the collection go abroad, and his plan was to find a buyer in England through whom the vases might eventually find their way into the British Museum.[162] When this failed, he attempted to sell them to the Russian monarch and then, in 1796, with the help of the Countess of Lichtenau, to interest the King of Prussia in their purchase. By then Hamilton owned more than 1,000 vases, 500 of which were painted with figures. In a letter to the countess, Hamilton explained that he would expect £7,000 for the collection, this being the sum which he had been paid for the first collection of vases when they entered the British Museum.[163] When this plan also fell through, he tried the same proposal upon William Beckford, again without success.[164]

The vases remained unsold in 1798 when the French invasion of northern Italy forced Sir William to pack and load the cream of his collection on board a warship bound for England. HMS *Colossus*, under Captain George Murray, sailed out of the bay in late November with her precious cargo on board. She never reached her destination, however, for in the second week of December, while moored in shallow water off the Scilly Isles to escape a storm, the ship was grounded and broke up. The story of the wreck and its

rediscovery is told by Roland Morris, who led an expedition in the 1970s to dive for lost vases.[165] Many broken and weathered sherds were recovered, some of which can be matched to the plates in the publication of the second collection (cat. no. 62). One wonders whether the divers might have been deterred from their quest had they had knowledge of a letter that only came to light afterwards, found between the leaves of a volume purchased in a Hampstead second-hand bookshop.[166] The letter was written by Major Bowen, commander of the local fort, and dated nearly a year after the wreck.[167] It was sent in response to enquiries made by Charles Greville on Sir William's behalf:

I fear there is no reasonable ground to hope that another article of Sir William Hamilton's interesting collection of antiquities will be recovered from the wreck of the Colossus. You will be sensible of this from the following statement of facts.

The Colossus being, as is generally thought here, in a very weak state, broke up uncommonly soon after striking on the rocks. The people of St Martin's Island met several packages drifting out at Crow Sound, among the rest those described to them as Sir W. Hamilton's. They assert that, anxious to fulfil Captain Murray's and my earnest injunctions, they used the utmost efforts for recovery of the latter; but that the sea running very high and the wind blowing a storm, they found it impossible to lift the packages which were very large into their boats. They then tried to disengage the contents. Unfortunately, in this also they failed. Their solemn declaration to me is, in their own words, that 'they saw on opening the canvass cases, several large pieces of most beautifully painted clome' (the name for all earthen ware here); 'but that, on their trying to lift them, whether from the effect of seawater on them, or a cement used in joining them, a single piece could not be taken into a boat, each giving way in their hands like wet dough'.

It will be evident to you Sir, that if articles of this, or even of a much more substantial nature, had remained in the hull when the guns shot, and ballast fell together in a mass, they must have been utterly demolished.

The few articles that were recovered were thrown on St Martin's Island by the sea. I had early intimation of it; and, though they were divided amongst the women of the island, to whom this part of the spoil was left, I succeeded after much toil and the distribution of four guineas in obtaining every piece saved. They were then carefully packed in a large cask of mine, and sent to my friend, William Augustus Pitt, who, having a particular regard for Mr Greville and Sir William Hamilton expressed great satisfaction in being . . . the conveyor of them to the former.[168]

Poor Sir William, how he must have suffered, first from shock at news of the wreck and then with anxiety at not

knowing whether his vases were saved or, as he feared, lost. Even when all hope seemed futile, he was still pressing his nephew for better news. As late as 25 January 1800, he wrote from Palermo,

> As to my vases, that is a sore point. They had better be at Paris, than at the bottom of the sea. Have you no good news of them? They were excellently packed up, and the cases will not easily go to pieces, and the sea water will not hurt the vases. All the cream of my collection were in those eight cases on board the Colossus, and I can't bear to look at some remaining cases here in which I know there are only black vases without figures. However, drawings were made of all and the prints for the fourth volume were engraved and are with Tischbein, who I hear is in Germany.[169]

As it turned out, Sir William was justified in not giving up to despair, for when he opened the packing cases of his remaining vases, soon after his return to England, to his great delight he found that they contained many of his best, left off the *Colossus* by mistake.[170] This stroke of good fortune came at a time when he was contemplating crippling debts, and early spring of 1801 found him drawing up a catalogue for the sale of both his vases and pictures at Christie's.[171] The vase sale did not go through, since, at the eleventh hour, the collector and rising arbiter of taste Thomas Hope[172] offered a lump sum of £4,000 for the lot. Sir William had wanted five, but settled for the bird in the hand.[173] Hope disposed of the dross of the collection soon after be bought it; the rest he arranged in his Duchess Street mansion, designed to be a paradigm of fashionable interior decoration.[174] The Hope vase collection was longer-lived than many, and remained in the family until 1917, when it too went under the hammer.[175] The vestiges of Sir William's second vase collection were thus finally dispersed, and the last chapter in its remarkable history closed.

Motivation and influence

It remains to sum up Sir William's antiquarian achievements, his aims and their impact upon contemporary taste. Sir William's primary motive seems to have been that which compels all successful collectors, namely a passion for *things* and a desire to own them. 'It is impossible', he wrote to his nephew, 'for me to be without an object, whilst I can command a farthing.'[176] His interest in old master paintings and in finely carved gemstones is described elsewhere in this book, but his single most important contribution to the history of collecting and of art is his recognition of the intrinsic beauty of Greek vases.[177] He, more than anyone of his time, saw their worth, not only as a source of archaeological illustration but also as primary evidence for the genius of ancient draughtsmanship and plastic form. In this Sir William exercised his enormous capacity as a connoisseur in the eighteenth-century and true sense of the word, as set out in Jonathan Richardson's influential *Discourse on the Dignity, Certainty, Pleasure, and Advantage of the Science of a Connoisseur* (1719). Principally, this was someone who could see the beauty of things and form an independent opinion about them.[178] He was by no means alone in recognising the peculiar qualities of Greek vases, and he shared his enthusiasm with a circle of hellenists in Naples and Rome. His, however, was the greater passion and he often pursued it beyond his means.

Hamilton took seriously his part in the traditional role of the enlightened British aristocracy as patrons of the arts and as promoters of good taste in contemporary manufacture. The sale of the first collection to the British Museum in 1772 was more than a mere financial transaction, for it formed part of a life-long mission to raise British, indeed European, consciousness in what are now called the decorative arts. He saw the incipient Museum, dominated in his day by librarians and natural historians, as the proper place for a national collection of antiquities, serving antiquary and artist alike. The acquisition of the first Hamilton collection sowed the seeds of the modern Museum, which has progressively moved towards becoming exclusively a repository of artefacts. In the course of its history, the pride of place that Hamilton's classical antiquities once held in the Museum has been superseded by others. His vases, much admired in his day, are less so now. The change in taste took place in the 1830s, when the Museum acquired vases from the rich Etruscan cemeteries of Vulci in southern Etruria.[179] Many of these were imported from the best Athenian workshops of the sixth and fifth centuries BC. Hamilton's collection contains some comparable vases, mostly from Nola, but includes a large proportion of products from fourth-century South Italian workshops.

He could not have foreseen this shift in taste, and truly believed his collection of vases to be the best ever formed and worthy of the nation. The sincerity of Hamilton's sense of public responsibility is borne out in the many and valuable gifts he made to the Museum, particularly of sculpture, after his first collection had been sold. The Warwick Vase (cat. no. 128) proved to be something of a test case in Sir William's campaign to educate the more unsympathetic of the Museum's Trustees. Their failure to accept his offer of the great marble vase for little more than what it cost to restore was a turning point in his relationship with the Museum. He had seen it as the natural centrepiece to his collection, but the Trustees thought otherwise. Although Hamilton continued afterwards to make them presents, his enthusiasm for doing so gradually waned.

To Sir William it was a matter of honour and reputation that he be seen as a modern Maecenas, promoting and pat-

FIG. 26 The Library, Bowood, near Calne, Wiltshire, with vases by Josiah Wedgwood inspired by the engravings in *AEGR*.

(RIGHT) FIG. 27 The outer hall, Newtimber Place, Sussex, with wall-paintings and tapestry furnishings inspired by the engravings in *AEGR*.

ronising the arts. When he brought the Portland Vase to England and saw it safely deposited in the Duchess of Portland's collection, he wished to advertise the fact and did so through a series of specially commissioned engravings (cat. no. 64). Hamilton's beautiful books were designed with similar intentions and had a considerable influence. This essay has shown with what dogged determination he battled against the odds to complete his publishing projects. It is estimated that the publication of the first collection of vases cost him nearly all of the £8,400 he was paid for the entire first collection of antiquities.[180] The only ones to make any money out of that affair were Josiah Wedgwood and his partner Thomas

Bentley, who reaped enormous profits from their pottery reproductions of ancient vases. Sir William, however, had the very real satisfaction of knowing that he had provided the vehicle for the proliferation of Classical taste that was to dominate interior design for decades to come.

The extent of the role Sir William played in this can be judged in an unpublished letter written to him by one John Eliot soon after his first collection entered the Museum. It reads as follows:

> Your collection forms one of the greatest and most admired ornaments of the Metropolis. Even foreigners come to see it. I have with much satisfaction seen the advantageous manner in

which these inestimable remains of antiquity are arranged. I really think that the national taste has received a rapid improvement from them. In place of the ponderous dull ornaments, we formerly had, we now have the pleasure of seeing new embellishments daily rising up, where everything is formed in the elegant manner of the ancients. The furniture of even the houses is already changed. These improvements are totally owing to that choice collection, which you have set before the public. In the most ordinary houses, in place of the unnatural, the distorted chinese figures, we see the chimney pieces and cabinets decorated with vases equal to the Etruscans . . .[181]

This neglects to mention the influence of other contemporary promoters of Classical taste, not least the Adam brothers, James and Robert, but there can be no doubt that Sir William played a key role. From fireplaces to papier mâché boxes,[182] and from wall-painting to tapestry,[183] the influence of his publications could be seen everywhere. Single prints circulated then, as now, among those who could not afford all four volumes of d'Hancarville's book.[184] Tischbein also found a market for his engravings and produced a series of 100 individually framed prints, arranged according to the ancient mythological stories they portrayed. Collectors could select examples according to the size of their rooms.[185] As late

as 1829, pirated editions of d'Hancarville's engravings and strikes from what seem to be Tischbein's actual plates were being sold to foreign visitors in Naples.[186] When the British Museum began to exhibit its vases by type rather than by collector, the publication of the first vase collection became better known than the vases themselves, and it has continued to serve painters and designers as a source of figured images and geometric patterns.[187]

There have been mischievous attempts to undermine Hamilton's reputation as the pioneering connoisseur of Greek vase-painting. He is blamed for inventing what is seen as the fraudulent claim that vases can be viewed as art and that they were valuable in antiquity.[188] This, so it is said, has distorted the true nature of this product of the humble potter's craft by turning it into a valuable commodity in an art-dealer's market, 'the consequence of a successful deceit perpetrated early in the last century [*sic*] by Lord [*sic*] Hamilton and his scholarly adviser d'Hancarville, in order to sell a collection of Greek vases to the British Museum'.[189] The publication of Sir William's first collection is seen as the product of a conspiracy which he entered into with d'Hancarville, to create a sort of sale catalogue that would increase the value of his vases. The book has been called a 'marketing job'.[190]

Suffice it to say on the matter of Sir William's integrity that his letters written in private, where he had no cause to hide ulterior motives, show that he was not given to such 'jobs'. He realised that others were capable of them and, when he could not persuade the British Museum's Trustees to purchase the Warwick Vase, he wrote to his nephew: 'We are so used to jobs at home that no one can imagine that another is acting a disinterested part.'

Also against the evidence of his own private letters, Hamilton has been called a dealer.[191] He would not have liked the label: 'I am delicate as to the manner of selling, as I should hate to be looked upon as a dealer.'[192] Nor was his selling comparable with that of his friends in Rome, such as Gavin Hamilton, who traded for a living. Sir William sold to facilitate other buying and he was particular about where his collections went. He sold reluctantly, as Tischbein explains, like a man said to have parted with his drawings to a wealthy banker in the morning, only to beg to buy them back in the afternoon for fear of dying from the sense of loss.[193]

Hamilton's was an essentially moral view and, like many of his class, he regarded art as an aspect of morality, or 'virtu' as it was known in his day. His collections and their publication were part private pleasure, part public responsibility. Born without fortune or title into a noble family, Hamilton had to work at establishing his reputation in polite society. 'Virtue is the only true nobility', Juvenal said, and the life of Sir William Hamilton may be seen as the embodiment of this humanist principle.

FIG. 28 De luxe version of an engraving for the publication of Hamilton's second vase collection: Tischbein, II, pl. 36. One of a set formerly at Mere Hall, Knutsford, Cheshire.

NOTES

1 *AEGR*, III, p. 3.

2 Lowenthal, pp. xvi and 191.

3 *AEGR*, II, p. 6.

4 *AEGR*, I, p. 168, and see pp. 149ff. of this catalogue.

5 *AEGR*, III, p. 3.

6 Bassani, pp. 13–16.

7 See p. 99.

8 *AEGR*, III, p. 34; Griener, p. 81.

9 D'Arms, *passim*.

10 Pliny, *Natural History*, XXXVI.4.27; cf. d'Hancarville, *AEGR*, II, p. 28, 'The tumult of affairs ... is ever drawing of the attention; and the admiration of masterpieces of art requires silence and tranquillity of mind'.

11 Christie's sale, 1809, p. 14, lot 132 and p. 9, lot 73.

12 Pliny, *Natural History*, IX. 8; preface, 15. For a recent sensitive treatment of Pliny's writings, see Isager, *passim*.

13 Pliny the Younger, *Letters*, VI.16.

14 Fothergill, p. 70.

15 Knight, 1981, pp. 186–9.

16 Krafft MS, letter to Lord Palmerston dated 18 June 1765.

17 Ward-Perkins and Claridge, cat. no. 218.

18 Grant, *passim*.

19 Knight, 1990, p. 14; Ramage, 1992b, pp. 653–8.

20 Krafft MS, letter dated 19 August 1766.

21 National Library of Scotland, 3942, f. 58, quoted by Fothergill, pp. 47–8; Ramage, 1992b, p. 654.

22 De Caro *et al.*, *passim*.

23 Letter dated 12 November 1765, British Library, Egerton MS 2634, f. 93.

24 Knight, 1990, p. 57; Ramage, 1992b, p. 656.

25 Bologna.

26 Hamilton, loc cit., n. 20 above.

27 Hamilton, *Archaeologia*.

28 Morrison, no. 111.

29 See Chapter 4, pp. 72–3; Knight, 1989–90, *passim*.

30 Knight, 1990, p. 166.

31 Bassi, *passim*; Knight, 1990, p. 166.

32 Morrison, no. 205.

33 Krafft MS.

34 British Museum, Townley Papers.

35 Townley Papers, *Diary*, March–April 1803.

36 Minute Book of the Society of Dilettanti, v (1798–1815), 6 March 1803; Ramage, 1992b, p. 658.

37 Society of Dilettanti Papers, letter dated 25 March 1803.

38 British Library, Add. MS 33,6102.2, ff. 64–86. The first page inscribed by Sir William: 'Papiri P. Antonio'.

39 The pioneering essay on d'Hancarville is Haskell, 1987.

40 The date of d'Hancarville's flight has previously been put at the beginning of 1770, but a letter from William Hamilton written in December 1769 to Horace Mann in Florence already discusses his expulsion. Public Record Office, State Papers, Foreign, 105/319.

41 Haskell, 1987, p. 30; Griener, pp. 34–8.

42 Haskell, 1987, p. 32; Griener, p. 35.

43 See pp. 149ff.

44 For Eratosthenes, see Dionysius of Halicarnassus, Loeb edition, p. 246; for Scaliger, see Berghaus, p. 155.

45 Newton, p. 4.

46 Griener, p. 35.

47 *AEGR*, I, p. iv; Griener, appendix I, pp. 18–143. I am grateful to Michael Vickers for putting into my hands copies of the original manuscript letters kept in the Bibliothèque Nationale, Paris.

48 See p. 101.

49 British Library, Add. MS 40,715, ff. 65–6.

50 Griener, pp. 79–81. D'Hancarville was actually buried in the church of San Niccolò, Padua; Haskell, 1987, p. 32.

51 For Caylus and Winckelmann, see pp. 94–7; for Caylus, see also *AEGR*, III, p. 193, n. 143.

52 The bibliography on Winckelmann is now vast. For his life see Justi, *passim*; for a reading of his art history, see Potts.

53 National Library of Ireland, Earl of Limerick MSS, no. 48, MS 16,086: Description of Edward Pery's tour of Italy, 1777–8, including copies of Sir William's own notes on his earlier tour of Rome. Reference courtesy of Sir Brinsley Ford. See also Constantine, 1993, pp. 81–3. For Byres see Ford, 1974, and Ridgway.

54 British Library, Add. MS 42,069, ff. 59–60, undated; transcribed by Griener, appendix I, p. 130. His conjectural date of this letter does not agree with Constantine's dates for the tour.

55 Knight, 1990, pp. 60–62; Griener, p. 54; Constantine, 1993, pp. 61 and 78–81.

56 Winckelmann, *Briefe*, III, 336.

57 Griener, pp. 53–4; Constantine, 1990, pp. 56–7.

58 British Library, Add. MS 42,069, ff. 46–7; Griener, appendix I, pp. 144–5; Constantine, 1993, pp. 57–8. Cf. Winckelmann, *Briefe*, III, 246.

59 Constantine, 1993, pp. 57–8. The two volumes were included in the Christie's sale in 1809.

60 Rossetti, *passim*, Potts, pp. 17–18.

61 *AEGR*, IV, pp. 69–70.

62 See pp. 149ff. and p. 97.

63 See pp. 149ff.

64 See pp. 96–100. For d'Hancarville's own gems, which he was forced by debt to sell, see Griener, pp. 53–4.

65 See p. 50.

66 Griener, appendix I, p. 139; see n. 93 below.

67 Jenkins, 1992c, pp. 19–24, 59–60.

68 For the date of publication of the various volumes of *AEGR*, see Vickers, 1987, p. 106; Griener, pp. 49–52; Constantine, 1993, pp. 63–7.

69 *AEGR*, I, p. 170.

70 Griener, appendix I, p. 131 (line 12). Contrast ibid., p. 54: 'Non scriverà nulla per le *Antiquités*', and also Constantine, 1993, pp. 65–6.

71 *AEGR*, II, p. 1, and IV, p. iii; Griener, p. 50.

72 Griener, appendix I, p. 127 (line 14).

73 Griener, p. 49 and appendix I.

74 Public Record Office, State Papers, Foreign, 105/317, ff. 730 and 738.

75 Haskell, 1987, p. 38.

76 Public Record Office, State Papers, Foreign, 105/321, f.1, letter from William Hamilton to Horace Mann, 1 January 1771. Could this be the 'Raimond' of d'Hancarville's letters to Hamilton, published by Griener, appendix I, e.g. 7, p. 129?; he is listed in 12, p. 136, as 'dessinateur', along with 'Cardon' and 'La Marra'.

77 Morrison, no. 28.

78 Griener, p. 52.

79 Krafft MS. Other letters concerning *AEGR* in the same papers are: 5 October 1779, Antonio Tenistori from Florence to Hamilton notifying him of the creditors' willingness to settle for a lump sum of £420; 18 July 1780, Giuseppe del Grande from Florence to Hamilton sending a receipt for 821 scudi, payment for fifty of each volume.

80 Krafft MS.

81 See cat. no. 60.

82 Griener, p. 52.

83 Haskell, 1987, p. 39; Schnapp, 1992, *passim*; and see p. 99.

84 D'Hancarville, 1785–6.

85 See pp. 149ff.

86 See pp. 156–7.

87 *AEGR*, III, p. 204, n. 176; Haskell, 1987, p. 39.

88 *AEGR*, II, p. 6 and engraving opposite.

89 *AEGR*, III, p. 210.

90 *AEGR*, II, p. 14, and engraving opposite p. 20.

91 Gombrich, pp. 114–15.

92 *AEGR*, IV, p. 97.

93 Griener, appendix I, document 16, p. 139.

94 Griener, appendix I, 17, p. 141.

95 Griener, pp. 81–2.

96 See p. 99.

97 Cited by Funnell, p. 55.

98 *AEGR*, I, p. xxii.

99 Jenkins, 1994, p. 168.

100 Jahn for this and other Neapolitan collections, p. xi; Lyons, *passim*.

101 Lyons, pp. 17–18; for Martorelli, see Strazzullo, II, *passim*.

102 Winckelmann (Lodge), I, p. 381; Tischbein, I, p. 14.

103 Momigliano, pp. 299ff., esp. 304–5.

104 Vickers, 1985/6, p. 159.

105 Passeri; Schiller, p. 178; cf. Winckelmann (Lodge), I, p. 381.

106 Strazzullo, II, p. 223, letter from Martorelli to Francesco Vargas Macciucca, Portici, 19 October 1767.

107 Tischbein, I, p. 104.

108 Krafft MS.

109 Tischbein, I, p. 20.

110 Jenkins, 1992c, p. 20.

111 Greifenhagen, 1939, p. 207.

112 Constantine, 1993.

113 Winckelmann (Lodge), I, p. 92.

114 Greifenhagen, 1939, pp. 200–15.

115 Jenkins, 1988, p. 450.

116 Clark, nos 309–10, pp. 308–9.

117 Beinecke Library, Yale. Bound volume of Hamilton Letters (MS Vault Shelves, Hamilton), I: Hamilton to Messrs Wedgwood and Bentley, 6 July 1773.

118 Morrison, no. 117, Hamilton to Greville, 26 May 1789.

119 Schiller, p.170.

120 Landsberger, pp. 97–107, 117ff; Griffiths and Carey, pp. 130–36.

121 Morrison, no. 180.

122 Morrison, no. 182.

123 Lyons, p. 3.

124 Von Alten, p. 51.

125 Goethe, *Italienische Reise*, p. 209.

126 Schiller, p. 175.

127 Schiller, p. 170. These were published as the first two plates of Tischbein, I.

128 Schiller, p. 175.

129 Von Alten, p. 56; Tischbein's letter to Duchess Amalia, 18 December 1792.

130 Schiller, p. 177.

131 Von Alten, p. 56.

132 For example *LCS*, *RVAp*.

133 Schiller, pp. 172–4; for Vivenzio, see Münter, pp. 60–62; Beazley, *ARV²* 189, 74.

134 Schiller, p. 173.

135 Von Alten, pp. 60–61; cf. Heyne.

136 Morrison, no. 182.

137 Schiller, p. 176; Landsberger, p. 129; cf. Tischbein, I, p. 10.

138 Von Alten, pp. 50–51. Tischbein, I, pl. 1, described on pp. 48–54. In fact, only the first vase-painting can be said definitely to depict the myth of Bellerophon. The other appears to be a generic wedding scene, rather than one specific to Bellerophon.

139 Von Alten, pp. 52–4: letter dated 19 March 1791; Tischbein, II, pl. 24.

140 British Museum, P&D, M 21.

141 Krafft MS.

142 Blagden MS, 86r, 3 March 1793; Tischbein, II, p. 4.

143 Tischbein, II, p. 2.

144 See pp. 101–2 and cat. no. 126.

145 Krafft MS.

146 British Library, Add. MS 34,048, f. 76.

147 Heydemann, *passim*.

148 Note inserted into the back of vol. 1.

149 Von Alten, pp. 68–9; Griffiths and Carey, p. 135.

150 Landsberger, p. 131; Jahn, p. x.

151 Landsberger, p. 131.

152 Irwin, pp. 81ff.

153 British Library, Add. MS 40,715, ff. 67–74. The paper is watermarked 1795.

154 Loc. cit.

155 Tischbein, I, p. 20.

156 Wilton.

157 Not located.

158 British Library, Add. MS 41,199, ff. 96–7; Tischbein, I, p. 156; Constantine, 1993, pp. 73–8.

159 Royal Society, Blagden MS, f. 85, 3 March 1793.

160 Tischbein, II, pls 61–2, explained in Hamilton's own 'addendum' to Italinski's text, p. 98.

161 Von Alten, p. 54, Tischbein's letter to Duchess Amalia, dated 19 March 1791. Cf. Hamilton's own estimates of his expenditure up to September 1790 in Morrison, nos 182 and 185.

162 Morrison, no. 182, 6 June 1790.

163 Letter from Hamilton to the Countess of Lichtenau dated 3 May 1796: Lichtenau, II, pp. 130–32. It can be inferred from this that the vases were valued separately from the rest of the first collection of antiquities, which altogether sold for £8,400.

164 Morrison, no. 292, 2 February 1797.

165 Morris, *passim*.

166 By Mr John Reeve of the British Museum's Education Service. With the permission of the bookshop's proprietor, he kept the document and subsequently presented it to the Museum.

167 For mention of whom see Morris, pp. 56, 60 and 79.

168 Dated Star Castle, Scilly, 26 November 1799; cf. Morrison, no. 396, Greville to Hamilton, letter dated 8 June 1799.

169 Morrison, no. 444.

170 Morrison, no. 544, Hamilton to Nelson, Piccadilly, 12 March 1801.

171 Morrison, no. 550, Hamilton to Greville, 31 March 1801.

172 Watkin, *passim*; Waywell, *passim*.

173 Morrison, no. 552, Hamilton to Greville, 3 April 1801.

174 Jenkins, 1988, pp. 450, n. 17, and 454.

175 Tillyard, *passim*.

176 Morrison, no. 182, 6 June 1790.

177 Michaelis, p. 110.

178 Gibson-Wood, *passim*; Pears, pp. 181 ff.

179 Jenkins, 1992a, *passim*.

180 Griener, p. 50.

181 Krafft MS, undated.

182 Krafft MS, letter from H. Clay, Birmingham, 1 August 1775.

183 Kiechler.

184 Griener, appendix I, p. 120 (line 4).

185 Von Alten, pp. 56–7, Tischbein's letter to Duchess Amalia, dated 18 December 1792.

186 Mere Hall sale, Knutsford, Cheshire, pp. 130–51, Christie's, 23 May 1994.

187 Griener, pp. 86ff.

188 The principal reference is Vickers, 1987 and 1994, but the suggestion was made earlier: see A. Ricco Trento, quoted and contradicted by Knight, 1990, p. 64.

189 Hoffmann, 1994, pp. 30–31.

190 Vickers, 1987, p. 106.

191 Ramage, 1990a.

192 Morrison, no. 185, 21 September 1790.

193 Schiller, p. 170.

'The Modern Pliny'
Hamilton and Vesuvius

JOHN THACKRAY

When William Hamilton arrived in Naples as Envoy Extraordinary to the court of the King of the Two Sicilies in November 1764, the modern compartmentalisation of science into such distinct disciplines as physics, astronomy, chemistry and biology had hardly begun. Indeed, geology as a science did not exist at all. Not only had the word not been coined, but there was no consensus on the proper ways to study the Earth and its phenomena. There were no textbooks and no common technical language, no organised theoretical structure and few shared techniques. There was no 'convergent thinking', to use Thomas Kuhn's useful phrase. A wide variety of techniques, many of which seem quite inappropriate to us, were brought to bear on the study of the Earth.[1]

The volcanoes of southern Italy had attracted naturalists ever since the Renaissance led to the rediscovery of Classical descriptions of them by Pliny the Younger, Lucretius, Strabo, Seneca and Lucan. The mountains of Etna, Vesuvius, Stromboli and Vulcano provided an opportunity to gaze into the mouth of hell. They were the most sublime of all natural theatres, providing moral and physical truths as well as the greatest of natural firework displays. English travellers sent breathless accounts of these marvels back to the Royal Society for publication in *Philosophical Transactions of the Royal Society* and *The Gentleman's Magazine*, with tales of torrents of mud, lava and boiling water, the death of thousands and the destruction of towns and villages.[2] Descriptions were frequently lurid and it became easy to believe that volcanoes, if not intrinsically evil, were part of God's punishment of sinful mankind. Italian philosophers living within reach of these wonders wrote longer and more learned books on the subject: Giovanni Borelli's account of the eruption of Mount Etna in 1669 became a standard source of information, as did Giulio Cesare Recupito on Vesuvius (1632 and later editions)

and Francesco Serao on the same mountain (1737, with editions in French and English).[3]

The causes of these phenomena were discussed in the large number of theories of the Earth that were published in the hundred years after 1650. The authors of these theories were not themselves observers, but combined the observations of others with Newtonian, Cartesian, Biblical or animistic science to produce a variety of all-embracing systems. Volcanic eruptions and earthquakes were generally linked in these systems to the existence of great open caverns under the Earth where inflammable vapours could accumulate until they were ignited. According to Thomas Burnet, much of the Earth itself was inflammable, with pitch, coal and brimstone all ready to burn. In William Whiston's theory the presence of underground air was necessary if ignition were to take place, while John Woodward stressed that water was essential.[4] Athanasius Kircher maintained that the caverns and sources of the heat were deep, and reached down towards the centre of the Earth, while other writers, notably Georges Buffon, believed they were relatively superficial, and that volcanic fires were seated well up within the volcanic cone itself.[5] A number of writers, most notably Thomas Robinson, believed that the Earth was an animal, and that its internal heat, earthquakes and eruptions were all signs of life.[6] This animistic philosophy was waning by the end of the seventeenth century, but traces continued well into the eighteenth, and are to be found in Hamilton's own writings.

Most seventeenth-century writers believed that the Earth had existed for only a few thousand years and that it would exist for only a few thousand more. Earth history was thought to consist of two long periods of stability with the great upheaval of Noah's Flood in between. Most writers believed that volcanoes were rare in the earlier period, and that the organic matter that fuelled them and the caverns that allowed

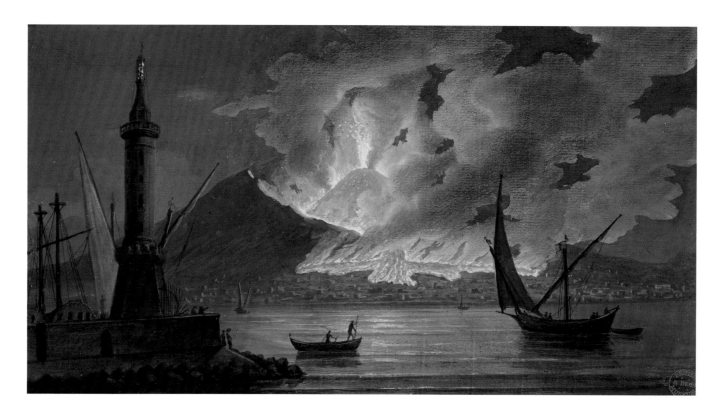

them to burn were a result of the Flood. Thomas Burnet, among others, believed that volcanoes were steadily gaining in ferocity, and would eventually lead to the burning of the whole world in the final conflagration.[7]

It seems unlikely that Hamilton had any detailed knowledge of this literature when he arrived in Naples in 1764. Neither his schooling at Westminster nor his short career in the army would have exposed him to the company of naturalists or philosophers, and even when he became MP for Midhurst in 1761 and would have met a wider and more intellectual range of people we have no reason to think he took particular interest in scientific pursuits. But, whatever his background, he kept a careful eye on Vesuvius from the moment he arrived, and his later writings betray a wide familiarity with the scientific literature of his day.

Certainly, when Vesuvius began to move into eruption in September 1765, not much more than a year after his arrival, Hamilton was ready with his pen, pencil and telescope. He spent days and nights up on the mountain, alone or with friends, observing the changing shapes of the cone and crater, the clouds of ash and smoke, the red-hot stones thrown up from the crater, the lava flows, the explosive and thunderous noises, and the lightning which flashed through the ash cloud. Nothing escaped his attention. Hamilton's observations of the eruption, which ran from September 1765 to October 1767, are recorded in two letters which he sent to the Royal Society and which were published in *Philosophical Transactions*

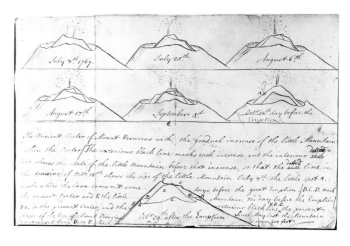

and reprinted elsewhere.[8] The letters testify to a combination of reliable observation and eager curiosity, and were received with acclaim when read to the Society in March and April 1767. Hamilton's election to fellowship of this, Britain's premier scientific society, followed rapidly. Lord Mountstuart wrote: 'I envy you much the night you passed on Mount Vesuvius, it must have been glorious. I think you richly deserve F.R.S. for the pains you have been at to send them a description of it.'[9] Hamilton's third letter, 29 December 1767, was accompanied by sketches showing the changing shape of the cone (fig. 30) as well as a painting in transparent colours which 'when lighted up with lamps behind it, gives a much better idea of Vesuvius, than is pos-

(LEFT) FIG. 29 The eruption of Vesuvius in 1767. Watercolour and gouache drawing by Pietro Fabris for plate VI of the *Campi Phlegraei*, 1776. British Library.

(BELOW LEFT) FIG. 30 Diagram by Sir William Hamilton showing the changing shape of the crater of Mount Vesuvius, May to December 1767. By permission of the President and Council of the Royal Society.

(RIGHT) FIG. 31 Specimens of polished rocks and lava from Mount Vesuvius (cat. no. 38), given by Sir William Hamilton to the British Museum, shown with a head in black basalt mounted on a coloured marble bust (cat. no. 39). In Hamilton's day the volcanic origin of basalt was disputed.

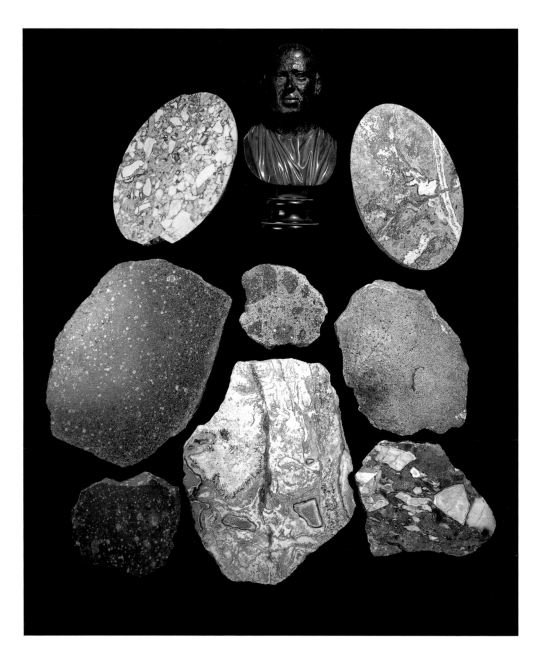

sible to be given by any other sort of painting'.[10] The President replied: 'The representation of that grand & terrible scene, by means of transparent colours, was so lively and so striking, that there seemed to be nothing wanting in us distant spectators but the fright that everybody must have been fired with who was so near.'[11] And again: 'Your memoir on the last eruption of Mount Vesuvius is a great ornament and has been prodigiously well received.'[12] Along with letters of congratulation came others of warning: 'He [Mr Simmons] was full of admiration at your philosophic fortitude in the midst of the Horrors of Vesuvius. I told him, with what tranquillity you had expresst your hopes to me, that another concussion would lay the mountain open to the observation of the

curious. We could not help fearing that you would suffer the fate of Pliny.'[13] Hamilton took no notice. He continued to climb the mountain at considerable personal risk until he was well over sixty years old, and would never accept second-hand reports where there was any chance of seeing the phenomena for himself.

At the end of 1767 Hamilton packed up a 'complete collection of every sort of matter produced by Mount Vesuvius, which I have been collecting with some pains for these three years past'[14] and dispatched it to the British Museum (cat. no. 38; fig. 31). Five chests of specimens duly arrived at the Museum in April 1768, as well as a picture which 'gives to the beholders the most striking representation of that

awfull phenomenon which you have with such resolution and constancy observed, and so minutely as well as philosophically accounted for and described.'[15] With becoming modesty Hamilton had proclaimed in his first letter to the Royal Society that he would simply provide facts for those more versed in natural philosophy to interpret, and in the same way he expressed the hope that the specimens sent to the Museum might lead to useful discoveries by those learned in natural history.

In the spring of 1769 Hamilton visited Sicily and Mount Etna, accompanied by his wife Catherine and Lord Fortrose. The little party set off up the mountain on 24 June and reached the summit on the early morning of the third day. They were rewarded by the most astonishing view as the sun rose. The whole of the island of Sicily was laid out like a map, and to the north they could see the Phare of Messina, the Lipari Islands and Stromboli. It was a moment Hamilton remembered all his life. The account of Etna he wrote for the Royal Society in October 1769 shows that it was the great age of the volcano that had impressed him most strongly. He estimated that lava must take at least a thousand years to yield fertile soil, and that a flow that has huge trees growing on it must be 'so very ancient, as to be far out of the reach of history'.[16] Looking at the cones and craters on the flanks of Etna, Hamilton could distinguish the more recent, with their sharp features, from the older and more rounded examples. He was now quite decided that all these cones were formed as a result of explosive eruptions, and was coming to the idea that volcanoes themselves formed as the result of eruptions, and were not simply the place where eruptions occurred. 'Mountains are produced by volcanos', he wrote, 'not volcanos by mountains'.[17] His letter to the Royal Society was read on 18 January 1770, and a further consignment of rocks dispatched to the British Museum about the same time. Dr Matthew Maty, President of the Society, wrote in July that 'soon after my return from Holland I shall begin to send to the press the memoirs for 1769, one of the first and certainly the most interesting of which is your excellent account of Mount Etna. I may safely judge of the effect it will have upon the readers, by the attention and universal approbation it met with from the Society when it was read to them.[18]

William Hamilton's approach to the natural sciences has many of the characteristic traits of the Enlightenment, and stands in contrast to that of most of the authors of the seventeenth and early eighteenth centuries mentioned above. First and foremost, the Enlightenment stood for a rejection of religious cosmology in which God could act as he chose and in a way which was unintelligible to helpless mankind, and in

favour of schemes in which nature was shown to be ordered, rational and benevolent. The range of types of evidence that were acceptable in natural history was narrowed, and cosmogony, natural theology and antiquities became divorced from observational natural history. The Holy Bible was no longer an acceptable source of information on the Earth, and neither the Creation nor the Flood make any appearance in Hamilton's writings. Indeed, Hamilton had little time for anything that he could not directly observe himself. He referred scathingly to system-makers on several occasions:

> I frequently receive letters from my fellow *Volcanistes*, who are pleased to call me *Le Pline moderne du Vesuve*. They all form the most ingenious systems imaginable; but if they would be at the trouble of coming to our active Volcano they would soon be, or ought to be, convinced that they know nothing of the matter. As for my part if I live the rest of my life here, I shall content myself with collecting facts, and let who will form them into a system afterwards.[19]

The centrality of facts was a theme that Hamilton returned to time and again. His own devotion to observation was impressive. He climbed Mount Vesuvius many times to see eruptions in action, and, in addition, had a battery of telescopes at the Villa Angelica, his house near Portici which overlooked the mountain.[20] He favoured Ramsden's telescopes, and was always on the lookout for the best model, writing to Sir Joseph Banks on one occasion that Ramsden 'is a dog if he does not send me a $4\frac{1}{2}$ inch telescope directly'.[21] He ordered two further instruments for the queen in 1776, anxious to instil his habits of good observation into others. Above all, he appreciated that when dealing with a subject such as a volcano, observation must be continued and continuous. He wrote:

> I do not wonder that so little progress has been made in the improvement of Natural History, and particularly in that branch of it which regards the Theory of the Earth. Nature acts slowly, it is difficult to catch her in the act. Those who have made this subject their study, have without scruple, undertaken at once, to write the Natural History of a whole province, or of an entire continent; not reflecting, that the longest life of man scarcely affords him time to give a perfect one of the smallest insect.[22]

The Enlightenment movement was not anti-religious, for God was still believed to be the Author of Nature, but He did play a smaller part in the day-to-day running of the world. Nature, and therefore natural history, was separated more clearly than it had been from divinity and humanistic studies. This led to greater freedom in differing from the tenets of 'revealed' history in matters such as the universality of Noah's Flood or, crucially for Hamilton, the age of the world. Enlightened thinkers began to view the world as a theatre

shaped by natural processes that worked gradually through time. This led to a realisation of the complexity and richness of natural phenomena, and Hamilton's detailed accounts of volcanoes certainly made many of the earlier simplistic accounts redundant. He scorned the idea that earthquakes or eruptions had any moral significance – they were natural events and nothing more.

The reference to 'Le Pline moderne' highlights how closely Hamilton's interest in Vesuvius was linked with his enthusiasm for Classical antiquity. He quoted Greek and Roman authors for their ideas and observations of volcanoes and earthquakes, and collected lava, ash and mud at Classical sites such as Pompeii and Herculaneum. He was able to show that the volcano that had erupted in AD 79 was not the present cone but the Monte Somma, and felt connected to that great event by the train of lesser eruptions that he was able to date and reconstruct from both literary and field evidence. His discovery of lava and burnt matter below the streets of Pompeii showed that there must have been earlier eruptions, stretching back into the remote past.

Certain ideas emerged during Sir William's first ten years in Naples as distinctively 'Hamiltonian'. First, he considered volcanoes to be basically constructive, not destructive. As Lord Rawdon observed, 'When William Hamilton came to Italy he was possessed with the idea, held by many English, that Italy was undermined by subterraneous fires, which were gradually preying upon it and would gradually destroy it ... He concluded that instead of undermining the country, the volcanos were imperceptibly building it up.'[23] Hamilton's thoughts had first appeared in his letter to the Royal Society of 16 October 1770, in which he described the volcanic rocks of the country surrounding Vesuvius and Naples, and concluded that the whole landmass had grown out of the sea by the action of volcanoes.

> I imagine the subterraneous fires to have worked in this country, under the bottom of the sea, as moles in a field, throwing up here and there a hillock; and that the matter thrown out of some of these hillocks, formed into settled volcanos, filling up the space between one and the other, has composed this part of the continent, and many of the islands adjoining.[24]

For Hamilton, volcanoes were both evidence of the great age of the Earth and the means by which its rich and varied history could be deciphered. Following from this came Hamilton's belief that no vestige of the original surface of the Earth had survived to the present day, and that everything we see is the result of subsequent actions of the rain, sea, volcanoes and earthquakes. Hamilton derided Joseph-Jérôme Lalande, the astronomer, for his published statement that Vesuvius was a 'primitive' mountain, that is, one that dated from the Earth's formation. Lalande had apparently relied on the local author Padre Giovanni Torre for the information, and Hamilton himself had demonstrated to the Padre that the supposed primitive rocks of Mount Vesuvius were only a recent lava discoloured by exposure to the air. He ends his description of the incident by writing sorrowfully: 'I mention these particulars to shew how difficult it is to get at the truth & how easily errors are propagated.'[25] It was with this in mind that he wrote to his nephew Charles Greville: 'I love every specimen that can serve to prove that there is nothing in its primitive state upon the surface of the globe within our reach, which I am confident is the case.'[26]

Hamilton did not develop any new theories of volcanic action. He was quite happy to accept the seventeenth-century belief that pent-up fire and exhalations in underground caverns would cause an earthquake if confined, but would erupt as a volcano if able to escape to the surface. In a passage reminiscent of Thomas Robinson's animism, he compared a country rich in eruptions and earthquakes with a body full of 'humours', which cause illness and agitation when confined, but whose symptoms are relieved once the humours discharge from a tumour.[27] He was, however, convinced that volcanic fires were deep-seated and, in a passage edited out of his 16 October 1770 letter to the Royal Society, he wrote: 'In short, I believe M. Buffon & all those who have placed the seat of the fire of volcanos towards the centre or near the summit of original mountains are quite mistaken.'[28] In support of this assertion Hamilton pointed to the huge volumes of lava and the widespread action of the earthquakes which accompanied eruptions. The role of water interested him, and he concluded that while a 'dry' eruption would result in the gentle flow of lava down the mountainside, an eruption which involved water in underground caverns would be more explosive, with fountains of lava thrown up from the crater.[29] The significance of electricity in eruptions was another thing that intrigued Hamilton. He had observed lightning in the ash cloud in the 1767 eruption, and acquired an electrical apparatus from Nooth in 1773 (fig. 32). He used the machine to mimic lightning discharge on a small scale with glass plates and iron filings, but was not able to draw any firm conclusions from what he observed. His observation of lightning in the great ash cloud produced by the 1794 eruption (fig. 33) convinced him that the electrical fluids were the result, and not the cause of the eruption, and that the amount of lightning in the ash cloud gave a clue to the force of the fermentation going on in the bowels of the mountain.[30] Hamilton had books on electricity and scientific works by Joseph Priestly and others in his library, and would have sympathised with Lord Cowper when he wrote to Hamilton: 'I am electricity mad'.[31]

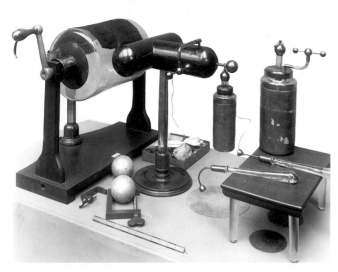

FIG. 32 Horizontal cylinder electrical machine by G. Adams (1792). London, Science Museum.

Among those who shared his interests, Hamilton was unusual in not being a collector of minerals and rocks. He gathered a number of volcanic specimens for the British Museum, and spent a great deal of time and trouble acquiring minerals for his nephew Charles Greville. But when Greville started giving him advice about developing his own collection he replied quite abruptly: 'As to my collecting minerals, I have no idea of it.'[32] Hamilton clearly valued rocks and minerals as evidence to back up his geological observations and ideas, but not as objects to be sought out for their beauty or rarity.

As has been noted above, Hamilton regularly gathered his thoughts and observations into a letter to the President of the Royal Society. These letters were first read at meetings of the Society, and then published in *Philosophical Transactions* and reprinted elsewhere. In 1772 the first five letters were reprinted as a book, *Observations on Mount Vesuvius, Mount Etna and other Volcanos*, which must have sold well, as a second edition appeared in 1773 and a third the following year. The letters were translated into German in 1773, and Hamilton's later writings became available in French, Dutch, Danish and Italian.[33]

Hamilton, however, clearly wanted something more than words in print. Some time in the 1770s he decided to re-publish the letters that had appeared in *Observations* as a luxurious folio, with the text in English and French, and copiously illustrated with hand-coloured engravings. Pietro Fabris, his own artist, prepared the fifty-four gouache drawings to accompany the text, showing general views, eruptions in progress, critical localities and rock specimens, and the volume was published in Naples in 1776 with the title *Campi*

Phlegraei: Observations on the Volcanos of the Two Sicilies (see cat. no. 43). Hamilton, writing to Greville, described himself as 'the translator, corrector, inspector &c. &c.', and reported that the book had already swallowed up £1,300 of his scarce resources.[34] Three years later, after the great eruption of August 1779, Hamilton published a supplement with five coloured plates. This was, without question, one of the most lavish books of the eighteenth century, and stands in stark contrast to most books dealing with aspects of the Earth, where the illustrations are few and lacking in confidence. Geology lacked any developed visual language, and it is noticeable that Fabris is more successful with landscapes and firework display paintings than he is with quarry faces and rock specimens.[35] Although *Campi Phlegraei* is Hamilton's chief monument today, it remains an expensive rarity, and little known except to vulcanologists during his own day.

While Hamilton was busily monitoring the volcanoes of southern Italy, other geologists were finding traces of long extinct volcanoes much closer to home. Jean Etienne Guettard had identified the mountains of the Auvergne as volcanic as early as 1751, although it was not until the 1760s that Nicholas Desmarest, studying the area in great detail, claimed that a rock called basalt, found throughout the area, was volcanic and had solidified from a molten state.[36] This was a startling claim, given that basalt was widespread among the sandstones and limestones of northern Europe, but had not been produced by any of the active volcanoes studied at that date, and it suggested that volcanoes were of greater significance than was commonly supposed. Rudolph Erich Raspe had independently reached the same conclusion after studying basalts in Hesse, and published his conclusions in 1769, sending a description of them to Hamilton at the same time.[37]

From his study of volcanic rocks around Naples, Hamilton became convinced 'that there have been volcanos in many parts of the world, where at present there are no traces of them'.[38] He received direct evidence of this in 1772 while travelling from Trento to Verona, when he saw a 'most noble havock, certainly made by volcanick explosion, tho' no one could give me any account of it. The earth has opened in many parts for the space of 4 miles, & thrown up the rocky soil in huge masses in a most wonderful manner.'[39] By the time *Campi Phlegraei* was published in 1776 he was convinced that basalt was a lava, and that active volcanoes had formerly been more frequent over the world. His most important observations on this subject were made on the return journey to Naples from England in 1777, when he identified volcanic building stones in use in Düsseldorf and Cologne, and traced them to the nearby Sevenbergen, a range of extinct volcanoes.[40]

FIG. 33 Xavier Della Gatta, *Eruption of Vesuvius in 1794*. Watercolour and bodycolour. © Bibliothèque centrale, Muséum National d'Histoire Naturelle, Paris.

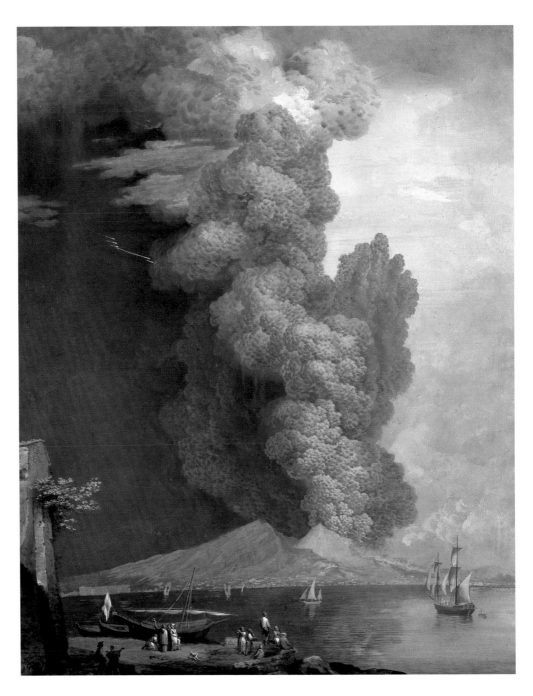

Hamilton certainly played a major part in the slowly growing acceptance of volcanoes as a major force. As one of his correspondents eloquently put it:

I know of no subject that fills the mind with greater ideas than the volcanic history of the world, which [?] enlarging itself every day & visibly spreading & marking its effects all over the globe & those so prodigious both in creation & destruction that they appear almost universal & omnipotent. That the world is turn'd inside out & upside down is clear & no agent half so powerful can have been employ'd tis certainly a part of the great system of dissolution & renovation which seems the Universal Law of Nature, by which a sparrow, a city, a region or a world, probably, have their beginning & end.[41]

In spite of his famous enthusiasm for all things volcanic, Hamilton was no narrow specialist. Like so many men of the time, he took an interest in the whole field of natural history, and, although he published nothing on these subjects, his letters reveal a considerable knowledge of animals and plants. He wrote about the intelligence of his pet monkey and the light this threw on the opinions of Monsieur Buffon; on migrating birds and on curious ducks; and on the marine life

FIG. 34 *Angelino di mare* or butterfly fish. Anonymous watercolour, 1792. British Library, Banks MS (Add. MS 34,048, f. 68).

found in the Bay of Naples. Hamilton had what he described as 'a little picina' dug out of the rock near his villa at Posillipo, with a channel connecting it to the sea, in which he kept a number of fish, crustaceans and anemones under observation, and sent consignments of dried specimens to the British Museum from time to time. As he wrote to Sir Joseph Banks in 1796, 'The natural history of fish, particularly shellfish & sea insects moluschi &c might be followed up at Naples with wonderfull success by anyone who had the leisure' (fig. 34).[42]

Although Hamilton never lost his enthusiasm for earthquakes and volcanic phenomena, he did become more discriminating. An eruption of Vesuvius in 1785, which visiting Britons described as 'most terrible', left Hamilton unmoved, being largely a repeat of 1766 and therefore not worth reporting. In 1787 Hamilton warned Joseph Banks to take no notice of exaggerated newspaper reports of a great eruption, and the lava flows produced in 1788 likewise showed 'no new phenomena'.[43] Hamilton came to feel isolated during these later years. He did not relish the steady stream of tourists, and refers to the English, Dutch and Russians as 'his plague', noting on one occasion that the English colony in Naples numbered ninety-two. Scientific visitors, on the other hand, he longed for. He was disappointed that Joseph Banks never came to visit him, and wrote on one occasion: 'I am much flattered by your kind remembrance of me, many of my *old friends* seem to forget that I am in this world, being out of theirs.'[44] He was always delighted to come across a fellow enthusiast of any nationality, and was pleased to correspond with and meet Horace Benedict de Saussure (1740–99) and other distinguished Continental naturalists. These personal

contacts often led to the gift of books, and Hamilton built up a fine library of books and engravings of travel, natural history and science, which he used as a resource to support his own researches.[45] He recruited Count Giveni of Catania in 1781 to keep an eye on Mount Etna for him, and the Sicilian sent him reports from time to time over the next ten years, at least one of which Hamilton sent on to the Royal Society.[46] He mentions the Duca della Torre as being 'an élève' for Vesuvius in an undated letter to Joseph Banks, but no more is heard of his activities.[47] Hamilton's employment of Padre Antonio Piaggio, an elderly Genoese monk who lived near Resina at the foot of Vesuvius, was much more productive. Piaggio was commissioned to keep a daily diary describing and illustrating the visible phenomena around the mountain. This diary, which Hamilton approvingly described as 'very curious', eventually covered the years 1779 to 1794 and filled eight sizeable volumes (fig. 35). The steady accumulation of data on the size and shape of the rising clouds of smoke and their relation to the atmospheric conditions, delighted Hamilton, and he incorporated some of Piaggio's drawings and observations into his own publications. However, he never produced the summary of the diary that he intended, and eventually gave it to Sir Joseph Banks, who passed the volumes on to the library of the Royal Society, where they are still preserved.[48]

Even into his fifties and sixties, Hamilton was still keen to see and learn. When a great earthquake struck Calabria in 1783 nothing could stop him heading south to test his long-held belief that earthquakes have the same root cause as volcanoes. As he wrote to Greville:

> We are assured of high mountains being rent from top to bottom in Calabria, & that all their strata are clearly exposed to view, that rivers are impeded & great lakes are forming; that hot water & ashes issue at times from the cracks. As such great operations of chymistry of nature do not occur often, I am determined to put myself to some little inconvenience to see with my own eyes.[49]

The letter he subsequently wrote to the Royal Society is one of his most detailed. In it he gives eye-witness accounts of the shocks and their effects, he describes the things he himself saw, and he gives his conclusions as to the nature of earthquakes. Hamilton was particularly anxious to link high temperature to the earthquake, and reported from interviews with fishermen on the coast facing Sicily that the sand on the seashore was hot on the night of the earthquake, and that fire (interpreted by Hamilton as exhalations charged with electric fluids) issued from the earth in many places. The sea off Messina had been observed to seethe and boil, pointing to an underwater eruption, and there were reports, which Hamilton reluctantly rejected, that a tidal wave which accompanied

FIG. 35 Pages from Padre Piaggio's *Diario Vesuviano, c.* 1794. By permission of the President and Council of the Royal Society.

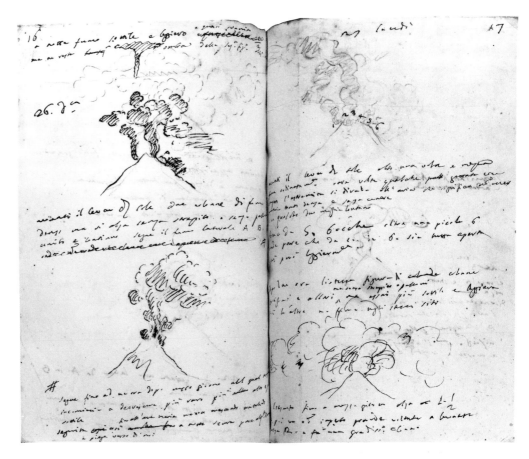

the quake was scaldingly hot. He summed up by stating that 'the present earthquakes are occasioned by the operation of a volcano, the seat of which seems to lye deep, either under the bottom of the sea, between the island of Stromboli and the coast of Calabria, or under the parts of the plain towards Oppido and Terra Nuova.'[50]

Hamilton was taken seriously ill at the end of 1792 and this, together with his advancing age, marked a slowing down in his activity. Early in 1794 he was ready to embark on his final vulcanological task, that of quietly preparing a summary of the Piaggio diaries for the Royal Society, when Vesuvius came up with what he described to Banks as 'a thumping eruption, certainly the greatest in history except those of 79 and 1631'. It lasted from June to August 1794, and kept Hamilton busy observing, annotating, visiting and even, on one occasion, climbing the mountain (his sixty-eighth ascent). Although the phenomena observed were familiar to Hamilton, there was food for thought in the details. As he wrote to Banks: 'Every operation of chymistry has been exhibiting, all sorts of airs produced, and the most curious electrical phenomena have been exhibited.'[51] He seems to have realised that there was a limit to how much more he would learn about his beloved volcano, even after a lifetime of observation, and the paper he sent to the Royal Society at the end of

the eruption in August ended on an uncharacteristically pessimistic note. Hamilton quoted Seneca on the great depth of the volcanic fires, to show that all man's careful observations of the surface of the Earth can only lead to an approximate idea of the operations of nature, and that many things will remain beyond human understanding: 'we see what we are permitted to see, and reason as best we can'.[52]

Hamilton returned to London with his wife Emma in November 1800, and he died in April 1803 at his home in Piccadilly at the age of seventy-three, without making any further contributions to the study of volcanoes. His published observations, however, lived on, and were frequently consulted and quoted by the geologists of the nineteenth, and indeed twentieth centuries. Hamilton is still acknowledged as the most reliable source of information about the eruptions of Vesuvius in the second half of the eighteenth century, and his writings have retained their interest and validity, long after the 'systems' of his contemporaries have been consigned to history.[53]

ACKNOWLEDGEMENTS

I acknowledge with gratitude the help given to me by the staff of the Palaeontology and General libraries of the Natural History Museum, and of the Department of Manuscripts at

the British Library, by Mary Sampson at the Royal Society and Sheila Meredith at the Geological Society. Henry Buckley and Peter Tandy, of the Department of Mineralogy at the Natural History Museum, kindly allowed me to see rock and mineral specimens associated with William Hamilton, while members of the Zoology Department searched unsuccessfully for the marine specimens he presented. I benefited greatly from discussions with Kim Sloan and Ian Jenkins of the British Museum at all stages of the project. Although not specifically cited in the references, Mark Sleep's University of London M.Sc. thesis on 'The geological work of Sir William Hamilton' (1967) gave me a very useful starting-point for my researches.

NOTES

1 The primitive state of the Earth sciences when compared with, for example, astronomy and mathematics is discussed by Paolo Rossi in the preface to *The Dark Abyss of Time*, Chicago and London, 1984, pp. vii–xv.

2 An example of this genre is 'An abstract of a letter from an English gentleman at Naples to his friend in London, containing an account of the eruption of Mount Vesuvius, May 18 and the following days, 1737', *Philosophical Transactions of the Royal Society*, XLI, 1737, pp. 252–61.

3 G. A. Borelli, *Historia et Meteorologia incendii Aetnaei anno 1669*, Reggio, pp. vi, 162; G. C. Recupito, *De Vesuviano incendio nuntius*, Naples, 1632, pp. viii, 119; F. Serao, *Istoria dell'incendio del Vesuvio*, Naples, 1737, pp. iv, 122.

4 T. Burnet, *The Theory of the Earth*, London, 1684, p. 54; W. Whiston, *A New Theory of the Earth*, Cambridge, 1708, pp. 84, 85, 422; J. Woodward, *An Essay towards a Natural History of the Earth*, London, 1695, pp. 133–42.

5 G. Buffon, *Barr's Buffon: Natural History*, London, 1797, II, p.166; A. Kircher, *Mundus subterraneus*, Amsterdam, 1664–5, pp. 75, 76, 113.

6 T. Robinson, *The Anatomy of the Earth*, London, 1694, pp. vi, 24.

7 T. Burnet, op. cit., p. 55.

8 W. Hamilton, 'An account of the last eruption of Vesuvius', *Philosophical Transactions of the Royal Society*, LVII, 1768, pp. 192–200; and W. Hamilton, [Extract of a letter from the Hon. Sir William Hamilton ... giving an account of the new eruption of Mount Vesuvius in 1767], *Philosophical Transactions of the Royal Society*, LVIII, 1769, pp. 1–12.

9 Morrison, no. 9.

10 Hamilton, 1769, p. 12.

11 British Library, Add. MS 42,069, f. 61.

12 Ibid., f. 81.

13 Ibid., f. 69.

14 Hamilton, 1769, p. 11.

15 British Library, Add. MS 40,714, f. 47.

16 W. Hamilton, 'Account of a journey to Mount Etna in a letter ... to Matthew Maty', *Philosophical Transactions of the Royal Society*, LX, 1771, p. 7.

17 W. Hamilton, 'A letter, containing further particulars on Mount Vesuvius and other volcanoes in the neighbourhood', *Philosophical Transactions of the Royal Society*, LIX, 1770, p. 21.

18 British Library, Add. MS 42,069, f. 81.

19 British Library, Add. MS 34,048. f. 15.

20 Fothergill, pp. 61–2.

21 British Library, Add. MS 34,048. f. 26.

22 W. Hamilton, *Campi Phlegraei*, Naples, 1776, I, p. 54.

23 Letter from Francis, 2nd Lord Rawdon to his father, the Earl of Moira, 28 August 1774. Public Record Office of Northern Ireland, Rawdon papers, D.2924/1, f. 174.

24 W. Hamilton, 'Remarks upon the nature of the soil of Naples and its neighbourhood', *Philosophical Transactions of the Royal Society*, LXI, 1772, p. 2.

25 British Library, Add. MS 34,048, f. 1.

26 Morrison, no. 30.

27 Hamilton, 1772, p. 10.

28 Royal Society, L&P V, f. 206.

29 W. Hamilton, *Supplement to the Campi Phlegraei*, Naples, 1779, pp. 22–3.

30 W. Hamilton, 'An account of the late eruption of Vesuvius. Letter to Sir Joseph Banks', *Philosophical Transactions of the Royal Society*, LXXXV, 1794, p. 80.

31 Morrison, no. 30.

32 Ibid.

33 Hamilton's publications are listed in H. J. Johnston-Lavis, *Bibliography of the Geology and Eruptive Phenomena of the More Important Volcanoes of Southern Italy*, London, 1918, p. 373.

34 Morrison, no. 71.

35 M. J. S. Rudwick, 'The emergence of a visual language for geological science, 1760–1840', *History of Science*, XIV, 1976, pp. 149–95, see especially p. 154, n. 12.

36 The basalt controversy is set in context by Rachel Laudan in *From Mineralogy to Geology, the Foundations of a Science, 1650–1830*, Chicago and London, 1987, pp. 181–5.

37 R. E. Raspe, 'A letter ... containing a short account of some basalt hills in Hassia', *Philosophical Transactions of the Royal Society*, LXI, 1771, pp. 580–83. See also Raspe's preface to J. J. Ferber, *Travels through Italy in the Years 1771 and 1772, Translated with Explanatory Notes by R. E. Raspe*, London, 1776, p. 377.

38 Hamilton, 1769, p. 12.

39 Morrison, no. 26.

40 W. Hamilton, 'An account of certain traces of volcanos on the banks of the Rhine', *Philosophical Transactions of the Royal Society*, LXVIII, 1778, pp. 1–6.

41 British Library, Add. MS 40,714, f. 222.

42 British Library, Add. MS 34,048, f. 86.

43 Ibid., ff. 38–8.

44 Ibid., f. 12.

45 *Catalogue of the Very Choice and Extremely Valuable Library of Books ... the Property of the Late Sir W Hamilton ... Which Will be Sold at Auction by Mr Christie on Thursday, 8th of June, 1809, and Two Following Days*, London, 1809. An annotated copy is in the British Library.

46 Count de Gioeni, 'Relazione di una nuova pioggia, communicated by Sir William Hamilton', *Philosophical Transactions of the Royal Society*, LXXII, 1782, pp. 1–7.

47 British Library, Add. MS 34,048, f. 86.

48 Royal Society, MSS 2–9.

49 Morrison, no. 122.

50 W. Hamilton, 'Account of the earthquakes which happened in Italy from February to May 1783', *Philosophical Transactions of the Royal Society*, LXXIII, 1783, p. 205.

51 British Library, Add. MS 34,048, f. 77.

52 Hamilton, 1794, p. 110.

53 See for example T. G. Bonney, *Volcanoes, their Structure and Significance*, London, 1899, pp. 7–20; J. L. Lobley, *Mount Vesuvius*, London, 1868, pp. 106–11; J. Phillips, *Vesuvius*, London, 1869, pp. 68–95.

'Picture-mad in virtu-land'
Sir William Hamilton's
Collections of Paintings

KIM SLOAN

On 8 June 1764 Horace Walpole wrote to Horace Mann, the British Minister to the Grand Duke of Tuscany at Florence:

You have a new neighbour coming to you, Mr William Hamilton, one of the King's equerries, who succeeds Sir James Gray at Naples. Hamilton is a friend of mine: is son of Lady Archibald, and was aide-de-camp to Mr [Henry Seymour] Conway. He is picture-mad, and will ruin himself in virtu-land. His wife is as musical, as he is connoisseur, but she is dying of an asthma.[1]

Walpole's prediction for Catherine Barlow fortunately proved inaccurate: she was indeed very ill when they met Mann on their way through Florence, but the climate in Naples eventually extended her life a further twenty years.[2] Walpole's prediction for Hamilton's financial future was, however, sadly closer to the mark, although his constant impecunious state was admittedly not due to his expenditure on paintings alone.

Hamilton's collections of Greek vases have attracted a great deal of study, and his fame as a connoisseur rests more on those than on his interest in other objects of 'virtu', or his work on natural history and volcanoes. His activities as a collector of paintings and patron of contemporary artists have attracted less notice, largely because, unlike his other collections, his paintings were not published and did not remain together in a public institution or private collection. They were sacrificed on his return to England to provide him with the cash to pay recent debts while he waited, in vain, for the British government to settle the account he had accrued during thirty-seven years of diplomatic duties.[3]

A further reason why Hamilton's collection of paintings has not attracted the attention of British writers on the history of taste is that the sales of his collection were held during a time when the London market was flooded with magnificent old masters, as well as a glut of less significant works from war-torn Europe, most of them purchased and sold again purely for profit. It was thus easy for someone like Joseph Farington, attending an exclusive preview of extremely important works collected in Rome by William Young Ottley on the same day he viewed Hamilton's sale (25 March 1801), to dismiss Hamilton's as 'a very indifferent collection'.[4] In his discussion of the sales which took place during this period, William Buchanan also stated that Hamilton's sale contained very few pictures of price or consequence, 'yet it might be deemed unpardonable to pass over unnoticed a collection which belonged to so distinguished a connoisseur, in all objects connected with virtu'. He included the collection, although only in part (he did not mention the sale in April at all),

more as in reference to a name that has made a noise in the world, than the intrinsic merit or value of the pictures themselves; for like that of Mr. Strange, who was a long time resident at Venice, it was formed at a period before the capital works of the great masters were separated from the walls of those palaces which they had so long adorned, and when copies of these, or works of a second-rate class only, could be procured.[5]

In fact many of Hamilton's paintings were not acquired in Italy at all, but came from earlier British collections, and he was collecting paintings not for profit as Ottley and others had, but for other reasons altogether.

Nearly two hundred years after the 1801 sales, however, our perspective of Hamilton's connoisseurship has changed dramatically. The two most prized paintings in his own eyes and those of his contemporaries have since been reattributed, from Correggio to Cambiaso (cat. no. 176; fig. 42) and from Leonardo to Luini (cat. no. 178), while two other paintings Hamilton is now known to have owned are two of the most

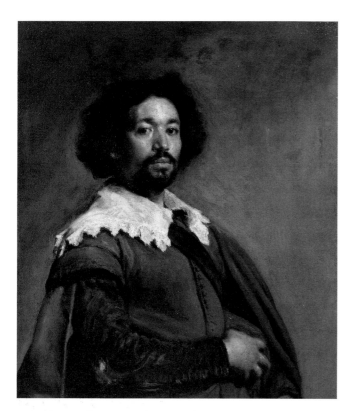

FIG. 36 Diego Velázquez, *Juan de Pareja*. Oil on canvas, 1650. New York, Metropolitan Museum of Art.

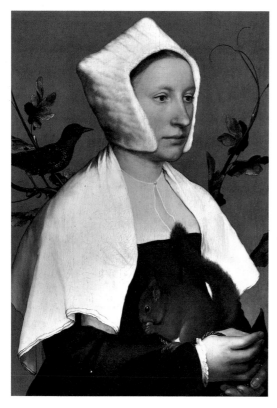

FIG. 37 Hans Holbein the Younger, *A Lady with a Squirrel and a Starling*. Oil on panel, *c.* 1527. London, National Gallery.

expensive and now famous old masters to have been acquired by public collections in the twentieth century: Velázquez's *Juan de Pareja*, purchased by the Metropolitan Museum in New York in 1970 (fig. 36), and Holbein's *Lady with a Squirrel and a Starling*, acquired by the National Gallery in London in 1992 (fig. 37).

The paintings in the two 1801 sales, however, were not the only ones that Hamilton had owned. Walpole described Hamilton as 'picture-mad' before he even departed for Naples, and he was quite aware that Hamilton had already formed one collection of paintings and small sculptures which he had been forced to sell three years before he even thought of going to Italy.

The formation and sale of Hamilton's early collections, c.1750–65

During the Seven Years War, Hamilton had served in the army under Walpole's favourite cousin, Henry Seymour Conway, whose residence was Park Place, Henley-on-Thames, Hamilton's birthplace.[6] It was no doubt partly through his great friendship with Conway that Hamilton became part of the circle of connoisseurs and collectors around Walpole, but Hamilton's own passion for collecting must also have been fired by his youthful friendships with the future diplomat and collector Lord Stormont and Frederick Hervey, the eccentric future Earl-Bishop. Hamilton's childhood had been spent at the court of one of the greatest royal collectors, Frederick, Prince of Wales.

Hamilton's resignation of his military commission in 1758, the year he married the heiress Catherine Barlow, and his setting up of house in London coincided with a period of great activity among the virtuosi in that city which Hamilton not only followed but in which he also sometimes took an active part. One of the most important institutions established in the 1750s was the British Museum. Frederick, Prince of Wales, had expressed a hope of its foundation in 1748, and Horace Walpole was one of Sir Hans Sloane's original trustees who ensured in the negotiations through the 1750s that the Museum became the 'ornament to the nation' that Prince Frederick had hoped for.[7] In 1759 it was opened for public use.

In 1755, the Society for the Encouragement of Arts, Manufactures and Commerce (the Society of Arts) was founded in London by 'several of the Nobility and Gentry of this Kingdom', sensible that 'the Riches, Honour, Strength and Prosperity of a Nation depend in a great Measure on the Knowledge and Improvement of useful Arts, Manufactures, Etc.' They founded the Society with the very specific moral

and national intention of giving encouragement and rewards 'which are greatly conducive to excite a Spirit of Emulation and Industry' in the form of premiums for 'such Productions, Inventions, or Improvements, as shall tend to the employing of the Poor, and the Increase of Trade'.[8] Membership at two guineas per year was to be by proposal by an existing member and ballot, and the name of the Honourable William Hamilton of Curzon Street, Mayfair was proposed by James 'Athenian' Stuart on 18 January 1758.[9]

A year afterwards the Society moved to new premises which contained a room large enough to house the first public art exhibition in Britain of works for sale by contemporary artists. This was held in April and May 1760 and attracted over 20,000 visitors. Hamilton may well have been present at the meetings when the group of artists proposed the exhibition to the Society.[10] He was elected to Parliament as member for Midhurst in 1761 and that year declined to renew his two-guinea membership, but he would have watched the proceedings of the exhibiting artists that year and until his departure for Italy in 1764 with some interest. In 1761 the artists who had shown at the Society of Arts split into two groups, only the Free Society of Artists continuing to exhibit there, while the others, calling themselves the Society of Artists of Great Britain, showed their work elsewhere. It was a group of the latter, including Joshua Reynolds, which went on to found the Royal Academy in 1768.

William Hamilton first sat to Joshua Reynolds in 1757, the same year as Horace Walpole, for a portrait eventually given to his mother-in-law for the Barlow estate in Milford Haven: his name appears as many as ten times in the artist's appointment books over the next three years as Captain and then Mr Hamilton. His final sitting for this portrait seems to have been in September 1762, but Reynolds was extremely busy that year and the painting still may not have been finished, as payment of £12 12s was not made until Hamilton's first return from Naples to London in 1772.[11] The portrait was a half-length informal one, showing him seated at a table, an open book in his hand, with another prominently labelled 'ART' standing on the table (fig. 38).[12] Hamilton was not in London when the Royal Academy of Arts was founded in 1768, but the friendship he had established with Reynolds was maintained by correspondence while he was abroad, Reynolds informing him of the foundation and purpose of the institution and Hamilton in turn sending welcome gifts of casts and prints for the use of the Academy.

Hamilton's involvement with the various early art institutions springing up in London in the 1750s and early 1760s, and his concern with the nationally beneficial purposes of the Society of Arts did not cease when he left England. Many artists and patrons of the arts withdrew their support from the

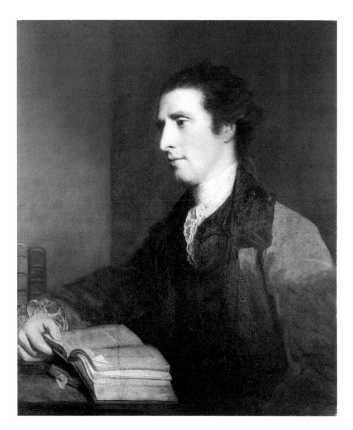

FIG. 38 Sir Joshua Reynolds, *William Hamilton*. Oil on canvas, 1762–72 and 1785. Toledo, Ohio, Toledo Museum of Art, Gift of Edward Drummond Libbey.

Society when the Royal Academy was created, and it seemed as if the Society was more involved with promoting the commercial or trade side of the arts than with the fine art of painting. Hamilton, however, throughout his life promoted with utmost zeal the primary aims of the Society which, as its full title indicated, were to encourage the improvement of arts, manufactures and commerce. His books on vases were intended not only to improve British taste but also to improve British design in both commercial and fine arts, and the assistance he gave Wedgwood was intended to have the same results (see cat. nos 58–61).[13] In Italy he conveyed the Society's purposes to Filippo Morghen, who dedicated a volume of views of Pozzuoli to the Society and individual plates to its members, and sent a copy for the Society's library in 1769 (cat. no. 42). On 31 October the same year, having already sent the first volume of his vase publication, Hamilton wrote to the Society of Arts from Naples, explaining that the second volume was under way. Mindful of the Society's wish to improve Britain's most important industry, textiles, he also informed them of Friar Antonio Miriasi's useful experiments in making thread, paper and lace from aloe.[14]

Hamilton had served as an ensign in the Third Regiment

in Holland from 1747 until the Treaty of Aix-la-Chapelle the following year, when he returned to London. In December 1752 he was in Paris with his parents and sister when his mother died; his father died two years later.[15] Back in London until the start of the Seven Years War, he had time, between duties as captain in his regiment and at court as equerry to his 'foster brother' George, Prince of Wales, to study the violin with Giardini and to attend the increasing number of picture sales and auctions. Cultivating his musical abilities and forming a collection of paintings was a method of demonstrating that he was a virtuoso, a man of taste. His upbringing at court and the classical education he had received at Westminster would have inculcated him with the standards concerning his role in society, which were peculiar to British 'polite culture' of the first half of the eighteenth century. The comprehensive dictates of this polite culture, which guided thought, word and deed of the society to which Hamilton belonged, have been discussed at length elsewhere, particularly as a part of a wider European discourse of 'civic humanism',[16] and they elucidate Hamilton's moral attitude to his wide-ranging interests and responsibilities, and in particular towards the collecting, connoisseurship and patronage of painting.

The ends of education in Britain in the first part of the eighteenth century were virtue and usefulness, a theme underlined by Defoe's argument that there was an obligation that a gentleman by rank should become a gentleman by virtue. Shaftesbury in particular contended that painting should contribute to the ethical instruction of mankind by giving concrete form to abstract notions of morality. But it was Jonathan Richardson who made the closest links between the connoisseurship of painting and the benefit of mankind, putting it most succinctly in his *Argument in Behalf of the Science of a Connoisseur* (1719):

> Our walls like the Trees of *Dodona*'s Grove speak to us, and teach us History, Morality, Divinity; excite in us Joy, Love, Pity, Devotion, etc. If Pictures have not this good effect, it is our Fault in not Chuseing well … If Gentlemen were Lovers of Painting … This would help to Reform Them, as their example, and influence would have the like Effect upon the common People.[17]

In this utopian vision of reforms that could be effected through the love of art, Richardson also noted that '*Connoissance* Had a Natural Tendency to Reform our Manner, Refine our Pleasure, and Increase our Wealth, Power, and Reputation'.[18] As Chesterfield noted, however, 'beyond certain bounds the man of taste ends, and the frivolous virtuoso begins …'[19]

The results of these early eighteenth-century writings on taste were well established by the middle of the century, and to be called 'picture-mad', as Walpole knew well, was in 1764

a compliment to a gentleman. However, to overspend one's means in the pursuit of 'virtu' was folly. Before he left England, Hamilton had been forced to sell a substantial and important collection of Italian, Dutch and Flemish old masters as well as works by British artists. Over twenty years later, he still felt the loss, writing to his nephew Charles Greville: 'If you find that your house is too expensive, get rid of it as soon as you can. I was obliged to sell my collection of pictures once, on which I doated, rather than bear to be dunned.'[20]

In his chapter on 'Ladies and Gentlemen distinguished by Their Artistic Talents' in his *Anecdotes of Painting*, Walpole mentioned that Sir William Hamilton drew 'caricaturas, and had a good collection of pictures, which he sold by auction in 1761 … he went young into the army … but drawing prettily and having an insuperable taste for painting and virtu, he got, being then groom of the bedchamber to the king, to be sent envoy to Naples, selling by auction a collection of pictures he had made so early.'[21] That William Hamilton was the owner of the 'Well-known and approved Collection of Pictures' whose sale by Prestage and Hobbs was addressed to 'all Lovers of Virtu' was known to Walpole and his contemporaries, but has only recently been re-established.[22] The sale took place on 20 and 21 February 1761 at Prestage and Hobbs's Great Room at the end of Saville-Row. One of the two copies of the catalogue in the British Library is inscribed in a contemporary hand, possibly Walpole's own, to read 'Collection of Pictures, "of Mr William Hamilton"', with prices for all and purchasers' names given for some of the lots in the first day's sale, while the second copy indicates the prices and more names for the second day.

More research remains to be carried out in order to identify the paintings, how Hamilton acquired them and how much he paid.[23] However, enough is known of the activities of the auction houses in London in the 1750s and of the contents of other collections being formed at this time to enable us to make some general statements concerning Hamilton's collection – how representative it was of the taste of the time, and the relative values of the paintings. Antwerp and Amsterdam were important centres for sales of paintings in the first half of the eighteenth century, and it is possible that Hamilton made some of his earliest acquisitions while serving in Holland in 1747–8. Holbein's *Lady with a Squirrel*, which was lot 75 on the first day's sale in 1761 (bought by 'Ld Chomley' for £47.5.0), had been in the Slingeland collection which was sold in The Hague in 1752. Hamilton probably acquired this and other important Dutch and Flemish works from dealers such as Robert Bragge, who purchased substantially in Holland in the 1740s and early 1750s for resale in London.

Hamilton's 1761 sale took place during the Seven Years War, just before the strong post-war boom in sales which began in 1763. Before that time there were five to ten sales per year, which generally catered to the middle range of the market, most of the paintings fetching between £2 and £15. A very small proportion, perhaps only 5 per cent, attracted prices over £40, and few sales were of a quality to attract consistently high prices throughout. The Earl of Oxford's in 1748 was one; another was that of Sir Luke Schaub in 1758, when the collection of the former diplomat to Spain fetched double its estimate of £4,000.[24] Hamilton was in London when Schaub's sale took place, recently endowed with his new wife's income. He later referred to this sale when cataloguing the collection he sold in 1801. He knew his Furini painting of *Sophonisba (Sigismunda)* to be a duplicate of the famous work which aroused Hogarth's ire at Schaub's sale, when it was attributed to Correggio and fetched a very high price, and he described his *Landscape and Figures Representing the Different Stages of Life* by Schiavone as 'like Titian, and most extraordinary for its Force of Colouring: It was once in the Collection of Sir Luke Schaub, and no Picture could stand near it.'[25]

The sale catalogue of Hamilton's first collection (1761) indicates that he was typical in his taste and prices. The majority of the prices were in the usual £2–15 range, and of the 132 paintings, nine attracted prices of over £40. Works which might have shown an unusual taste included a pair of paintings, *Summer* and *Winter*, by Watteau and a Raphael of *The Crowning of Charlemain*, which must have failed to fetch its reserve and been taken to Naples by Hamilton, as a work of the same description appeared in the Hamilton sale of 1801.[26] In this later sale the Raphael was bought by Edward Coxe for £56.14.0; in the catalogue of his own sale, Coxe claimed that Hamilton had told him that with the Parmigianino (see cat. no. 179) it was one of the most valuable pictures he possessed.[27]

Lists of paintings which attracted the highest prices at sales are not necessarily a reliable guide to a collector's taste, but as this is the first time this sale has been published in connection with Hamilton, and since the prices fetched and the names of the purchasers of the nine paintings over £40 so fortuitously survive, it is worth listing those nine here in full:

First Day's sale, 20 February 1761

LOTS 55, 56 Paulo Veronese, *Mary telling our Saviour of the Death of Lazarus* and *Paul, his Wife and Children making a Vow to the Virgin, introduced by Joseph and St. Anne* [Duke of Grafton, £52.10.0]

LOT 75 Holbein, *A Woman with a Squirrel and a Starling, (called Nurse to King Edward VI. in Monsieur Slingeland's collection)* [Lord Cholmondeley, £47.5.0]

LOT 77 Lodovico Carracci, *St Peter repenting* [Mr Offley, £105.0.0]

LOT 78 Rubens, *A little Girl (one of the Gerbier Family) leaning on a Tree* [no name recorded, £95.11.0]

Second Day's sale, 21 February 1761

LOT 65 Sal. Rosa, *Witches at their several hellish Ceremonies* [George Knapton, £76.13.0]

LOT 66 Zuccarelli, *Macbeth and Banquo meeting the wayward Sisters in a Storm* [Sir Richard Grosvenor, £76.13.0]

LOT 73 Gaspar Poussin, *A capital Landscape* [Mr Child, £47.5.0]

LOT 76 Titian, *A finished Sketch of the Pesaro Family returning Thanks to the Virgin for having conquered the Turks, (see Titian's life by Vasari) etched by Le Fevre* [Joshua Reynolds, £42.10.6]

LOT 77 Lodovico Carracci, *The Resurrection of Lazarus, our Saviour saying, 'Father I thank thee that thou hast heard me.'* [Mr Offley, £73.10.0]

Most of these purchasers, especially Reynolds, bought a number of other, less expensive works at the sale, and Lord Bessborough and the Duke of Ancaster were also listed as buyers. The sale included bronzes, terracottas and some marble sculpture. According to the annotations on the catalogue, the total for the complete sale was £1,928 for fewer than 200 lots, which indicates that it was, as the auctioneers claimed, 'a Well-known and approved Collection'.

We know from his comments over twenty years later that Hamilton had been forced to sell to satisfy creditors, but the reasons for his debt at this stage, only three years after marrying the heiress Catherine Barlow, are not fully known. However, the annual income from his wife's estate was probably not much more than £1,000 per annum,[28] and his inheritance as a younger brother would have been small. In order to gain his seat in Parliament in 1761, he had to raise around £2,000 and was asked to put forward another £1,000 to help another candidate.[29] In a letter to his nephew in 1780 he was to advise, 'I find, likewise, as I imagined & foretold to yourself, that a younger brother's pretending to keep house in London is certain destruction. I know what it is for an honest man to be distressed in his circumstances.'[30] He had probably, therefore, been forced by debts to give up the residence in Curzon Street where he was living in 1758 when he became a member of the Society of Arts, and it was from a house in

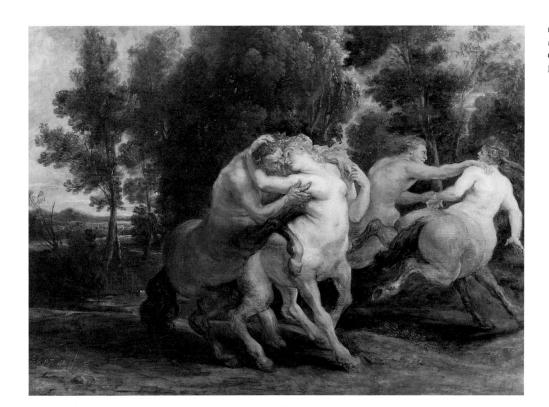

FIG. 39 Peter Paul Rubens, *Loves of the Centaurs*. Oil, *c.* 1635. Lisbon, Calouste Gulbenkian Foundation Museum.

the King's Mews, possibly a grace-and-favour house with his position as King's Equerry and Groom of the Bedchamber, that a second collection of pictures was removed for a sale in early 1765, only four years after the first sale in 1761 and six months after he had left for Naples.[31]

A letter from his banker, George Ross, written from London on 27 September 1765, a year after Hamilton had arrived in Naples, suggests how he came to be in such debt. Ross assures Hamilton that if he can obtain the additional income from being promoted to a plenipotentiary, he will soon be out of debt, and able to live within his allowance; but if the promotion does not come soon, 'which I am afraid will be the case, you must even have patience, and take the longer time, depriving yourself of the favourite passion of buying pictures'.[32]

Hamilton's second sale of pictures from the house in the King's Mews was held by Prestage on 24 and 25 January 1765. Walpole's copy of the sale catalogue (British Library, c.131.h.4(6)) identifies the anonymous 'Gentleman lately gone abroad' with the inscription 'Mr William Hamilton, Minister at Naples'. It is not known whether the sale was held because it was not possible to take such a collection abroad or in order to raise cash to pay debts left behind. No purchasers' names or prices are given in Walpole's copy, and a number of the paintings had already appeared in the previous sale of 1761. Curiously, this group included the Titian listed above as being purchased by Reynolds for £42, the pair

of paintings by Veronese purchased by the Duke of Grafton for £52, and five others. Some had in fact been bought in, while others were bought back from the purchasers by Hamilton after the sale.[33] He obviously could not bear to part with these important works for such small sums and bought them back, only to sell them again in 1765 after he went abroad, still in debt. Most of the sale consisted of items which had not been in the earlier sale, and it included drawings and oils by a substantial number of British landscapists, including several works by Richard Wilson, William Marlow, Jonathan Skelton, and George Smith of Chichester, indicating that he had been purchasing heavily during the intervening years. One of the few works by a contemporary European artist was a *Venus* by Anton Raffael Mengs. Most of these and the smaller genre pictures and landscapes were obviously being sold because they were not worth transporting to Naples or putting into store (as Hamilton did not have a permanent London residence), but the end of the sale, usually reserved for the most important works, included paintings with which he must have been loath to part.

We know this to be the case with the final lot (75) on the second day of the sale, Rubens's '*The Centaurs in a Landscape*, an exceeding fine Picture' (fig. 39). Redford recorded the sale of a painting by Rubens called 'Centaurs in a landscape' by Lord Waldegrave in 1763;[34] it is not a common subject in Rubens's oeuvre, so presumably the painting can be identified with the one in this Hamilton sale of 1765. Its subsequent

history and Hamilton's attachment to it is related by Farington, writing in May 1802 when it reappeared at auction:

> [May 24] Mr Nesbitts sale in Grafton St. I went to and saw Peter Coxe. The loves of the Centaur by Rubens is a very extraordinary picture. For beauty and clearness of colouring exceeding any I remember to have seen of the Master … West had been some hours in the morning studying the Rubens …
> [May 25] … went to Nesbitts Sale … Bourgeois was there. He had bid for the Centaur by Rubens which was selling when I went in —— Lord Darnley bid 225 guineas for it but Sir Wm. Hamilton bought it for 260 gs. —— Sir Wm. formerly had the picture and sold it for 100 gs.[35]

Remarkably, only a year after Hamilton had been forced by debt to sell the entire collection he had brought back from Italy, he was spending again, money he could little afford, on a painting he had been forced to sell nearly forty years previously.[36]

Hamilton's collecting and patronage in Naples, 1764–99

When Hamilton left for Italy in his mid-thirties, he took with him a reputation as a collector of paintings and of small objects of virtu (bronzes and terracottas) which had proved him to be a connoisseur of undisputed taste, and even passion (he had more than once permitted his desire to own certain works to outstrip his immediate resources). Having lost all once, in Italy Hamilton always attempted to ensure that the means to pay for his latest acquisitions were within reasonable grasp, and his correspondence is full of schemes for funding his collecting. He has often been labelled a dealer, frequently buying with another purchaser in sight. In fact, Hamilton seldom purchased for profit alone: for most of his career the antiquities that he sold had been purchased less to make a profit than to secure important works for British collections, and he only sold to private British collectors when he failed to interest a public collection. A careful reading of his letters indicates that his profit margin was nominal, with prices calculated to ensure only that he could recoup what he had laid out. His constant argument was that the item should be acquired for the good of the nation.

This was made clear in 1776 when he was attempting to sell the large marble krater now known as the 'Warwick Vase' to the British Museum (cat. no. 128). He wrote to Charles Greville that no one could believe he was acting disinterestedly – he had the collection at the Museum at heart and couldn't afford to lose what he had paid, but

> I should rather give to that collection than let it go elsewhere for twice the sum. … The presents I have made, & have further to make to the Museum since my return here [in 1773], have I am sure, cost me near £300, tho the old dons do

not so much as thank me when I send a work of art. They are delighted with a spider or a shell, & send me many thanks for such presents. I do not care, it is the honour of the Hamiltonian collection that spurs me on.[37]

Although Hamilton has frequently been labelled a 'diplomat-dealer', there appears, in the letters published by Morrison, only one instance of his shipping a number of paintings back to England for sale. Even so, these included important works he had purchased for his nephew and himself for their own collections, and the instructions he gave to Charles Greville indicated that he should sell only 'my Velasquez & some of the middling bits that I bought cheap here & will sell well'. At the time the Civil List was frozen (see p. 32), and having financed the publication of the *Campi Phlegraei* himself for over £1,300, Hamilton needed money to pay Fabris for his drawings and prints (cat. no. 43).[38] Apart from these instances, there is no indication that he purchased old master paintings or copies in quantity for shipment and sale back in Britain. Although he advised others, and was frequently involved in shipping their purchases home and commissioning works from local artists on their behalf, there do not appear to be any incidents where he purchased for them and profited by it.[39] When Hamilton purchased significant old master paintings, they were for his collection in the Palazzo Sessa or for his nephew to retain for him in London until his return. When he made his most important early purchases of old masters he did not believe he would be remaining in Naples for more than five or ten years.[40]

Hamilton's collection of paintings reflected his character as a man of taste and a connoisseur, and after leaving England he tried to maintain this reputation by ensuring that his name was publicly associated with the paintings and antiquities he sent back. He insisted, for instance, that the British Museum call the items acquired in 1772 'the Hamiltonian Collection' and advised them on their display and cataloguing. He advertised the imminent arrival of choice works by first informing Walpole – a certain means of spreading information to the *cognoscenti* – and by placing them on display in Lord Cowper's house, where Walpole was one of the first visitors.[41] Another method of ensuring that his connoisseurship and taste remained recognised during his absence from England was through gifts: Hamilton enriched Walpole's collection at Strawberry Hill with presents, which Hamilton knew would be seen by large numbers of visitors to the house and published in Walpole's catalogue of the collection;[42] the additions to Walpole's collection continued through the 1770s after Hamilton's return to Naples. In 1768 Hamilton presented George III and Queen Charlotte with a pair of paintings by Fabris (see cat. no. 148; figs 8–9). He made a number of small gifts of medals and antique rings to various

people, including one to Lord Mountstuart.[43] Other gifts were to public institutions and advertised him as a patron of the arts: his gifts to the British Museum continued regularly until the end of his life (mostly discussed elsewhere in this catalogue, and listed on p. 305) and included a painting of Vesuvius, unfortunately now untraceable.[44] Dr William Hunter was attempting to establish a medical school in London when Hamilton sent him a volume of anatomical drawings by Pietro da Cortona which had been presented to him in Naples,[45] and George III received an album of ancient maps and fortifications of Naples (now British Library).

He also regularly sent gifts to the newly founded Royal Academy. Reynolds had written to Hamilton in 1769, informing him of the foundation and enclosing a plan; he appended a request that Hamilton inform the King of Naples, in the hopes that he might contribute a copy of the 'Antiquities of Herculaneum' (*Le Antichità di Ercolano*). In just over a year, Reynolds was thanking Hamilton for casts he had sent: 'The Basrelievo of Fiamingo I never saw before it is certainly a very fine group and the only thing of the kind that we have ... that, and the Apollo are ordered by his Majesty to be placed in Somerset House.'[46] The casts were followed by a bas-relief in 1771 (an original sculpture, not a cast), Piranesi's prints of the Warwick Vase (cat. no. 128) in 1775, and a cast from an antique bas-relief given only weeks before Hamilton's death in 1803.[47] In December 1787 he had written to George Cumberland about an idea of Charles Greville's (which eventually came to nothing) of forming 'a collection of Casts from the best Bas-Relievos':

> [it would enlarge] the confined ideas of our artists ... We have no want of lovers of the Arts in England & there are many who would generously subscribe for the advancement thereof, but of true Connoisseurs I know but few & when I have named Townley, Mr Lock & Charles Greville I know not where to look ... [the Dilettanti might subscribe to the scheme] as they have a large fund and know not how to use it ... but unhappily few of the members of that Society are men of true taste.[48]

There are other instances in his correspondence of his lack of faith in the state of British connoisseurship and taste for painting (see cat. no. 176).

It is impossible to state for certain which of the paintings collected by Hamilton during his thirty-six years in Naples decorated which villas. They undoubtedly moved frequently, but we can assume that the main collection, hung for his most important visitors to see, was displayed at the Palazzo Sessa. Our information about what it contained just before Hamilton was forced to pack the paintings and leave Naples in 1798 is extensive. Hamilton himself made a 'Catalogue of my

pictures July 14th 1798', a manuscript list of the paintings, room by room (now in the British Library[49] and used by Fothergill to give a 'tour' of the collection in which he mentioned the works which sounded most important).[50] Carlo Knight has recently located a few of these works and reproduced the room plans he has discovered of the various floors of the Palazzo Sessa.[51] Unfortunately, it is still difficult to distinguish which rooms correspond with those on Hamilton's list, although Flora Fraser has suggested a possible layout in a vivid description of the apartments and decorations of the rooms in her recent biography of Emma.[52]

During 1994–5, using annotated copies of the catalogues of the two Hamilton sales of 1801, the sale with Nelson's effects in 1809, Greville's sale of 1810 and that of Edward Coxe of 23–5 April 1807,[53] and with the valuable assistance of several colleagues and the Getty Provenance Index,[54] the present locations of the following old masters from Hamilton's collection have been established: *Democritus Contem-*

(LEFT) FIG. 40 Peter Paul Rubens, *The Conversion of St Paul*. Oil on panel, *c.* 1618–20. Oxford, Visitors of the Ashmolean Museum.

(LEFT) FIG. 41 David Teniers the Younger and François Ryckhals, *Shepherds with their Flocks*. Oil on panel, 1640. Toledo, Ohio, Toledo Museum of Art, Gift of Edward Drummond Libbey.

(RIGHT) FIG. 42 Hamilton's 'Correggio', *Venus Disarming Cupid*, now attributed to Luca Cambiaso. Oil on canvas (cat. no. 176).

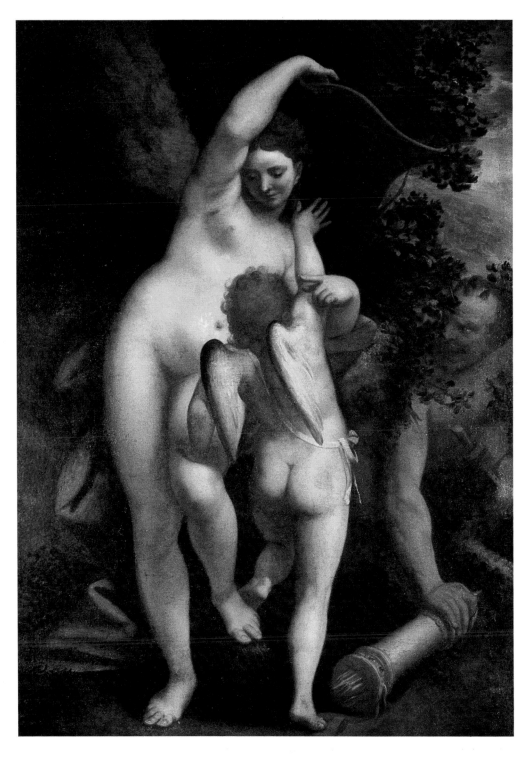

plating Mortality by Salvator Rosa (or an almost contemporary copy, private collection on loan to the Metropolitan Museum, New York; fig. 102); the *Conversion of St Paul* by Rubens (oil sketch on panel, Ashmolean Museum, Oxford; fig. 40); *Head of a Young Woman*, once attributed to Rubens and now to a follower (oil sketch on panel, Barber Institute of Fine Arts, Birmingham); *Shepherds with their Flocks* by David Teniers the Younger and François Ryckhals (Toledo Museum of Art; fig. 41); *Portrait of a Young Nobleman*, called a member of the Barberini family and attributed to Titian by Hamilton, now attributed to William Key (Los Angeles County Museum of Art; fig. 43); and a drawing of *The Prodi-*

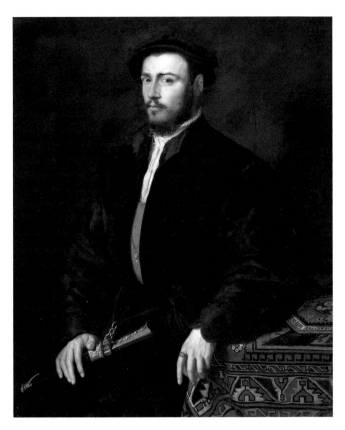

FIG. 43 Attributed to Willem Key (c. 1520–68), *Portrait of a Young Nobleman.* Oil on canvas. Los Angeles County Museum of Art, Gift of Paul Rodman Mabury.

gal Son in his Pride by Guercino (private collection). The only major parts of Hamilton's collection which remain unknown to us are his smaller watercolours and prints.[55]

It is often possible, through Hamilton's own notes in the 1801 sale catalogue and through his correspondence published by Morrison as well as some unpublished letters, to trace the sources of Hamilton's old masters. He purchased his Correggio (now attributed to Luca Cambiaso) and Rosa from the Duke of Laurenzano's collection, apparently through the agency of Cesare Gaetano, Conte della Torre. Reynolds wrote recommending a Veronese he had seen in the Francavilla collection, which Hamilton was unable to purchase although he did acquire a *Holy Family* by Bartolomeo Schedoni from this collection. Hamilton seems to have visited the Baranello collection in Naples along with Charles Greville during his nephew's visit to Naples in 1769, and five years later he began negotiating with the family to purchase a number of works, which included the Velázquez for himself and a painting attributed to Annibale Carracci of *Children Tormenting a Cat* for Greville, both now in the Metropolitan Museum in New York. He purchased a number of paintings from other collections in Naples and Rome.[56]

By 1781, the Correggio and a number of works were still with Greville in London, and with diplomatic duties, hunting with the King of Naples and his interest in volcanoes taking up more of his time, Hamilton appears to have stopped actively purchasing. Greville was worried: 'Surely you cannot be dead to virtu; a few additions of good pictures (not furniture ones) & some fine drawings might be purchased by you without distressing yourself; one of these days you will repent your prudence', and a year later, 'you seem dead to that in which your eye & taste distinguish you eminently'.[57] When he returned to England in 1783 after his first wife's death, Hamilton was preparing to settle in Naples for the remainder of his diplomatic career and arranged for the Correggio and all the old masters which had been stored with Greville to be sent to him.[58]

Little more than a year after his return to Naples in 1784 two people arrived who were to alter the pattern of his patronage in the arts. The second of these is the better known: Emma Hart. She was Hamilton's living embodiment of ideal Greek beauty, the Galatea to his Pygmalion, whom he regarded with the eyes of a connoisseur and who became his own living work of art. Shortly after her arrival she complained '[he is] constantly by me looking in my face. I can't stir a hand, leg, or foot; but he is marking [it] as graceful and fine ... poor Sir William is never so happy as when he is pointing out my beautyies to [his friends] ... He does nothing all day but look at me and sigh.'[59] She had arrived by the end of April 1786 and by July there were already artists painting and sculpting her. A year later there were nine paintings of her in the house and two more had been commissioned (see cat. nos 162, 166–71).[60] Another arrival at about the same time as Emma was John Graefer, the gardener sent at Hamilton's request by Joseph Banks to supervise the installation of an 'English Garden' in the palace grounds at Caserta. Hamilton's role in the planning, laying out and creation of this garden has been discussed elsewhere (pp. 17–22; cat. nos 182–4); it is mentioned here, however, as one of the distractions which – in addition to Emma, increased duties at court and the newly discovered Greek vases which were to form his second collection – seriously curtailed his collecting of old masters during the later 1780s.

By the early 1790s Hamilton's debts with his bankers back in London were higher than ever, due to lack of income from the Welsh estate, the cost of a new apartment in the Palazzo Sessa and the increasing numbers of royal and other British visitors requiring entertainment. His debts were aggravated by the cost of the new collection of vases and their publication, where his object was principally, as it always had been, 'to assist & promote the Arts'.[61] In 1794 and 1795, however, Hamilton acquired a group of Flemish paintings from the

London dealer Benjamin Vandergucht and then from his widow. It is not clear whether these were purchased or taken in part exchange for the Correggio which Vandergucht had finally taken off Hamilton's hands (see pp. 278–80). Nevertheless, the paintings were selected for him by Charles Greville and Hamilton's purpose in acquiring these particular works is enlightening:

> The pictures arrived safe and are already placed, and make a great noise at Naples, where never were there such Flemish pictures. I am obliged to you for insisting on the Berghem & Teniers being very excellent pictures of the Masters; the Vandyke is a sublime picture, and the Jordans will perhaps be of more use in improving the Neapolitan school in point of colouring than most Flemish pictures that cou'd have been sent.[62]

This brief flutter of acquisitions of old masters in 1795 continued when Sir William purchased a Giorgione from Gavin Hamilton, as well as a portrait said to be by Titian of a man connected with the Barberini family (fig. 43), 'as much superior to all modern portraits as a diamond is to a Bristol stone', which he found in Naples from a Spanish collection.[63] From then on Hamilton's diplomatic duties in preparation for war precluded the purchase of any further paintings. As William Buchanan was to explain later, in the 1790s when William Young Ottley, Alexander Day, Guy Head and the Earl-Bishop were free to profit from the rush by private families all over Italy to liquidate their assets and sell their most treasured works, Hamilton was busier and poorer than at any time in his life.

It is important to note also that during most of his period in Naples Hamilton was commissioning copies of his own collection (he had the Correggio copied several times) and at least twenty copies of well-known works in churches and in private and royal collections in Naples – particularly the famous Farnese collection belonging to the king and housed at Capodimonte, generally one of the first sites on the itinerary of British visitors to the city. For this he employed a succession of local artists, including Francesco Saverio Candido, Paolino Girgenti, Giuseppe Pesci, and later James Clark, who also acted as a *cicerone* for Grand Tourists and as Hamilton's agent.[64] In the 1790s Clark dealt in Greek vases from South Italian tombs, marketing them carefully and selling them in quantity as decorative adjuncts to fashionable interiors. When he died in Naples in December 1799, he left an estate worth £8,000, much of which was bequeathed to his former customers and patrons. It included a substantial number of vases (fifteen went to Hamilton) and copies of famous paintings still in his hands (two to Hamilton).[65]

In his roles both as a diplomat and as a connoisseur, Hamilton made his collection freely available to visitors. There are numerous accounts of Hamilton's painting collection in the Palazzo Sessa, but apart from Charles Burney's of 1770, which discussed all aspects of the collection, not just the paintings, most date from a later period. Burney's and Lord Gardenstone's accounts are well known and reprinted by Fothergill.[66] The painter Wilhelm Tischbein's account, though less well known, is one of the most extensive: in Hamilton he felt he had a great patron and friend and regarded him as the greatest connoisseur in Naples, a '*Weltman*'. Of Hamilton's old masters he remarked upon his *Venus and Cupid* 'by Campagnola' and Leonardo's *Laughing Boy* (now attributed to Bernardino Luini; cat. no. 178), and described the busts of two philosophers, Democritus and Heraclitus, the one laughing at the world and the other weeping for it. These adorned the staircase in the Palazzo Sessa, on either side of a painting by Rosa (Hamilton called it a Giordano), which satirised his fellow countrymen as imitators, talkative asses and cuckolds.[67] A few years after Tischbein first saw Hamilton's collection, it was visited by the Conte della Torre Rezzonico. He too mentioned the Correggio, but noted it had been restored several times and that Mengs thought it was actually by Luca Cambiaso. He felt, however, that the Leonardo *Laughing Boy* deserved greater praise, and identified the toy the boy was holding. Among Hamilton's many paintings he retained a 'vivid recollection' of the following:

> A painting by Giordano depicting a man playing the colascione [a long-necked lute], wearing a vast Spanish-style hat . . .
> A 'metis' or moor by Velasquez; only nature could be more palpable and true; the skin is clear and *ontuoso*; the eyes sparkle; only speech is missing. It is painted with strong masterly strokes which produce an admirable effect from a distance.
> A portrait of the young Charles with a dog, by the same . . . a fine painting by Salvator Rosa known by the engravings he himself published. [It is] of the philosopher, the laughing Democritus . . . [see cat. no. 180]. Some paintings by Titian, a Lucrezia by Guido Cagnacci and other fine paintings and drawings brought me much pleasure.[68]

The grand rooms on the *piano nobile* of the Palazzo Sessa shown to most visitors were intended to reflect Hamilton the connoisseur and patron. The two galleries contained the finest of the old masters and copies of others, along with the Flemish paintings Hamilton had purchased in the mid 1790s. The rooms just before and after them contained the usual landscapes by Antonio Joli, Pietro Antoniani (cat. nos 5–6), Canaletto, Francesco Zuccarelli and Louis Ducros (the watercolours by G. B. Lusieri had apparently been sent straight to England), along with other old masters and portraits of artists and friends, such as the copy of Pompeo Batoni's portrait of the Duke of Brunswick (fig. 21). Draw-

FIG. 44 Giovanni Benedetto Castiglione, *A Procession of Shepherds*. Brush drawing in red-brown paint on paper (cat. no. 175).

ing rooms were scattered with sketches and views of Vesuvius and portraits of the British royal family. Throughout the Palazzo, copies were mixed with original old masters, British with French and German contemporary artists' works, and prints mixed with drawings and works in oil. The library was notable for containing the few old master drawings Hamilton owned, such as his lovely works by Guercino and Castiglione (see cat. no. 175), sketches of Emma, including the charcoal one removed from a door of the villa at Posillipo (cat. no. 169) and three by Tischbein for his painting *Orestes and Iphigenia*,[69] and Flaxman's terracotta self-portrait (now Victoria and Albert Museum). Also in the library were a large number of sketches in oil, including the sketch of Christ by Mengs for the altar of All Souls Chapel at Oxford (cat. no. 174) and a number which Hamilton believed to be the preparatory works for larger important paintings by old

masters, at least one of which most certainly was – the Rubens sketch for *The Conversion of St Paul* (fig. 40; now Ashmolean). Apart from the portraits of Emma, Hamilton's oil sketches, of which there were many scattered throughout the rooms of the Palazzo Sessa, were the most distinctive aspect of his collection.

A special mark of favour for visitors was to be taken up into the private apartments on the upper floor of the Palazzo in order to see the view so beautifully conveyed in the painting Hamilton commissioned from Lusieri (cat. no. 4). This was taken from the famous semicircular balcony room, the back of which was lined with mirrors. Tischbein's description of the room is the most complete, but as an intimate of Hamilton he was also familiar with the envoy's most private room, and has left a description of it recently translated into English by John Gage and worth reprinting here:

I have never seen a more pleasant room (*Kabinett*) than the one where [Hamilton] lived and slept. The paintings on the walls were of little importance, but they all had a meaning and

content that he enjoyed, and recalled things to his mind in the most pleasant way. Thus there was among them a pen-drawing scribbled by a lady-friend who had shown her children in a nice group as they tumbled about together on the ground. Many people would not have kept this sort of drawing, but [Hamilton] respected it for the naive way in which the figures were caught, and which a painter concerned with the rules of art would never have been lucky enough to capture. Everything here was hung higgledy-piggledy, without rhyme or reason: the various eruptions of Vesuvius and the other volcanoes on the Lipari Islands; next to these a small picture by Heinrich Roos, *A Shepherd family sitting quietly and contentedly with a few sheep*; then a well-known warlike Pasha; next to him a medal with the head of a great scholar and flanking him a miniature of a famous beauty. The whole arrangement seemed chaotic, but, looked at in the right way, it revealed the sensibility of the man who was at home in this Cabinet, and who had assembled these various objects with discrimination and taste.[70]

The lady's drawing which indicated so much to Tischbein was by an old friend of Hamilton, Lady Diana Beauclerk, and had been sent to him in 1782 by the son of another old friend, the Earl of Pembroke. Two years earlier he had sent a Bartolozzi engraving after Lady Diana's drawing of her two daughters; thanking him, Hamilton wrote 'I always thought Lady Di. had more true taste than any creature living and I defy any artist in Europe to compose two figures with more grace and elegant simplicity than these two delightfull little girls. Do kiss the hand that produced them ... and tell her Ladyship that I can never cease being her admirer, as I was long before you was born.'[71] Horace Walpole believed her to be the finest amateur in Britain and decorated an entire room at Strawberry Hill with her drawings in 'soot-water' (brown wash).

Hamilton's cabinet was undoubtedly a private one, decorated floor to ceiling with an eclectic selection of works which each contained a very personal reference for him. There were numerous additional smaller, less public rooms in the Palazzo Sessa, each decorated with pictures of various eruptions of Vesuvius and small Dutch and Flemish works, as well as contemporary genre paintings of Neapolitan life by David Allan, Xavier Della Gatta and Pietro Fabris, whose name appears more often in the list of Hamilton's collection than that of any other artist (cat. nos 16, 43, 148–51). Some of these contemporary genre paintings were in oil, as were some of the larger views of Vesuvius, and these were hung in the more public rooms, while the gouache versions were placed in the smaller rooms. Hamilton's patronage of the mainly Italian artists who produced these works reflects the more 'scientific' side of his painting collection. The images

of Vesuvius documented particular eruptions, while the paintings depicting Neapolitan life were collected not only as charming images but as records of manners and morals, costumes and social customs that Hamilton and many of his contemporaries believed reflected those of antiquity (see pp. 241–51).

As the king's representative in Italy, Hamilton's patronage of British artists abroad was almost as much a national duty as entertaining British visitors to Naples. His patronage of them was, however, also born of his own aesthetic and scientific interests and his concern with keeping his reputation as a patron alive in Britain. This might account for his constant reference to Fabris as a British artist and his purchase from Thomas Jones of a large oil of the *Campi Flegrei*, which was sent back to England to be shown in the Royal Academy. Hamilton was assiduous in helping British artists, not only by commissioning and publicising their work (he permitted David Allan to send his portrait to the British Museum, where it introduced the artist to a wider public), and giving their names and studio addresses to foreign travellers, but also by lending assistance with their accommodation, financial and even health problems. Although on his first visit to Rome Hamilton had commissioned his and his first wife's portraits from Mengs's pupil Anton von Maron, in Britain he was represented in portraits by the British artists David Allan, George Romney and Joshua Reynolds. Hamilton's promotion of British artists in Naples was most successful, however, in the portraits of Emma he commissioned in the 1780s, when he was buying few old masters. It was these portraits which attracted most of the comments on his collection in the public galleries of the Palazzo Sessa.

In 1783 when he first met Emma Hart, while she was still his nephew's mistress, Sir William had commissioned portraits of her as a bacchante from Reynolds and Romney which had both been shown publicly before being sent to Naples. They arrived around the same time as Emma herself, and were accompanied by two or three others commissioned by Greville which he had been unable to pay for and which Hamilton had taken off his hands (see cat. nos 166–8). Within months of Emma's arrival the Palazzo Sessa was filled with mainly British painters, sculptors and gem engravers who had come from their studios in Naples and Rome to capture her ideal Greek features, so that by the time the Conte della Torre di Rezzonico visited in 1789 his description of the main gallery went on from a mention of a Velázquez to:

> Various portraits of Madame Hart, the cavaliere's lover, and
> worthy of being the new Campaspe, a canon of beauty for
> those English Apelles Romney, Reynolds, Hamilton the
> painter, Hamilton the pastel painter – all competed to paint her
> in various guises, all beautiful, now draped on a sofa with book

in hand, now in a thoughtful pose under the shade of a tree, and now half undressed, pulling a goat and preceded by a dog; in this guise she smiles and displays a certain wantonness which makes her resemble an antique Bacchante. Romney who had painted her this way seems to have excelled all his fellow artists.[72]

Although Hamilton had visited James Barry in his studio in Rome in 1768 and passed on complimentary comments about his history painting of *Adam and Eve* then in progress,[73] apart from the Gavin Hamilton paintings of *Painting and Poetry* (cat. no. 172), Hamilton does not ever seem to have commissioned a history painting from a British artist. This was a serious omission in his support of the arts in Britain, but one possibly excused by his distance from the arguments raging there, and certainly a 'fault' shared by most of his contemporaries. Patrons of Gavin Hamilton such as Sir James Grant and the Duke of Hamilton, and others such as the Earl-Bishop were unusual in their commissions for large history paintings. Like William Hamilton, most British patrons relied on their old master paintings for historical subjects and contented themselves mainly with commissioning portraits and the occasional allegory from contemporary British artists. Hamilton attended Royal Academy dinners when he was home on leave and managed to see a number of the annual exhibitions; one of them, in 1784, contained paintings by Reynolds and Jones commissioned by him.[74]

But Hamilton did not restrict his patronage of contemporary artists to the British. He had admired contemporary Italian artists since his early ownership of a *Venus* by Mengs (sold with his first collection) and his 1768 commission for a large double portrait with his first wife by Mengs's pupil Anton von Maron.[75] He also owned one of the copies of Mengs's *Self-Portrait*, and accounts exist for copies and paintings by local artists such as Antonio Joli, Nicola Passieri, Giuseppe Pesci, Gabriele Ricciardelli, Pierre-Jacques Volaire and Antonio Pascucci.[76] G. B. Lusieri's reputation abroad was boosted by Hamilton sending his large views to London, and he benefited enormously from Hamilton's recommendation of him to Lord Elgin (see cat. no. 4). Italian printmaking in particular was given a great push by Hamilton's most active involvement; he may have been responsible for Ferdinand IV sending Mariano Bovi to England to study printmaking under Francesco Bartolozzi. Hamilton's other involvements with Italian printers are hinted at by the prints made by the Morghens and Bovi from paintings in his collection (cat. nos 171–2, 177, 179), the aquatints after Fabris by Paul Sandby and Archibald Robertson (cat. nos 17, 18, 149), Fabris's own etchings of Neapolitan 'Cries' (cat. no. 150), and of course in the publications of Hamilton's vase collections (see cat. nos 28–36, 62).[77]

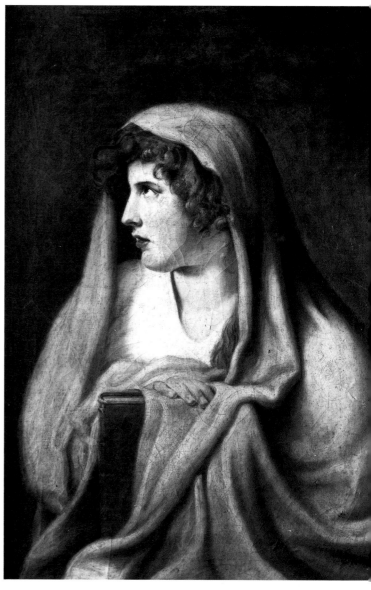

FIG. 45 Wilhelm Tischbein, *Emma as a Sibyl*. Oil on canvas, c. 1788. Weimar, Stiftung Weimarer Klassik.

The reputation of a number of other contemporary European artists, from Elisabeth Vigée-Le Brun (cat. no. 70) to Angelica Kauffman (cat. no. 171) and Louis Ducros (cat. no. 181), benefited a great deal from the works Hamilton commissioned from them and placed on display in the Palazzo Sessa, but it was his relationship with German artists which was the most mutually rewarding. Of these, Tischbein's relationship with Hamilton was probably the closest, as is evident from his fond and familiar descriptions of Sir William and the Palazzo Sessa.[78] Emma was his model for a painting which illustrated his friend Goethe's play *Iphigenia in Tauris*, on which he was working while in Rome and Naples, and the collection of his drawings at Weimar contains many

sketches of Emma, in her 'attitudes', at a musical entertainment, and even weeping after failing to buy a captive from the Turks in the Bay of Naples.[79] The *Orestes and Iphigenia*, in which she was a model for all the figures, may have been commissioned by Hamilton; it is now in a private German collection, but Hamilton did hang drawings for this painting in his library. A portrait of *Emma as a Sibyl*, showing her in profile, holding a book, with her brown cashmere shawl draped over her head (fig. 45) is one of the most unusual and striking images of her. Emma was undoubtedly Tischbein's greatest muse, appearing in different forms during the remainder of his artistic career. The publication of Hamilton's second vase collection also provided Tischbein with a source of income, not only because he was paid to supervise the drawings and the publication, but also because for years afterwards he was able to sell decorative prints based on his illustrations (see pp. 55–7). Tischbein's knowledge of vase paintings and his interpretation of the antique even extended to painting his own scenes on antique vases.[80]

The inclusion in so many British country house collections of landscapes by the German artist and engraver Philipp Hackert no doubt owes as much to his own marketing abilities, for which he was famous, and to the presence of his paintings in a long series of public reception rooms at the palace at Caserta, as it does to Hamilton's recommendations. Nevertheless, Hamilton was one of his earliest patrons in Naples; on one of his first visits to the city with his brother Johann, Philipp Hackert painted views of the Campi Phlegraei. The English Garden at Caserta which Hamilton helped to create (see cat. no. 182) provided the inspiration for Hackert's late series of ideal 'English' landscapes, on which he based his theoretical writings on landscape and nature. Another treatise by Hackert, on the restoration of old masters and the history of varnishing in art, as well as its current uses and misuses, was published in the form of a letter dedicated to Hamilton.[81]

Hamilton's last sales and purchases, 1799–1803

When Hamilton was forced to flee Naples for Palermo in December 1798, he left behind three furnished villas. He took only two servants, instructing those left behind in the Palazzo Sessa to 'go on another month as if I was there, and we shall see what sort of respect the French will show me; certainly for 35 years I have been hospitable to many French travellers and perhaps they may not plunder my house.'[82] Events of the following year, however, were to shatter all his hopes: the Palazzo Sessa was occupied by a French marshal; a bomb had gone off in the new apartment; any remaining furniture was sold; some paintings had been stored with General Acton and were safe, but could not find buyers in

Naples in 1802; his servants who had hoped for his return were turned out with no hope of income; his debts with his banker in Naples mounted as payments were made to his servants, coachmaker and tailor on outstanding bills; and his outgoings for setting up and furnishing a new establishment when the court moved to Palermo had been crippling.[83] Finally, eight crates of vases from his second collection were lost on the *Colossus* off the Scilly Isles. Hamilton's collections of bronzes and cameos had been sold in the early 1790s, and the only thing he had left to sell in order to meet his present debts was the collection of paintings the faithful James Clark had managed to pack between October and December 1798. Clark was ill, but wrote on 22 December 1798 promising to superintend the packing of all the cases before he left Naples himself, even though he had not yet taken steps to secure his own property.[84]

In April 1799 Hamilton had reported to Greville that, through the friendship of Nelson, the best vases were on the *Colossus* and the rest were with the paintings on a British transport in the harbour at Palermo.[85] The paintings reached England safely and were sold by Christie's in March and April 1801 at two sales which realised just over £5,700. Several paintings failed to reach their reserve prices and were bought in, and some reappeared in a sale at Christie's on 13–14 November later that year.[86] When Hamilton's will was proved in 1803, Greville was asked to comment on a number of points, including one which mentioned the bequest to Greville of 'All my old Pictures, according to a former agreement'. Greville explained there had been no signed agreement but when Greville had given up his house in Portman Square in 1784/5 and sent his uncle the paintings belonging to him, Hamilton had told him then and repeatedly that he would leave Greville 'all his Naples virtu & Pictures at his death. His distress obliged him on his return to England to sell all his collections and none but a few pictures bought in from want of purchasers at the sale remained.' In the end all that remained of the 'virtu & Pictures' promised to Greville were the few pictures bought in and '2 Pictures purchased since his sale'.[87]

One of these was Rubens's painting, by then titled *Loves of the Centaurs* (fig. 39), of which Farington recorded Hamilton's remarkable repurchase at a sale in May 1802 for 260 guineas. The other painting was a work then attributed to Titian, described as 'Chess Players'; even more surprising is the fact that Hamilton had purchased it for 210 guineas at the Earl of Bessborough's sale on 5–7 February 1801 (lot 79) the month before his own paintings were sold in March. Both paintings were indeed inherited by Greville and were included in the sale after his death in 1810, where they fetched around £640 and £88 respectively.[88] When Hamil-

ton purchased both of these paintings, he had not yet completely abandoned the hope that the government would reimburse him for his extraordinary expenses at Palermo and the losses he had suffered in his villas at Naples and on the *Colossus*. Nevertheless, they are clear evidence that he did indeed, to use Walpole's phrase, possess 'an insuperable taste for paintings' and had never been able to follow his banker's advice to curb his 'favourite passion of buying pictures'.

NOTES

1 *Wal. Corr.*, XXII, p. 243.

2 Ibid., pp. 260, 354n.

3 Envoys were expected to run their establishments (staff, accommodation, etc.) out of their salaries and could claim for extra extraordinary expenses only; repayments of these were difficult to achieve. Hamilton had managed to collect some of the money owed him on his few visits to London, but at his death believed the Government still owed him around £30,000 for his extra extraordinary expenses and losses during the last ten years of his post in Naples and Palermo. All claims, and his pension, only £1,200 per annum, ceased at his death (Fothergill, pp. 292–3).

4 Farington, *Diary*, IV, p. 1527, 24 March 1801.

5 W. Buchanan, *Memoirs of Painting*, II, London, 1824, pp. 73–4.

6 Conway had been supplying Walpole with information about Hamilton since the latter's early dalliance with Lady Diana Spencer (later Beauclerk) in 1757. In May 1758, a few months after their marriage, William and Catherine Hamilton stayed with Conway at Park Place, which Hamilton was to visit nearly every time he returned to England (*Wal. Corr.*, XXXVII, p. 499, 527). Park Place had been sold by his parents, Lord and Lady Archibald Hamilton, around 1738 to Frederick, Prince of Wales, but the Hamilton family continued to live there, probably in another house on the estate until around 1752 or 1754 following the deaths of Lady and then Lord Hamilton (see C. Lloyd and M. Evans, *Royal Collection of Paintings from Windsor Castle*, National Museum of Wales, Cardiff, 1990, nos 53–4). Park Place was purchased by Conway in 1752 (*DNB*). In 1765 Hamilton was writing regularly to Conway in the latter's new capacity as Secretary of State for the south (*Wal. Corr.*, XL, p. 384), and Hamilton's relations with the Conway family were to continue when he welcomed Conway's daughter, the sculptress Anne Seymour Damer, for a long visit to the Palazzo Sessa in 1786 and rumours reached England of their possible marriage (Anson, p. 305).

7 Quoted from the *Gentleman's Magazine*, 1748, in A. MacGregor (ed.), *Sir Hans Sloane*, London, 1994, p. 35.

8 Plan of the Society transcribed in D. G. C. Allan, *William Shipley*, London, 1968, pp. 192–4.

9 Information from the archives of the Society concerning Hamilton's membership kindly conveyed by Susan Bennett, Librarian of the Royal Society of Arts. Stuart, described in the minutes as 'Painter and Architect', was to win an award later that year for designing the medal used for honorary awards (Allan, p. 75).

10 He would have been aware of the great successes of the Society's Drawing School during William Shipley's last years as its head before he handed over responsibility for teaching to Henry and William Pars late in 1761 (Allan, pp. 71–2, 85–7).

11 Graves and Cronin, IV, p. 1330.

12 *The Toledo Museum of Art European Paintings*, Pennsylvania, 1976, pp. 137–8, pl. 310. In 1784, when Hamilton was clearing a number of effects from the Welsh estate after his first wife's death, he brought the portrait and a family dinner service to London to give to his favourite niece, Mary Hamilton, who was soon to be married. Sir Joshua, who was a great friend of Mary Hamilton, learning she had been given it, offered to 'renovate it with lasting Colors' (Anson, pp. 265–70, reproduced opp. p. 252).

13 See Ramage, 1990b, *passim* and Young, pp. 58–61, 76–8.

14 He enclosed specimens, promising more, and indicating that the friar had no support for his work in Naples and would be willing to come to England should anyone wish to employ him. The Society's response in 1771 was grateful but not sufficiently encouraging to send for Friar Miriasi. The specimens took some time to arrive and the Society duly considered them, writing in December 1771 to thank Hamilton and indicating they would be glad to hear of any of the Padre's further experiments. I am once again grateful to Susan Bennett for searching the Society's archives for this information.

15 Lady Jane Hamilton's death was reported by Hamilton's friend and fellow officer James Wolfe; see B. Willson, *The Life and Letters of James Wolfe*, London, 1909, pp. 193–6.

16 The discussions of polite culture in the eighteenth century are many and various but the ones I found most useful were Pears, esp. pp. 22–50 for connections between taste, virtue and connoisseurship; and two essays in J. Barrell (ed.), *Painting and the Politics of Culture*, Oxford, 1992: S. Copley, 'The fine arts in eighteenth-century polite culture', pp. 13–38, for connections with fine art in general, and D. Solkin, 'ReWrighting Shaftesbury', pp. 73–100; equally helpful were two reviews of the latter book by J. Gage in *Oxford Art Journal*, XVI, pt 2, 1993, pp. 76–80, and A. Kidson, in *Burlington Magazine*, CXXXV, August 1993, p. 568.

17 Quoted in Pears, p. 37.

18 1719 edition, p. 216, cited in C. Gibson-Wood, 'Jonathan Richardson and the rationalisation of connoisseurship', *Art History*, Spring 1984, p. 49. This essay (pp. 36–56) is the most extensive and useful discussion of Richardson's 1719 discourses.

19 Pears, p. 194.

20 Morrison, no. 95: Portici, 12 September 1780.

21 *Anecdotes of Painting*, ed. F. W. Hilles and P. B. Daghlian, V, 1937, pp. 228–9.

22 F. Lugt (*Repertoire des Catalogues de Ventes 1600–1825*, 1938) had not seen the annotated versions of this sale catalogue in the British Library (c.131.h.4 (3,4)), recording only the anonymous copy in the Rijksprentenkabinet, so that Hamilton's name was not published in connection with this sale in his book and it has not previously been mentioned in published accounts of Hamilton's collection. The copy in the British Library had been seen by various art historians researching the provenance of Holbein's *Lady with a Squirrel*, but they had not been able to identify 'Mr William Hamilton' definitely with the later envoy to Naples. During the preparation of this exhibition, Francis Russell very kindly conveyed the information that the identity of William Hamilton with the envoy is established by correspondence he has found in the Bute papers, which he will publish in his forthcoming book *John, 3rd Earl of Bute, Patron and Collector*. Ulrike Ittershagen kindly informed me that the British Library now identifies the original owner of its

inscribed copies of the catalogues as Horace Walpole.

23 Research has only begun on this sale and the one of 1765 which can now be identified as William Hamilton's. These early collections and the sources of his acquisitions of old masters in London and in Italy will be discussed in a paper to be given by the present author at a colloquium on Hamilton at the British Museum in April 1996.

24 See Pears, p. 248, n. 9, and *Wal. Corr.*, XXI, pp. 198–9.

25 Christie's, 27 March 1801, lots 21, 72. For Schaub's *Sigismunda* by Furini, see Pears, pp. 124–5.

26 Watteaus, lots 66, 67, £30.9.0 and £18.18.0; Raphael, lot 50. In the 1801 sale it was on second day, lot 73, near the end of the sale, where it was claimed to be Raphael's original sketch for the composition in the Vatican.

27 P. Coxe, 23 April 1807, lot 72.

28 In 1792 it was only worth £1,200 per annum in income, see Morrison, no. 204.

29 Namier and Brooke, p. 572, where they note that he was unable to pay the extra £1,000 requested.

30 Morrison, no. 95.

31 Walpole in his *Anecdotes*, quoted p. 78 above, described him as 'groom of the bedchamber'. Fothergill (p. 36), who did not know the Walpole reference, was not certain of Hamilton's position in the king's household.

32 British Library, Add. MS 40,714, ff. 2–3.

33 British Library, Add. MS 41,197, f. 1, Charles Greville to Hamilton from Edinburgh, 1 April 1761: 'I did not much relish your pictures being turned out of Doors, before I read that you took the good ones into favour again.'

34 Redford, I, p. 323.

35 Farington, *Diary*, V, p. 1781.

36 In 1810 the Rubens was the main item in the sale after Charles Greville's death (Christie's, 31 March, lot 95), where it was purchased by the Duke of Hamilton for £640.10.0. He retained it until the Hamilton sale in 1888 when it was bought by 'Stewart' (probably an agent) for £2,100. It is probably identifiable with the work now in the Gulbenkian Collection in Lisbon which came from Lord Rosebery's collection.

37 Morrison, no. 61, pp. 43–4, 2 January 1776.

38 Morrison, no. 71, 12 March 1776: Hamilton was on his way to Britain shortly and, although he had intended to sell them when he arrived, the works listed in the letter to

Greville all appeared in his 1801 sale, so he either found them difficult to sell or decided to retain them.

39 For a list of people whom he advised on paintings and for whom he purchased on their behalf, see cat. no. 5. See Hamilton's remark in Morrison, no. 185, 21 September 1790, that he had laid out £4,000 for his new apartment and £2,000 for the new collection of vases, the sale of which should give him twice that in return 'but I am delicate as to the manner of selling, as I shou'd hate to be looked upon as a dealer, & some of my vases & bronzes are so extraordinary I shou'd wish them to be in England [he had found a buyer for the bronzes in Payne Knight]; my cameos & intaglios I shall probably soon dispose of, which I will do in order not to swell my account with Ross too much.' He was also publishing his vases, which he described as a 'treasury for artists', and the sale was mainly in order to finance the publication of them.

40 Baranello list, Morrison, no. 71: he sent home his Rosa, Velázquez and Correggio, which hung in Charles Greville's house in October 1780 (Morrison, no. 96). The works he purchased from the Baranello and Laurenzano collections during the early years in Naples will be discussed in my paper for the Hamilton colloquium, April 1996. It is worth noting here, however, that the works he sent home to London to await the end of his ministry at Naples decorated Greville's walls in Portman Square and were returned by him to his uncle when he was forced to give up the house in 1784 (British Library Add. MS 40,715, ff. 147–8).

41 *Wal. Corr.*, XXXV, p. 409, March 1771; XLII, p. 460, December 1771.

42 Among the items Hamilton sent to Horace Walpole for Strawberry Hill were: parts of a thirteenth-century mosaic shrine by Pietro Cavallini (sent 1768); a table made out of a fragment of a 'Gothic Saracen mosaic' from a church at Salerno and a marble bas-relief of Tasso's mistress (sent 1771); three 'gothic' shields (1774); and a tortoise-shell case studded with silver (1777). At this point Walpole wrote to Hamilton saying that 'Your name is in every page of my catalogue [of Strawberry Hill] . . . I do beg you will never give me anything more' (*Wal. Corr.*, XXXV, pp. 406–9, 420–21, 430–31). For a discussion of Walpole's collection at Strawberry Hill, see Wainwright, ch. 4.

43 Morrison, no. 9.

44 See cat. no. 44.

45 This was around 1772 and they were

bequeathed with the rest of Hunter's collection to the University of Glasgow in 1783. See M. Kemp, 'Dr Hunter on the Windsor Leonardos and Pietro da Cortona drawings', *Burlington Magazine*, XCVIII, March 1976, pp. 144–8: I am grateful to Antony Griffiths for this reference.

46 Hilles, pp. 20–27. The volumes of *Le Antichità* were published by the King of Naples as prestigious gifts and Hamilton received several similar requests. In 1766 he tried to persuade the king to publish them for sale (see p. 43).

47 RA Archives, 'Council Minutes', I, 72, 118, 206; III, 178. Charles Townley and Thomas Jenkins were the only other regular donors to the Academy during this period.

48 British Library, Add. MS 36,495, f. 267.

49 British Library, Add. MS 41,200, ff. 121–8. I am extremely grateful to Ulrike Ittershagen for a copy of her typed transcription.

50 Fothergill, pp. 297–9. He also published the Fitzwilliam manuscript by James Clark of the 'Catalogue of Pictures, Marbles, Bronzes &c. The Property of The Right Honble. Sir William Hamilton K.B.', a list of the contents of the cases packed under his direction in October to December of the same year (Fitzwilliam Museum, Percival Bequest MSS; Fothergill, pp. 427–42). This packing list and unmarked and partial catalogues of three Christie's sales of Hamilton's collection (on 27, 28 March and 17, 18 April 1801, and of Nelson's and the remainder of Hamilton's library and paintings of 6–8 June 1809) were the sources for O. E. Deutsch's summary article on Hamilton's 'Picture Gallery' in 1943, which listed 'only the more important items' and gave the current location of only one old master (*Burlington Magazine*, LXXXII, February 1943, pp. 36–41).

51 In 1985, Carlo Knight reprinted the entire July 1798 manuscript list, using modern names and incorporating the sizes from the Clark packing list and some of the additional information from the sale catalogues: see Knight, 1985, pp. 45–59; and Knight, 1993, p. 537.

52 *Beloved Emma*, 1986, pp. 80–84, based on the rooms in their present ruinous state, much altered since the eighteenth century.

53 I am very grateful to Dr Peter Schatborn of the Rijksmuseum for providing me with a copy of the Rijksbureau voor Kunsthistorisches Documentatie annotated copy of the Christie's sale of Hamilton's paintings on 27–8 March 1801. Jeremy Rex-

Parkes at Christie's kindly provided copies of their annotated versions of Hamilton's sale of 17–18 April 1801, as well as of the Hamilton-Nelson sale at Christie's, 8–10 June 1809, and Greville's sales at Christie's, 31 March and 4 April 1810. Edward Coxe purchased some of the most important works at the sales in 1801 and provided additional provenance for the works from information apparently given to him by Hamilton as well as extensive descriptions.

54 The assistance of Burton Fredericksen at the Getty Provenance Index and Elizabeth Powis who operated the new CD-ROM of the Index at the PMC was invaluable. Carol Blackett-Ord generously and patiently followed dozens of leads to the Witt Library and Christie's archives.

55 Since he was known to have had such close contact with artists such as Cozens and Pars, and since Charles Greville inherited a number of paintings directly, Greville might reasonably be assumed to have inherited one or two portfolios of smaller watercolours and drawings. Certainly there were works by these two artists and several others one might expect to find in Hamilton's collection in the sale after Greville's death of his 'Loose Prints and Drawings' at Christie's, 4 April 1810.

56 Research in progress; see n. 23.

57 Morrison, nos 100, 102.

58 See Morrison, no. 139, and letter from Charles Greville: British Library, Add. MS 40,715, ff. 147–8.

59 Morrison, no. 150.

60 Ibid., no. 152.

61 Ibid., no. 208.

62 Ibid., no. 247.

63 Ibid., nos 268, 115.

64 Clark wrote up the packing list (see n. 50). His date of birth was around 1745 and he died in 1799. He was sent to Rome by James Grant of Grant and other Scottish patrons. He studied in Rome from 1768 until he established himself in Naples two years later and began sending his patrons copies of old masters painted there. See Scottish Record Office, Seafield MSS GD 248/838 and GD 248/50/5, in which Abbé Grant wrote from Rome in 1773 that Clark was travelling to the Greek Islands with Dashwood and Winchelsea and Hugh Smith Barry. James Clark's remaining collection of vases (118) and bronzes (30) were sold at Christie's, 9 June 1802. For the use of 'Etruscan' vases in decorative schemes in British interiors, see Jenkins, 1988, pp. 454–5.

65 Scottish National Portrait Gallery files, a paper given by William Simpson of the *Inverness Courier*, January 1919.

66 Fothergill, pp. 114–16.

67 Schiller, pp. 100–101.

68 F. Mocchetti (ed.), *Opere del Cavaliere Carlo Castone Conte della Torre Rezzonico*, VII, Como, 1819, pp. 238–43.

69 *Iphigenie und Orest*, private collection; see Schulze, no. 304; it will also be discussed by Ulrike Ittershagen in her Ph.D. thesis on Lady Hamilton's Attitudes, for University of Bochum, Germany.

70 J. Gage, 'Letter', *Burlington Magazine*, CXXXV, November 1993, p. 766.

71 Morrison, no. 119, explains who had sent the drawing hanging in the cabinet. The previous year Lord Pembroke had written 'If you was to see six pieces of Ly Di's, from a story in Ossian, you would fall down & worship her more than ever' (Morrison, no. 99). Hamilton's letter thanking Pembroke's son, Lord George Herbert, is published in Herbert, 1950, p. 76.

72 Mocchetti, op. cit., pp. 241–2.

73 Morrison, no. 13. James Barry was writing to thank Hamilton for passing on his 'civil good natur'd things of my picture of Adam & Eve & my other little studies' to Lord Fitzwilliam and Mr Crofts, who passed them on to Barry's friend Edmund Burke in a conversation they had with him on their return: 'The satisfaction my friend had in hearing that anything of mine was honor'd with your favourable notice (whose character as a man of taste I find he is no stranger to) is a thing that very much affects my concerns, as I am supported during my stay abroad by that gentleman & another of the same name … Indeed, were it not for this single account my friends in England had of me, 'tis more than probable they must have imagined that I had done nothing & slept away my time here.'

74 He attended that Annual Dinner along with other important patrons of the arts, including Sir Watkin Williams Wynn, Sir George Beaumont, William Lock, Charles Burney, the Earl of Carlisle, Lord Palmerston and Charles Greville, many of whom were his close friends (newspaper excerpts, *Whitehall Evening News*, 4 April 1784, p. 2, Paul Mellon Centre cuttings). Also attended 1801, see Farington, *Diary*, IV, p. 1542.

75 In the spring of 1768, when this portrait was commissioned, Catherine Hamilton left the artist a dress to work from and Hamilton left a cameo he wished her to be shown wearing. Both were returned in September (Fitzwilliam Museum, Perceval MS N.5, Byres to Hamilton, 9 September 1763). The painting was included in James Clark's packing list but it was not in any of Hamilton's sales and its present whereabouts are unknown.

76 British Library, Add. MS 40,715, ff. 4, 6, 12, 58, 85, 89.

77 Little work has been done on Hamilton's relationship with printmakers, which would reward a particular study on its own.

78 There is a portrait attributed to Tischbein in the Goethe Wohnhaus Museum at Weimar which is said to depict Tischbein along with Hamilton and the philosopher C. P. Moritz.

79 See Oppel, pp. 44–7, and Mildenberger, pp. 43, 243.

80 One of the volute kraters painted by Tischbein is now in the Kunstsammlungen zu Weimar, Stiftung Weimarer Klassik, and the other was reproduced and discussed by D. Ahrens, 'Zwei Werke aus dem Tischbein-Umkreis', in D. Ahrens (ed.), *Räume der Geschichte: Deutsch-Römisches vom 18. bis 20. Jahrhundert*, Trier, 1986, pp. 56–60, fig. 11.

81 P. Hackert, *Lettere sull'Uso della Vernice nella Pittura*, Perugia, 1788; translated into German by 'F.L.R.' as *Ueber den Gebrauch des Firnis in der Mahlerey. Ein Sendschreiben des berühmten Landschaftmahlers Philipp Hackert, an den Ritter Hamilton, ehemaligen Grossbritannischen Gesandten in Neapel*, Dresden, 1800.

82 Morrison, no. 369.

83 British Library, Add. MS 41,200, ff. 214, 217.

84 Ibid., f. 149.

85 Morrison, nos 369, 381.

86 Fothergill, p. 401; I am once again grateful to Ulrike Ittershagen for obtaining a copy of this sale catalogue from Christie's archives and marking the items which had appeared in the earlier sales.

87 British Library, Add. MS 40,715, ff. 147–8.

88 An annotation of the copy of Greville's sale catalogue in the Paul Mellon Centre attributed the Titian to Jacopo Bassano. The work last surfaced attributed to Giovanni Battista Moroni in the Earl of Bessborough's sale in 1848, when an anonymous purchaser paid 200 guineas for this painting described as 'Two men seated at a table playing at chess – the apartment is decorated with rich hangings; and the table is covered with a Persian carpet'.

'Talking stones'
Hamilton's Collection
of Carved Gems

IAN JENKINS

Ancient semi-precious stones, carved either in intaglio or as cameos, were greatly prized in the eighteenth century. In the first instance the design is engraved into the surface; in the second it is raised in low relief. The fascination for collecting these miniature sculptures reached back through the Renaissance to Classical antiquity itself when, writing in the first century AD, Pliny described the *dactyliothecae* or cabinets of such illustrious Romans as Pompey the Great, Julius Caesar and Marcellus, nephew of the Emperor Augustus.[1] Indeed, Scaurus, stepson of the Republican dictator Sulla, is said to have been the first Roman to form such a cabinet, and was therefore founder of both the ancient and modern traditions.

Sir William Hamilton's vases have tended to overshadow the importance of his intaglios and cameos, and these have been little remarked upon hitherto.[2] They divide into two: those that came to the British Museum with the first collection of antiquities, and those from the second, which was rich in cameos and the major part of which was sold in 1791 to Sir Richard Worsley, British ambassador at Venice. Like many of the collections that came into the Museum early in its history, Sir William's first collection cannot now be reconstructed completely. Some of his objects have 'lost' their collection provenance and it is not always possible to trace them back to Hamilton, while those that are identifiable as his are scattered among several Museum departments. Invaluable in reconstructing Sir William's first gem collection, therefore, are the impressions made of them by James Tassie (1735–99), shortly after the collection entered the Museum. This enterprising Scot built up a healthy business selling portrait medallions to fashionable society and manufacturing casts after intaglios and cameos, which he supplied to collectors throughout Europe.[3]

In the eighteenth century serious gem collectors not only had originals in their cabinets, but also – for reference – impressions of gems in other collections. One very serious collector was Catherine the Great of Russia, who in 1781–2 ordered a complete set of Tassie's entire stock, which then stood at some 6,076 subjects.[4] By 1791, when the catalogue of Tassie's gem impressions was published, this had risen to over 15,000. The catalogue was compiled by Rudolph Erich Raspe, mineralogist and author of Baron Munchhausen's *Travels*. Its thoughtful introduction, clear descriptions and generous indexes, make this one of the great books of the eighteenth century. Used together with surviving sets of Tassie's casts, such as those in the Victoria and Albert Museum and in the Scottish National Portrait Gallery, it is still an indispensable tool of gem studies.

Among the many collections to which James Tassie gained access was that of the British Museum. Thinking it sufficient to give 'British Museum' as the provenance, Raspe does not tell us in whose collections the gems were before they entered the Museum. Since, moreover, his catalogue is largely unillustrated, we should be hard-pressed to distinguish Hamilton's first collection of gems from the other anonymous collections listed in it, if it were not for the existence in the Museum of two sets of eighteenth-century sulphur impressions, the documentary value and significance of which have not before been recognised (cat. no. 75). The physical appearance and method of framing these casts in gilt card indicate that they were almost certainly made by Tassie. When compared with Raspe's descriptions and the manuscript catalogue of Hamilton's collection drawn up by Baron d'Hancarville in 1778, they hold the key to the identity of Hamilton's gems. Further, because they are arranged in the order of d'Hancarville's unillustrated catalogue, they provide a pictorial illustration of the theories underlying his peculiar system of classification.

The first collection of antiquities assembled by Hamilton came to the British Museum in 1772; it contained a few cameos and a much larger number of intaglio sealstones. In the printed *Abstract* of the collection, under the heading 'Superstitious Gems', we find: '149 Amulets: chiefly scaraboei, and the greater part of them set in Gold. This collection as compleat as it is rare.'[5] Hamilton's gems are indeed 'rare', on account of the high proportion of stones formed as scarab beetles – including not only Etruscan examples, which he would have acquired direct from the tombs of southern Etruria, but also Egyptian and Near Eastern scarabs. Hamilton purchased his Egyptian scarabs *en bloc* from the Neapolitan collection of the Duca di Carafa Noia.[6] For a collection made in Italy, the Noia collection was unusual in containing so many Early Dynastic stones which are among the finest ever found. While Late Period scarabs were commonly imported into Italy by the Etruscans, Greeks and, later, the Romans, earlier examples of the Egyptian Bronze Age are rare. The high proportion of them in the Noia collection might suggest that they were acquired direct from Egypt, perhaps through contact with the Jesuit missionaries, whose connections with the Christian Copts enabled Cardinal Stephano Borgia (b.1731) to build up a considerable museum of Egyptian antiquities at Velletri.[7] In a letter to Charles Townley, dated 9 February 1788, the antiquities dealer James Byres wrote from Rome describing Borgia as 'a very worthy, liberal-minded man and has a great deal of knowledge'.[8] In other words, Borgia was a man Byres could do business with, and he was the probable source of a number of Egyptian antiquities in the Townley collection at a time when Townley was craving after them. This was all some years after Hamilton's important Egyptian scarabs entered the Museum (cat. nos 94–105), and it is indicative of the advantages of his diplomatic post in Italy that he was able to find pieces of high quality at a relatively early stage in the development of British interest in such things.

The same can be said of his Near Eastern sealstones, which are also striking for comprising both early and later pieces. One at least of these (cat. no. 93) was from the Noia collection but, for the rest, it is not known how Hamilton came by them. Jesuit missionaries to the lands of the Ancient Near East may have been involved here, as with the Egyptian antiquities,[9] but there is reason to suppose that they could also have been found far from their country of origin. In antiquity these small and portable objects were dispersed far and wide, and the Comte de Caylus published a pyramidal stamp seal which had been found at Braine between Soissons and Reims in northeast France.[10] Wherever they were found, it was known from the style of the carving and from the as yet undeciphered cuneiform scripts that these stones were from the 'Levant', and they were generally classified as Persian. In the first volume of his great work Caylus published two Near Eastern cylinder seals which, although found in Egypt, he nonetheless recognised as Persian.[11] Commonly called Persepolitan,[12] such relics of the civilisations of the Ancient Near East – at that time still little understood – were identified on the basis of comparison with the standing monuments of Persepolis, one of the great cities of the Achaemenid empire of Persia that flourished from the sixth to the fourth centuries BC until it was conquered by Alexander the Great in the 330s. Knowledge of the surviving monuments of Persepolis circulated in such publications as those of John Chardin's travels through Persia and India in the later seventeenth century, Cornelius de Bruin's *Voyage au Levant* (1725) and Carl Niebuhr's *Description de l'Arabie* (1773).

Winckelmann and the Stosch collection of intaglios

In its treatment of the past the eighteenth century was an age of 'universal' histories, and engraved sealstones drawn from all the known civilisations of the ancient world provided, like coins, a portable set of monuments that could be arranged into a material series representing the progress of man's history. The alternative approach was to concentrate upon subject-matter and to arrange sealstones by the type of image they carried. Most cataloguers sensibly opted for a combination of both systems. Thus in Raspe's catalogue, Tassie's impressions are arranged first in series – Egyptian, Persian, Indian, etc. – and then, for the great majority of Graeco-Roman gems, by subject. An important and influential publication, which was to provide a model for the way intaglios were classified in the later eighteenth century (there were no cameos in the collection) was Johann Joachim Winckelmann's account of the Stosch collection in Florence.[13] It was, more importantly for our purpose, the contemporary work most referred to in d'Hancarville's own writing on the subject of intaglios, and we must look at it first before tackling the more complex theorising of d'Hancarville.

Winckelmann's catalogue, which appeared in 1760, aimed both at an index to subjects and an analysis of style, and his concentrated study of this miniature glyptic art was a vital element in the growth of his ideas about the stylistic difference and relative development of Etruscan and Greek sculpture, a major theme of his *History of Ancient Art* published in 1764. The Stosch collection, much of it now in Berlin, was unusually comprehensive, comprising ancient sealstones and sulphur casts as well as modern pastes of original pieces in other collections, of which Baron Philipp von Stosch (1691–1757) had acquired casts during his travels throughout

Europe.[14] 'It represented', as Winckelmann explained, 'almost all Egyptian, Etruscan, Greek and Roman mythology, their principal uses, the representation of numerous memorable events of antiquity and the images of the most famous people.' He went on to explain the value of the collection for illustrating the 'birth, growth and different phases' of art: 'Certainly no other cabinet possesses so many stones of so early a period and of the first style of Etruscan and Greek art.'[15]

Compiled at the request of Stosch's heir Wilhelm Muzel-Stosch, Winckelmann's catalogue offered a model of how to arrange a cabinet in eight sections: first, the 'Egyptian' stones, or at least those that related to Egyptian religion, which he lumped together with a small number of 'Persian' stones; second, 'Sacred Mythology' or the history of Greek, Etruscan and Roman gods and everything having to do with their cults; third, what Winckelmann called 'Mythological History', comprising the legendary phase of Greek history including the Trojan War; fourth, the stones illustrating recorded history; fifth, the games, festivals and such sacred objects as rings occurring on gems; sixth, the representations of boats and other marine subjects; seventh, animals; and in the eighth class were the gnostic or magical gems of the Christian era, combined with a selection of modern pieces by the chief exponents of the modern, revivalist movement of gem-engraving, including Johann Lorenz Natter, Francesco Ghinghi, Carlo Costanzi and Marcus Tuscher. Such a collection provided an index of the ancient world in miniature.

In the course of compiling his catalogue Winckelmann secured a post in Rome as secretary to Cardinal Alessandro Albani, where he gained access to the Albani library and therein the so-called 'Paper Museum' of the seventeenth-century antiquary Cassiano dal Pozzo. Winckelmann remarks upon how valuable he found this encyclopaedia of drawings from all manner of antique objects, arranged by subject, in identifying and arranging the Stosch gems.[16] The most striking aspect of Winckelmann's catalogue is the claims he made regarding what he took to be the earliest gems in the collection. These were to have a great impact on d'Hancarville in drafting the extensive discussion of sealstones which he wove into the fabric of his publication of Hamilton's first vase collection. Winckelmann explained that the Stosch collection was remarkable for possessing what he took to be the oldest engraved stone in the world, a cornelian scarab carved with five of the heroes who feature in the legend of the Seven against Thebes.[17] This is now in Berlin and may be dated to c.500–480 BC.[18] Winckelmann rightly recognised the work as Etruscan, but thought the letters in which the names of the individual heroes were inscribed differed from the usual Etruscan forms and that the script was Pelasgic. The Pelas-

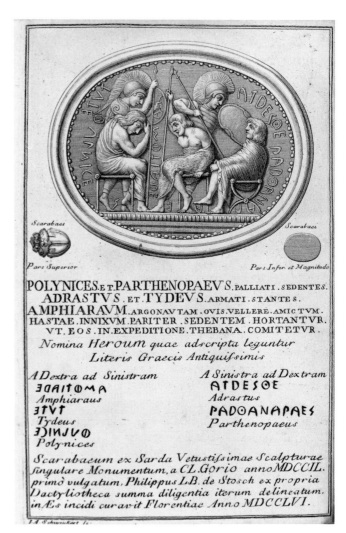

FIG. 46 'Five heroes' gem. Engraved by I. A. Schweickart, from Winckelmann's catalogue of the Stosch cabinet of intaglios.

gians were regarded in antiquity as the aboriginal people of Greece and were credited with the introduction of civilisation into Italy. Their language was regarded by many in the eighteenth century as the mother tongue of Etruscan and Greek.[19]

Antonio Francesco Gori had already published the gem as Etruscan, but the illustrative wood-engraving did not accurately reproduce the finish of the gem-cutting, nor did Gori include the letters.[20] When, therefore, the gem came into Stosch's possession, the collector had it engraved in copper by I. A. Schweickart (fig. 46). This engraving, dated 1756, was already in circulation when Winckelmann published his description. So important was the gem to him that it later reappeared as the title page of his *History of Ancient Art*. There Winckelmann revised his former opinion, calling the gem not *the* oldest, but one of the oldest.[21]

In spite of what he perceived to be deficiencies in the

FIG. 47 'Tydeus pulling a javelin from his leg' (in fact, an athlete scraping himself). Engraved by I. A. Schwieckart after a drawing by G. A. Nagel; reproduced from Winckelmann's catalogue of the Stosch collection.

anatomy. Not only is everything in its place, but the form is carefully studied so as to show the suffering of Tydeus in the effort of pulling out the javelin. This correct representation of nature had not yet arrived, however, at the *beau idéal*. Again Winckelmann makes an interesting comparison with the art of the Italian Renaissance: the Tydeus gem stands in the same relation to the art of the Greeks as the drawing of Michelangelo does to Raphael's. He makes a similar point in his *History*, where Michelangelo is presented as a 'descendant' of the Etruscans, sharing that same *outré* quality that is found in the Italian Mannerist painters, notably Daniele da Volterra and Pietro da Cortona.[26] That is not to suggest, explains Winckelmann, that the artistic character of the Tydeus gem is the product of an individual artistic personality; rather, the stiffness of the contours and the mannered feeling are attributable to the character of Etruscan art in general.[27]

Another gem in the Stosch collection was not engraved in Winckelmann's catalogue and so is less well known than the other two.[28] It is, however, no less important. Carved in chalcedony, the subject is the wounded Spartan hero Othryades bravely inscribing 'victory' into his shield as he and his companion each pull an arrow from their breast. This, also now in Berlin, has been dated to *c*.200–100 BC.[29] Winckelmann, however, having read in the ancient authors that Othryades lived around the time of Croesus, the Lydian, dated the gem to *c*.500 BC. The inscription, moreover, which has been read as four letters of Latin 'Victoria', he saw as Greek 'Nikai'.

For Winckelmann the Othryades gem became a paradigm of Greek, as opposed to Etruscan, art in the century preceding that in which Phidias was to bring sculpture to the sublime condition it reached in the 83rd Olympiad, that is, at the time of the building of the Parthenon, *c*.440 BC. As a historical subject, the execution of which he took to be contemporary with the actual *floruit* of Othryades, the gem provided a fixed point of chronological reference. He therefore placed the 'five heroes' scarab a little before it, and the more advanced Tydeus gem a little after. Alternatively, because everything the Etruscans did was seen as inferior to the Greek, the Tydeus gem could have been executed shortly after the time of Phidias.

D ' H a n c a r v i l l e

Sir William Hamilton's first collection contained numerous examples of the kinds of Etruscan scarab discussed by Winckelmann in his catalogue of the Stosch cabinet. And yet, although in his publication of Hamilton's vases d'Hancarville had much to say about gem-engraving, he did not mention Hamilton's own gems. The reason is twofold: first, by 1775 when d'Hancarville came to write the last two volumes of

drawing, Winckelmann thought the carving nonetheless accomplished, sure proof that it is possible to perfect the mechanics of art before arriving at the beauty of drawing. He made this an interesting point of comparison between the works of Raphael and of those painters who preceded him, continuing: 'this stone is, therefore, of all engraved stones, that which Homer is among the poets'.[22] The desire to find the visual equivalent of Homer among the art of the ancients and the comparison of the development of ancient art with that of Renaissance painting were both ideas that re-emerged in d'Hancarville's publication of Hamilton's vases.[23]

If the 'five heroes' gem represented the earliest Etruscan work of art, then another cornelian scarab in the Stosch collection (fig. 47) was the most beautiful.[24] Predictably for Winckelmann, this portrays a nude male athlete bent to one side and caught in the action of scraping his calf with a strigil. It, too, is now in Berlin and may be dated to 500–475 BC.[25] In Winckelmann's day the subject, with its inscription TYTE (now inexplicable), was taken for Tydeus pulling the javelin from his leg, his body taut with pain. Unlike the last, this stone – according to Winckelmann – shows knowledge of *la belle nature* and evinces a fuller understanding of human

his book, in which his main discussion of gem-engraving appears, he had already fled to Florence to escape his creditors in Naples, and Hamilton's first collection of gems had been purchased by the British Museum; second, his main aim in publishing a study of gems in *Antiquités Etrusques, Grecques et Romaines* (*AEGR*) did not arise so much from an interest in the objects themselves, as in a desire to promote his own theories about the prehistory of Greek art and, in so doing, to discredit Winckelmann and the Comte de Caylus. All the gems illustrated and discussed by d'Hancarville are therefore, as he himself explains, drawn from their publications (fig. 49).[30] Only in 1778, when d'Hancarville came to London, did he apply his theories of ancient art directly to the gems in Hamilton's first collection, during the compiling of his manuscript catalogue of it.

In *AEGR* d'Hancarville took the trouble to quote Winckelmann at great length on the 'five heroes', Tydeus and Othryades gems so as to argue against him point for point.[31] He recorded that he had actually examined the gems themselves when they were still owned by Stosch. He presumably did not know that Winckelmann had warned their owner to watch d'Hancarville's fingers.[32] According to d'Hancarville, Winckelmann had failed to realise the significance of the Pelasgian letters for the date of the gems, which on this and other considerations, including their style, d'Hancarville put much earlier.

The Comte de Caylus, to whom the third volume of *AEGR* is dedicated (fig. 48), also stands corrected for having suggested that the letters ΘΕΣΕ on a scarab in the collection of the antiquary Baron von Riedesel (1740–85), signifying the hero Theseus, are Etruscan and not Pelasgian.[33] D'Hancarville fails actually to explain how he came to distinguish the two scripts, and instead offers a parallel with the process of elimination employed by the infant Attius Navius (later a renowned augur in the time of Tarquinius Priscus), who divided and divided again the vintage to find the single best grape, which he had promised to dedicate to the gods in return for their having assisted him in locating his father's stray herd.[34] D'Hancarville was certainly familiar with the copious literature of his day in which Gori, Mazzocchi and others dissected the archaic inscriptions of ancient Italy, but, in spite of the claims he makes here and elsewhere in his book of being able to distinguish the Phoenician, Pelasgian, Cadmeian, Etruscan and Classical Greek scripts, the real basis of his argument is not so much epigraphic as historical.

Relying heavily upon the testimony of Dionysius of Halicarnassus, d'Hancarville explains that Pelasgian letters are named after Prince Pelasgus, the son of Niobe and Zeus. Pelasgus' grandson, Oenotrus, is credited with the Pelasgian migration to Italy. According to Dionysius of Halicarnassus,

FIG. 48 Dedication to Anne-Claude-Philippe de Thubières, Comte de Caylus (1692–1765), from volume III of *AEGR*.

seventeen generations – or 459 years at 27 years per generation – separate the birth of Oenotrus and the Trojan expedition.[35] Pelasgian letters will have begun, according to d'Hancarville, around 513 years (29 generations) before the taking of Troy (conventionally set at 1184 BC) and therefore, says d'Hancarville, blinding his audience with science, 3,472 years before his own time of writing, which we may compute to be the year 1775.[36]

Pelasgian letters, long disused by the period to which Winckelmann assigns the Stosch gems, were of much higher antiquity than that scholar had thought and were, according to d'Hancarville, contemporary with subjects carved on the gems. Startling though it seems, d'Hancarville simply accepted the mythological imagery of ancient Greece as literal history, and where Winckelmann had preferred to make separate categories of myth and history, he made no such distinction. The 'five heroes' gem, for example, was made 700 years before the time of Phidias, that is to say around 1140 BC when the descendants of the age of heroes in the previous century deified their ancestors and inscribed their

images upon sealstones.[37] Some engraved gems d'Hancarville thought earlier still. These included those carved in the aptly named *a globolo* style. Today this is seen as the decadent end of Etruscan gem-engraving in the fourth and third centuries BC, but d'Hancarville dated it to before the Trojan War. According to him, it was then that artists invented the device of using spherical shapes in order to articulate the respective elements of their subjects. In his theory of the evolution of figured art, this constituted an intermediate stage between the

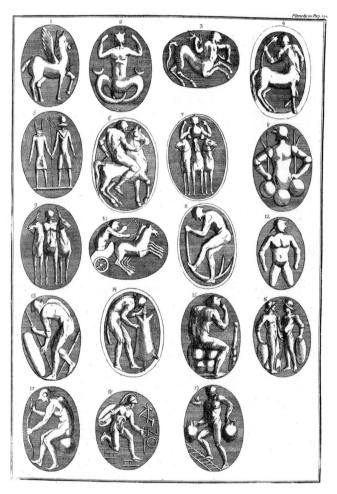

FIG. 49 'Gem engraving around the time of the Trojan War': engraved plate from volume III of *AEGR*. Many images are borrowed from Caylus's work.

earlier abstract tendency, whereby a 'sign' was employed to symbolise a form, rather than to portray it, and the later approach, which aimed at more naturalistic representation.[38]

D'Hancarville was not alone in thinking *crude* must equal *early*: Caylus thought so too and, in reworking his thoughts on the Stosch gems for the *History of Ancient Art*, Winckelmann devised a chronological scheme in which the stones he had previously called the oldest became works of the second,

rather than the first style, the earlier style being represented by the *a globolo* type.[39] We see how great, however, is the gap between Winckelmann's ideas of ancient art and those of d'Hancarville in the contrasting reasons which are given to explain the 'knobbly and globular' forms of the first style of Etruscan gem-engraving. Winckelmann adopted a purely mechanistic line whereby spherical forms were not so much an elementary principle of art as a primitive craftsman's coming to terms with the finer points of working with the lathe, while d'Hancarville sought an explanation in terms of his theory of signs.

Pierres parlantes

As with painted vases, d'Hancarville was greatly interested in the light engraved sealstones could shed upon the motivation for and meaning of man's earliest artistic endeavours. Central to his theories were the accounts given by Pausanias (writing in the second century AD) of the Greeks anciently having worshipped gods in the form of rough stones.[40] For d'Hancarville the origin of amuletic sealstones was to be found in the corresponding use of small, roughly shaped stones for private and domestic worship. These stood for the gods, under whose protection the wearer was placed.[41] Fossil shells had special significance, with the different deities corresponding to the variety of shapes and types.[42] The practice of adorning the body with 'portable gods', as he called them, gave rise to the use of amulets which, in turn, led to the wearing of jewellery. To prevent the wearer being wounded by sharp edges, the stones were shaped into cylinders, prisms or ovoids. Finger rings started off as stones hung around the neck as pendants;[43] suspension holes were subsequently enlarged for the finger to pass through.[44] In d'Hancarville's day, he remarked, jewellery had lost its sacred meaning, being valued more as luxury; in antiquity, it had represented an object of religion. He makes the surprising claim that jewellery was hardly ever regarded as luxury in antiquity.[45]

D'Hancarville's manuscript catalogue of the first Hamilton collection also offers some instances of the meaning of various objects themselves (as distinct from engraved designs). There was, for example, a yellowish pebble, touched with red, in the shape of a heart and pierced near the top for stringing around the neck. This, he suggests, was an example of the representation of a heart which, according to Clement of Alexandria, was put into a mystic *cista* during the festivals of Bacchus and Ceres at Eleusis, the heart in this instance standing for the god Bacchus.[46] Again, an ancient amethyst had in former times stood for the goddess Ceres (cat. no. 76).

In time, the wearing of symbolic stones or 'signs' was

partially replaced by figures, often represented on necklaces, bracelets or earrings: 'I have seen a great number of hair pins and earrings in gold, silver or ivory and even in bronze with representations of Cupid, Venus, Acratus, Bacchus ... but above all Harpocrates, the god of silence.' Suspended from the ears of women, the image of Harpocrates indicated that one must not repeat all that one knows, and that wisdom consists in listening and saying little.[47]

Sealstones in the form of a scarab beetle were a source of especial fascination for d'Hancarville. Without citing any ancient authority, he claimed that the scarab represented the most ancient of all the deities of antiquity, namely the earth goddess Cybele; if shown with wings, it signified the sun.[48] D'Hancarville recognised Hamilton's scarabs as among the earliest gems in the collection. Before the invention of engraving, such zoomorphic stones were used as 'signs'. Even older still were the shapeless but sanctified stones or 'Baetyles', the invention of which was attributed in antiquity by Sanchoniathon to Uranus. Sanchoniathon, according to d'Hancarville, called them *pierres parlantes* or *animées*, 'because superstition sometimes consulted them, just as the negroes of the coast of Guinea consult still their Manitous and the Lapons their Tambours'.[49]

D'Hancarville is here at his most obscure. Sanchoniathon is the early historian of Phoenicia, whose fragmentary text translated by Philon of Byblos is preserved in the first book of Eusebius' *Praeparatio Evangelica*.[50] He is now thought to be an ancient forgery, perhaps invented by Philon for nationalist reasons. In d'Hancarville's day Sanchoniathon was still believed in by many and widely used as a means for reconstructing the time chart of ancient history. He had a particular appeal among atheists like d'Hancarville, who found in him an alternative authority to the Holy Bible for the early history of the world. The relevant extracts of Eusebius were translated into English and published in 1720 by Richard Cumberland, Bishop of Peterborough (presumably not an atheist), with a commentary asserting the authenticity and historical implications of the work and attempting to reconcile it with the 'parallel' chronologies of Eratosthenes and the Old Testament.[51] D'Hancarville's particular interest is explained when we turn to the text of a work which appeared in 1768 and which he shamelessly plagiarised. This is the now little consulted *De l'Usage des Statues chez les Anciens* by the Abbé Octavian Guasco.[52] Here we read that Sanchoniathon, the Phoenician from Beyrut – of the time of Gideon or David – is the oldest of all historians.[53] Guasco was struck by a reference in the text to Uranus having dedicated Baetylia in Phoenicia, 'contriving stones that moved as having life', as Cumberland's translation of Sanchoniathon puts it.[54] Guasco, and subsequently d'Hancarville, seem to have taken this Uranus (normally the sky god of the Greek creation myth) for a historical person. His actions represented the proliferation of a practice, the origins of which could be traced further back still, to the lives of the Patriarchs, Abraham and Jacob.[55]

In the Book of Genesis (28:10 ff) we read of Jacob's journey from Beer-sheba to Haran and of the night he spent sleeping on the earth with a stone for a pillow. It was then that he dreamed of the ladder, 'set up on the earth, and the top of it reached to heaven: and behold the angels of God ascending and descending upon it'. The Lord spoke to Jacob in his dream and when he awoke, 'Jacob ... took the stone that he had put under his head, and set it up for a pillar, and poured oil upon the top of it and called the name of that place Beth-el', meaning 'house of god'. Guasco conjectured that the etymological origin of Sanchoniathon's Baetylia was the mysterious stone Jacob set up at Bethel.

Guasco goes on to explain that the setting up of such commemorative and other symbolic stones became common among ancient peoples. In due course the stones themselves took on divine identity.[56] He cites among other instances the example given by Pausanias, who saw thirty square stones revered as ancient gods. Nor was this practice restricted to the ancient world, and Guasco cites numerous instances of the 'same' phenomenon among the primitive aboriginal peoples of the contemporary world. 'One could ask', he says in the preface to his book, 'why in a work that has to do with ancient statues, I have often taken examples from the practices of the barbarians and savages of modern times; I would reply nothing could be more appropriate for a correct idea of the state of the arts, customs and usages of the ancients, as yet little civilised, than to point out the practice of peoples who in our own time still live in a state of barbarism.'[57] Anticipating by several generations the comparative social anthropology of the late nineteenth century, Guasco goes on, 'This should be a rule for antiquaries always to keep before their eyes, in order to judge intelligently the customs, usages and the monuments of earliest antiquity, because the same situation, the same needs, the same deficiencies in the arts produce the same ideas, the same opinions, the same practices, according to the climate ... There, I repeat, is the antiquarian philosophy, but how few antiquaries are philosophers!'[58]

At one stroke Guasco's particular brand of environmental determinism succeeded in linking the art and religion of the Greeks on the one hand with the primitive practices of their biblical predecessors, and on the other with the Stone Age cultures of contemporary primitive societies. His learned and metaphysical speculation upon the origins of art represented an approach which d'Hancarville found irresistible and, without acknowledging the source, made his own. Adhering to the Guasconian model, he located the invention of sealstone

engraving at the point when shapeless signs had given way to an idolatry of human form. According to Guasco, first the stars and productive nature were personified, and then the gods proliferated through the heroisation of mortals.[59] As we have seen, in d'Hancarville's version of this evolutionary system the deification of men happened around 1140 BC, following the fall of Troy in 1184, when the heroes of the preceding century were revered as gods and their images worn as amulets. The actual invention of the technique of engraving d'Hancarville placed before the Trojan War – some fifty or sixty years before, to be precise. It was then that Talus, nephew of the legendary proto-craftsman Daedalus, invented the 'lathe'.[60] D'Hancarville had forgotten that, although – according to Pliny – the invention of various tools was attributed to Daedalus, the lathe (Latin *tornus*) was said to have been invented by one Theodorus of Samos.[61]

The reason for asserting that gem-engraving was already known by the time of the Trojan War was argued on the basis of a single literary source (Pausanias, *Guide to Greece*, x.30.4), where we are told that in a painting by Polygnotus at Delphi, Iaseus is seen taking a gold ring mounted with a stone from the finger of Phocus, son of Aeacus and father of Peleus, and therefore grandfather of Achilles who fought in the Trojan War.[62] In attributing the invention of gem-engraving to the Greeks, d'Hancarville displays that tendency to assert the autochthony of Greek art which he had in common with Winckelmann. The Greeks, says d'Hancarville, owed their cultural origins and their religion to the Orient, but not their art.[63] There were others, however, who expressed different opinions, including d'Hancarville's phantom mentor, Guasco. He subscribed to the diffusionist principle, whereby culture was thought to have been dispersed from an original cradle of civilisation: 'As it is in Asia that the first inhabitants of the world appeared, the first polite societies, the first monarchies and the first religious systems, so it is in these countries also that one sees colonies detaching themselves and the first migration of peoples into countries near and far.'[64] Sculpture was, therefore, according to Guasco, more advanced at an earlier stage in Egypt and Phoenicia. The arts of figured carving were not born in Greece but imported by Phoenician colonists led by Inachus the Phoenician around 1880 BC.[65] Raspe had a different view again. Almost certainly with d'Hancarville in mind, he questioned the claim that the Greeks invented gem-engraving and rightly pointed out numerous instances in the biblical books of Genesis and Exodus of the wearing of signet rings by the Egyptians and the patriarchs who came into contact with them.[66] The origin of the technique of gem-engraving, however, he located outside Greece, Egypt or Mesopotamia. By the 1790s interest in the 'Hindoo' religion of India had become fashionable, not

least among the circle of leading British antiquaries including Charles Townley and Richard Payne Knight.[67] Raspe asserted the claim of India as the original home of civilisation. His reasons, however, are remarkably free of contemporary speculation about oriental mystic religions, being simply empirical: India is rich in the natural resources required for gem-cutting; real diamond, ruby, sapphire, emerald, cornelian and jasper all abound there. In India, therefore, the art was invented and from there it spread to Persia, where it was slow to develop, finding a more fertile field among the Egyptians and Phoenicians and their numerous colonies in Greece and Italy.[68] The earliest stones produced by the Greeks are dated to the years immediately following the time of Homer and are mostly engraved as scarabs, clear indication of Egyptian influence and of the fact that the art of gem-engraving was introduced into Greece from Egypt. That these scarabs were Greek, and not Etruscan as Winckelmann had claimed, Raspe was in no doubt.[69]

When, finally, in 1778 d'Hancarville came to catalogue Hamilton's gems, which had entered the British Museum in 1772, he was afforded the opportunity to present in tangible form his theory of the origins of amuletic stones and the priority of Greek gem-engraving over that of other ancient civilisations. The physical arrangement of Hamilton's gems, according to d'Hancarville's own ideas, is recorded in the casts Tassie made of them and that were arranged soon after d'Hancarville wrote his catalogue (see cat. no. 75).

Cameos

Hamilton parted with very few cameos at the sale of this first collection, which is not surprising given their relative scarcity and the high value that was placed upon them, antique cameos fetching much higher prices than those made later. Of one cameo (cat. no. 74), R. E. Raspe wrote, 'A fine engraving of the Cinquecento, which some greedy dealer has alleged to be a work of the second century'.[70] There seems to have been a higher proportion of cameos to intaglios in what we might call the second collection of gems. Many will have been acquired from James Byres, the principal purveyor of them in Rome, who supplied Hamilton with one of the greatest of all cameos, the celebrated Portland Vase (cat. no. 63).

With Hamilton's cameos, as with his intaglios, casts can be an invaluable source of information. Divided between the Departments of Greek and Roman, and Medieval and Later Antiquities in the British Museum is an unpublished group of casts of cameos in white glass made by James Tassie. Many are inscribed in a hand which may be that of the collector Charles Townley, with the name of the owner of the original and the price. Almost always the name given is Byres, and

these casts can be correlated with the descriptions given of the originals in Raspe's catalogue of Tassie's impressions.[71] Townley perhaps acquired the casts direct from Tassie and, after corresponding with Byres, inscribed them with the price. Sums of thirty and forty pounds are mentioned, which were relatively low in a trade where higher figures of five and six hundred pounds were not unknown. On the reverse of one cast of a cameo carved with a bacchic orgy (cat. no. 73) is written: 'cameo on a sardonyx bought by Lord Fortrose from Mr Byres for £500'.[72] Fortrose was a fun-loving friend of Sir William from the days when the former was the life and soul of the English colony at Naples.[73]

Sir Richard Worsley's 'Hamiltonian Collection' and the Museum Worsleyanum

As well as himself collecting, and helping his friends to buy and sell their collections, Sir William also profited from the trade in gems, selling his second collection to Sir Richard Worsley (1751–1805), who was for a time Hamilton's diplomatic counterpart at Venice. At the beginning of his final decade in Naples, Sir William found himself under financial pressure. As he confided to his nephew, Charles Greville, on 21 September 1790, he had just spent £4,000 fitting out a new suite of rooms in the Palazzo Sessa; he was spending £200 a year on keeping Emma and her mother in 'clothes and washing' and, apart from other sundry presents, 'she so longed for diamonds that, having an opportunity of a good bargain of single stones of a good water and tolerable size, I gave her at once £500 worth'. He continues:

> Besides the above-mentioned extraordinary expenses, I have surely laid out more than £2,000 in antiquities since I returned, but I have such a curious collection that must bring me back the double, but I am delicate as to the manner of selling, as I should hate to be looked upon as a dealer, and some of my vases and bronzes are so extraordinary I should wish them to be in England; my cameos and intaglios I shall probably soon dispose of which I will do in order not to swell my account with Ross [his banker] too much. A publication of 50 drawings from my new collection of vases will be ready in two months.[74]

This was written, as we are told, at the time Hamilton was putting the publication of his second collection of vases through the press. He was particularly in need of ready cash, therefore, and planned to recoup some of his losses by selling off parts of his collection. His bronzes went largely to Richard Payne Knight (cat. no. 126), while a number of his gems were sold to Worsley.

Hamilton spent the summer of 1791 in England with Emma, whom he married at the end of September, shortly before their return to Naples. Richard Worsley was himself resident in England at this time, and it is clear from his letters to Charles Townley that he received the gems from Sir William himself. On 2 September 1791, he wrote referring to a purchase of some antiquities Townley was planning, 'I wish to know what progress you have made with the lead mine. I hold Sir William's gems to be my coal mine. The more I examine them in detail, the more I am pleased with my purchase and with you for persuading me to make it.'[75] Worsley himself returned to Italy soon after this, taking with him his new purchases.

On 18 January 1794, Worsley wrote from Venice to compliment Sir William on the first volume of the publication of the second vase collection, which had just appeared.[76] Worsley was then putting together his own handsome folio publication entitled *Museum Worsleyanum*, with text – largely attributable to E. Q. Visconti (1751–1818) – in English and in Italian. It illustrated not only his own collection, amassed in Italy and during travels in Greece and Asia Minor, but also other antiquities including the sculptures of the Parthenon

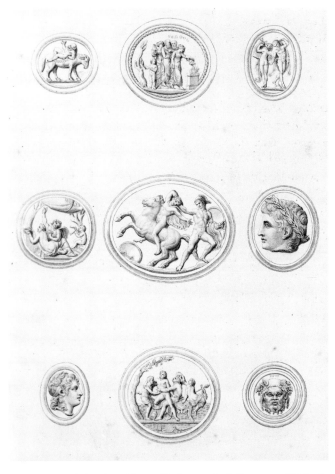

FIG. 50 Engraved plate from *Museum Worsleyanum*, including some of Richard Worsley's 'Hamiltonian' gems.

from drawings made earlier by William Pars. 'I hope', says Worsley, 'to have in the Spring the two volumes of my work here, I shall take the earliest and safest opportunity of transmitting it to you in Naples. I have printed 150 copies only and those are not to be disposed of [i.e. sold, as against given away]; without vanity I think it is the finest printed book I have yet seen.' It is to be wondered what Sir William, who had expended so much of his life and wealth in the production of fine printed books, made of such a boast.

Some of the 'Hamiltonian gems' would eventually be engraved in Worsley's book and a few words must, therefore, be said about it, and the confusion that surrounds its publication. This stems from the manner of its issue in fasicules, or as Worsley called them 'classes', which he presented to a select group of individuals and institutions, and which are confusingly also sometimes referred to as 'volumes'. The recipients are listed in the Worsley Papers together with letters of acknowledgement for separate instalments. The British Museum's Department of Greek and Roman Antiquities has Nathaniel Marchant's set, which is bound into two handsome volumes with title pages declaring the date of publication as 1794. As A. H. Smith pointed out, this is certainly misleading, but he was wrong to claim that the two volumes were issued in 1798 and 1802 respectively.[77] The letters of acknowledgement in the Worsley Papers, on which this assumption is based, refer to the receipt of 'classes', which only afterwards went together to make the two volumes.

In all there were six 'classes', three per volume. The process of publication can tentatively be reconstructed as follows. Following Sir Richard's letter to Hamilton of 1794, at least one class and probably two were published, hence Worsley's confusing reference to 'two volumes'. These were in circulation by 5 January 1796, when Townley wrote to Worsley notifying him that he had seen 'a copy' of *Museum Worsleyanum* in a bookseller's list for five guineas.[78] Townley was indignant on Worsley's behalf that one of those who had received a copy gratis had apparently sold it for profit. On 2 January 1798, Worsley wrote to Townley notifying him that the first volume of the book was finished and ready for presentation.[79] This may be taken to mean that the third 'class' was finished, which, in addition to the other two already existing, completed one volume. Sir William's copy was entrusted to Charles Greville, who wrote his letter of acknowledgement on 9 June 1798.[80] On 21 July that same year, Worsley wrote to Townley informing him that the gems were being engraved.[81] These were destined to form the content of the fourth 'class', but it seems there was some delay, since at the time when Sir William wrote his letter of thanks from Piccadilly on 6 February 1803, it was to express regret that none of his gems were yet engraved.[82] We can

only infer that what Sir William must have received on this occasion, therefore, was an advance set of proof plates of some other 'class'.[83] Sir William died a few weeks later and never lived to see his gems engraved, as they eventually were – and handsomely so – in the characteristic sepia ink of Worsley's book.

Gonzaga or Grimani?

A mystery surrounding Sir William's second collection of gems concerns Worsley's claim that at least two of them belonged to a group which originated from what he calls 'the Mantua collection', that is to say of the Gonzaga family. Chief among the group is a large cameo which Worsley bought from Roger Wilbraham (1743–1829)[84] and which became known as the 'Mantuan Gem' (fig. 51).[85] This fine large sardonyx is well known to art historians as having been copied in the sixteenth century for the subject of one of the tondo sculptures, attributed to the school of Donatello, forming the exterior decoration of the Medici Palace in

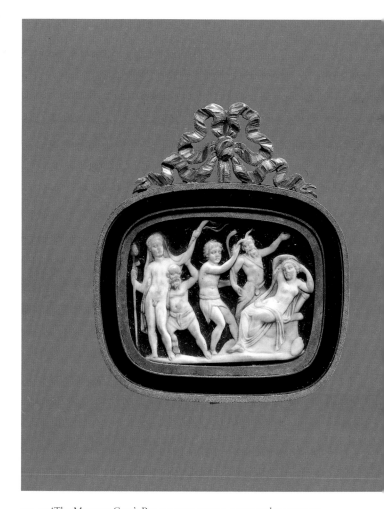

FIG. 51 'The Mantuan Gem': Roman onyx cameo, 1st or 2nd century AD. Private collection.

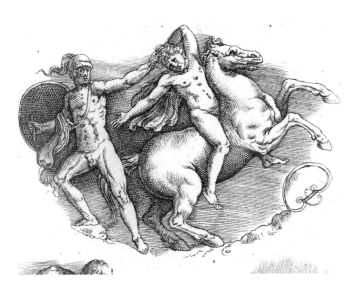

FIG. 52 Sixteenth-century engraving by Battista Franco (d. 1561) after a cameo sold by Hamilton to Sir Richard Worsley. British Museum, P&D 1874.8–8.423–6 (part).

Florence.[86] The subject of the gem was also engraved in the sixteenth century by Battista Franco (d.1561), in a set of engravings thought to have been commissioned as a visual inventory of the collection of the powerful Grimani family in Venice.[87] Among these same engravings is found another gem assigned by Worsley to the Gonzaga collection, namely the large cameo sold to him by Sir William showing Achilles and Troilus (cat. no. 71).[88] Both this and the 'Mantuan Gem' have been traced in inventories of the Venetian Nani family, into whose collection they passed in the eighteenth century.[89] Also in the Nani collection was the fine medieval cameo of Joseph and his brothers, which Sir William once owned and is now in the Hermitage, St Petersburg (cat. no. 74).[90]

The evidence for discounting the Mantuan source of Worsley's gems and attributing to them a Venetian origin instead seems overwhelming. It is impossible to say how and when the label 'Mantuan' was applied; nor is it known how and when the gems left Venice. The problem has been compounded in a previous discussion by a confusion of Sir William with the Scottish dealer and painter Gavin Hamilton.[91] One of the Tassie casts in the British Museum, which reproduces the Achilles and Troilus cameo, may hold a clue. This is inscribed on the reverse, 'Sir William Hamilton, from Miliotti, 1784'. Alphonse Miliotti of Paris is listed in Raspe's catalogue of Tassie's impressions as the owner of a great many intaglios and cameos. He was also author of a volume published in Vienna in 1803 of the Russian royal collection of gems under the title *Description d'une collection des pierres gravées qui se trouvent au Cab. Imp. de St Pétersbourg*. It was perhaps he who brought the 'Mantuan' gems from Venice.

Sir Richard Worsley died in 1805 and his collection was inherited by his niece Miss Simpson. She married the Earl of Yarborough, and Worsley's house, Appuldurcombe on the Isle of Wight, was subsequently sold and the contents moved to Brocklesby Park in Lincolnshire, where it was combined with the few antiquities already collected by the 1st Baron Yarborough.[92]

Last Acquisitions

After disposing of the major part of his second gem collection, Sir William continued to buy and to sell. In that same letter written from Venice in 1794 in which Worsley announced his publication of parts of *Museum Worsleyanum*, he wrote:

> I long to see your cameo and intaglio. They ought properly, being so fine, to belong to what I call my Hamiltonian Collection of gems which I fully prize. I have these now before me. If you are of the same opinion, you will be so good as to send them to me, and I will send you a draft in Naples for any sum you think proper.

It is not known to which cameo and intaglio Worsley is referring.

We hear of other 'Hamiltonian' gems from the painter Wilhelm Tischbein, who has left us lively accounts of life at the Palazzo Sessa and of Sir William's collections in the 1790s.[93] During this period, simultaneously with the project of publishing Sir William Hamilton's second collection of vases, Tischbein was gathering material for a book of ancient monuments illustrating the works of Homer. Publication of this, which has been described as 'the greatest illustrated book produced in Germany at the time', began in Göttingen in 1801 with explanations by the Homeric scholar Christian Gottlob Heyne (1729–1812). The last parts were not published until 1823, with a text by Dr Ludwig Schorn.[94]

Tischbein, who himself made a collection of gems and cameos, engraved at least two of Hamilton's gems for his work.[95] The first is described in a letter addressed to Duchess Amalia in Weimar, dated 8 November 1796, as a cornelian found recently and carved with a scene from the story of Odysseus and the Cyclops Polyphemus.[96] The text of the eventual publication records the find-site as 'not far from Pompeii'.[97] The second engraving accompanied one of Heyne's introductory essays to the book.[98] It shows the scene from a cameo interpreted by Tischbein as Homer inspired by the Muses. The gem is lovingly described and the use of its seven layers of colour carefully recorded. According to the text Hamilton acquired this stone at Rome in 1798. He did not, in fact, go there himself in that year, although King Ferdinand did lead a march against the French-controlled Roman Republic. He entered the city in triumph on

FIGS 53–4 'Odysseus and the Cyclops' and 'Homer inspired by the Muses': Tischbein's engravings of two gems formerly in Sir William Hamilton's collection.

29 November, only to be chased out by a French counter-attack a week later.[99] Ferdinand had set up his headquarters in the Farnese Palace, and it is not inconceivable that he himself brought the cameo away upon his departure and made a present of it to Hamilton, to whom he had every reason to be grateful at this time.

Modern gems and restorations

Some of Sir William's gemstones had been handed down from antiquity through the Renaissance; others were discovered in his own day. Others still were modern inventions, created by the great exponents of the eighteenth-century revival of gem-carving, notably Nathaniel Marchant, Giovanni Pichler and Filippo Rega (fig. 55). Marchant cut intaglios for Sir William, including a portrait of Emma and a head of the ancient statue of Niobe in Florence (cat. nos 113–114). Pichler was especially important to Hamilton for his ability as a restorer of cameos and James Byres's correspondence with Sir William contains occasional references to Pichler's restorations. On 9 August 1774, for example, he writes: 'Pichler has finished the retouching your Medusa. It comes extremely well, better than expected. He has likewise retouched your little Hymen, but it is impossible to make it good.'[100] In another letter dated 22 January 1785 we read, 'Pichler has got a stone that answers to your Tiberius, which he daily promises to set about, as also to begin the restoration of the Faun and Goat …'[101] This is listed by Sir Richard Worsley as 'A faun and a goat the head of the latter restored by Pichler'. The 'Tiberius' is the ancient fragment showing a young Julio-Claudian prince, of which Tassie made a cast

FIG. 55 Chalcedony intaglio of Sir William Hamilton, with a vase and Vesuvius in the ground. The gem, by Filippo Rega, is mounted on a bracelet braided from a rope of Emma's hair. Greenwich, National Maritime Museum (from the family of Lord Horatio Nelson).

before the restoration took place (cat. no. 68). On 5 August 1785, Byres corresponds about Pichler's commission from Hamilton to copy an ancient bronze bull in onyx, and in the same letter we read: 'Pichler has restored your intaglio of the faun and goat so well, that it is scarce perceptible. I have not seen a restoration answer so well and shall have the pleasure of forwarding it to you by the first safe hand.'[102] Hamilton made no secret to Worsley of the fact of a gem being restored, nor does the restoration seem to have affected the purchase price.

Conclusion

Sir William's passion for collecting persisted, as we have seen, right until the eve of his hurried departure from Naples. Next to vases, of all ancient artworks, cameos and intaglios seem to have given him most pleasure. He lacked space and a permanent residence, which were prerequisites of accumulating

sculpture on a large scale. Cameos, therefore, afforded the opportunity to own portable sculpture in miniature which could cost as much, if not more than, marble sculpture itself. Hamilton's two gem collections survive remarkably well for such precious and small objects. Although now dispersed through the collections of the British Museum, the first collection is preserved largely complete, while many gems in the second collection can still be traced. Sir William would have been pleased to find so many of his cameos and intaglios brought together here. D'Hancarville, however, would surely be dismayed that the stones that he found loquacious in his day have remained silent for so long, or if they talk still, then it is not in the symbolic language in which they spoke to him.

NOTES

1 Pliny, XXXVII.5; Richter, 1968, 1, pp. 20–22. For eighteenth-century gem collecting see Furtwängler, *AG*, pp. 409ff; Rudoe, *passim*.
2 Knight, 1994, p. 11.
3 Raspe, pp. lv–lxii; Holloway, *passim*; Smith, 1995, pp. 6–20.
4 Holloway, p. 13.
5 *An Abstract of Sir William Hamilton's Collection of Antiquities*, p. 3 (British Library, 7707, f. 1, and 215.i., f. 132).
6 D'Hancarville, MS Catalogue, II, p. 571; Strazzullo, 1984, pp. 247–50 and 315–16; Lyons, p. 3.
7 Barocas, 1983 and 1989, *passim*.
8 Townley Papers, BM Central Archives.
9 Caylus, I, p. 56.
10 Caylus, IV, p. 63, nos 3 and 4, pl. 21.
11 Caylus, I, p. 54, nos 1 and 2, pl. 18.
12 Raspe, pp. 62–6.
13 Winckelmann, 1760; cf. Raspe, p. lxii.
14 Zwierlein-Diehl, p. 9.
15 Winckelmann, 1760, preface, pp. 2–3.
16 Ibid., preface, p. 4; Jenkins, 1992b, p. 62.
17 Winckelmann, 1760, pp. 344–7.
18 Zwierlein-Diehl, pp. 103–6, no. 237.
19 See pp. 97 and 150ff. of this catalogue.
20 *Storia Antiquaria Etrusca*, p. 133, pl. 8.
21 Winckelmann, 1764, pp. 99–100; cf. Winckelmann (Lodge), pp. 352–3.
22 Winckelmann, 1760, p. 37.
23 See pp. 152–3 of this catalogue.
24 Winckelmann, 1760, pp. 348–50.
25 Zwierlein-Diehl, p. 106, no. 238.
26 Winckelmann (Lodge), p. 372.
27 Winckelmann, 1760, p. 349.
28 Ibid., pp. 405–9.
29 Zwierlein-Diehl, p. 133, no. 327.
30 *AEGR*, III, pl. facing p. 194, explained p. 193, n. 143; IV, pl. facing p. 24, explained pp. 61–2, nn. 56–7.
31 *AEGR*, IV, pp. 62 ff, n. 57.
32 Constantine, 1993, p. 60.
33 Caylus, VI, p. 107, pl. 36, no. 1; *AEGR*, IV, pp. 65–6; cf. Winckelmann (Lodge), p. 328; the stone is now in St Petersburg; see Zazoff, p. 144, no. 307.

34 *AEGR*, IV, p. 68.
35 Dionysius of Halicarnassus I.11.2.
36 *AEGR*, IV, pp. 70 and 74.
37 *AEGR*, III, pp. 191–2; IV, pp. 34–5 and 61–3.
38 *AEGR*, III, p. 192.
39 Winckelmann, 1764, p. 108; Winckelmann (Lodge), pp. 356 and 366.
40 D'Hancarville, MS Catalogue, pp. 508ff.; the principal passage in Pausanias is VII.22. 1–5; cf. *AEGR*, pp. 5ff.
41 *AEGR*, pp. 34–5; MS Catalogue, p. 510.
42 MS Catalogue, p. 511.
43 *AEGR*, IV, pp. 26–37; MS Catalogue, p. 514.
44 MS Catalogue, pp. 521–2.
45 MS Catalogue, p. 522.
46 MS Catalogue, p. 515, no. 297; this has not been located in the Museum's collections.
47 *AEGR*, IV, pp. 29–32.
48 *AEGR*, IV, p. 33.
49 *AEGR*, IV, pp. 26–7.
50 Smith, *Dictionary*, pp. 703–4.
51 Cumberland, 1720, British Library 960.d.5 is Sir Joseph Banks's copy.
52 Griener, pp. 81–2.
53 Guasco, pp. 5–6.
54 Cumberland, p. 32.
55 Guasco, pp. 4–5.
56 Ibid., pp. 13–15.
57 Ibid., p. xiii.
58 Ibid., p. xiv.
59 Ibid., pp. 25 and 38.
60 D'Hancarville, MS Catalogue, pp. 524–5.
61 Pliny, VII.36; Raspe, p. vii.
62 D'Hancarville, MS Catalogue, p. 524; *AEGR*, III, p. 191.
63 D'Hancarville, MS Catalogue, p. 523.
64 Guasco, p. 57.
65 Ibid., pp. 51–2.
66 Raspe, pp. 10–12.
67 Mitter, esp. ch. 4.
68 Raspe, pp. xiv–xviii.
69 Ibid., p. xx.
70 Tassie, no. 13832.
71 Tassie, 'Lists of cabinets and names of owners', p. 2.
72 British Museum, MLA, OA 2709.

73 See pp. 15 and cat. no. 16.
74 Morrison, no. 185.
75 BM Central Archives, Townley Papers.
76 British Library, Add. MS 51,315, Misc. Correspondence and Papers 1766–1800, WH.35.
77 Smith, 1897, p. 4.
78 BM Central Archives, Townley Papers.
79 Ibid.
80 Worsley Papers, XXXI, f. 7.
81 BM Central Archives, Townley Papers.
82 Worsley Papers, XXXI, f. 32.
83 Cf. Christie's sale, 1809, p. 28.
84 For whom see Ridgway, p. 221.
85 *Museum Worsleyanum*, facing p. 3.
86 Wester, p. 30 and fig. 13.
87 Lemburg-Ruppelt, 1981, *passim*; 1984, p. 108ff., pl. 48, figs 1 and 2.
88 Lemburg-Ruppelt, 1981, fig. 5; 1984, pl. 46, fig. 1.
89 Lemburg-Ruppelt, 1981, pp. 88; 96 and 106, n. 59.
90 Ibid., p. 88.
91 Ibid., pp. 88, 102.
92 Smith, 1897, p. 5.
93 Schiller, pp. 98–120 and 121–80.
94 Heyne; Landsberger, pp. 132ff.; Griffiths and Carey, pp. 135–6.
95 Heyne: (i) 'Homer instructed by the Muses', p. 14 and (ii) part 4, 'Ulysses passes the cup to Polyphemus', p. 22; on Tischbein and gems see Furtwängler, *AG*, pp. 421–2.
96 Von Alten, p. 67, letter dated Naples, 8 November 1796.
97 Ibid., n. 102, p. 23.
98 Ibid., n. 101.
99 Fothergill, pp. 322–3.
100 Cambridge, Fitzwilliam Museum, Perceval MS, N 7.
101 Paris, Muséum National d'Histoire Naturelle, Krafft Bequest.
102 Cambridge, Perceval MS, N 8; Knight, 1994, p. 11.

A View of Vesuvius

I DAVID ALLAN (1744–96)

Sir William Hamilton, 1775

Oil on canvas, 228 × 181.2 cm

Inscribed: *Painted by D. Allan & by him humbly presented to the British Museum. Anno. Dom. .1775.–*

Provenance: Presented by the artist to the Trustees of the British Museum, 1775; transferred to the National Portrait Gallery, 1879; on long-term loan to British Museum from 1982

Trustees of the National Portrait Gallery, NPG 589

Vesuvius is seen smoking in the distance through the window of this grand room in what is presumably the Palazzo Sessa. Sir William Hamilton is shown in the full regalia of a Knight of the Order of the Bath, the magnificent ostrich-plumed hat on a gilt chair beside him. He is holding diplomatic papers, which he is about to place on a *verd'antico* table with lion-head supports of a type found at Pompeii, and the Duke of Hamilton's crest is displayed as a large badge on the table's side, reminding the viewer of his membership of that family. The gilded furnishings and rich draperies are in keeping with the formality of this presentation portrait, in strong contrast with the intimate personal image provided by the same artist's portrait of Sir William and the first Lady Hamilton in their small *casino* at Posillipo (cat. no. 129).

This painting had not been commissioned by the sitter nor by the British Museum, which now housed Hamilton's collection, but was offered to the Directors of the British Museum by the artist himself. He had written to Dr Maty, Secretary of the Museum, from Rome on 6 October 1775 indicating that he was offering this portrait of 'Sr Wm Hamilton my Protector painted by me, my Gratitude and Regard for him has made me beg to do his picture [and] as it may be of utility to me he has been so good as to give me leave.' He wished to give the painting as a small testimony of his respectful regard for Hamilton,

> who is a true lover and Promoter of the fine Arts and protector of Artists, of which I have had the honor of a very particular share of his Generosity and Goodness in assisting me in the pursuit of my studys in painting . . . considering his great ingenuity and merit in making such a Noble Collection of interesting and beautiful monuments of Antiquity which are at present rightly placed in the B. Museum has induced me to think a portrait of the worthy collector might very properly find a place in that collection, on this consideration I have ventured to offer the picture to the Directors, which if they thought the weak performance worthy of being put up with this collection, woud do me an honnor and be of service to me as the work woud be seen.

In the PS, Allan hoped he would be forgiven the bill of lading for sending so large a work, 'but I have thought in fully imitating his resemblance to the life, it was best to add likewise his Character as a man of taste; which is expressed by the different things about him' (British Museum Archive, OL&P, I, f. 293). The arrival of the painting was duly reported to a meeting of the General Committee on 1 March 1776 (British Museum Archive, CM, p. 1505).

A number of objects from the collection Hamilton sold to the British Museum in 1772 are featured in the portrait, displayed in a pedimented cabinet which is itself ornamented with an acroterial statue of Jupiter and a head of the gorgon Medusa in relief. The cabinet takes the form of a Roman *lararium* or household shrine, similar to those discovered in houses at Pompeii. A horizontal shelf divides it in two, and on the upper level the principal object is a vase (cat. no. 2), which the painter took from the engraving in d'Hancarville's publication. This accounts for the fact that the subject of the vase-painting is reversed, as it is in the engraving. To the left of the vase is a bronze statuette of Athena Promachos and, immediately below, a bronze tripod and bowl (cat. no. 3). Other vases are lightly sketched in.

This magnificent painting is David Allan's finest achievement in the grand style of portraiture. Its purpose was to do honour to the man responsible for the Hamiltonian collection in the British Museum. However, in spite of the artist's efforts to include a number of objects from the collection in the image, the painting is dominated by the tall, elegant figure of Sir William in his striking robes of the Order of the Bath, and the overall impression is of a diplomat rather than a connoisseur. Hamilton must have seen it hanging in the Museum on his visit in 1776, and when he sat to his old friend Joshua Reynolds for the Society of Dilettanti portraits the following year, he commissioned a more appropriate full-length portrait to preside over the Hamiltonian collection in the British Museum (cat. no. 51).

LITERATURE: Gordon, p. 22; B. Skinner, *The Scots Abroad*, exh. cat., Scottish National Portrait Gallery, 1966, no. 14; Thompson, pp. 250–53; Skinner, 1973, no. 41; Clarke and Penny, no. 172.

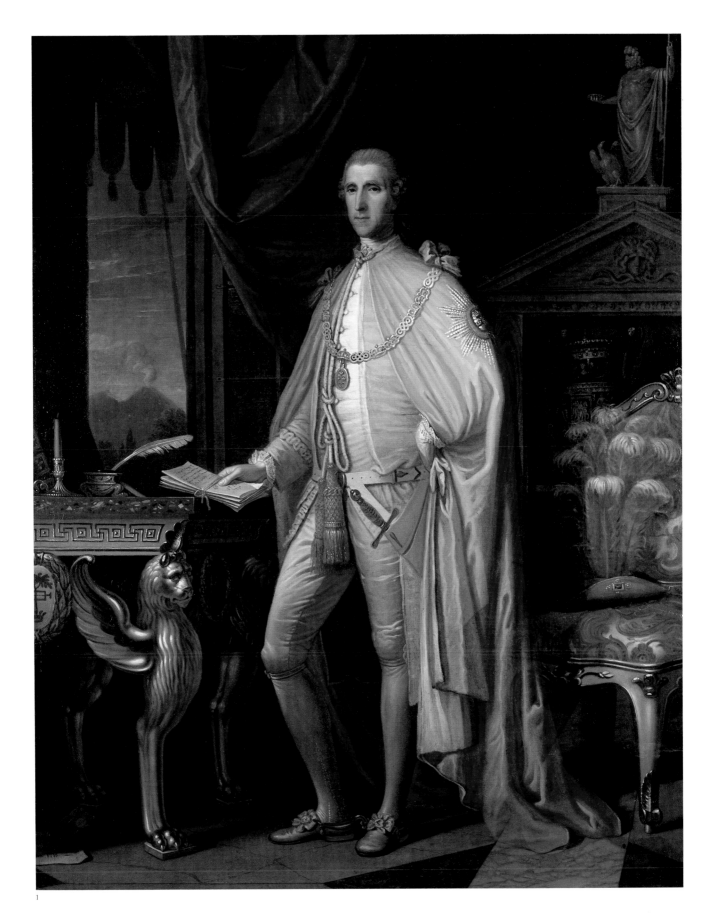

2 'The Hamilton Vase'

Red-figured volute-krater (wine-mixing bowl)
Ht 88.5 cm
Made in Apulia, southern Italy, about 330–310
 BC. Attributed to the Baltimore Painter. Said
 to have been found at Bari with BM Vases
 F282
British Museum, GR 1772.3–20.14* (BM Vases
 F284)

The principal scene shows a youth standing in a *naiskos* (a small temple-like structure) which he shares with his horse and (top right) his body armour. To left and right are shown two youths and two women holding various objects: top left, a *pilos* type helmet, shield and spear; bottom left, a mirror and a wreath; top right, two phialai (offering bowls), a fillet and a branch; bottom right, a situla and oinochoe (ritual bucket and jug). On the reverse of the vase is depicted a scene of four figures, again two male and two female, around a stele. The volutes are ornamented with female heads in low relief. The subject of the painted decoration is probably a generic one, common enough in Apulian vase painting, of homage being paid to the deceased.

Of all the shapes of Greek vase, the volute-krater was that most admired in the eighteenth century. Wedgwood produced replicas of Hamilton's vase in black basalt and, during the French occupation of Naples, a similar Apulian volute-krater (the name-piece of the Capodimonte Painter, now in the Metropolitan Museum, New York) was smuggled out of Italy and purchased by James Edwards, the wealthy and eccentric bookseller, at the astronomic cost of one thousand guineas. The Hamilton Vase was given star treatment in d'Hancarville's *Antiquités Etrusques, Grecques et Romaines (AEGR)*, being illustrated in no less than three single black-and-white and two double-page coloured engravings. In the black-and-white images the subjects of the vase painting are reversed, which accounts for David Allan's reversing his reproduction of the principal scene in his portrait of 1775 (cat. no. 1). In *AEGR* d'Hancarville explained the figure in the *naiskos* as Castor, one of the Dioscuri or twin sons of Zeus, standing in a temple. The identification was made on the basis of Homer's literary epithet for Castor, 'hippodamos' (horse-

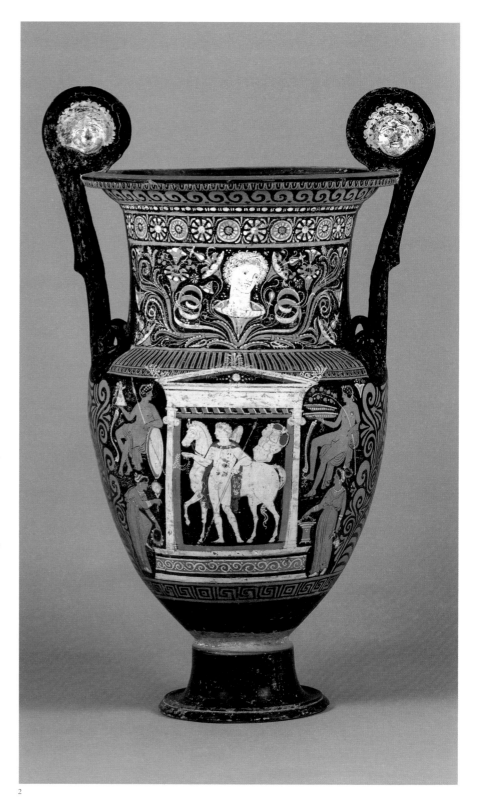

2

taming, quoting *Iliad* II. 237), and on the basis of a pictorial comparison with the Dioscuri as they are shown on Roman Republican coins. The swan-head protomes ornamenting the shoulders of the vase were ingeniously interpreted by d'Hancarville as betokening the union of Leda and Zeus, who took the form of a swan during the love-making that resulted in the birth of the Dioscuri. The female head on the neck of

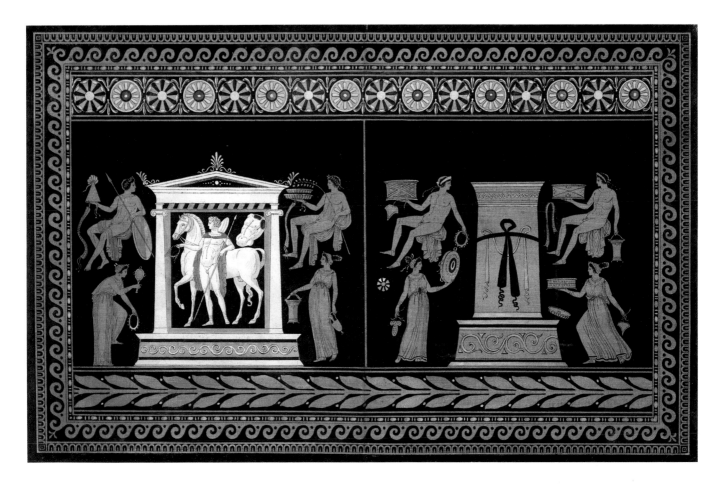

FIG. 56 Engraving of the 'Hamilton Vase' from volume I of *AEGR*.

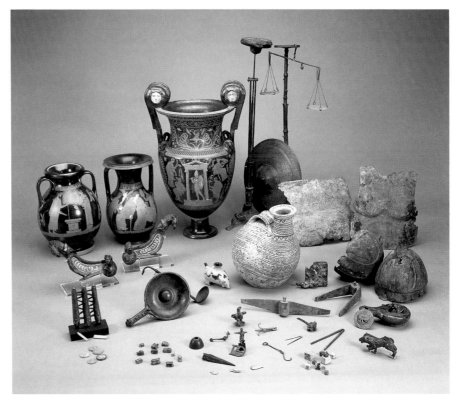

FIG. 57 Objects from Sir William's first collection: 'If Lord Ossory has a mind to enrich Ampthill', wrote Horace Walpole in 1771 to Lady Ossory, 'Sir William has brought over a charming Corregio, and a collection of Tuscan vases, idols, amulets, javelins and casques of bronze, necklaces and earrings of gold from Herculaneum, Pompeii and Sicily, sacrificing instruments, dice, ivory, agate etc . . .'.

the vase must, according to d'Hancarville, be Leda herself or her daughter Helen.

D'Hancarville gives a fuller version of the iconography of the vase, as he saw it, in the manuscript catalogue of Hamilton's collection, where he includes the vital information, curiously omitted in *AEGR*, that it was found at Bari together with another Apulian volute-krater also in the Hamilton collection (fig. 57: BM Vases F282 attributed to the Varrese Painter; see Trendall, *RVAp*, p. 341, 27). The principal scene of this vase is similar to that of the last, except that the youth, who carries two spears in one hand and a shield in the other, has no horse. D'Hancarville thought the one vase was a companion to the other, and identified the second figure as representing Castor's twin brother, Pollux. Of the two, according to d'Hancarville, Castor is given greater prominence, being celebrated, by virtue of the crown he holds in his right hand, as victor at the Olympic Games. He cites Pausanias as the source for knowledge of Castor's Olympic victory, but omits all the information that might otherwise weaken his argument: Pausanias (*Description of Greece*, v.7.2) explains that both Castor and Pollux were Olympic victors, the first in a foot-, not a horse-race, the second at boxing, and both were crowned by Herakles. Such was the authority with which d'Hancarville wrote, however, that he seems in this case to have persuaded even the usually more sceptical Winckelmann.

In the fourth volume of d'Hancarville's publication of Hamilton's vases, which appeared some nine years after the first, he revised his interpretation of the scene on the reverse. In the earlier version he saw the central funerary stele as an altar, but in keeping with his later, more developed theory of 'signs' (see p. 50), he now took it for a column, symbolic of Castor, to whom the vase was dedicated.

LITERATURE: *AEGR*, I, pls 52–6, commentary in II, p. 163 (pl. 55); IV, pp. 38–9; d'Hancarville, MS Catalogue, II, pp. 631ff; Winckelmann (Lodge), pp. 392–3; Trendall/Cambitoglou, *RVAp*, II, p. 860,1, pls 319, 1–2; Jenkins, 1988, p. 455, for Edwards's thousand-guinea volute-krater; Young, pp. 59–60, C6, for Wedgwood's reproduction. NB The sum paid by the British Museum for Hamilton's first collection was not £84,000 as given in this last source but £8,400.

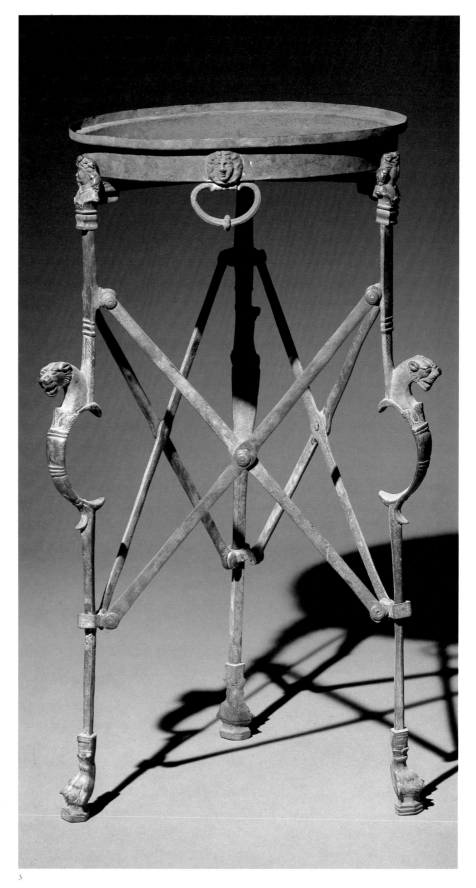

3

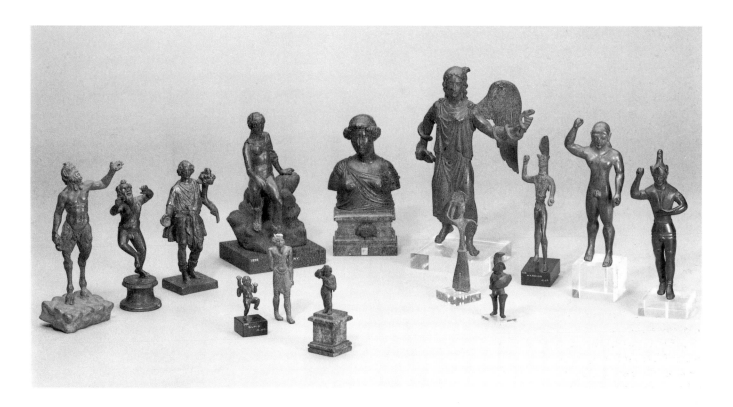

FIG. 58 Sir William's first collection was rich in bronzes, including a fine series of statuettes.

3 Roman bronze folding tripod and bowl

Ht of tripod 82 cm; diam. of bowl 42 cm
Probably made in southern Italy in the first
 century BC or first AD. Said to have been
 found in the vicinity of Mount Vesuvius
British Museum, GR 1774.6-3.1a and b

Each support of the tripod is ornamented (from the top down) with a head of Bacchus and the head and paw of a feline animal, probably a panther. The flat-bottomed bowl is decorated with bacchic heads supporting the handles. The brace locking the legs into position and supporting the bowl is probably a modern replacement for the original. D'Hancarville was interested especially in the fact that the tripod folded and was therefore portable. He conjectured that it was made to be carried in the night-time processions of Bacchus. According to him, the tripod and bowl were presented to the Museum by Sir William, together with two bronze bowls and a bronze candelabrum, all showing signs of burial in the lava of Mount Vesuvius (GR 1772.3-4.56-59).

LITERATURE: D'Hancarville, MS Catalogue, I, pp. 300–1; Hawkins, III, pp. 158–9.

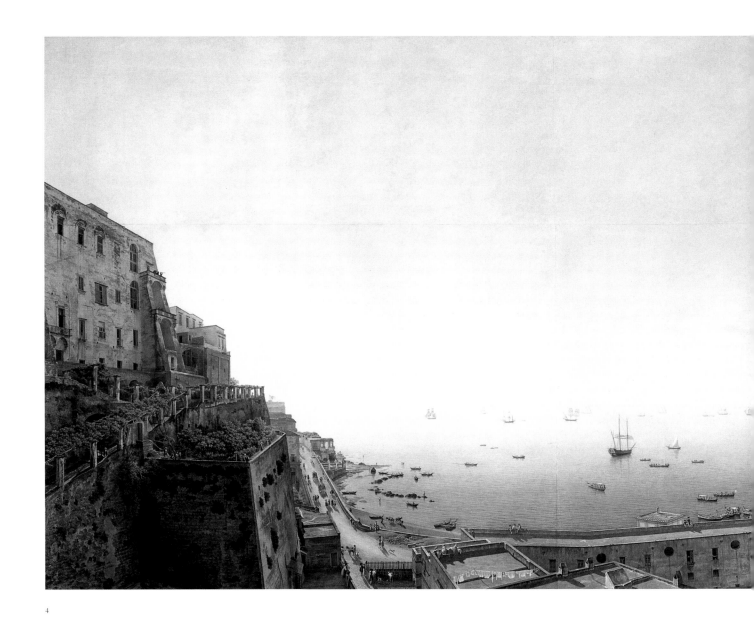

4

4 GIOVANNI BATTISTA LUSIERI
(1755–1821)

View of the Bay of Naples from the Palazzo Sessa, 1791

Pen, ink and watercolour, 102 × 272 cm

Provenance: Sir William Hamilton; his sale
 Christie's, 28 March 1801, lot 24; bt Richard
 Grenville, Earl Temple, £107.2.0, later 1st
 Duke of Buckingham and Chandos, Stowe
 (possibly purchased with Lusieri, *View of the
 Castle of S. Elmo from Palazzo Sessa*, Hamilton
 sale, 27 March 1801, lot 26, £19.8.6, present
 location unknown); both paintings included in
 his son's sale in 1848 and mentioned in two
 further sales at Stowe, but unsold or
 unclaimed; acquired by Allied Schools when

Stowe School founded 1922; purchased by
 present owners through Artemis Fine Art,
 1984
Collection of the J. Paul Getty Museum, Malibu,
 California, 85.GC.281

On 22 March 1787 Goethe, with his com-
panion the artist Wilhelm Tischbein, visited
Sir William Hamilton at the Palazzo Sessa
and was inspired to write that if he were not
driven by his German mentality and 'a desire
to learn and do rather than to enjoy', he
would 'linger somewhat longer in this school
of light and merry living and try to profit
from it more ... To be sure, anyone who
takes the time, and is wealthy and adroit,
can settle down very comfortably here. Thus
Hamilton has created a lovely existence for

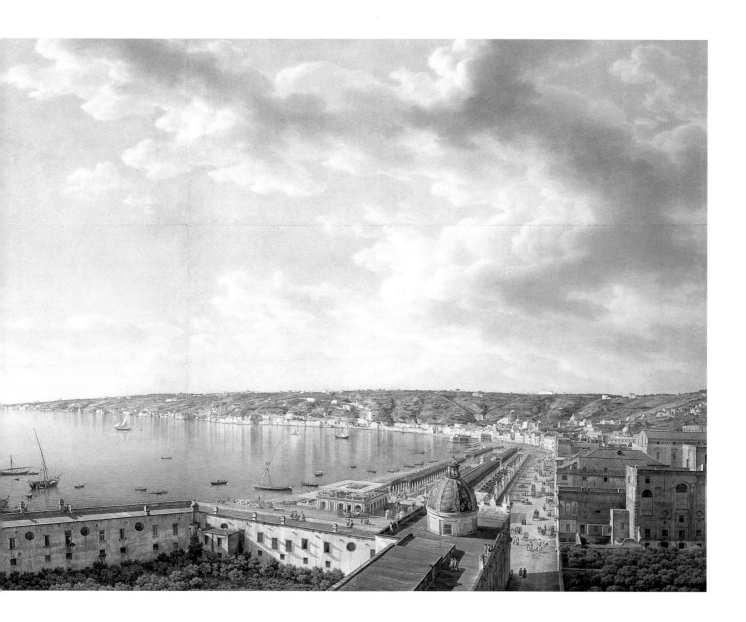

himself and is enjoying it now in the autumn of his life.' He went on to describe the Palazzo itself, and the famous view from the 'bow window' recorded in the present watercolour:

> The rooms he has decorated in the English taste are charming, and the view from the corner room is perhaps unique. Below us the sea, Capri facing us, Posillipo to the right, the Villa Reale promenade nearer by, to the left an old Jesuit building, in the distance the coast from Sorrento to Capo Minerva. There may well be nothing in Europe to match this, at any rate not in the middle of a large populous city. [*Italian Journey*, p. 177]

The balcony room was on the corner of the upper floor Hamilton had added for the benefit of the first Lady Hamilton's health in 1782 (see fig. 3), and in his own *Memoirs* Tischbein noted that it had been designed and decorated by Hamilton himself. Although the walls of the small room were at right angles, the bow window formed a semicircle, and the impression of an oval room was reinforced by the oval moulding of the ceiling. The walls and doors opposite the window were covered with mirrors, reflecting the view outside. According to Tischbein, it was Hamilton's favourite place for reading: 'If you sat on the sofas arranged round, you imagined you were out of

doors, sitting on a rocky peak above the sea and land' (Gage, p. 765).

Like the *View of the Campi Flegrei* purchased from Thomas Jones in 1783 (see cat. no. 19), this view of the Bay of Naples and the two other works Hamilton commissioned from Lusieri were not intended to hang in any of his villas in Naples, but instead he hoped they would reach him in England while he was there on leave. The other two watercolours were smaller in size. One was the view towards S. Martino and the Castel di S. Elmo from the other corner of the Palazzo Sessa. (According to Charles Townley's annotation in his copy of the 1801 sale catalogue, it was bought in, but Hamilton must have

sold it to Earl Temple later, as for some time it hung with the larger view at Stowe.) The other drawing Hamilton commissioned was of the room he called his 'Cabinet' (see p. 86), but Lusieri admitted he did not have the courage to finish it. Hamilton did not commission these works to sell in London, nor to decorate his residence there, as he did not have one. Instead, his intention was to show his family and friends in England how he lived in Naples (Knight, 1993, p. 536). At the same time the drawings would provide him with souvenirs of his villa when he finally retired and returned to England.

Lusieri was active in Rome from 1761, but his arrival in Naples was probably due to the patronage of another travelling Englishman, Philip Yorke, who had ordered six views of Rome before he left the city in 1781 and in September commissioned views of Naples (Public Record Office, Northern Ireland, Yorke MS D2431–3; Sir Brinsley Ford Archive, Paul Mellon Centre). In May 1782 Thomas Jones met Lusieri in Naples, where the latter was already painting landscapes for the queen. He was popular with the German and Russian ambassadors, who sent their visiting countrymen to his studio in the same street as Jones, and his generosity in introducing them to the Welsh artist helped the latter to attract some much-needed patronage, eventually resulting in Hamilton's visit to Jones's studio (Jones, *Memoirs*, pp. 112–3, 124–5).

It was in the 1790s, however, that Lusieri found his greatest patronage amongst the English, and his watercolours still hang at Stourhead, Attingham and elsewhere. On 23 March 1793, Sir William Forbes took his wife to Lusieri's studio: 'His landscapes in transparent watercolours are the most exact & elegant transcripts of nature I ever saw . . . Although we had made a resolution on coming abroad not to purchase either painting or antique as being an expence of which there is no end I thought I might venture to indulge myself with a few prints and drawings of remarkable places.' He described Lusieri's method, noting that 'in order to represent with accuracy the lights & shades & natural hues of his landscapes, [he] often actually finishes them on the Spot' (National Library of Scotland, Forbes MSS 1542, f. 248; 1544, f. 211). Lusieri's

meticulous method of drawing outline contours with Middleton graphite pencils and careful colouring done on the spot, in pure colours without shading, is documented by several other travellers (see Williams, 1982, p. 495).

As painter to the king, Lusieri fled to Sicily when the Hamiltons and the royal family were there in 1799, and it was at Messina that Lord Elgin, searching for an artist to accompany him on his embassy to Athens, secured the services of 'the first painter in Italy', on Sir William Hamilton's recommendation, for a salary of £200 per annum. The artist spent the rest of his life in Athens, where he continued to draw and also served as a popular *cicerone* to British visitors to the city.

LITERATURE: Williams, 1982, pp. 492–6; Knight, 1985, pp. 47–8; Williams, 1987, pp. 457–8; Briganti, 1989, p. 407; Knight, 1993, pp. 536–8; Gage, pp. 765–6.

5 PIETRO ANTONIANI (*c*.1740/50–*c*.1781)

Eruption of Vesuvius in 1767, 1776

Oil on canvas, 64.5 × 130.5 cm

Inscribed on verso: *Erruzzione Ultima Celebre del Vessuvio del 1767 / Petrus Antoniani delint. ed fect. 1776*

Provenance: Acquired in Naples in March 1778 by the Hon. James Mackenzie Stuart (d.1799), younger son of the 2nd Earl of Bute, for £14.1.3; James Archibald Stuart-Wortley-Mackenzie (d.1818), nephew of the above and younger son of the 3rd Earl; James, 1st Baron Wharncliffe (d.1845), son of the above; by descent to 4th Earl of Wharncliffe: his sale, Christie's, 23 May 1958, lot 63 (as one of a pair); anonymous sale (Toynbee-Clarke), Christie's, 16 October 1959, lot 119; with Peter Claas; acquired by the present owners 1960

The Mostyn-Owen Family

After two years of watching fairly constant but relatively subdued activity on Vesuvius, the major eruption of 1767 was Hamilton's spectacular introduction to a phenomenon which would hold a compelling fascination for him for the next thirty-three years. It was here in this slight valley between Vesuvius and Monte Somma that he was making his observations in October 1767 when:

on a sudden, about noon, I heard a violent

noise within the mountain, and at the spot about a quarter of a mile off the place where I stood, the mountain split; and, with much noise, from this new mouth a fountain of liquid fire shot up many feet high and then, like a torrent, rolled on directly towards us. The earth shook, at the same time that a volley of pumice stones fell thick upon us; in an instant clouds of black smoke and ashes caused almost total darkness; . . . My guide, alarmed, took to his heels; and I must confess that I was not at my ease. I followed close, and we ran near three miles without stopping. [*Campi Phlegraei*, p. 25]

Within a year of his arrival in Naples, Hamilton was constantly receiving letters from friends back in Britain requesting that he commission for them paintings from local artists. Thomas Worsley wrote from Hovingham Hall in June 1766 that he was fitting up a new apartment and 'would like good views of Naples if they fall your way' (British Library, Add. MS 41,197, f. 36). Two Antonio Jolis were sent to Earl Spencer in 1766, four Ricciardellis to the Duke of Brunswick in 1768, and in December 1769 Hamilton paid P. J. Volaire 300 ducats for a picture painted for himself (Add. MS 40,714, ff. 4, 58, 85). Paintings by the Milan-born Antoniani were popular with Grand Tourists, and Lords Fortrose and Brudenell are just two of the many who owned views of Naples by him. He probably painted several views of the 1767 eruption; one was sold at Christie's on 24 May 1985 (lot 51, 49.5 × 128.2 cm).

A traditional but unsubstantiated belief that this painting could be identified with that offered as one of a pair in Hamilton's sale at Christie's (18 April 1801, lot 8) was accepted at the time of the Naples and London exhibitions *In the Shadow of Vesuvius*; the correct provenance was established by Francis Russell, and further information on Mackenzie Stuart's collection will be given in his forthcoming book *John, 3rd Earl of Bute, Patron and Collector*.

It must be assumed that the inscription on the reverse was either invisible or not noticed at the time of the 1958 sale at Christie's where the catalogue entry reads 'Vernet – a volcano in eruption, moonlight – a pair', which would seem to correspond to Mackenzie Stuart's two paintings by Antoniani listed as 'View of the Eruption of Vesuvius in 1767 – taken from above the Hermitage' and 'do. do. in Decembr. 1766 & Jany. 1767

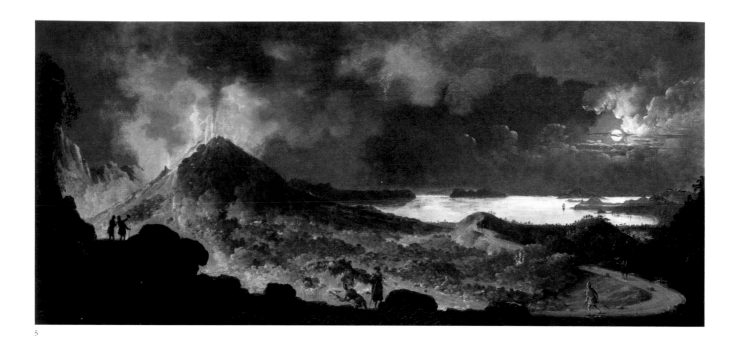

5

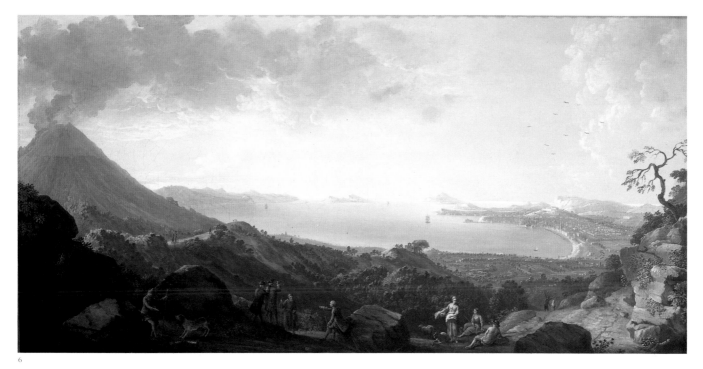

6

– taken from the uppermost Montagnolo (raised in 1760)'. He also acquired a third Antoniani described as 'View of Naples – taken from 2 or 3 miles out at Sea'. This cost £33.15.0 but is recorded as undelivered in August 1778. It is presumably the picture referred to by Mackenzie Stuart in a letter to Hamilton in May 1781:

> to beg the favor of you to have my Picture of the View of Naples from the Sea done by the late poor Antoniani sent ... more particularly to request of you as to be so good, as to *see* it put up (when the opportunity offers of sending it) with the greatest care, so that it may not Receive any damage from the Sea Water, or otherwise ... [he also requested copies of plans of Naples and its environs] ... These Plans might be sent at the same time, my Picture is sent, but in a *separate* Package from the Picture for fear of hurting the Picture which, I would not for twenty times its value have the least injury done to it. [National Library of Scotland, MS 2618, f. 59 Misc.]

This letter establishes a latest date for Antoniani's death (not previously known). The painting it describes was also in the Wharncliffe sale in 1958; at 117 × 261 cm it was much larger than its companions, and it may be the painting offered at Bonham's on 20 March 1986, lot 104.

LITERATURE: A. Martini, 'Notizia su Pietro Antoniani milanese a Napoli', *Paragone*, XVI, 1965, 181, p. 85, fig. 64; M. Causa Picone, 'Volaire', *Antologia di Belle Arti*, II, 1978, 5, p. 38; Russell, 1985, p. 1538, fig. 6; Briganti *et al.*, 1989, pp. 363–4, ill. p. 287; *Shadow of Vesuvius*, p. 114, ill. p. 58. We are greatly indebted to William Mostyn-Owen for kindly contributing information concerning the provenance of this painting.

6 PIETRO ANTONIANI
(c.1740/50–c.1781)

A View of Vesuvius with the Bay of Naples

Oil on canvas, 65 × 131 cm

Inscribed on verso: *Pietro Antoniani* and *Veduta del Vesuvio e tutto il Cratere di Napoli*

Provenance: Acquired from Colnaghi's c.1918 for private collection, Wales; Clovis Whitfield Fine Art Ltd, from whom acquired by present owner

Private collection, Switzerland

Hamilton's villas were decorated with many painted views of Venice and Rome but there

were no views of the Bay of Naples, unless one includes the watercolours and body-colour drawings by Fabris and Della Gatta of peasants dancing in grottoes with the bay in the background (see cat. nos 22, 148–9). However, it is not surprising that Hamilton did not acquire paintings for his walls to represent in two dimensions what he could see in glorious reality: the windows and terraces of his villas commanded the finest views of a bay described since antiquity as the most beautiful in the world. It was in the face of such beauty that Goethe abandoned all hope of becoming an artist and even despaired of describing it on paper: 'When I want to put down words it is always pictures that come before my eyes, of the fertile land, the open sea, the shimmering islands, the smoking mountain, and I lack the organs to represent it' (Boyle, p. 459).

Hamilton did, however, have a pair of paintings by Antoniani entitled *A View of Naples* and *The Eruption of Vesuvius of 1767*, which appeared in his second sale in 1801 (18 April, lot 8), where they were purchased by Charles Townley. Like the Lusieris (cat. no. 4), they do not appear in the list of works hanging in the Palazzo Sessa and they, too, may have been sent home to England shortly after they were purchased or commissioned, to serve during Hamilton's retirement as reminders of the view he would miss when he eventually left Naples. Their present whereabouts are not known. According to Townley's manuscript catalogue of his pictures (British Museum Archives), the painting of the eruption was similar in appearance to cat. no. 5. The companion piece showed the view from Posillipo near Hamilton's *casino*.

There are many views of the Bay of Naples by Antoniani which show it from the usual viewpoints of Posillipo or Portici or from the hills above Capodimonte, but few daylight views show it from the point used in this painting, the Atrio di Cavallo. It was a point chosen frequently by artists to represent the spectacular effect of the 1767 eruption by night; Volaire employed it, as did Antoniani in the painting in cat. no. 5. The present view, with a purple-grey Vesuvius smoking on the left, the sun shining on the bay with its distant city and 'shimmering islands', the familiar figures of resting peasants, Grand Tourists with their telescopes, a monk from the hermitage and the king's *volante* (messenger), is a wonderful evocation of the experience Hamilton was to enjoy on many of his seventy-odd ascents.

7 JOHANN HEINRICH WILHELM TISCHBEIN
(1751–1829), formerly attributed to Tischbein and PHILIPP HACKERT
(1737–1807)

A Boar Hunt at Persano under Ferdinand IV, c.1792–3

Oil on canvas, 215 × 295 cm

Provenance: Archibald Philip, 5th Earl of Rosebery (1847–1929) at the Villa Rosebery, Posillipo, which he purchased in 1897 (formerly called the Villa Delahante, it had earlier belonged to the Bourbon Count of Syracuse); presented to HM Government by the 6th Earl of Rosebery in memory of his father, 1932

Government Art Collection of the United Kingdom. On loan to the British Embassy, Rome, GAC 0/826

Illustrated on pages 26–7, fig. 7

Tischbein travelled throughout Holland and his native Germany in the 1770s as a portrait painter before becoming a court artist in Berlin. In 1780 he spent almost a year in Zurich as a guest of J. C. Lavater, whose theories on the correlation between animal and human physiognomies and character were a strong influence on Tischbein's later work. It was Lavater who recommended Tischbein to Goethe, but as Tischbein went to Rome from Zurich in 1782, they did not actually meet until Goethe arrived in Rome four years later, when Tischbein painted his famous portrait of the poet in the Campagna (Frankfurt am Main, Städelsches Kunstinstitut).

Tischbein decided to settle in Naples after spending the early part of 1787 there with Goethe. Philipp Hackert, chiefly a landscapist and engraver (cat. nos 182–3), was already well in place as court painter, and at first Tischbein had trouble obtaining royal commissions, having to settle for portraits of the Princess Maria Theresa and her husband, later Emperor Francis I of Austria, and giving drawing lessons to the princess. However, in 1789 Tischbein was appointed director of the Neapolitan Accademia di Belle Arti, where he placed a greater emphasis on life drawing and history painting, in line with other European academies and his own particular skills. He had some success obtaining commissions for history paintings, including one based on Goethe's play *Iphigenia in Tauris* for the Prince of Waldeck, in which Emma Hart was the model for all the figures (Schulze, no. 304). He continued to paint portraits, in particular one

of Goethe's patroness, Anna Amalia, Dowager Duchess of Saxe-Weimar (whom he had introduced to Hamilton), showing her seated on an antique bench in front of the ruins of Pompeii.

On 18 December 1792 Tischbein wrote to Duchess Anna Amalia that he was 'painting an important piece for HM the King wherein appear all the persons who were here this year and whom he invited to a hunting party. This picture is giving me much pleasure though it is laborious work painting the portraits of the persons and numerous horses. I know most of them very well and most are notable people' (von Alten, p. 59). The following February, Charles Blagden visited Tischbein's studio, where he saw his 'representation of the Royal Hunting of boars, That which the King gave last year to the Princess of Carignan. He is pretty correct in his outline, but not happy in taking likenesses' (Royal Society, Blagden Diary, II, f. 74).

Several of Tischbein's preparatory drawings of the portraits of the Italians in the painting were sold at Sotheby's and most bore inscriptions giving the identities of the sitters (25 June 1981, lots 207–14; 19 June 1986, lots 480, 482). The present location of the drawings for the British who are included in the painting is not known, but their faces are well-enough known from other images to make them recognisable. King Ferdinand IV, the central figure on a horse, identified by his unmistakable profile, is shown taking part in the hunt. The most important female sitters are (from left to right in the left-hand cart): an unidentified woman, Lady Emma Hamilton (looking up at the standing Queen Maria Carolina), the Duchessa di Cassano (Lady-in-Waiting to the queen) and Princess Maria Luisa (recently married to the Duke of Tuscany). The queen's other daughter, Maria Carolina of Austria, is the first figure in the second cart. The Queen of Sardinia, whose country was currently under threat from the French, is the young woman in the standing group on the right. Below the figures in the left cart stand Prince Augustus, sixth son of George III, shown next to a prominent figure who may be Sir John Acton, the Prime Minister of Naples; he stands next to the Duca di Castagneto, Sir William Hamilton, and several other prominent members of the Italian nobility.

Prince Augustus is shown in the same uniform he later wore in his portrait by Guy Head (cat. no. 9), but the pose is remarkably similar to that in the full-length portrait of him by Louis Gauffier (1761–1801), painted in Florence in 1793 (Collection of HM the Queen). Lady Hamilton's red cap has been described as Phrygian, but it is far more likely to be based on those worn by the loyal Neapolitan *lazzaroni*, of whom we are reminded by the group in local costume on the right and the boys in the tree.

The inclusion of this group of loyal Neapolitans, peasants and nobility, and the presence of these particular British sitters to the exclusion of other foreigners in this large painting seems to indicate it held some political meaning. At this date, the king and queen, their family and their subjects were all looking to England for support against the French. The French were already at war with Austria, and their squadron was anchored threateningly in the Bay of Naples when Tischbein wrote his letter to Anna Amalia. Only months later Queen Maria Carolina's brother-in-law, Louis XVI, was executed and the French declared war on Britain.

Hunting was Ferdinand IV's most constant occupation and Sir William was more and more frequently called upon to attend him. This highly symbolic painting showing one fox and one boar as the result of a hunt does not accord with the descriptions of the slaughter of forty or fifty boars a day recorded by many visitors and Sir William's own account (Morrison, no. 102). Up to 2,000 peasants and soldiers and hundreds of dogs were used to circle a wood and drive the boars towards the fourteen *chasseurs* in their green and gold uniforms.

Hackert had painted several scenes of the royal hunt which adorned the palace at Caserta, and the present large painting has traditionally been attributed to him, with Tischbein's collaboration in the figures. However, when this painting was included in the 1994 Hackert exhibition at Rome (no. 34), V. I. Furina noted that in this case the collaborator appeared to be more Hackert than Tischbein, as the landscape and tent are very sketchy. Furina thought this was due to the work being unfinished, but noted that this was highly unusual in such a meticulous artist as Hackert. Close comparison of the landscape and foreground details in this painting with works in oil by Hackert at Caserta would seem to rule out the possibility that Hackert had any hand in this painting at all, and the style and colours of the landscape have far more in common with the background in Tischbein's portraits of Goethe and Anna Amalia than with any landscape by Hackert.

Hackert's name was not mentioned by Tischbein in his letter to Anna Amalia, nor by Charles Blagden. The hunting scenes Hackert had painted for the king included figures, but they tended to be of a generic type and the few portraits that they include are not easily recognisable. Tischbein, a known portraitist whose powers of landscape painting on this scale were unproven, would seem to have been selected for this commission specifically because it was important that the figures in this hunt be clear and instantly identifiable. It is unfortunate that it is not known where this large, obviously political statement was intended to be hung – its location from the time it was painted until it appeared in the Villa Rosebery is unknown – but it is entirely appropriate that it now graces the walls of the British Embassy at Rome.

LITERATURE: Mary Beal of the Government Art Collection has been researching the identification of the figures and has been particularly helpful in cataloguing this entry; V. I. Furina in P. Chiarini, *Il Paesaggio secondo natura – Jacob Philipp Hackert e la sua cerchia*, exh. cat., Palazzo delle Esposizioni, Rome, 1994, no. 34. We are grateful to Carlo and Ella Knight for informing us of their doubts concerning the traditional attribution of this painting to Hackert and Tischbein.

The Art of Diplomacy

8 GEORGE ROMNEY (1734–1802)

Sir William Hamilton, c.1783–4

Oil on canvas, 76.8 × 65.1 cm

Provenance: Given to the Hon. Charles Greville
by the sitter, 1788 (but not delivered until
May 1789, according to Ward and Roberts);
Greville's sale 31 March 1810, lot 41, bt Col.
Greville; Hon. Robert Fulke Greville; his
daughter, Lady Louisa Greville, who married
the Revd Hon. Daniel Hatton; by descent to
Nigel Hatton; by 1917 with M. Knoedler,
London; purchased from their New York
branch by Andrew W. Mellon 1918; gift to his
daughter, Ailsa Mellon Bruce, by whom
bequeathed to National Gallery of Art
National Gallery of Art, Washington, DC,
1970.17.133 (2505)

A letter from Richard Cumberland, staying
at Warwick Castle in August 1774, to Rom-
ney in Rome informed him that Charles
Greville was sending him a letter of intro-
duction to Sir William Hamilton in Naples
(Romney, p. 108). Romney is not known to
have visited Naples, but a brief unrecorded
visit may have been made during his year-
and-a-half stay in Rome.

Romney's sitters books record that Sir
William visited his studio eight times nearly
ten years later, in November and Decem-
ber 1783, to sit for his portrait – his nephew
Charles Greville's portrait was already com-
plete (cat. no. 49). During this time Hamil-
ton had also commissioned a portrait of
Charles's mistress, Emma Hart, as a *Bacchante*
(cat. no. 167). Greville presented Hamilton
with his portrait by Romney and had it sent
to Naples some time before August 1788.
Greville wrote to Romney to inform him
that he himself would only be paying for his
own portrait which he had given to his
uncle and for one portrait of Emma in a
straw hat. He apologised to Romney for not
purchasing all the paintings he had com-
missioned himself: 'I wish I could have
completed all my plans, I should not restrict
myself to two of your works; and as I have
speculated deeply to be proprietor of a

house, and cannot look to occupation of it
above a year, after which I shall be obliged
to let it, I shall beg to have Sir William
Hamilton's picture to hang up' (Romney,
p. 210). Sir William had presented his
portrait by Romney to Greville and £100
from Sir William's account was sent on 18
August to settle the final bill.

The portrait shows Sir William wearing
a fur-edged red coat decorated with the sash
and star insignia of the Order of the Bath.
Although the size is modest, as in the por-
trait of Greville, Romney's ability to capture
his sitter's character is instantly evident in
both portraits. They not only convey more

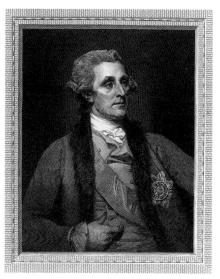

FIG. 59 W. Sharp after George Romney, *Sir
William Hamilton*. Engraving, 1794. British
Museum, P&D 1833–6–10–36.

insight into their characters, but at the same
time are somehow both more flattering and
realistic than Reynolds's portrayals of uncle
and nephew as the central figures in the two
Society of Dilettanti portraits (cat. no. 52).
This seems to have been apparent to their
contemporaries as well. When the reviewer
in the *Public Advertiser* (13 April 1785)
discussed the relative merits of Reynolds

and Romney in 'delineating the mind' he
concluded: 'If from a cloud of witnesses for
Romney's cause, we must select, – we
would be content to take those first occur-
ring – as Sir William Hamilton's head'
(Hayes, p. 240). When this portrait of Sir
William was first exhibited by Romney in
his studio in 1784, the *Morning Chronicle*
described it with another as 'perhaps two of
the best heads he ever painted' (19 January
1784: British Museum, P&D, Whitley
Papers, X, p. 1278).

Charles Greville had this portrait en-
graved by 'our best engraver' William Sharp
in 1794 to serve as frontispiece to a new
quarto edition of Hamilton's books. The
project was planned by Greville and the
bookseller Thomas Cadell, but the latter
reneged and Greville found himself '*planté*
with my *planche* of 100 Louis' (British
Library, Add. MS 40,715, f. 53). Unlike the
mezzotints after Romney's paintings, the
line engraving does not in fact do the paint-
ing or the sitter justice (fig. 59). On the basis
of it, Graves and Cronin (II, p. 424) cata-
logued the original painting, which they
had not seen, as a work by Reynolds. The
engraving also may have led to the misiden-
tification of another Romney portrait
which first appeared identified as Sir
William Hamilton in a sale at Christie's on
7 May 1898 (lot 42, bought Colnaghi's:
Ward and Roberts, p. 69). It was published
as such by W. Roberts in one of his series on
famous British paintings in 1921 and was
exhibited as Sir William Hamilton in the
Inaugural Exhibition of the Art Gallery of
Toronto five years later. It retained this
identification until 1985 when Jennifer
Watson demonstrated that it is probably a
lost portrait of General Lord George Lennox
(*Romney in Canada*, exh. cat., Kitchener-
Waterloo Gallery, Ontario, 1985, no. 20).

LITERATURE: Ward and Roberts, II, pp. 69–70;
J. Walker, *Paintings in the National Gallery of Art
Washington*, 1976, no. 510; J. Hayes, *British
Paintings in the National Gallery of Art Washington*,
1994, p. 240.

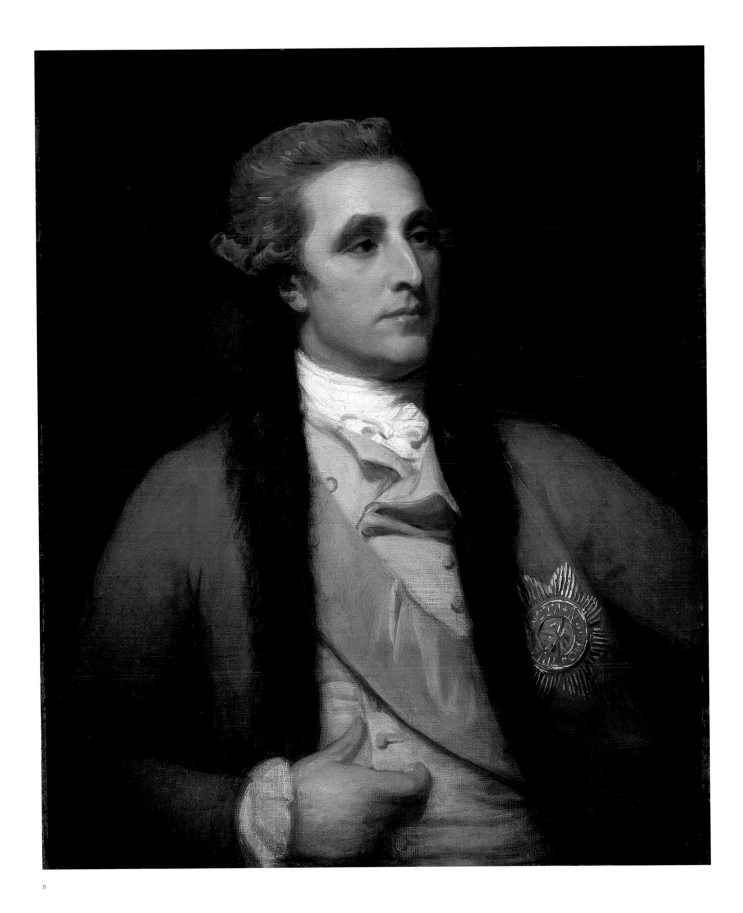

8

9 GUY HEAD (1760–1800)

Portrait of HRH Prince Augustus, later Duke of Sussex (1773–1843),

c.1798

Oil on canvas, 94.6 × 80 cm

Provenance: Bequeathed by William Page
 Wood, Baron Hatherley, 1881

National Portrait Gallery, NPG 648

9

Augustus Frederick was the sixth son of King George III. Because he was asthmatic, he was educated at the university at Göttingen and lived mainly in Italy in the 1790s. It was not only his ill health that kept him abroad, however, as his liberal political views and clandestine marriage to the Catholic Lady Augusta Murray in 1793 ensured his estrangement from the king, who declared his marriage void in 1794.

The prince had arrived in Rome in 1791, spent from December to April 1792 in Naples, and continued to divide his time between the two cities for much of the decade. James Bland Burges, Under Secretary of State in the Foreign Office, wrote to Sir William Hamilton in November 1791 concerning the prince's approaching visit to Naples, asking Hamilton to send him reports, fully and confidentially, of the prince's 'health, conduct and tendencies' in order to allay the anxiety of Queen Charlotte, who was particularly attached to him. When Prince Augustus arrived he had already formed a dangerous passion for Lady Anne Hatton, the mistress of the British Minister at Florence. Sir William duly reported this attachment to Burges, his efforts to thwart it, and how the prince was received at the Neapolitan court. The prince became very ill while in Naples but recovered and returned to Rome. When he met Lady Augusta Murray in that city later that summer, and Hamilton reported this news to Burges, the latter requested that Hamilton from then on send two letters – one that he could show the queen and the other for

Burges's superior, Lord Grenville (Bland Burges deposit, Bodleian Library, c.47, ff. 292, 397, 512).

Prince Augustus married Lady Augusta secretly in Rome in April 1793 and returned briefly at the end of that year to England, where his marriage ceremony was repeated and a son was born, but he was forced to return to Italy alone. He was still often ill:

Lady Plymouth found him 'far from well' and 'much alter'd' in Rome in August 1795 and most reports described him as growing more plump as he grew older (Sir Brinsley Ford Archive, Paul Mellon Centre). He held weekly *conversazioni* in Rome and from 1793 he was involved in the excavations at Campo Iemini with Robert Fagan. He was able to ensure that a number of the impor-

tant sculptures found there were sent to his brother, the Prince of Wales, in England. The loveliest of these was the *Venus*, comparable with the one in the Capitoline Museum, which King William IV eventually gave to the British Museum (Bignamini, pp. 548–52).

Prince Augustus wintered several times at Naples, where he was not only a great favourite at court but spent much of his time improving his voice under the instruction of music masters he shared with Lady Hamilton. Writing to Burges from Caserta, where the prince was staying with him in March 1795, Hamilton stated that

> The King and Queen of Naples love him as if He was Their own child & H.R.H. is certainly a good hearted young man – but without much judgement & perfectly bewitched by Ly Augt. M. who is by no means worthy of the regard he seems to have for her … H.R.H. is certainly much improved in health – but *entre nous* he has an odd way of crossing himself when he sets down to dinner – My idea is that he wishes it to be observed that it may alarm at home that he may be sent for. [Burges deposit, Bodleian Library, b.20, f. 12.]

As the French army approached, occasionally the diaries of Grand Tourists in Rome mentioned the prince's 'dangerously liberal views' and even 'depraved morals' (Lady Knight, *Letters*, 1905, pp. 206–10), and in June 1796 he left for Naples, where he was to remain for at least a year and a half. During his residence there, the Royal Neapolitan Club, composed of all the English noblemen and gentlemen travelling in Italy and resident some time at Naples, was formed under his auspices.

The prince was still at Naples in March 1798, but Hamilton wrote in June that, having no longer felt it was safe, he had sent the prince from Manfredonia to Trieste and that he should already have been through Vienna (British Library, Add. MS 41,200, f. 107). An old label on the present painting indicated that it was painted in Rome in 1798, but the painting itself is neither signed nor dated. The prince is shown standing, leaning on a plinth, and wearing the Windsor uniform (a dark blue coat with gilt buttons, scarlet collar and cuffs), decorated with the star of the Order of the Garter, the same uniform he wears in the Tischbein painting of the *Boar Hunt at Persano* (cat. no. 7).

Guy Head, a history and portrait painter originally from Carlisle, was in Italy by 1787 and was settled in Rome through the 1790s. He spent a great deal of his early career in Italy making copies of old masters 'with the View of forming a valuable gallery or Collection of Pictures, from those great Masters, for the Advantage of his own Countrymen' (sale Christie's, 13 March 1802). Other sale catalogues (27 February, 3 April and 26 May 1802) indicate that he had also amassed a large collection of important original old master paintings, as well as Greek and Etruscan vases and sculpture. Head was a good friend of Flaxman, whose portrait he painted in 1792, and they shared the patronage of Sir William Hamilton in Naples. At least two of the old masters Head copied were in Hamilton's collection, the Velázquez *Juan de Pareja* (fig. 36) and *Rubens's Wife*. He made several copies from the king's collection at Capodimonte, probably in the summer of 1797, when Sir William Hamilton obtained permission for him to draw around the area of Naples (Archivo di Stato, Napoli, Ministero Affari Esteri, f. 674, 3 June 1797, courtesy of I. Bignamini). He was still in Naples when William Artaud wrote in December 1797 saying he was expecting him in Rome shortly (Sewter, p. 277).

In February 1798, Head fled again from Rome back to Naples with his family, making doubtful the label on the verso of the present portrait – Head and Prince Augustus were not there at the same time that year. When Sir William Hamilton drew up his list of the paintings in the Palazzo Sessa in July 1798, it included a portrait of Prince Augustus in the Green Room (no artist's name given) and *Lady Hamilton with a Lamb* by Head in one of the bedchambers. Neither of these paintings was included in Hamilton's sales in 1801, but a small portrait of Emma by Head was engraved much later. Guy Head and his family and the crates with his paintings were evacuated by Nelson to Palermo at the same time as the Hamiltons and the Neapolitan royal family at the end of 1798, and Nelson secured the family's passage back to England in May 1799. Head painted Nelson receiving the French colours after the Battle of the Nile (National Portrait Gallery) at some time during this period in Naples or Sicily. In 1800 he exhibited a pair of history paintings and a portrait of Prince Augustus at the Royal Academy and purchased a large house in Duke Street, St James, where he intended to hold his exhibition of copies. He died unexpectedly in September, on learning of the sudden death of his daughter.

When Sir William and Lady Hamilton arrived back in London with Nelson late in 1800, Prince Augustus and Lady Augusta were among the first to visit them. The present portrait was engraved in stipple by Anthony Cardon and published by him in April 1801. A few months later the prince's second child by Lady Augusta was born, and in November Prince Augustus was raised to the peerage as Duke of Sussex in 1801. His encouragement of liberal policies embraced support for the abolition of the slave trade, Catholic emancipation and the repeal of the Corn Laws, and his encouragement of the arts and sciences led to his election as President of the Society of Arts in 1816 and of the Royal Society in 1830.

LITERATURE: I. Bignamini, 'The "Campo Iemini Venus" rediscovered', *Burlington Magazine*, CXXXVI, August 1994, pp. 548–52.

10 FILIPPO MORGHEN (1730–after 1777)
 and RAPHAEL MORGHEN (1758–1833)
 after FRANCESCO LIANI (fl.1765–77)

Portrait of Ferdinand IV, King of the Two Sicilies, 1777

Engraving, 39.8 × 29.9 cm (trimmed from
 41.5 × 30 cm)
Provenance: Part of a large collection of
 Morghen prints formed by Signor Paruli of
 Venice, purchased from Colnaghi's
British Museum, P&D 1843–5–13–603

Ferdinand IV ruled the Kingdom of the Two
Sicilies under a regency from the age of
eight until he reached his majority at sixteen
in 1767. The following year he married
Maria Carolina, the daughter of Empress
Maria Theresa of Austria, who was to make
up in intelligence and will to rule what her
husband was said to lack. Early ill health and
insanity had resulted in the deaths of Ferdi-
nand's uncle and brother and were to
appear in at least one of his sons. As a
countermeasure, his father had insisted on
an emphasis on sports and hunting in his
upbringing to the detriment of his educa-
tion. His skill in the former and lack of the
latter were notorious throughout Europe
and remarked upon by most British visitors
to Naples. Henry Quin's comments of 1787
are typical:

> The King of Naples & Jerusalem, (for he
> too as well as the King of Sardinia claims
> that empty Title) is acknowledged to be
> the best Billiard Player, the best Shot, the
> keenest Sportsman & the Greatest
> Blackguard of any crowned Head in
> Europe – He is the fittest Man in the world
> to be the King of the Laz[zaroni]; He talks
> the barbarous Neapolitan jargon
> [exceedingly] well, and it is no wonder,
> for it is his Custom at Caserte when the
> Weather permits his taking the field, to call
> out of the window & enter into familiar
> Conversation with every Blackguard that
> passes by – In the affairs of the State he
> takes no Share whatever; he seems to think
> *that* the last thing in the world a sovereign
> should meddle with – Of course the

Queen's Influence in these matters is very
considerable – He leaves the management
of them entirely to her – 'Fate voi' he says
to her on all occasions – With the
Qualifications & Accomplishments above
mentioned it is no wonder he should be
popular – Whether he be equally so
amongst the enlightened part of his
Subjects it is not so easy to determine – As
he holds all outward appearances in as

FIG. 60 F. Morghen after F. Liani, *Ferdinand IV at
the age of eight*. Engraving, 1760. British Museum,
P&D Bb–3–18.

much contempt as his worthy and
mahogany-coloured Father it is presumed
he spends less money on Velvets and
Embroidery than on Powder or Shot … he
appears to be a large Man, with hair almost
white, and the true Hispanic-Bourbon
Nose, which is not of the smaller kind.

However, the comments of the perceptive
first Lady Hamilton about the king provide
an enlightening antidote to the usual tourist's
impression:

> The King … has neither education or Art,
> it is a thousand pitys he has not the former

for he *deserves* it, his heart is excellent & his
head by no means deficient, on the
contrary he has an uncommon deal of
quickness, he is sincere, constant in his
friendships, benevolent, a natural
disposition to justice, and his love to please
is genuine … he cannot bear a lie nor does
he ever forget the Man whom he has
caught in one; he has a great regard for the
Queen, & She has some weight with him,
but he sees a good deal into her character,
& will have his own way. [Anson, p. 146]

Ferdinand IV remained on the throne of
Naples until his death in 1825, with two
interruptions when the French invaded in
1799 and 1805. Hamilton was the British
envoy to his kingdom for a large part of his
reign, during which time he accompanied
him on countless hunts in addition to at-
tending him at court, and he recognised the
king's efforts to continue the cultural re-
forms begun by his father, even though he
could not always respect his ability as a ruler.

In 1760, shortly after his arrival in Naples,
Filippo Morghen made an engraving after
his father-in-law Francesco Liani's portrait
of Ferdinand IV, who had been left on the
throne of Naples in October the previous
year at the age of eight (fig. 60). He was
shown half length, wearing a cuirass and the
Order of the Golden Fleece, his waist draped
with ermine. In 1777, Filippo's son Raphael
reworked the same plate to make the present
print, cancelling and re-engraving only the
head and neck of the king to show him as
he appeared that year, aged twenty-six, and
thus creating a pair to his own engraving of
the queen in the same format (cat. no. 11).
Raphael Morghen himself was only nine-
teen and the following year went to Rome
to work with Giovanni Volpato, where he
made prints of three of the paintings in
Hamilton's collection (cat. nos 171–2) and
was to become one of the most prolific and
best known of Italian engravers.

LITERATURE: Diary of Henry George Quin, III
(original diary in possession of Cormack Quin,
Esq., in 1964), Trinity College Dublin, Mic.
32–ff. 96–9.

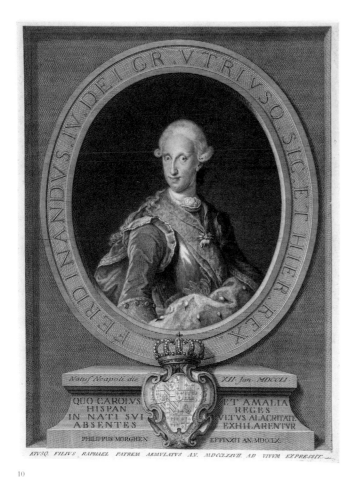

10

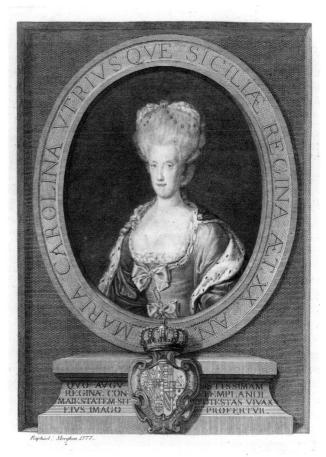

11

II FILIPPO MORGHEN (1730– after 1777)
and RAPHAEL MORGHEN (1758–1833)
after FRANCESCO LIANI (*fl.*1765–77)

Portrait of Maria Carolina, Queen of the Two Sicilies, 1777

Engraving, 41.7 × 30 cm

Provenance: Purchased from Colnaghi's as part
of Paruli's collection of Morghen prints

British Museum, P&D 1843–5–13–612

In 1777, Raphael Morghen re-engraved his
father's 1760 portrait of Ferdinand IV (cat.
no. 10) and created a pair to it, in the same
format, of Queen Maria Carolina. Accord-
ing to the inscription around the image, the
original painting by Liani on which it was
based shows her at the age of twenty. She
wears an ermine-lined mantle over a dress
decorated with bows and pearls and her hair
is swept up over a cushion and ornamented
with jewels, one lock falling over her shoul-
der in the same manner as her husband's.
Like the plate of Ferdinand IV, the head and
neck of this plate were later reworked to
show her slightly older, her hair decorated
with roses and dressed in the fashion of
about ten years later.

Maria Carolina was the daughter of Em-
press Maria Theresa of Austria, and the sister
of Marie Antoinette of France, and of Leo-
pold, Duke of Tuscany, who later inherited
the Austrian throne. Through her marriage
to his son, Charles III of Spain was able to
unite the great Bourbon and Habsburg dyn-
asties, which had frequently been at war
during the previous century. However,
Maria Carolina was as strong a ruler as her
mother and brother and worked through-
out her reign to weaken the Spanish Bour-
bon domination of the Kingdom of the
Two Sicilies and create an independent
kingdom with strong ties to her own Habs-
burg dynasty, arranging marriages of several
of her numerous children to their Habsburg
cousins. She was very close to her sister
Marie Antoinette, but hated the French
with a passion which only increased after
her sister's death. She was responsible for

Ferdinand's ignominious attempt to liberate Rome from the French in 1798 and for the harsh reprisals carried out against the rebels in Naples in 1799.

Emma Hamilton was flattered to be accepted into the queen's close circle after her marriage to Sir William, and Maria Carolina found her a useful conduit to Hamilton and later to Nelson. The first Lady Hamilton, however, disliked court life and was less susceptible to flattery. Of the Queen of Naples she wrote:

I know her Majesty's disposition too well to place any confidence in any encouragement she may please to give me … she is quick, clever, insinuating when she pleases, hates & loves violently, but her passions of both kinds pass like the Wind, she is *too* proud, & *too* humble, there is no dependance on what she says, as she is seldom of the same opinion two days, her strongest & most durable passions are ambition and Vanity, the latter of which gives her a strong disposition to Coquetry, but the former, which I think is her principle Object, makes her use every Art to please the King, in order to get the Reins of Government into her hands in as great a measure as is possible. With all of this she is an excellent Mother, & is very generous & charitable, did you ever know such a compound! [Anson, pp. 145–6]

12 MARIANO BOVI (c.1740–1805) after ANGELICA KAUFFMAN (1741–1807)

Ferdinand IV, King of the Two Sicilies, and the Royal Family, 1790

Stipple engraving, 47.5 × 58.1 cm
Provenance: Purchased from Colnaghi's
British Museum, P&D 1871–12–9–617

Illustrated on page 31, fig. 10

After Angelica Kauffman married the Italian decorative painter Antonio Zucchi (1726–95) the couple decided to live in Naples, arriving there in 1782. She painted a large oval composition representing Penelope working with two maidens, which she gave to Sir William Hamilton, presumably by way of thanking him for the assistance he had lent her in Naples, either by obtaining for her permission to copy in the Royal Collection (a service he was often called upon to perform for British artists) or for helping her to find Italian patronage in that city. Her list

of works executed in Naples during the summer and autumn of 1782 indicates that her new patrons were all members of the court circle.

Kauffman's most important commission of the five months spent in Naples in 1782 was from the queen for a large portrait of the entire royal family. She began by painting each individually and, when she decided to set up house in Rome rather than Naples, she took these studies with her in December 1782. Two years later, having completed the large work in her studio in Rome, Kauffman delivered it herself as requested to the queen in Naples. This enormous (310 × 426 cm), extremely flattering painting, which could not fail to please, still hangs in Capodimonte. It brought her a further royal commission, from Joseph II, Emperor of Austria and brother of Queen Maria Carolina.

The Bourbon features of King Ferdinand IV are almost unrecognisable and Queen Maria Carolina's face is much more flattering than most portraits of her (cat. no. 11). In her 'Memorandum of Paintings' Kauffman described the figures as life-size:

… in one big picture, representing a pedestal with antique vase in a garden with boscage. The King is standing and is supposed to have just returned from the hunt, the Queen is sitting encircled by her children. Beside her is a sort of cradle or a children's small cart. Princess Maria Teresa is playing the harp, Princess Donna [Maria] Luisa is sitting on the said cradle and is holding in her arms the infant child Princess Maria Amelia. The Prince Royal, Don Francesco, is standing beside his father and playing with a grey hound; Princess Donna [Maria] Christina is leaning on the Queen and Prince Don Gennaro, is sitting on a cushion playing with a canary which he has tied by a ribbon so as to let it fly. There are also two hunting hounds. All the Royal Family are dressed simply and the whole picture portrays a rural scene. [Manners and Williamson, p. 145].

Mariano Bovi's stipple engraving of Kauffman's painting was published on 18 December 1790. It may be significant that Hamilton's list of correspondents for that year (Bodleian Library, Eng MS g.16, f.26) indicates that on 4 May he wrote to Kauffman and on 3 August to Mariano Bovi. In 1802, Bovi issued a *Catalogue of Prints* which included paintings and drawings as well as

prints, which were all on display for sale in his Exhibition Room in Piccadilly (British Library, Add. MS 33,397, ff. 183–90). No. 118 in the catalogue was a drawing by Bartolozzi 'after Kauffman's Royal Family of Naples', probably for the present print, and no. 159 was a 'painting of the Royal Family of Naples by Kauffman', an indication that she herself had made a copy of this important work and may have had publication as a print in mind from the beginning. The print of this painting by Bovi was listed among those for sale, as no. 8, and the price, in colours, was £2.12.6, the fourth most expensive print in the stock-list of 151 items.

LITERATURE: Manners and Williamson, pp. 59–61, 142–3, 145. We are grateful to Antony Griffiths for informing us of Bovi's 1802 catalogue.

13 FRANCESCO BARTOLOZZI (1727–1815) after C. MARSIGLI (fl.1773–97)

Sir John Francis Edward Acton

Stipple engraving, 57.1 × 40.9 cm
Provenance: Archive Engraving Collection, accessioned in 1908
Trustees of the National Portrait Gallery, D 7112

John Francis Edward Acton (1736–1811) was born in Switzerland where his English father had settled. He served in the French navy before joining his uncle, Commodore Acton, who commanded the Tuscan fleet. The light, swift ships Acton designed were so successful that in 1778 the Queen of Naples asked her brother Leopold, the Grand Duke of Tuscany, to send Acton to help improve the king's navy. Queen Maria Carolina was impressed with his self-assurance and ability to cut through the corruption in Naples and in 1779, on presenting his plan for reorganising the navy to the king, he was appointed Secretary of State for the Marine, with the rank of Lieutenant General. Sir William Hamilton found in him a friend and ally, and, describing him as still 'an Englishman at heart', he also found a source of useful military and naval intelligence: it was Acton who enabled him to inform the British Foreign Office that Charles III of Spain, the father of King Ferdinand, was intending to declare war on Britain in 1779, and it was Acton who helped

persuade the King and Queen of Naples not to join Spain.

Soon afterwards Acton was appointed Minister of War and Finance as well as the Marine; adept at saving money as well as reorganising the army and navy, building roads and hospitals, he was a firm favourite with the king and queen. After the failure of a plot by the King of Spain and his ambassadors to oust Acton in 1783, he was made a Chevalier of the Order of San Gennaro. Eventually, in 1788, he was also made Minister of Foreign Affairs and the following year became chief minister. In his study of this period of Neapolitan history, Harold Acton wrote: 'For twenty-five years Acton had held all the reins, and his omnipotence at Naples had become proverbial. Though never popular, he was feared and respected. "Always a minister and never a man, he lived aloof and never climbed any stair but that of the royal palace"' (Acton, p. 489, citing Blanch).

At Castellammare, further around the bay from Vesuvius, Acton modernised the shipbuilders' yard to such an extent that it vied with the Arsenal at Venice, eventually constituting a fleet of around 150 ships. The naval yards are shown in the background of this print, but were commemorated more elegantly in four large watercolours of the yards commissioned from Ducros by Acton and still with his descendants. Ducros also painted for Acton a splendid view (with Hazlitt, Gooden and Fox, London, 1990) of his villa seen from the gardens in the hills behind, which is just visible behind Acton's gesturing hand in the present print. When Lady Palmerston visited Naples in the 1790s, she described his villa as a magnificent palace 'fitted up with every kind of elegance and comfort, and the best things of France and England are here to be found'; dinner 'had all the splendour of a prince's entertainment with the ease of a private dinner. He himself is a thin genteel looking man; not handsome, but neat and quiet and gentlemanlike' (Connell, pp. 281, 300).

In 1792, Acton's cousin, a British baronet, died, leaving Acton his title and his seat in Shropshire. During the last ten years of his life Acton became more British in his sympathy than he had ever been. In 1795 he was made Grand Chancellor, still in charge of foreign affairs, and in 1799, in exile with the court in Palermo, he was Prime Minister of Sicily. But he was sixty-three and ready to

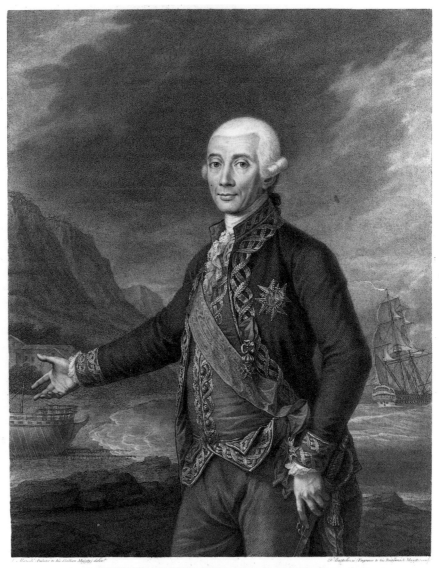

JEAN EDOUARD ACTON.

Chevalier de l'Ordre Royal de St. Janvier, Lieutenant Général et Directeur de la Marine, Conseiller et Secrétaire d'État de Sa Majesté Sicilienne, ayant le Département des Affaires Étrangères, de la Guerre, de la Marine, et du Commerce, &c. &c. &c.

13

give up any role in government. Although he had never set foot in England, the family seat and title he had inherited were there and it was there that he wished to retire. In 1800, in order to ensure the continuance of the baronetcy, he married his thirteen-year-old niece with papal dispensation. Again he asked to retire to England, but by then the king had great affection and confidence in this minister who had served him for so long and would not let him go. Eventually, in 1804, the queen forced his resignation on

the king and Acton retired to Palermo with £6,000 a year. Only two years later the royal family would themselves be forced to retire to Palermo. Acton's two sons and daughter were born in 1801, 1805 and 1806, and he died in 1811, aged seventy-five.

LITERATURE: De Vesme and Calabri, no. 745; Acton, reproduction p. 238 and *passim*; for Ducros's paintings, see Chessex, 1985, nos 77–9, and *Shadow of Vesuvius*, pp. 90, 119–20.

14

14 DOMINIQUE VIVANT DENON
(1747–1825)

Le Corps diplomatique à Naples,
1784

Etching, 14.9 × 17.1 cm
Provenance: Purchased from Mr Daniell
British Museum, P&D 1871–8–12–2140

Vivant Denon was to become Director of
the National Museums in France, respon-
sible for the installation in the Louvre of the
treasures brought by Napoleon from all over
Europe. From 1772 until 1785, however, as
Chevalier de Non, he was a diplomat in the
service of Louis XV and later Louis XVI.
He came from the minor nobility of Bur-
gundy (the Revolution was to change de
Non to Denon), and combined great intel-
ligence and charm (especially to women)

with a passionate devotion to the arts, form-
ing his own collection. His first diplomatic
post had been to the court of Catherine the
Great at St Petersburg, where he met
Diderot; from there he was sent on missions
to Stockholm and then Geneva, spending a
week with Voltaire in Ferney *en route*.

From 1777 to 1779 Denon undertook a
long journey through Sicily, Malta and
Calabria in order to supervise a group of
artists and to provide a travel diary for a
publication being prepared by J. B. de
Laborde and the Abbé de Saint-Non – the
*Voyage Pittoresque ou Description des Royaumes
de Naples et de Sicile* (1781–6), one of the
most celebrated books of the eighteenth
century (Griffiths, pp. 408–11). He applied
for and took up his post as secretary to the
French embassy in Naples in the spring of

1779. When the ambassador left in 1782 he
became chargé d'affaires.

It was a very difficult time to be a French
diplomat at the court in Naples. The queen
and her new favourite, John Acton (cat.
no. 13), were working together to pull
Naples away from its political dependence
on the Bourbon court of the king's father in
Spain. The latter was pushing Ferdinand IV
to join the Spanish and French in the war
against Britain, but the queen was deter-
mined to forge connections with her own
Habsburg family and inclined strongly to-
wards the British for assistance; both she and
Acton were very anti-French. When Denon
reported the queen's indiscretions with
various young political advisers a little too
assiduously to his superiors in Paris, he earned
himself a reprimand – the queen's sister was

Marie Antoinette, and reports that dealt too much with gossip about her personal affairs were not welcome in dispatches that might reach royal eyes in France.

A situation which was delicate to begin with soon became difficult and even insupportable. When a French ship arrived in the harbour in 1782, Acton found a reason to accuse Denon of using one of the queen's ladies to gain information, and early in 1784 he found himself, along with the French consul and Spanish ambassador, removed from guest lists for certain functions. Cardinal de Bernis, the long-serving, well-respected French ambassador to the Holy See at Rome, was dispatched to Naples to calm the situation in the summer of 1784. The presence of the rotund cardinal in this etching which depicts the *corps diplomatique* at Naples indicates that it was drawn during his visit to the Neapolitan court. The carefully regulated diplomatic formalities are observed with some humour and skill, Bernis standing benignly in the centre between a young man who may be Denon on the right and the tall bowing figure of Sir William Hamilton on the left, the representatives of other European courts around them.

De Bernis seems to have persuaded Denon to resign his diplomatic post, as he sent a request to be recalled for personal reasons shortly afterwards and in 1785 the new French ambassador to the court of Naples, Baron de Talleyrand, finally arrived. Denon returned to a pension in Paris and in 1787 he was received into the Académie de Peinture as an engraver. A year later he left for Venice, where he remained until events in Paris forced him to return at the end of 1793. He returned to prevent his estate being confiscated as Emigré property, but J.-L. David vouched for him and found him employment engraving republican costumes. In 1798 he joined Napoleon's expedition to Egypt and began his brilliant career as an administrator of arts.

LITERATURE: Chevallier, pp. 104–21; Chatelain, pp. 31–56; Antony Griffiths, 'The contract between Laborde and Saint-Non for the *Voyage Pittoresque de Naples et de Sicile*', *Print Quarterly*, V, 1988, no. 4, pp. 408–14; P. Lelièvre, *Vivant Denon Homme des Lumières, 'Ministre des Arts' de Napoléon*, Paris, 1993, pp. 27–48, 55–62.

15 DOMINIQUE VIVANT DENON (1747–1825)

Sir William Hamilton, c.1784

Black chalk, pen and brown ink, 10.8 × 9.5 cm
Provenance: One of a group of drawings assembled by a member of artist's entourage; sale Christie's, 4 July 1989, lot 163, purchased by present owner
Private collection

Although there is no correspondence between Denon and Hamilton, they must have known each other during Denon's diplomatic posting in Naples between 1779 and 1785. The two men had much in common; both were steeped in the classics, were connoisseurs of the arts, had made a study of antiquities and collected in similar fields. On his tour of Calabria and Sicily, Denon had been able to amass a large collection of vases: 'La découverte d'un vase grec ou d'un vase quelconque de forme nouvelle me paraissait un service signalé que je rendais au bon goût. Je revins en France si chargé de poteries que je ne savais où les placer' (The discovery of a Greek vase or of some vase of a novel shape seemed to me a singular service which I could render to good taste. I returned to France so laden with ceramics that I didn't know where to put them). He judged his collection 'fort considérable et peut-être la plus complète qui existe pour les formes' (very considerable and perhaps the most complete so far as shapes are concerned) (Chatelain, p. 51). He sold his collection to the king on his return to France.

Denon was a compulsive draughtsman, making hundreds of small drawings and etchings, including one after this sketch which seems to be a study for the *Corps diplomatique* (cat. no. 14).

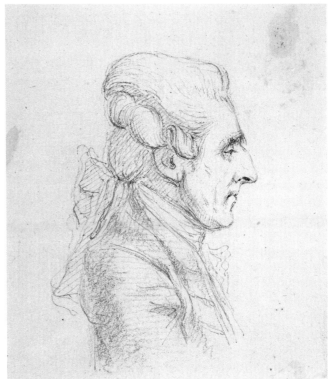

15

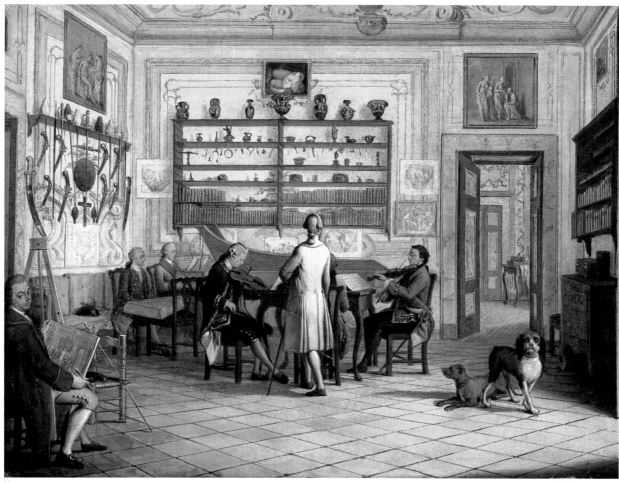

16a

16 PIETRO FABRIS (*fl.*1756–84)

a) *Lord Fortrose at Home in Naples:
Concert Party*, 1771

b) *Lord Fortrose at Home in Naples:
Fencing Scene*, 1771

Both oil on canvas, 35.5 × 47.6 cm
Inscribed on verso: *P. Fabris p.1771*
Provenance: By descent from Lord Fortrose's
 daughter, Caroline, Comtesse de Melfort;
 purchased in France by Jocelyn Fielding Fine
 Art Ltd, London; purchased 1984 by the
 National Galleries of Scotland with assistance
 from the National Art Collections Fund
Scottish National Portrait Gallery, Edinburgh,
 PG 2610–1

Kenneth Mackenzie (1744–81) was the
grandson of the 5th Earl of Seaforth, at-
tained in the 1716 Scottish rebellion. He
had spent a year abroad with a tutor when
only ten and was in Naples ten years later
before returning to Britain in 1764. He be-

came Viscount Fortrose when he was given
an Irish peerage in 1766. His first wife died
in 1767 and he returned to the Continent.
He toured Sicily with William and Catherine
Hamilton and Pietro Fabris from April to
July 1769. In May 1770, Catherine Hamil-
ton organised a concert where Leopold
Mozart and his son Wolfgang Amadeus
played to an assembly of Scots in Naples,
and in November that year Charles Burney,
along with the Hamiltons and others,
attended a 'sumptuous musical feast' arranged
by Lord Fortrose at which the castrato
Caffarelli and the violinist Emanuele Barbella
entertained (Scholes, *Burney*, pp. 281–2).
Receipts from the violinist survive in
Hamilton's papers, indicating that Hamil-
ton had paid him to attend his own musical
accademia in January 1768 and January
1770 (British Library, Add. MS 40,714,
ff. 38, 99).

Hamilton must have found Lord Fortrose
one of the most sympathetic visitors ever to

stay in Naples. Charles Burney saw Fortrose's
collection of Greek vases, medals, cameos,
intaglios and pictures, many of which are on
display in the room depicted, and he des-
cribed Fortrose as 'a lively, sensible and
accomplished young nobleman, – with a
person very manly and pleasing; he has great
talents and taste – He both draws and paints
very well, understands perspective, rides,
fences, dances, swims and plays the harpsi-
chord' (Scholes, *Burney*, p. 267). He was an
amateur artist of some note, and gave paint-
ings to several friends, including William
Hamilton, who noted *A Rising Sun* by Lord
Fortrose on his list of paintings in the
Palazzo Sessa.

The way of life and surroundings in the
residences of Fortrose, Hamilton and other
British visitors to Naples is portrayed more
clearly in these two small charming paint-
ings by Pietro Fabris than in countless letters
and journals. Fabris included his own self-
portrait in the corner and seems to have

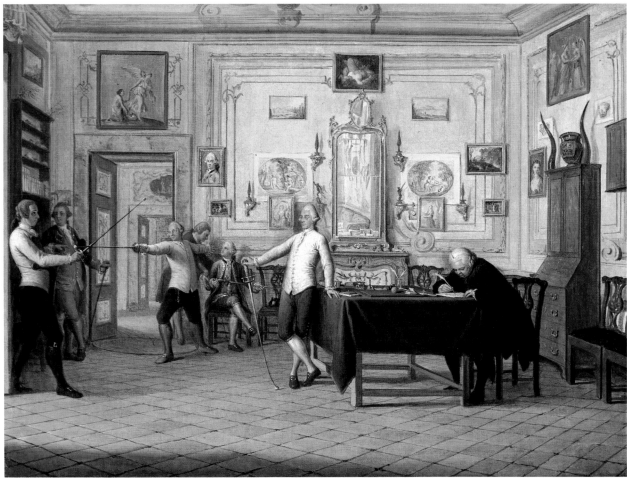

16b

conflated a number of events and visits during the year 1770 into these two paintings of a single room in Lord Fortrose's apartments in Naples. The same room is seen from either end: sunlight falls from a window on the side of the room and the mirror in the one painting reflects the couch and weapons in the other. The weapons and their protective green bags, hanging so prominently in the musical painting, become the principal subject of the other, and the empty couch in the mirror in the fencing image is filled by the most important guests in the musical scene. Leopold Mozart is shown playing the harpsichord while his son, reading from the same music, plays a small octave spinet (letter from Grant O'Brien, University of Edinburgh, 3 December 1991 in Scottish National Portrait Gallery files). Sir William Hamilton, in a brown coat with gold braid, plays the violin, accompanied by a man in blue who may be Barbella, while the gentleman in the white coat with his back

to the viewer may represent Lord Fortrose; he is certainly portrayed as the central figure facing us in the fencing scene. The latter includes three men who are probably, by their dress, British Grand Tourists. The lower edge of the frame of the mirror over the mantelpiece is filled with visiting cards. The man writing at the green-covered table provides a further link between the two images of the same room, since he has been identified as the composer Nicolò Jomelli (notes by James Holloway in Scottish National Portrait Gallery files).

The paintings on the walls include copies of wall paintings found at Pompeii and Herculaneum, and two Correggio-like paintings of Venus and Cupid hang high in the centre of each room. The red chalk-like works have been identified as either drawings or prints after Gavin Hamilton's *Oath of Brutus* and his *Allegro* and *Penseroso* (letter from Martin Hopkinson, Scottish National Portrait Gallery files). The large engravings

tacked up either side of the mirror are after scenes by Francesco Albani (Lambert, p. 180). The small portraits in the fencing scene can be assumed to be pastels of Fortrose and his wife, and the three small watercolours or bodycolour views of the Bay of Naples in the same painting are no doubt Fabris's own work. Although the manner in which the walls are panelled and painted is very close to that in Hamilton's Palazzo Sessa, the arrangement of the paintings, prints and drawings does not reflect that in Hamilton's residence, as they are hung in a manner here which indicates that this is a temporary residence, albeit one in which Fortrose remained for over three years.

The shield hanging with the guns and rapiers on the left wall of the musical scene is painted leather, and is similar to the 'Gothic' shields 'for tournaments, painted by Polidore' which Hamilton sent to Horace Walpole to hang in the Armoury at Strawberry Hill in 1774 (*Wal. Corr.*, XXXV, p. 419;

one is now in the Museum and Art Gallery, Glasgow). The vases displayed on the wall bracket are of the type William Hamilton was collecting at this time, and perhaps even more interesting is the collection of bronze figures, lamps, candlesticks, stirrups and other objects of everyday life from antiquity displayed on the upper shelves. This appears similar in type, although not quantity, to Hamilton's collection purchased for the British Museum in 1772. The case by the door on the left of the fencing scene contains rock samples, and the feathery items at the corners might be coral.

Lord Fortrose, who was already a member of the Society of Dilettanti (see cat. no. 52), returned to London by the end of 1771 when he was created Earl of Seaforth, and became a Fellow of the Society of Antiquaries. His second wife also predeceased him and he raised the first regiment of Seaforth Highlanders in the late 1770s. He was sailing with them to India in 1781 when he died. Before he left for India he sent a cameo, the subject of which was 'not fit for a lady', to Greville to send to Hamilton to sell for 400 guineas or to keep (see cat. no. 73).

LITERATURE: F. Powell-Jones, 'A Neo-Classical interior in Naples', *National Art Collections Fund Annual Review*, 1985, pp. 104–7; Scholes, *Burney*, I, pp. 267, 281–2; Hawcroft, no. 88; S. Lambert, *The Image Multiplied*, exh. cat., Victoria and Albert Museum, London, 1987, pp. 164, 180.

17 ARCHIBALD ROBERTSON (*fl.*1765–75) after PIETRO FABRIS (*fl.*1756–84)

A View of the Ruins of a Palace built for Queen Joan II

Published June 1778, from a set of *Views in and near Naples*, by Paul Sandby and Archibald Robertson, 1777–82
Aquatint, 32 × 55.5 cm
Provenance: Purchased from Mr Daniell
British Museum, P&D 1865–6–10–964

This view shows the Villa Emma, with the Palazzo Donn'Anna (here called Palace of Joan II) behind. Like the Palazzo Sessa and the Villa Angelica, the Villa Emma still exists, although it is the most altered and dilapidated of the three. It was visible from the famous bow window of the Palazzo Sessa, and easy to locate by its proximity to the large ruin of the Palazzo Donn'Anna jutting out into the sea. Presumably named after Emma sometime after her arrival in 1786, it was previously used by Hamilton and his first wife almost from the beginning of their arrival in Naples. David Allan's charming painting of 1770 of the two of them seated in a room with a view of Vesuvius across the bay (cat. no. 129) was obviously painted in the room off the semicircular balcony clearly visible in this print after Fabris (see also cat. no. 23). When Hamilton first began to use the villa it was called the Casino di Mapinola, but it was later known to British travellers simply as Hamilton's Casino at Posillipo. The cliffs of Posillipo rose directly behind it and it was the furthest point a carriage could reach from Naples. The villas further along the coast were reached by boat or by travelling over the top of the cliffs. The balcony was built on part of a natural rock arch, through which passage was possible on foot to the so-called 'Palace of Queen Joan 2nd', which was in fact a building begun for Donn'Anna Carafa, wife of the Spanish viceroy, the Duke of Medina, *c*.1642, but left unfinished in 1644.

Hamilton was a passionate observer of all

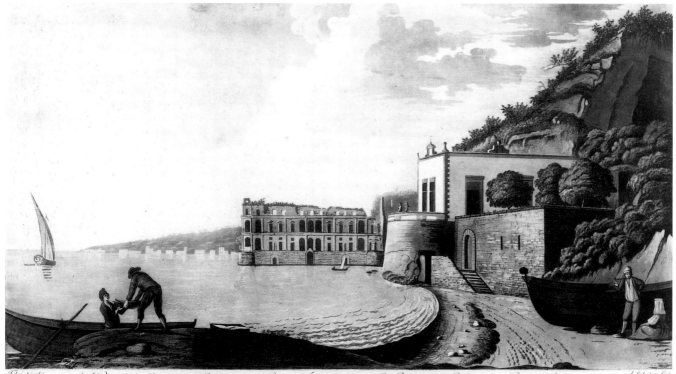

Fabris pinx. A View of the Ruins of a Palace built for Queen Joan 2.ᵈ Les Ruines du Palais de la Reine Joanne II. *A.Robertson fecit*

Publish'd by A.Robertson as the Act directs June 1778.

17

the productions of nature and in 1774 wrote that he had been able to make a 'little Picina in a rock near my villa at Pausillipo, where the sea water has free ingress & egress, by which I have the means of examining the manners of so many curious sea productions … if I had more time to partake of these experiments, I am sure very great discoveries might be made.' Six years later, when Hamilton had been in Naples for seventeen years, he still found it a 'bewitching place': when the court was at Naples in the summer, he and Lady Hamilton were able to dine every day at their *casino* at Posillipo 'where it is as cool as in England. Spring and autumn we inhabit our sweet house at Portici … and in winter I follow the King to Caserta' (Morrison, nos 36, 92).

Hamilton later renamed it the Villa Emma, and it was described by several visitors, who remarked most frequently on the magnificent view, ideal for watching the incendiary displays provided by Mount Vesuvius. One visitor was so enchanted with his visit that he recreated the villa and even the volcano on his return: in the English garden he was creating at Wörlitz, the Prince of Dessau built a small 'Villa Emma'

on the slopes of a remarkable volcano, rising out of a rustic grotto he constructed on the bend of a river flowing through the grounds. Once a year the cone of the volcano erupted in a spectacular display of fireworks (fig. 61).

The grottoes along the coast provided sites for picnics for Neapolitans and Grand Tourists alike, and Fabris was best known for his paintings, in bodycolour and in oil, of these entertainments in the grottoes of Posillipo (see cat. nos 148–9). Hamilton owned two large oils of these *bambocciate*, one a 'View of Pausilipo, with Figures dancing the Tarantella' and 'Its Companion, with the Ruin of the Palace of Donna Anna, vulgarly called Queen Joan's Palace at Pausilipo' (sale Christie's, 17 April 1801, lots 91–2). A painting similar to the latter was presumably the source of this aquatint, enlivened here by a boatman delivering what appears to be a large book, and by two figures on the balcony of the villa.

18 ARCHIBALD ROBERTSON (*fl.*1765–77) after PIETRO FABRIS (*fl.*1756–84)

A View near the English Minister's House at Naples

Published June 1778, from a set of *Views in and near Naples*, by Paul Sandby and Archibald Robertson, 1777–82
Aquatint, 33.4 × 58.3 cm
Provenance: Purchased from Mr Daniell
British Museum, P&D 1865-6-10-963

This aquatint, and the three others after Fabris catalogued here (cat. nos 17, 149a–b), are from a series of twenty-four published by Paul Sandby and Archibald Robertson between 1777 and 1782. Sixteen of them were issued first in 1777, mainly the work of Paul Sandby, who had made the first aquatints produced in Britain in 1774; the expanded series of twenty-four came out in 1782. His early aquatints contained a substantial amount of etching, but these views from Naples from only a few years later are almost pure aquatint. This method was justly celebrated as the most effective way of reproducing watercolours in print form; Sandby was proud of this achievement and exhibited two from the series at the Royal Acad-

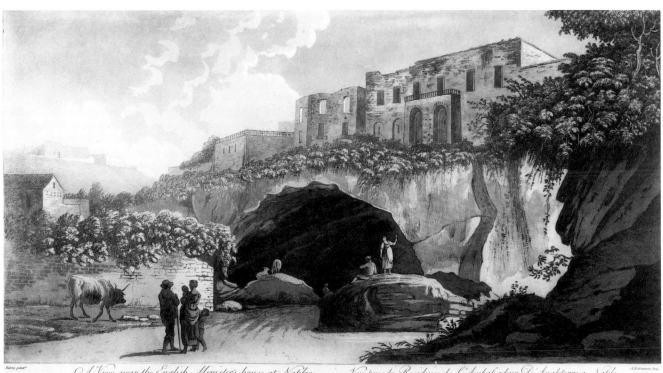

Fabris pinxt. A View near the English Minister's house at Naples. Vue pres la Residence de L'Ambassadeur D'Angleterre a Naples. A Robertson fecit.

Publish'd Jan.r 25th 1782 by A Robertson Charles Street, Street St. James's Square.

18

emy in 1777. The exact contents and titles of the groups of sixteen and twenty-four views produced by Sandby and Robertson is unclear (Abbey, pp. 140–43), but they were obviously a success with armchair travellers and collectors, inspiring Sandby to purchase David Allan's drawings of the Carnival at Rome, from which he made a further series of four prints.

The grotto in the present aquatint was a large and famous one inside the Pizzofalcone, within the grounds of the convent of Sta Maria Capella, next to the Palazzo Sessa. It was so large that it was used by rope-makers. Lord Herbert described a door in Sir William's first courtyard, 'which leads through a very long passage to the spinning grotto, so called from there being a considerable number of people occupied in this place in spinning [rope]. It is only an excavation to furnish materials for building, but its being large and elevated offers a majestic appearance' (Herbert, 1939, p. 235). The scale provided by Fabris, with the size of the buildings and figures in front of the opening, is deceptively inadequate, as is evident from other contemporary views of the grotto. Thomas Jones painted it in the summer of 1783, when Hamilton let him use the billiard room in the Palazzo Sessa as a studio. In his *Memoirs*, Jones wrote that the view provided him with 'fresh opportunities of copying Nature, particularly One fine Object, which was an immense Cavern cut out of the Rock of the *Pizzi Falcone*, and which I

had a full view of from the Windows, together with the Buildings above' (p. 122; see the oil sketch now in the Vivian Art Gallery, Swansea).

LITERATURE: J. R. Abbey, *Travel in Aquatint and Lithography 1770–1860*, I, repr. 1972, Folkstone and London, pp. 140–43; see Dibbits, no. 6 for a reproduction of Ducros's drawing of the grotto interior with people making rope.

19 THOMAS JONES (1742–1803)

Houses in Naples, 1782

Oil on paper, 25.4 × 38.1 cm
Inscribed on verso: *Naples August 1782 TJ*
Provenance: Artist's descendants until 1954;
 Christie's, 2 July 1954, lots 21–3,
 bt Colnaghi's, from whom purchased
British Museum, P&D 1954-10-9-12

The *Memoirs* of Thomas Jones provide one of the most entertaining and informative accounts of the life of British artists in Italy in the eighteenth century. Jones had studied with fellow Welsh landscape painter Richard Wilson in London and exhibited forty paintings at the Society of Artists before joining the growing list of landscape and portrait painters who felt they could not be successful without a period of study in Italy. Arriving in Rome in December 1776, he was conducted to the English Coffee House by the Scots *cicerone* James Byres, but set up his bank account with Byres's rival antiquarian Thomas Jenkins.

By March 1780, Jones had ceased to receive commissions from the British in Rome, and suspected that he had managed to offend both Byres and Jenkins, upon whom artists relied for contacts with and commissions from potential British patrons. He felt it would be prudent to move to Naples, where there was less competition and where he might obtain the patronage of Sir William Hamilton. A letter of introduction ensured he was received courteously at the Minister's *levées*, but Sir William did not visit his studio in return. The *cicerone* James Clark was cool towards him, and Jones suspected that Byres's animosity was being extended through this fellow Scot and friend of Byres. When potential clients from Rome who had seen Jones's work there asked to be directed to Jones's studio in Naples, Clark denied any knowledge of him. Jones gave up all hopes of Sir William's patronage and concentrated on painting large oils to attract buyers, and on painting from nature to improve this work.

Jones had found a studio not far from the Palazzo Sessa where a *lastrica*, a flat roof surrounded by parapet walls, provided views over the city and where he spent many hours painting finished studies from nature in oil on primed paper. These studies are so fresh and vivid in their light and colour and snapshot approach to composition, that they are much more attractive to modern taste than Jones's large finished oils and have been coveted ever since they were 'rediscovered'

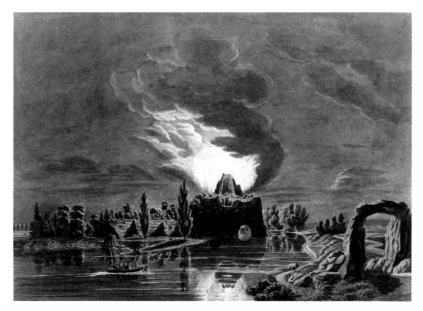

FIG. 61 Carl Kuntz (1770–1830), *Der Stein zu Wörlitz*. Etching and aquatint, *c*. 1796. A view of the 'volcano' built for the Prince of Dessau. Wörlitz, Staatliche Schlossen und Gärten.

19

in the 1950s. When Sir William eventually did visit Jones's studio, in August 1782, the month in which this study of Neapolitan houses near the Palazzo Sessa was painted, he may have seen these sketches, but they would have been viewed as merely part of the artist's working process and would not have been for sale. Sir William complimented Jones's efforts and lent him a copy of the *Campi Phlegraei*.

Visiting the Camadoli a few months later, Jones decided to paint the extensive view from the convent there as described in plate XVII of the *Campi Phlegraei* 'on a grand Scale' on a 'Cloth 7 palms by 5, particularly prepared with a white ground for the Purpose'. In April 1783, Sir William saw it almost finished and bespoke it for £50; a few days later he took Jones to Posillipo to see a palm tree there which he wished to have introduced into the view. The next month, Jones's offer to accompany Sir William to Calabria to see the extent of the earthquake damage was declined, but Sir William kindly offered Jones the use of the billiard room in

the Palazzo Sessa as a studio for the last month or two of his stay in Naples, and provided him with assistance in wrapping his canvases for the return journey to England. Jones received 135 ducats in part payment for the *View of the Campi Flegrei from the Camaldolise convent near Naples*, the remainder to be paid in England, where the painting was to be conveyed by Jones. This painting does not appear in any of the lists of contents of Hamilton's collection and its present whereabouts are unknown. However, a small *Sunset View of Lake Albano*, which Jones had painted for Count Dillon but which was never claimed, was left for Hamilton as a thank you for the use of the studio. This appeared as in the Green Drawing Room in the list of contents of the Palazzo Sessa, and was lot 40 on the second day of the second Hamilton sale at Christie's (bt Ewen, £9.9.0).

On his return to England, Sir William arranged a petition signed by Reynolds and other members of the Royal Academy to exempt Jones from paying duty on the

paintings he brought back from Italy. Jones's *View of the Campi Flegrei* was exhibited at the Royal Academy the following April. Hamilton proved a loyal patron, trying to obtain commissions for Jones, but without effect, at length telling Jones he could be of no service to him in England, 'but if I should return to *Naples* – he supposed his Influence would be greater' (*Memoirs*, p. 139). Jones eventually returned to Wales, where he inherited his father's estate at Pencerrig on the death of his elder brother and all but gave up painting.

LITERATURE: Jones, *Memoirs*, pp. 93–125, *passim*; J. A. Gere, 'An oil-sketch by Thomas Jones', *British Museum Quarterly*, XXI, 4, 1959, pp. 93–4, pl. XXXII; L. Gowing and P. Conisbee, *Painting from Nature*, exh. cat., Fitzwilliam Museum, Cambridge, and Royal Academy, London, 1980–81, no. 22; L. Gowing, *The Originality of Thomas Jones*, London, 1985, p. 63, pl. 43; Hawcroft, no. 104.

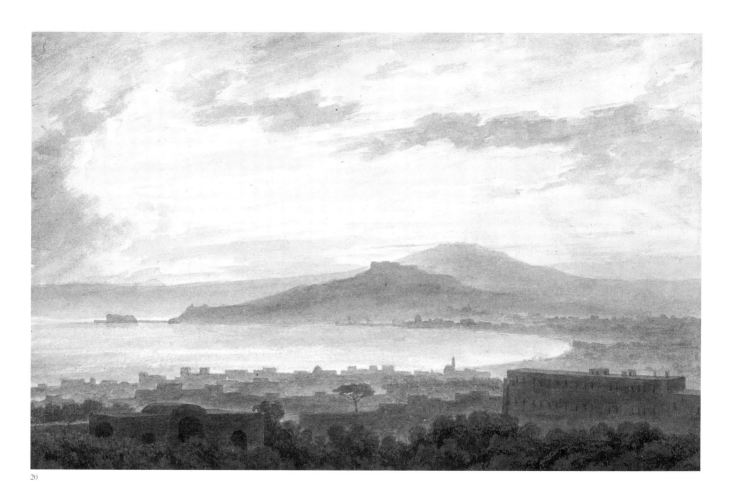

20

20 JOHN ROBERT COZENS (1752–97)

View of Naples from Sir William Hamilton's Villa at Portici, 1782

Watercolour, 23.2 × 36.5 cm
Provenance: William Beckford; his sale
 Christie's, 10 May 1805, lot 57,
 bt Champernowne, £9.0.0; John Edward
 Taylor, Gift to Victoria and Albert Museum
Board of Trustees of the Victoria and Albert
 Museum, London, 121–1894

In 1780 William Beckford, whose mother was first cousin to Sir William, spent the month of November with the Hamiltons in Naples. Already full of dreams and visions and preparing his letters from the tour for publication, on this first visit to Naples he formed a close friendship with Lady Hamilton. He later described her as 'an angel of purity [who] lived uncorrupted, in the midst of the Neapolitan Court ... I never saw so heavenly-minded a creature. Her power of musical execution was wonderful

– so sweetly soft was her touch – she seemed as if she had thrown her own essence into the music.' Near the end of his life he recalled Sir William's house as full of 'all the clever people, the artists, the antiquarians, musicians, the beauty and gaiety of the city! It was my home.' But by the end of his visit, having spent time in Hamilton's various villas, first in Naples, then at Portici, he was finally settled peacefully with Lady Hamilton at Caserta, conversing quietly and composing music based on Homer, while Sir William hunted with the king (Melville, pp. 94–8).

After his return to England, Beckford came of age in 1781 and was intended to go into politics and attend to his business in the West Indies, but he had kept up a constant correspondence with the sensible and soothing Lady Hamilton and, early in 1782, wrote that he could no longer bear London and hoped to be in Naples by June. 'I wish for some snug Casino or other amongst the Cliffs of Posilippo where I may deposit Mr.

Lettice, Cozens' first born (a painter I bring with me) and that eccentric Animal Burton ... I shall bring ample stores of Musick and a Painter worthy to imitate the Scenery of the Gardens of the Hesperides' (Melville, pp. 148–9). Beckford travelled this time with an entourage so large, including three carriages, outriders and servants with reserves of horses, that at Augsburg he was mistaken for the Emperor of Austria. The Revd John Lettice was Beckford's former tutor and John Burton was his musician. John Robert Cozens was the son of Beckford's old drawing master and confidant, Alexander Cozens.

He had not had a letter from Lady Hamilton for some months before he finally arrived in Naples in July 1782. He there found her very ill, and himself succumbed to a fever along with Cozens and Burton. Cozens had been keeping sketchbooks which recorded their tour (now Whitworth Art Gallery, Manchester). The dated drawings indicate that he was well enough to draw again on 26 July when he made a sketch from the

21

'garden of the Villa at Pausilippo' (Sketch-book II, 3) (fig. 62) – evidently from a garden which extended up the hillside behind the villas on the beach, near the one later called Villa Emma (see cat. no. 23). By 9 August the invalids were all removed to Hamilton's villa at Portici to complete their recovery, and six washed drawings in the sketchbook (II, 7–10, 13) show the magnificent panoramic view of Naples, the bay, Capri and the volcano that Sir William enjoyed from his villa near the king's palace at Portici at the foot of Vesuvius.

Cozens made finished versions in water-colour of three of these views for William Beckford, thus recreating for his walls back home his favourite panorama of Naples from Hamilton's villa at Portici. His initial desire in bringing Cozens with him had been to create visual memories of the views he associated with his first visit to Naples, one of the happiest periods of his life. However, his memories this time were destined to be tinged with sadness, perhaps reflected in the mood of this watercolour in particular, as Lady Hamilton died near the end of August and Burton, his musician, a week later. Lady Hamilton's physician, Dr Drummond, had also died earlier in the month when he was thrown from a horse after attending Beck-ford for a fever at Portici (James Byres to Charles Townley, 21 August 1772, Town-ley Papers, British Museum).

Beckford coped in his usual manner by retreating to the *pagliaro* (straw hut) in the myrtle plantation to drown himself in reverie and to work on his novel *Vathek*. He fled from Naples shortly afterwards, 'leaving behind his Draughtsman Cousins Once more a free Agent and loosed from the Shackles of fantastic folly and Caprice' (Jones, *Memoirs*, p. 114). Cozens's sketch-books (II, III) indicate precisely the areas around Naples in which he worked over the next four months, all of which would have been familiar to Beckford and Hamil-ton, either of whom may have suggested the various sites. It is extremely curious that Hamilton did not own a single work by Cozens – that he knew his work is certain from a letter to Beckford, after the latter had returned to England, in which Hamilton mentioned 'Cozens pass'd a day with me here ... the vermin plays a good stick upon the violoncello which was a fine discovery. We play'd 4 hours – he is very firm as to time and a lover of Handel which suited me – He has made some charming sketches but I see by his book he is indolent as ever.' He obviously shared Beckford's opinion that Cozens was an accomplished artist but not as productive as he ought to be, and Hamil-ton promised to call on Cozens in Rome, on his own way to London on leave in May 1783, and bring Beckford any finished water-colours he had ready (Oppé, pp. 112–13).

Beckford eventually owned at least ninety-four watercolours by Cozens, mostly based on drawings in the sketchbooks, and which he sold in 1805. They are amongst the most beautiful English watercolours ever painted, a view endorsed by John Constable, who

saw several of them in the collections of friends who had acquired them at or after the 1805 sale. In August 1821 he wrote to his friend Fisher: 'In the room where I am writing, there are hanging up two beautiful small drawings by Cozens; one, a wood, close, and very solemn; the other, a view from Vesuvius, looking over Portici, very lovely. I borrowed them from my neighbour, Mr Woodburn. Cozens was all poetry, and your drawing is a lovely specimen' (C. R. Leslie, *Memoirs of John Constable*, 1951 edn, London, p. 82).

LITERATURE: C. F. Bell and T. Girtin, 'Sketches and drawings of John Robert Cozens', *Wal. Soc.*, XXIII, 1934–5, no. 240; A. P. Oppé, *Alexander and John Robert Cozens*, London, 1952, pp. 112–13; *Catalogue of the Seven Sketch-books by John Robert Cozens (formerly in the collection of William Beckford)*, sold by order of the Duke of Hamilton, Sotheby's, 29 November 1973 (reproduces all drawings in the sketchbooks); Hawcroft, no. 85.

21 JOHN ROBERT COZENS (1752–97)

Vesuvius from the Myrtle Plantation at Sir William Hamilton's Villa at Portici, 1782

Watercolour, 25 × 33.3 cm

Provenance: Dyce Bequest to Victoria and Albert Museum, 1869

Board of Trustees of the Victoria and Albert Museum, London, D. 716

John Robert Cozens was not the only British artist to record the view of the Bay of Naples from the balcony of Hamilton's villa above Portici. In 1778 or 1779, John 'Warwick' Smith (1749–1831) drew the same view and in 1798 published it in his *Select Views in Italy* (pl. 58). The text accompanying the plate explained that the spacious royal palace at Portici was open on one side to the sea, but on the other to

a large garden and wilderness of evergreen oaks, planted by the late King on the ashes of Vesuvius, which forms the background,

and seems to rise out of the grove itself. Behind this wilderness, higher up the mountain, stands a most delightful villa, belonging to Sir William Hamilton, the English Ambassador. From the balcony in front of this house was the present view taken; it commands a prospect of the whole of the city and Bay of Naples, which is justly considered one of the most interesting and beautiful scenes in the world.

Trapped in London, Beckford had written to Lady Hamilton that he dreamt of her 'labyrinth at the base of Vesuvius, its broom and cypress waving with the breeze from the bay', and it was there that he and Cozens recovered in August 1782. 'I lead a peaceful retired life at Sir Wm. Hamilton's Casino at Portici and get up at Sunrise to breathe the fresh morning Air in a shrubbery of myrtles. In the midst of the thickets a little straw hut is erected, and further on you meet with some pines. Vineyards lie extended all around quite to the Sea Shore ... Vesuvius crowns the scene with its crags and

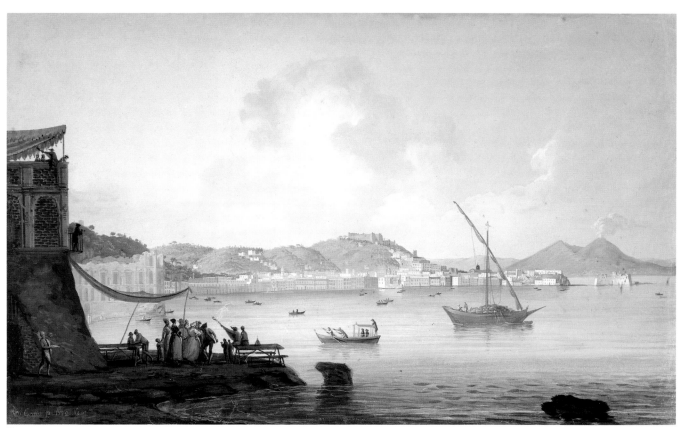

22

conical summit continually breathing forth a thin vapour' (Melville, pp. 113–14, 161). The present watercolour does not seem to have been painted for Beckford, as it does not appear in the 1805 sale, but it was certainly based on a washed drawing dated 18 August that extended over two pages in Cozens's sketchbook (Whitworth, II, 9v–10).

A drawing of Monte Somma only, with a pine tree and small gazebo (II, 13: 22 August), is evidently the view from the door of the *pagliaro* (straw hut), and it was this one that was worked into a finished watercolour souvenir for Beckford (unfortunately now lost). Another drawing in the sketchbook is devoted to a study of the *pagliaro* (II, 22), which was presumably a smaller version of the king's de luxe *pagliaro* described by Tischbein.

LITERATURE: C. F. Bell and T. Girtin, 'Sketches and drawings of John Robert Cozens', *Wal. Soc.*, XXIII, 1934–5, nos 236–51; *Shadow of Vesuvius*, pp. 72, 116–17.

22 XAVIER DELLA GATTA (*fl.*1777–1827)

View of Naples from Posillipo, signed and dated 1782

Bodycolour, 36 × 62.5 cm

Inscribed: *Xav Gatta p. 1782 Neap*

Provenance: Bequeathed by Mr P. C. Manuk and Miss G. M. Coles through the National Art Collections Fund

British Museum, P&D 1948-10-9-19

Della Gatta made his living from this type of souvenir view of Naples, taken from the most popular traditional viewpoints around the bay. This particular view is from just the other side of the Palazzo Donn'Anna, looking in the opposite direction from the view of Villa Emma (cat. no. 23), out towards the city and the Bay of Naples, rather than along the Posillipo coast. This drawing is an early example of these views, which the artist varied only by minor alterations in the figures and which were repeated by him endlessly over the next thirty years. Not

surprisingly, their quality fluctuated enormously, from the skilful depiction visible in the lovely view of Villa Emma, through the slightly less careful attention to detail in the present work, to hasty and slapdash works, produced to satisfy an obviously enormous market but often unworthy of his name, which should probably be attributed to studio assistants.

Because Della Gatta's viewpoints were the most popular with his clients, they seem instantly familiar and some authors have even suggested that he merely copied favourite views by other artists, rather than making preparatory drawings or careful studies on the spot (*Shadow of Vesuvius*, p. 118). Certainly he worked closely with Alessandro D'Anna when they were commissioned in 1783 to paint costumes of the Kingdom of Naples for the decoration of the Real Fabrica china. As Fabris's costume publication was the first to record these in etchings, it is natural they would use his work as a source (cat. no. 150). Della Gatta also made copies

23

of several of Fabris's gouache landscapes of the 1770s. In this, however, and in his variations on such famous views as Lusieri's taken from a balcony at Portici (cat. no. 4), he was only providing the market with the quantity of these views that Fabris by that time, and Lusieri with his slow methods, could not hope to supply. Certainly, his view of the Villa Emma is an accurate and up-to-date record of the house as it appeared twenty years after Fabris's view of the same (cat. no. 17), and must be the result of careful study from nature. To imply that Della Gatta was a mere copyist of their work or imitator of Hackert, whose work strongly influenced his own in the 1790s, is not to give due credit to the artist of such original, powerful and well-executed compositions as those he painted in 1802 to commemorate the return of the Neapolitan monarchs.

Although Hamilton did not own either of these views of Posillipo by Della Gatta, his manuscript list of the paintings on the walls of the Palazzo Sessa included 'Gatta – Day View in Watercolour of the last Eruption of Mount Vesuvius'. It was described as a 'superb representation' in Hamilton's sale at Christie's (18 April 1801, lot 24, bt Lutridge, £2.10.0; possibly the one now in the Krafft Bequest, Muséum National

d'Histoire Naturelle, Paris, OA KR 24: see fig. 33). Hamilton's letter to the Royal Society describing the eruption of 1794 was accompanied by a group of coloured drawings by Della Gatta, which were published in the Society's *Philosophical Transactions* the following year. Hamilton noted in the text that of the seven plates, four were taken from nature by 'Signor Xavier Gatto' whom he described as successor to the 'late ingenious Mr Fabris'. These drawings are now with Hamilton's original letter in the Royal Society (L&P, X.103).

23 XAVIER DELLA GATTA (*fl.*1777–1827)
View of the Villa Emma at Posillipo, signed and dated 1795

Bodycolour, 35.5 × 54.5 cm
Inscribed on verso: *Lady Palmerston Veduta del Casino del Cavalier Hamilton a Posilipo*
Provenance: Lady Palmerston; Whitfield Fine Art, London, from whom purchased by present owner, 1994
Private collection

There are many views of the Villa Emma on the shore at Posillipo by various artists, including Cozens, Pars, 'Warwick' Smith,

Fabris, Vernet and Ducros, but this gouache, apparently painted for Lady Palmerston, is the loveliest and shows most clearly the exact structure of the building, the awning, and the nature of the terrace and the garden. A gouache of the same view signed and dated 1813 by Della Gatta (J. L. Picard sale, Hôtel Drouot, Paris, 23 March 1995, lot 57) shows that by then a road had been constructed. This rose as a wall abutting the back of the villa and proceeding along to the upper floors of the Palazzo Donn'Anna, thus removing the garden behind the Villa Emma and direct access to the grottoes, gardens and cliffs behind, with their magnificent views.

Collecting Vases

Apart from gifts, Sir William acquired his vases from three principal sources: purchases from other collections (cat. no. 24), the art market (fig. 22) and excavations (cat. nos 25–7).

24 Two red-figured kraters (wine-mixing bowls)

a) *Red-figured calyx-krater*

Ht 37.7 cm

Made in Apulia, southern Italy, about 350 BC. Attributed to the Varrese Painter. Said to be from Bari

British Museum, GR 1772.3–20.33* (BM Vases F269). Like (b), this vase was purchased by Hamilton from the collection of the Marchese Felice Maria Mastrilli

The principal side of the vase shows a scene from a *phlyax* play (a burlesque form of comedy), with armed actors named Daidalos and Enyalios fighting a duel before the seated goddess Hera.

By the time it came into Hamilton's possession this vase was already well known as one of those discussed by A. S. Mazzocchi in his important study of the so-called Aeneas Tables. These were Greek inscriptions on bronze found at Heraclea in Lucania (south Italy). Mazzocchi analysed the letter forms, comparing them with other inscribed objects, including coins and vases. Of particular interest on this vase was the use of the sign to mark the rough breathing in front of the letter *eta* of the name Hera. It is from Mazzocchi that we know of Bari as the find-site of the vase. Bari was not then thought to have been a place settled by the Greeks, but Mazzocchi asserts the Greek origin of the vase on the basis of its subject and the inscriptions. He was one of the first to realise that the vases found in tombs in southern Italy were Greek and not Etruscan, as had previously been thought.

LITERATURE: Mazzocchi, part I, pp. 137–8 with illus.; Passeri, III, pl. 255; d'Hancarville, *AEGR*, III, pl. 108, commentary at IV, p. 36; Winckelmann (Lodge), p. 383; Trendall/ Cambitoglou, *RVAp*, I, p. 339, 11; Lyons, p. 7, n. 49.

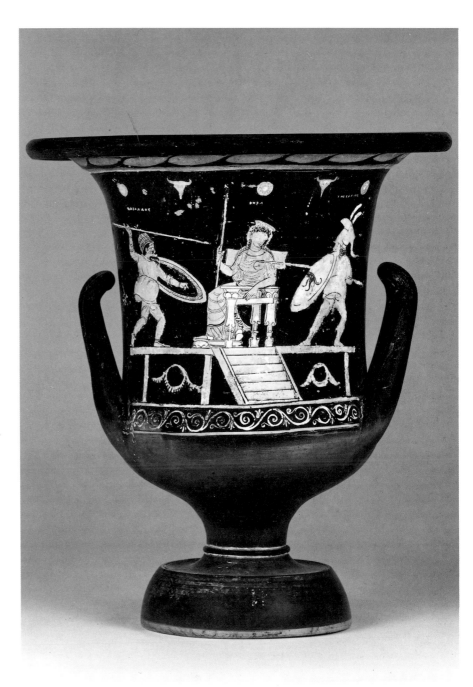

24a

b) *Red-figured bell-krater*

Ht 38.7 cm

Made in Athens around 400–390 BC, probably as
a pair with BM Vases F75. Attributed to the
Erbach Painter

British Museum, GR 1772.3–20.32* (BM Vases
F77)

The principal side shows Apollo and Diony-
sus, seated and turning back to look at each
other. Apollo holds a lyre in one hand and
a (?)laurel branch in the other; Dionysus
holds a drinking horn and supports the other
arm with a staff topped with a pine cone
(thyrsus). The two gods are accompanied by
a group of satyrs and maenads.

This is almost certainly the vase Hamil-
ton had in mind when, in the introductory
preface to the publication of his second vase
collection, he was at pains to explain that
Tischbein's engravings were accurate repro-
ductions. He recalls how G. B. Passeri had
reproduced the scene on a vase which
Hamilton had bought from the Mastrilli
collection (fig. 63):

> The learned Antiquarian has displayed in
> his dissertation on that vase much of his
> erudition to explain the reason why a
> Silenus was represented there completely
> clothed, and not naked as in most
> monuments of antiquity. When that vase
> came into my possession, having purchased
> the whole collection, I soon perceived that
> the drapery on the Silenus had been added
> with a pen and ink, as was the case on the
> figures of many other vases in the same
> collection, the late possessor being very
> devout having caused all the nudities to be
> covered. However, soon as the vase was
> mine, a sponge washed off at once the
> modern drapery, and Passeri's learned
> dissertation.

Overpainting is indeed apparent on this and
a number of the vases published by Passeri
that eventually passed from the Museo Mas-
trilli into Hamilton's collection.

In the fourth volume of *AEGR* d'Han-
carville mistook the figure of Apollo for
Bacchus *Musagete* (leader of the Muses) and
the Dionysus for Ariadne. In the manuscript
catalogue Apollo is identified as Hermes,
inventor of the lyre, in the midst of the
followers of Bacchus.

LITERATURE: Passeri, II, pl. 103; *AEGR*, II, pl. 68,
and IV, p. 42; d'Hancarville, MS Catalogue, II,
p. 662; Tischbein, I, pp. 10–12; Beazley, *ARV²*
1418, 5; Lyons, pp. 11–12 and 16, figs 22–3.

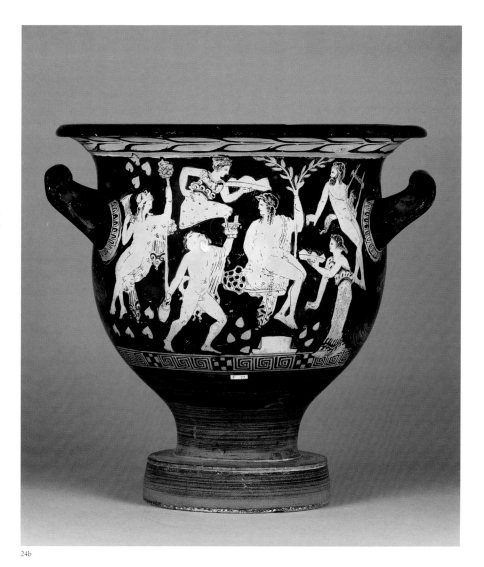

24b

FIG. 63 The overpainted version of BM Vases F77, from Passeri.

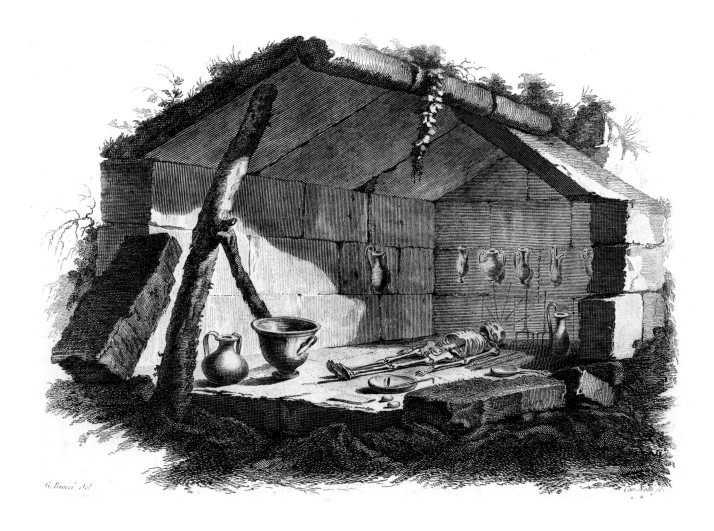

25 Objects from the Trebbia Tomb

One of the most striking images in the second volume of *AEGR* is Carlo Nolli's engraving after a drawing by Giuseppe Bracci of the interior of an ancient tomb. Three contemporary descriptions of this tomb survive. First, there is d'Hancarville's own, not in the same volume of *AEGR*, but in volume IV, which appeared in 1776. Second is Winckelmann's report, probably based upon notes he made during his sojourn in Naples in the autumn of 1767, and which was also published in the second edition of the *History*, also in 1776. Third, there is d'Hancarville's second account, which largely follows the first, in the manuscript catalogue of 1778.

Winckelmann's account was subsequently translated for the English edition of his work and reads as follows:

> Vases of this kind were found even in the tombs situated in the midst of the Tiphates mountains, ten miles above the ancient city of Capua, near to a place called Trebbia,

which is reached by untrodden and toilsome paths. Mr Hamilton, the Minister from Great Britain to Naples, caused these tombs to be opened in his presence, partly for the purpose of seeing the mode of their construction, and partly for the purpose of ascertaining whether vases of the kind would be found in tombs located in places so difficult of access. On the discovery of one of these tombs, a drawing of it was made on the spot by this amateur and connoisseur of the arts, of which a copperplate engraving may be seen in the second volume of the large collection of his vases [see fig. 64]. The skeleton of the deceased lay stretched upon the bare earth, the feet turned towards the entrance of the tomb, and the head near the wall, into which six short, flat iron rods, spread out like the sticks of a fan, were driven by means of the nail about which they are enabled to turn. In the same place, and by the head, stood two tall, iron candelabra,

FIG. 64 Engraving from *AEGR* of a tomb opened by Sir William Hamilton at Trebbia, southern Italy.

corroded by rust. But at some height above the head, vases hung from bronze nails driven into the wall; one stood near the candelabra; and two others were placed at the right side of the skeleton, near the feet. On the left side, near the head, lay two iron swords, together with a *colo vinario*, 'wine-strainer', of bronze, which is a deep cup, pierced with holes like a sieve, and furnished with a handle; this cup fits nicely into another cup, not perforated, and it served, as it is known, for the filtering of wine … On the same side, at the feet, stood a round bronze cup, in which was a *simpulum*, that is, a smaller round cup with a long handle, the upper extremity of which is bent like a hook, and which was used to dip wine from the casks, in order to taste it, and also for the purpose of pouring

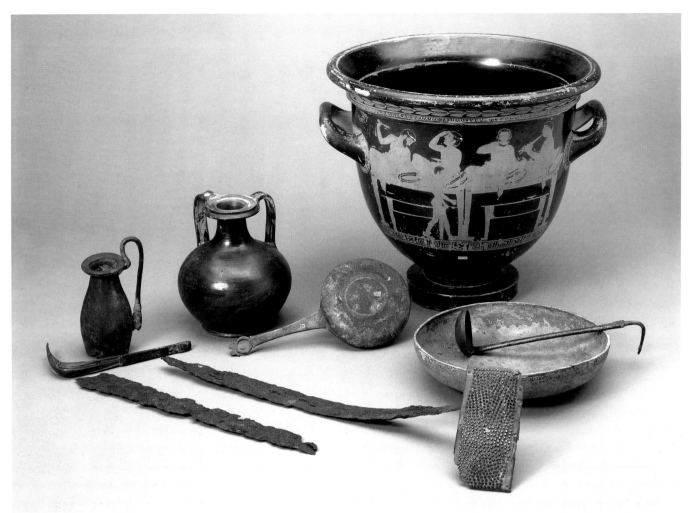

25a–i

into a larger cup the wine of libation, at sacrifices. Near the cup lay two eggs and a grater, resembling a cheese-grater.

The second volume of *AEGR* did not appear until 1770, and Winckelmann, who died in 1768, must have seen the engraving in its prepublished state. He alone mentions that it was based upon a sketch by Sir William himself. Bracci, it seems, worked up his drawing from this sketch.

In his published account, d'Hancarville adds other information: he is at pains to describe the massive blocks of masonry and the manner in which they were worked to form the walls and pitched roof of the tomb; he tells us that the skeleton and the eggs were reduced to dust, soon after exposure to the air; he conjectures that the object behind the skull, which Winckelmann saw as a fan, was a sort of aureole, indicating the sanctity of the deceased. He regrets the lack of a coin or inscription for dating the tomb and its

contents, but judging by the vase-painting, estimates its age as 2,000 years, at least. In his other account d'Hancarville gives the date of the opening of the tomb as 1776. Such a date is impossible and this must be a slip of the pen for 1766. He remarks that the tomb had no door and recounts how it was opened by removing one of the slabs of the roof covering. The date of the tomb was now put much earlier than before, being an estimated 2,600 years old, that is to say around 824 BC. This was arrived at on the reckoning that the tomb must predate the time of Numa Pompilius, the second king of Rome (conventional dates 715–673 BC). The reason given is that in Numa's day tombs were inscribed; since the Trebbia Tomb has no inscription, it must predate such use of inscriptions.

With no real fixed points of reference, d'Hancarville's attempts at dating were never more than wild guesswork. Today the vase

is dated to the decades 440–420 BC, and this date may be taken as good for the manufacture of the other objects found with it.

Nine objects ((a)–(i) below) featured in the engraving and listed in d'Hancarville's manuscript catalogue can be identified with either certainty or probability in the collections of the British Museum. Others, including the so-called iron candelabra and the iron fan, cannot be found. The bronzes may all be assumed to have been made in Campania, perhaps at Capua which, by Roman times at least, is known to have been a great centre for bronzeworking.

LITERATURE: D'Hancarville, *AEGR*, II, p. 57 for the engraving; *AEGR*, IV, pp. 42–3 for d'Hancarville's description of the tomb and its contents; cf. d'Hancarville, MS Catalogue, II, pp. 594*–602*; Winckelmann (Lodge), pp. 389–91; Constantine, 1993, p. 69.

a) *Red-figured bell-krater (wine-mixing bowl)*

Ht 35.8 cm

Made in Athens around 440–420 BC. Attributed to the Lykaon Painter

British Museum, GR 1772.3–20.1* (BM Vases E495)

Four symposiasts are depicted being served by a boy holding a jug for pouring wine in his left hand, and a strainer in his right. Their names are written above them.

LITERATURE: D'Hancarville, *AEGR*, II, pl. 74; d'Hancarville, MS Catalogue, II, pp. 594*–5*; Beazley, *ARV²* 1045, 8.

b) *Black-glazed two-handled 'mushroom jug'*

Ht 20 cm

British Museum, GR 1772.3–20.463

This shape of jug, with handles set characteristically close together and rising above the rim, served as part of the paraphernalia of wine-drinking parties (*symposia*) and appears in drinking scenes on Attic vases of the early fifth century BC. This example was made in Campania in Southern Italy; roughly contemporary examples are known from Corinthian, Attic and South Italian workshops, and the shape persisted into the Roman period. The precise function of this peculiar form of vase, however, is not known, although the twin handles would have made it easier to pass the vessel from one guest to another. There is probably no truth in Sir John Beazley's suggestion, cited by Sparkes and Talcott, that it served as a urinal.

LITERATURE: D'Hancarville, MS Catalogue, II, p. 599*; for the type see Sparkes and Talcott, pp. 66–8, pl. 9 and their n. 47 for its illustration in vase-painting.

c) *Bronze jug with a handle terminating in the form of a crouching lion*

Ht 18 cm

British Museum, GR 1918.1–1.52 (perhaps to be identified with 1772.3–4.34)

The identification of this jug with that found in the tomb is not certain. It has been chosen on the basis of its shape, the character of the patina, consistent with other bronzes from the tomb, and the fact that it belongs with a group of bronzes entered into the Museum register in 1918 as having come from an old collection. A number of these have since

been shown to have been in the Hamilton collection. In his manuscript catalogue d'Hancarville says the jug contained a strigil, used for removing oil from the body as part of the bathing process. No such instrument appears in the engraving, and the jug in question is a drinking, rather than a bathing vessel. Nevertheless, a strigil (see (d) below), said to be from the Hamilton collection, is included here.

LITERATURE: D'Hancarville, MS Catalogue, I, p. 294, and II, p. 598*.

d) *Bronze strigil with a flat handle and reeded decoration on the blade*

L. 20.5 cm

British Museum, GR 1975.11–9.3 (BM Bronzes 2431)

LITERATURE: Hawkins, III, no. 4.

e) *Bronze wine-strainer*

L. 28 cm

British Museum, GR 1772.3–4.6(1)

This wine strainer is similar to that shown being carried by the boy on the red-figured bell-krater found in the tomb (a) above. The bowl is inset with a perforated disc designed for sieving wine lees. The flat handle carries engraved decoration, has a loop for suspension and terminates in a pair of duck heads.

LITERATURE: D'Hancarville, MS Catalogue, I, pp. 282–3, and II, p. 598*.

f) *Two iron swords*

L. 41 cm and 55 cm

British Museum, GR 1975.6–2.1 and GR 1975.6–2.3

The identification of these swords is not certain, but since they are listed in d'Hancarville's manuscript catalogue as having come to the Museum, and there are no other possible candidates in the collection, they are likely to be the ones from the Trebbia Tomb.

LITERATURE: D'Hancarville, MS Catalogue, II, p. 597*.

g) *Bronze wine-ladle, the handle terminating in the exquisitely modelled head of a mule*

L. 26 cm

British Museum, GR 1772.3–4.5(4)

D'Hancarville believed that the terminal decoration of the handle was chosen to sig-

nify the deity in whose service the implement was used. A swan, for example, indicated the myth of Leda, with whom Zeus made love, disguising himself as the bird; a horse signified Neptune (Poseidon). Here, he saw the head of a donkey and associated it with Bacchus or Silenus.

LITERATURE: D'Hancarville, MS Catalogue, I, pp. 281–2, and II, p. 598*.

h) *Bronze undecorated bowl*

Diam. 28 cm

British Museum, GR 1918.1–1.12 (perhaps to be identified with 1772.3–4.9)

The wine-ladle (g) above rests on a bowl which is only vaguely described by d'Hancarville as a krater or basin. That shown in the engraving may possibly be identified with this one, on the basis of similar arguments to those in favour of the inclusion of (c).

LITERATURE: D'Hancarville, MS Catalogue, I, p. 286, and II, p. 598*.

i) *Bronze grater*

L. 16 cm

British Museum, GR 1975.8–4.20 (perhaps to be identified with 1772.3–12.105)

Originally mounted upon a wooden board, this grater is made, as d'Hancarville put it, exactly like our own.

LITERATURE: D'Hancarville, MS Catalogue, II, pp. 439 and 598*.

26 ANG. CLÉNER after CHRISTOPH HEINRICH KNIEP (1748–1825)

A Tomb at Nola

Engraving, 44 × 35 cm
British Museum, Department of Greek and
 Roman Antiquities

This engraving after a drawing made in 1790 by Christoph Heinrich Kniep was included as the frontispiece to the first volume of the publication of Hamilton's second vase collection. Although a copy of it survives, the drawing itself is lost. It was formerly in the collection of the Insititute of Anatomy of the University of Göttingen, destroyed in the last days of the Second World War. In the edition of Tischbein's engravings published in Florence in 1800–3, the image is reproduced as an aquatint.

Sir William and Emma, both idealised, are shown standing beside an open tomb admiring newly discovered vases. In the introductory text ('To the Reader') of the first volume, Hamilton explains the image as 'a representation of an ordinary sepulchre found lately at Nola'. By 'ordinary' he meant to distinguish this type of tomb from the more elaborate sort with the appearance of a small room, such as that found at Trebbia, near Capua, and published by d'Hancarville in *AEGR* (see cat. no. 25). The depth of earth above the tomb shown in the engraving was typical of the region of ancient Nola, as Hamilton explained in his account of the various types of tomb in which vases were found:

> I have been present at the opening of many of those ancient sepulchres, in which, and no where else, such vases are found; both in the neighbourhood of Capua, at Nola, in different parts of Puglia, and in Sicily. I have constantly observed that those sepulchres were placed near, and without the walls of the town; under ground and at no great depth from the surface, except at Nola, where the volcanic matter issued from the neighbouring mountain of Vesuvius, seems to have added much to the surface of the soil since those sepulchres were made; so that some of the sepulchres, which I saw opened there, were six and twenty palms beneath the present surface of the earth. The most ordinary sepulchres, are constructed of rude stones or tiles, and are of a dimension just sufficient to contain the body, and five, or six vases, a small one near the head, and the others between the

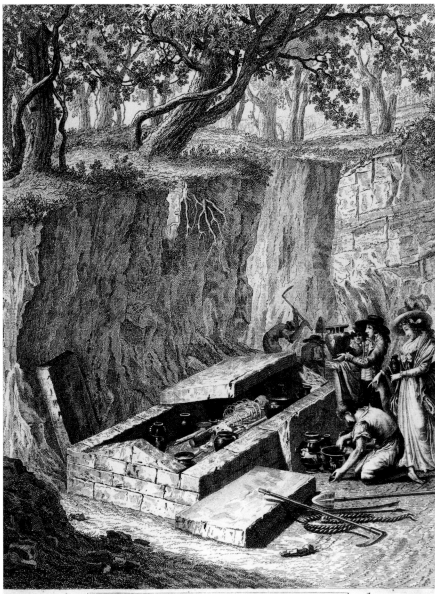

ARCHAEOPHILORVM . SODALITIO . LONDINENSI.
GVGL.HAMILTONVS.BAL.ORD.EQVES.
D.D.D.

26

legs, and on each side, but oftener on the right side, than on the left.

Hamilton's illustrations of the Nola and Trebbia tombs were frequently pirated after their original publication for use as generalised examples of the types of tomb from which Greek vases came.

LITERATURE: Tischbein, I, pp. 22–4; Thiersch, pp. 78ff.; Greifenhagen, pp. 84–7; Griener, p. 59 and n. 3. Greifenhagen, pls 2–3, publishes photographs of the copy: German Archaeological Institute, Rome, neg. no. 1938, 149–51.

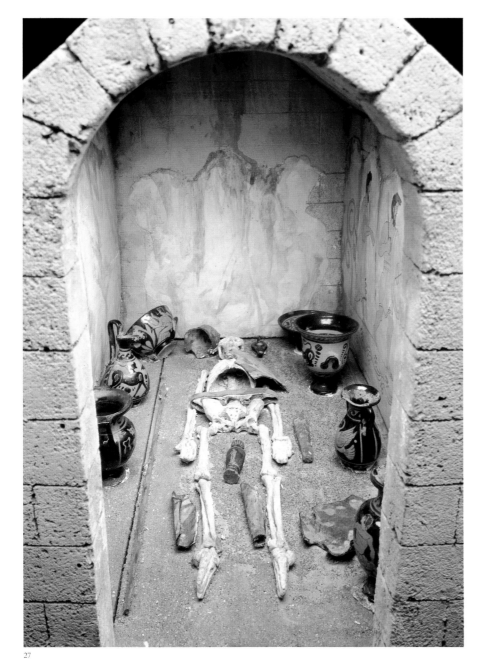

27

temporary fashion for model volcanoes. He was also probably the first to have a model of an ancient Campanian tomb. Writing from Naples on 3 March 1793, Sir Charles Blagden reports how Hamilton showed him a model of a tomb, 'such as those in which the vases are found'. He goes on, 'It is an oblong trough of stone, with a roof of stones'.

This model shows a tomb excavated in one of the cemeteries outside Paestum in 1805, after Sir William's death. The tomb (now lost) was made from blocks of the local travertine stone, coated with stucco for painting on the inside. It dates to the fourth century BC, after the Greek settlement of Poseidonia (later Paestum) had been taken over by Lucanians, a local Samnite people. The model reveals the style of the wall-painting to have been typically Lucanian and the armour (painted paper), especially the belt around the waist, is Samnite. Such vases as were actually found in the tomb would have been of local Paestan manufacture, but here the modeller has supplied a series of miniatures in terracotta painted with details copied from vases of various schools and periods.

Three models of similar tombs, including a larger version of this one, are to be found in Sir John Soane's Museum in Lincoln's Inn Fields, London. There were originally four, but one was recorded as damaged in 1837 and has since disappeared. Soane placed his models in the 'Crypt', where they accompanied other sepulchral monuments, principally the Egyptian alabaster sarcophagus of Sety I. It is thought that Soane's models were made by Domenico Padiglione, who from around 1804 made models for the Royal Museum at Naples. This model, however, may be attributed to one 'Bramante', who is said to have been the maker of another version of the same tomb previously displayed in the National Archaeological Museum of Naples.

27 Cork model of a tomb at Paestum

L. 50.5 cm
Made in Naples c.1805. Formerly Singleton
 Abbey (Lord Swansea)
British Museum, GR 1919.10–18.1

Models made from cork were used since the Renaissance by architects and their patrons to illustrate projected designs and as convenient records of existing buildings. By the eighteenth century they had become popular as subjects for public exhibitions, and the repertoire was extended to include archaeological ruins. One such exhibition in London was the Classical Exhibition at 24 St Albans Street, Pall Mall, assembled from the life-long labour of Richard Dubourg. His show was terminated unexpectedly in April 1785, when a mock Vesuvius effect went wrong and spread fire to the rest of the collection. Sir William Hamilton's richly illustrated *Campi Phlegraei* (cat. no. 43) was a great influence in promoting the con-

LITERATURE: Singleton Abbey, sale cat. 13 October 1919 and six following days, lot 739; for cork models in general, see the exhibition catalogue *Rom über die Alpen tragen. Fürsten sammeln Antike Architektur: Die Aischaffenburger Korkmodelle* (Bayerische Verwaltung der Staatlichen Schlösser, Gärten und Seen, 1993); for cork models in London, see Altick, pp. 114f.; for Soane's cork models see Richardson, also Elsner, pp. 172–3; for Soane's model of the 'hypogeum Montserisi Rossignoli' at Canosa, see Mazzei, p. 130, fig. 42.

The Publication of the First Vase Collection

28 *The dedication plate of the first volume of d'Hancarville's publication of the first vase collection (AEGR), c.1766*

Anonymous engraving, 38.5 × 26.5 cm
Private collection

The introductory text opens with an unrestrained homage to HM King George III, Sir William's sovereign and childhood friend. D'Hancarville's explanation of it is as follows:

> On a plaque recognised as Etruscan by its ornament, an inscription is engraved putting this work under the patronage of His Britannic Majesty, whose name is crowned with laurel. The rocks in the foreground represent the Apennines in which Etruria is situated. On the bank of the Clanis, one of the rivers of Etruria, is engraved a vase representative of the subject of the book. A fragment of Tuscan architectural entablature, indicates one of the principal discoveries of the Etruscans, a people formerly celebrated for their strength and for their taste in the arts. The *fasces*, symbolic of sovereign power, were invented by them, and those placed here are bound in laurel, according to the habit of Roman generals following victory or during their triumph.

Mention of 'Tuscan' architecture refers obliquely to d'Hancarville's view that Greek architecture derived from that of the early Etruscans, which is discussed in the first volume of *AEGR* (p. 73ff.). It is perhaps surprising that so much emphasis is put on the Etruscans in the dedication plate and in d'Hancarville's explanation of it, when the principal subject of the publication as a whole is vases, which – including the one in the picture – d'Hancarville recognised as Greek. But if the vases were made by Greeks and their subject-matter related to Greek myth and history, nevertheless they were made, or so he thought, by Greeks living in Italy. That country was thought of, first and foremost, as the land of the ancient Etruscans, and the dedication plate provides a natural prelude to d'Hancarville's copious dissertations upon their life, art and culture.

The so-called Etruscan ornament of the dedicatory plaque was taken from the

28

Greek vase in the picture. It is curious to note that, although the reproduction of the vase scene as plate 122 of the first volume retains the vase's original neck ornament, in the dedicatory plate it has been substituted with another pattern. A suspicious mind might think the switch was made deliber-

ately so that the claim that the ornament of the plaque was Etruscan could not be seen to be undermined by its having been lifted from a Greek vase.

LITERATURE: D'Hancarville, *AEGR*, I, pl. 3, explained in I, p. 174.

29 Red-figured pelike (storage-jar)

Ht 35.5 cm
Made in Athens about 460–450 BC. Attributed to
the Niobid Painter
British Museum GR 1772.3–20.23* (BM Vases
E381)

Illustrated as part of fig. 57

This is the vase featured in the dedication plate of the first volume of *AEGR* (cat. no. 28). The principal side shows a king or god holding a sceptre and phiale (shallow bowl), and a woman pouring a libation at an altar. On the other side, the goddess Eos (Dawn) pursues Tithonos. This vase was one of those purchased by Hamilton from the Mastrilli collection. No doubt the sacrificial scene was selected for the dedication plate as a compliment to the royal dedicatee. Probably because of its prominence in *AEGR*, the vase – or at least the figures upon it – was one of those chosen for reproduction by the Wedgwood pottery.

D'Hancarville had definite views about the identity of the male figure. This he thought perfectly resembled Plato. He probably had no good evidence, pictorial or literary, for this suggestion and subsequently changed his interpretation of the scene to 'a priest and priestess of Bacchus making a libation at an altar'. The priest, he now thought, bore a resemblance to Bacchus himself, but Bacchus with the features of Pisistratus, the tyrant of Athens who died in 527 BC. The vase was therefore made during the reign of Pisistratus. The idea of Bacchus resembling the Athenian tyrant may be traced to a brief reference in Athenaeus' *Table Talk*, where the ancient author records a tradition that Pisistratus' likeness was used for one (or more) images of the god Dionysus (Athenaeus, *Deipnosophistae*, XII, 533c). This argument demonstrates what a hit-or-miss affair was d'Hancarville's dating of vases. His former identification of the male figure as Plato would put the manufacture of the vase into the fourth century BC or later, while his second attempt dated it some two hundred years earlier.

LITERATURE: D'Hancarville, *AEGR*, I, pl. 122, commentary in II, p. 166; the scene on the reverse of the vase, showing Eos and Tithonos, was published in IV, pl. 61; Lyons, p. 17 and fig. 26; Beazley, *ARV²* 603, 45. For Wedgwood reproductions of the vase see Ramage, 1989b.

30 M. BLOT (1753–1818) after
ANTON RAFFAEL MENGS (1728–79)

Johann Joachim Winckelmann

Engraving, 31.5 × 21.4 cm
Provenance: Purchased from Messrs Colnaghi
British Museum, P&D 1862–2–8–225

Born the son of a shoemaker at Stendal on 9 December 1717, Johann Joachim Winckelmann (d.1768) rose to become the principal antiquary of his time. The legend under his image reads: 'In the midst of Rome Winckelmann lit the flame of the rational study of the works of Antiquity'. He is still regarded by many as the founding father of modern Classical archaeology.

In Mengs's portrait (now in the Metropolitan Museum of Art, New York) the sitter is shown holding a copy of Homer's *Iliad*. In the engraving Homer's poem is paralleled, on the right, by an open copy of Winckelmann's own great work, *The History of Ancient Art*, published in Dresden in 1764. On the left are shown two token pages from his book: 'Description of the Ancient Torso' (i.e. the fragmentary torso, probably of a seated Herakles, kept since the Renaissance in the Belvedere Courtyard of the Vatican and admired by, among others, Michelangelo) and 'Description of the Apollo Belvedere', another of the treasures of the Vatican. These were among the works of Classical antiquity in the explanation of which Winckelmann was at his most poetical. The engraving, therefore, celebrates Winckelmann not only as a connoisseur of the visual arts, but also as a leading figure in eighteenth-century German Romantic literature.

LITERATURE: Berghaus, p. 221; Baetjer, p. 311.

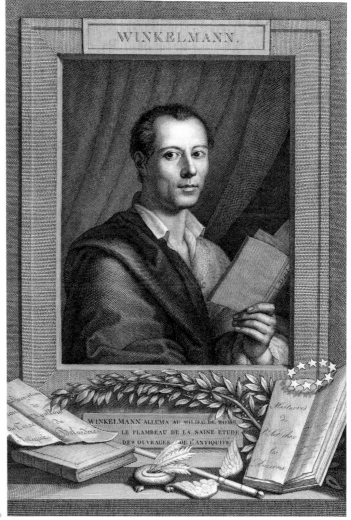

30

3 1 CARMINE PIGNATARI after
GIUSEPPE BRACCI

The Tomb of Winckelmann, c.1770

Copperplate engraving, 39 × 27 cm
Private collection

Johann Joachim Winckelmann was mur-
dered by Francesco Arcangeli at Trieste on
8 June 1768. News of his death shocked the
cultured world and brought to an end Sir
William's plans for involving him in the
publication of his first vase collection (see
p. 46). This engraving formed the frontis-
piece to the second volume of *AEGR*, and
the inscription on the sarcophagus records
d'Hancarville's own grief at the loss of a
friend and fellow scholar.

The walls of the imaginary tomb depicted
are lined with columbarium niches, used by
the ancient Romans for the safe-keeping of
cinerary urns. In the centre stands a sar-
cophagus, carved with strigillated decora-
tion and the valedictory inscription, and
ornamented with lion-head handles. The
sarcophagus may be compared with a type
of the late second or early third century AD,
examples of which can be found in Rome
in the Capitoline Museum (formerly in the
Villa Doria Pamphili) and in the Vatican.
The tomb itself is a caprice, but owes some-
thing to the Tomb of the Freedmen of Livia
engraved by G. Rossi after a drawing by
A. Buonamici for F. Bianchini's *Camera ed
inscrizioni sepulcrali dei Liberti, Servi ed Ufficiali
della Casa di Augusto* (Rome 1727). Piranesi
later reproduced this same plate in his *Camere
Sepolcrali* of about 1752, and then as plate 26
of his *Antichità Romane* (1756). It was prob-
ably in Piranesi's publication that Bracci
sought inspiration for Winckelmann's tomb.
Similarities between the two tombs are to
be found in the cupola ceiling, the colum-
barium niches with their labels below, and
the placement of the sarcophagus, which is
strigillated in both cases.

LITERATURE: Griener, p. 62, fig. 14; for the
sarcophagus, see Koch, pp. 75 and 242, fig. 295;
Calza, p. 231, no. 272, pl. 150. For the Tomb of
the Freedmen of Livia and eighteenth-century
interest in columbaria, see de Polignac, *passim*.

G. Bracci inv. et del. C. Pignatari Scul.

31

D'Hancarville's 'Exhibition'
of Hamilton's Vases

D'Hancarville's theory of the origin and development of painting in antiquity centred upon a handful of vases, the importance of which he expounded at length, returning to them and revising his ideas over the ten or more years during which the publication of *AEGR* was in progress. Even afterwards he concocted corrections and made revisions in the manuscript catalogue he compiled in 1778 during his stay in London, under the patronage of Charles Townley and, again, in the smaller revised edition of *AEGR* he published in Paris in 1785. His chronological series began with the vase illustrated here as fig. 65. Its present whereabouts is unknown: in the manuscript catalogue, d'Hancarville tells us that it was lost during transport to England of Sir William's first collection.[1] It makes its first appearance in the second volume[2] and is seen again in the third, where d'Hancarville developed his interpretation of the subject-matter. It was now seen to represent Song and Meditation, two of three Muses who, together with Memory, were responsible for man's ability to recall his own history.[3]

FIG. 65 'Song and Meditation': engraving after a lost vase thought by d'Hancarville to represent the earliest surviving attempt at drawing.

The subject is, in fact, a non-specific pipe-player (*auletes*) and a standing companion, and today the style of painting may be associated either with Etruscan vase-painting, or perhaps with the so-called Owl-Pillar group of vase-painters whose oeuvre Professor Dale Trendall described as, 'semi-barbarous Campanian imitations of Attic red-figure', dating to around 450 BC.[4] D'Hancarville had a very different view, seeing its naivety not as a bastard imitation of Greek vase-painting, but as a pioneering first attempt. He accepted the ancient literary account of the origins of painting and attributed its invention to Euchir, kinsman of the legendary Daedalus who was credited among other things with the invention of sculpture. D'Hancarville calculated Euchir's *floruit* as *c.*1214 BC[5] and saw this vase as roughly contemporary with him. Its method of drawing preceded, he argued, the linear form of painting which characterised later productions and, not knowing how to make lines with the point, the artist had made the mistake of drawing with the wrong end of the pencil. D'Hancarville goes on: 'However barbarous this monument may be, it is nevertheless very interesting and curious, since on one hand it shows the infancy or as one may [say] the cradle of art, and on the other shows us in the clearest manner a commerce between the artists of great [i.e. Magna Graecia or southern Italy and Sicily] and little [mainland] Greece, which continues without interruption from the beginning of painting till the time that the former submitted to the Romans.'[6]

D'Hancarville's aim in setting out the chronology of Greek vase-painting was to guide his readers back through the maze of antiquity to the beginnings of man's first artistic efforts. His own history of early Greek involvement in Italy now reads as a confused conflation of the accounts of the ancient authors, principally Dionysius of Halicarnassus' *Roman Antiquities* and Strabo's *Geography*, uncorrected by modern archaeological excavation, and the works of various eighteenth-century authors who had pondered the same problems. The result is tortuous and, before we enter d'Hancarville's labyrinth, let us first grasp the Ariadne's thread of another, contemporary account, based upon the same sources. In the revised edition of his *History of Ancient Art*[7] Winckelmann explains that the ancient authors give an account of two migrations of Greeks into Italy, the first of which took place around

600 years before the second. The earlier was that of the 'Pelasgi'. These were regarded by the ancients as the aboriginal inhabitants of the Aegean, whose involvement in prehistoric Italy may now be equated with that of the Mycenaean Greeks. Their maritime sphere of influence, unknown to Winckelmann, spread all over the Mediterranean world during the latter half of the second millennium BC. Winckelmann declared that since the art of drawing does not seem to have been known during this period, either to the Greeks or the Etruscans, this first migration was foreign to his purpose.

The second migration of the Greeks to Italy took place, according to Winckelmann, about three hundred years after the time of Homer, and the same length of time before Herodotus. Winckelmann would have reckoned Herodotus' *floruit* as *c*.450 BC which, plus 300, brings the time of the second migration to around 750 BC. This is roughly the date archaeologists still accept for the planting of the first Iron Age Greek colony in Italy, at Pithekoussai on the island of Ischia off the northern promontory of the Bay of Naples.[8] Following Strabo, Winckelmann explains how Megasthenes and Hippocles led an expedition from Chalcis in Euboea and settled first on Ischia, and then, because of the earthquakes and other volcanic activity, moved to the mainland. The ancient tradition has been upheld in this century by excavations, both on Ischia and at the citadel of Cumae on the mainland opposite.[9]

Although Winckelmann was mistaken in dismissing the possibility of an art existing among the Greeks and the Etruscans before his 'second colonisation', nevertheless it is now possible to fit the modern archaeological picture into the broad frame he provides. The vital element in his account is the distinction he makes between two separate migrations, one set in what we should now call the Greek Bronze Age, the other 600 years later. The date of the second migration in the eighth century BC provided a *terminus post quem* for all the monuments of Etruscan and Greek art in Italy and thus applied a chronological limit, which was lacking in the wilder speculation of d'Hancarville.

It is clear from the repeated references d'Hancarville makes to Winckelmann's works that he felt a compulsion to prove the great man wrong. In disavowing the existence of Greek art before 750 BC, Winckelmann had failed to see the potential of vases (and other monuments) for reconstructing a prehistoric art. According to d'Hancarville, Euchir was working at the time when Italy was still inhabited by Pelasgians, who had migrated to Italy and there mixed freely with the Tyrrhenians, whom he equates with the Etruscans, and who were originally descended from the Phoenicians.[10] According to Dionysius of Halicarnassus, the first Pelasgians were from Arcadia, their migration led by Oenotrus, grandson of Pelasgus, who was himself the son of Niobe and Zeus. Oenotrus was born, according to Dionysius, seventeen generations before the Trojan War.[11] The Tyrrhenian Etruscans lived happily and mixed freely with the newcomers but, so d'Hancarville claimed, eventually succumbed to the same calamity that Dionysius of Halicarnassus tells us befell the Pelasgians.[12] Following this ancient source (I. 26), d'Hancarville dated their fall to sixty years before the siege of Troy. Some Pelasgians retired to Athens, where word got out that there were Etruscan towns lying ruined and undefended and ripe for colonisation. One of these was Cumae in Campania.[13] The inhabitants of Chalcis under Hippocles and Megasthenes set out to refound Cumae. Confusing the Greek Iron and Bronze Ages, d'Hancarville puts the Iron Age colonisation of Italy, which Winckelmann had sensibly dated to around 750 BC, back into the Bronze Age and dates the founding of Chalcidian Cumae to before the Trojan War.[14]

D'Hancarville concludes that the invention of painting by Euchir preceded by a

short time only his projected date for the arrival of the Greeks at Cumae. By putting the date of the manufacture of the vase back into remote antiquity, he could lay claim to the discovery of a hitherto unsuspected period of Greek art. Not only was the date of the vase extremely early, but it stood at the very beginning of man's first artistic endeavours and, as such, was a vital component in the development of d'Hancarville's theory of origins. The following passage is striking and goes so far towards explaining his approach as to merit translation in full:

> The drawing of these Muses recalls that of children in which the imitating spirit naturally seeks, not as one might think, to show everything that one sees, but to imitate the way older people do things. For one can be certain that it is impossible to have an idea of drawing, if one has never seen a drawing before. The author of these figures seems never to have known any better, and his figures bear no resemblance to anything art has thought to create, since there is no reminder of anything better. The artist seems constrained, therefore, to divine the possibility of an art which does not exist, or at least one which has been in existence for a very short time only. Since one finds some 'maxims' in the manner of treating the figure, and as they are the ones which are found in sculpture (of the same period) it necessarily falls out that painting had not already had sufficient time to invent them for itself.
>
> But if, from its extreme naivety, this drawing appears to be made by children, the intention, the arrangement, the ideas it develops, show it is a man who is responsible and even one who is very ingenious in his work. The lack of paradigms, and of the knowledge that only practice, experience, thought and time can bring, prevent him from doing what he would like. He seeks simultaneously painting and the means of creating it. Here one sees genius struggling against the odds, and without yet being able to overcome them.[15]

In this passage we find d'Hancarville at his most visionary, reaching deep into the imagined past for a glimpse of primitive man, who, like Rousseau's noble savage, stands intelligent but culturally naked before us. From this modest beginning d'Hancarville attempts to sketch the progress of vase-painting.[16] He rightly recognises the importance of the inscriptions on vases for identifying them as Greek and as a possible guide to their date. One can sympathise with the errors he makes in his attempt to make sense of the chronological development of Greek letter forms, when so little was known of the early epigraphy of Greece. His confusion of the Greek Bronze Age and Iron Age, however, meant that his few 'fixed points' of epigraphic evidence were not, in fact, at all secure.

One of the best guesses of the eighteenth century at the date of a Greek vase is that of A. S. Mazzocchi. D'Hancarville himself informs us that Mazzocchi had dated a fine cup 'made in the manufactures of Campania' to around 500 BC on the basis of Athenian letter forms. He gives a reference to Mazzocchi's illustration of a red-figured kylix now in Boston and attributed to the Penthesilea Painter. Its date would be c.460 BC. Mazzocchi's Latin text, however, does not say what d'Hancarville claims it does about the cup. Although the inscriptions certainly interested the Neapolitan scholar when he saw the vase in the royal museum at Herculaneum,[17] Mazzocchi does not comment upon their date. D'Hancarville should perhaps have referred instead to a bell-krater also discussed and illustrated by Mazzocchi.[18] This was in the collection of Felice Maria Mastrilli, from whom Hamilton bought many vases; this one escaped him and is now in Toronto.[19] Mazzocchi read the inscription as ΚΑΛΟΣ ΨΟΛΩΝ ('Psolon is beautiful'), and we may infer the date he attributed to the vase from his mention of the long vowel, *omega*, in the name Psolon. The

invention of the letters for such long vowels and for double letters in the Athenian alphabet was traditionally attributed to Simonides of Keos (*c*.556–467 BC).

D'Hancarville himself thought he could date another vase (cat. no. 34) after the death of Alexander the Great (323 BC), again on the basis of the forms of the letters: 'One can then by the means of a collection of antique vases show the whole progress of painting from its beginning to its fall.'[20] Subsequently, he altered his view of the date of this vase and in the manuscript catalogue of 1778 put it at 'a little before the time of Homer', whose *floruit* we are told elsewhere was around 212 years after the Trojan War. He put it before Homer because he thought that the style of the painting did not yet exhibit the influence of that poet, the sublimity of whose verses had succeeded in transforming all the arts.[21] The letters of the inscription were now seen to represent a mixture of 'Cadmean' (i.e. of the age of the Theban hero Cadmus) and the preceding Pelasgian alphabets: 'from which emerged the Greek and Latin languages'. The Cadmean letters eventually replaced the Pelasgian altogether, but not before the 61st Olympiad in the time of Simonides. The style of the vase-painting represented a transitional stage between his 'exaggerated' (*outré*) and 'commonplace' (*trivial*) phases, a style which he thought characterised the verses of Homer himself, but which the poet had raised to a sublime level, thus providing a model for sculptors and painters to follow.

All of this now seems naive, but it was not exceptionally so for the age in which d'Hancarville was living. Equally foreign to modern thinking are his attempts at filling in the gaps between his chronological 'fixed points' by interpreting the subjects of some vases as illustrating historical events.[22] According to his first explanation of it, cat. no. 35 depicted Valeria coming to beseech Volumnia (Plutarch, *Life of Coriolanus*, XXXIII, 2–5), mother of Coriolanus, to ask her son to negotiate with the Roman Senate. This choice of subject at least put the vase into the right period, the fifth century BC, since the *Annals* of Roman history located the events surrounding the wrath of Coriolanus at *c*.490 BC. Later, however, d'Hancarville acknowledged that vases did not carry subjects relating to Roman history or myth, only to Greek. He went on to give an equally improbable explanation from Greek history, namely the account of the Argive poetess Telesilla rallying the women of Argos to defend their city against the marauding Spartans.[23] Pausanias explains that this Spartan campaign was lead by Cleomenes, son of Anaxandrides, whose reign is now put at around 520–490 BC. The Spartan king-lists were one of the principal systems of chronology handed down from antiquity, and d'Hancarville, who was an accomplished chronographer, will have known the relative *floruit* of King Cleomenes.

Both the options he discusses give the vase a date which is considerably closer to modern reckoning than most of his attempts at dating other vases. D'Hancarville's understanding of the subject-matter of this vase was not, however, the determining factor of his placing it relatively late in his chronology. The choice of subject was, in fact, founded upon a stylistic judgement, rather than any real iconographic insight: cat. no. 35 played a key role in d'Hancarville's developmental series as representing a place in the rise of Greek art equivalent to that which Raphael was seen to occupy in the growth of modern European painting from its primitive state to its maturity: 'And, as in a gallery of pictures one endeavours to unite those of the masters from Giotto and Cimabue down to our time, so in this collection one may see the styles of the different periods in the arts of the ancients.' D'Hancarville is here applying to the study of vase-painting the Vasarian model of the development of European panel painting. A collection of vases could provide a complement to a collection of prints and drawings and thus be the means for extending the perspec-

FIG. 66 'The Argive poetess Telesilla rallying the women of Argos to defend their city against the marauding Spartans': engraving after cat. no. 35.

tive of art history back in time. 'With its assistance', wrote d'Hancarville, 'a man of taste and letters . . . may see, as in a kind of geographical chart, the whole progress, and as one may say, count every step of human industry in the most agreeable art it has invented.'[24]

Winckelmann had already spoken of a collection of vases constituting a 'treasury of drawings', but was making a rather different point: in the first edition of the *History* we find a remarkable passage in which he anticipates the modern connoisseurship of vase-painting that is now identified with the work earlier in this century of Sir John Beazley: 'As the smallest, meanest insects are wonders in nature, so these vases are a wonder in the art and manner of the ancients; and, as in Raphael's first sketches of his ideas, the outline of a head, and even entire figures, drawn with a single unbroken sweep of the pen, show the master to the connoisseur not less than his finished drawings, so the great facility and confidence of the ancient artists are more apparent in the vases than in other works. A collection of them is a treasury of drawings.'[25] Here we find an essential difference between the two scholars: Winckelmann, the founder of the modern tradition of art history in the study of antiquity, is interested in the minutiae of a drawing as a means of reconstructing an artist's personal style. He is by no means blind to the larger picture and yet his is a different emphasis from that of d'Hancarville, who is less interested in the object *per*

se than he is in its potential to serve as a vehicle for his theories about the origin and development of art.

The Cimabue and Giotto of d'Hancarville's gallery were provided by two other vases that feature prominently in his publication: cat. no. 32 was recognised as one of the earliest vases in the collection. Its composition was founded on the same maxims as that of the Muses, and as such it constituted a piece of 'figured writing, *écriture figurée*, where everything – even its deficiencies – contributes to an understanding of the subject. Nothing expresses, but everything speaks; the figures do not signify much, but they signify better than those of the Muses.' The style was more advanced than that of the Muses vase and in this respect was closer to the style of cat. no. 33. One important omission, however, made this vase earlier than the latter, namely the fact that the names of the figures were not inscribed. The *signe*, as d'Hancarville liked to call it, of the iconography was more considered and less pronounced than that of the Muses, but was still not as restrained as in the 'Hunt Krater', cat. no. 33.[26]

D'Hancarville's Giotto was this large krater showing a boar hunt. He never suspected that it was, in fact, an import from Corinth, and supposed it to have been made at Capua, near where it was found. He was nevertheless fully aware of its Greekness, revealed in the inscriptions, and speculated that it was a product of a Campanian Greek workshop. Hamilton himself in the publication of his second collection recalled this vase as being the one which made him first realise the Greekness of what had previously been called 'Etruscan' vases[27] (see p. 51). The 'Hunt Krater' was thought to represent one of the earliest examples of ancient painting to have survived and was given great prominence in *AEGR*, where d'Hancarville tried to relate it directly to Pliny's account of the early history of ancient painting. 'The imbecility of art in its infancy' was to be located a little before it was painted, conjectured d'Hancarville.[28] It was then that the first outline of a human figure was traced around a shadow[29] (see cat. no. 36). There follows an account of the origins of ancient painting: first, lines only were used following the first tracing of an outline. Afterwards, the interior of these outlines was elaborated with further lines, the subjects identified by means of writing. These advances Pliny attributes to Ardices of Corinth and Telephanes of Sicyon. Ecphantus of Corinth, whom d'Hancarville calls Cleophantes, was the first to give colour to these outlines, which he did in a monochrome form of painting using powdered earthenware.[30]

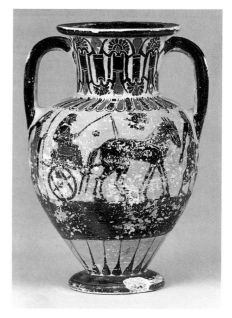

FIG. 67 'Laius at the crossroads' (cat. no. 32).

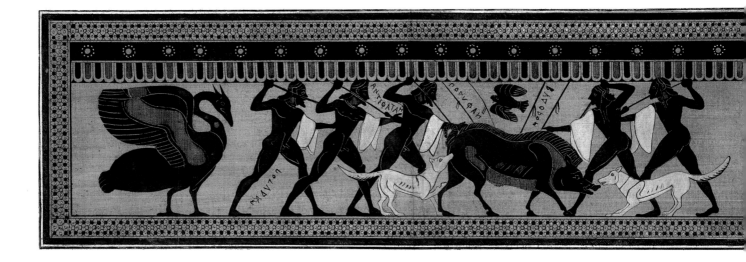

FIG. 68 Engraving from the principal scene of the 'Hunt Krater' (cat. no. 33).

Pliny repeats but rejects the claim by Cornelius Nepos (b. *c*.110 BC) that this Ecphantus had followed Demaratus, father of the Roman king Tarquinius Priscus (*c*.616–518 BC), when he fled to Italy to escape the violence of Cypselus, tyrant of Corinth. The inference of this claim is that Ecphantus was responsible for the introduction of painting into Italy, a notion which Pliny rejects 'since in Italy also painting had by then been brought to perfection'.[31] Pliny goes on to give an account of ancient paintings which he knew to predate the founding of Rome.

In spite of Pliny's scepticism, d'Hancarville latched onto the tyranny of Cypselus as a vital clue to the date of Hamilton's vase. Accepting the Classical tradition that Cypselus' rule began in the 30th Olympiad, he was able to compute (in four-year periods from the foundation of the Olympic Games in 776 BC) that the vase should date to around 658 BC.[32] In view of Pliny's rejection of the suggestion that the inventor of colour painting at Corinth was also responsible for the introduction of painting to Italy, d'Hancarville took the precaution of saying that 658 could only serve as a *terminus ante quem*. Besides, he thought he recognised the great antiquity of some of the letter forms on the vase and the boustrophedon writing, which not only reads from right to left, but also turns back upon itself (*boustrophedon* means, literally, 'turning like oxen in ploughing'). Pausanias, in describing the celebrated chest of Cypselus, housed in his day in the Temple of Hera at Olympia, had remarked upon the boustrophedon nature of the inscriptions upon it and saw them as a mark of great age.[33]

Subsequently, in volume III of *AEGR* d'Hancarville substantially revised his chronology of vase-painting, greatly decreasing the length of time which he had earlier allowed between the proto-pictor Euchir and his Cleophantes (Pliny's Ecphantus).[34] Abandoning his former acceptance of Pliny's link between Ecphantus (Cleophantes) and Cypselus, he decided to update Ecphantus, and with him Ardices and Telephanes, to the years immediately preceding the fall of Troy (which d'Hancarville seemed here to compute to the year 1218 BC instead of the usual acceptance of Eratosthenes' date of 1184–1183 BC). The artistic tradition to which these painters belonged was established by Euchir and the first sculptor Daedalus, whose *floruit* he now dated back to 1308 BC.[35] In spite of the dubious epigraphic arguments he uses to support this dramatic change of opinion, the real motive seems simply to bring the 'Hunt Krater', and vases like it, closer in time to the first beginnings of Greek art, and so to glamorise his claims to have discovered the prehistory of Classical art through association with a great archaeological monument.

Much of what d'Hancarville says of the origins of art as seen through Hamilton's vases is intended ultimately to provide a challenge to Winckelmann's claim that art did not exist among the Greeks or Etruscans until after 750 BC, and to go one better than the *History* by charting a previously unknown course of Greek art: 'The examination of these vases (that part of antiquity hitherto so neglected) is nevertheless the only one that can show, as in a Genealogical Chart, the progress of human industry in the finest of the Arts of its invention, which is surely a great exhibition for the Curious and Philosophers.'[36]

D'Hancarville's 'exhibition' is here reconstructed with the vases arranged according to his chronology.

NOTES

1 D'Hancarville, MS Catalogue, II, p. 601★.
2 *AEGR*, II, pl. 13 opp. p. 125, pp. 124–6.
3 *AEGR*, III, p. 151.
4 Trendall, *LCS*, Appendix 1, pp. 667ff.
5 *AEGR*, II, p. 124; Pliny, VII.56.205.
6 *AEGR*, II, p. 126.
7 Winckelmann (Lodge), pp. 324–5.
8 Boardman, 1973, p. 165.
9 Strabo, V.4.4.
10 *AEGR*, I, pp. 60 and 66.
11 Dionysius of Halicarnassus, *Roman Antiquities*, I.11.2.
12 Dionysius of Halicarnassus, *Roman Antiquities*, I.23; *AEGR*, II, p. 128.
13 *AEGR*, I, p. 66.
14 *AEGR*, I, pp. 44–6, and 66; II, p. 130.
15 *AEGR*, III, pp. 202–3.
16 *AEGR*, II, p. 126.
17 *AEGR*, II, p. 126; Mazzocchi, pp. 551–2, illus. opp. p. 554.
18 Mazzocchi, p. 139, illus. 4 on the preceding page.
19 Beazley, *ARV²* 1607.
20 *AEGR*, II, p. 126.
21 Cf. *AEGR*, III, p. 208, n. 176.
22 *AEGR*, II, p. 128.
23 Pausanias, *Description of Greece*, II.20.7.
24 *AEGR*, I, p. 168.
25 Winckelmann (1764), p. 123; Winckelmann (Lodge), p. 397.
26 *AEGR*, III, p. 203.
27 Tischbein, II, p. 14.
28 *AEGR*, II, p. 108.
29 *AEGR*, II, p. 116.
30 *AEGR*, II, p. 118.
31 Pliny, XXXV.5.16 and 43.151–2; Overbeck, pp. 67–9.
32 *AEGR*, I, p. 162.
33 Pausanias, V.1.17, 6.
34 *AEGR*, III, p. 201ff.
35 *AEGR*, III, p. 206.
36 *AEGR*, II, p. 128.

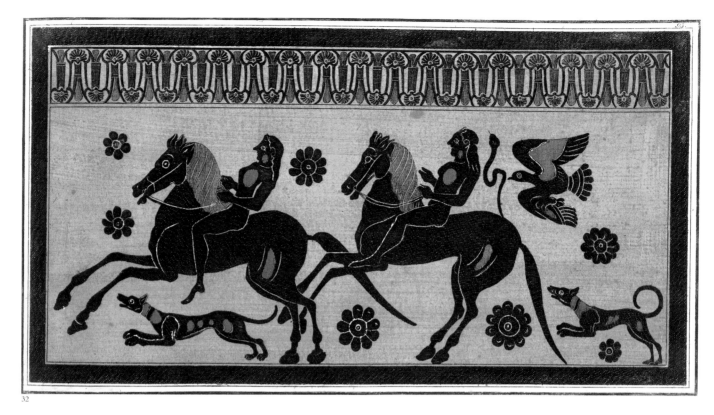

32

32 'Ecriture figurée': black-figured neck-amphora depicting King Laius at the crossroads

Ht 27.3 cm
Made in southern Italy about 520 BC. Attributed
to the Memnon Group (Pseudo-Chalcidian)
British Museum, GR 1772.3–20.5* (BM Vases B17)

The principal side shows a man in a mule cart with companions walking on either side; on the reverse, two youths on horseback. In the second volume of *AEGR* (p. 165), d'Hancarville declared that he could not interpret the subjects of this vase. In the third volume he revised this view with the ingenious suggestion that the principal side shows Laius, king of Thebes. The omission of this identification from the commentary of *AEGR* II is curious, since on p. 120 of that same volume d'Hancarville alludes to what is obviously the same vase, showing Laius on the 'journey where he met Oedipus'.

D'Hancarville's full description of this vase is reserved for volume III and for the manuscript catalogue of 1778. Here we read that Laius is shown in a cart accompanied by a guide in front and a guard behind. The figure walking ahead has arrived at a crossroads and his manner expresses uncertainty as to

which road to take. Meanwhile, on the other side of the vase, Oedipus is arriving on horseback with his companion, about to enact the fated murder of Laius, his estranged father, in fulfilment of the prophecy that he would kill his father and marry his mother. Oedipus is the leading horseman, identified by the holes in his left foot, shown in the engraving as two white marks. According to the story, Oedipus (whose name in Greek means 'swollen foot') was exposed at birth on Mount Cithaeron, with his feet pierced and bound. In the vase-painting, the smaller size of Oedipus' hands and feet is contrasted by d'Hancarville with those of Laius and his companions. D'Hancarville thought this difference intentional on the part of the vase-painter, to show the power of Laius' companions and their suitability for long marches; Oedipus' strength, by contrast, resided not so much in the size of his feet as in the vigour of youth. Everything in the picture is thought to have some specific meaning, and d'Hancarville even finds an explanation for the serpent shown behind one of the horsemen, suggesting that it betokens the myth of the metamorphosis of Cadmus, founder of Thebes, into a serpent.

D'Hancarville displays his scholarly virtu-

osity in this clever but improbable interpretation. The suggestion of holes in the foot of Oedipus is the most sensational part of his argument, but is unfortunately not supported by the evidence. The vase has suffered a good deal more damage to the surface than the engraving shows. Although the marks shown in the engraving are present on the vase itself, they are part of a larger complex of damage. It is, however, interesting that the holes on the foot of the leading horseman are alone reproduced, and from this it may be inferred that d'Hancarville deliberately directed the engraver to include them or, rather, to exclude the others that might have weakened his case.

LITERATURE: D'Hancarville, I, pls 91–4; II, pp. 120 and 165; III, pp. 156–7, n. 76, and pp. 202–3; Winckelmann (Lodge), p. 365: Etruscan of the earliest style; d'Hancarville, MS Catalogue, pp. 608*–10*; Rumpf, p. 156, d, pl. 199.

33 *'Vase-painting before the Trojan war' (the 'Hunt Krater'): column-krater (wine-mixing bowl)*

Ht 27.9 cm

Made in Corinth about 575–550 BC. Found near Capua, Campania

British Museum, GR 1772.3–20.6 (BM Vases B37)

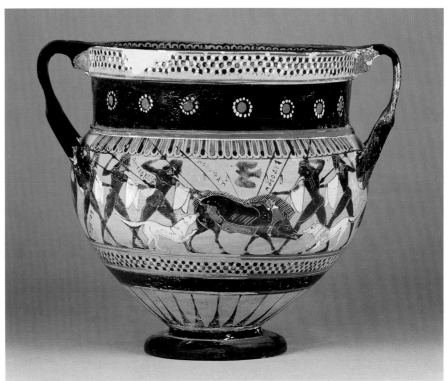

33

The principal side shows a boar hunt; the names of four of the hunters – Polydas, Antiphatas, Polyphas and Eudoros – are inscribed in the archaic Corinthian alphabet. On the other side are three horsemen galloping to the left. Two of their names are inscribed: Pantippos and Polydoros.

This image of an ancient hunt must have been resonant with reminders to Hamilton of the many expeditions he had joined, in the company of King Ferdinand IV, hunting boar in the woods above the royal palace at Caserta. We can imagine Hamilton, on the occasion he presented the king with a copy of the first volume of his work, attempting to engage the interest of His Sicilian Majesty, who was notorious for his stupidity, by pointing out the subject of this vase. The king might be flattered by the parallel to be drawn between the sport of modern monarchs and that of ancient heroes (*AEGR*, I, p. 90).

In the first volume of *AEGR* d'Hancarville took the view that, since the names of the hunters were not those of the participants in either of the great Calydonian or Erymanthean boar hunts of mythology, this must therefore be an otherwise unknown hunt of legendary fame in Campania itself. He was at a loss to explain the presence of the birds. Later, in the third volume, he revised this opinion, arguing that such was the nature of early Greek art that nothing was without meaning. The birds included in the hunt were therefore more than merely incidental to the action: those shown in flight, accompanying the human protagonists, were intended to signify fate or destiny, birds being one of the media of divination in the ancient world. As owls, moreover, they were birds of ill-omen.

The standing birds also carried particular messages: on the side of the vase showing three horsemen, d'Hancarville saw the smaller bird arranging its plumage as an eagle, *aetos* in ancient Greek, betokening Aetolia, the region of the Greek world in which the hunt is set. On the other side of the vase, the large bird standing on the left (surely a crested swan) was seen as a Meleagrid, or guinea-fowl. The Meleagrids of mythology were the daughters of Oeneus, king of the Aetolians of Calydon. Their brother Meleager was the hero of the hunt for the Calydonian boar and, upon his death, his sisters grieved so much that Artemis turned them into guinea-fowl. The flowers beneath the belly of the horses signified the vineyard which, in the hunt for the Calydonian boar, was being ravaged by the beast. Returning once again to the scene with the three horsemen, d'Hancarville saw the large bird standing on the left of the picture as a swan, in which he was surely right. He saw it as a bird of omen prefiguring the death of one or more of the hunters.

D'Hancarville was clearly frustrated by the lack of any name among those of the hunters that could be associated definitively with the Calydonian hunt. He was, however, determined to link this vase with that legendary episode. Two figures, one on each side of the vase, are without names, and he hypothesised that the unnamed hunters were Meleager and his companion Ancaeus, who was killed in the hunt. Ancaeus is thought to be the unnamed horseman with the long lance, Meleager the unnamed man on foot in the principal scene, his name being '*dégagé*' as in the solution to an algebraic problem . . . Thus one sees how, phrase by phrase, through the order of discourse represented in the figures, the artist has succeeded in revealing the place, time, nature, cause and conclusion of the action, which he undertook to describe. In his sparing use of both writing and *signe* he has clearly expressed the names and even the characteristics of those whom he judged it necessary not to name.'

LITERATURE: D'Hancarville, *AEGR*, I, pp. 152–64, with plates; II, pp. 108 and 118–22; III, pp. 204–9; Winckelmann (Lodge), pp. 380–83; d'Hancarville, MS Catalogue, II, pp. 610–21; Tischbein, I, p. 14; Amyx, I, p. 268, 8, II, p. 585, 104: kraters of 'Chalcidian type'. Schnapp, 1992, pp. 214–15. For Hamilton's presentation of the first volume of *AEGR* to the king, see Griener, p. 50.

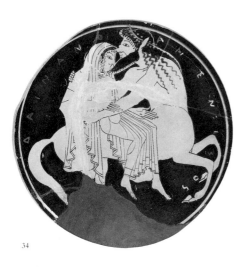

34

34 'Vase-painting just before the time of Homer': red-figured tondo from a kylix (drinking-cup)

Ht 5 cm
Made in Athens about 520–510 BC. Attributed
to the Ambrosios Painter. Only the MS
Catalogue records that Hamilton acquired
it from the Jesuits in the Roman College
British Museum, GR 1772.3–20.12*
(BM Vases E42)

The subject is the rape of Deianeira, wife of Herakles, by the centaur Nessos.

D'Hancarville's chronology of vase-painting relied heavily upon his theories about the development of writing. This vase-painting is one of those about the dating of which d'Hancarville expressed more than one opinion. He eventually settled on its being executed just before the *floruit* of Homer, but in his earlier speculations he thought this vase post-dated the death of Alexander the Great in 323 BC. Then it was, as he supposed, that the Greek and Etruscan languages 'were at last blended together and formed one only'. The letter forms by which the names of the centaur Nessos and his victim Deianeira are inscribed 'were no longer Greek or Etruscan, but made use of the characters of each' (*AEGR*, II, p. 134).

Laying aside his theory about the fusion of the Greek and Etruscan alphabets, it can now be revealed that d'Hancarville's reading of the vase inscription was based partially upon a forgery: in Hamilton's day this fragment of a drinking-cup had been restored, and the original inscription tampered with. Today the inscription may be read as Dainanera (*sic*) and Nisos. In the engraving published in *AEGR*, however, it is given as

Deinani/Anenisos (in the text referred to as Deianina and Anenisos). It seems probable that d'Hancarville was the inventor of the wrong reading, and he himself may have interfered with the original painted inscription by incising additions.

In this he failed to realise that the last two letters of Deianeira's name, *rho* and *alpha*, were written to the right of the centaur's head. D'Hancarville saw these two letters as *alpha* and *nu* and, if this is not to accuse him falsely, strengthened his argument by scratching in the downstroke of his projected A, the upstroke of his N and, between this letter and the next, inserted an E.

LITERATURE: D'Hancarville, *AEGR*, I, pp. 126 and 134 and see also IV, pp. 192–3, pls 30–31; d'Hancarville, MS Catalogue, II, pp. 627–30; Beazley, *ARV²* 174. For the inscription see Kretschmer, p. 77. The removal of the restoration is recorded in the interleaved section of the British Museum's 'Old Catalogue' of vases, where the correct reading of the inscription is

also first given. It is said there that the fragment had been restored as a pinax (plate), and so it appears to be in the engraving of its profile in *AEGR*, IV, pl. 30. D'Hancarville was nevertheless aware that the original had been a cup (MS Catalogue, p. 627: 'On trouve ici le fond d'une très grande coupe dont les bords se sont perdus').

35 'Vase-painting as Raphael might have done it': red-figured hydria (water-jar)

Ht 28 cm
Made in Athens around 440–430 BC.
British Museum, GR 1772.3–20.216
(BM Vases E221)

D'Hancarville thought the subject portrayed a historical event (see p. 152). In fact, it is a generic scene of daily life showing two women, heavily draped in mantles, standing before a third, who is seated. The two outer-

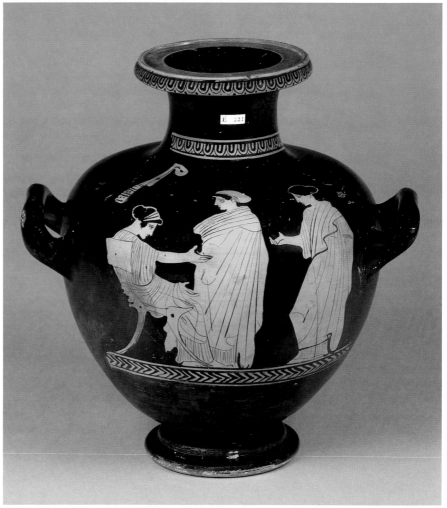

35

most figures are playing a game of catch, throwing balls, probably of unworked wool, from their outstretched hands. The balls are faintly discernible, having once been added in white or purple pigment, which subsequently flaked off leaving only a shadow. D'Hancarville, who was probably working from the engraving, which does not indicate them, was unaware of the existence of these balls.

The prominent publication of this vase-painting in *AEGR* inspired Wedgwood about 1785 to produce a jasperware plaque of it, transforming the subject from painting to bas-relief.

LITERATURE: D'Hancarville, *AEGR*, I, pp. 164ff, with plate; d'Hancarville, MS Catalogue, II, pp. 709–10; for the Wedgwood plaque see Reilly, I, p. 608, fig. 899.

36 'Dibutades' daughter': black-figured lekythos (oil-bottle)

Ht 15.8 cm
Made in southern Italy about 330–300 BC.
 Attributed to the so-called Pagenstecher Class
British Museum, GR 1772.3–20.35
 (BM Vases F518)

The subject is the head of a woman wearing a headdress and jewellery.

Black-figured vase-painting is rare in southern Italy, and the date and artistic context of this vase would have been little understood in Hamilton's day. The subject was much flattered by the reproduction of it in *AEGR*, chiefly because of d'Hancarville's theory that it represented to the ancients a memory of the origins of art.

Pliny recounts how in Corinth the daughter of a potter from Sicyon wished to record the features of her lover, who was going abroad. She drew his profile from the shadow on the wall cast by the light of an oil lamp. Her father, Butades – whom d'Hancarville calls Dibutades – was inspired to model the silhouette thus made by raising it with clay in bas-relief. Pliny tells this anecdote by way of explaining the origin of modelling in clay. D'Hancarville, however, seems to want to treat it as a part of the story of painting:

> As this ingenious artist added afterwards Rubrick [red pigment] to the earth which he made use of for his models, it seems probable that he made use of it also in his vases, and perhaps it is to him we owe

36

the idea of that red colour which is their ground. The profile of which his daughter gave him the idea, was probably placed upon these vases to which it was an ornament, hence it is that we frequently find heads upon these sort of works, and which was [*sic*] continued to mark the origin of the art, as we have shown that the ancients made it a rule to preserve in all times the types of architecture and sculpture, because they called to mind their origin.

Pliny records that Butades' paradigm was kept in the shrine of the Nymphs at Corinth until the sack of the town by the Roman general Mummius in 146 BC. D'Hancarville has stretched the point of his text beyond reason in order to relate it to the vase in Hamilton's collection.

This vase is probably the same as the small lekythos shown in the black-and-white engraving that concludes the text of the first volume of *AEGR*.

LITERATURE: *AEGR*, I, pls 36–8; II, pp. 116–18; Pliny, XXXV.43.151–2; Overbeck, p. 46; for the vase type see Mayo, pp. 218–19, nos 99 and 100, p. 241, no. 114; for eighteenth-century interest in 'the Maid of Corinth', see Bermingham, *passim*.

FIG. 70 'Dibutades' daughter': engraving after cat. no. 36.

Fields of Fire: Hamilton and Volcanoes

37 'Eminent Moderns': two portrait plaques

a) Jasperware portrait plaque of Sir William
 Hamilton mounted in a gilt wood frame.
 Made by Wedgwood and Bentley at Etruria in
 1779
Ht 26.6 cm
British Museum, MLA (Pottery Cat. I. 67)

Hamilton's was one of a series of large-scale
portrait medallions produced in 1779. These
were to have been issued in pairs, Sir
William's matched with that of the French
antiquary and collector the Comte de Caylus
(1692–1765). The latter seems never in fact
to have been made. Wedgwood's letter to
his partner Thomas Bentley on the subject
reads as follows:

> Can you think of a better match than
> Count Caylus for our very good friend Sir
> Wm. Hamilton? We have bosted him out
> the size of Mr Banks [see (b)], and I think a
> suit of eminent moderns, naturalists,
> amateurs etc., should be made of the same
> size and style, and so form a constellation,
> as it were, to attract the notice of the great,
> and illuminate every palace in Europe.

Hamilton must have been flattered to have
been included among the illustrious com-
pany thus honoured by Wedgwood and
Bentley.

LITERATURE: Reilly and Savage, pp. 182–3; Reilly,
pp. 84–5; Ramage, 1990b, p. 75; Dawson, p. 79,
pl. 7.

b) Jasperware portrait plaque of Joseph Banks
 (1743–1820). Made by Wedgwood and
 Bentley at Etruria in 1779, probably from a
 model by John Flaxman
Ht 26.5 cm
British Museum, MLA (Pottery Cat. I. 60)

Banks was a naturalist and President of the
Royal Society from 1778. He received a
prolonged correspondence from Sir William
on all matters of scientific interest relating
to the Bay of Naples, and especially the
activities of Mount Vesuvius.

This plaque was made as one of the series
of large portrait plaques of 'eminent mod-
erns', which included: Hamilton; Robert
Boyle (1627–91), the natural philosopher
and chemist; Daniel Charles Solander

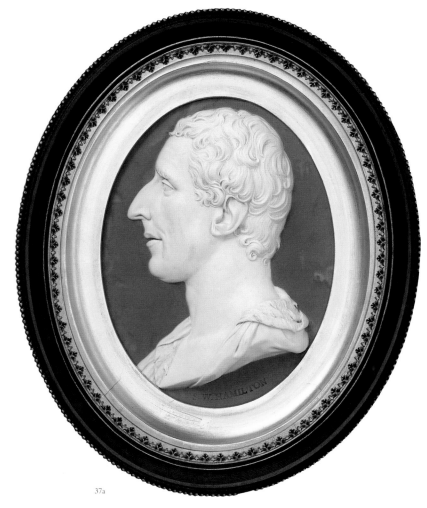

37a

(1736–82), the Swedish naturalist; Ben-
jamin Franklin (1706–90), the American
statesman; and Isaac Newton (1642–1727),
natural philosopher and mathematician (this
last was to form a pair with that of Dr Joseph
Priestley (1733–1804)).

LITERATURE: Reilly and Savage, p. 56; Dawson,
p. 79, fig. 64.

38 'Curious stones' from Vesuvius
Illustrated on page 67, fig. 31

From April 1768 onwards Sir William made
several presentations of rock specimens
from Vesuvius and the Naples region to
both the British Museum and the Royal
Society. The Royal Society Museum was
presented to the British Museum in 1781,
and Sir William's specimens presumably

went with it. The British Museum's former
natural history collections are now part of
the independent Natural History Museum
in South Kensington, where some 122 rock
specimens have recently been identified as
coming from Sir William's collection. Like
those illustrated in *Campi Phlegraei*, they are
cut and polished to bring out textural and
structural features, but unfortunately none
can be matched to Fabris's illustrations of Sir
William's own collection.

a) *Lavas from Mt Vesuvius*

Natural History Museum, London, BM80138

Four specimens from rocks and minerals sent
to the British Museum from the Naples
region by Sir William Hamilton. The lavas
are of two types: one is a pale trachyte, rela-
tively poor in silica, and the other three are

the darker basanite, rather richer in silica, containing grey crystals of the mineral leucite. The largest specimen is 33 cm across.

b) *Skarns from Monte Somma*

Natural History Museum, London, BM80138

Monte Somma is the old summit of Vesuvius, active in the eruption of AD 79 and the source of these four specimens from one of the collections of rocks sent to the British Museum by Sir William Hamilton. All consist of limestones brought up from deep in the Earth by the force of an eruption. They have been broken in pieces, recrystallised by the great heat, and altered in composition by the volcanic waters and gases, to form the rock called 'skarn'. The largest specimen is 36 cm across.

LITERATURE: Woolley and Moore, *passim*; esp. pp. 185–6.

39 *'Controversial basalt'*

Black basalt portrait head mounted on a rosso
 antico bust
Ht without stand 21.4 cm
Probably not ancient. Said to be from Rome
Provenance: Hope, Christie's sale 1917, no. 178a
British Museum, GR 1947.3–28.2

Illustrated on page 67, fig. 31

Sir William's sculpture collections were rich in pieces carved from coloured marbles, especially porphyry, basalt and the red and yellow stones termed rosso and giallo antico. This, no doubt, reflected the current taste, but in Hamilton's case it was also part of his interest in natural philosophy. One of the great controversies of his day was the question of the origin of basalt, which some claimed was volcanic. If true, this had far-reaching consequences for the geological history of northern Europe, large areas of which were covered by basalt strata. Rudolph Erich Raspe (1737–94), who is known to art historians as the compiler of the catalogue of James Tassie's impressions from ancient sealstones, was also a mineralogist and a firm believer in the volcanic origin of basalt. In 1769 he wrote to Sir William asking for confirmation of his theory that columnar basalt was the result of submarine eruptions.

This head, not previously identified as being from the Hamilton collection, was purchased at the Hamilton sale of 1801 by Thomas Hope. It was then sold again at the Deepdene auction of 1917 and purchased by Mr O. Raphael, who bequeathed it to the British Museum in 1941. In Hamilton's day it was thought to resemble Cicero.

LITERATURE: For the basalt controversy see pp. 70–1; for correspondence between Raspe and Hamilton see Moore, p. 189, n. 9; the bust was itemised in James Clark's list of Hamilton's property compiled in 1798 (Fitzwilliam Museum, Cambridge, Perceval MS N27) as follows: 'Case 3. no. 4. A small antique head in black marble resembling Cicero, with a modern bust of Rosso Antico attached to it, as also a round pedestal of black marble. The whole height, pedestal inclusive is 1 palm, 1 oncia.' The last page of Clark's inventory is an appendix added in Sir William's own hand, where significantly the head is described as 'basalt' (no. 18). This is also how it is described in the Christie's sale catalogue, where it is said to come from Rome: Christie's, 27–8 March 1801, lot 39. An annotated copy of this catalogue gives the purchaser as Hope and the price £15.15.0. See also Waywell, p. 101, no. 67.

40 *Portraits of Joseph Banks*

a) J.R. SMITH (1752–1812) after
 BENJAMIN WEST (1738–1820)

 Joseph Banks, 1773

Mezzotint, 61.5 × 38 cm
Provenance: One of a group of prints after West
 purchased from Messrs Smith
British Museum, P&D 1841-8-9-150

b) W. DICKENSON (1746–1823) after
 SIR JOSHUA REYNOLDS (1723–92)

 Joseph Banks, 1774

Mezzotint, 50 × 35 cm (trimmed within plate)
Provenance: Sir Thomas Lawrence
British Museum, P&D 1831-5-20-55

Although they did not begin to correspond until 1777, Hamilton would have been aware throughout the previous decade of Banks's activities as a natural historian, particularly as a botanist, in Newfoundland, New Zealand, Tahiti, South America and Iceland. The discoveries made during Cook's voyage

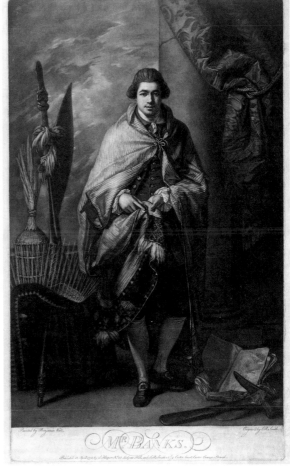

40a

on the *Endeavour* from 1768 to 1771 had already been published, detailing not only the adventures but also the work done by Banks, who was accompanied by two artists and the assistant librarian of the British Museum, Dr Daniel Solander. Banks's portrait was painted after his return in 1773 by Reynolds and West, each artist emphasising different aspects of his accomplishments. Reynolds showed him as a wealthy young man of letters, working on discoveries made on the other side of the globe; while the young American, Benjamin West, concentrated on Banks the natural historian and collector of objects representative of the culture and customs of exotic peoples.

Mathematics and astronomy were well established as the primary subjects of interest in the Royal Society in 1766, the year that both Banks and Hamilton became members, but thanks to Banks's efforts, botany and zoology were to become the subject of more serious and systematic study as the century progressed. Natural history, much like antiquity, was still a study for virtuosi, and since much of the activity centred around collecting, the Royal Society already had a substantial museum of natural history. When the British Museum was opened in 1759, however, the Society's activities in this field were subsumed into the Museum's, which the members regarded as naturally complementing the Society's own.

Hamilton played a role in the encouragement of the study of botany and zoology, searching out curious specimens of plants and especially of fish around the Bay of Naples, which he sent regularly to the British Museum. But Hamilton's greatest contribution to the broadening of interest in natural history lay in his empirical observations of the activities of Mount Vesuvius and the entire volcanic area around Naples and Sicily, and in his regular gifts of different types of volcanic rock, minerals and fossils which he also sent regularly to the British Museum. Banks was *ex officio* a trustee of the British Museum from 1778, the year he was appointed President of the Royal Society, and under his influence, until his death in 1820, the Museum continued to collect widely, 'maintaining the undifferentiated culture of the virtuoso' (Gascoigne, p. 117) – a culture shared by Hamilton, but widened even further by his own earlier addition to the Museum of a foundation collection of Greek and Roman antiquities. Hamilton failed, however, in his efforts to encourage the Museum in the collection of old master paintings and the finest examples of Roman sculpture. Although he offered them the opportunity to purchase first his Correggio and then the 'Warwick' vase, 'the old dons' – he complained – 'do not so much as thank me when I send a work of art' (Morrison, no. 61).

Joseph Banks, like Hamilton, was a member of the Society of Dilettanti, his portrait included on the right of the group with Lord Fortrose and Charles Greville (cat. no. 52). Banks and Hamilton corresponded several times a year, nearly every year from 1777 and particularly in 1785–8, when Banks found a gardener, John Graefer, to send to Naples to assist Hamilton in the creation of an English Garden for the Queen of Naples at Caserta. Banks continued to assist Graefer through the 1790s (Dawson, *Banks Letters*, p. 391, no. 58).

Hamilton's last letter to Banks, written only two months before his death, returned to a favourite subject on which the two men had corresponded over the years. In his letter of January 1802, Hamilton called Banks's attention to the danger of ships being struck by lightning, and implored the Royal Society to take measures to have ships fitted with lightning conductors (Dawson, *Banks Letters*, p. 392, no. 64).

LITERATURE: J. Gascoigne, *Joseph Banks and the English Enlightenment: Useful Knowledge and Polite Culture*, Cambridge, 1994, pp. 110–18.

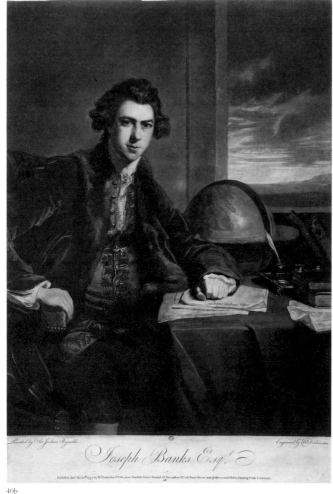

Joseph Banks Esqr.

40b

41 FILIPPO MORGHEN (1730–after 1777)

Two plates from *Raccolta delle . . . famoso viaggio dalla Terra all Luna* ('Voyage . . . to the Moon'), *c.*1766/7

a) *N. 1. Rappresenta un Selvaggio montato sopra un Serpente alato che combatte con un fiera samigliante ad un Porco spino*

b) *N. 5. Maniera di transportare le merci sopra Zattere tirate da un Mantice*

Etchings, 24.8×35.2 cm; 26×36.8 cm
Provenance: Purchased from Christopher
 Mendez
British Museum, P&D 1984–6–9–10 and 11

These two prints are from a fanciful series of nine delightful rococo-chinoiserie images of the life and economy of men on the moon, engraved by Morghen on the basis of a voyage to the moon related by 'Cavaliere Wild Scull' and 'Sig.r de la Hire'. The series was dedicated on the title page 'A S. E. il Signor Guglielmo Amilton Inviato di S. M. B.ra alla Corte di Napoli'. The title page shows Wild Scull and de la Hire climbing out of their box-like winged flying machine, greeting the inhabitants. The second edition substitutes the name Bishop John Wilkins for Wild Scull and de la Hire, apparently on the recommendation of William Hamilton, who was familiar with the various accounts of voyages to the moon. He knew that Philippe de la Hire did not believe the moon was inhabited, while Bishop Wilkins, first Secretary of the Royal Society, argued that it was not only inhabited but that it might be possible one day to voyage there. Wilkins's *The Discovery of a World in the Moone* was published in 1638 and revised in 1640. Imaginary voyages to the moon delighted and fascinated readers of the seventeenth and eighteenth centuries, and Wilkins's contemporary Bishop Francis Godwin published his *Man in the Moone* the same year. The accounts of de la Hire, a member of the French Royal Academy of Sciences, were published in 1731.

A third edition of the title page had two interesting additions: the date 1764 was added after the dedication to Hamilton, indicating the date of his arrival at court, and a hydro-

41a

gen balloon was added to the flying machine. Balloons were not invented until 1783 and this particular type was not in use until 1785, the year of the first cross-channel flight. It serves to indicate the new fascination with the possibility of voyages to the moon boosted by these miraculous inventions. The moon was very much in Hamilton's thoughts in 1787 when, during his regular correspondence with Sir Joseph Banks, he wrote that he had read of the astronomer Herschel's discovery of lava on the moon and his theory explaining it. Banks wrote by return that Herschel's discovery of volcanoes on the moon was generally accepted, and Hamilton must have marvelled at the thought that his own work on volcanoes as creative forces might have repercussions on future scientific discoveries about the planets (Dawson, *Banks Letters*, p. 385).

LITERATURE: G. McColley, 'The three editions of Filippo Morghen's *Raccolta*', *Art Bulletin*, XIX, 1937, pp. 112–18.

42 FILIPPO MORGHEN (1730–after 1777)

Veduta a Ponente degli avanzi d'un insigne edificio in Pozzuoli da molti creduto il Tempio di Serapide

Plate 11 from *Le Antichità di Pozzuoli, Baja, e Cuma*, 1769

Engraving, 28.5 × 39 cm

Provenance: Part of a large group of Italian prints purchased from Lady Fanny Geary

British Museum, P&D 1886–11–24–285

Filippo Morghen and his brother Giovanni, originally from Florence, had been working in Rome in the 1750s when they were brought to Naples by Charles III to work on the publication of *Le Antichità di Ercolano* which the king was publishing to send as gifts to courts and cultural societies throughout Europe, thus circulating the finds being made by his excavations.

Morghen had engraved views of Herculaneum, Paestum and the environs of Naples for the king, but he must have seen a new potential market for his plates with the arrival of William Hamilton, an envoy with a reputation as a man of taste and one who was already well informed and fascinated by the rich antiquities around Naples. A new patron-engraver relationship was obviously established, with Hamilton advising Morghen on the subjects and marketing of his prints. It must have been Hamilton who told Morghen of the respective discussions of Wilkins's and de la Hire's voyages to the moon, which resulted in the correction of the title page of that series dedicated to Hamilton (cat. no. 41). It was obviously Hamilton who informed Morghen of the activities of the Society for the Encouragement of Arts, Manufactures and Commerce to which Morghen dedicated his series of forty views of the antiquities of Pozzuoli.

The dedication indicated that the purpose of his careful topographical views of these magnificent ruins of the past was to point out the luxury and grandeur of their inhabitants to the learned antiquarians in Britain. He not only paid tribute to the members of the Society of Arts as scholars able to link the views with passages by Classical authors, but gave fulsome praise

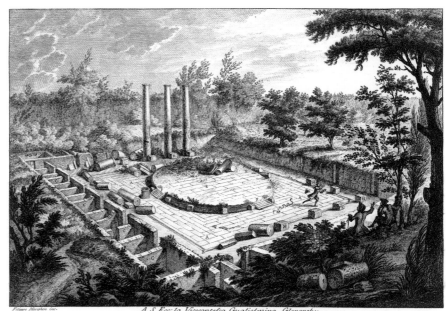

A.S.Ecc:la Vicecontessa Guglielmina Glenorchy.

Veduta a Ponente degli avanzi d'un insigne edificio in Pozzuoli da molti creduto il Tempio di Serapide, in cui A. Piazza lastricata di Bianchi marmi; B. canale in ogni intorno per ricevere l'acqua piovana e dirigerle fuori l'Edificio; C. Stanze Sacerdotali incrostate di scelti marmi; D. Stanza di Bagni espiatorj; E. Tempio Monoptero Sacro a Serapide; F. quattro scalinate per ascendervi; G. Atrio Tetrastilo che introduceva in altra fabrica; H. Varj piedistalli per Simulacri diversi; I. Anelli di Bronzo a legarvi le Vittime.

42

to their roles as protectors, patrons and promoters of the fine arts and manufactures. The first plate was the portrait of Ferdinand IV at the age of eight (see cat. no. 10), but the second, a view of the entrance to the grotto leading to Pozzuoli, was dedicated to William Hamilton. Plate 24, a view of the Temple of Juno near Lake Avernus, was dedicated to Catherine Hamilton. Some of the landscapes are remarkably like those by Fabris in composition and style (see cat. no. 43), and it is quite likely that Fabris made some of the original drawings on which Morghen's engravings were based.

Other plates in Morghen's *Antichità* are dedicated to important British patrons known to have travelled in Naples and Sicily in the 1760s, and a further group to diplomatic and other friends of Hamilton and known members of the Society of Arts. Lady Glenorchy, to whom the present plate is dedicated, was a Scot known for her accomplishments and her good works, and several other Scots peers and societies, such as the Colleges of Physicians and of Advocates in Edinburgh, were also honoured. It was a British commonplace to dedicate

prints of views to existing and potential sponsors, but such dedications could not be made without permission and Hamilton was obviously instrumental in obtaining this for Morghen. This is an important instance of Hamilton assisting a Neapolitan engraver in a practice which would prove so successful for Piranesi in the dedication of prints from his *Vasi, Candelabri, …*, issued individually from 1768 and published in book form in 1778. Lengthy information about prominent British collectors was provided in the dedications – a form of advertising and promotion which was mutually beneficial to the reputation of both the engraver and the dedicatee. This group of views published by Morghen was issued in sets, to be bound for libraries, but could also be purchased as individual sheets, such as the present print on coloured paper.

The incident of a tourist running from a snake in this view draws attention to one of the temple's greatest features, its floor of oblong squares of marble. Along with the massive pillars, it indicates that this was 'a building of the highest taste and magnificence' (Scholes, *Burney*, p. 251).

43 SIR WILLIAM HAMILTON (1730–1803)
and PIETRO FABRIS (*fl.*1756–84)

The Campi Phlegraei

Campi Phlegraei, Observations on the Volcanos of the Two Sicilies, As They have been communicated to the Royal Society of London, by Sir William Hamilton, Naples, 1776

'… With 54 Plates illuminated from Drawings taken and colour'd after Nature, under the inspection of the Author, by the Editor, Mr Peter Fabris', hand-coloured etchings, *c.*39×21.5 cm

Supplement to the Campi Phlegraei being an account of the Great Eruption of Mount Vesuvius in the month of August 1779. Communicated to the Royal Society, by Sir William Hamilton, Naples 1779

'To which are annexed 5 Plates illuminated from Drawings taken and colour'd after nature under the inspection of the Author, by the Editor, Mr Peter Fabris', hand-coloured etchings, *c.*39×21.5 cm

Copy I: Presented or sold by Sir William Hamilton to 'Mr White'; bound by Staggemeier *c.*1802–10; purchased from E. Daniel of Mortimer Street, London by British Museum in 1865 (2 vols with 40 original bodycolour drawings bound in along with a number of others not connected with the original publication)
British Library, Tab 435 a 15

Copy II: Presented by Sir Joseph Banks to British Museum
British Library, 459 f 12

Copy III: Bequeathed by the Revd Clayton Mordaunt Cracherode to British Museum in 1799
British Library, 681 k 13

Framed group of the following plates: XXVII 'View of the interior of the crater of Monte Nuovo', XXXIII 'View of the Atrio del Cavallo, between Vesuvius and Mount Somma', IX 'Interior of the crater of Vesuvius before the eruption of 1767', XVI 'Entrance to the Grotto of Pausilipo'
Carlo Knight, Naples

Today the term 'Campi Flegrei' is used to describe the volcanic area around Pozzuoli to the west of Naples. Hamilton's magnificent publication was based on his letters to the Royal Society, which detailed the volcanic activities he had witnessed not only in that area, but on the islands off its coast, in the area around Vesuvius and at Etna in Sicily, Stromboli and the Lipari islands. He had concluded that the entire area owed its very existence to volcanic explosions. Although his findings had already been published in the Society's *Philosophical Transactions* and in his 1772 *Observations*, he decided to publish them again because he found that words alone were not sufficient to convey 'the true idea of the curious country I have described'. The most important point he wished to establish is clear from the

BELOW Pietro Fabris, *View of the Isle of Ischia from the Convent of the Camaldoli of Naples* [*View of the Campi Phlegraei*]. Gouache and watercolour drawing for *Campi Phlegraei*, pl. XVII, 1776. Copy I, British Library.

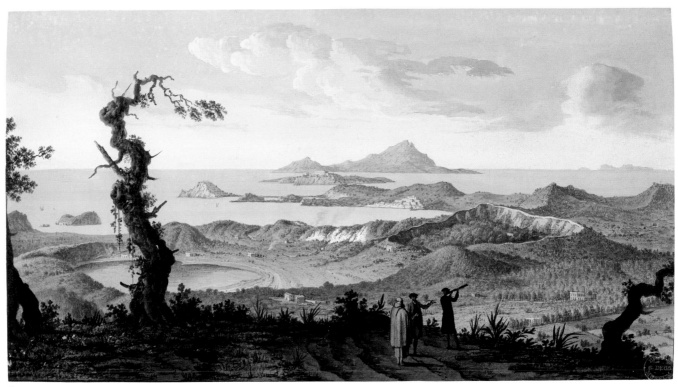

43

43

last sentence of his introduction: 'I flatter myself at least by these exact representations of so many beautifull scenes, all of which have been undoubtedly produced by the explosions of Volcanos, that this tremendous operation of nature will now be consider'd in a CREATIVE rather than a DESTRUCTIVE light' (p. 13).

In order to convey these ideas in such a manner that those who could not visit the area might be able to visualise it, and hoping thus to enable further discoveries to be made, Hamilton explained that:

> Soon after my return hither from ENGLAND, I employed Mr. Peter Fabris, a most ingenious and able artist, a native of GREAT BRITAIN, to take Drawings of every interesting spot, described in my letters, in which each stratum is represented in its proper colours ... likewise the different specimens of Volcanick matters, such as lava's, Tufa's, pumice stones ... EC., of which the whole country I have described, is evidently composed. [*Campi Phlegraei*, p. 5]

According to his introductory text, these drawings executed under Hamilton's eye and direction with 'utmost fidelity' and 'as much taste as exactness' were for Hamilton's own personal use. However, seeing that the public might benefit from them,

> and that the ingenious artist himself, might at the same time reap a moderate and constant benefit from his labours, particularly as he is unfortunately in a declining state of health; in a word I encouraged, and enabled Mr Fabris to undertake the Publication of an edition of my letters ... accompanying the same with Plates, imitating the original drawings above mention'd, and which, to his honour as well as that of the able artists of this country, employ'd in this laborious work, are executed with such delicacy and perfection, as scarcely to be distinguished from the original drawings themselves.
> [*Campi Phlegraei*, p. 6]

The purpose of this publication was thus manifold. It provided a clearer, more precise and useful explanation of volcanic activity than ever published before, which underlined Hamilton's own theories about volcanoes being creative forces and enabled him to answer in one publication the lists of questions about volcanoes and rocks he had been receiving from correspondents all over Europe. Its publication in French and English provided it with a market not only in his own country but throughout Europe as well, and an international audience for a British discovery. Finally, as an act of patronage, it gave employment not only to a British artist 'in a declining state of health' but to Italian artists as well.

The work was originally planned to have forty plates, but Fabris had produced sixty images by January 1776, not all of which were used. One hundred and fifty copies of the book were nearly ready in March before Hamilton left for his next visit to England: the last of the fifty-four plates was in hand and Hamilton had laid out over £1300, 'but the plates which are the material will I am sure surpass any thing of the kind'. He had managed to get the original drawings as well, although they had suffered from 'handling, flies, etc.' (Morrison, no. 71). Forty of these drawings were apparently sold or given by Hamilton to a 'Mr White', and these were bound into a copy of the book in about 1802 (copy 1), but a group of sixteen, including some of the most interesting and lovely, are now in a private collection in Italy. They were purchased in London around 1957 in a red morocco folder labelled 'The Original Designs of Mount

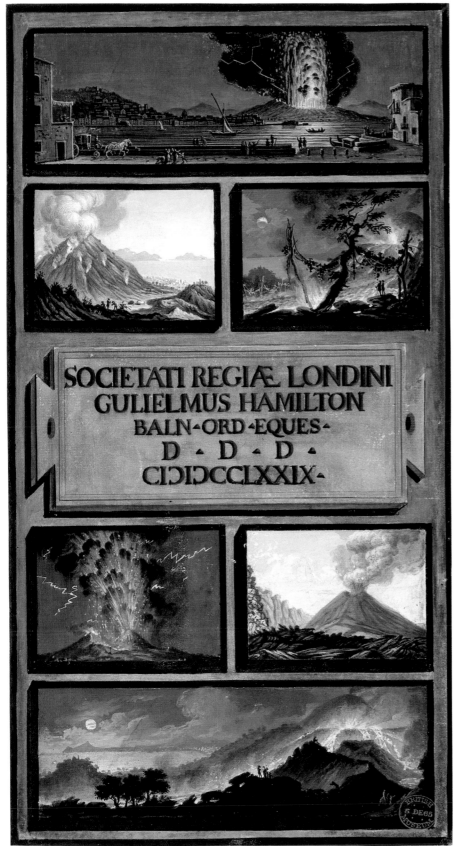

Vesuvius'. Fabris was almost unknown at that time and because Goethe's biography of Philipp Hackert had claimed that the German artist had worked on the *Campi Phlegraei*, the drawings were for a long time attributed to him (see Knight, 1984, pp. 196–208; Mancini, pp. 34–7). In fact Hackert only made three drawings for Hamilton in 1770 and they may have been intended for the *Observations* published in 1772, rather than for the *Campi Phlegraei*. Hackert complained that they were badly engraved and in the end they did not appear in any of Hamilton's publications. They were purchased by Townley at Hamilton's sale in 1801 (18 April, lot 23).

The original bodycolour drawings by Fabris have understandably much deeper colours than the etchings, which were hand-coloured, mostly in watercolour. The *Campi Phlegraei*, half-bound, could be ordered from Fabris in Naples for 60 ducats, but some copies have bodycolour and gum arabic added to the etchings, perhaps indicating that they were de luxe versions. Every copy differs slightly in the skill with which the etched plates were washed and the colours used. Fabris's initials appear in some of the etchings, indicating he was one of the engravers, some of whom were extremely skilful – the lines in the plates of square samples of rocks are so fine that they give the appearance of a mezzotint.

Although Fabris described himself as British, his place of birth has not been established. There were many French Huguenots named Fabre or Faber in London in the first half of the eighteenth century and he may have altered his name to Fabris in Naples. (Only one Italian family named Fabris appears in the London parish registers during this period, but the names do not include Peter or Pietro.)

Although they appear characteristically Italian, the original bodycolour drawings may in fact owe much to British influence. They show a close affinity in colour, composition and style to the Venetian Marco Ricci, whose works were well known in England. Paul Sandby was certainly familiar with them, and his bodycolour drawings from the 1760s are the closest English works to the bodycolour views Fabris produced for the *Campi Phlegraei*. Fabris's earliest paintings from

LEFT Pietro Fabris, frontispiece to *Campi Phlegraei, Supplement*. Gouache and watercolour, 1779. Copy 1, British Library.

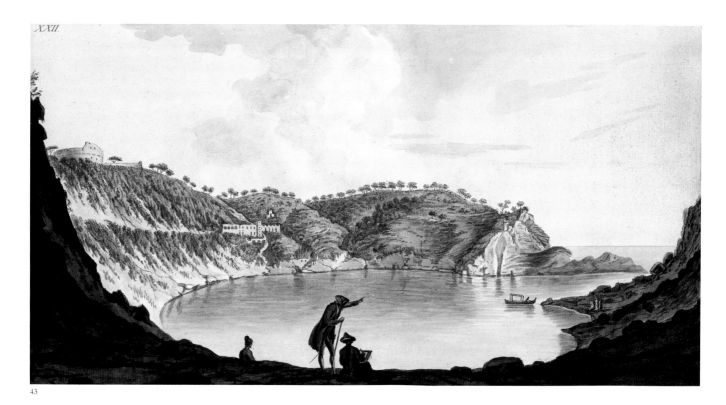

43

the 1750s were oil paintings of Neapolitan scenes, and he exhibited at the Society of Arts and Free Society in London in the 1760s. Sandby and Fabris may have known each other in London and Fabris was to provide the drawings of scenes around Naples which Sandby issued in aquatint from 1777 (cat. nos 17, 18, 149). Before Fabris brought this bodycolour tradition to Naples sometime in the 1760s, it was not widely practised in that city. From that time onwards, however, Fabris and Hackert, and their pupils Xavier Della Gatta and Charles Gore, with their detailed, prettily coloured views beloved of tourists, created a type of view which proliferated in the nineteenth century and has come to be known as characteristically Neapolitan.

According to the descriptions accompanying the plates, the subjects chosen and viewpoints taken were for the most part directed by William Hamilton. Fabris acknowledged this visually by portraying his patron in red and himself in blue throughout, showing Sir William examining the features of the landscape through a telescope, pointing them out to other travellers, occasionally to Lady Hamilton, and even to the king and queen. In one image Sir William is indicating specific features to the artist. It was a commonplace for artists to show themselves in paintings – Fabris had depicted himself at least twice before (see cat. no. 16) – but this constant guiding presence of 'the Author' makes a very specific point about the contents of the text and the images. The Palazzo Sessa was hung with images of eruptions of Vesuvius by P. J. Volaire, C. J. Vernet, Pietro Antoniani and Antonio Joli, but there were literally dozens of paintings and bodycolour drawings by Fabris, with images of eruptions he had painted before Hamilton even arrived in Naples, and with genre scenes and paintings of Neapolitan life. Fabris had accompanied Hamilton in 1768 on his examination of the volcanoes of Sicily and the Lipari islands, and Hamilton clearly saw this artist as the one who could best fulfil his requirements for images of the Campi Phlegraei. He needed drawings which were accurate in colour and detail and at the same time were beautiful landscapes, but not so overlaid with excessive effects, like Volaire's and Antoniani's, as to obscure truthful observation.

Philipp Hackert arrived in Naples in 1770

and assisted Hamilton by making three drawings of *montagnuoli* (Goethe, *Hackert*, p. 26). Although he returned to Rome shortly afterwards, the influence of Hamilton's attitude to nature and Fabris's views had an immediate effect on the German artist's work. This effect was equally evident in Thomas Jones's work after Hamilton lent him a copy of the *Campi Phlegraei* in 1782. The British artist disliked Hackert's attention to the minutiae of landscape, but some of Jones's works are in their own way so close in their composition and attention to rock formations and texture in Fabris's plates as to be almost copies.

LITERATURE: See Chapter 4; and M. A. Cheetham, 'The taste for phenomena: Mount Vesuvius and transformations in late 18th-century European landscape depiction', *Wallraf-Richartz-Jahrbuch*, XLV, Cologne, 1984, pp. 131–44; C. Knight, 1984, pp. 192–208; Moore, pp. 169–93; for modern reprints of the *Campi Phlegraei* see Knight, 1992 and Knight, 1994.

44 FRANCESCO PROGENIE (*fl.*1779–86)

View Taken from the Outside of the Harbour of the Island of Ponza near the Lighthouse, 1785

Watercolour with touches of white bodycolour, 30 × 45.5 cm

Inscribed below image with title and signed: *Francesco Progenie del. dal vero*; image numbered and inscribed with legend below: *1) Rock of Volcanick Matter converted to pure clay 2) Do. with Strata of Pumice Stone 3) Rocks of Lava inclining to take Basaltic forms 4) Rock composed of spherical Basaltes*

Provenance: Sent to the Royal Society by Sir William Hamilton with letter dated 24 January 1786

The President and Council of the Royal Society, London, L&P VIII.186

Several of the letters that William Hamilton sent to the Royal Society describing the eruptions of Vesuvius were accompanied by drawings. The earlier ones included schematic diagrams, drawn by himself, showing changes in the shape of the crater (fig. 30); another at the end of December 1767 was accompanied by bodycolour drawings of the eruption in October that year, probably by Fabris, now lost but engraved in the published *Observations* of 1773 and very close to the version published in the *Campi Phlegraei* (fig. 29). Early in 1768 Hamilton sent Dr Maty, the Secretary of the Society and of the British Museum, a painting of the eruption of 1767 in 'transparent colours', probably on glass which was lit from behind. When set up in the Museum according to Hamilton's instructions, Dr Maty reported that it 'gives the beholder the most striking representation of that awfull phenomenon' (British Library, Add. MS 40,714, f. 47). Hamilton presented another of these transparencies to David Garrick. When it was sold in 1823 (23 June) it was accompanied by a letter from Hamilton 'descriptive of a mechanical contrivance to heighten the effect of the eruption'. As a precursor of de Loutherbourg's *Eidophusikon* and Gainsborough's smaller 'Exhibition Box' (Victoria and Albert Museum) the painting must have been a wonderful attraction for visitors to the British Museum, but sadly it is now lost.

The supplement to the *Campi Phlegraei* included views of the 1779 eruption, but the letter to the Royal Society was sent with a bodycolour view different from those published by Fabris, and signed 'F. Progenie'. The same artist was responsible for a drawing after two sculptures in Hamilton's collection (including cat. no. 137) and for a bodycolour drawing of an excavation showing deposits of volcanic lava (Knight, 1990, p. 153). Progenie was obviously a student of Fabris, who was in declining health in 1776. Three watercolour drawings accompanied Hamilton's next letter to the Royal Society on 24 January 1786 and show a great deal of artistic progress in the intervening years. Progenie was especially skilled at drawing geological formations, and his views showing the rocks around the harbour of Ponza were extremely useful for explaining Hamilton's theories about the formation of basalt. The figures are well drawn and, although they are not portraits, the artist is present in his red-orange coat and Hamilton is distinguished by his pale green coat and pink sash

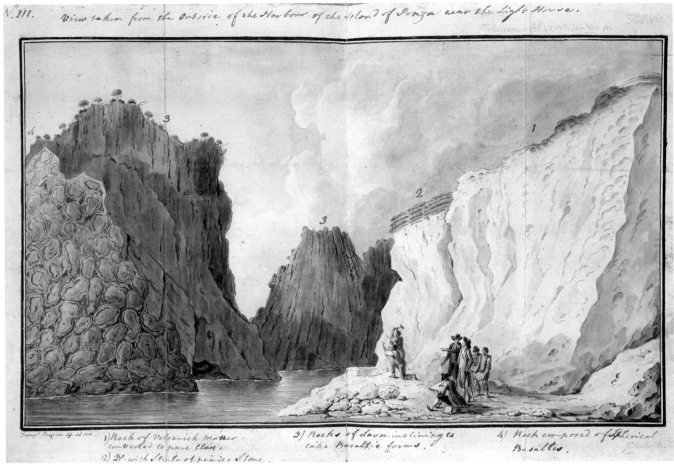

44

of the Order of the Bath, pointing out to the men which samples to take. A print of this watercolour was made by James Basire (1730–1802) and published in the *Philosophical Transactions*, XXVI (pl. 12).

During the 1780s, Hamilton mostly relied on Padre Piaggio's *Diario Vesuviano*, but the eruption of 1794 was so spectacular that it occasioned another letter to the Royal Society, this time with three bodycolour drawings by Xavier Della Gatta and an engraving by Giovanni Morghen which showed the extent of the lava that covered Torre del Greco. The original drawings are with the letter in the library of the Royal Society, but they are cracked, torn and flaking; however, they too were engraved to accompany the publication of this last letter from Hamilton in the Society's *Transactions*. Hamilton owned a larger version of the eruption in daylight (fig. 33), which hung in the Palazzo Sessa.

LITERATURE: For the publication of Hamilton's letters to the Royal Society, in the Society's *Philosophical Transactions* and separately, see Chapter 4 and under Hamilton in the Bibliography.

45 JOHN 'WARWICK' SMITH (1749–1831)

The Summit and Crater of Vesuvius, c.1778

Watercolour, 16.7 × 24.3 cm
Provenance: Purchased from Sir W. C. Trevelyan
British Museum, P&D 1871–11–11–1

From April until September 1778 Sir William Hamilton paid 'John Smith of Rome' a total of £100 on behalf of the Earl of Warwick for Smith's maintenance and for drawings he had in hand for the Earl (British Library, Add. MS 40714, ff. 160, 163, 169, 178). It was not the only occasion Hamilton was asked to provide this service for artists working for Lord Warwick: in the 1790s, he found himself waiting years for the repayment of £500 he had paid on Warwick's behalf to George Wallis (cat. no. 184).

Smith stayed in Naples until July the following year, sharing lodgings with Thomas Jones in December and January, before the latter returned to Rome. Smith and Jones and some of the best eighteenth-century British watercolourists – William Pars, Francis Towne and John Robert Cozens – all worked in the Naples area over the next two

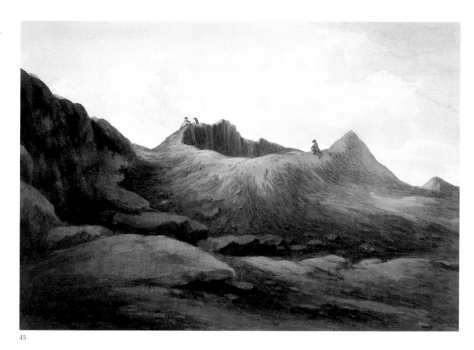

45

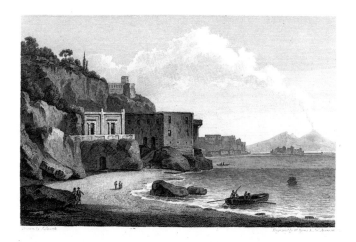

On the Shore of Posilipo

FIG. 71 J. 'Warwick' Smith, *On the Shore of Posillipo*. Engraving from *Select Views in Italy* (1792–8), pl. 56 (engraved 1798). British Library.

years. They all met Hamilton, even making views of and from his villas, but, as noted in the entries on John Robert Cozens's watercolours (cat. nos 20–21), Sir William Hamilton did not list watercolours by any of them in his manuscript list of paintings, nor do they appear in the sale catalogues. In October and November 1774 Joseph Wright of Derby had also visited Naples and met Hamilton, returning to Rome with views of Vesuvius in eruption, 'the most wonderful sight in nature', which he turned into some of his most spectacular paintings (Fraser, pp. 11–12). Hamilton does not appear to

have commissioned any views of Vesuvius from Wright, but this is probably because he already owned several by Volaire, Vernet and Hackert and he was currently bearing the cost of a large group of bodycolour paintings of the Campi Phlegraei by Fabris.

John 'Warwick' Smith's views of the area around Naples included the present watercolour, a previously unrecorded view of the Villa Emma (fig. 71), and a view of Naples from Sir William Hamilton's villa at Portici (watercolour versions in Birmingham City Art Gallery and private collection, London). They were published with an accompany-

ing text between 1792 and 1798 as *Select Views in Italy* (pls 56, 58, 60). In print form they are particularly reminiscent in composition and style of Fabris's views in the *Campi Phlegraei*. The Earl of Warwick, obviously inspired by the plates in this magnificent publication, commissioned these views shortly after its appearance in 1776. Smith's later, less expensive collection of topographical prints found a ready market and J. M. W. Turner copied every plate in a sketchbook when he was preparing for his own trip to Italy in 1819.

The text in Smith's *Select Views in Italy* which accompanied the engraving of this watercolour (pl. 60) gives a graphic description of the difficulties of ascending the volcano, as well as explaining the shape, size and colour of the crater at the top:

> The ascent up that part of the mountain called the *Cone of Vesuvius* is extremely fatiguing and laborious; it can only be

large fissures, through which issued small volumes of sulphurous vapours and smoke. Near the middle there was another small mountain in the form of a sugar-loaf, in height about 50 yards, & wholly composed of ashes and small cinders, intermixed with large cakes of sulphur of many different hues, of orange, red, yellow, etc. On the top of the small cone is the *crater* or opening of the mountain. Its form is circular about 100 yards in diameter, perpendicular on its sides and about 100 yards in depth. The bottom was entirely covered with cinders that seemed to be cemented into one cake by heat; at intervals this covering heaved up, and as the rarefied air underneath got vent, it all at once, or by degrees subsided.

LITERATURE: D. Fraser, *Joseph Wright of Derby in Italy*, exh. cat., Gainsborough's House, Sudbury, 1981, pp. 11–12, no. 31; L. Stainton, entries in *Shadow of Vesuvius*, p. 132.

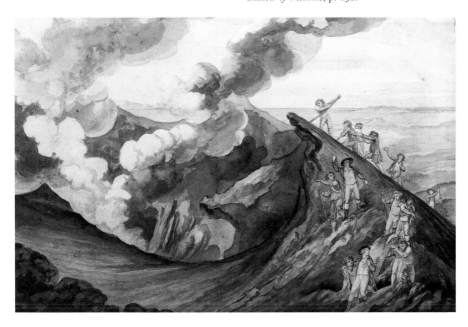

accomplished on foot, and with the assistance of a guide, who fastens a girdle around his body, by means of which the adventurer is helped forwards [see fig. 72]; the difficulty arises from this part of the mountain being exceeding steep, and entirely covered with loose cinders and ashes, so that on ascending every step sinks to the knee, and generally one half is lost by sliding backwards ... The top of the mountain which is here represented was about a quarter of a mile in diameter, and was broken and irregular on the surface; in many places it was cracked, and rent in

FIG. 72 Henry Tresham, *The Ascent of Vesuvius (the Crater of Vesuvius)*. Pencil and watercolour. New Haven, Yale Center for British Art, Paul Mellon Collection.

46 GIOVANNI BATTISTA LUSIERI (1755–1821)

Vesuvius from Posillipo by Night, during the Eruption of 1787, 1797

Pen, ink and watercolour, 64.2 × 94.3 cm

Inscribed: *47*; signed and dated on verso, and inscribed, over an erased inscription: *Veduta di Napoli con l'Eruzzione del Vesuvio presa da Posilipo dipinta da Gio: Battista Lusieri 1797./ L'eruzzione e del 1787*

Provenance: ? Sir Richard Colt Hoare, Stourhead (1838 inventory); anon. sale Christie's, 5 July 1983 (lot 133)

Private collection

In the March 1801 sale of Hamilton's paintings, in the section of 'Capital Drawings', lot 23 on the second day was by 'Don Tito Luzzi':

> A most exquisite finished Drawing in Water Colours, taken by this great Master from Pausilipo, and giving an exact View of Naples, and its Bay; with the Eruption of Mount Vesuvius, by Moonlight, exactly as it appeared in the Year 1796. Don Tito lived several Years at Pausilipo, where he had the best opportunity of Studying this beautiful View, which he saw constantly from his own Window.

It was purchased for £52.10.0, but the name of the buyer is unknown. Lord Temple bought the following lot, the panoramic view of the Bay from the Palazzo Sessa (cat. no. 4).

Hamilton had used Fabris, Antoniani, Progenie and others to provide him with coloured views of the earlier eruptions of 1767, 1779 and 1787, but by the time of the latter eruption Lusieri was settled in Naples and apparently ideally placed to provide British travellers with watercolour views of it. Unlike Fabris's views, which relied heavily on bodycolour for their effect, Lusieri's technique consisted mainly of watercolour washes, producing a drawing closer to the type to which English patrons were accustomed. His sketchbook (cat. no. 48) contains two or three light pencil sketches obviously drawn on the spot at the time, showing the lava first erupting from the top and then pouring down the left side of Vesuvius, then winding its way down the slopes between Vesuvius and Monte Somma, as it is shown in the present watercolour. The sketchbook also contains a series of more carefully washed and composed drawings of this view, in which he added the ships, figures and trees seen in the present

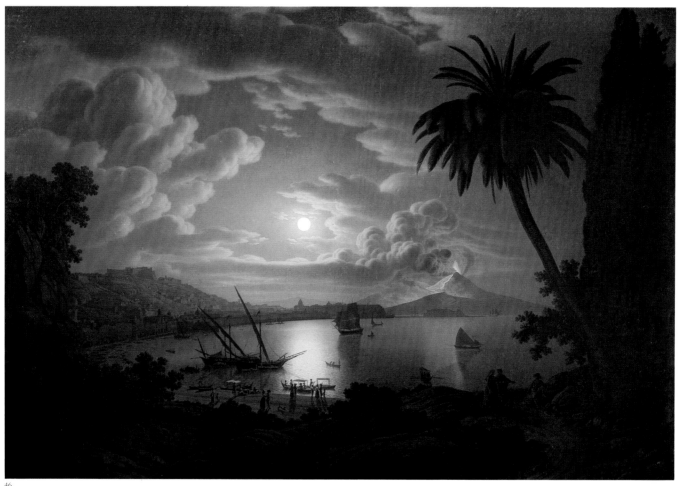

46

watercolour, or focused more closely on the mountain itself and the shadowy outline of the Castel dell'Ovo before it. Lusieri was thus able to combine the romantic atmosphere of moonlight with this always popular viewpoint of the Bay of Naples, set off by a spectacular eruption, the orange lava seen to its best effect against the grey moonlit sky. The success of this composition is indicated by the number of versions of it that exist.

On his Grand Tour in 1792, Lord Bruce sent a view of Vesuvius by Lusieri to his father, the Earl of Ailesbury, and a year later, having seen works by several other artists, wrote that he still admired 'Don Tito's drawings more than any'. By then he had purchased several views by him, including one of the three temples of Paestum, 'where he has been all the summer working for Sir Richard Hoare and me' (*HMC Ailesbury*, 15th Rpt, App. Pt VII, pp. 249–60, Sir Brinsley Ford Archive, Paul Mellon Centre).

There were numerous drawings by Lusieri at Stourhead until the late nineteenth century, and there are views of Vesuvius similar to the present watercolour in the Duke of Wellington's collection at Stratfield Saye House (64×97 cm, signed and dated 1793) and in the Berwick collection at Attingham (59.4×82.8 cm).

Like Ducros (cat. no. 181), Lusieri printed a number of outline etchings of his most popular compositions which he then coloured by hand in order to produce multiple copies to supply demand. It is very difficult to distinguish watercolours on pen from those that are on etched outlines; the version at Attingham is etched. There is no doubt, however, that they were coloured by Lusieri himself, as his absolute insistence on truth to nature and his use of watercolour to achieve it was his hallmark. In 1786–7 he was granted copyright for twelve years to print twelve views of Naples and the surroundings. Permission was granted by

Queen Maria Carolina, who had ordered a set for the Governor of Flanders (*Shadow of Vesuvius*, p. 127).

This watercolour and all the other finished views of Vesuvius discussed above show the eruption of 1787. It is very curious, then, that the one included in Hamilton's sale should have been of an eruption of 1796, especially as, according to the inscription on the present drawing, Lusieri was still producing views of the eruption of 1787 ten years later in 1797, when he signed and dated this version. Even more significant, however, is the fact that there was no eruption in 1796 – the most spectacular Hamilton witnessed was the one in 1794 when the lava poured down the mountain towards Resina, turned and flowed into the sea, covering four-fifths of Torre del Greco and narrowly missing Hamilton's Villa Angelica. When the ash cleared several days later, the top cone of Vesuvius had been blown off and Monte Somma rose over what was

left. The date of 1796 given in the entry in Hamilton's sale catalogue must have been an error, and it seems more likely that the view he owned recorded the 1787 eruption shown in this watercolour or the 1794 eruption (see cat. no. 47).

LITERATURE: C. I. M. Williams, 'Lusieri's surviving works', *Burlington Magazine*, CXXIV, August 1982, p. 492; Hawcroft, no. 93. We are grateful to Alastair Laing for his advice concerning the Lusieri watercolours at Attingham and formerly at Stourhead.

47 GIOVANNI BATTISTA LUSIERI (1755–1821)

Vesuvius Seen from the Bay of Naples during the Eruption of 1794

Pen, ink, watercolour and bodycolour,
 61 × 76 cm
Provenance: Part of contents of artist's studio, acquired from the artist's heirs by 7th Earl of Elgin, 1824; by descent to present owner Earl of Elgin and Kincardine, K.T.

As noted under cat. no. 46 all Lusieri's other studies and finished watercolours of Vesuvius in action show the eruption of 1787. The present spectacular watercolour shows that of 1794. It remained in Lusieri's studio with the sketchbook and does not include any figures, shipping or framing trees, probably indicating that it was made as a record of the eruption for future use in more complicated compositions like those he produced of the 1787 eruption. If the date 1796 given in the 1801 Hamilton sale catalogue for the Lusieri painting of an eruption of Vesuvius is an error for 1794, then the one Hamilton owned may have been based on the present watercolour.

The 1794 eruption taken from this viewpoint is instantly recognisable in hundreds of later souvenir views of the Bay of Naples. Several of these, in thick bodycolour, have been inserted into the British Library volume of the *Campi Phlegraei* (cat. no. 43). By that date, Fabris had died and been succeeded by Progenie and Della Gatta as Hamilton's painters of volcanoes for his reports to the Royal Society. Lusieri's ability to depict 'every vein in the marble' so that 'even the nature and qualities of the stone itself might be recognised' with a veracity of colour owed to finishing large works on the spot (E. D. Clarke, quoted in Williams, 1982, p. 495), made his skills invaluable to a vulcanologist like Hamilton. While Lusieri was in Sicily with Hamilton in 1799 he made very careful detailed drawings of Mount Etna and the country around. However, Lusieri was very slow in producing finished works because he worked on a large scale, insisted in drawing in great detail and colouring from nature, and was in great demand. Hamilton could employ him for large, beautifully finished works to be hung on walls, but was forced to rely on other artists for his reports to the Royal Society.

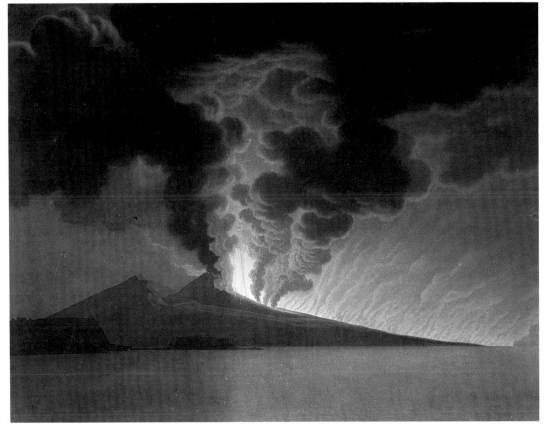

47

48 GIOVANNI BATTISTA LUSIERI
(1755–1821)

Page from a sketchbook showing a view of Vesuvius seen from the myrtle plantation near Portici

Pencil, pen and ink, and grey wash,
 23 × 34 cm
Provenance: Part of contents of artist's studio,
 acquired from the artist's heirs by 7th Earl of
 Elgin, 1824; by descent to present owner
Earl of Elgin and Kincardine, K.T.

48

As noted above, this sketchbook contains several pencil sketches and more finished wash studies for Lusieri's finished watercolour views of the eruption of 1787 (cat. no. 46). There are also sketches for some of his earlier Roman views, and several detailed studies for other finished watercolours of the area around Naples, like the one shown here which was used in his 1784 view of the *Lower Slopes of Vesuvius from Portici* (private collection, Turin; Briganti and Spinosa, p. 407, reproduced p. 262).

It was while Lusieri was engaged in making drawings in this area for the Queen of Naples that Thomas Jones and his family came to see him to take their leave in July 1783. In the previous summer and autumn, John Robert Cozens had made sketches from the myrtle plantation (cat. no. 21) while staying at Hamilton's villa. The contrast between Cozens's poetic and atmospheric approach and the meticulously accurate view recorded by Lusieri provides an instructive insight into the requirements of their very different patrons.

49 HENRY MEYER (1783–1843) after
GEORGE ROMNEY (1734–1802)

The Hon. Charles Greville, 1810

Mezzotint, 35.5 × 25 cm
Provenance: From the collection of portrait
 mezzotints bequeathed by Lord Cheylesmore
 in 1902
British Museum, P&D 1902–10–11–3458

Illustrated on page 16, fig. 4

Charles Francis Greville was the second son of the 1st Earl of Warwick and his wife Elizabeth, the sister of Sir William Hamilton. He was educated with his brothers in Edinburgh and a Grand Tour followed in 1769, when he found a kindred spirit in his uncle in Naples. As a younger son like Sir William, he had only a small private income and, also like his uncle, began his career as an MP,

being returned for his brother's seat of Warwick when the latter succeeded as 2nd Earl in 1773. He supported North's administration, and was rewarded with a seat at the Admiralty in 1780. In April 1783, a few months before his uncle's visit to England that year, he was made Treasurer of the Household (Namier and Brooke, pp. 550–51). This would have ensured a solid regular income and he made many plans on this basis, including the commissioning of a number of portraits from Romney of his mistress Emma Hart. However, he resigned his appointment when Pitt came to power at the end of 1783; he remained an opposition MP, but from then on a marriage with an heiress – which never happened – was his only hope of income. He ran his uncle's estate in Wales, hoping to turn it to profit to help pay his uncle's and his own debts, but neither ever saw enough income from it to be of substantial assistance to themselves. They were, however, to a large extent responsible for the building of the 'New Town' at Milford Haven, thus improving a harbour which Nelson later considered one of the most important in Britain (see Gill, pp. 33–7).

From the time of visiting Sir William in Naples, Greville began collecting minerals with great knowledge and skill, using his uncle and his connections all over Europe to help him acquire obscure samples, creating an almost unrivalled collection which was purchased by the British Museum after his death with money provided by the Treasury (British Museum Archives, GM, p. 1076). He also collected paintings and

sculpture, again using his uncle for some of his most important acquisitions, and in December 1784 he was so financially embarrassed that he offered this collection, amassed over a period of twelve years, to the Duke of Rutland (*HMC Rutland*, III, 269). The Duke did not take up his offer, forcing Greville to give up his house in Portman Square and his mistress Emma and begin the negotiations and letters which resulted in her being sent to Naples.

Greville sat to Romney for his portrait in 1781, just after he was given a seat at the Admiralty. He had known the artist at least since 1774, when Greville had provided Romney with a letter of introduction to Sir William in Naples. In 1783 when Hamilton returned to England after his first wife's death, he sat to Romney for his portrait (cat. no. 8) and commissioned a painting of Emma Hart as a *Bacchante* (cat. no. 167). Greville presented his own portrait by Romney to Sir William and had it sent to Naples, where it hung in the Palazzo Sessa from around 1785; Hamilton in return presented his portrait by Romney to his nephew.

The portrait of Charles Greville on which this mezzotint was based is not the painting in the Metropolitan Museum, New York (50.169), traditionally said to have been the one Greville gave to Hamilton. The provenance of a slightly different painting, on which the mezzotint certainly is based, makes it far more likely to be the one Greville gave his uncle. That portrait hung in one of the smaller rooms of the Palazzo Sessa and was included in Clark's packing list, but did not

appear in either of Hamilton's sales in 1801. It must have been kept by Hamilton and inherited by Greville when Hamilton died in 1803. Greville himself died without issue and his collection was sold in 1810, but it did not include this portrait, which must have remained with his younger brother's descendants, the Finch Hattons, who inherited Sir William's Welsh estate. The version of the portrait with this Welsh Finch Hatton provenance is the one which is closest to the mezzotint (sold by the family, Sotheby's, 21 July 1943, lot 51; last sold by Sotheby's, 28 November 1973, lot 54; present whereabouts unknown). In 1810, at Greville's sale, his younger brother purchased the Romney portrait of Sir William Hamilton and the two paintings hung together on the estate in Wales until the portrait of Sir William was sold by a descendant around 1917.

LITERATURE: Ward and Roberts, II, pp. 65–6.

50 GEORGE ROMNEY (1734–1802)

The Hon. Charles Greville, William Hayley, George Romney and Emma Hart, c.1784

Pencil, pen and brown ink and wash,
 37.7 × 53.6 cm
Provenance: Presented by J. P. Haseltine
British Museum, P&D 1914-2-16-1

In 1781 at the age of sixteen, pregnant and dismissed from Uppark by her lover, Sir Harry Fetherstonhaugh, Emy Lyon was taken in by Charles Greville, who put her child into care and set her up with her mother as housekeeper in his small villa in Edgware Row, Paddington Green. He had been sitting to Romney for his portrait and the following year took his young mistress, by then known as Emma Hart, to have her portrait painted, initially in a three-quarter-length portrait holding a dog, which came to be known as *Nature* (cat. no. 168) and later as *The Spinstress* (Kenwood).

The artist found in Emma not only a classically beautiful young woman, but an engaging model, eager to please, and from the same northern part of the country as himself. She sat to him regularly over the next four years, not only for portraits for Greville, William Hayley and others, including Greville's uncle, Sir William Hamilton (cat. no. 167), but also for Romney's ambitious history paintings, most of which were never completed. He sketched her constantly, in poses for both types of

painting, and visited her at Edgware Row, traditionally said to be the setting for the present drawing.

William Hayley (1745–1820) was introduced to Romney in 1776 when, having acquired a villa at Eartham in Sussex, he wished to adorn it with portraits of his London friends. A poet and man of letters, Hayley penned his *Epistle to Romney* shortly after they met and they became close friends, Hayley eventually writing the first biography of the artist in 1809. Well-respected as a poet in his day, Hayley was also a friend and patron of John Flaxman and William Blake, and he encouraged Romney in his project celebrating the life of the great prison reformer John Howard. In 1780 Hayley published his most successful work, *The Triumphs of Temper*, an allegorical poem instructing young ladies, via the heroine Serena, how to retain a sweet nature against all odds.

In his life of Romney, Hayley praised Emma for her generosity and kindness to-

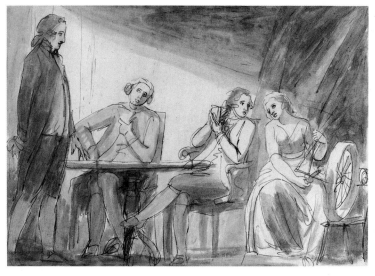

50

wards the artist and noted that she delighted in music and painting: 'in the first she had great practical ability and in the second great taste and expressive powers. Her features like the language of Shakespeare, could exhibit all the feelings of nature and all the gradations of every passion, with a most fascinating truth, and felicity of expression. Her peculiar force, and variations of feeling, countenance and gesture, inspirited and enobled the productions of his art' (p. 119). Hayley owned Romney's paintings of Emma as *Miranda* and *Sensibility* (Ward and Roberts, II, pp. 184–6).

In her turn, in a letter to Romney written from Caserta on 20 December 1791, Emma declared that she owed her present life as Lady Hamilton to Hayley:

Tell Hayly I am allways reading his *Triumphs of Temper*; it was that that made me Lady H., for, God knows, I had for 5 years enough to try my temper, and I am affraid if it had not been for the good examples Serena taught me, my girdle would have burst, and if it had I had been undone, for Sir W. minds more temper than beauty. He, therefore, wishes Mr Hayly would come, that he might thank him for his sweet-tempered wife. I swear to you I have never been once out of humour since the 6th of last September [the date of her wedding to Sir William].
[Morrison, no. 199]

Although the identification of the figures is traditional rather than certain, the British Museum's unusual sketch purporting to show the three men most important in Emma's life at the time represents the milieu in which Sir William Hamilton first encountered 'the fair tea-maker of Edgware Row' when he returned to England in the summer of 1783 after the death of the first Lady Hamilton.

LITERATURE: Sichel, reproduced opp. p. 62; Jaffé, 1972, no. 12; P. Jaffé, *Drawings by George Romney from the Fitzwilliam*, exh. cat., Cambridge, 1977; for Hayley see V. Chan, *Leader of My Angels: William Hayley and His Circle*, exh. cat. Edmonton Art Gallery, Alberta, 1982.

5I SIR JOSHUA REYNOLDS (1723–92)

Sir William Hamilton, 1777–82

Oil on canvas, 255.3 × 175.2 cm

Provenance: Commissioned by Sir William
Hamilton; presented by him to the British
Museum 1782; transferred to the National
Gallery 1843; transferred to the Tate 1954;
transferred to the National Portrait Gallery
1957

Trustees of the National Portrait Gallery, 680

Sir William Hamilton's long leave from the
summer of 1776 to the autumn of 1777 was
his first visit to Britain since the British
Museum had purchased his collection in
1772. The Museum already had a grand
portrait of him by David Allan, presented by
the artist (cat. no. 1). It hung with Hamil-
ton's collection, but with its emphasis on his
robes and dispatches, it may have seemed to
Hamilton to depict him more as a diplomat
than a connoisseur. Sitting to Reynolds for
the Society of Dilettanti portrait in 1777
(cat. no. 52) provided him with an oppor-
tunity to present his collection in the
Museum with a more appropriate image.

The nine sittings to Reynolds recorded in
June that year were nearly twice as many as
those given to any of the other members of
the Society, implying that Hamilton was
indeed sitting for this second portrait, even
though the pose of the head is the same in
both. It has been suggested that the paint-
ing given to the Museum is the work of
Reynolds's studio assistants, but there are
several reasons for believing Reynolds to
have painted much more of the canvas him-
self than the attribution 'Studio of Reynolds'
would suggest. The extra sittings would
have been required for a full-length por-
trait, and in fact two surviving oil sketches
may show Reynolds working out the com-
position. Vesuvius has more prominence in
one than the other, which places more
emphasis on a broader figure and less on
the grand space and surrounding objects
(photographs in National Portrait Gallery
Archive). The composition of the portrait
and its overall impact is masterly, bearing all
Reynolds's hallmarks in this type of por-
traiture, but the detail and finish is problem-
atic, and this is what has led to it being called
a studio work. However, as is well known,

Reynolds's experiments with oil painting
media were often disastrous, and this paint-
ing has undergone at least six treatments
since its first recorded 'restoration' in 1827.
Early photographs (National Portrait Gallery
Archive) show a painting with much more
clearly defined edges than the present
condition displays. Finally, Reynolds's nor-
mal practice was to paint the head and work
out the composition, and the assistants
would help, to a greater or lesser extent,
with the objects and filling up. According
to a note in the National Portrait Gallery

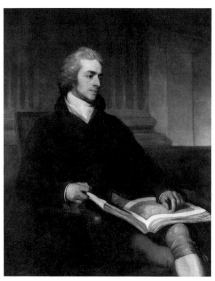

FIG. 73 John Hoppner, *Portrait of William Beckford.*
Oil on canvas, c. 1795. Salford Museum and Art
Gallery

Archives, the origin of the attribution of the
present work to the 'Studio' of Reynolds
was an inspection of all the works called
Reynolds in the National Portrait Gallery in
1937 by H. M. Hake, C. K. Adams and
J. Steegman, who decided this work was a
'copy made in Reynolds' studio'. A work is
usually called studio when it is a copy,
executed mainly by the assistants, but in the
case of this portrait for the British Museum,
it is the only version.

Reynolds had known Hamilton person-
ally since at least his first portrait in 1757, and
they had corresponded since 1769 about col-
lecting old master paintings and about the
Royal Academy, particularly as Hamilton

was a regular donor of sculpture, plaster casts
and other material to the Academy. In his
letters, Reynolds commented several times
upon Hamilton's position as a patron, judge
and even 'Maecenas' of the arts in Britain,
but he also showed himself aware of Hamil-
ton's more scientific interests, and in this
portrait he appears to have created a new
genre of portraiture appropriate for such a
patron. It is significant that when Hamil-
ton's young relation William Beckford, one
of the greatest patrons and collectors of the
age, and Hamilton's friend and fellow
collector and Museum beneficiary Richard
Payne Knight had their portraits painted by
Hoppner and Lawrence respectively, it was
in a similar pose, with a large volume rest-
ing on their laps (see fig. 73 and pl. VII in
Clarke and Penny). The book in Hamil-
ton's lap is the first volume of his collection,
open at plate 71, which is inscribed with a
cryptic dedication to Sir William in archaic
Greek letters (cat. no. 53). On the table and
on the floor beside him are vases acquired
by the Museum in 1772, including the cele-
brated 'Meidias Hydria' (cat. no. 55). The
ancient bronze sword, of which the handle
alone is visible, is also with his collection in
the British Museum (cat. no. 57).

Hamilton paid £105 for this painting, but
not until September 1784, although it had
been finished and hung in the Museum
since 1782. It was varnished, with Rey-
nolds's and Hamilton's agreement, in July
1784 (British Museum Archives, CM, 3 July).
From 1775 to 1782 Reynolds was charging
£150 to £200 for full-length portraits,
which were usually 94 × 58 ins, whereas
this painting is larger at 102 × 71 ins, imply-
ing there may have been an earlier un-
recorded payment for this work at the time
of the first sitting, as was Reynolds's usual
custom (see E. K. Waterhouse, *Reynolds*,
London, 1973, p. 40). When Hamilton
wrote from Naples presenting the painting
to the Museum's Trustees in February 1782,
it was finished, but he had not yet seen it.
A mezzotint engraving of it by Henry
Hudson, made while the painting was still
in Reynolds's studio, was published on 6
March 1782 and dedicated to the Trustees.

LITERATURE: Graves and Cronin, I, pp. 423–4, IV,
pp. 1329–31; Thompson, pp. 252–3.

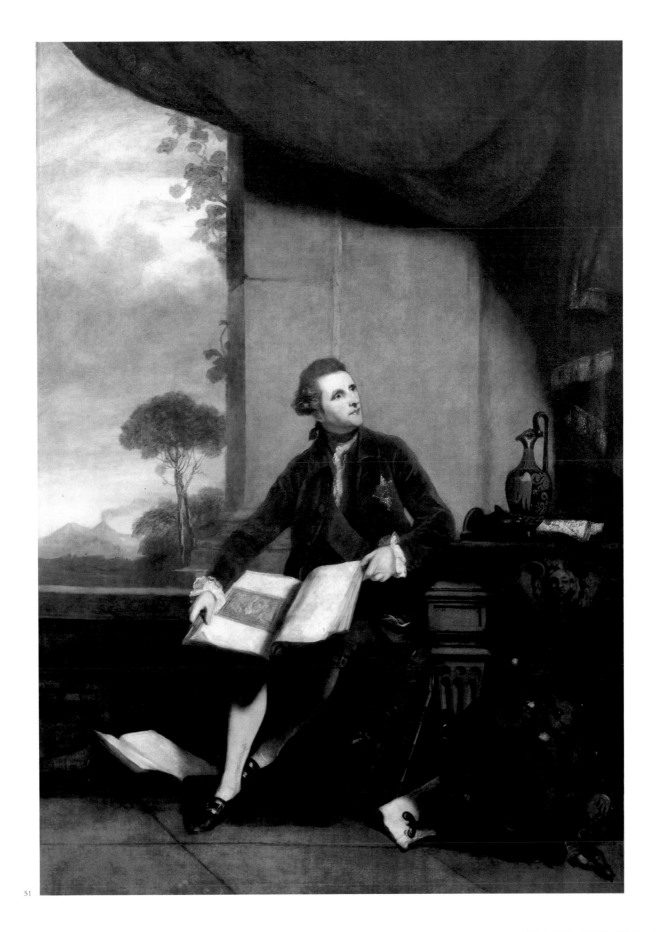

51

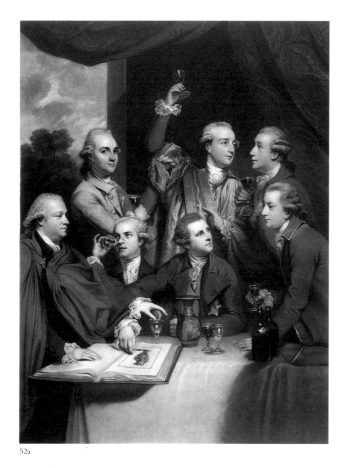

52a

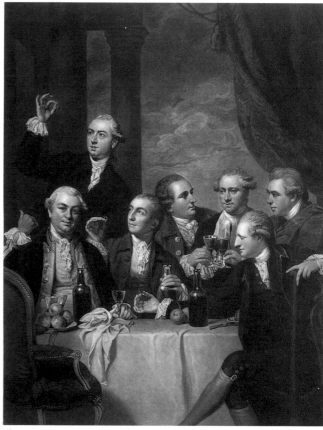

52b

52 After SIR JOSHUA REYNOLDS (1723–92)

a) *Members of the Society of Dilettanti, 1777*

Mezzotint by William Say (1768–1834), 58.5×41.5 cm

Provenance: Lord Northwick; one of a group after Reynolds purchased from Messrs Smith

British Museum, P&D 1838–7–14–47

b) *Members of the Society of Dilettanti, 1777*

Mezzotint by Charles Turner (1774–1857), 45.5×42 cm

Provenance: From the collection of portrait mezzotints bequeathed by Lord Cheylesmore

British Museum, P&D 1902–10–1–5483

The Society of Dilettanti was founded in 1732, with members from all political parties, various levels of society and different degrees of wealth. What they had in common was the experience of the Grand Tour, a passion for collecting and a love of Italian culture. They lent their financial and powerful social support first to Italian opera and later to the discovery and publication of the ancient art, architecture and civilisations of Greece and Italy, as well as giving their patronage to young British artists. The Society of Dilettanti attempted to set up an Academy of Art in London and employed these artists for their publications and portraits, also awarding them scholarships to study abroad.

The idea of two group portraits was first suggested at a meeting in January 1777. One of the portraits appears to depict Hamilton's reception into the Society two months later, on 2 March. He is shown as the central figure in (a), gesturing to plate 60 in the first volume of his vase publication. Around him and in the other portrait are many of the men with whom he not only shared a commitment to the improvement of the arts in Britain, but whose collections he often helped to form. They include Sir Watkin Williams Wynn, on the left in the Hamilton portrait, wearing the 'toga' as President for the evening, who shared with Hamilton a passion for music and theatricals as well as admiration for the work of Raffael Mengs, from whom he commissioned a large painting of *Perseus and Andromeda* (St Petersburg, Hermitage).

In the other portrait, celebrating the collecting of ancient gems, are Lord Fortrose, seated second from left, whose apartments in Naples had been depicted by Fabris (see cat. no. 16) and who by then was the Earl of Seaforth; just behind him to the right is Hamilton's nephew, Charles Greville, touching glasses of vintage claret with the Society's Secretary, John Charles Crowle, and Joseph Banks, who succeeded him as Secretary (cat. no. 40), and in front of them with his arm extending across the table to show a gem, is Lord Carmarthen, later Duke of Leeds and recipient of many of Hamilton's diplomatic dispatches.

LITERATURE: Clarke and Penny, nos 87–8, pp. 4–6; Penny, 1986, nos 109–10.

53 'To Mr Hamilton': plate from AEGR

Engraving, 23 × 29 cm

The copy of *AEGR* shown on Hamilton's lap in Reynolds's portrait (cat no. 51) is open at this plate. It was chosen presumably because of the inscription, probably concocted as a private joke by d'Hancarville. This is written backwards in archaic Greek letters and reads: A Mᶜ HAMILTUN.

LITERATURE: D'Hancarville, *AEGR*, I, pl. 71; Ramage, 1989b, p. 11, for the inscription.

54 Red-figured pelike (storage-jar)

Ht 37 cm

Made in Athens around 350 BC. Attributed to Group G. Said to be from Chios or Alexandria British Museum, GR 1772.3–20.27* (BM Vases E433)

The subject is perhaps Demeter in the House of Kelos.

This vase, which can be seen in fig. 57, is exceptional in that, unlike the majority of Hamilton's vases, it is said to have been found outside Italy. In *AEGR* d'Hancarville claims it was from an island in the Greek archipelago. In the manuscript catalogue, he says specifically that it was found on Chios in 1761. It must also be mentioned, however, that according to Winckelmann, the vase was brought from Alexandria in Egypt.

D'Hancarville's first thought was that it represented Cassandra, the Trojan princess, and other members of the royal house of Troy, before Queen Hecuba, who is seated. He goes on, however, to explain that at the point of writing he had just received a letter from Rome, drafted by Winckelmann shortly before his murder in 1768. Winckelmann suggested that the subject was Herakles (the male figure on the left of the picture) approaching Omphale. D'Hancarville summarises Winckelmann's explanation and we find the latter's own account in the revised edition of the *History*.

LITERATURE: D'Hancarville, *AEGR*, I, pls 69–71; II, pp. 164–5; Winckelmann (Lodge), II, pp. 162–4; D'Hancarville, MS Catalogue, II, facing p. 657; Beazley, *ARV²* 1466, 104; Constantine, 1993, p. 66.

53

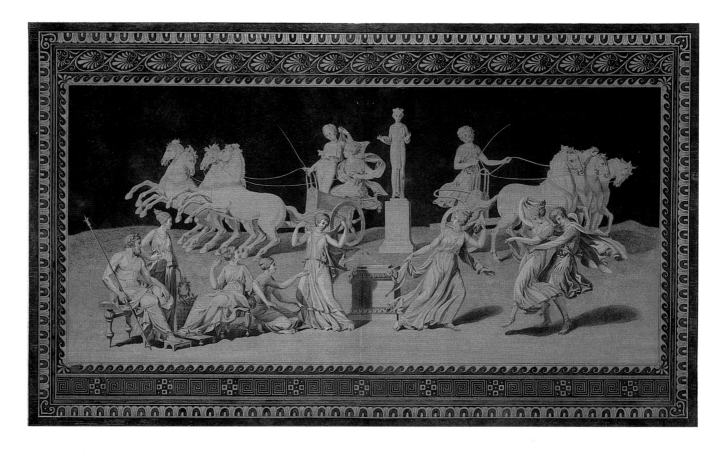

55 'The most beautiful vase in the Hamilton collection': red-figured hydria (water-jar)

Ht 52.1 cm

Made in Athens c.420–400 BC. Attributed to the
Meidias Painter

British Museum, GR 1772.3–20.30* (BM Vases
E224)

The upper scene shows the rape of the daughters of Leucippus by the Dioscuri, Castor and Polydeuces (Pollux); the lower, Herakles in the Garden of the Hesperides with Attic heroes and others.

This vase, also known as the Meidias Hydria, was, together with the volute-krater (cat. no. 2), the most celebrated vase of Hamilton's first collection. In addition to the usual manner of reproducing the figured scenes in *AEGR*, d'Hancarville had the painter L. Pécheux, whom he had consulted on matters relating to the ancient technique of vase-painting (II, p. 150), translate the scene on the shoulder into a remarkable *trompe l'oeil*, showing the figures standing in a landscape, those at the front highlighted with lead white. His stated purpose was to give artists the opportunity

of seeing what use they could make of vase-paintings as models, by abstracting and correcting the figures from them. In the main text of *AEGR*, moreover, d'Hancarville discusses the vase in the same breath as he mentions Raphael, and it seems clear that his intention in commissioning a more painterly version of it was to put before the viewer an impression of what it might have looked like, had it been Raphael's own work. The strange luminosity of the picture, which was engraved by Carmine Pignatari, the flatness of the landscape and the hard edge of the division between the ground and the black 'sky' beyond, is curiously suggestive to modern eyes of television pictures of the American moon landings of the 1960s. Much artistic licence was used in adapting the scene and much is altered in the process.

D'Hancarville correctly interpreted the frieze around the belly of the vase as showing Herakles in the Garden of the Hesperides. Herakles is the figure seated on his lion skin to right of centre, his right arm supported by a club. Close to the centre is the tree that bore the golden apples, the fruit Herakles has come to fetch out of the Garden of the Hesperides, nymphs of the

evening. Two of them are shown to the left, and one more to the right of the tree, which is guarded by a scaly serpent. These and the other mythological figures ranged to right and left were identified by their names, written above them. D'Hancarville was unaware of this, and his identification of the other figures in the scene as the daughters of Atlas and the Argonauts is mere guesswork.

D'Hancarville was similarly unaware that the subject of the scene on the shoulder of the vase, the carrying away of the daughters of Leucippus by Castor and Polydeuces, the twin sons of Zeus, could be identified by its inscriptions. The names were painted in added white clay, which fused with the body of the vase at the firing stage of its manufacture. Subsequently these inscriptions flaked off, leaving only a ghost of what was once there. On close inspection, however, the relict inscriptions are still legible. Either d'Hancarville and his contemporaries did not look sufficiently closely

or, more probably, the inscriptions were obscured by the eighteenth-century practice of overpainting and varnishing the vases to improve their condition and lustre. Without this information d'Hancarville interpreted the scene as the race of Atalanta and Hippomenes. This was a curious choice, since Atalanta's race against her suitors took place on foot, rather than by chariot. He perhaps thought the chariots were incidental, for he identified the two main protagonists of the story with the figures on foot wrestling immediately in front of the statue. One advantage of his interpretation, if correct, would have been to provide a link with the subject-matter of the lower frieze through the golden apples which Hippomenes is said to have strewn in the path of Atalanta, in order to slow her down.

In the revised edition of his *History* Winckelmann came rather closer to the actual subject of the shoulder scene. This was for him the most beautiful vase in the Hamilton collection and he thought the chariot scene the very best specimen of drawing to have come down to us from antiquity. 'My first thought', he says, 'fell upon the chariot-race which Oenomaus, King of Pisa, had established for the suitors of Hippodamia, and in which Pelops obtained the victory and a bride. This conjecture seemed to be supported by the altar in the middle; for the course extended from Pisa to the altar of Neptune at Corinth. But there is no token of this divinity here, and as Hippodamia had only a single sister, named Alcippa, the other female figures would be imaginary.' He goes on to explain that he subsequently changed his mind in favour of the race which Icarius proposed to the suitors of his daughter Penelope at Sparta, 'who would fall to the lot of him who outstripped the others', namely Odysseus.

Winckelmann's imprimatur, together with the star treatment it had received in *AEGR*, ensured that the vase took pride of place in Reynolds's portrait and in the Hamilton Room of the British Museum. Its figured scenes, and the lower frieze in particular, were much reproduced in fashionable decorative arts, making this one of the great icons of late eighteenth- and early nineteenth-century taste.

LITERATURE: D'Hancarville, *AEGR*, I, pls 127–30; II, pp. 142–3 and 166–8, pl. 22 for the *trompe l'oeil*; d'Hancarville, MS Catalogue, p. 660; Winckelmann (Lodge), pp. 397–9; Constantine, 1993, p. 67; Beazley, *ARV²* 1313, 5; Burn, pp. 13–25, 1a–9b.

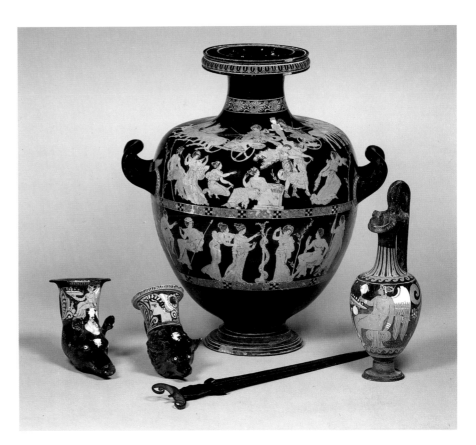

ABOVE Cat. nos 55–7: vases and other objects depicted in Sir Joshua Reynolds's portrait of Hamilton (cat. no. 51).

56 Three red-figured vases

a) Oinochoe (wine-jug)

Ht 33 cm
Attributed to the Hamilton Painter. Made in Apulia, southern Italy, about 350–300 BC
British Museum, GR 1772.3–20.335 (BM Vases F379)

The subject is a woman and Eros.

LITERATURE: D'Hancarville, *AEGR*, II, pls 23–4, and IV, pl. 126; Trendall/Cambitoglou *RVAp*, 829, 121.

b) Rhyton (drinking-horn) ending in a boar's head

L. 15.8 cm
Made in Apulia about 350–300 BC. Said to be from Basilicata
British Museum, GR 1772.3–20.385 (BM Vases F430)
LITERATURE: D'Hancarville, *AEGR*, I, pl. 110.

c) Rhyton ending in a dog's head

L. 17 cm
Made in Apulia about 350–300 BC. Attributed to the Split Mouth Group
British Museum, GR 1772.3–20.380 (BM Vases F419)

LITERATURE: D'Hancarville, *AEGR*, II, pls 28–9; Trendall/Cambitoglou, *RVAp*, II, p. 817, 511.

57 Bronze sword

L. 58 cm
About 1300–700 BC
British Museum, PRB POA 205

In addition to the vases in Reynolds's painting, there is a bronze sword lying on the floor, partially hidden by the Meidias Hydria. The distinctive handle has been successfully identified by Dr Donald Bailey as that of a sword of the 'antennae-hilted' type in the British Museum's Department of Prehistoric and Romano-British Antiquities. This has no recorded provenance and has not previously been linked with the Hamilton collection.

'Sacred Fire': Etruria Reborn

Sir William's stated aim in publishing his vase collection was to revive the principles of Greek vase manufacture and so provide a model for contemporary manufacturers to follow. This he achieved through the enterprise of Josiah Wedgwood and his partner Thomas Bentley at their Staffordshire pottery works, aptly named Etruria.

58 'First Day's Vase': Black Basalt ware vase with encaustic decoration

Ht 25.5 cm
Made at Etruria, June 1769
Private collection

The opening of the new pottery works at Etruria on 13 June 1769 was marked by Wedgwood's own ceremonial throwing of six commemorative vases, while Bentley cranked the wheel. Four of these now survive. One side bears a painted inscription:

> June XIII. M.DCC.LXIX
> One of the first Days Productions
> at
> Etruria in Staffordshire
> by
> Wedgwood and Bentley

58

The other side is painted with a scene from one of the engraved plates of Sir William's first vase collection, with a Latin inscription below, 'Artes Etruriae renascuntur' – the arts of Etruria are reborn.

The choice of the name 'Black Basalt' for this type of ceramic was no doubt influenced by the so-called basalt controversy over the disputed volcanic origins of the black basalt rock (see cat. no. 39). Wedgwood and Bentley may have seen a romantic link between the firing of their own black ware in modern Etruria and the forging of the hard black rock in the white heat of Vesuvius. The ancient shape chosen for the First Day's Vase was the *lebes gamikos*; its original usage was, as the name 'marriage bowl' suggests, to hold water for a washing ceremony undertaken by groom and bride before their wedding. The painted decora-

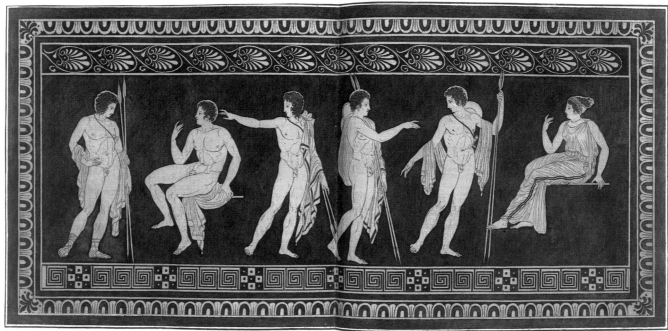

FIG. 75 Engraving from which the scene on the First Day's Vase was taken.

tion was carried out in Wedgwood's London Decorating Studio. The figures are taken from plate 129 of volume I of *AEGR*, and from the right-hand side of the plate. This illustrated part of the painted scene around the belly of the so-called Meidias Hydria, thought the most beautiful of all vases in Hamilton's collection (cat. no. 55). According to d'Hancarville the figures were to be identified as Maia, mother of the god Mercury (Hermes), seated before the brothers of Leda. These identifications were made in ignorance of the inscriptions on the actual vase naming the figures as (left to right) Oineus and Demophon, two of the tribal heroes of Athens, and the Hesperid Chryseis.

LITERATURE: Reilly, I, pp. 70–71 and 414; Young, p. 71, D3.

59 *Black Basalt portrait plaque of Sir William Hamilton*

Ht 16 cm
Modelled by Joachim Smith, *c.*1772
BRITISH MUSEUM, MLA 1909,12–1,127

Not illustrated

Sir William Hamilton proved to be a popular subject in Wedgwood's line of portrait medallions. The plaque, showing Sir William with his hair dressed in a long queue, was made in a variety of colours and materials and included in every stock catalogue from 1773 until 1788. A version of the plaque (fig. 76) was presented to Sir William in 1772. Cast in 'Basaltes', the ground and the reverse were painted in red encaustic, so as to give it the look of a Greek vase. The reverse bears a dedication to Sir William by Bentley:

> Wedgwood and Bentley beg Sir Wm. Hamilton will do them the honour to accept of an Etruscan bas-relief portrait of himself, as a small testimony of respect and gratitude to a gentleman who has conferred his obligations upon this kingdom in general and upon themselves in particular which may be the means, not only of improving and refining the public

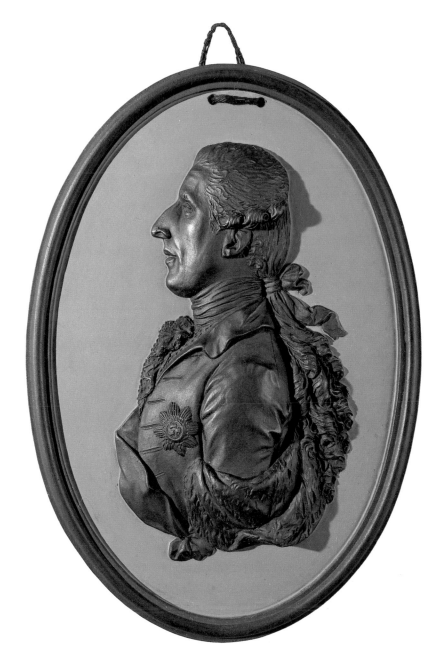

taste, but of keeping alive that sacred fire, which his collection of inestimable models has happily kindled in Great Britain, so long as burnt Earth and Etruscan painting shall endure. Great Newport Street, April, 30, 1772.

LITERATURE: Reilly and Savage, pp. 182–3; Reilly, I, p. 84; Ramage, 1990b, p. 75; Adams, pp. 76–7, col. pl. 55 and fig. 13; Dawson, p. 79; Young, p. 59, C4.

FIG. 76 Black basalt portrait plaque of William Hamilton, with red encaustic background, presented to him by Josiah Wedgwood and Thomas Bentley. Birmingham, Alabama, Dwight and Lucille Beeson Collection.

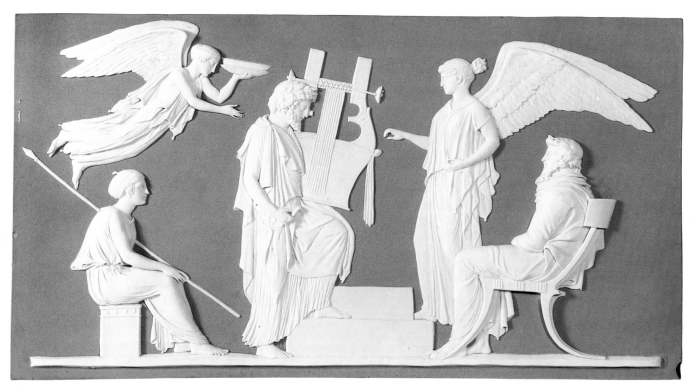

60

60 'The Apotheosis of Homer': jasperware plaque

Made at Etruria after a design modelled by John
 Flaxman in 1778, and marked with his name
Ht 19.5 cm
Provenance: Given by Mr and Mrs I. Falke
British Museum, MLA 1909,12–1,186

The inspiration for this decorative plaque is usually said to be an engraving in the third volume of *AEGR* (printed in 1776) after a vase now in the British Museum (see cat. no. 61). A letter from Thomas Bentley to Sir William, however, suggests that at the time Flaxman modelled the design in 1778, the engraving was unknown to Wedgwood and Bentley and that they had relied upon a drawing sent by d'Hancarville himself, who was now resident in England. The letter was written by Thomas Bentley on 26 February 1779 by way of explaining the gift of one of the plaques to Sir William: 'Having modelled a large tablet from one of the unpublished designs in your Excel-

lency's collection at the British Museum, which we copied from a drawing lent us by Mr d'Hancarville . . . we could not resist the desire of presenting you with a copy.' Bentley went on to quiz Hamilton on the subject of the vase, which Wedgwood and Bentley will have been told by d'Hancarville represented the Apotheosis of Homer. The latter gave this explanation in *AEGR* and repeated it in his manuscript catalogue of the Hamilton collection compiled in 1778. Hamilton was more circumspect about the subject in his letter of acknowledgement: 'I have the pleasure of receiving safe your delightful bas-relief of the Apotheosis of Homer, or some celebrated poet.'

LITERATURE: Reilly, I, pp. 583–4, fig. 845; Ramage, 1990b, pp. 74–5; Dawson, p. 107; Young, p. 61, C8. The correspondence quoted is: Birmingham, Ala., Chellis Coll. MS (Bentley), and Barlaston, Wedgwood Museum, Wedgwood MS E32–5365 (Hamilton's reply dated Naples, 22 June 1779).

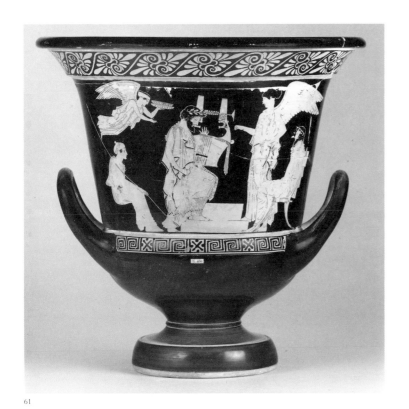

61

61 Red-figured calyx-krater (wine-mixing bowl)

Ht 45.5 cm

Made in Athens around 440 BC. In the manner of
the Peleus Painter. Found in the river Gela,
Sicily

British Museum, GR 1772.3–20.26 (BM Vases
E460)

The main side shows a kithara-player mount-
ing a platform, watched by a winged figure
of Victory, a judge and other onlookers. On
the reverse are shown youths and women.
D'Hancarville's interpretation of the subject
as the Apotheosis of Homer must now be
regarded as fanciful.

LITERATURE: D'Hancarville, *AEGR*, III, pl. 31,
p. 210, note; d'Hancarville, MS Catalogue, II,
pp. 654–7; Beazley, *ARV²* 1041, 2.

FIG. 77 Engraving after the painted scene on
cat. no. 61.

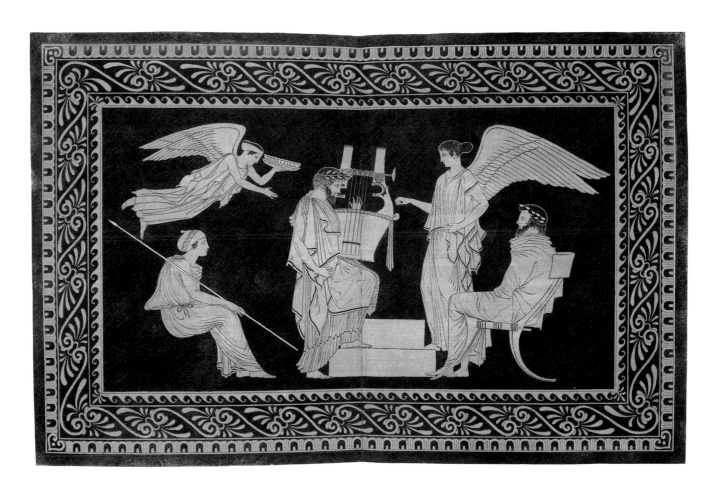

The Second Vase Collection

62 The wreck of the Colossus

A number of vases from Hamilton's second vase collection were lost when the *Colossus* sank *en route* for England in 1798. Those that escaped the disaster were sold by Hamilton to Thomas Hope. The British Museum acquired a few of the Hope vases (e.g. (a)–(c) below) at the Deepdene sale of 1917. The history of Sir William's second collection of vases is given above (pp. 52–9).

a) Red-figured bell-krater (wine-bowl) showing Dionysus rising from the ground

Ht 33 cm

Made in Athens around 370 BC. Found at Sant' Agata de' Goti

British Museum, GR 1917.7-25.1

LITERATURE: Tischbein, I, pl. 32; Tillyard, pp. 97–9, no. 163, pl. 26.

b) Red-figured bell-krater showing Apollo on a swan

Ht 32 cm

Made in Athens around 400–380 BC. Attributed to the Meleager Painter

British Museum, GR 1917.7-25.2

LITERATURE: Tischbein, II, pl. 22; Tillyard, pp. 96–7, no. 162, pl. 26; Beazley, *ARV*² 1410, 16.

c) Red-figured stemless kylix (drinking-cup) showing Theseus and the Minotaur

Ht 7.5 cm

Made in Athens around 400–380 BC. Attributed to the Meleager Painter

British Museum, GR 1917.7-26.3

LITERATURE: Tischbein, II, pl. 25; Tillyard, p. 105, no. 179, pl. 28; Beazley, *ARV*² 1414, 92.

ABOVE Volume IV of the publication of the second collection of vases, open at plate 16, showing the scene (Hera and Nike) from an Attic red-figured lekythos (oil-bottle) attributed by Beazley (*ARV*², 384, 207) to the Brygos Painter (*c.* 490–480 BC). Sherds from this vase, recovered from the *Colossus* in the 1970s, are placed over the engraving. To the right of the volume is a group of vases salvaged from the wreck and subsequently restored. These include a large Attic red-figured bell-krater (wine-bowl) attributed to the Peleus Painter (*c.* 450 BC) and showing the return to Olympus of the smith-god Hephaestus. To the left of the volume are the vases which came into the British Museum from the collection of Thomas Hope (cat. no. 62 (a)–(c)).

The Portland Vase

63 *'The Portland Vase'*

Cobalt blue blown glass vase with opaque white
 decoration of a mythical subject, possibly
 connected with the story of Peleus and Thetis
Ht 25.4 cm
Roman first century BC. Said to be from Rome
British Museum, GR 1945.9–27.1 (BM Gems
 4036)

The Portland Vase is the most famous of all
objects to have passed through Sir William's
hands. It was already well known when he
acquired it from the Scottish dealer James
Byres between 1780 and 1783, and it was
discussed by d'Hancarville in the second
volume of *AEGR* (p. 74), which appeared
in 1770. In the eighteenth century it was
accepted that the Portland Vase had been
discovered in a funerary monument known
as the Monte del Grano, a few miles south-
east of the old city wall of Rome. The Vase
was said to have been found in a large marble
sarcophagus, thought to have been that of
the third-century Roman emperor Alexan-
der Severus and his mother, Julia Mam-
maea. That the Vase came from the funerary
monument has recently been upheld in a
thorough review of the evidence as 'proba-
ble, but not certain'. What is doubtful is that
it contained the ashes of the emperor him-
self; nor is it likely that the sarcophagus is
that of Alexander Severus.

The first recorded mention of the Port-
land Vase is by the French antiquary
Nicolas-Claude Fabri de Peiresc, who saw
it in Rome during the winter of 1600–1,
when it was in the collection of Cardinal del
Monte. The seventeenth-century 'Republic
of Letters', including Peiresc, the Flemish
painter Peter Paul Rubens and the Italian
antiquary Cassiano dal Pozzo, exchanged
correspondence about the Vase and draw-
ings and casts of it. They were fascinated by
every aspect, from its beauty, the technique
of its manufacture and the interpretation of
its iconography down to its capacity.

Cassiano dal Pozzo (1588–1657), whose
so-called 'Paper Museum' contained more
than one drawing of the Vase, was secretary
to Cardinal Francesco Barberini. In 1626,
following the death of Cardinal Del Monte,
the Vase passed into the hands of Fran-
cesco's brother, Antonio. These two were

nephews of the Barberini Pope, who was
elected as Urban VIII in 1623. Now the
property of the most powerful family in
Rome, and placed at the heart of the city's
most important artistic circle, the Barberini
Vase, as it was known before it entered the
Portland collection, became even more
famous.

By the end of the seventeenth century it
was one of the most important 'sights' of
Rome, its fame increasing with the rise in the
number of printed books on antiquarian
subjects. In 1697 it was discussed and
copiously illustrated in *Gli antichi sepolchri*,
P. S. Bartoli's book on ancient tombs and
mausolea in Rome, which repeated the claim
that it had been found inside the sarcopha-
gus in the Monte del Grano. It was pub-
lished again by Bernard de Montfaucon in
his substantial and influential encyclopaedia,
L'Antiquité expliquée, the author repeating
an erroneous claim, already made by M. A.
de la Chausse in his *Romanum Museum* of
1690, that the Vase was made of agate.
G. B. Piranesi engraved the tomb, sar-
cophagus and Vase for his *Antichità Romane*
(1756, pls 31–5).

The Vase was in the possession of the
Barberini family for more than 150 years,
but their fortune was declining and around
1780 Donna Cordelia Barberini-Colonna,
having had a bad run at cards, was forced to
sell off the family heirlooms. In a letter
dated 24 July 1786, Hamilton described
how he reacted when he first saw the Vase
with James Byres: 'The person I bought it
of at Rome will do me the justice to say, that
the superior excellence of this exquisite
masterpiece struck me so much at first sight,
that I eagerly asked – Is it yours? Will you
sell it? He answered, Yes, but never under
£1000.' Hamilton offered Byres that sum,
but only in the form of a bond on which
there was 5 per cent interest. Hamilton could
not resist the purchase, even though he could
hardly afford it. The precise date at which
he actually came into possession of the Vase
has not previously been known, but an
unpublished letter of James Byres to Charles
Townley, dated 13 October 1782, informs
us that Byres visited Hamilton in Naples in
the summer of that year. It seems likely that
he took the Vase with him, unable to entrust

the transport of so valuable a cargo to another
pair of hands.

Hamilton probably never intended to keep
the Vase for long and, when he returned to
England on leave in August 1783, it was
included with a number of things he took
with him to sell. Among these were other
antiquities and the painting Hamilton him-
self attributed to Correggio (see cat. no. 176).
With the assistance as go-between of his niece
Mary Hamilton, he attempted to interest
the Duchess of Portland in a block purchase
of the painting and the antiquities. Horace
Walpole described the duchess as 'a simple
woman, but perfectly sober, and intoxi-
cated only by *empty* vases'. She was, there-
fore, the ideal person to be offered such a
prize. (*Wal. Corr.*, XXXIII, p. 489, letter
addressed to Lady Ossory, 19 August 1785).
The duchess, who already had a substantial
collection of antiquities and specimens of
natural history, was not tempted by the
painting, but she and Hamilton were able to
settle, in secrecy at her request, on the Vase,
together with a select group of antiquities.

The purchase negotiations were com-
pleted by the end of January 1784, but some
months elapsed before the Vase entered the
duchess's museum at her house in the Privy
Gardens, Whitehall. In March, without dis-
closing its true ownership, Hamilton showed
the Vase to the Society of Antiquaries, of
which he was a Fellow. He had already
arranged for G. B. Cipriani to 'borrow' the
Vase in order to make drawings from it. It
was not returned until 13 July, when Cipri-
ani handed it over to Mary Hamilton. The
duchess had only a year in which to enjoy
her purchase, for she died in July 1785, and
the Portland Museum, as it became known,
was sold. The sale ran for six weeks from 24
April 1786, excepting Sundays and the
king's birthday, the Vase listed as the penul-
timate item of the last day.

Not surprisingly, previous discussions of
the Portland sale have focused on the Vase,
with little mention of the small group of
objects also bought by the duchess from
Hamilton. These appear in the catalogue
immediately before the Vase and comprise
the following: a mosaic ring, described in
the sale catalogue as 'A small chimera of fine
antique mosaic, set in gold as a ring, and

turns upon a swivel. The figure has the wings and feet of a bird, with a human face and seems to be an *Hieroglyphic*; a cornelian intaglio of Hercules, who is described as sitting in a boat and using the lion skin as a sail, set in gold for a ring. This was followed by a sardonyx cameo of the head of Augustus (see cat. no. 67), said to come from Malta, and a head of Sarapis, described in the sale catalogue as green basalt, as coming from the Barberini cabinet, and about four inches high. The purchaser of the Vase and the cameo was the 3rd Duke of Portland, while Horace Walpole bought the Sarapis.

Some of these objects are first mentioned in the correspondence of Byres to Townley. In that same letter giving an account of his visit to Naples, Byres writes:

> Sir William Hamilton has got some fine Etruscan vases and two curious rings, the one a Hercules playing the lyre on a fine jacinth, the other an ancient paste about a third of an inch square, on which is a Syren or a figure masked as a Syren, with its wings extended. This is executed on a blue ground in lively colours, the most minute parts distinctly marked, its a kind of small mosaic run together, it's about an eighth of an inch thick and the same on both sides, and has a wonderful effect in the microscope.

The Sarapis makes its first appearance in another letter of Byres to Townley, dated 21 August 1782:

> I have lately got the very finest head of Jupiter I ever saw, it is most excellent Greek work of green basalt, three inches and a half high from the end of the beard (which is on line with the joining of the clavicles) to the top of the hair on the forehead. The head, hair and beard are quite perfect, neither wore nor fragmented in the least, but this is all that remains of it. Whether it belonged to a bust or full figure is impossible to say. I got it out of an old collection. Its case which seems exactly adapted to it seems very old, so I suppose it has been found about the fifteenth century. I esteem it at £50. I forgot to mention that on the top of the head, behind the lock that rises on the forehead, is a [?] with a small hole drilled in the middle. I suppose

to attach the modium of [?], for it's the Jupiter Sarapis.

Byres's statement that he had acquired it from an old collection ties up well with the description of the head in the Portland sale catalogue as coming from the Barberini collection. Byres, then, was the source of

FIG. 78 Drawing by John Carter of a basalt head of Zeus Sarapis from the Barberini collection (not traced). Wash, pen and ink. Courtesy of the Lewis Walpole Library, Yale University.

Hamilton's acquiring both the Vase and the Sarapis, both of which came originally from the Barberini collection. Walpole had the Sarapis restored by Mrs Damer in 1787, who modelled a bust for it and had it cast in bronze. Although it cannot now be traced, a watercolour drawing of it survives (fig. 78).

Hardly was the Portland sale over than Josiah Wedgwood was applying to borrow the Vase with a view to copying it in jasperware. On 10 June 1786, he signed a receipt for both the Vase and the cameo of Augus-

tus. Wedgwood's copies of the Vase, first in black and later in the lighter blue version, spread its fame still further. In 1810 the 4th Duke of Portland deposited it in the British Museum for safe-keeping, where it went on public display. Alas, thirty-five years later, at 3.45 p.m. on 7 February 1845, a young man named William Lloyd, suffering from acute paranoia brought on a by a week-long bout of drinking, picked up a sculpted stone in the room where the Vase was displayed and smashed both it and the showcase into fragments. In spite of the damage, the event and the ensuing trial of the culprit served only to increase the celebrity of the Vase, which was restored soon afterwards by John Doubleday. A hundred years after its destruction, the Portland Vase was bought for the British Museum, since when it has twice been dismantled and restored, the second restoration being by the late Nigel Williams in 1989.

LITERATURE: The bibliography of the Portland Vase is too great to give even a summary here. Fortunately much of it is gathered together in the valuable survey essays by Kenneth Painter and David Whitehouse (1990). Meanwhile, new studies of the problematic iconography continue to appear, see most recently Haynes. Specifically on Sir William's involvement with the Vase, see Thorpe, 2; Fothergill, pp. 192–6; Wills. For the other objects purchased by the Duchess of Portland from Hamilton, see Byres's letters to Charles Townley among the Townley Papers in the Central Archives, British Museum. For Horace Walpole's possession of the Sarapis and its later history, see *Wal. Corr.*, XI, p. 29. At the sale of Strawberry Hill, the bust passed to William Beckford and from him to the 'Hamilton Palace Collection' (to Mary Berry, 9 July 1789, *Wal. Corr.*, XI, p. 29, n. 33; cf. to Conway, 18 June 1786, XXXIX, p. 442, where it is said, s.h. XIII, 82, to have been sold to Hume, Berners Street). Its present whereabouts are unknown. On Wedgwood and the Vase, see Mankowitz; Dawson, pp. 112–25, with bibliography. For the bust of Sarapis with the Barberini see Lavin, where possible mention of it in the inventories is p. 184: IV, 44.729.

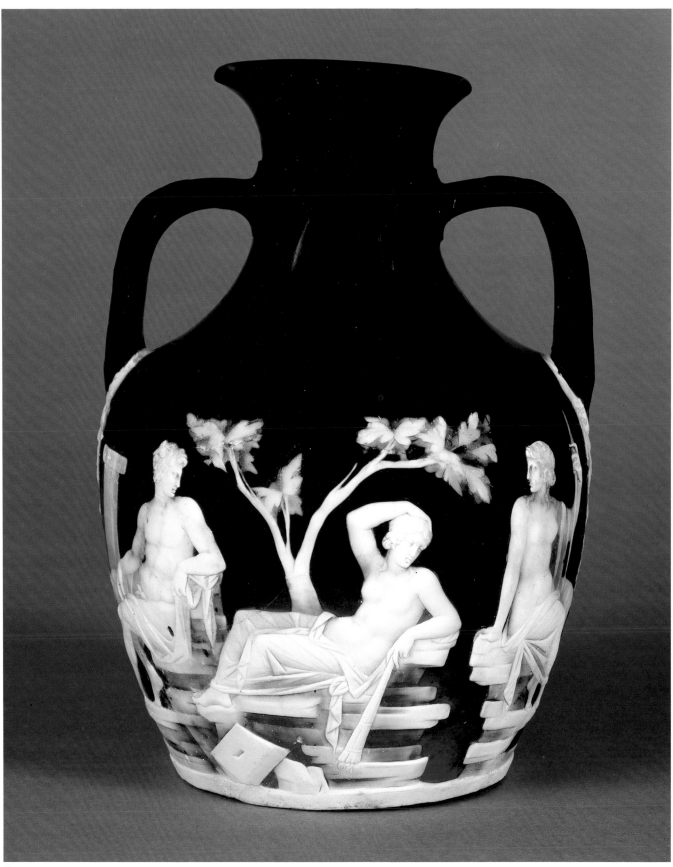

63

64

64 Attributed to CHARLES GREVILLE (1749–1809)

Commemorative engraving

Frontispiece privately printed by the Hon.
 Charles Greville to accompany a set of five
 engravings by Francesco Bartolozzi, after
 drawings by G. B. Cipriani, commemorating
 Sir William's bringing the Portland Vase to
 England.
Aquatint, 25 × 35 cm
British Museum, Department of Greek and
 Roman Antiquities

Sir William was proud of having brought
the 'Barberini Vase' to England and wished
to mark the event with a commemorative
set of engravings. Previous accounts of his
involvement with the Vase have overlooked
the importance of the correspondence that
passed between him and his nephew Charles
Greville. This gives a remarkably detailed

account of the processes involved and repre-
sents a fascinating chapter in the history of
eighteenth-century printmaking.

The Vase is shown perched on a bracket,
below the sarcophagus in which it was tra-
ditionally said to have been found. A seated
figure points to a Latin inscription, which
may be translated: 'Sir William Hamilton
brought this vase, outstandingly distinguished
among ancient works of art, to England,
and had it engraved in copper, being ambas-
sador from King George III of Great Britain
to Ferdinand IV, King of the Sicilies, so as
to adorn his country with the so famous
name of this ancient work.' On the left side
of the picture a sheet of paper unfurls to
display a view of the monumental tomb, the
Monte del Grano, in which the sarcopha-
gus was found. Its position in the tomb is
indicated on the upper of two large internal
chambers. The cross-section image of the

tomb was clearly taken from the engraving
published by P. S. Bartoli. From this we see
that his image of the sarcophagus in the tomb
is cleverly enlarged to produce the three-
quarter view of it on the right of the picture.

At least as early as January 1784, Hamil-
ton conceived of a publication to celebrate
the Portland Vase in England. His chosen
draughtsman was the Italian artist Giovanni
Battista Cipriani (1727–85), who had come
to England in 1755 and soon established his
reputation as an able recorder of antique
subjects. The drawings were made by 13
July 1784, when Cipriani returned the Vase
to the safe-keeping of Mary Hamilton (see
cat. no. 63). In the following September,
Hamilton's leave of absence came to an end,
and he set out on the return journey to
Naples. He entrusted the publication of
Cipriani's drawings to his nephew Charles
Greville. In October 1784 the latter wrote

informing Sir William of arrangements thus far:

I have settled with Bartolozzi; gave him the drawings, and have been obliged to alter the conditions. It was settled that the ground should be in the dotted way, and the figures engraved. On due consideration, Bartolozzi says he must engrave the ground as well as the figures, because the ground will be harsh and not print off so well. I concluded that you only wished it done in the best way, provided it was capitally engraved and not dotted over in the slight modern fashion. [Morrison, no. 131]

Francesco Bartolozzi (1727–1815) frequently engraved the drawings of Cipriani, often using the then fashionable stipple technique. It was this method of stipple engraving that Greville knew Sir William did not like, because it was normally used for decorative prints and the subject here was worthy of more serious treatment.

A full year passed before Greville wrote again on 11 November 1785 to report that the copper plates were almost ready. He requested instructions on the matter of how the eventual prints were to be sold, and what inscription and letterpress was required. He ends: 'The publication may be made more bulky by an etching from Pyranesi, or S. Bartoli of the sepulchre and also the Syrcophagus in which it was found, and most people love bulk' (Morrison, no. 139). Hamilton's only instruction was that one of the plates should bear a short Latin inscription mentioning the fact of his having brought the Vase to England in 1783. There he hoped it might remain, in spite of the fact that the sale of the duchess's museum, following her death, might attract foreign buyers (Morrison, no. 146, 7 March 1786, also no. 145).

After a good deal of haggling over costs, the series was eventually published by Boydell and Torre and the plates were dated 20 April 1786. It is doubtful, however, whether they were actually printed then. Certainly, negotiations over the selling of them dragged on at least until the following autumn: Sir William had laid out £150 on the cost of the drawings and £400 for the plates. He wanted, therefore, at least to recover these expenses from the sale of the prints. At one point Greville, frustrated by the publisher's proposed 40 per cent interest in the proceeds, and seemingly hoping to make something for himself, suggested cutting out the middleman and publishing the plates himself. This would be done in time to cash in on the demand he anticipated, when the Vase went under the hammer in the following June:

I have thought the time of the sale favorable for the sale of the prints. I therefore have bought a press and paper, and have engaged a printer and have set it up in Edgware Row, in the laundry, and shall myself watch the printer. I shall not have made much progress before you write to me ... but I shall be about ready to deliver some when your answer shall arrive, whether you approve of my arrangement or will have it done on your own account. [Morrison, no. 151, May 1786]

It must be concluded that Hamilton did not approve of his plates being published thus, and on 24 October 1786 Greville wrote again to say that he had settled with Torre to sell 150 sets of five prints each at a price no higher than five guineas the set, three pounds of which was to go to Sir William. Greville adds: 'I sent a few with Greek inscription, whereby I distinguish proofs from prints.' This explains a fact which seems not to have been remarked upon hitherto, namely that two versions of the prints with the 'rolled-out' views of the vase were produced, those with the Greek and those without. The copy in the British Library is without the Greek, while Wills (1979) and Painter and Whitehouse (1990) illustrate the other version, where the two sides of the Vase are labelled *Aphanismos* (Disappearance) and *Euresis* (Finding). Each of these headings is then followed by two lines of the *Idylls* of Theocritus dedicated to the cult of Adonis.

The aquatint frontispiece was produced separately from the other engravings in the set of five, and seems to have been the personal responsibility of Greville: 'The fifth plate or frontispiece I drew and engraved, and the paper, printing press, etc., were my only outgoings' (Morrison, no. 154). The plate was printed on his own press in the laundry at his house in Paddington, which explains the fact that no publisher's inscription appears on the print itself. Greville is recorded elsewhere as an amateur artist and a pioneer in the development of the aquatint printing process, and was one of the first to apply it in England.

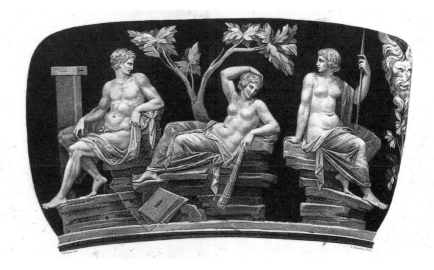

FIG. 79 Proof plate from Hamilton's engravings of the Portland Vase. British Library.

Sir William did not recover his outlay on the publication of the Vase. In 1791 Wedgwood's close friend Erasmus Darwin applied, through his publisher, to include impressions from Bartolozzi's plates in his epic poem *The Botanic Garden*; he was refused on the grounds that Hamilton 'is a considerable sum out of pocket' (Keynes, pp. 68–9). In the end William Blake engraved a new set of plates, which seem to borrow heavily from Bartolozzi's.

LITERATURE: Morrison, nos 131, 139, 145, 146, 151 and 154. Wills, pp. 197–201; Painter and Whitehouse, pp. 42–61. For Greville and the origins of aquatint, see Griffiths, p. 263, fig. 182. The copper plates engraved by Bartolozzi remained with Greville and were sold at Christie's on 4 April 1810, lot 24.

Cameos

Good ancient cameos were both rare and expensive in the eighteenth century. Only a few entered the British Museum with Sir William's first collection. The second collection contained some very fine examples, a selection of which was reproduced by James Tassie in both his sulphur and white glass impressions. The majority of these cameos were sold together with a number of intaglios to Sir Richard Worsley, Hamilton's diplomatic counterpart at Venice. Sir William brought them to England himself in 1791, when Worsley was also resident here.

Cameos from the First Collection

65 Onyx cameo: a bucolic fantasy

L. 3.4 cm
Post-Classical, possibly 16th or 17th century
British Museum, MLA 1772,3–14,113 (Dalton
 Gem Cat. 78)

In the foreground on the right are Apollo with a kithara (stringed instrument) and a goat-legged satyr, perhaps Marsyas, holding pan pipes. On the left are two male lovers. In the middle ground are carved two terminal figures of satyrs, while the distant landscape is indicated by etching.

LITERATURE: D'Hancarville, MS Catalogue, II, p. 488: 'une fête de Priape'.

66 Sardonyx cameo: Cleopatra

L. 4.5 cm
Post-Classical, ?16th century. The break at the
 neck was already recorded in Dalton's day
 (1915)
British Museum, MLA 1772,3–14,188 (Dalton
 Gem Cat. 319)

Cleopatra, bare-breasted, looks out at the viewer, while an asp coils around her left wrist. The subject was popular with Renaissance gem-engravers: a similar version in chalcedony is in the Cabinet des Médailles, Paris, while a sardonyx cameo in the Munich Münzkabinett adapts the same figure to portray Lucretia piercing her heart with a dagger. The cameo itself is mounted on a thin backing, perhaps added later to support the head. This snapped off at some point in the history of the gem. The break is punctured with fine drill-holes, perhaps to hold a choker necklace in place, with which to disguise the break line.

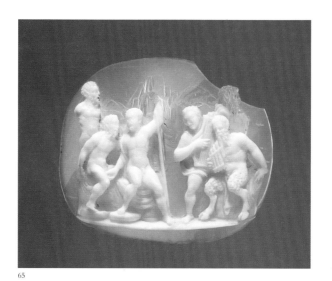

65

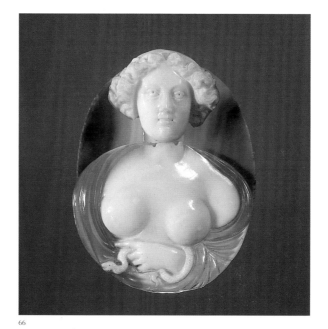

66

LITERATURE: D'Hancarville, MS Catalogue, II, pp. 503–4: antique but retouched; cf. Babelon, pl. 60, no. 671; Furtwängler, AG, I, pl. 67, no. 16.

67 *Cast glass head of the Emperor Augustus*

Ht 3.5 cm
British Museum, GR 1996.1–16.1

Made by James Tassie, this glass cast reproduces a cameo head of the Roman emperor Augustus sold to the Duchess of Portland by Sir William at the same time as the Portland Vase.

LITERATURE: The original cameo is reproduced as a line engraving in Tassie, no. 11050, pl. 54; it is the same as a cast published by Megow, p. 154, A5, pl. 1.17.

68 *Sardonyx cameo: head of a Julio-Claudian prince wearing a laurel crown*

Ht 5.2 cm
First century AD. Part restored. Setting modern
Provenance: Gonzaga or Grimani collection (Worsley Papers); Hamilton; Sir Richard Worsley; Earl of Yarborough
Private collection

In April 1783 James Irvine wrote to George Cumberland: 'Sir William Hamilton has lately got a head of Augustus without the neck and half the chin, which he values at an enormous price. He sent it to Byres to get it restored, only to show how little was wanting and in such a manner that the modern part might be separated from the Antique at pleasure.' Tassie's sulphur cast in the Victoria and Albert Museum shows the object before it was restored in Rome by Giovanni Pichler (Worsley Papers).

LITERATURE: British Library, Add MS 36494, f. 59 (Irvine to Cumberland); Tassie, no. 11065: 'Augustus'; Worsley Papers, XLII, 'Large cameos set in medallions': 'young Tiberius'; Smith, 1897, no. 42: 'beardless laureate head'.

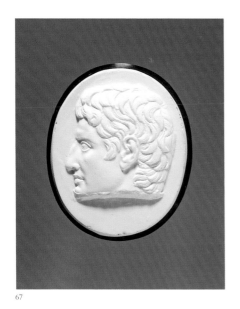

67

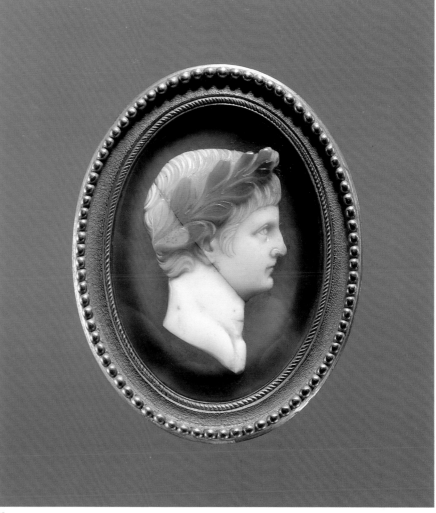

68

69 Sardonyx cameo: bust of the Roman emperor Claudius wearing a laurel crown

Ht 2.6 cm

First century AD. Setting modern

Provenance: Gualtieri (Worsley Papers); Hamilton; Sir Richard Worsley; Earl of Yarborough

Private collection

Tassie writes of the portraits of Claudius: 'Most of them are like his medals (coins) and all of them abundantly expressive of his stupidity.'

LITERATURE: Tassie, no. 11332; Worsley papers, XLII, no. 1, bought from Hamilton for 800 sequins (about £400); Smith, 1897, no. 39.

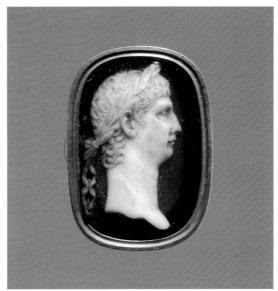

69

70 Onyx cameo: a faun, shown frontally, and a bacchante, seen from the rear and holding a kithara

Ht 2.8 cm

Said to have been sent to Sir William from Constantinople. It was already broken and repaired in the eighteenth century. First or second century AD

Provenance: Hamilton; Sir Richard Worsley; Earl of Yarborough

Private collection

LITERATURE: Tassie, no. 4861; Worsley Papers, XLII, no. 7; *Mus. Wors.*, II, p. 37 and plate facing; Furtwängler, *AG*, I, pl. 57, no. 24. Smith, 1897, no. 6.

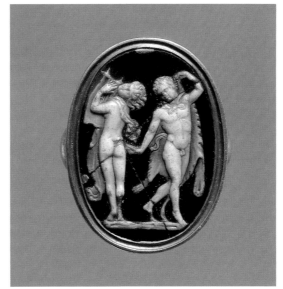

70

71 Sardonyx cameo: a warrior pulling another from a horse

Ht 4.5 cm

Second century AD. Setting modern

Provenance: Gonzaga or Grimani collection;
 Miliotti; Hamilton; Sir Richard Worsley; Earl
 of Yarborough

Private collection

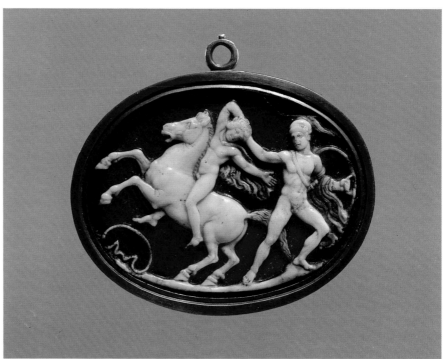

71

Both figures appear to be male and have variously been described as 'Mars and a horseman' (Tassie), Diomedes and Troilus (*Mus. Wors.*) or Achilles and Troilus (Smith). In Classical art this compositional arrangement of figures is found more often in scenes of combat between male Greeks and female, usually more modestly attired, Amazons. It also occurs, however, in a few representations in both Greek and Roman art of the ambush of the Trojan prince Troilus by Achilles. The design on a glass paste cameo in the Metropolitan Museum of Art in New York comes close to this one, but the style of the carving of the present cameo is more comparable with that of similar scenes in sarcophagus reliefs.

Richard Worsley gives the following account of it: 'This large and beautiful cameo on one of the finest onyx imaginable belonged to the Mantuan Collection and was purchased of Sir William Hamilton in the year 1791. It represents Diomed in the act of pulling Troilus from his horse, which is perhaps the most beautiful one handed down to us in ancient sculpture.'

LITERATURE: Tassie, no. 7622, pl. 44; Worsley Papers, XLII, listed under 'Large cameos set in medallions'; *Mus. Wors.*, II, facing p. 37; Smith, 1897, no. 29. For other representations of the same subject, see *LIMC*, I, 2. 349a ff., including the glass paste cameo.

72

72 Glass cast by James Tassie of cat. no. 71

Ht 4.5 cm

British Museum, GR 1996.1–16.2

Raspe records the original as being in Sir William's collection. This is confirmed by an inscription on the back of this cast: ' Sir Wm Hamilton, from Miliotti, 1784'. Related to Tassie's cast of the Hamilton cameo are two bronze plaques, one in the National Gallery of Art, Washington, the other in the British Museum's Department of Medieval and Later Antiquities.

LITERATURE: Tassie, no. 7622.

73 Onyx cameo: bacchanalian scene

Ht 3.7 cm

First or second century AD. Said to have been
found near Albano, in the ancient Tomb of
the Horatii and Curiatii. The setting is
eighteenth-century

Provenance: Sold by James Byres to Lord
Fortrose (Seaforth), from whom it passed to
Charles Greville who gave it to Sir William
Hamilton, who sold it to Sir Richard Worsley,
from whom it went to the Earl of Yarborough

Private collection

The subject shows two satyrs attempting to
ravish a third, while a maenad looks on. The
size, colour and no doubt the subject of the
cameo contributed to the high value placed
upon it. Lord Fortrose had bought it from
James Byres for £500, the price inscribed
on the reverse of a white glass cast by James
Tassie in the British Museum. On the eve
of sailing to India in 1781, Fortrose left
instructions with Charles Greville to send
his cameo to Sir William with a view to his
selling it (Morrison, no. 107). On 24
September 1782, Greville wrote again to Sir
William notifying him that, owing to Lord
Fortrose's dying during his voyage, the
cameo was now Hamilton's own property:
'By the way, I told you I had sent the cameo
to you, but the opportunity failed me [i.e.
he had not yet sent it]. I did not sufficiently
explain to you how it belonged to you. Ld.
Seaforth desired me to send it to you, to sell
for 400 guineas or to keep it. This might
have been thought slender ground to with-
hold it from the heirs, but I explained it to
the executors that the subject was obscene,
and not fit for a lady, and Ld. Seaf. had made
a codicil which he sent to me by which he
left me the choice of any antique, or gem,
in preference to all his heirs' (Morrison, no.
121). Greville now made a present of
Fortrose's cameo to Sir William, who did

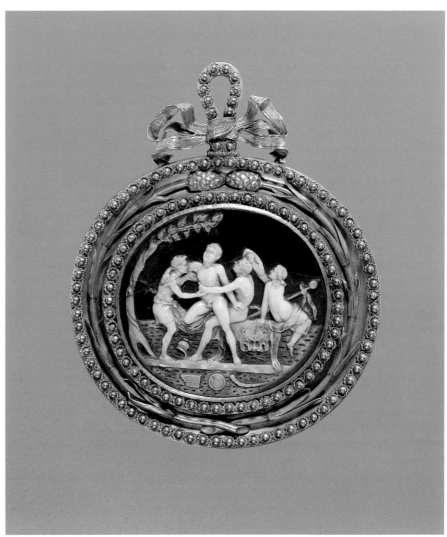

73

indeed sell it, to Richard Worsley in 1791,
for 800 sequins, about £400 (Worsley
Papers).

LITERATURE: Morrison, nos 107 and 121; Worsley
Papers, XLII, 'Large cameos set in medallions';
Mus. Wors., facing p. 37; Smith, 1897, no. 8a.

74 *Glass cast by James Tassie of a sardonyx cameo showing Joseph and his brothers*

Ht 5.4 cm
The original is now in the Hermitage in
 St Petersburg, having passed from Hamilton
 through the collection of the Duc d'Orléans
British Museum, MLA OA 2707

The story of Joseph is told in Genesis (37ff.). Joseph, favourite son of Jacob, was cast into a pit by his jealous brothers. They stripped him of the coat of many colours which his father had given him and, dipping it in the blood of a he-goat, took that to Jacob with the lie that Joseph had been devoured by a wild beast. Jacob remained inconsolable while, unknown to him, Joseph was rescued by Midianite merchants, who sold him to the Ishmaelites for twenty pieces of silver. They in turn took him to Egypt where, although a slave, he prospered and rose to become vice-regent, commanding the grain-stores of the country. In due course famine in the land of Canaan brought Judah and Jacob's other sons to buy grain. Joseph recognised his brothers and on their second visit hid a silver cup in the sack of the youngest, Benjamin. The latter was born of the same mother as Joseph and, being the youngest, was innocent of the crimes against him. When the cup was discovered, Joseph threatened to make a slave of Benjamin, but told the rest they were free to go with the words 'Get you up in peace unto your father'. Judah pleaded with Jacob for the freedom of his youngest brother and, unable to contain himself, Joseph revealed his true identity.

In the cameo Joseph is shown enthroned on the right, his brothers huddled before him. Judah cowers at his feet, while a beardless Benjamin stands behind the throne holding a cup. On the left the coat is held up, cleverly highlighted by the colour of the stone. Above the scene the words of Joseph are inscribed in Hebrew: 'Get you in peace unto your father'. This is one of the great masterpieces of medieval cameo carving and is part of a group attributed to the artistic circle of the court of Frederic II Hohenstaufen (d.1250). It may be paired with a similar cameo with a biblical subject, a representation of Noah and his family entering the Ark, now in the British Museum and formerly in the collection of Lorenzo de' Medici (fig. 80). The Joseph cameo is

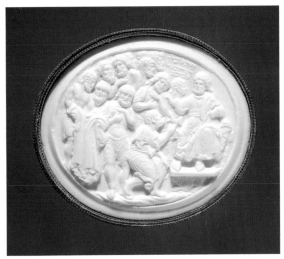

74

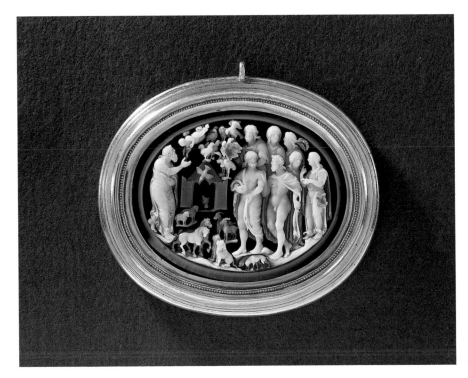

listed in an eighteenth-century inventory of the Nani family in Venice.

LITERATURE: Tassie, no. 13832; Wentzel, 1956, pp. 85–105, illus. 1–11; Wentzel, 1962, pp. 42–77; cf. R. Kahsnitz, *Zeit der Staufe*, exh. cat., V, Stuttgart, 1977, pp. 498–9. In the Royal Collection at Windsor is an onyx replica of the Joseph cameo without the Hebrew inscription: *Archaeologia*, 1874, pl. 2: also *Connoisseur*, Dec. 1902–Feb. 1903, fig. 1, p. 77. H. Tait (ed.), *Seven Thousand Years of Jewellery*, London, 1986, p. 218, fig. 541; Lemburg-Ruppelt, 1981, pp. 87–8.

FIG. 80 Sardonyx cameo showing the entry of Noah's family into the ark, possibly carved by the same hand as the original of cat. no. 71. Mid-13th century. British Museum, MLA 1890,9–1,15.

Intaglios

Intaglios from the First Collection

75 Two trays of sulphur impressions of intaglios attributed to James Tassie

The impressions are arranged in the order of d'Hancarville's manuscript catalogue of 1778 and are invaluable as a pictorial index to the actual gems in Hamilton's first collection, purchased by the British Museum in 1772. These were said to number 149, and since more than that number are represented by the casts, it must be concluded either that some were left out of the original count, or that Hamilton presented others to the Museum subsequently.

The casts illustrate the manner in which d'Hancarville viewed the classification and historical development of ancient gem-engraving: the first two in the series are two sides of the same scaraboid (cat. no. 77), that is to say a scarab-shaped stone as distinct from one which is actually carved as a beetle. This and the next three (see nos 78–80) were chosen so as to show that the primitive idea of sacred stones, which he traced back to prehistoric times, lived on into later antiquity. The next, showing a lion (d'Hancarville, no. 305), is chosen for the crudeness of its technique, indicative of its status as an early attempt in the first trials of gem-engraving. It is in fact a type of seal known from the island of Ischia off the northern promontory of the Bay of Naples and dates to the latter part of the eighth century BC (Buchner and Boardman).

The rest of the first row and the next two rows are given over to the so-called *a globolo* style of Etruscan intaglio, which is now dated to the fourth and third century BC but which d'Hancarville saw as contemporary with the Trojan War, or just before it. In the fourth row the finer Etruscan scarabs make their appearance, many being of the fifth and early fourth centuries BC but dated by d'Hancarville to the twelfth century BC and the aftermath of the Trojan War.

In the penultimate and the last rows of the first set, we find the Near Eastern cylinder seals, including cat. nos 86–93, which

75

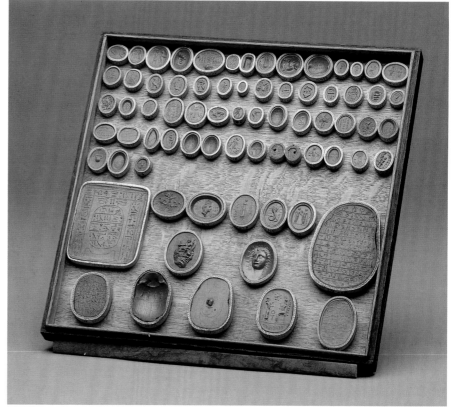

75

d'Hancarville thought of largely as Achaemenid Persian, and therefore of the sixth to the fourth centuries BC. A number of these are likely to have been found in Turkey or on the eastern Mediterranean coast. In the next set the 'Persian' sealstones continue in the top row until the Egyptian stones are introduced, along with the heretical 'Gnostic' gems of the Christian era. The order of the casts is interrupted here by the fact that the large scarabs have been pulled out of the series and placed below. In addition, at the end of d'Hancarville's series, which terminates in the third row, there is an additional series of gems, which were not given numbers, but are distinguished instead by Greek letters.

The following actual gems (76–109) are arranged according to d'Hancarville's principles of classification.

76

76 Unengraved amethyst pendant

Ht 1.8 cm
British Museum, GR 1772.3–15.299
 (BM Jewellery 3018)

The pendant is suspended from a piece of wire.

For d'Hancarville this represented the primitive use of stones to betoken deities. He remarked that the shape here was sufficiently like a scarab for it to signify Cybele: alternatively, it could be seen to represent a bean and, therefore, stand for Ceres (Demeter).

LITERATURE: D'Hancarville, MS Catalogue, II, pp. 517–18.

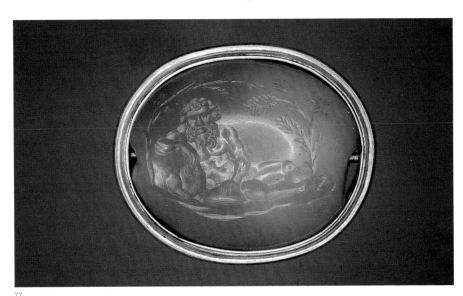

77

77 Chalcedony scaraboid

L. 3 cm
Eighteenth-century forgery
British Museum, GR 1772.3–15.300 (Dalton Gem
 Cat. 704–5)

The gem is engraved on both sides: on one side is the head of Silenus, on the other Silenus reclining on a wineskin, with one hand resting on an upturned bowl.

D'Hancarville thought the scaraboid shape of the stone, coupled with the advanced style of the carving, indicated that the primitive function of sacred stones persisted into historical times.

LITERATURE: D'Hancarville, MS Catalogue, II, pp. 518–20; Tassie, no. 4464; Dalton, p. 101, pl. 25, nos 704–5.

78 Chalcedony ellipsoid seal

Ht 2 cm
Sasanian, c.AD 400–500
British Museum, 1772.3–15.302
 (WAA Seals 119521)

D'Hancarville thought the shape of this seal, showing an eagle preying on a mountain goat, and the following two indicative of their status as 'sacred stones'. He was vague about their date but placed them somewhere between the transition between rough stones worn around the neck and refined stones worn on the finger as a ring.

LITERATURE: D'Hancarville, MS Catalogue, II, pp. 521–5; Tassie, no. 1089; Bivar, HI 5.

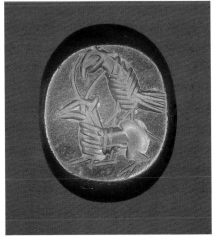

78

79 *Chalcedony decorated ellipsoid seal*

Ht 2 cm
Sasanian empire, c.AD 300–400
British Museum, 1772.3–15.303
 (WAA Seals 119359)

This seal shows a female figure seated on a couch, with a child on her lap holding a diadem in an outstretched hand. It is inscribed in Pahlavi (the script of the Sasanian empire), perhaps saying 'Hupande', the name of a person, 'reliance upon the gods'.

LITERATURE: D'Hancarville, MS Catalogue, II, pp. 521–5; Tassie, no. 680, pl. 13 (Parthian); Bivar, CD 5.

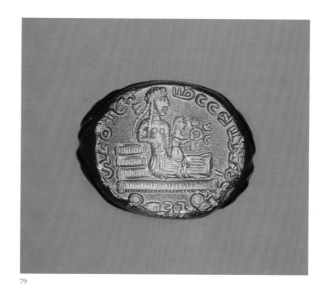

79

80 *Grey-brown chalcedony in the form of a Sasanian stamp seal*

Ht 3.27 cm
British Museum, 1772,3–15,304 (MLA G198)

Two male figures in Persian dress are shown facing each other in profile, with a scorpion in between. The meaning of the inscription above and below cannot be deciphered. The form of the seal is Sasanian, while the image is based upon Near Eastern iconography.

LITERATURE: Michel (forthcoming), 639; cf. Macarius, pl. 28, facing p. 57, no. 120.

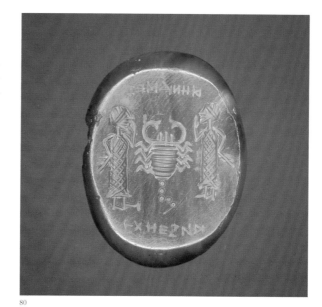

80

81 *Cornelian*

Ht 1.1 cm
Etruscan, 400–250 BC
British Museum, GR 1772.3–15.308
 (BM Gems 803)

Herakles, holding the club, reclines on a raft of amphorae.

 The so-called *a globolo* style of Etruscan gem-engraving represented a stage in d'Hancarville's system when, before the Trojan War, artists began to assert their understanding of form by 'signifying' the various elements of their subject through abstract shapes. D'Hancarville got the scene wrong here, seeing the figure as Bacchus (Dionysus) reclining on wine-jars. Tassie, however, interpreted it correctly. The subject was a favourite one of the late *a globolo* style of gem-engraving, being an abstracted version of a composition found on earlier Etruscan gems.

LITERATURE: D'Hancarville, MS Catalogue, II, p. 530; Tassie, no. 5988; for the type, see Zazoff, pl. 44, and cf. pl. 18, no. 68.

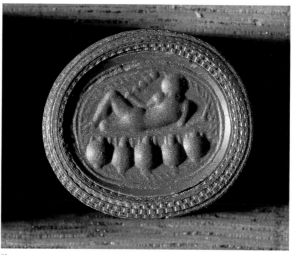

81

'PELASGIAN'

To d'Hancarville these Etruscan scarabs represented the art of Pelasgian Greek gem-engraving in the immediate aftermath of the Trojan War, when the heroic figures of the previous age were deified by their descendants.

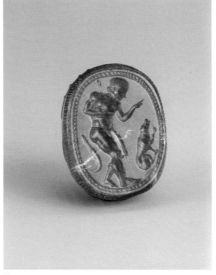
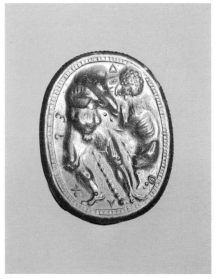

82

83

82 *Cornelian*

Ht 1.9 cm

Etruscan, 450–400 BC

British Museum, GR 1772.3–15.343 (BM Gems 691)

A youth with two spears plays with a dog; behind his back, a strigil. D'Hancarville found the subject difficult to explain, unless the 'sickle' in the background betokened the knife which Mercury (Hermes) gave to Perseus for combating the Gorgon.

LITERATURE: D'Hancarville, MS Catalogue, II, p. 543; Tassie, no. 8845; Richter, I, p. 185, no. 736; Zazoff, p. 68, no. 91, pl. 22.

83 *Cornelian*

Ht 2.1 cm

Etruscan, 420–400 BC

British Museum GR 1772.3–15.348 (BM Gems 719)

Herakles and the Nemean lion. The inscription, now thought modern, was a source of interest for d'Hancarville, who read it as Δ Ε Ρ Χ Λ Θ, the *delta* standing for Herakles's fourth labour, the *theta* for *theos* (god).

LITERATURE: D'Hancarville, MS Catalogue, II, p. 545; Tassie, no. 5684; for the inscription see Furtwängler, *AG*, III, p. 180.

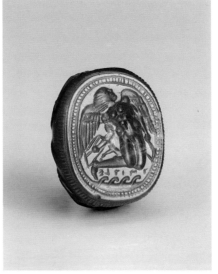

84

85

84 *Cornelian*

Ht 1.7 cm

Etruscan, 500–450 BC

British Museum, GR 1772.3–15.366 (BM Gems 663)

Taitle (?Daidalos) flying over the sea, his name written beside him. D'Hancarville thought the inscription Pelasgian Greek, indicating the name of a genie of death.

LITERATURE: D'Hancarville, MS Catalogue, II, pp. 550–51; Tassie, no. 8736; Richter, I, p. 211, no. 862.

85 *Sardonyx*

Ht 1.5 cm

Etruscan, 450–400 BC

British Museum, GR 1772.3–15.475 (BM Gems 631)

Engraved with a youth bending over a bow and quiver, his name, Paris, written beside him. Not listed by d'Hancarville.

LITERATURE: Tassie, no. 7421; Furtwängler, *AG*, I, pl. 17, no. 34.

In the eighteenth century Ancient Near Eastern seals were loosely classified as Persian, meaning for the most part the Persia of the Achaemenid empire, which flourished in the sixth to fourth centuries BC.

86

86 *Haematite cylinder seal*

L. 2 cm
Old Assyrian, *c.*1900–1800 BC
British Museum, 1772.3–15.417
 (WAA Seals 89804)

This is the seal of a person involved in trade between Assyria and central Anatolia and shows (from left to right) a figure holding snakes before a seated, deified king; a hero holding a lion above his head; a bull with a tree growing from its back; a female figure with a bird on her head, and a standing sphinx.

D'Hancarville remarks of this stone that, on the basis of comparison with the carvings on the ruined walls of ancient Persepolis, it appears to belong to the era before Persia was conquered by Alexander the Great.

LITERATURE: D'Hancarville, MS Catalogue, II, pp. 567–8; Tassie, nos 634–7, pl. 10; Frankfort, p. xxxviii, pl. 41a.

87 *Haematite cylinder seal*

H. 2.2 cm
Old Babylonian, *c.*1900–1800 BC
British Museum, 1772.3–15.418 (WAA Seals 89303)

This seal shows a lion fighting a bull-man, with pot (later recut) and ball-staff behind; a goddess (later recut) and a worshipper approach a deified king who is seated beneath astral symbols with a monkey before him. The seal was partially recut around 1800 BC and small filler motifs (a fish-man, inverted man, lion, goddess, two birds and drill-holes) were added in a style that indicates that the owner must have been involved in trade with Anatolia.

LITERATURE: D'Hancarville, MS Catalogue, II, p. 568; Tassie, nos 638–41, pl. 9; Münter, pl. 2. 24.

87

88

89

ABOVE Engravings from Tassie of Near Eastern cylinder seals (cat. nos 86–9), after drawings by David Allan. The sequence of figures is not necessarily as described in the catalogue entries; furthermore, the 18th-century interpretations differ from the modern.

88 *Chalcedony cylinder seal*

L. 3.1 cm
Achaemenid Persian, *c.*500–400 BC
British Museum, 1772.3–15.419
 (WAA Seals 89781)

This seal shows a royal hero fighting a human-headed winged bull; palm tree and rampant ibex. A tradition has grown up that this stone was found on the site of the Battle of Marathon, but this has no documentary basis in the archival records of Hamilton's collection.

LITERATURE: D'Hancarville, MS Catalogue, II, p. 568; Tassie, nos 649–50, pl. 10; J. Callum, 'An attempt to illustrate the British Museum' (*c.*1834, unpublished); Collon, p. 90, no. 421.

89 *Chalcedony cylinder seal*

L. 4 cm
Neo-Assyrian, *c.*800–650 BC
British Museum, 1772.3–15.420
 (WAA Seals 89334)

This seal shows a male figure between deities standing on attribute-animals, with astral symbols in the ground.

D'Hancarville thought the various signs indicative of the religion of Zoroastrianism practised at the time of Cyrus the Great (559–529 BC).

LITERATURE: D'Hancarville, MS Catalogue, II, p. 568; Tassie, nos 642–5, pl. 9.

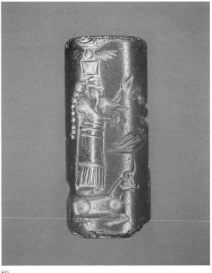

89

90 Chalcedony pyramidal stamp seal

Ht 2.2 cm
Achaemenid Persian, c.500–300 BC
British Museum, 1772.3–15.421
 (WAA Seals 115534)

This seal shows seated royal sphinxes facing each other with one paw raised. The symbol in the ground is thought to indicate Lydian origin.

LITERATURE: D'Hancarville, MS Catalogue, II, pp. 568–9; Tassie, no. 664, pl. 11; Boardman, 1970, p. 42, no. 118.

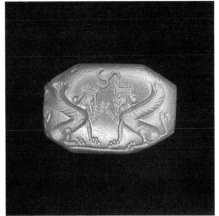
90

91 Chalcedony pyramidal stamp seal

Ht 2.3 cm
Achaemenid Persian, c.500–300 BC, made in the
 western provinces of the empire
British Museum, 1772.3–15.422
 (WAA Seals 89881)

A kilted hero fights a lion; the symbol in the ground is thought to indicate Lydian origin.

LITERATURE: D'Hancarville, MS Catalogue, II, p. 569; Tassie 659; Boardman, 1970, p. 41, no. 77.

91

92 Rock crystal pyramidal stamp seal

Ht 2.5 cm
Achaemenid Persian, c.500–300 BC, made in the
 western provinces of the empire
British Museum, 1772.3–15.423
 (WAA Seals 127399)

A hero fights a winged lion-griffin.

LITERATURE: D'Hancarville, MS Catalogue, II, p. 569; Tassie, no. 658, pl. 11; Münter, pl. 2. 21.

92

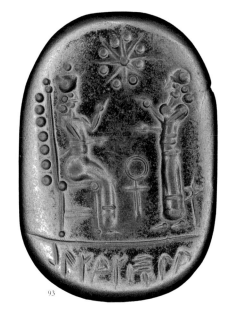
93

93 Greenstone scarab

Ht 4.5 cm
Egyptian 19th–26th Dynasty type, c.700–600 BC
British Museum, 1772.3–15.433
 (WAA Seals 48508)

The iconography is Assyrian in the west of the empire: an astral goddess sitting on a star-studded throne, with a worshipper before her; the inscription in Aramaic has been read as saying, 'To Handu the scribe'.

 This stone is illustrated by C. T. de Murr in his *Description du Cabinet de Mon. Paul de Praun (1548–1616) à Nuremberg* (Nuremberg, 1797), where it is described as formerly in the collections of Baron von Stosch and the Duca di Noia, from where it entered the royal collection at Naples. It was in fact purchased by Sir William along with the Noia collection of Egyptian scarabs (see cat. nos 94–109). D'Hancarville recognised that the engraving was not Egyptian and took it to be Persian work, following the conquest of Egypt by Cambyses, son of Cyrus the Great, in 525 BC.

LITERATURE: D'Hancarville, MS Catalogue, II, p. 578; Tassie, no. 654, pl. 11.

In his manuscript catalogue to the Hamilton collection, d'Hancarville gives a valuable reference to the source of Hamilton's collection of Egyptian scarabs: 'Here one finds the finest collection of Egyptian scarabs which has ever been made, which the Duc de Noia took more than twenty years to put together.' This is perhaps the source of Raspe's note in the collections index to Tassie's casts: 'Caraffa, Noya, Duc de à Naples: The scarabs and the more ancient sealstones from his cabinet are today in the British Museum; the rest are with Mr Charles Greville.' Tassie lists a scarab from the Carafa Noia collection at p. 5, no. 36 as being with Greville. Giovanni Carafa (1715–68), Duca di Noia, was a professor of mathematics at the University of Naples. He had a collection of specimens of natural history and another of artworks and antiquities, including vases, coins and inscriptions.

D'Hancarville's claim regarding the quality of the Carafa Noia collection of scarabs was no empty boast. Today the assemblage is outstanding, even to Egyptologists, both for its beauty and for its high proportion of Middle and Late Bronze Age pieces.

When the Hamilton collection was first displayed in the British Museum, those objects that were obviously Egyptian were shown in a gallery separate from the Hamilton Room. The connection between some stones seen here and the Hamilton collection therefore became forgotten and has only been re-established in the course of research for this catalogue.

94 Green jasper scarab

L. 2.4 cm
Late Middle Kingdom, c.1850–1750 BC
British Museum, 1772.3–20.471. H A (EA 17872)

The inscription names the Elder of the Portal, Seneb, with the signs for the epithet 'repeating life'.

LITERATURE: Tassie, no. 11, pl. 2; Martin, p. 116, no. 1498. See also R. S. Poole's manuscript catalogue of the Cracherode, Knight, Hamilton and Townley Gems (c.1850) for the Greek letters he designated to a group of previously

unnumbered Hamilton gems. These were subsequently given a number in the running sequence.

95 Steatite scarab

L. 1.7 cm
Second Intermediate Period or early New
 Kingdom, c.1700–1500 BC
British Museum, 1772.3–15.459 (EA 17900)

Hieroglyphs of the 'anra' motif, within a coiled border.

LITERATURE: Tassie, no. 9.

96 Glazed steatite scarab

L. 1.6 cm
Second Intermediate Period or early New
 Kingdom, c.1700–1500 BC
British Museum, 1772.3–15.457 (EA 4204)

Two pairs of uraei (cobras) enclosing a hieroglyphic motif

LITERATURE: Tassie, no. 8.

97 Glazed steatite scarab

L. 1.5 cm
18th Dynasty, c.1450–1350 BC
British Museum, 1772.3–15.454 (EA 16791)

Engraved with the throne name of Thutmose III, 'chosen of Amun'.

LITERATURE: Tassie, no. 5; Hall, p. 75, no. 740.

98 Glazed steatite scarab

L. 1.6 cm
18th dynasty, c.1450–1350 BC
British Museum 1772.3–15.455 (EA 16792)

Engraved with the prenomen of Thutmose III in a cartouche between winged uraei (cobras).

LITERATURE: Tassie, no. 6; Hall, p. 87, no. 884.

99 Green jasper scarab

L. 1.9 cm
19th dynasty, after 1279 BC
British Museum, 1772.3–15.448 (EA 17803)

Engraved with the throne name of Ramesses II, with the epithet of 'the strong lion'.

LITERATURE: D'Hancarville, MS Catalogue, II, pp. 583–4; Tassie, no. 13; Hall, p. 211, no. 2107.

100 Green jasper scarab

L. 2.1 cm
Late Period, after 600 BC
British Museum, 1772.3–15.472. H β (EA 17765)

Engraved with a hieroglyphic inscription.

LITERATURE: Tassie, no. 10.

101 Glazed steatite scarab

L. 1.3 cm
Late New Kingdom, after 1300 BC
British Museum, 1772.3–15.456 (EA 17238)

The hieroglyphic inscription is possibly derived from the throne name of Sety I.

LITERATURE: Tassie, no. 7.

102 Black jasper mummy pectoral with heart scarab

L. 8 cm
Late New Kingdom, after 1300 BC
British Museum, 1772.3–15.429 (EA 7828)

Inscribed for a scribe of 'the house of life', Pyay. The heart scarabs were inscribed with chapter 30 of the Book of the Dead, in which the deceased appeals to the heart not to bear witness against him, when weighed against the goddess of truth.

To d'Hancarville this was the largest known scarab and, because of its size, he conjectured that it was meant as a piece of altar furniture. He thought the inscription represented the plan of a temple, three sides bounded by strips of hieroglyphs, the fourth

102–5

104 *Siltstone heart scarab*

L. 4.3 cm
Late Period, after *c.*600 BC
British Museum, 1772.3–15.432 (EA 7895)

Inscribed with chapter 30 of the Book of the Dead for a man named Djedasetiufankh, son of Merneitites.

D'Hancarville catalogued this together with 1772.3–15.431. Of the ankh sign (*croix ansée* or handled cross), present on 431 but absent on 432, d'Hancarville remarked that Athanasius Kircher (1602–80) had interpreted it as the sign of the Creator, while others had seen it as a compass, or even a tool for planting lettuces. To d'Hancarville it was nothing more than a well-disguised phallus, evoking the myth of the castration and other sufferings of Osiris.

LITERATURE: D'Hancarville, MS Catalogue, II, pp. 476–8; Tassie, no. 21.

105 *Greenstone heart scarab*

L. 5.2 cm
Late Period, after *c.*600 BC
British Museum, 1772.3–15.437 (EA 7966)

The stone was recut in the Roman period with a bust of Jupiter on one side and a procession of deities on the other.

LITERATURE: Tassie, no. 849.

by an altar. The 'floor' of this temple was inscribed with more hieroglyphs set in an oval.

LITERATURE: D'Hancarville, MS Catalogue, II, pp. 571ff; Rymsdyk, p. 36, pl. 14, 2–3; Tassie, no. 25, pl. 1.

103 *Greenstone heart scarab*

L. 8.7 cm
Early New Kingdom, *c.*1500 BC
British Museum, 1772.3–15.430 (EA 7923)

Inscribed with chapter 30 of the Book of the Dead for the high steward Ra. D'Hancarville thought the inscription, like the last, represented a temple floor.

LITERATURE: D'Hancarville, MS Catalogue, II, p. 476; Tassie, no. 24.

FIG. 81 Engraving after a drawing by David Allan of cat. no. 102, reproduced in Tassie.

'BASILIDIAN'

The magical or 'Gnostic' gemstones are named after the Gnostic heresies in the Christian Church of the second and third centuries. 'Gnostic' is really a misnomer, however, since the circulation of such magical stones in the Christian era was much more widespread than the restricted use of the term suggests. In the eighteenth century they were known as Gnostic or 'Basilidian', after Basilides of Alexandria, a Christian heretic of the second century AD. Tassie quotes St Jerome in his commentary on the Book of the Prophet Amos, where he explains that Basilides called the Almighty God 'Abraxas', ruler of the 365 heavens, the name being the Greek numerical equivalent for the number of days in the solar year: *alpha* = 1, *beta* = 2, *rho/alpha* = 101, *xi* = 60, *alpha* = 1, *sigma* = 200; total 365.

The name Abraxas is commonly found on such gems along with other magical inscriptions, some of which can now be deciphered as having meaning, while the sense of others remains obscure.

LITERATURE: On Gnostic amulets in general see Bonner.

106 *Rock crystal lentoid*

Ht 2.1 cm
British Museum, 1772.3–15.439 (MLA G 279)

On one side a lion; on the other ABRAXAS.

The Gnostic inscription, perhaps of the third century AD, is written upon an earlier seal, perhaps of the Island Gem class, dating to the seventh century BC.

Tassie records that this stone was formerly in the collection of Giovanni Carafa, Duca di Noia, Naples.

LITERATURE: D'Hancarville, MS Catalogue, II, p. 581; Tassie p. 5, nos 38–9; Michel (forthcoming), no. 579.

107 *Cornelian*

L. 2.9 cm
Fourth to fifth century AD
British Museum, 1772.3–15.425 (MLA G 262)

The decoration is arranged in tiers, the principal one showing a central figure enthroned and approached by a procession on both sides. It has been suggested that the enthroned figure represents King Solomon.

D'Hancarville thought the 'inscriptions' below the main scene were Persian.

LITERATURE: D'Hancarville, MS Catalogue, II, pp. 569–70; Tassie, p. 58, no. 593; Michel (forthcoming), no. 463.

108 *Lapis-lazuli*

Ht 1.55 cm
Third century AD
British Museum, 1772.3–15.477. H.Θ/I
 (MLA G 15)

Pantheistic figure with the body of a beetle and a cobra for a head. The reverse is inscribed 'Protector Happy Abraxas'.

LITERATURE: Tassie, pp. 44–5, nos 505–6; Michel (forthcoming), no. 177.

109 *Brown-green jasper*

Ht 1.7 cm
Third century AD
British Museum, 1772.3–15.485. H.Φ/X
 (MLA G 41)

Harpocrates between lotus buds on long stems. The reverse is inscribed 'Sabaoth'.

LITERATURE: Tassie, pp. 48–9, nos 529–30; Michel (forthcoming), no. 136.

106

107

108

109

110 *Large sard representing the forceful features of the mature Herakles*

Ht 3.4 cm

Said to be from Taranto, third or second
 century BC

Provenance: Hamilton; Sir Richard Worsley; Earl
 of Yarborough

Private collection

In spring of 1789 Sir William and Emma
made a tour through southern Italy. Sir
William was disappointed not to come across
more antiquities for sale, but explained in
his report to Charles Greville that the finds
from what little search was made for them
were sent direct to Naples. He did not, how-
ever, return empty-handed: 'I got a large
intaglio of the head of Hercules of good
Greek sculpture at Taranto and at Canosa a
little one just like Emma.' Worsley bought
the former from Hamilton for 80 sequins,
about £40.

LITERATURE: Morrison, no. 177; Worsley Papers,
XLII, no. 59; *Mus. Wors.*, facing p. 36; Smith,
1897, no. 107.

111 *Red jasper set in a modern gold ring*

Ht 2 cm

First century BC to first century AD

British Museum, GR 1814.7–4.1529 (Dalton Gem
 Cat. 701)

A terminal bust of a bearded and garlanded
Bacchus inscribed ASPASIOU (of Aspasios,
meaning 'made by Aspasios') in Greek letters.

This stone came to the Museum with the
collection of Charles Townley, but he seems
to have acquired it from Sir William. The
signature drew it to the attention of E. Q.
Visconti, who in a paper published in 1793
recalled holding the intaglio in his own
hands and said that it was then in Sir

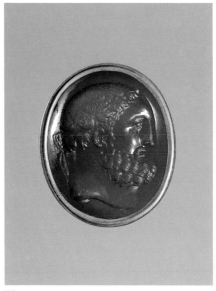

110

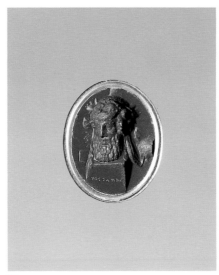

111

William's possession. Visconti considered it
to be an ancient copy of a finer original, and
Furtwängler also thought it antique. Subse-
quently its antiquity was doubted and it was
said to be a copy after one of two terracotta
busts formerly in the Townley collection

and now in the British Museum. These
were found near Porta Latina, Rome, and
date to around AD 50–100. Two other
uninscribed intaglios exist of the same
subject, both amethysts – one in Florence,
the other in New York.

In recent years the intaglio has again been
published as ancient; this and other pieces
signed *Aspasios* have been brought together
by M. L. Vollenweider and discussed as
the oeuvre of an accomplished gem-carver
working around the middle of the first
century BC. G. M. A. Richter, on the other
hand, thought that differences in the
inscriptions indicated that two artists were
at work at different times.

Townley must have acquired the gem
because it related to the terracottas, and it
seems probable that these and the other in-
taglios carved with the same terminal figure
of Bacchus are all copied after an earlier, lost
Greek original. How and when he acquired
it is not clear, but the intaglio probably
passed to Townley through his friend Sir
Richard Worsley, who purchased most of
Hamilton's second collection of gems. From
Worsley's correspondence among the
Townley Papers in the British Museum it is
clear that he and Townley were on close
terms, and there is besides a tantalising refer-
ence in the Worsley Papers in Lincoln to
Townley and Worsley having made an
exchange. The entry reads as follows:
'Marcus Modius, Augustus's physician.
Bought by Charles Townley esq. (who
ceded it to me in exchange) at Mr Dalton's
sale, who got it in Egypt.' The sale of
Richard Dalton's property took place in
1791, the very year in which Sir William
sold his gems to Worsley.

LITERATURE: Worsley Papers, XLII, 9 June 1798;
Visconti, 1821, p. 65; Visconti, 1827, p. 194;
Dalton, p. 101, no. 701, pl. 25; Furtwängler, *AG*,
I, pl. 49, no. 12; Furtwängler, 1888, pl. 10,
no. 11, and 1889, p. 48f: Vollenweider, p. 31,
pl. 22. 1; Richter, II, p. 137, no. 643 (for
Aspasios, see p. 132).

112 Cast of an intaglio once in Sir William's collection, showing a Venus

Ht 2.5 cm
Private collection

112

The original stone, described as an unusually large cornelian cabochon, was recut by Nathaniel Marchant (1739–1816) at Sir William's request. Interestingly, the resulting image seems to have been based upon a marble statue of Venus Pudica (British Museum, Sculpture 1577), found by Gavin Hamilton in a bath building at Ostia and sold to Charles Townley in 1775. The discovery of the sculpture, its restoration in Rome and eventual purchase are documented in the correspondence of Gavin Hamilton and Charles Townley.

We first hear of the Venus in a letter from Gavin Hamilton to Charles Townley dated 6 April 1775. Then the figure lacked its head, but on 21 April Hamilton wrote again, enthusiastically reporting the discovery of what he claimed to be the missing head. On 17 August he sent Townley a sketch, showing the Venus restored (fig. 82). The left arm is bent at the elbow with the forearm just below the breast, while the right turns back, with the index finger extended towards the chin. This restoration awkwardly places a piece of drapery in both hands. On 10 October Townley was in possession of the sculpture itself (letter dated 30 October) and, although delighted with it, was doubtful about the arms. In two following letters, dated 17 and 30 December 1775, Gavin Hamilton explains that the position of the arms was chosen so as not to obscure the breasts. There was also the consideration of a 'puntello' on the chin, thought to be a trace of a finger. Hamilton disapproved of Townley's idea of a mirror in the left hand, which tended to cut the neck off. A mirror ('glass') was not thought to be an ancient object by Hamilton.

The sequel is told in a remarkable anecdote recorded in J. T. Smith's life of the sculptor Joseph Nollekens. The latter knew Townley from his days in Rome, where he lived and worked as a sculptor-restorer between 1762 and 1770, eventually with his

FIG. 82 Drawing in black chalk, attributed to Gavin Hamilton, showing the original restoration of BM Sculpture 1577. British Museum, Department of Greek and Roman Antiquities, Townley Drawings.

own studio close to the Via Babuino. Smith recalls a chance encounter between collector and sculptor in a London street. For some reason, better known to himself, Nollekens proceeded to address the assembled company very loudly in Italian, or, as Smith drily observes, what Nollekens thought to be Italian. Townley grew alarmed at the public spectacle into which he had been so unexpectedly drawn, and begged

Nollekens to resume his native tongue. Smith explains how Townley's purpose in engaging Nollekens in conversation had been to ask the sculptor to take on the task of re-restoring the statue of Venus. Townley instructed Nollekens to try out various other solutions, such as holding a dove, a wreath or a serpent. An anonymous drawing in the British Museum shows the Venus holding a serpent, while in another, attributable to Nollekens, she holds a cup. The point of Smith's telling the story is to inform us that he himself eventually stood as model for the arms, while Nollekens tried out his various proposals. The current restoration is the result and shows the right arm held down, with the hand covering the pubis, while the left is bent at the elbow and holds the handle of a mirror, the reflecting part of which, now missing, was presumably once there. That the object in the hand is meant to be a mirror is confirmed by the transcript of a letter to Townley from Gavin Hamilton published by A. H. Smith (1901).

Previous versions of these events have concluded either that the Venus arrived in England without the arms (Cook, p. 53), or that she was restored in Rome as seen in Marchant's gem (Seidmann). A close reading of Gavin Hamilton's letters, however, together with the hitherto unpublished drawing by him, shows that the restoration was first carried out as it is in the drawing and altered afterwards. Sir William's intaglio, where Venus is shown with the apple of discord, seems therefore to be a hypothetical, rather than an actual restoration. It does not relate so closely to Gavin Hamilton's restoration as previously thought, and could have been done after the sculpture had been dispatched to England. Gavin Hamilton retained casts of it, one of the statue restored, the other of the torso alone (Gavin Hamilton's letter of 30 December 1775). The intaglio was probably cut in Rome, using and adapting these casts, as part of the continuing discussion that followed the departure of the original.

LITERATURE: Townley MS as cited; Marchant, p. 18, no. 40; J. T. Smith, p. 168; Smith, 1901, p. 316; Cook, pp. 21–2 and 52–3; Seidmann, p. 67, no 106, fig. 109.

113 *Chalcedony: head of Emma Hamilton by Nathaniel Marchant*

Ht 2 cm
Set in a gold ring with moulded oval bezel.
 Signed in reverse: MARCHANT
Metropolitan Museum of Art, New York,
 40. 20. 1.

Not in exhibition

From two letters of Emma to Charles
Greville, Marchant is known to have carved
one or more portraits of Emma for a ring.
Emma speaks of 'a cameo', but this has been
questioned by Gertrud Seidmann, who
points out that Marchant is known only
for intaglio work. Moreover, Seidmann has
recently discovered this intaglio of Emma.
It may be the very one which Marchant says
was owned by the Hamiltons, or, since that
is described as sardonyx, another version.

LITERATURE: Morrison, no. 152 (22 July 1786),
no. 168 (4 August 1787); Seidmann, p. 78,
no. 138.

113

114

114 *Sard intaglio with a head of Niobe, by Nathaniel Marchant*

Ht 2.5 cm
Said by Marchant to be in the collection of Sir
 William Hamilton. Signed MARCHANT
Provenance: Sir Richard Worsley; Earl of
 Yarborough
Private collection

The engraver tells us that he based his sub-
ject upon the head of the ancient statue of
Niobe in the Uffizi Palace in Florence. An
impression of this cast is interestingly paired
with the supposed head of Emma in Sir
Richard Worsley's boxed set of gem im-
pressions (cat. no. 115).

LITERATURE: Marchant, p. 13, no. 23; Smith,
1897, no. 212; Seidmann, p. 62, no. 92.

115

115 *A set of casts of intaglios and cameos once in the collection of Sir Richard Worsley (1751–1805)*

Ht of box 23.5 cm
British Museum, GR 1996.1–16.3

Some pieces from Sir William's second gem
collection are represented here. At the bot-
tom right of tray 2, for example, is a cast of
cat. no. 114. Interestingly, this is paired with
a cast of the stone thought to be a portrait
by Nathaniel Marchant of Emma Hamilton
(cat. no. 113). The intaglio of Niobe passed
from Worsley upon his death into the Earl
of Yarborough's collection.

Jewellery

Amuletic rings

The ancient Greek word for a signet ring is *symbolon* and d'Hancarville insisted that finger rings, like all jewellery in antiquity, were bearers of meaning. He seems not to have made anything of the ancient story that the Titan Prometheus was the first to wear a ring as a reminder of his perpetual penance. This Zeus forged from the iron fetters and a piece of the rock by which he had originally chained him. Thus the Roman poet Catullus introduces Prometheus at the wedding of Peleus:

Came wise Prometheus; on his hand he wore

The slender symbol of his doom of yore.

[Catullus, I. 295; cf. Pliny, XXXIII.4.8 and XXXVII.I.I]

Instead, d'Hancarville traced the origins of wearing rings to the amuletic use of seal-stones (see p. 98). These were originally pierced for hanging around the neck; gradually the holes were made bigger and the amulets moved for convenience from the neck to the finger.

116 *Six amuletic rings*

a) *Inscribed*
Diam. 2.3 cm
British Museum, GR 1772.3–14.37 (BM Rings 639)

b) *Inscribed*
Diam. 2 cm
British Museum, GR 1772.3–14.20 (BM Rings 575)

c) *Eros*
Diam. 2.1 cm
British Museum, GR 1772.3–14.17 (BM Rings 54)

d) *Head of Silenus*
Diam. 2 cm
British Museum, GR 1772.3–14.14 (BM Rings 228)

e) *Victory*
Diam. 2 cm
British Museum, GR 1772.3–14.19 (BM Rings 215)

f) *Cornelian sealstone with mule/goat-
 fish/club*
Diam. 2.5 cm
British Museum, GR 1772.3–14.3 (BM Rings 389)

116b

116c

'Brooches of the Gods'

D'Hancarville was so struck by the great size and seeming monumentality of some of the bronze dress fastenings in Hamilton's first collection that he assumed they must have been used for the vestments which, as he knew from the Classical authors, were sometimes draped around ancient cult statues.

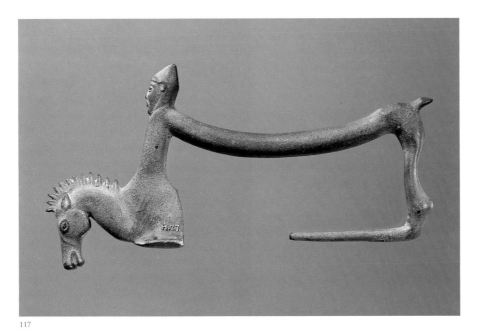

117

117 *Bronze fibula (brooch) incorporating horse and rider*

L. 17.8 cm
North Italian, 550–450 BC
British Museum, GR 1772.3–9.27 (BM Bronzes 2129)

D'Hancarville took this to be a representation of a centaur and therefore a brooch from a statue of Bacchus (Dionysus), whose processional car is sometimes shown being pulled by centaurs. Part of the pin is missing.

LITERATURE: D'Hancarville, MS Catalogue, II, pp. 386–7.

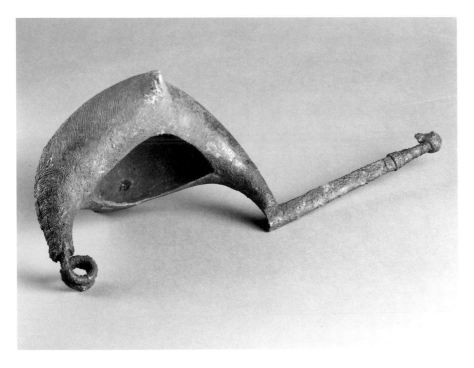

118 *Large bronze fibula of the 'boat type'*

L. 34.9 cm
Picene (?), 700–600 BC
British Museum, GR 1772.3–9.29 (BM Bronzes 1989)

Perhaps a votive; the catchplate terminates in a monkey-like head.

LITERATURE: D'Hancarville, MS Catalogue, II, pp. 382ff.

119 *Bronze bow brooch with engraved bow and disc foot*

L. 13.9 cm
Italic, 850–800 BC
British Museum, GR 1772.3–9.31 (BM Bronzes 2007)

The rings were sewn on to a garment for the pin to pass through.

LITERATURE: Bietti Sestieri, p. 10, fig. 22.

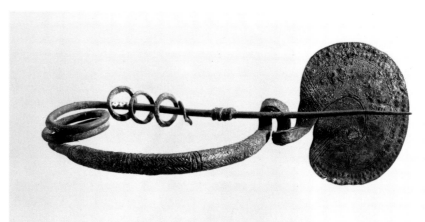
119

120 *Bronze brooch*

L. 17.9 cm
Picene (?), 500–400 BC
British Museum, GR 1772.3–9.39 (BM Bronzes 2052)

The catchplate ends in what seem to be copies of three 'boat type' fibulae.

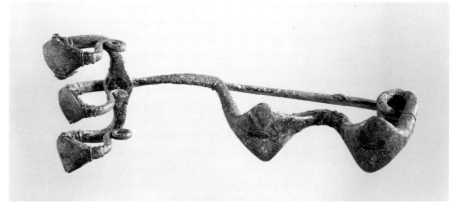
120

121 *Bronze brooch in the form of a peacock, and a spiral pin*

L. 3.9 cm
Roman
British Museum, GR 1772.3–9.88 (BM Bronzes 2142)

D'Hancarville took the peacock as the 'sign' for the goddess Juno (Hera).

LITERATURE: D'Hancarville, MS Catalogue, II, p. 387–8.

121

122 *Two bronze fibulae decorated with ducks*

L. (both) 11.4 cm
Campanian, 800–700 BC. Said to have been found near Pompeii
Provenance: These two pieces are part of a group said by d'Hancarville to have been presented to the Museum by Sir William Hamilton
British Museum, GR 1772.3–18.12–13 (BM Bronzes 349–50)

According to d'Hancarville's theory of signs, the swan signified Zeus, as it was in this guise that the god had ravished Leda. Stretching a point, d'Hancarville saw these brooches with their duck ornaments as fastenings from the dress of a statue of Jupiter (Zeus). Pendants in the form of ducks may have been hung from the holes along the edges.

LITERATURE: D'Hancarville, MS Catalogue, II, p. 605.

122

The Villa Borghese Tomb Group

123

123 Jewellery from the Villa Borghese tomb

The following objects are said by d'Hancarville to have been found together in a porphyry vase on the estate of the Borghese family in Rome. The vase later passed into the possession of Cardinal Alessandro Albani. The jewellery appears to be a single group dating to the second century AD.

a) Sard intaglio in an original gold setting; the
 intaglio shows Narcissus accompanied by Eros
 at a shrine of Diana (Artemis)
Ht 1.8 cm
British Museum, GR 1772.3–14.185 (BM Gems
 1456)

Diana's statue, holding two torches, is placed on a rock behind Narcissus. He is holding his cloak open and appears to be looking down, no doubt at his reflection in the water, which we are meant to imagine lying at his feet.

Gems with other versions of the same subject were known and published in the eighteenth century, including that in the Medici collection in Florence and another, very close in detail to Hamilton's, which Winckelmann published as being in the possession of Thomas Jenkins, the painter and antiquities dealer in Rome.

The attractive gold setting with its delicate filigree work appears to be ancient and probably contemporary with the gem. D'Hancarville records the interesting fact of Hamilton's having had it copied by a jeweller in Rome as a frame for a cameo of a youthful Bacchus, also in Hamilton's collection. This cameo was unfortunately destroyed in the Second World War, but a photograph shows the setting converted into a frame with the addition of an ornamental bow for suspension. A sulphur cast by James Tassie of the cameo also survives and this measures 5.5 cm in height. This same cameo, praised by d'Hancarville for the beauty of its colouring, is possibly that which is referred to in a letter from James Byres to Sir William dated 9 September 1768, which also makes mention of a 'fine cameo' which Hamilton wished to have included in a portrait by Anton Maron of him and his first wife

Catherine Barlow. This painting has not been traced (see p. 92, n. 75).

LITERATURE: D'Hancarville, MS Catalogue, II, pp. 501–2; for the intaglio cf. Gori, 1731–2, II, pl. 36; Winckelmann, 1760, p. 338, 124; Winckelmann, 1767, II, pt 1, p. 29, fig. 24; Furtwängler, AG, II, p. 200, no. 14. For the cameo, Byres to Hamilton, 9 September 1768, Cambridge, Fitzwilliam Museum, Perceval MS N 5; d'Hancarville, MS Catalogue, II, p. 503; Tassie, p. 265, no. 4230; Davenport, pl. 19; Dalton, p. 22, no. 136: a bacchante.

b) Two gold bracelets with eye-shaped
 ornaments
Diam. (both) 7.5 cm
British Museum, GR 1772.3–14.182–3
 (BM Jewellery 2826–7)

c) Gold pendant in the form of a vase, inside
 which was found, tightly rolled up, a Gnostic
 inscription on a sheet of gold
Ht (vase) 2.4 cm
British Museum, GR 1772.3–14.186
 (BM Jewellery 3150)

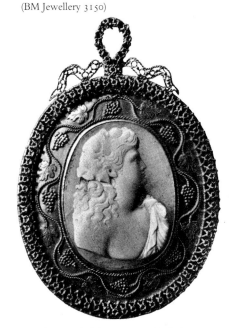

FIG. 83 Photograph (after Davenport) of a lost cameo from the Hamilton collection, mounted in a modern gold frame copied from the ancient setting of cat. no. 123a.

The Herakles and Mlacuch Mirror Group

This rich group of Etruscan objects is said by d'Hancarville to have been found at Atri (Atripaldi?) in the Abruzzi, while another anonymous source says 'they were found together in a sarcophagus at Viterbo in the Roman state in the year 1771'. The latter does not include the mirror in the group, while d'Hancarville does.

LITERATURE: For the mirror see d'Hancarville, MS Catalogue, I, p. 284, no. 4; II, p. 492; Swaddling (forthcoming); for the jewellery, d'Hancarville, MS Catalogue, II, pp. 491–3; Misc. Hamilton Papers, p. 13.

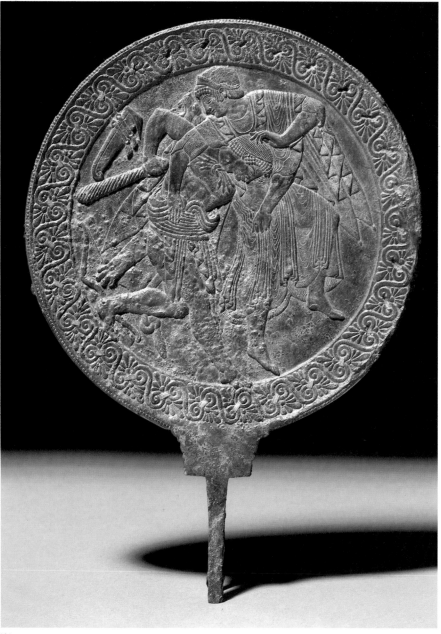

124

124 *Bronze mirror*

Diam. 17.8 cm
Etruscan, about 500–475 BC
British Museum, GR 1772.3–4.7(4)
(BM Bronzes 542)

Cast in low relief, with added silver decoration, the design on the back shows Herakles abducting Mlacuch. Both Herakles and Mlacuch have their names inscribed below them.

In keeping with the thinking of his day, d'Hancarville believed such one-handled mirrors to be sacrificial *paterae*, the scenes on them relating to the cults of the deities at whose altars they were used. He thought the female figure in the scene to be Minerva, who is shown 'restraining Hercules from entering on the path of valour'.

125 *Etruscan jewellery*

a) Part of a necklace with pendants in the form of perfume bottles shaped as *bullae*
Diam. of *bullae* 2 cm
British Museum, GR 1772.3–14.128
(BM Jewellery 1460)

Three of the bottle-stoppers, fashioned individually in gold, are still in place. One side of each bottle is worked in the form of a gorgon's head, the other as a lion's head with enamelled eyes.

The lower illustration shows the *bullae* forming a continuous band, using the smaller, decorated 'plates' as spacers. This was how Sir William intended it to be seen, as is made clear by the anonymous eighteenth-century compiler of an aborted catalogue of the Hamilton collection (Misc. Hamilton Papers). The same source records that he commissioned a goldsmith in Rome to make a lion-headed clasp to match the only surviving ancient one. A comparison of the two clasps easily reveals which is the modern replacement (that on the left). The spacer nearest it is also modern and there was perhaps one other (ancient or modern? now lost) to complete the alternating sequence. Sir William's reconstruction of the necklace is, however, wrong and probably combines two separate pieces of jewellery, a necklace of *bullae* and a bracelet (b).

125a/c/d

125

b) Part of a bracelet, incorporating two gold
 settings for semi-precious stones
British Museum, GR 1772.3–14.129 and 133

A series of individual plates, decorated with
filigree and granulation, alternates with oval
sardonyx stones in gold settings. Only two
of these settings now survive and one of
them has lost its stone. The inward curve of
the plates, and of the lion-head terminal
pieces, corresponds exactly with the out-
ward curve of the settings. Moreover, the
reverse of the plates has two connecting
devices in the form of long thin tubes,
which line up perfectly with those on the
back of the settings. These connecting tubes
cannot function if they are interrupted by
the *bullae*, as in Sir William's arrangement.

c) Finger-ring decorated in high relief showing a
 youth with a jug and phiale. The beaded and
 plain lines around the bezel are formed of
 wires separately attached
Diam. 1.9 cm
British Museum, GR 1772.3–14.131 (BM Rings
 216)

d) Two gold earrings formed of a hollow tube
 with a ring of beaded wire at one end and a
 female head at the other
Diam. 1.7 cm
British Museum, GR 1772.3–14.130 and 132
 (BM Jewellery 2196–7)

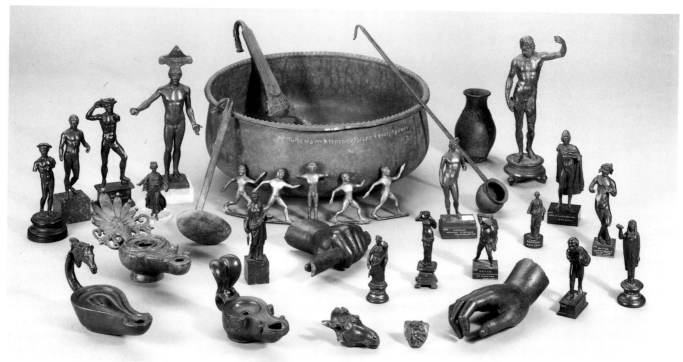

126

126 *Bronzes sold to Richard Payne Knight*

By September 1790 Sir William was planning to dispose of his second collection of vases, cameos and bronzes, in order to reduce his growing debts (Morrison, no. 185). In the summer of 1791, Sir William was in England with Emma and together they visited Downton Castle, home of Richard Payne Knight, then the foremost collector and connoisseur of ancient bronzes (see cat. no. 127). It was probably then that Hamilton first introduced Payne Knight to the notion of a block purchase of his bronzes. The progress of the purchase negotiations can be traced through a series of unpublished letters. In October 1791, Payne Knight was already looking forward to the arrival of the bronzes. He was destined, however, for a long wait and by July 1792 had still not received even the advance invoice. It seems Sir William's inpecuniousness at this period necessitated his being paid in advance.

Emma, who at this time entered wholeheartedly into all of Sir William's doings, seems to have taken charge of Payne Knight's

purchases, and the two maintained a lively, even flirtatious correspondence. At one point Emma made a particular point about Payne Knight's behaviour to her by sending him a gift of a bronze head of an ass (Morrison, no. 253, BM Bronzes 2562; illustrated above, centre front) that had been found near Naples in 1792. In a letter dated 25 August 1792 Payne Knight spoke warmly of 'acquisitions' made through Emma's acting on his behalf, even in advance of the main purchase, the arrival of which was yet to come. Meanwhile, Payne Knight was writing to Hamilton in such enthusiastic tones at the prospect of receiving his collection, that the latter felt obliged to warn him not to expect too much. Payne Knight in his turn tells Hamilton to have no fear, and in that same letter of 25 August 1792 we find Payne Knight living up to his reputation as 'the arrogant connoisseur'. It begins:

> High as my opinion is of your taste and skill in matters of art, do not be apprehensive of my forming too exalted notions of your collection of bronzes; for I well know the extreme scarcity of very fine specimens of ancient sculpture in all

branches, and more particularly in this. Fortune, indeed, has thrown into my possession a few extraordinary ones, which might incline me to be fastidious; but different things have different merits, and I am persuaded everything of yours has merit of some sort, either to gratify taste or curiosity – either to please or instruct. An affectation of fastidiousness is a kind of pedantry under which our young English travellers often attempt to hide their ignorance – Because they have seen a Raphael they will not look at a Mieris, which only proves that they are incapable of enjoying either.

By 24 January 1793, the bronzes were packed and sent off, but now there was the fear that they might become casualties of the impending war with France. All was well, however, and exactly a year later, Payne Knight wrote to announce that, following long 'delays of quarantine and being kept near a month at the custom house', the

FIG. 84 Bronze military parade mask taken from the 'face' of a skeleton found in a tomb at Nola (BM Bronzes 877).

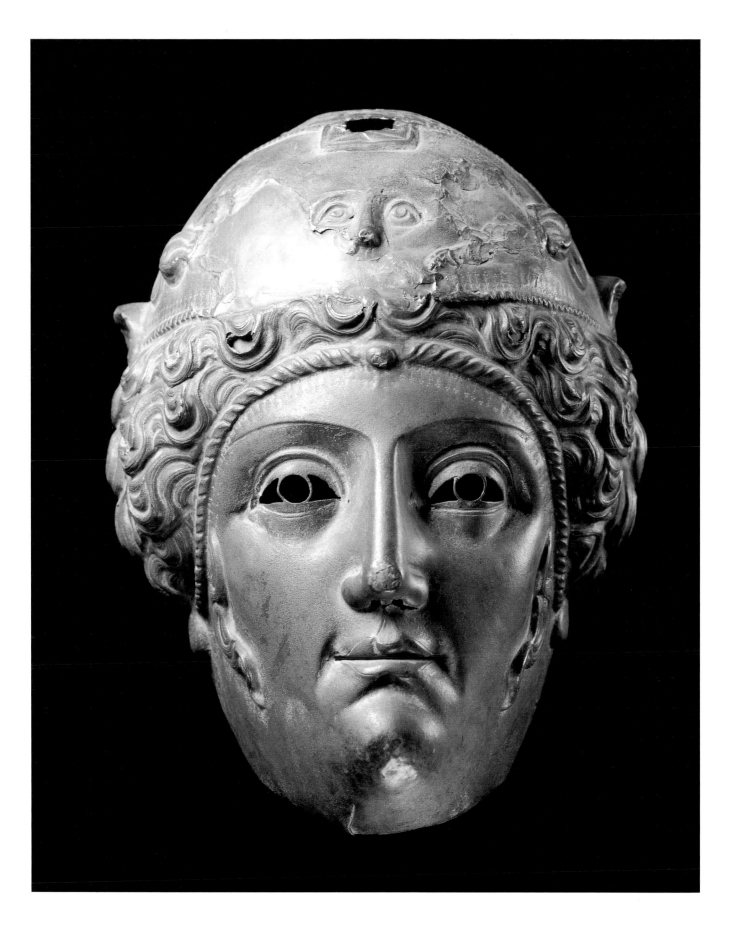

bronzes had at last arrived. Nor was their new owner disappointed. He singled out the candelabra and lamps for especial mention, the male figure cast as a mirror handle (BM Bronzes 514), the fauns, the cupids and above all a little figure of Isis with a vessel in one hand and a patera in the other (BM Bronzes 1468). On 10 April 1794 Sir William somewhat grumpily informed his nephew Charles Greville that he had received £400 from Payne Knight for the bronzes: 'Which I am happy he is pleased with, they certainly cost me more.'

In all, Payne Knight acquired well over a hundred bronzes of all descriptions. Many of them are mentioned in his manuscript catalogue as having come from Sir William. In addition, Hamilton's own rough inventory and valuation of the collection is preserved among the Hamilton Papers in the Bodleian Library in Oxford. Payne Knight was supplied with certain information by Sir William about some of the pieces which was later incorporated in his own manuscript catalogue. This includes occasional find-sites, such as that for the bronze military parade mask (fig. 84), said to have been taken from the face of a skeleton in a tomb at Nola. It was engraved and forms one of the preliminary illustrations to the text of the second volume of the publication of Sir William's second vase collection. Other provenances were more unusual. There is, for example, the pair of hands from a life-size female figure (BM Bronzes 28), which Hamilton came across as it was in the process of being dismembered by two peasants. They had found the statue in the region of Naples, but immediately broke it into pieces 'so as to avoid the fine'. The head of a bearded deity, thought to be Pluto or perhaps Sarapis (fig. 86), was found by Hamilton being carried in the hand of a Calabrian peasant, who was using it for the handle of his walking-stick (BM Bronzes 947).

Payne Knight bequeathed his collections to the British Museum in 1824, and so Sir William's second collection of bronzes joined the first, acquired in 1772.

LITERATURE: Christie's sale catalogue, 20 June 1990, p. 271: R. Payne Knight, seven letters signed to Sir William Hamilton, Whitehall and Downton, 30 June 1791–24 January 1794; Morrison, no. 253; Hamilton Papers, Bodleian Library, Oxford (Eng. hist. g. 14, ff. 20–21); Payne Knight, MS Catalogue; Clarke and Penny, pp. 69–70.

FIG. 85 Among the bronzes sold to Payne Knight was a group of fine candelabra, some of which were engraved in volume III of *Le Antichità di Ercolano*. It was probably this fact Goethe had in mind when he surmised that a pair of candelabra he saw in Hamilton's collection had 'somehow strayed from the cellars of Pompeii'. This story is often repeated as evidence for Hamilton having acquired the objects from the Neapolitan royal collection by illegal means. It is quite probable, however, that the candelabra were one of many gifts made to him by the King of Naples.

FIG. 86 Bronze head of Pluto found by Sir William on the handle of the walking-stick of a Calabrian shepherd (BM Bronzes 947). Roman, 1st or 2nd century AD.

127 MARGARET CARPENTER
(1793–1872) after THOMAS
LAWRENCE (1769–1830)

Richard Payne Knight (1751–1824)

Oil on canvas, 74 × 61.5 cm
Provenance: Presented by the artist in 1852
Trustees of the British Museum

The original portrait was painted for the
Society of Dilettanti in 1805, the year of the
publication of Payne Knight's *Analytical
Inquiry into the Principles of Taste*, written in
response to Uvedale Price and James Burke's
treatises on the aesthetics of the picturesque
and the sublime. Thomas Lawrence had
succeeded Reynolds as official painter to the
Society of Dilettanti and Payne Knight had
been elected to the Society in 1781, the
same year as his friend Charles Gore (see cat.
no. 182). Lawrence's full-length portrait of
Richard Payne Knight, painted for the
library at Downton Castle and exhibited at
the Royal Academy in 1794 (see Clarke and
Penny, pl. VII), shows him seated with an
open album of drawings on his lap (possibly
some of Charles Gore's drawings made in
Sicily) and a bronze vessel with a figured
handle, now in the British Museum, on the
table at his elbow. This portrait of a con-
noisseur owes much in composition and
character to Reynolds's portrait of Sir
William Hamilton which presided over the
Hamiltonian collection in the British
Museum (cat. no. 51).

Although Hamilton was on leave in Eng-
land while Payne Knight was in Italy, it is
likely that they had known each other before
that date. Payne Knight had toured Sicily in
1777 with Charles Gore and Philipp Hack-
ert and spent some time in Naples, where
he climbed Vesuvius and collected samples
of lava. In 1781 Hamilton had sent his letters
giving his account of the worship of Pria-
pus to the Society, which Payne Knight had
recently joined, and it was Payne Knight
who was to supervise their publication in
1786 for the Society, to which he added his
own lengthy discourse (cat. no. 142).

On their visit to England in 1791, Sir
William and Emma visited Payne Knight at
Downton, where Lawrence drew Emma's
portrait (cat. no. 154) and where they nego-
tiated the sale of Hamilton's collection of
bronzes to Payne Knight, which he even-
tually received in 1794 and later bequeathed
to the British Museum (cat. no. 126).
Knight's extensive landscaping of Downton
Vale and the preparation of his treatise in
verse on the principles of landscape design,

The Landscape, A Didactic Poem, to be pub-
lished in 1794, would have been of great
interest to Hamilton, who at the time was
deeply involved in the creation of the Eng-
lish Garden at Caserta (see cat. no. 182 and
pp. 17–22).

A year after the original of the present
portrait was painted by Lawrence, Lord
Elgin brought the first of the Parthenon
sculptures to Britain, and Knight's enthusi-
asm was lukewarm. By the time the Select
Parliamentary Committee decided on the
acquisition of the marbles by the British
Museum in 1816, he had lost his position as
the pre-eminent arbiter of taste and
connoisseurship in Regency Britain.

Payne Knight was a Trustee of the British
Museum and bequeathed not only his
bronzes and gems, but also a magnificent
collection of drawings. Margaret Carpenter
was the wife of William Carpenter, Keeper
of the Department of Prints and Drawings
from 1845 to 1866. She presented her copy
of Lawrence's portrait of Payne Knight to
the British Museum in 1852 in the hope that
the Trustees would 'allow of the portrait
being hung up in the Department of Prints
and Drawings, which owes so much of its
interest to the Valuable bequest of Mr Payne
Knight' (British Museum Archives, OL&P,
21 May 1852).

LITERATURE: Clarke and Penny, nos 40, 184, 185,
pp. 4–5, 13.

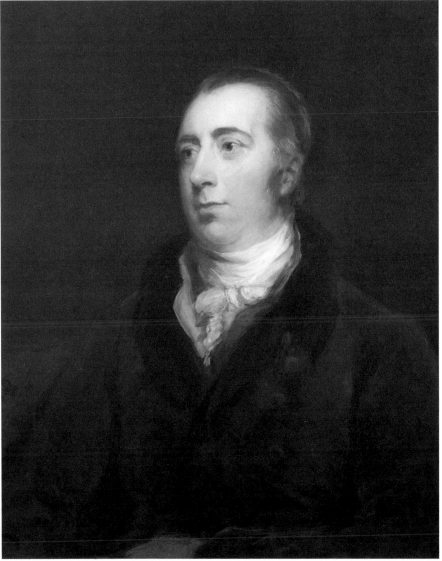

127

The Warwick Vase

128 GIOVANNI BATTISTA PIRANESI
(1720–78)

Three engravings of the Warwick Vase

a) Principal view with pedestal and inscription,
71 × 47 cm

b) Reverse side with a head of a female satyr,
43 × 57.5 cm

c) Side view with twisted stem handle, 48 × 47 cm

Presented to the British Museum by Sir William
Hamilton and inscribed by him on the verso,
1775. The engravings, issued separately at first,
were part of the series later collected together
by Piranesi and published under the heading
Vasi, candelabri, cippi, sarcofagi . . . (Rome 1778)

British Museum, GR 1775.11–3.1 to 3

Sir William's donation of Piranesi's engravings will have carried an unspoken reminder to the Trustees of the Museum of his offer of the Warwick Vase itself. The modern base on which the Vase stands in the principal engraving is inscribed in Latin: 'Sir William Hamilton, ambassador from King George III of Great Britain to King Ferdinand IV of the Sicilies, had this monument of ancient art and Roman majesty, which was excavated among the ruins of the Tiburtine Villa – delightful home of the emperor Hadrian Augustus – restored and, having sent it to his country, dedicated it to the native Genius of fine arts.'

This memorial appears to be that mentioned in correspondence between Sir William and James Byres, the Scottish architect, antiquary and dealer, where Byres explains the trouble he has taken to get the wording right:

Enclosed is an inscription which my friend Mr Walker was so good as to compose, I think greatly better than Galliani's or the other two which I got done here, being the shortest and more in the old lapidary style. I think, however, that the last line, I mean the date might be [retracted ?] without any prejudice as the reign of George the 3rd marks the time sufficiently. You'll let me know your opinion. In your letter to me say something civil to Mr Walker . . . Ps. If the enclosed inscription should not meet with your approbation, I should wish that whatever is put should be kept short for otherwise we'll be obliged to make the letters small, to be contained in the [frame ?] of the pedestal.

The ancient parts of the much-restored Warwick Vase were discovered by Gavin Hamilton during excavations in 1769–70 at the lake called Pantanello, near Hadrian's Villa at Tivoli. In a letter to Charles Townley, Gavin Hamilton later recorded the difficulties he encountered at the site and mentions Piranesi's involvement in the proceedings. The Vase is not spoken of specifically, but in his list of the finds from the excavations and their various recipients, Hamilton assigns to Piranesi 'A great number of Fragments of Vases, Animals of different sorts, and some elegant ornaments and one Collosial head' (Smith, 1901). From various sources it is possible to piece together the processes by which Sir William came into possession of the Vase, had it restored and finally sold it to his nephew the Earl of Warwick.

Our first knowledge of the Warwick Vase is in a hitherto unpublished letter dated 26 February 1772. It was sent from Rome by James Byres to Sir William, who was then on leave in England. Byres writes:

The model of your great vase is at last finished in stucco and all the ancient pieces inserted. I have the honour of sending you three drawings of it. Although I supposed you will not think of having it executed in marble until you see it yourself, I thought it best to send you these drawings at present in case you should have any intention of parting with it, that you might be the better judge of the value and able to show what it is. The expense of the model in stucco as it now is amounts to 113 crowns, 14 baiocchi. The sculptor whom Piranesi employed to make this model demands a thousand crowns to execute it in marble, but I called the sculptor I commonly employ to estimate what it might really be done for. After measuring it with exactness, calculating the quantity of marble necessary, the expense of working and other charges, found that it might be done for 800 crowns. Suppose you get it done for that, what with the expense of the model, the price of the ancient pieces, the case, embalming, freight and duty, it would cost you near three hundred and fifty pounds sterling before you got it set down in London, but it would certainly be well worth five hundred pounds and you ought not to part with it for less. You know that it is a noble style of sculpture and the most noble thing of that kind I ever saw. It would be a thousand pities if it were not restored. But notwithstanding this, I would not advise you to be at that expense, except you have almost a certainty of disposing of it, for it is by far too great a thing for any private gentleman's house. Perhaps if you cannot dispose of it in England, the Pope may wish to purchase it for his new Museum, which he is fitting up at great expense . . .

This remarkably detailed document gives a fascinating insight into all the preliminary stages of Sir William's involvement with the Vase and does much to explain what follows. It shows, moreover, that Piranesi was responsible only for the design of the Vase and not for its actual execution. Unfortunately, the name of the sculptor who eventually carried out the work is not given.

A drawing enclosed with a letter addressed by Piranesi to Charles Townley, dated Rome 3 August 1772, gives us our next sighting of the Vase. Townley had reached Naples in the course of his second Italian tour. There he failed to meet Sir William, who was still on leave in England. In his reply Townley enthused about both the drawing and the Vase, praising Piranesi's unique ability to revive such a 'Phoenix'.

Sir William took Byres's professional advice to heart and, once he was financially committed, embarked upon a campaign with the help of his nephew Charles Greville to interest the British Museum in the Vase. We next hear of the Vase in a fragment of a letter addressed by Hamilton to Charles Greville. In Morrison's printed edition of the Hamilton correspondence the letter is dated 5 June 1775. This is an error and it should be dated 1774 (see Byres's letter, below, written some weeks later). Part of the letter is lost and what survives picks up the thread in mid-sentence. It seems that the restoration was still not complete: '. . . great vase of which

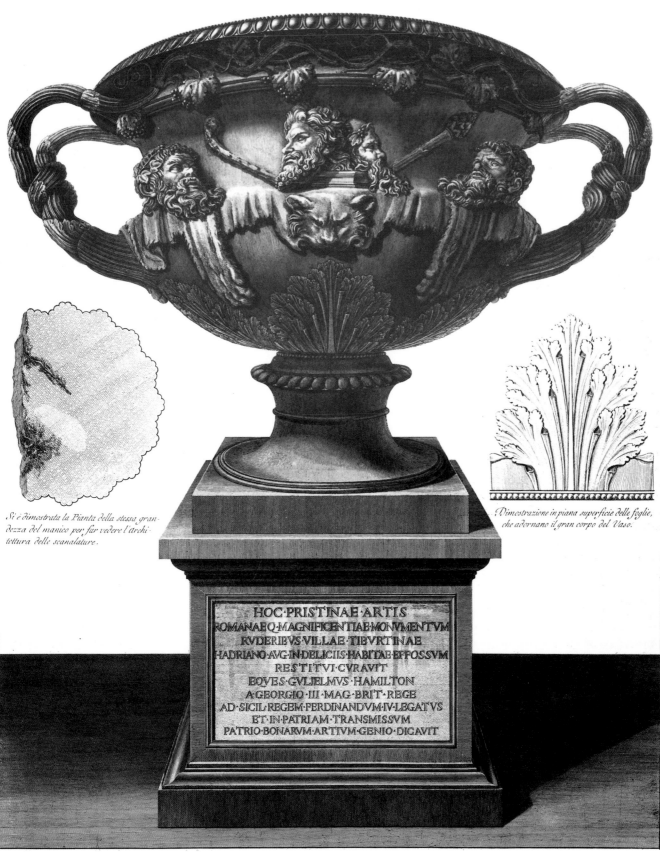

Si è dimostrata la Pianta della stessa grandezza del manico per far vedere l'Architettura delle scanalature.

Dimostrazione in piana superficie delle foglie, che adornano il gran corpo del Vaso.

HOC·PRISTINAE·ARTIS
ROMANAEQ·MAGNIFICENTIAE·MONVMENTVM
RVDERIBVS·VILLAE·TIBVRTINAE
HADRIANO·AVG·IN·DELICIIS·HABITAE·EFFOSSVM
RESTITVI·CVRAVIT
EQVES·GVLIELMVS·HAMILTON
A·GEORGIO·III·MAG·BRIT·REGE
AD·SICIL·REGEM·FERDINANDVM·IV·LEGATVS
ET·IN·PATRIAM·TRANSMISSVM
PATRIO·BONARVM·ARTIVM·GENIO·DICAVIT

128a

FIG. 87 Sketch of the Warwick Vase sent by Piranesi to Charles Townley in Naples. Formerly Townley Papers.

you had the drawing, but tho' I offered it to him for £500 he did not take it, it is only now upon the point of being finished, and is far beyond any monument of the kind at Rome, it has cost me near £300, for I was obliged to cut a block of marble at Carrera to repair it, which has been hollowed out and the fragments fixed on it, by which means the vase is as firm and entire as the day it was made' (Morrison, no. 53).

The story continues in a letter written by Byres from Rome dated 9 August 1774. It illustrates the care that was taken over detail in the vexed matter of restoration:

The great Vase is nearly finished and I think comes well. I begged of Mr [Gavin] Hamilton to go with me the other day to give his opinion. He approved much of the restoration but thought the female mask copied from that in Piranesi's candelabro ought to be a little retouched to give more squareness and character, he's of the opinion that the foot ought neither to be fluted nor ornamented but left as it is, being antique, and that no ornament ought to be introduced on the body of the Vase behind the handles, saying that it would take away from the effect and grouping of the masks. Piranesi is of the same opinion relative to the foot, but thinks there is too great an emptyness behind the handles and proposed putting the *crotole* and *zampogni*

[castanets and pipes]. It's difficult to say which of these opinions ought to be followed, but I rather lean towards Mr Hamilton's, being persuaded that there was originally no ornament on that place, as there certainly rose what the Italians call a *puntello* from here to strengthen and support the handles, of which there is a vestige attached to one of the ancient pieces. This *puntello* would have interrupted any ornament that could have been introduced.

The candelabrum in mind must be that now in the Louvre reconstructed by Piranesi as his own tomb for the Chiesa della Certosa, which he published with a dedication to Sir Charles Morris in *Vasi, candelabri* It has bacchic heads paired similarly to those on the Warwick Vase.

It was Hamilton's ambition to see the Vase as the centrepiece of the collection he had sold to the Museum only three years before. On 3 December 1775, Greville wrote to his uncle as follows:

Knowing how much you set your heart on placing the fine vase in the Museum, and while you make them pay the purchase money you in reality make them a present, a circumstance which the world seldom can combine or give credit to, I have not neglected any opportunity of doing it justice and describing its merits. I have enquired the proceedings at the Museum meetings. There have been more than one on the subject of your offer, but none favourable, and on Saturday last it was

decided to decline your offer by the post. Lord C. Cavendish and some of the old Dons object to the sum of that amount being given to one article, and particularly as it is bulky, and in a kind of collection they do not aspire to . . . [Morrison, no. 59]

Hamilton was asking £500 for the Vase, which was too much for the Museum to contemplate spending on an ancient marble at a time when books, manuscripts and specimens of natural history took precedence. Greville fought on his behalf to overcome the Museum's prejudice against antiquities, and on 2 January 1776 Hamilton wrote to him from Caserta, still hopeful that he might succeed:

I should be really unhappy if that superb piece of antiquity was not to be at the head of my collection. We are so used to jobs at home that no one can imagine that another is acting a disinterested part. I really could get £600 for my vase at Rome. The Pope wants to keep it, for it is universally avow'd to be the first vase in the world. As I have had no letter, it is very probable your last effort may have taken effect. I do assure you I have the collection at the Museum so much at heart that tho' I can ill afford to lose such a sum as £350, which is (I believe) about the cost of my vase, I should rather give it to that collection than let it go elsewhere for twice the sum. [Morrison, no. 62]

Hamilton's hope was to be frustrated and the Vase went eventually to Warwick Castle, home of Charles Greville's elder brother, the Earl of Warwick. In a letter dated 5 May 1778, Greville reported to Sir William how well it looked in its new home. The Vase remained in the family until 1979, when it was purchased by the Trustees of the Burrell Collection.

LITERATURE: Byres's letter to Sir William, 26 February 1772, Krafft Bequest. Drawing with explanatory letter addressed to Charles Townley, Rome, 3 August 1772: Sotheby's, 22–3 July 1985, lot 557, now Pierpont Morgan Library, New York, see Denison *et al.*, p. 119, no. 65; Morrison, nos 53, 59 and 62; Byres correspondence, Cambridge, Fitzwilliam Museum, Perceval MS N 7; Howard, p. 146 for Cardelli's workshop; Piranesi (1778) in Wilton-Ely, 1994, pp. 964–6, nos 889–91; cf. Wilton-Ely, pp. 1083–4, nos 1002–3 for the candelabrum. Michaelis, p. 663, 1; Smith, 1901, pp. 306–10; Vermeule and Bothmer, p. 345; Penzer, 1955, pp. 183–8, and Penzer, 1956, pp. 18–22; Ramage, 1990a, pp. 475–6.

Sculpture

Many of the pieces shown here were acquired specifically by Sir William with the intention of presenting them to the British Museum, as adjuncts to the first Hamilton collection of antiquities, which was acquired in 1772.

129 DAVID ALLAN (1744–96)

Sir William and the First Lady Hamilton, 1770

Oil on copper, 45.8 × 61 cm

Inscribed on verso: 'Dav. Allan Pt / Naples 1770'

Provenance: In collection of Dukes of Atholl at Dunkeld until 1844; by descent to present owner

His Grace the Duke of Atholl's Collection, Blair Castle, Perthshire

Illustrated on page 14, fig. 2

This charming portrait of William Hamilton and his first wife, Catherine Barlow, was painted by David Allan two years after he had first made their acquaintance through the introduction of William's sister, Lady Cathcart. A very personal portrait intended for her family, it shows the Hamiltons informally seated in the balcony room of the small villa at Posillipo with Vesuvius clearly visible across the Bay beyond the figure of the king's messenger (volante), shown leaving on an errand. Catherine Hamilton is seated at her pianoforte, her favourite dogs at her feet, while William, lounging comfortably in an armchair, listens attentively. His violin, official seal and papers and a vase are all laid aside on the table beside him. Behind it a cabinet, of a lararium type (see cat. no. 1), holds books on the lower shelf and a number of bronzes (including a figure with a harp), an ewer and other objects of antiquity in the pedimented recess above, while his most important treasures are displayed prominently at his elbow – a recently discovered altar from Capri topped by the bust of Sarapis (cat. nos 130a–b). On the wall above his head hangs a small-scale copy of his favourite, most valuable painting, his 'Correggio' of Venus Disarming Cupid, then hanging at the Palazzo Sessa (see cat. no. 176).

As this is the only known image of the first Lady Hamilton, who shared the first eighteen years of William's life in Naples, it is worth quoting here a hitherto unpublished account of her character and musical abilities, which adds to and confirms the accounts of Charles Burney and William Beckford. Abbé Peter Grant had written to James Grant from Rome on 18 May 1774 saying that he had spent the months of March and April in Naples in order to visit Sir William and Lady Hamilton at their invitation:

> Lady Hamilton is one of the most accomplished of her sex I ever have been acquainted with. You would be greatly delighted with her for on the face of the Globe there's none touches the Harpsichord with more taste or delicacy. She plays every piece of musick at sight, and will continue hours and hours playing out of her own head, which she composes, as fast as she plays and they are the most enchanting and delightful Harmony ever heard. She is likewise most sensible and clever and possessed of a most noble and generous heart, and is remarkably attached to the Scotch in general, and for me, has a most sincere and unfeigned friendship. I am to return back to her in the month of October. [Scottish Record Office, Seafield MS, GD 248/226/4(2)]

The recipient of this letter, Sir James Grant, had his and his wife's portraits painted by David Allan when he returned to Scotland, in a composition in an interior, with a running Highland footman, remarkably similar to the present portrait.

Catherine Hamilton was fond of her husband's family and corresponded regularly with her sisters-in-law, the wives of Lords Cathcart and Warwick and of William's eldest brother, Charles Hamilton. Her letters indicate her sense of exile from England and her distaste for life at the Neapolitan court. Writing to Mrs Charles Hamilton from Naples in 1768, she hoped the family would be able to visit and assured them 'we live in so English a Stile that you need not fear any of the Italian ceremonies and nonsense with us. We enter as little as we can into their stupid Assemblys, – in the Winter are almost entirely with the English, in the Summer live much to ourselves' (Anson, pp. 3–4). On their visit to England in 1776–7, Sir William and Lady Hamilton succeeded in setting up Mary Hamilton with a position at court, and a series of letters from Lady Hamilton on her return to Naples indicates her fondness for this particular niece. She described their attempts at their villa at Portici to

> lead as English a life as we can make it. In the Morning we go out in an open Chaise, I work, & draw, in the Evening we have musick, afterwards I work & Sir Wm reads to me, & you cannot think with what pleasure I heard him tell an Italian the other day, who wonder'd at our not going to the Conversationes a mile off, that our Evenings pass'd so pleasantly that he could not have the heart to try a change ... we have a charming room for Musick & my Piano forte is placed just Vis a vis to Vesuvius which now & then treats me with an explosion while I am playing. [Anson, pp. 146–7]

In December 1774, two of Hamilton's other nieces, the daughters of his sister, Lady Cathcart, married the Duke of Atholl and Thomas Graham of Balgowan. They had had their portraits painted in 1773 by David Allan, who was on a brief visit to London, and Thomas Graham had also had his full-length portrait painted by Allan in 1769 in Italy (now Yale Center for British Art, New Haven). William Hamilton was so close to the children of Lady Cathcart that it is not surprising that two versions of the present painting still belong to the descendants of the two eldest, the Duchess of Atholl and the Earl of Cathcart. It is no coincidence that they were among the greatest later patrons of David Allan – in fact it was their parents, Lord and Lady Cathcart, who had helped financially to support the artist's study in Italy from 1767 and provided him with his introduction to Sir William. On 19 March 1768, Sir William wrote from Rome that he had met 'Lady Cathcart's little painter Allan, one of the greatest geniuses I ever met with; he is indefatigable' (Gordon, p. 22).

Both versions of this painting which belonged to Cathcart children bear signatures on the versos with the date 1770, yet Sir William wears the Star of the Order of the Bath, which was not conferred until 1772. It is likely that when Allan paid his brief visit to London in 1773 he added the star and the new address on the letter on the floor before delivering the portraits.

On his return to Britain in 1777 David Allan found it difficult to find commissions in London and after two years returned to Scotland, where he found patronage with the Cathcarts once again. In November of 1780 he wrote to Sir William telling him of the whereabouts and health of the latter's nephews and nieces, and in a postscript mentioned that on leaving London he had delivered 'your group on copper of yourself and Lady Hamilton playing to Crichton to keep safe for you' (Gordon, p. 32). David Crichton was Hamilton's cabinetmaker in King Street, Soho, and presumably was to make the frame; he later made a pedestal for the Barberini/Portland Vase (see cat. no. 63). This third version of the portrait, apparently painted after the others and carried to London for Sir William by Allan, may be the one which appeared in the Earl of Morton's sale at Christie's, 26 June 1925, lot 1.

LITERATURE: Gordon, pp. 22–3; Hawcroft, no. 79.

.

130a *The Capri altar*

Ht 69.8 cm
Roman, first century AD. Found in the Villa Jovis on Capri
British Museum, GR 1775.6–16.1 (BM Sculpture 2487)

The sculpted decoration features sphinxes at the corners and four relief panels showing Apollo standing by a tripod, a sacrificial group, a group preserving only the feet, and (illustrated here) Artemis feeding a deer.

This is the altar that appears in David Allan's portrait of Hamilton and his first wife, Catherine Barlow (cat. no. 129), where it is shown as a support for the bust of Jupiter Sarapis (cat. no. 130b). The altar was presented to the Museum by Sir William in 1775.

In the letter quoted under cat. no. 128, in which James Byres reports progress on the restoration of the Warwick Vase, it seems not to have been noted hitherto that Byres also makes reference to the restoration of the Capri altar: 'Your altar is now restoring. I have agreed to pay Signor Cardelli a hundred crowns for the restoration of it and, as we could find nothing that corresponded exactly to the fragmented basso-relievo, we agreed to leave that side plain. I hope it will be finished by the end of next month.'

Byres's letter explains exactly why it is that one side of the altar is left unrestored: the only surviving ancient fragment from it – preserving the feet of a group of figures – is inserted below a new block of unworked stone. It seems the possibility of a full restoration was raised at some point, only to be rejected later, since the ancient fragment appears in a drawing as part of a projected restoration. This is one of seven drawings of the altar in the collection of the Department of Greek and Roman Antiquities at the British Museum, and may be attributed to Cardelli himself. The three figures are restored in the drawing as (left to right) Apollo, a young Pan and a Muse (?) playing a rather doubtful-looking kithara (stringed musical instrument). The line of division between the original part and the proposed restoration is clearly marked in the drawing.

The altar is said by d'Hancarville to have been found in the ruins of the Villa of Tiberius on Capri, popularly known today as the Villa Jovis. Eighteenth-century excavations on Capri are documented in a treatise by Domenico Romanelli, who, in 1816, issued three previously unpublished manuscripts by different authors on the antiquities and geography of the island.

Sir William is twice mentioned as one of those who acquired objects from the excavation by a German named Hadrava, but these were all carried out after the altar entered the Museum. Another altar, found at the so-called Palazzo della Marina, is said to have come into Sir William's possession and subsequently to have entered the British Museum. It was cylindrical, decorated with a ram's head between festoons and said to be dedicated to Cybele. If Sir William did indeed acquire it, then it certainly never came to the Museum.

LITERATURE: D'Hancarville, MS Catalogue, I, pp. 4–5; Romanelli, *passim*, esp. pp. 82 and 86; Ramage, 1992b, p. 659; Fitzwilliam Museum, Cambridge, Byres correspondence to Hamilton, letter dated 9 September 1768.

130b *Marble bust of Zeus—Sarapis*

Ht 34.3 cm
Roman, first to second century AD
British Museum, GR 1775.11–8.4 (BM Sculpture 1527). Probably presented by Sir William Hamilton

Sarapis (Latin Serapis) was a benign god of fertility, his head crowned with a *modius* or corn basket. His cult is said by Tacitus to have been brought by Ptolemy I to Egypt from Sinope on the Black Sea, and from there it spread throughout the Greek and, later, Roman world.

The sculpture appears in the portrait of Sir William and his wife Catherine, where it is displayed on the Capri altar (cat. nos 129, 130a).

LITERATURE: D'Hancarville, MS Catalogue, I, pp. 6–7.

FIG. 88 The sculptor Cardelli's proposed restoration for one side of the Capri altar. The lower, ancient part is separated from the restoration by a diagonal line. The restoration was never, in fact, carried out, and the modern stone replacing the lost ancient part was left plain and uncarved.

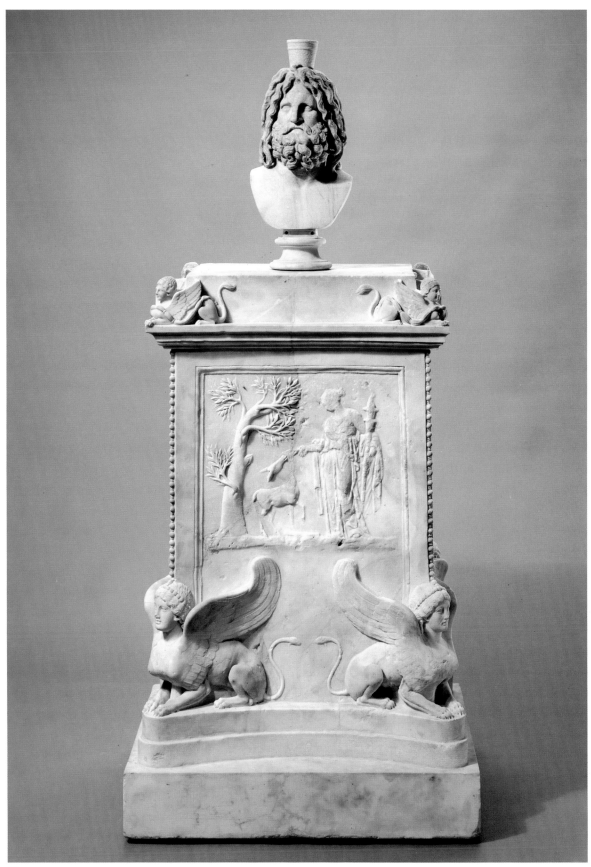

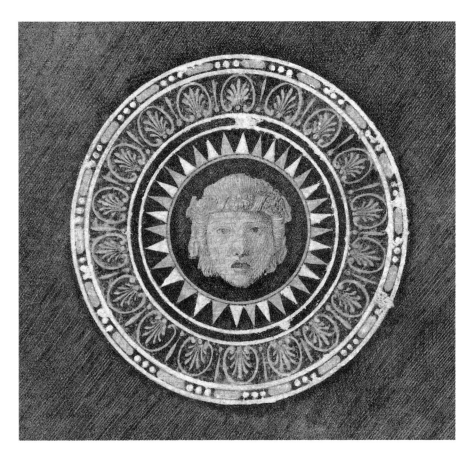

131 *Marble mask of Dionysus (?) crowned with a wreath of ivy berries*

Ht 22.8 cm
Roman, second century AD
British Museum, GR 1772.3–1.10 (BM Sculpture 2440)

Theatre masks in marble were common ornaments in classical antiquity. Sometimes, as here, they were made as separate objects for suspension. D'Hancarville, however, made the improbable suggestion that this heavy sculpture was actually worn by an actor in performance. The image was engraved as part of the decoration of the title page for the third volume of *AEGR*.

LITERATURE: D'Hancarville, MS Catalogue, I, pp. 16–17.

FIG. 89 Engraving after cat. no. 131 for the title page of volume III of *AEGR*.

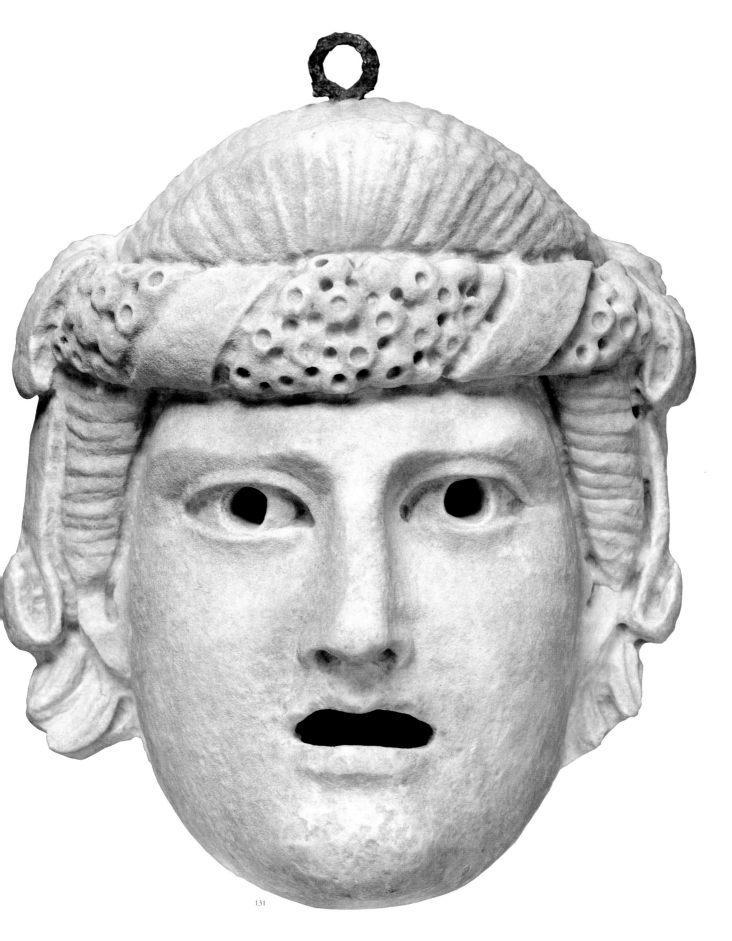

131

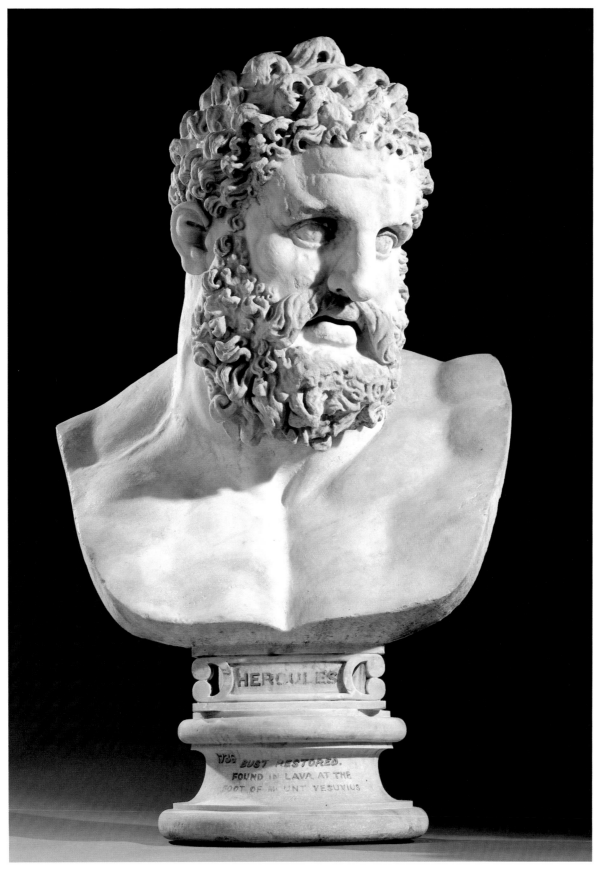

132

132 Colossal bust of Hercules

Ht (incl. bust) 74.7 cm
Roman copy of an original of about 325–300 BC.
 Said to have been found at the foot of Mount
 Vesuvius
British Museum, GR 1776.11–8.2 (BM Sculpture
 1736)

This impressive head of Hercules, set on a
modern bust, was presented to the Museum
by Sir William in 1776. It was restored in
Rome, probably under the supervision of
Gavin Hamilton, on the model of the cele-
brated Hercules Farnese. This was itself in
Rome until 1787, when the Farnese collec-
tion was transferred to Naples. Sir William
owned a statuette copied in white marble
from the Farnese Hercules, said to be by
Pisano. This was brought back to England
at the end of Hamilton's stay in Naples and
sold subsequently.

Sir William was anxious that his gift
should be well displayed in the Museum.
On 2 January 1776 he wrote to Charles
Greville from Caserta: 'Do let the Hercules
bust be well placed, Hamilton [Gavin]
declares the head is better than that of the
Farnese.' In the Museum, during Hamil-
ton's lifetime, the bust was displayed on the
Capri altar (cat. no.130a) at the top of the
great staircase in old Montagu House. The
pedestal support was designed by Joseph
Nollekens.

LITERATURE: British Museum Archives, CM, 1784,
pp. 1855, 1888; Morrison, no. 61; d'Hancarville,
MS Catalogue, I, pp. 5–6; Ramage, 1989a,
p. 705, n. 18; Ramage, 1990a, pp. 477–8;
Moreno, p. 359.

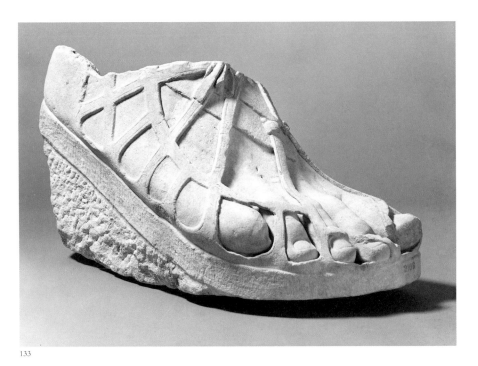

133

133 Colossal right foot in a sandal

L. 88.9 cm
Roman, first to second century AD. Found near
 Naples
British Museum, GR 1784.1–31.5 (BM Sculpture
 2109)

Presented to the Museum by Sir William in
1784, the sculpture arrived too late to be
included in d'Hancarville's manuscript cata-
logue of 1778. It is one of two sculptures
from Sir William's collection drawn by
Francesco Progenie, a pupil of Pietro Fabris
(for whom see cat. no. 44).

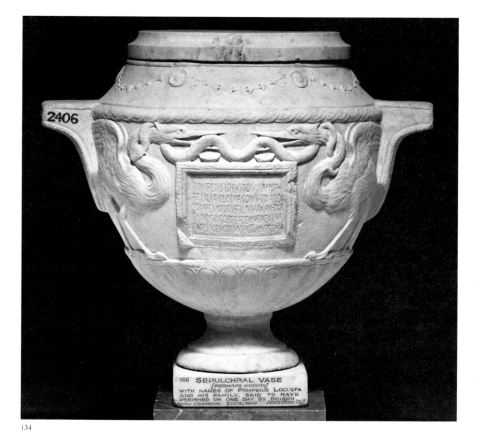

134

134 *Marble funerary vase*

Ht 33 cm

Roman, second century AD. Said to have been
 found in the Roman Campagna

British Museum, GR 1776.11–8.7 (BM Sculpture
 2406)

The vase is decorated with two pairs of
storks, the first drinking from a large krater,
the second fighting over a snake. The
inscription records the names of Pompeius
Locusto and his family, who all perished
through poisoning. (There is doubt over
the authenticity of the vase, particularly the
inscription.)

The family name recalls that of the noto-
rious Locusta, arch-poisoner of the Julio-
Claudian dynasty. According to Tacitus
(*Annals* 12.66), she served Agrippina in con-
cocting the poison that killed the emperor
Claudius; later she assisted Nero in his
murder of the young Britannicus (Sueto-
nius, *Life of Nero*, 33).

LITERATURE: D'Hancarville, MS Catalogue, I,
pp. 11–12; *CIL*, VI, 3514*.

FIG. 90 Engraving of a sculpture in the Villa
Albani, Rome, showing the full composition of
the scene only partly reproduced in Hamilton's
marble relief (cat. no. 135). From
J. J. Winckelmann's *History of Ancient Art* (1764).

135 *Marble relief showing Apollo Kitharoidos receiving a libation from a winged Nike*

Ht 88.9 cm

Roman, archaising in style, 1st–2nd century AD

British Museum, GR 1776.11–8.6 (BM Sculpture
 774)

The ancient upper part of the relief is distin-
guishable from the eighteenth-century res-
toration by the break line running through
the neck, breast and arm of Apollo, on the
left, and the upper thighs and wings of the
figure of Victory on the right. The restora-
tion cleverly completes the authentic frag-
ment, with its mannered archaising style.
The restored figures would have been copied
from one of the other surviving examples of
this subject known in Hamilton's day.

In the eighteenth century, one of the
great sculpture collections in Rome was
housed in the Villa Albani, where Johann
Winckelmann served as secretary to Cardi-
nal Alessandro Albani while compiling his
History of Ancient Art. In this publication
Winckelmann discusses one of five exam-
ples of this type of relief which were then
in the Albani collection. The one he des-
cribes and illustrates is the most complete

and alone remains in the Villa. It shows three deities, Leto, Artemis and Apollo, approaching an altar at which stands a winged figure of Victory. She pours a libation from a jug into a bowl, which she passes to Apollo. As the god of Music he supports a stringed instrument (kithara) and plucks the strings with his left hand.

The exaggerated gestures, the raising of heels off the ground and the flying, swallow-tailed drapery are all typical of the archaising style of sculpture in the Roman period. Winckelmann rightly recognised the relief as archaising rather than archaic: 'At first glance', he says, 'it seems to be Etruscan, but the architecture of the building contradicts it. It seems, therefore, that this is the work of a Greek master, not of the older time, but one who wished to copy the style of that time.' D'Hancarville was characteristically more interested in the subject matter than in the style. He took the figure of Apollo to be Erato, the Muse of erotic verse, receiving a patera from a winged genius of poetry. The latter pours a libation destined for the 'altar of desire'.

The figure of Victory from this same relief was copied by Nathaniel Marchant for a sard intaglio said, in Marchant's own catalogue, to be 'From a small Etruscan bassorilievo, formerly in the possession of the Rt. Hon. Sir William Hamilton, K.B. now in the British Museum'.

LITERATURE: D'Hancarville, MS Catalogue, I, pp. 8–10; Winckelmann, 1764, pp. 238–9; Bol, pp. 380–88; pls 218–21; Seidmann, p. 68, no. 109, fig. 112.

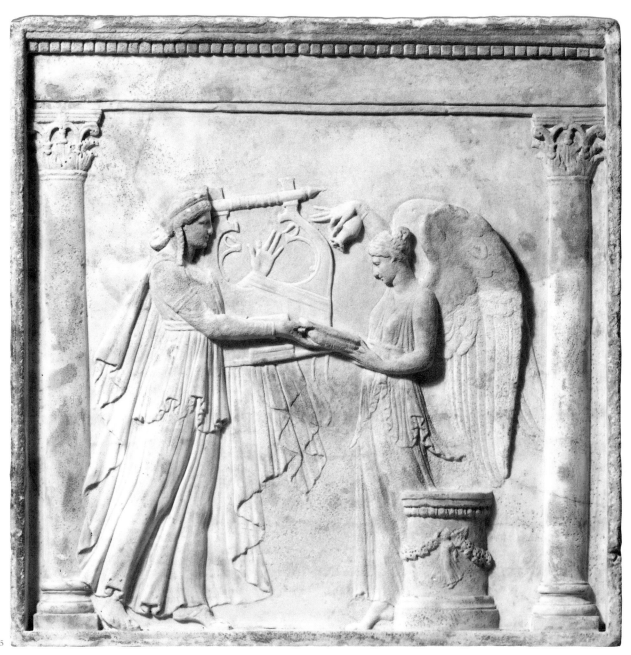

135

136 *Marble eagle with outstretched wings*

Ht 33 cm

Perhaps an eighteenth-century copy of an ancient
 original

British Museum, GR 1776.11–8.5 (BM Sculpture
 2134). Presented by Sir William Hamilton

The eagle from Sir William's collection bears
a striking resemblance to a much larger
sculpture of the bird, once the property of
Horace Walpole. The latter was dug up in
the garden of the Boccapadugli family, near
the Baths of Caracalla. It was shown to
Walpole, who greatly admired this 'glorious
fowl', and he purchased it with the help
of Horace Mann, the British Minister in
Florence. At Strawberry Hill the eagle was
displayed on a marble funerary altar, deco-
rated with similar eagles.

Two prints were produced of Walpole's
eagle, engraved by C. Grignion after draw-
ings by S. Wale.

LITERATURE: D'Hancarville, MS Catalogue, I,
pp. 7–8; for Walpole's eagle see Michaelis, pp. 69
and 486.

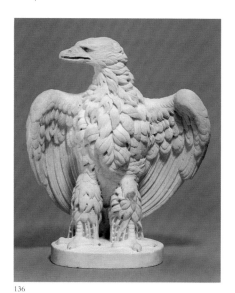

136

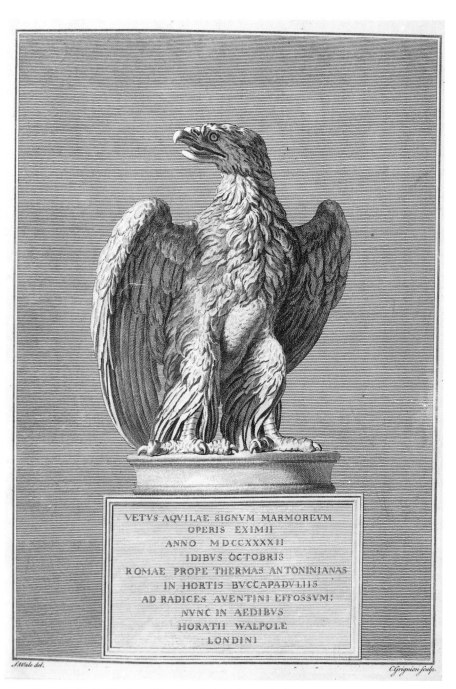

FIG. 91 Engraving by C. Grignion of Horace Walpole's 'glorious fowl'.

Curiosities

137 Blown glass urn containing cremated bones

Ht (with cover) 31 cm
Roman, made about AD 50–200
British Museum, GR 1772.3–17.1

A piece of woven asbestos was found inside the vessel. This or the other similar glass vessel in the Hamilton collection (1772.3–17.3) is shown in an engraving in *AEGR*, I, p. 173.

LITERATURE: D'Hancarville, II, pp. 594–6.

137

138 Objects from a tomb at Paestum

a) Pottery askos (jug)
Ht 27 cm
British Museum, GR 1777.3–20.351 (BM Vases
 H69)

b) Flint knife
L. 28.3 cm
Both this and (a) are Italic, probably from the
 region of Paestum, Campania. Made about
 2800–2400 BC
British Museum, PRB 1772.3–3.30

138

In spite of d'Hancarville's elaborate claims
to the contrary, Hamilton's collection con-
tained only three pieces that were made in
Italy before the time of the Trojan War.
Two of these objects are shown here, while
a third, a flint arrow-head, has not been
identified. Both belong to the Chalcolithic
phase of Italian prehistory and are named
after the Gaudo cemetery on the northern
outskirts of Paestum.

D'Hancarville missed the significance of
the early date of the askos. He engraved it
in the second volume of *AEGR*, along with
the rest of Sir William's Greek vases of later
date, and offers no commentary upon it. Nor
does his description of the same object in
the later manuscript catalogue of Hamilton's
collection make any acknowledgement of
its chronological status. Interestingly, how-
ever, it is one of the objects chosen to be
engraved in one of the supplementary illus-
trations to the text of the second volume of
AEGR (see fig. 17). The objects here were all
selected to illustrate d'Hancarville's theories
of the symbolic survival of primitive forms
in artefacts made later than the period in
which those forms were current. Thus, we
see bronze candelabra, found in Roman
houses at Pompeii and Herculaneum, shaped
in the manner of young trees stripped of
their branches. These, claimed d'Hancar-
ville, evoked earlier ages when such objects
were literally made of natural wood. The
askos, he tells us in the manuscript cata-
logue, is shaped in the manner of a shell, and

FIG. 92 Engraving from Hamilton's prehistoric
askos for volume II of *AEGR*.

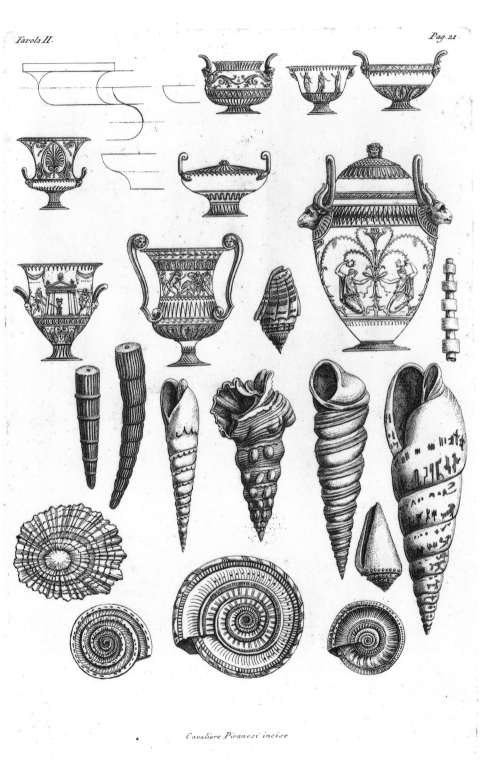

Cavaliere Piranesi incise

so evokes an age when shells actually served as vessels. G. B. Piranesi expressed a rather different view of the relationship between vases and shells, arguing that the beauty and refinement of the former were owed to their direct inspiration from the matchless shapes of natural shells. Piranesi even engraved a plate to show how one depended upon the other.

D'Hancarville's choice of a shell for comparison with the askos is surprising when, as others have pointed out, the vase is apparently a ceramic version of a leather bottle, the stitches for joining the leather pieces indicated by etched decoration.

In his manuscript catalogue of the Hamilton collection, d'Hancarville correctly guessed that the knife belonged to a time before the widespread use of metals in antiquity. In *AEGR* he had followed Dionysius of Halicarnassus' account of the peoples of early Italy. The knife, therefore, belonged to the Ausonians, one of the aboriginal peoples who inhabited Italy before it was colonised from Greece by Oenotrus, grandson of Pelasgus, seventeen generations before the Trojan War.

D'Hancarville made four excursions with Hamilton to Paestum and described how they circled the walls of the city in search of antiquities. The askos and knife could very well have been acquired during one of these visits.

LITERATURE: Dionysius of Halicarnassus, 1.11.2, for Oenotrus; d'Hancarville, *AEGR*, I, p. 80, for the survival of primitive forms in later artefacts; p. 96 for the excursion to Paestum; p. 112 for the engraving of the askos with other comparable objects, which engraving is explained on p. 177. The principal engravings of the askos are in *AEGR*, II, pls 92 and 93. For the influence of shells on vases see Piranesi, 1769, p. 21, pl. 2; d'Hancarville, MS Catalogue, pp. 275 for the knife and 323 for the askos; Barfield, *passim*.

FIG. 93 Piranesi's engraving illustrating his theory of the origin of the shapes of vases in the forms of natural shells.

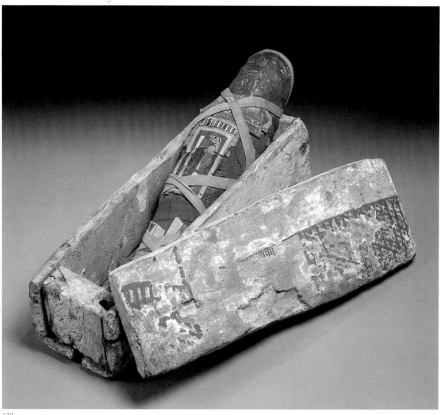

139

139 *Fake mummy*

L. 50 cm

The ancient parts include a cartonnage plaque
 showing a falcon-headed figure, one of the
 four sons of Horus, dating to after 600 BC, and
 fragments of a wooden mummy case

British Museum, EA 6952

The faking of mummies is known to go back
to Pharaonic times in Egypt, and actual
examples have been found in tombs of the
Roman period. The revival of the practice
in the eighteenth century is attributed by
contemporary sources to the Jews and Arabs
of Cairo and Saqqara. Debris was taken from
ancient tombs and combined with modern
elements to supply collectors, who were too
inexpert to detect a forgery. A number of
these forgeries are now in collections
throughout Europe, sometimes having been
identified with the help of X-rays. For the
most part, as here, the outward appearance
of the object is alone sufficient to reveal its
true nature.

The identification of eighteenth-century
forgeries is by no means new, and in 1794
the physician John Frederic Blumenbach
FRS published a remarkable account of a
number of fake mummies which he detected
by opening them and examining their con-
tents. One such examination took place at
the home of Charles Greville, Sir William
Hamilton's nephew. The mummy itself
belonged to a certain John Symmons and,
says Blumenbach,

Having with Mr Symmons' leave taken this
mask, together with some other very
interesting pieces of his mummy, with me
to Göttingen, I there steeped it in warm
water, and carefully separated all the parts
of it. By this means I discovered the various
fraudulent artifices that had been practised
in the construction of this mask: the
wooden part was evidently a piece of the
front of the sarcophagus of the mummy of
a young person, and in order to convert its
alto-relievo into basso-relievo of the usual
cotton mask of a mummy, plaster had been
applied on each side of the nose; after
which paper had been ingeniously pasted
over the whole face, and lastly, this paper
had been stained with the colours generally
observed on mummies.

Blumenbach reports that there were origi-
nally two small mummies in the Hamilton
collection at the British Museum, and one
in the collection of Sir Hans Sloane. He
applied for and was granted permission to
open the latter and found its only human
part to be a leg bone: 'On sawing it open, a
resinous smell was immediately emitted and
glutinous particles of resin adhered to the
heated saw. This was owing to the cotton
bandages having been from without im-
pregnated with resin …. On opening it
completely we found in the inside a human
os humeri … the upper end (*caput*) of the
bone was inserted in the head, and the
lower extremity was at the feet of the little
figure.' The rest of the mummy was made
up from fragments of the resin and wrap-
pings of an ancient mummy and 'traces of
our common lint paper, with which it
seemed to have been restored, and after-
wards painted over'.

Soon after their arrival in the British
Museum, Sir William's Egyptian objects
were separated from the rest of the collec-
tion and displayed in a room devoted to
Egyptian antiquities. In time, the connec-
tion of some of these pieces with Hamilton
was lost, and this mummy is one of a num-
ber of Egyptian antiquities only recently
identified as formerly belonging to Sir
William. A second fake mummy also reputed
to be from his collection was 'opened' at
some point in its history, and is now a rather
gruesome sight (not displayed).

LITERATURE: Blumenbach; Germer *et al.*

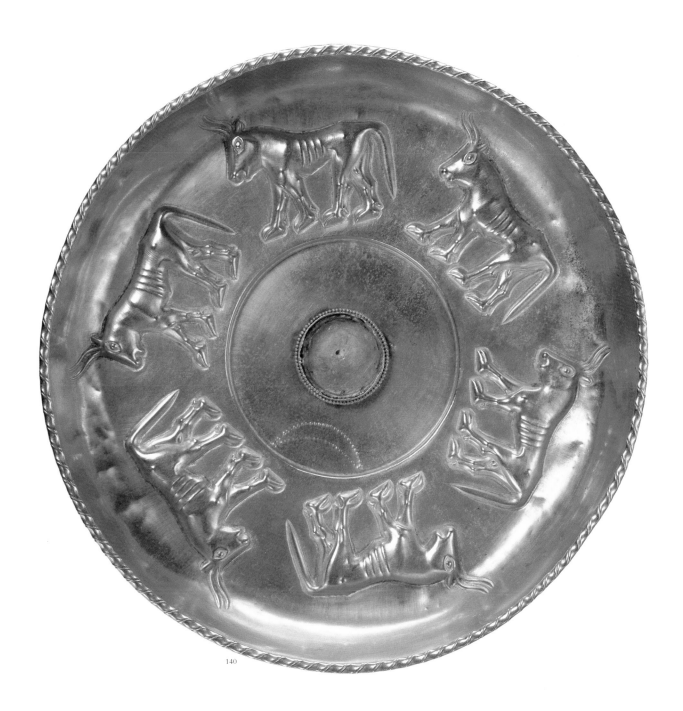

140

140 *Gold phiale (libation bowl)*

Diam. 14.6 cm

Made about 600 BC

British Museum, GR 1772.3–14.70 (BM Jewellery 1574)

This bowl is said to have been found in an ancient tomb in the village of Sant'Angelo Muxaro, some ten miles away from Girgenti, Sicily. In 1769, according to one source, there were four bowls, two plain and two decorated with bulls, in the Episcopal Library at Girgenti. A canon there is reported to have sold two to an Englishman (Hamilton?), as though they had been the bishop's own property.

The bowl is thought to be local Sicilian workmanship, but perhaps under the influence of contact with the Phoenicians.

LITERATURE: D'Hancarville, MS Catalogue, p. 476; Rymsdyk, pl. 25; Houel; Carratelli, pp. 125–6, col. pl. 97.

141

141 *Gold pendant attached to a piece of lava(?)*

L. 4.2 cm
British Museum, GR 1772.3–14.135
 (BM Jewellery 2903). Presented by
 Sir William Hamilton

The decoration shows a female figure, pro-
bably Ariadne, asleep on a chair. She is
approached by Pan, a young satyr and – on
the left – Bacchus with a torch and *thyrsus*,
supported by Silenus. This is the same subject
as that shown in the so-called Mantuan
Gem (fig. 51). In fact, so close are the two
scenes in size and design that the one exactly
fits over the other. From this it must be
concluded that the first was formed by
pressing the gold sheet over the cameo, or
a reproduction of it, and that the gold orna-
ment is a forgery.

142 *St Cosmo's 'big toe'*

L. of the largest penis 10 cm
Wax *ex votos* from Isernia, southern Italy
British Museum, MLA M560–64 (part); combined
 with W319–20

On 17 July 1781 Sir William wrote to Joseph
Banks, President of the Royal Society,
notifying him that he had, as he thought,
discovered 'the Cult of Priapus in as full
vigour, as in the days of the Greeks and
Romans, at Isernia in Abruzzo'. He goes on
to explain that the cult consisted of an
ancient festival in reverence of St Cosmo's
'big toe', a local euphemism for a phallus. It
is not known what was meant exactly by
this. Perhaps it was a relic of the saint, or
another term for the wax models of male
genitalia that were sold at the festival for
dedication in the shrine.

Hamilton had got to hear of the 'cult'
through an engineer who was supervising
the construction of a new road through
Isernia. Assuming the cult had its origins in
antiquity, Sir William asked the governor of
the town to make a search for evidence of
an ancient temple near St Cosmo's shrine.
The search was fruitless, but a number of
inscriptions were copied in the process, and
Hamilton passed on a record of these to the
Royal Society. He also sent a copy of the
eye-witness report of the festival. This was
subsequently published, with Sir William's
explanation, by the Society of Dilettanti in
a volume that principally consisted of a
Discourse on the Worship of Priapus by Hamil-
ton's younger contemporary Richard Payne
Knight.

Sir William explains how an annual fair
lasting three days was held at the shrine of
SS Cosmo and Damiano. Relics of the saints
were exposed and then carried in proces-
sion from the cathedral to the shrine:

> In the city, and at the fair, *ex voti* of wax,
> representing the male parts of generation,
> of various dimensions, some even of the
> length of a palm, are publicly offered for
> sale. There are also waxen vows, that
> represent other parts of the body mixed
> with them …. The devout distributers of
> the vows carry a basket full of them in one

hand, and hold a plate in the other to
receive the money, crying aloud, 'St
Cosmo and Damiano!' If you ask the price
of one, the answer is, *più ci metti, più meriti*:
'The more you give, the more's the merit'
… The Vows are chiefly presented by the
female sex, and they are seldom such as
represent legs, arms, etc, but more
commonly the male parts of regeneration.

Hamilton goes on to explain how prayers
are said as the votive is handed over. One
woman was heard to say 'Blessed St Cosmo,
let it be like this'. Other worshippers ap-
proach the great altar to receive unction
with the oil of St Cosmo, exposing the
afflicted part of the body, 'not even except-
ing that which is most frequently repre-
sented by the *ex voti*'.

Hamilton had not himself been present at
the festival proceedings and, between his
first becoming aware of it and the Dilettanti
Society's publication, the rites were sup-
pressed by the local Catholic clergy. (Even-
tually Isernia itself was to be destroyed in an
earthquake that struck the area on 26 July
1805.) Sir William did, however, manage to
acquire some of the wax *ex votos*. He
deposited five of these in the British Museum
when he was in England in 1784, with
instructions to the Revd Dr Paul Henry
Maty, Keeper of Natural and Artificial
Productions, to 'keep hands off of them'.
The intentional irony of this remark shows
that, although Sir William was in earnest
about his claims to have discovered a sur-
vival of an ancient cult, and therefore wished
to see the *ex votos* placed alongside his
collection of ancient 'Priapi' in the Museum,
he nonetheless saw the funny side of it all.
Earlier he had signed a letter to Joseph
Banks with the wish that his 'big toe' may
never fail him.

No contemporary record in the Museum
has been found of Sir William's gift, but a
register compiled in the second part of the
nineteenth century does include it. This
document lists erotic objects principally in
the collection of George Witt, presented to
the Museum in 1865, but also in other
collections, Sir William's included. It is
noted that two, M562 and 563, were broken.

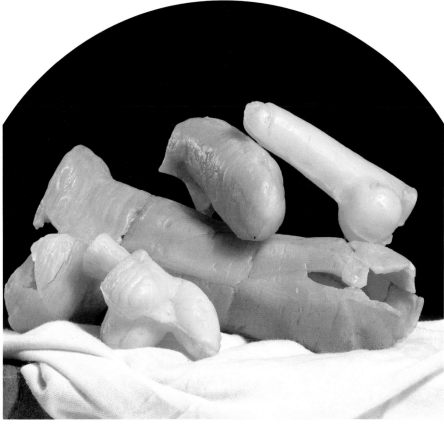

142

Subsequently, it seems, all five of these unusually fragile objects were reduced to fragments. Their original appearance can, however be seen in the engraving that formed the frontispiece to the Dilettanti Society's publication (below left). Two have recently been reconstructed by Frank Minney of the Museum's Department of Conservation.

Sir William, it seems, was not the only collector to acquire examples of St Cosmo's 'big toe'. The Witt collection itself contains two (W319–20) which are carefully preserved by virtue of the case made especially for them. These are identical with pieces in the engraving and show that more than one cast was struck from the master mould taken from any one member.

LITERATURE: British Library, Add. MS 34,048, ff. 12–14, Hamilton to Banks, letter dated 17 July 1781; Add. MS 34,048, f. 17, letter dated 7 June 1784; Hamilton's account in a letter dated 30 December 1781 is published in Payne Knight, pp. 3–8 of the reprinted edition (ed. Garrison); Johns, p. 25, fig.11 (the Witt Collection pieces are illustrated here); Funnell, pp. 50–51; Carabelli (forthcoming).

ABOVE LEFT 'Reconstruction' of the engraved plate forming the frontispiece (LEFT) of Richard Payne Knight's *Discourse on the Worship of Priapus* (1786). The darker-coloured phalli in the picture have been restored from surviving fragments of Sir William's original gift to the Museum of *ex votos* from Isernia (cat. no. 142).

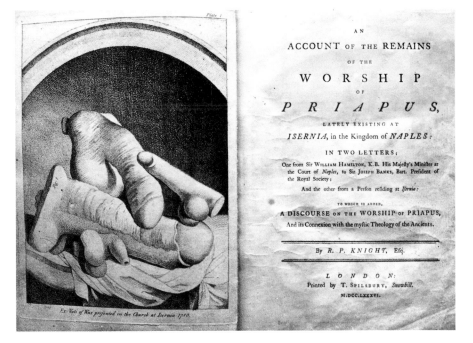

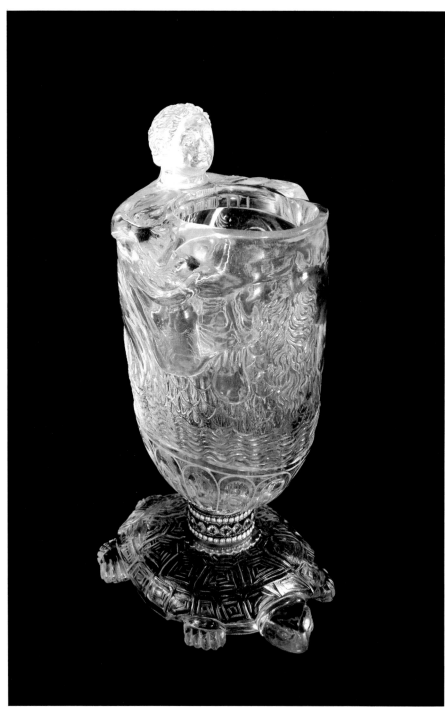

143

143 *Carved rock-crystal vase showing a Nereid and a sea-monster*

Ht 15 cm
Attributed to Dionysio Miseroni of Prague
(d.1661)
British Museum, MLA 1772,3–20,190

The Miseroni (originally of Milan) worked for the Habsburg court in Prague throughout the seventeenth century. Theirs was one of the great workshops specialising in the carving of rock crystal. This example demonstrates the virtuosity involved in carving a head in the round from the same piece as the body of the vessel.

A female Nereid is seen from behind, long hair falling down her naked rear. She clings with both arms to the back of the head of a sea monster (Triton?). His eyes can be seen on either side of her neck and his mouth gapes wide open, the upper row of teeth marked by deep incision. He wears a goatee beard flowing over the fish scales of his neck. The vase is mounted on a pedestal in the form of a tortoise, the two parts joined by a neck ornamented with emeralds and pearls.

D'Hancarville lists this vase as ancient in his manuscript catalogue of the Hamilton collection.

LITERATURE: D'Hancarville, MS Catalogue, II, pp. 505–6; Tait, 1991, pp. 311–12.

Life Ancient and Modern

In the eighteenth century, archaeology was in its infancy and the terms 'social anthropology', 'science' and 'geology' were not yet in common use. The study and collection of antiquities with the aim of revealing man's earlier cultures was complementary to the study of natural history and its search for clues to the history of the Earth and its creatures. The founding of the Society of Antiquaries in 1707 was the first symptom that the two studies were beginning the process of separation which would eventually lead to the areas of specialisation we are familiar with today, but the fact that the Royal Society and the Society of Antiquaries frequently shared not only members, but occasionally presidents, is indicative of their close relations throughout the century. Antiquarians had relied in the past on information provided by Classical authors and extant monuments to discover what was to be learnt about ancient societies, but the remains being discovered in excavations throughout Europe since the late seventeenth century were providing a new wealth of material. Moreover, just as Hamilton and other students of natural history were discovering that they could learn about the past history of the Earth by careful observation of its present activity, so those wishing to interpret the newly discovered material remains of earlier cultures began to think that clues might be provided by survivals of those cultures in the society and customs of their descendants, the living local inhabitants.

Many historians in the eighteenth century argued that surviving primitive cultures, such as those discovered by Joseph Banks on his voyages with Cook, were unchanged from ancient times and were thus living reflections of the life and even languages of ancient, primitive peoples. Similarly, some indication of the daily lives of the people of Pompeii and Herculaneum could be obtained from the examination of the objects used by them, in their temples, houses, kitchens, baths and armouries, all found *in situ*; but additional information about the way they used these objects, and indeed the manner in which they lived, worshipped and amused themselves, could be discovered by studying the lives of those whose way of life had changed least since that time. When Richard Payne Knight arrived in Rome in 1776 and was about to set out on his voyage to Sicily, he indicated to Romney that the journey was intended to be an exercise in 'history and morality, that is, an investigation of ancient remains and modern manners' (Clarke and Penny, p. 20).

Less ambitious than Payne Knight, Banks and Hamilton both considered themselves antiquarians who were happy to observe, record and report items which might help elucidate daily life and customs of the past, but neither would have called himself a historian and both left the writing of ancient political and military history to others. In his publication on the excavations of Pompeii in 1777, Hamilton followed the same empirical methods he had used in his letters to the Royal Society and in the *Campi Phlegraei* (see Chapter 4): he provided a series of images and limited his commentary to explaining the manner in which the discoveries were made, identifying the objects and buildings in the illustrations, and showing how the positions in which they were found helped to reveal their purpose and manner of use (see p. 43 and figs 15, 16).

If ancient customs did survive in local inhabitants, Naples and the areas around it would be fertile ground for observing them. James Byres believed that the islands of the Mediterranean had been a refuge for survivors of the Flood and that therefore the inhabitants were descendants of the antediluvian world, protected by their

isolation from the changes inflicted on the ancient cultures of the mainlands. Whether visitors to Procida and Ischia believed this to be the case or not, the local customs of the inhabitants were unique and certainly picturesque, providing David Allan and others with opportunities to satisfy a growing demand for images of such unique cultures. Local games such as *mora*, dances such as the tarantella, and religious customs all seemed to have reflections in objects and paintings discovered in the excavations, and thus appeared to have ancient roots. Musical instruments still commonly used by the locals, especially the tambourine and finger cymbals, were also found in the excavations, and Charles Burney, researching his history of music, believed that genuine Neapolitan singing was 'a very singular species of music, . . . as different from that of all the rest of Europe as the Scots, and is, perhaps, as ancient, being amongst the common people merely traditional' (Scholes, *Burney*, p. 254). Even local gestures, it was argued, could be studied for helpful clues to narratives found on ancient vases.

Such parallels provided artists such as Allan and Fabris with an excuse to imbue genre paintings of the Neapolitan *popolino* with the grace and attitudes of the ancients. One of the plates in the French edition of d'Hancarville's publication on Hamilton's first vase collection drew attention to the similarity between ancient and local modern costume (pl. LIII). The King of Naples commissioned a series of studies of the various costumes of his kingdom; the images were used for decorating wares made by the royal porcelain manufactory and provided source material for numerous souvenir prints, watercolours and drawings (see cat. no. 152), but they were also a means not only of instilling pride in the wearer and reinforcing his local and national identity but also of underlining the direct descent of the contemporary inhabitants of the kingdom from the inhabitants of Classical antiquity.

LITERATURE: For the effect of ancient history on the antiquarian tradition, see Momigliano, pp. 296–313; for its effects on artists, see Errington, *passim*; D. Macmillan, *Painting in Scotland: The Golden Age*, exh. cat., Talbot Rice Art Centre, Edinburgh, and Tate Gallery, London (Oxford, 1986), pp. 64–6; Macmillan, p. 128; F. Haskell, *History and its Images*, London and New Haven, 1993, pp. 155–8; for Banks, see Gascoigne, pp. 119–30; for Neapolitan historians' own interest in their ancient culture, see M. Calaresu, 'Political culture in late eighteenth-century Naples: the writings of Francesco Mario Pagano', Ph.D. dissertation, Cambridge, 1994, ch. 2.

144 DAVID ALLAN (1744–96)
Evening Amusement at Rome, 1769

Pen and ink and watercolour, 33.5 × 45 cm
Inscribed: *D. Allan 1769. Evening Amusement at Rome*
Glasgow Museums: Art Gallery and Museum, Kelvingrove, 729

In 1755 David Allan was sent to Foulis's Academy of Fine Arts in Glasgow by his patrons Lord and Lady Cathcart. (The latter was the sister of William Hamilton.) Allan remained at the Academy, where James Tassie (cat. no. 67) was a fellow pupil, until 1762. Over the next few years he produced a number of portraits and some small domestic genre pictures, including a *Cottage Interior*, before Lord Cathcart sent him to study at Rome in 1767 (Skinner, p. 6). Some of his earliest Italian works were portraits, notably his own of 1770 (Royal Scottish Academy) and the charming group of William Hamilton and his first wife, painted the same year but altered in 1772 after Hamilton's knighthood (cat. no. 129). The grand style portrait of Sir William that Allan gave to the British Museum was begun immediately afterwards (cat. no. 1). Allan also painted historical and mythological subjects, including *The Origin of Painting*, which won the Gold Medal at the Academy of St Luke in Rome in 1773 (owned by James Byres, now National Gallery of Scotland). This is one of his best works, the subject of which was later taken up by several British artists.

It was Allan's genre pieces, however, that were to have the greatest effect on later artists, most notably on the work of David Wilkie. During Allan's own lifetime there seems to have been a mutually beneficial exchange between the watercolours and prints of this type in the work of Allan, Paul Sandby and Pietro Fabris. Paul Sandby's *Twelve London Cryes* had appeared in 1760, and both Fabris and Allan were to create comparable series of the local costumes and street vendors of Naples (cat. nos 145–51). Allan filled a sketchbook with such studies from 1770; it included figures not only from Naples and Rome, but also from Sicily, Malta and France, and two series of more finished small watercolours after them are now in the National Gallery of Scotland and the Aberdeen Art Gallery. After his return to Scotland, Allan followed these with a series of Scottish 'cries'; it was his paintings in oils and watercolours based on them which were to have such a strong influence

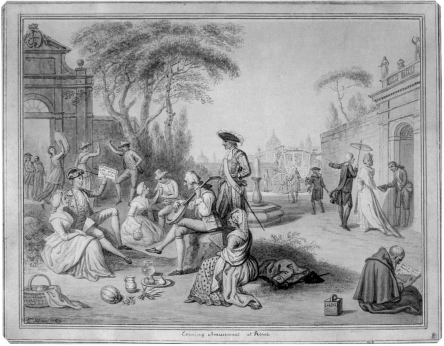

144

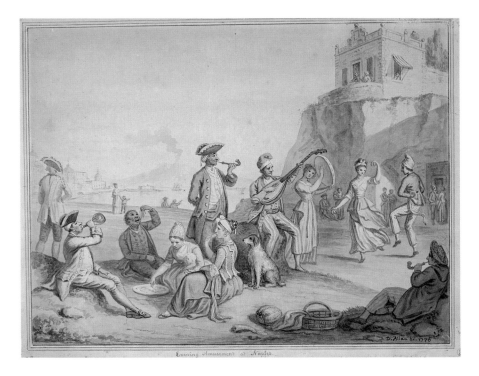

FIG. 94 David Allan, *Evening Amusement at Naples*. Watercolour, *c*. 1770. Glasgow Museums: Art Gallery and Museum, Kelvingrove.

on Wilkie. Neither of his series of costumes and street cries was ever engraved.

The present watercolour is one of a pair based on two large preparatory drawings, now in the British Museum; clues given in both these and the watercolours seem to indicate a close connection between the figures and activities represented and William

and Catherine Hamilton. Hamilton had written from Rome on 19 March 1768 to the Cathcart family that he had met 'Lady Cathcart's little painter Allan, one of the greatest geniuses I ever met with; he is indefatigable' (Gordon, p. 21). Traditionally the central figure in the Roman scene has been identified as William Hamilton, and although no written evidence supports this, further examination of the figures indicates it is not impossible. The central figure does not seem to belong to the usual stock Roman characters singing, eating, drinking and dancing around him. His coat, hat and sword have been thrown carelessly aside, and in the finished watercolour he is distinguished from the rest of the group by the embroidery on his coat, his powdered wig and the presence of a Swiss Guard from the Vatican standing behind him in place of the Roman matron in the drawing. Off to the right an abbé *cicerone* directs a young woman bearing some resemblance to Catherine Hamilton who is preceded by a servant carrying her dog and another British gentleman. Hamilton's first visit to Rome was in February and March 1768, when, accompanied by Catherine and Lord Stormont, he was guided by James Byres and Abbé Winckelmann.

The pair to this watercolour, *Evening Amusement at Naples* (fig. 94), was painted when Allan visited Naples sometime around 1770. The original sketch shows figures dancing by one of the famous rocky grottoes on the shore at Posillipo, but in the finished watercolour the vague rock becomes the actual one on which Hamilton's villa at Posillipo was built, with William Hamilton and other figures visible on the balcony. The artist has had to twist the rock to get the villa into the painting, since the villa actually faced Vesuvius, as is clear from Allan's oil painting of William and Catherine in the balcony room, painted the same year (cat. no. 129).

The figures from these images recur again and again in Allan's Italian genre scenes. The two dancers on the right of the Neapolitan scene, for example, appear in the Sandby aquatint of the *Neapolitan Dance* (fig. 95). The pair of watercolours in Glasgow, with their references to his patrons, are the first instances of a formula Allan was to use again, once back in Scotland, with charming effect in *The Highland Dance* of 1780 and *The Penny Wedding* of 1795.

LITERATURE: Skinner, *passim*; Gordon, p. 21.

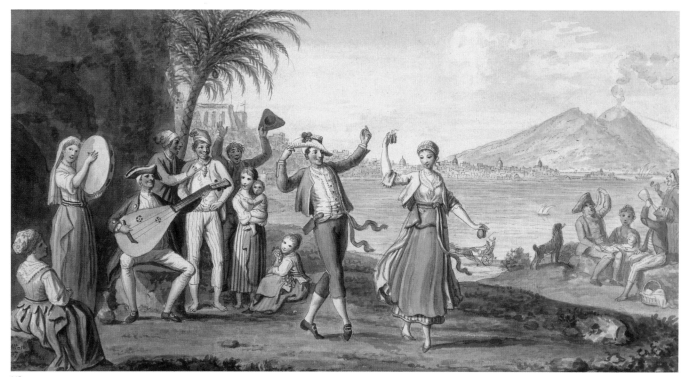

145

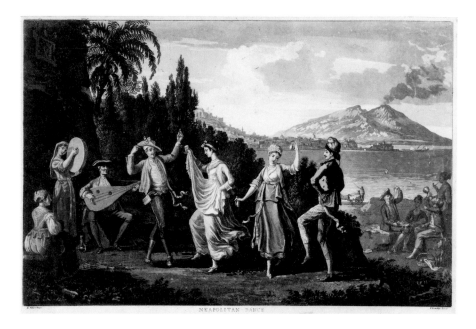

NEAPOLITAN DANCE

FIG. 95 Paul Sandby after David Allan, *Neapolitan Dance*. Aquatint. British Museum, P&D 1904–8–19–784.

145 DAVID ALLAN (1744–96)

Neapolitan Dance, 1787

Watercolour, 20 × 37.5 cm
Inscribed: *D. Allan 1787*
Provenance: Purchased from Messrs Evans
British Museum, P&D 1861–2–9–158

In 1780, after he had been back in Britain for three years, Allan wrote to Sir William that while still in Rome in 1775 he had done a set of eight drawings in bistre representing the amusements of the Carnival in Rome, 'which Sandby bought from me for London, and he has executed them charmingly in aquatinta prints at a guinea a sett' (Gordon, p. 32). Five were shown at the Royal Academy in 1778, and eventually came into the hands of the Prince Regent. They are some of the best known and most charming images of the Grand Tour. The present watercolour is less well known but this subject was also issued in a large aquatint by Sandby (fig. 95). Sandby obviously realised the potential market for such images in his new medium of aquatint, so well adapted to reproducing the effect of watercolour washes. He had already had some success with a series of twenty views around Naples based on a group of similar images by Hamilton's other indefatigable painter, Pietro Fabris (cat. no. 148). The figures in these views by both Fabris and Allan are equally charming, and their types and poses are naturally similar as they are engaged in the same activities, but each artist brings his own individual style to them.

In the same letter to Sir William, Allan wrote that he was enjoying the patronage of the Duke of Atholl (the Duchess was Hamilton's niece) and he intended to make similar drawings 'of the manners in Scotland, which would be new and entertaining and good for engraving. I have painted at Athole for myself a Highland Dance as a companion to the Neapolitan, but the Highland is the most picturesque and curious.'

The painting of 1780 is now in a private collection in Scotland (for reproduction see Macmillan, pp. 129–30), but Allan produced several versions, including a watercolour similar in size to the present work and possibly its pair (National Gallery of Scotland) and another oil exhibited at the Royal Academy in 1787, the same date as the present watercolour. The aquatint produced by Sandby of the *Neapolitan Dance* differs slightly from the watercolour, indicating that there were several versions of this subject by Allan as well. The print lacks the crowd in the background and has two pairs of dancers, with the additional woman dressed in a costume with many folds of drapery reminiscent of the dancers found on the walls of Pompeii.

LITERATURE: Gordon, pp. 31–2; Macmillan, 1990, pp. 128–31.

146 DAVID ALLAN (1744–96)

Procidan Girl, 1776

Oil on canvas, 63.5 × 34 cm

Inscribed on verso: *Procitan Girl. D. Allan Pinxt. 1776*

Provenance: In the Duke of Hamilton's inventory of 1793; with the Marquis of Clydesdale, 1938; his Grace, the Duke of Hamilton from 1952

Part of the Hamilton Collection, Lennoxlove, Haddington, East Lothian, Scotland

This painting appeared in 1793 in an inventory of the Duke of Hamilton's collection as 'added to the Library from the Painting Room', along with *A Family of the Island of Procida*, both in gilt frames (from notes in Scottish National Portrait Gallery archives). The latter is no longer in the collection.

David Allan's sketchbook of 1770–76 includes a number of studies of women spinning as well as of the costumes peculiar to the children, men, married women and even widows of the island of Procida. In addition to studies of local figures, including the *volante* used in the portrait of William Hamilton and his first wife (cat. no. 129), the sketchbook also contains studies of antiquity in the form of Classical reliefs and altars and a statue of Hercules.

The people of the island of Procida, off the coast of Naples, were said to have retained purer links with the past because they were isolated from developments on the mainland. There was also a belief that

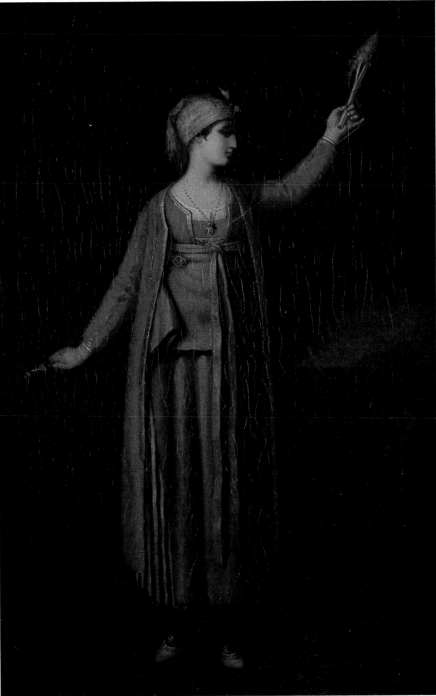

146

folk costumes were unaffected by changing fashions and thus the manners and customs on the island reflected more closely those of the ancient inhabitants of Italy (Macmillan, p. 128).

At some date David Allan issued a print of this subject with the letterpress 'ad viv del. 1769 et tinta fecit', which seems to be some experimental form of aquatint. The date probably refers to the date of the original drawing rather than the date of the aquatint. He was attempting to find a method that would enable him to issue his own prints after his drawings and watercolours, something he did not achieve until his illustrated edition of Ramsay's *Gentle Shepherd* in 1788 (Griffiths, 1987, p. 265, n. 37).

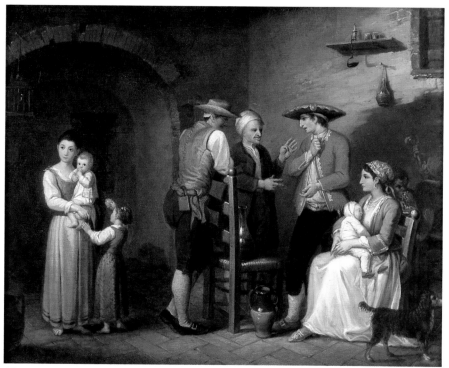

147

147 DAVID ALLAN (1744–96)
Neapolitan Tavern Scene

Oil on panel, 35 × 44.3 cm
Inscribed on verso: *Neapolitan figures by – Allan*
Provenance: Sotheby's, 11 March 1987 (lot 102),
 as *Haggling inside the Tavern*
James Holloway

As in his *Neapolitan Dance* and scenes of evening amusements in Rome and Naples, in this painting Allan was following the very eighteenth-century artistic practice of recording the 'manners and morals' – the social customs, amusements, religion and daily life – of the Neapolitans. The costumes are observed down to the finest details, and the objects of daily life and the social customs are depicted with equal fidelity. The costumes are based on studies in Allan's sketchbook in the National Gallery of Scotland, and are similar to those worn by the two main figures in the *Neapolitan Dance*, which also contains the dog and stock figures of men drinking from a flask and eating macaroni (cat. no. 145). The men are not haggling but playing the Neapolitan game of *mora*, where two men throw out their hands with a number of fingers extended and at the same time one calls out a guess of the total that will be shown. There are several watercolours by Allan of groups of men, both peasants and people of fashion, playing *mora* (British Museum and National Gallery of Scotland).

148 PIETRO FABRIS (*fl.*1756–84)
Peasants Dancing at Posillipo

Oil on canvas, 36 × 71 cm
Private collection

Very little is known of Fabris's early years. He was said to be British, but was working in Naples from the mid-1750s. In 1768 he exhibited four drawings of 'Views in Naples' at the Free Society in London and in 1772 he showed two oils of views of 'The Posilipo at Naples', which were probably very similar to this painting, at the Society of Artists.

Thomas Worsley of Hovingham Hall in Yorkshire wrote to Hamilton in June 1766 that he was fitting up an apartment and would like good views of Naples if they fell Hamilton's way (British Library, Add. MS 41,197, f. 36). Three years later, on 26 May 1769 (f. 101), he wrote again, having delivered to George III, as a favour for Hamilton, two paintings sent by Hamilton to Worsley with a case of paintings:

> I yesterday had the honour of presenting your two very agreable pictures to his Majesty, who was extreamly pleased with them; & expressed an uncommon satisfaction in them, which I did my best to improve by throwing in what ever I could to heighten their value. I wish you had wrote me a little detail *raisonné* upon the hand & dresses, I explained the Lazzaroni & contadine & the *sciles* as well as I could & indeed both their Majestys were charmed. Is P. Fabris a frenchman or Italian I could not tell. The King related to the Queen the miscarriage of the first Pair; so that upon the whole I think you have gained credit.
>
> I hope I was right when I asserted that where the cards were upon the ground, was not gaming but telling the fortune of the young contadina looking on. I confess that picture struck me & others, more than the Dancers in the other. If it did not come too high, I should like to have one like it.

In fact these paintings, *A Gaming Scene with Musicians* and *The Tarantella*, signed and dated 1766 (figs 8–9), are versions of two of a group of four, now in a private collection in Naples, which are Fabris's earliest known works, dated 1756 and 1757 (Knight, 1990, p. 84). Figs 8 and 9 are both set in the grottoes at Posillipo; the other two in the group showed vendors of meat and water-melons on the waterfronts of the Marinella and Mergellina. A large number of British collectors, including the Earl of Exeter, the Earl of Bute, Watkin Williams-Wynne and, most notably, Lord Fortrose (cat. no. 16), owned similar paintings by Fabris of the *popolino* of Naples engaged in their daily pursuits. Sir William Hamilton had one or two versions of this particular group of four and at least twenty other works by Fabris in oil as well as several in watercolour, in addition to the numerous paintings of Vesuvius which illustrated his *Campi Phlegraei* (cat.

no 43). One of Hamilton's paintings by Fabris, *Ferry over the Volturno, near Caizzano* (sale 18 April 1801, lot 79) is now in the Fitzwilliam Museum, Cambridge. When Lord Gardenstone visited the Palazzo Sessa in 1788, he remarked upon one room which was 'adorned with paintings by Fabris, an Englishman, which represents in a very pleasing style, the characters and humours of the people of Naples' (*Travelling Memorandums*, III, p. 97). These views had become well known in Britain when Sandby and Robertson issued their *Views in and near Naples*, 1777–82, a series of twenty-four aquatints based on similar works by Fabris (cat. nos 17, 18, 149).

Fabris's earliest works concentrated on panoramic views of the city which served as the background for court events, such as the *Cuccagna al Largo del Castello*, the *Procession of Royal Ships at Palazzo Donna Anna* and the *Gioco della Palla* (Ball Game). These *veduti* have been described as owing a great deal to the influence of Antonio Joli, but Joli was in England in the 1740s and early 1750s, overlapping some of this time with

Canaletto, and did not arrive in Naples until 1756, about the same time as Fabris. Their similar styles may have been the result of working in England first. Fabris's peasant scenes date from the same time; they owe a great debt to a series of charming paintings of contemporary Neapolitan life produced around 1750 by the little-known Neapolitan artist Filippo Falciatore, which in turn are French in their inspiration (there are two in the Detroit Institute of Arts: see *Golden Age of Naples*, I, pp. 99–101).

Because of Hackert's own self-promoting statement, published by Goethe in his biography of the artist (p. 26), that when he first came to Naples in 1770 he was employed in the early stages of the *Campi Phlegraei*, it has become an erroneous commonplace in the discussion of Fabris's landscape style and his scenes of contemporary life to state that they were the result of the influence of the work of Philipp Hackert. In fact Hackert only made three small watercolours of *montagnuoli* for Hamilton in 1771, which he stated were badly engraved in copper. No doubt they were intended for the *Philosophical*

Transactions or the 1772 or 1773 publications of *Observations* rather than the 1776 *Campi Phlegraei*. In fact Hackert's later views in bodycolour and oil of the area around Naples owe a great deal to Fabris's compositions in the *Campi Phlegraei*. Fabris enjoyed royal commissions long before Hackert, including a large painting of 1773 of *Ferdinand IV after a Boar Hunt*, in which the artist included his own portrait (see *Golden Age of Naples*, I, no. 19). Hamilton had mentioned that Fabris was 'in a declining state of health' in 1776 and the last time he is mentioned by any Grand Tourist is in 1784 (J. Parkinson, MS journal, 2 Feb. 1784, note in Sir Brinsley Ford Archive, Paul Mellon Centre). This was the year before Hackert moved to Naples to become official painter to the king.

LITERATURE: Mancini, pp. 34–7; R. Middione and B. Dapra, *Reality and Imagination in Neapolitan Painting of the 17th to 19th Centuries*, City Art Centre, Edinburgh, 1988, pp. 26–8; *Shadow of Vesuvius*, 1990, pp. 120–22.

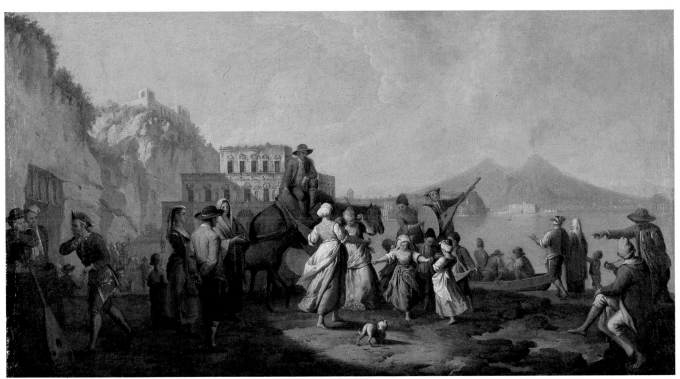

148

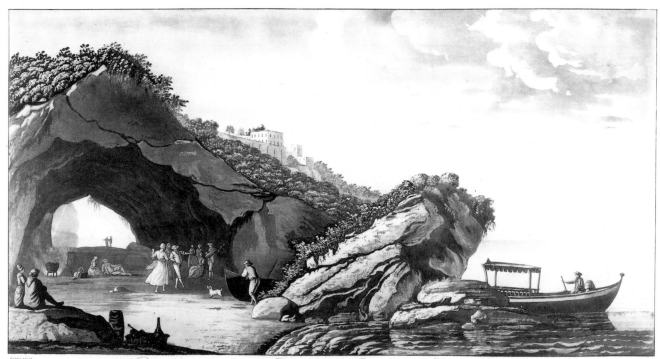

View of a Grotto between Gaiola & Bagnoli Vue d'une Grotte entre Gaiola et Bagnoli

Fabris pinxt Published Janry 15th 1782 by A. Robertson, Gratia Street, St. James's Square

149b

149 PAUL SANDBY (1725–1809)
and ARCHIBALD ROBERTSON
(*fl*.1775–85) after PIETRO FABRIS
(*fl*.1756–84)

a) *A View of a Remarkable Grotto, in
 the Hills of Posilipo*, 1777

Aquatint from a set of *Views in and near Naples*
 (1777–82), 32.3 × 57.5 cm
Provenance: Purchased from Mr Daniell
British Museum, P&D 1865-6-10-966

ARCHIBALD ROBERTSON
(*fl*.1775–85) after PIETRO FABRIS
(*fl*.1756–84)

b) *View of a Grotto between Gaiola &
 Bagnoli*, 1782

Aquatint from a set of *Views in and near Naples*
 (1777–82), 33.4 × 59.5 cm
Provenance: Purchased from Mr Daniell
British Museum, P&D 1865-6-10-961

The beaches along the base of Posillipo, the
long western arm of the Bay of Naples, as
well as the hills themselves were honey-
combed with grottoes. That side of the bay
afforded magnificent views of the city with
Vesuvius dominating the distant shore. The
cliffs of Posillipo were dotted with villas and

casinos, including Hamilton's own, later
called the Villa Emma. Visiting the grottoes
by boat, picnicking and dancing in them,
and fishing at night by torchlight were
favourite pastimes of all Neapolitans –
peasants, nobility and royalty alike.

Fabris's series of drawings depicting these
picturesque scenes was published in England
as a successful set of aquatints by Paul Sandby
and Archibald Robertson in 1777; further
views were added to the series in 1782.
Sandby knew his market and also issued
aquatints after similar watercolours by David
Allan (see cat. no. 145).

150 PIETRO FABRIS (*fl*.1756–84)

*Raccolta di varii vestimenti ed arti
nel Regno di Napoli*, 1773

Book of 34 etchings including title page,
 20.5 × 15.5 cm each
British Library

From the sixteenth century there has been
a strong tradition of images of street cries in
European paintings, books, prints and even
children's broadsheets. In Britain Marcellus

Laroon's *London Cries*, first published in
1688, was still being issued throughout the
eighteenth century and was joined by Paul
Sandby's *Twelve London Cryes from the Life*
in 1760. In Italy Annibale Carracci's series
Le Arti di Bologna was first issued in the mid-
seventeenth century and continued to appear
in new editions during the eighteenth,
prompting imitators such as G. Zompini in
Venice in 1753 and Fabris in Naples. David
Allan's examples in watercolour were made
at approximately the same time, but because
they were never issued in print form, and
because Fabris's book was apparently not
issued in large numbers, neither Allan's nor
Fabris's street cries are widely known. Allan's
remain mostly unpublished, and although
F. Mancini reissued Fabris's book in Naples
in 1985, his work remains largely unknown
to those studying street cries and costumes.

Fabris's images of the street sellers and
costumes of Naples have no precedent there,
unless it was his own and other painters'
drawings and studies made for their paint-
ings in oil. The prints seem to be based on
a selection from a large group of pencil and
pen and ink sketches by Fabris now in the
Museo di San Martino, Naples. Fabris, who

described himself as 'Inglese' on the title page, undoubtedly knew Laroon's series as well as Zompini's; Sir William Hamilton's patronage gave him encouragement to produce his own, as the long dedication to Hamilton on the title page with its view of Vesuvius makes clear (fig. 96). There is no text to the plates to indicate their purpose, but such figures provided a useful stock of images for artists to use in their paintings. They also served as a guide to the local costumes of the people of Naples in much the same way as the *Campi Phlegraei* served as a guide to the local volcanic landscape (cat. no. 43) and the series *Views in and near Naples* aquatinted by Sandby and Robertson (cat. nos 17, 18, 149) to the local antiquities and sights.

Some of the images in this book are striking in their charming simplicity and the

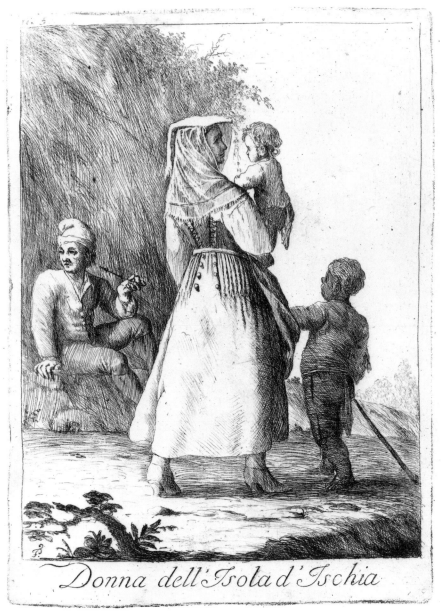

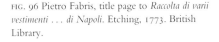

150

FIG. 96 Pietro Fabris, title page to *Raccolta di varii vestimenti . . . di Napoli*. Etching, 1773. British Library.

original way in which the figures are placed with their backs to the viewer to show the details of the costumes. Poses characteristic of the activities in which the figures are engaged take on another quality when they are isolated and no longer in groups of active figures. John Gage has mentioned that some of them are reminiscent of Goya; the Spanish artist had been apprenticed to a court painter before visiting Naples in 1770 and himself settling as a court painter in

Madrid in 1775. The art of the two courts had much in common and, although no direct borrowings may be found, Fabris's images of Neapolitan peasants surely find an echo in Goya's own work.

However, these images by Fabris had a more immediate and decided effect on Neapolitan art. They were to be repeated endlessly by Xavier Della Gatta, Alessandro D'Anna, Antonio Berotti and an army of anonymous artists working for the souvenir trade throughout the next hundred years in all manner of media. Fabris's book of etchings dedicated to Hamilton was rare and not recognised as the source of many of them,

but his example had led Venuti, the director of the royal porcelain manufactory at Capodimonte, to commission a number of artists, including the three above-mentioned, to travel throughout the area and build up a stock of similar images, which were used for a porcelain service called 'The Costumes of Naples'. These images were issued in a volume of plates in 1793.

LITERATURE: F. Mancini, *Pietro Fabris, 'Raccolta di varii vestimenti'*, Naples, 1985, with an introductory essay and reproductions of original drawings and proofs for the plates.

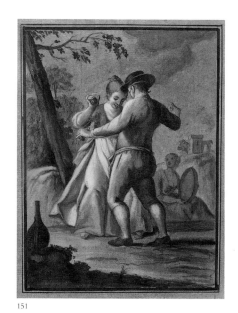

151

151 PIETRO FABRIS (*fl.*1756–84)

Ballo di Napoli, detto la Tarantella,
*c.*1773

Watercolour, 23 × 17 cm
Carlo Knight, Naples

The tarantella is a mimed courtship dance, usually performed by a couple playing the tambourine and castanets and surrounded by others singing. It derives its name from Taranto (ancient Tarentum) in Apulia. In the eighteenth century, it was popularly believed that the dance and the music were a cure for the bite of the tarantula.

This drawing was made either as a study for, or finished drawing after, a plate in Fabris's *Raccolta di varii vestimenti ed arti nel Regno di Napoli*, published in 1773 and dedicated to Sir William Hamilton (see cat. no. 150). It is an early example of a type of image which David Allan was at the same time beginning to develop for British Grand Tourists (see cat. no. 146) and was to evolve further in watercolours and oil for a Scottish market. Fabris's images of the costumes and street vendors of Naples and the surrounding area were destined to become part of a tourist industry which from 1783 produced such figures, individually and in groups, for the decoration of porcelain as well as in the form of coloured prints, watercolours and paintings in bodycolour and oil (see cat. nos 149, 152).

152 XAVIER DELLA GATTA
(*fl.*1777–1827)

*Vicinanze di Napoli, c.*1803

Watercolour, 31.4 × 44 cm
Inscribed: *Xav.r della Gatta 1803* and below image
 with title and the types of costumes
Carlo Knight, Naples

Della Gatta, a pupil of Fabris, produced

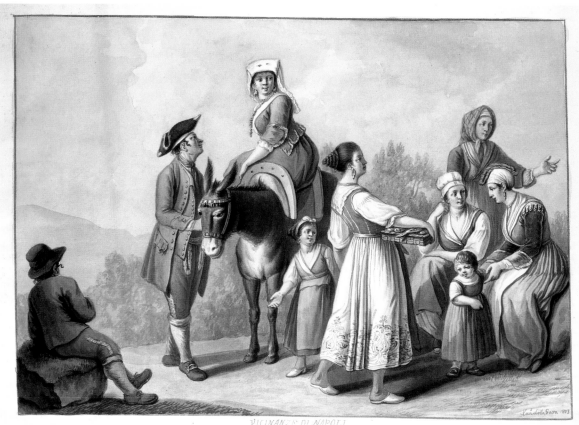

152

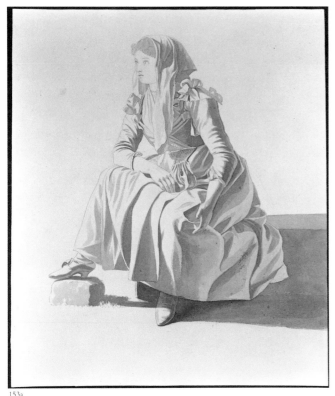

153a

153b

numerous bodycolour *veduti* of Naples (see cat. nos 22–3), and like his master issued throughout his career copies of favourite compositions with slight variations, staffed by the same stock figures. In 1783, however, ten years after the publication of Fabris's book of costume studies of Naples (cat. no. 149), Della Gatta and his fellow pupil Alessandro D'Anna were given a royal commission to travel throughout the kingdom to document all its costume types. This watercolour illustrates seven costumes from the various coastal villages around Naples. The images were originally intended to decorate a table service but they were also issued as a book of plates in 1793. The engravings could be coloured and were popular with tourists, who would order a series of watercolours or bodycolour drawings as souvenirs.

The second sale of Sir William Hamilton's collection, in April 1801 at Christie's, included several lots described as 'Six Drawings in Water Colours, Framed and Glazed, representing the Dresses and costumi of the peasants in the Kingdom of Naples, by the famous Danna and other Neapolitan artists'. What had begun as charming views of picnics in grottoes and views of Naples with street vendors, painted by Fabris from the 1750s through the 1770s, had become an

industry where the figures were less stereotyped and more carefully studied, becoming the focus of the composition, while the landscape not only became more generalised and receded into the background, but often disappeared altogether.

LITERATURE: *Golden Age of Naples*, I, pp. 193, 195, n. 22, II, p. 395.

I 53 GIOVANNI BATTISTA LUSIERI (1755–1821)

Four Studies of Neapolitan Women

Pencil, pen, ink, grey wash, approx. 25 × 20 cm
Provenance: Part of contents of artist's studio, acquired from the artist's heirs by 7th Earl of Elgin, 1824; by descent to present owner
Earl of Elgin and Kincardine, K.T.

The approach of Fabris, Allan and Della Gatta to the study of the costumes of Naples was that of artists interested in reflecting the life, society and customs of the people who wore them. Their peasants are engaged in social activities – dancing, eating or selling their wares – and some indication is usually given of the area of the city or landscape in which they could be found. When inserted into compositions, the figures enliven the landscape and become the focus of activity

or central feature of the work. In the larger views by artists who were professional landscapists, such as Hackert and Ducros, they have a similar enlivening effect, and although they are incidental, they are nevertheless appropriate. If they are sometimes slightly intrusive or awkwardly drawn, it is because these artists often employed others to insert figures into the areas they had left blank.

The figures in Lusieri's finished watercolours, however, are like manikins. There is no doubt that, unlike Hackert and Ducros, Lusieri himself filled the blank areas in his large works, but his figures are posed and stiff, depicted with a scientific accuracy that indicates they have been removed from their normal activity and made to stand still so that the artist could draw every detail, rather than sketching them moving about in their daily occupations. A large number of these careful, posed figure studies, some coloured, some washed and some in pencil outline only, remained in his studio at his death. They are lovely, no doubt extremely accurate studies of the costumes, hairstyles and jewellery worn by these women, but when these individually charming figures were inserted into finished works, even though they are usually shown engaged in conversation, they have about as much animation as Lusieri's rocks.

Lady Hamilton's 'Attitudes'

Emma Hart was famous in her own right all over Europe long before she became Lady Hamilton or met Horatio Nelson. Between them, Emma and Sir William Hamilton seem to have created, and certainly popularised, a new performance art which swept England and the Continent and spawned imitators in private and public parlours for the next thirty years. The art of performing 'attitudes' died out as suddenly as it had begun, but it left legacies in various forms of *tableaux vivants* – bringing paintings to life with groups of figures and music – which became a popular home and theatre entertainment that lasted throughout the nineteenth century. The game of charades owes much to this tradition.

When he first met her in London late in 1783, Sir William recognised in Emma all that he thought beautiful in Classical sculpture, Roman wall- and Greek vase-paintings, and the works of the old masters. He commissioned paintings of her in the guise of a young bacchante from Romney and Reynolds while she was still his nephew's mistress. Critics who reviewed these paintings agreed that Emma was the personification of ideal beauty, as did the artist-antiquarian Gavin Hamilton when he met her at Charles Greville's in 1785 and declared he would 'not rest untill he has prevail'd on her to sit' (Morrison, no. 139). As soon as she arrived in Naples, Sir William commissioned artists to paint her, but others clamoured to have the privilege without commission, or at the request of patrons who had heard of her beauty. During the six years after her arrival, in addition to the artists whose paintings of her are illustrated in this catalogue, she was painted by Gavin Hamilton, Alexander Day, Guy Head, and particularly Wilhelm Tischbein, who found in her a model to inspire him throughout the rest of his career. Several of his sketches of Emma are now in the Goethe Museum at Weimar (Oppel, pp. 45–7), while all his paintings of her, such as *Orestes and Iphigenia* (Schulze, no. 197) and his little-known but striking image of her as a Sibyl (fig. 45), appear to have been commissioned by German patrons.

The news of Emma's instalment at the Palazzo Sessa fanned the flames of her famous beauty back in Britain, but in Italy she quickly became as much a sight of Naples for artists and travelling visitors from all over Europe as a visit to Pompeii or Vesuvius. An envoy's wife would normally be expected to entertain the constant stream of visitors with her *conversazioni* or musical entertainments, as Lady Catherine had done, but when she arrived Emma was not yet conversant in other languages than English and had no musical training. Her accomplishments lay elsewhere, and a means of exploiting them for the entertainment of guests was soon found when Sir William devised a large black box with a gold frame in which she could pose to imitate Pompeian wall-paintings. However, the box was discovered to be cumbersome and confining and was relegated to the store-room, where Goethe saw it when he visited Sir William in 1787 and wrote the earliest and most famous of the numerous descriptions of Emma Hart's 'attitudes':

> She lets down her hair and, with a few shawls, gives so much variety to her poses, gestures, expressions, etc., that the spectator can hardly believe his eyes. He sees what thousands of artists would have liked to express realized before him in movements and surprising transformations – standing, kneeling, sitting, reclining, serious, sad, playful, ecstatic, contrite, alluring, threatening, anxious, one pose follows another without a break In her he [Hamilton] has found all the

antiquities, all the profiles of Sicilian coins, even the Apollo Belvedere. [Goethe, *Italian Journey* (1962 edn), p. 208]

Others remarked upon the skill with which she used her cashmere shawl, her ability to imitate all the passions in her face, and her use of props such as vases, knives and even young girls. At the time there was a fashion for visiting sculpture collections in the evenings, to view the statues by torch or candle light, in which they would appear to have come to life. Some observers commented that Emma was lit during her performances in a similar manner. Most of all, however, they remarked upon her long, flowing hair and how it enlivened and enhanced her movements, which were not static poses, but fluid and continuous metamorphoses from one recognisable attitude into another.

Even before William Hamilton began collecting in Italy, both Walpole and Hamilton's banker had remarked upon his 'passion' for collecting paintings and feared it would be his ruin. In Italy, Hamilton's passion for objects of beauty quickly extended to vases, bronzes, sculpture and gems as well as painting. When he had first met Emma, it had been enough to possess images of her beauty in paintings by Reynolds and Romney; mindful of his very public position as a king's minister, his passion did not aspire to possessing Emma herself, and he resisted strongly when Greville suggested it a few years later. He acceded to his favourite nephew's request only under relentless pressure from him, a sense of empathy for his situation as the younger son of a peer, and in the belief that it was to be a temporary arrangement. Emma herself remarked shortly after her arrival in Naples upon the form Hamilton's admiration for her took: 'Sir William is never so happy as when he is pointing out my beautyies to [his friends]' (Morrison, no. 150). Accepting the situation, Hamilton found he could make it acceptable to the society in which he had to live in Naples by ensuring that Emma possessed some of the accomplishments necessary for the companion of a man in his position. He thus became Pygmalion to Emma's Galatea, creating an adornment similar to that normally provided by an envoy's wife, and carefully nourishing her accomplishments so that she could in fact become one. At the same time, however, he created his own living embodiment of all that he had always admired in the art of Classical antiquity and the old masters, breathing life, movement and passions into cold marble, pottery and paint, and enabling him, as Walpole so shrewdly commented, to marry his 'Gallery of Statues' (*Wal. Corr.*, XI, p. 349).

LITERATURE: Most of the biographies of Emma discuss her 'Attitudes', most recently Flora Fraser, *Beloved Emma*, London, 1987; but K. G. Holmström's *Monodrama, Attitudes, Tableaux Vivants*, Stockholm, 1967 remains the most thorough account, and places them within the context of similar types of performances by artists throughout Europe before and after Emma.

154 SIR THOMAS LAWRENCE
(1769–1830)

Emma, 1791

Black and red chalk with stump, 20 × 15 cm, oval
Inscribed: *Emma 1791*
Provenance: Bequeathed by Richard Payne
Knight in 1824
British Museum, P&D OO–5–22

Illustrated on page 19, fig. 5

Richard Payne Knight had known Thomas Lawrence from at least 1788, when he commissioned a painting from Lawrence of *Homer Reciting his Poems*. It was exhibited at the Royal Academy in 1791, the year Sir William Hamilton and Emma were in London during the summer before their marriage. Knight's friendship with Hamilton probably dated back to his first visit to Naples in 1777, and his collection of bronzes, many purchased from or given to him by Sir William, began seriously in 1785 (see cat. no. 126).

Early in their visit of 1791, when Hamilton was putting his affairs at home in order and Emma spent much of her time sitting to Romney, Thomas Lawrence wrote to his friend the topographer Daniel Lysons, saying that a 'particular friend of mine [Payne Knight?] promised to get me introduced at Sir William Hamilton's, to see this wonderful woman you have doubtless heard of – Mrs Hart'. The appointment overlapped one with Lysons, and Lawrence asked what he should do:

> I hear it is the most gratifying thing to a painter's eye that can be; and I am frightened, at the same time, with the intimation that she will soon be Lady Hamilton and that I may not have such another opportunity; yet I do not know that I can receive greater pleasure than I should have in viewing the beautiful scenery of Nature with Mr. Lysons.
>
> [D. E. Williams, *The Life and Correspondence of Sir Thomas Lawrence*, London, 1831, I, p. 103]

The immediate outcome of the proposed introduction is not certain, but Emma and Hamilton paid a visit to Downton Castle, Payne Knight's seat in Hertfordshire, sometime later in 1791, when Lawrence was there. The result of that visit was the present drawing and a promise from Emma to sit to Lawrence for a large formal portrait once she returned to town. In a letter to Payne Knight which must have been written shortly afterwards Lawrence wrote:

Lady Hamilton has left her best portrait with you. I found her in town, too much engaged to give me the time I wished for and was necessary, but I must put it down to a good motive, viz., the gratitude to Mr. Romney, whose portraits of her are feeble, – more shew the artist's feebleness than *her* grandeur. [G. S. Layard (ed.), *Sir Thomas Lawrence's Letter-Bag*, London, 1906, p. 29; date and name of addressee not given] Evidently the drawing Lawrence had made of Emma at Downton had been taken to a degree of finish to be presentable as a gift, and Emma had asked that it be given to Payne Knight.

During the brief sittings in town, Lawrence managed to produce an oil sketch of Emma's head and shoulders, wearing the same scarf around her hair, but shown three-quarters face and with her chin lowered, as it is in the magnificent large portrait of her as *La Penserosa*, painted for Lord Abercorn and exhibited at the Royal Academy the following year. Lawrence prided himself on how quickly he could capture a likeness and how few sittings he required even for grand portraits. On 27 October 1791, just over a month after the Hamiltons had left London, Payne Knight wrote to Sir William that he had just seen the large painting of Lady Hamilton by Lawrence, 'which will be one of the finest Portraits ever painted. The Likeness however is not quite so fortunate as that of the little Drawing which he made at Downton, & which is now engraving under his Direction' (Payne Knight letters, Christie's MSS sale 20 June 1990, lot 271).

The print was a stipple, engraved by Charles Knight in 1792 (cat. no. 155). On 11 October 1794, Payne Knight reported to Hamilton that 'In the Month of July last I left with Vandergucht to send to you with some Pictures, a Parcel containing the Plate from Lawrence's Drawing of Lady Hamilton & a few Impressions, together with two Books [one was his poem *The Landscape, a Didactic Poem*]. ... I have about 20 more Impressions of the Plate which shall be distributed to any of Lady Hamilton's Friends here, as she shall direct' (Payne Knight letters, as above).

This drawing, which Emma signed and presented to Payne Knight, was not the only gift she made to him. In January 1795, Payne Knight wrote to her from London (Morrison, no. 253) thanking her for her letter and her 'elegant present'. She had

written commending his poetry (*The Landscape*) and sent the gift by way of apology for not having written for some time. Knight wrote that he accepted 'her elegant fragment of Greek sculpture as a memorial' of their renewed friendship and would value it accordingly. The present was the bronze ass's head (see cat. no. 126).

LITERATURE: K. Garlick, *Thomas Lawrence*, exh. cat., Royal Academy, 1961, no. 44; Jaffé, no. 57.

155 CHARLES KNIGHT (1743–1826)
after SIR THOMAS LAWRENCE
(1769–1830)

Emma 1791, 1792

Stipple engraving, 24 × 17.6 cm
Inscribed in pen and ink below pressmark: *Lady Hamilton*
Provenance: Bequeathed to British Museum by the Revd Clayton Mordaunt Cracherode (1730–99)
British Museum, P&D Q.3–151

See cat. no. 154.

156 WILLIAM LOCK (1767–1847)

Emma, Lady Hamilton Dancing the Tarantella

Pencil, pen and ink and wash, 37.3 × 28.7 cm
Provenance: Purchased from Colnaghi's
British Museum, P&D 1906–7–19–4

Although this drawing probably never belonged to Sir William Hamilton, he knew several members of the family known as the 'Locks of Norbury'. William Lock the elder (1732–1810) had made an extensive Grand Tour around 1750, bringing back a fine collection of antique sculpture and old master paintings which he installed in the house he had built in the 1770s at Norbury Park, near Mickleham, Surrey. His wife was the daughter of Sir Luke Schaub, whose own famous collection of pictures had been sold in 1758, when William Hamilton made some purchases from it (see p. 79). Renowned for his hospitality in a circle which included the Angersteins, Fanny Burney and Samuel Johnson, William Lock was also a patron of contemporary British artists including Sandby, Fuseli and Lawrence. Sir William Hamilton knew Lock's collection

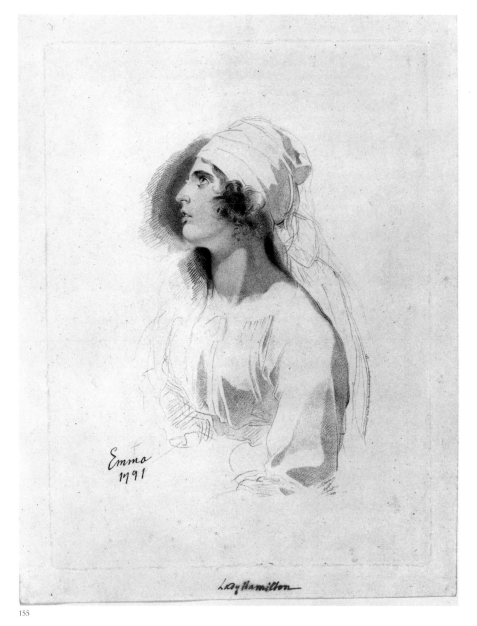

Emma
1791

Lady Hamilton

155

this time, 1781–3. Gilpin wrote that 'energy of character, & expression must take the lead' in sources of the sublime in history, whereas Lock the elder, using the authority of Reynolds, felt that simplicity and repetition of ideas create a grandeur in design which is marred by violent and affected contrasts (Barbier, pp. 129ff.).

Simplicity and repetition certainly work most effectively in the present drawing, and a number of drawings similar to it in style survive from the younger Lock's earlier period along with numerous pen and ink and wash sketches for ambitious historical compositions. Lock's father complained of his son's indolence, however, in his attempts to learn to paint in oil, and Gilpin wrote a mock obituary, to shame him into activity:

> All that remains of this master's works are the outlines of a few heads, characters, & slightly detached figures, which were ... etched in a masterly manner, by sign. [or] Stampozzi. ... The fact is, he was a born gentleman; & lay under the misfortune of not being obliged to use his pencil for his maintenance. If his father had been so kind as to have disinherited him; & bequeathed him only a pot of oil – a few bladders of paint – a pallet, & a dozen brushes, it is thought he would have made one of the greatest masters in the art of painting, the world ever saw. [Barbier, p. 160]

In 1789, Fuseli visited the Locks several times, commenting favourably on the younger Lock's drawings and encouraging him to go and study in Rome. Lock left in the autumn of 1789 and was still in Rome in May 1791, but he was not popular with the artists there. The sculptor Christopher Hewetson wrote to George Cumberland that month that Richard Colt Hoare was abused because he only employed landscape artists, while 'A Mr Lock has not been better treated for presuming to draw remarkably well, for giving his opinions and for not employing any body at all' (British Library, Add. MS 36,496, 14 May 1791). The family history, which is not at all specific about dates, merely indicates that the result of his time in Italy was to realise he could never compete with the great masters of the past and he gave up painting in oil, but continued to draw (Sermonetta, p. 49). The date of his return to England is not known: it has always been assumed to be late in 1791, but the *Note dei Forestieri* for Venice (763, Sir Brinsley Ford Archive, Paul Mellon Centre)

well and in 1787 described him as 'one of the three true Connoisseurs of the arts in England' that he could name, the other two being Charles Townley and Charles Greville (British Library, Add MS 36,495, f. 267). William Lock was able to return the compliment in kind in the summer of 1791 when, after Sir William Hamilton had taken Emma to visit, Lock wrote to a friend that 'All the Statues & Pictures I have seen were in grace so inferior to Her, as scarce to deserve a look' (Anson, p. 316; the phrase incorrectly given to William Lock the younger by Fraser, p. 239, and Sermonetta, p. 155).

William Lock the elder conducted a lengthy correspondence about the picturesque and various aspects of the sublime with the Revd William Gilpin, headmaster of Cheam School, in the 1780s. Lock's eldest son, William, was attending Cheam School in 1781 and may have helped Gilpin obtain the 'secret process' of aquatint which enabled him to publish the first of his well-known picturesque tours (*Tour of the Lakes*) (Barbier, p. 68, no. 7). William Lock the younger was an extremely talented young artist, and Gilpin also advised on his interpretation of the sublime in the historical compositions on which he was working at

156

same date, 1791. But as we know that Lock the younger was in Italy, probably Rome, during 1791, this drawing could only have been made at the end of that year when the Hamiltons passed through Venice and Rome on their return to Naples. Not enough is known about William Lock's travels in Italy to say whether he might have visited the Hamiltons in Naples. His brother Charles Lock and his wife Cecilia came to know the Hamiltons almost too well, when Charles was appointed Consul to Naples and joined the royal family and court at Palermo in 1799 (see pp. 35–6).

LITERATURE: For William Lock see C. P. Barbier, *William Gilpin*, Oxford, 1963, *passim*; Sermonetta, *passim*; and D. Shackleton, *Exhibition of Drawings by William Lock of Norbury 1767–1847*, Edinburgh, 1990.

157 MARIANO BOVI (1757–1813) after WILLIAM LOCK (1767–1847)

Emma, Lady Hamilton Dancing the Tarantella, 1796

Coloured stipple engraving, 38.7 × 29.8 cm
Provenance: Purchased from Colnaghi's
British Museum, P&D 1906–7–19–5

The engraver and print-seller Mariano Bovi (see also cat. no. 12) had been sent to England by Ferdinand IV to study under Bartolozzi. An exhibition of the extensive stock held in 1802 in his rooms in Piccadilly included drawings and furniture prints as well as the usual decorative stipple engravings. Many of the drawings he engraved were by well-known amateurs, including Lady Diana Beauclerk, Lady Bessborough and the Countess Spencer. The print after William Lock's drawing was titled *The Two Sisters* in the 1802 catalogue (no. 48, price £0.7.6 in colours). The original drawing by Lock (cat. no. 156) came into the British Museum identified as Lady Hamilton dancing the tarantella, and there is another edition of Bovi's print lettered below the image 'Grace is in all their steps, &c. Milton'. The impression owned by Walter Sichel, Emma's biographer (reproduced opp. p. 109) was inscribed in pencil 'Lady Hamilton'. Bovi's print was probably issued without Lady Hamilton's name for reasons of propriety – the same reason Friedrich Rehberg's set of her 'Attitudes' did not identify her as the original subject (cat. no. 160).

indicate the presence of a 'Mr Lock' there four times in 1792, the last in September. Farington, who knew the family well, did not record his presence back in London until 1794 (Farington, *Diary*, I, p. 182).

The present drawing is one of William Lock's finest of this type. It was dismissed as insipid by Barbier and other earlier commentators on his work, perhaps because so many of his drawings were reproduced as decorative stipple prints (as was the present drawing in 1796, see cat. no. 157). His drawings, so admired by Fuseli, who even in 1795 still claimed to Farington that they could not be rivalled by any man of the day

for invention, taste, spirit and execution (*Diary*, II, p. 417), show something of Fuseli's own style, but the present work owes an even greater debt to the influence of another child prodigy – Thomas Lawrence. William Lock had known the young artist since the latter's period in Bath in the mid-1780s. Lawrence painted the portraits of father and son in 1789–90 and called Lock the younger 'Raphael William'.

Thomas Lawrence drew and painted Emma Hart in London and Downton in the summer of 1791, just before her marriage to Sir William (cat. no. 154). Flora Fraser (p. 239) gives William Lock's drawing the

Drawn by Wm Locke Esq London Published by Mrs Born No 247 Piccadilly, May 2d 1796. Engraved by Mrs Bovi

157

158 JEAN SUNTACH (1776–1842) after
DOMINIQUE VIVANT DENON
(1747–1825)

Madame Hart, 1791

Etching, 23 × 17 cm (trimmed)
Provenance: Sir Austen Henry Layard; his papers
presented to Department of Manuscripts,
British Library, by Gordon Waterfield, 1970;
transferred to Department of Prints and
Drawings 1989
British Museum, P&D 1989–11–4–430

Denon was in Venice working on a history
of painting when he made an etching of the
recently married Lady Hamilton. The print
shown here is a later reissue, in reverse, by
Jean Suntach, mistakenly titled *Madame
Hart*. After their wedding in London in
September 1791, Sir William and Emma left
immediately for Paris, where they stayed a
few days before going on through Europe.
They were in Geneva near the end of

September (Anson, p. 314) and spent some
time in Rome, arriving back in Naples only
in December. They appear to have stopped
in Venice *en route*, as Hamilton had done in
1771, and there renewed acquaintance with
Denon. The Hamiltons' presence in this
city would also explain the group of draw-
ings of Emma by the Venetian artist Pietro
Novelli (cat. no. 159).

Denon made other etchings of Emma
which show her in a double image, moving
from one attitude to another, and also as a
standing figure of *Innocence*, with a lamb at
her feet (*Illustrated Bartsch*, vol. 121, .011,
.048). This etching, however, is a more
formal portrait, emphasising her youth and
beauty. Framed in profile by her shawl, she
is standing next to an urn which she fre-
quently used as a 'prop' and admiring a stat-
uette of Diana, one of the goddesses she
imitated in her attitudes and in whose guise
she had been painted by Romney and others.

159 PIETRO ANTONIO NOVELLI
(1729–1804)

Attitudes of Lady Hamilton, 1791

Pen and brown ink, 19.5 × 32 cm
Inscribed: *Pietro Antonio Novelli Veneto, dis.* and
Attitudes of Ly. Hamilton, and numbered 3
Provenance: One of a group of drawings sold at
Christie's 6 July 1977 (lot 69); Kunsthandel
Bellinger, Munich (exhibited at Harari &
Johns, London), 1987; purchased 1988
National Gallery of Art, Washington, DC,
1988.14.1

Novelli was an artist and writer who worked
mainly in his native city of Venice. He must
have made this drawing when Sir William
and Lady Hamilton stopped there on their
way back to Naples at the end of 1791. It is
one of a group of four drawings which give
a clearer indication of the nature of Lady
Hamilton's 'attitudes' than the more famous
Rehberg series (see cat. no. 160) or any of
the paintings for which Emma sat to a
multitude of artists in over twenty years of
performances. Novelli's drawings, which
show her full-figure, indicate how clever
manipulation of her long shawl while stand-
ing could change her from a figure of
tragedy to a demure supplicant or a devo-
tional saint on her knees; how props such as
a vase, an axe or a child enabled her to depict
a Roman maiden making an offering or
Medea slaying her child; and how a lying or
kneeling pose could with the slightest move-
ment turn Agrippina clutching the ashes of
Germanicus into a drunken bacchante.

Two other drawings in the group by
Novelli focus on Lady Hamilton's face and
head (fig. 97), showing her to be as young,
round-faced and large-eyed as in Denon's
etching of the same year. They also demon-
strate how, in the performance of her atti-
tudes, Emma relied as much on her ability
to depict the passions through facial expres-
sions and the careful arrangement of her
long hair or her shawl, as she did on the
graceful movements of the rest of her
figure. The Conte della Torre di Rezzonico
confirmed this in his account of one of her
performances in 1789:

> I observed with great delight that just as the
> Greeks learnt to preserve the beauty of
> their females' faces even when expressing

Dessiné par M. De Non *gravée par M. Jean Suntach*

158

159

tears or pain, equally the new Campaspe
when adopting an attitude of pain never
lost her beauty, and even when occasionally
opening her eyes round in fright, did not
seem to act, but imitated to perfection now
the Medusa of Rondanini and of Strozzi,
now the Marys at the Sepulchre of
Annibale Carraci. [pp. 246–7]

FIG. 97 Pietro Novelli, *Attitudes of Lady Hamilton*.
Pen and ink, 1791. Sold Christie's, 6 July 1977,
lot 70.

160 TOMMASO PIROLI (1750–1824)
after FRIEDRICH REHBERG
(1758–1835)

Drawings faithfully copied from Nature at Naples and with permission dedicated to the Right Honourable Sir William Hamilton,
1794

Original stitched folder, containing engraved title page and twelve etchings, 26.9 × 20.8 cm
Provenance: Purchased from Mr Bihn
British Museum: P&D 1873–8–9–131 to 143

Rehberg studied with A. R. Mengs in Rome at the end of the 1770s and on his return to Germany was appointed drawing master to Hamilton's friend the Prince of Dessau at Wörlitz. A Prussian art academy was projected for Rome in 1787, and Rehberg returned to Italy. There he must have come into contact with Tischbein, who was soon to be working on the publication of Sir William Hamilton's second collection of vases. The outline drawings Rehberg made in Naples for this set of Lady Hamilton's attitudes clearly show the influence of the artistic circle in which he was working (Wendorf, n.p.), an influence emphasised by the employment of the engraver Tommaso Piroli, whose prints of John Flaxman's outline illustrations to Homer had appeared the previous year.

The twelve attitudes in which Emma is represented in this publication have their origin in a variety of sources familiar to all connoisseurs and Grand Tourists. No doubt this contributed to the enjoyment of the performances, adding the pleasure of recognition to the experience. Some of her poses which were easily recognisable to her contemporaries are less obvious to us now without the assistance of their accounts:

> ... she single-handedly created a living gallery of statues and paintings. I have never seen anything more fluid and graceful, more sublime and heroic; the English Aspasia knows very well how to assume every part; thus at one moment I was admiring in her the constancy of Sophonisba in taking the cup of poison ... at another the desperation of Gabriella de Vergy, on discovering the heart of her warrior lover still beating in the fatal vase;

160

afterwards, changing countenance at a stroke, she fled, like the Virgilian Galatea who wishes to be seen among the willow after she has thrown the apple to the shepherd, or else she cast herself down like that drunken Bacchante extending an arm to a lewd satyr. [Rezzonico, pp. 247–8]

When she began to perform her attitudes around 1786, Emma's repertoire was at first based on old masters and the wall-paintings at Pompeii or Classical sculpture such as the Niobe group. No doubt Sir William's vases also provided inspiration. Some of the poses, such as the one shown here (Lady Hamilton seated in a klismos chair in a pose entitled *Penseroso* in the later German edition), indicate literary sources; Milton's *Penseroso* (see cat. no. 154) and Sterne's *Maria* had been the subject of many recent paintings by Joseph Wright of Derby and others. The eleventh plate in the series was described as *Saint Rosa* in the German edition,

but the figure is remarkably similar to Flaxman's image of Dante's *Beatrice*, engraved by Piroli only the year before he produced these plates.

The publication of Rehberg's drawings of Emma's attitudes went through several editions. Piroli's name is given in one edition, apparently the first (not dated), and in another the date 1794 replaces the engraver's name. A third edition was frequently sold with a drawing book of twelve similar plates of outlines 'selected with great care from Antient Statues, Monuments Basrelievos &c representing the principle Characters in the Plays of Racine ... from the most correct & chaste Models of Grecian & Roman Sculpture' and included on the title page a reference to several other drawing books, including 'Lady Hamilton's Attitudes'. Finally, a French and German edition was issued which provided titles for the 'attitudes'.

Lady Hamilton's attitudes were already well known in court circles throughout Europe, as Emma had performed them not only in Naples to visitors from all countries for over eight years, but also in London, Paris, Geneva, Venice and Rome in the year of her marriage, 1791. With Rehberg's publication, their fame was extended to other levels of society, to collectors of prints and to the growing numbers of amateur artists who used them as copy-books, not just in Britain, but also in France, Germany and Switzerland.

LITERATURE: Holmström, pp. 119–25 (reproduced in full); and Jaffé, pp. 36–9; for an exhibition based on the publication see Wendorf.

161 WILLIAM ARTAUD (1763–1823)

Sketches of Lady Hamilton's Attitudes, 1796

Pencil, in sketchbook, 11.3 × 18 cm
Provenance: Descendants of Anna Susanna
 Tayler, sister of the artist; presented by
 Mrs E. M. Tayler
British Museum, P&D 1973–12–8–85 (6, 7)

The Huguenot history painter William Artaud arrived in Rome as a Royal Academy travelling scholar in January 1796. Shortly afterwards, on hearing of the French advance

161

through northern Italy, he left for Naples with a number of other artists. In May he reported to his father:

> The environs at Naples are truly Classic Ground, I have visited Lake Avernus, have been in the Elysian Fields, in the Baths of Nero, & in the Tomb of Virgil. I have also descended upwards of 100' into the Crater of Vesuvius, & saw the astonishing effects of the destruction of the Village of Torre del Greco. ... I have been at Herculaneum & Pompeii & the Museum at Portici, & saw Lady Hamilton's attitudes, & made several drawings from the King of Naples' Collection at Capo de Monte. [Sewter, p. 115]

Lady Hamilton had given performances of her attitudes in London and several cities in Europe in 1791 and had been presenting them in Naples for ten years when Artaud arrived in the city; by then, they were as much a part of the sights of Naples as the wonders of nature and antiquity. The quick sketches he made of Lady Hamilton in several attitudes are not labelled, but they are readily recognisable from records by other artists. They are quite different in character from other drawings in the sketchbook, such as his pen and ink sketches for historical compositions or the more careful pencil and wash studies he made three years later of the daughters of British families in Dresden, acting out their own parlour versions of the 'attitudes'.

Artaud's four or five pages of sketches of Emma were made very quickly and are very faint and difficult to decipher, but, like the drawings by Novelli, they emphasise the fact that the attitudes were a series of movements rather than static poses. Artaud's depictions, clearly showing Emma's long hair and swirling shawl, include Medea, a penitent Magdalen, the Muse of dance and a bacchante, all recognisable to him from their echoes of figures in history paintings he had painted himself or seen by other artists in Britain and Rome.

LITERATURE: For Artaud, see Sewter; also K. Sloan, 'William Artaud: history painter and "violent democrat"', *Burlington Magazine*, CXXXVII, February 1995, pp. 76–85.

Hamilton's Collection of Paintings

162 HUGH DOUGLAS HAMILTON
(1740–1808)

Portrait of Emma, Lady Hamilton as Three Muses, c.1789–90

Oil on canvas, 35.5 × 43.8 cm

Inventory label on verso: *BL 86*

Provenance: Possibly in collection of William Beckford; inherited by his daughter, Susan Beckford, who married Alexander, 10th Duke of Hamilton; by descent to present owner

Part of the Hamilton Collection, Lennoxlove, Haddington, East Lothian, Scotland

Traditionally attributed to Angelica Kauffman, this painting was assigned in the mid-1980s to the Austrian artist Ludwig Guttenbrunn (1750–post 1813), who was active as a portraitist and history painter in Italy in the 1780s and in London between 1790 and 1795. It has also been described as by Gavin Hamilton (Knight, 1985, p. 52). The oval portrait of Sir William (cat. no. 163) which hangs next to this painting of Emma at Lennoxlove, has been attributed to an equally lengthy list of artists. However, both can now be confirmed as the work of the Irish artist Hugh Douglas Hamilton.

Sir William's manuscript inventory of the paintings in the Palazzo Sessa (British Library, Add. MS 41,200, f. 122) lists two related images of Lady Hamilton in the room next to the library: 'Small picture in chalk of Ly H. reposing on a couch – by Hamilton; Lady H. in 3 different views in the same picture – by Hamilton'. James Clark's packing list described him as 'Crayon Hamilton' and indicated that the medium of both was crayons on paper (see Fothergill, p. 438). The image of Lady Hamilton on a couch was described by him as a profile, and Conte di Rezzonico, noting that it was by 'Hamilton the pastel painter', said she held a book (pp. 242–3). It was bought at the 1809 Nelson/Hamilton sale by Tresham (10 June 1809, lot 45), but its present whereabouts are unknown. There are three surviving versions of the triple portrait of Lady Hamilton, all similar in size to the dimensions given by Clark: the present oil from Lennoxlove, another oil (private collection) and a crayon version which was purchased earlier this century from the estate of the Earl of Ilchester, a descendant of Lady Holland, who spent a long period in Naples in the early 1790s (present whereabouts of crayon version unknown).

Hugh Douglas Hamilton trained in Dublin and was already well known in Ireland and London as an excellent portraitist in crayons before he travelled to Italy in 1779. While there, he attempted to extend his abilities by increasing the scale of his works and by painting in oil, traditionally considered a more important medium, which he could employ in works of the highest academic category, history painting. He may have visited Naples several times, but he was certainly in the Naples area early in 1788, when he visited Pompeii (Cullen, p. 168, and n. 28), and Conte di Rezzonico mentions that Hamilton the pastellist was with him when Emma performed her attitudes for them (he was in Naples from 1789 to June 1790, p. 357). Hugh Douglas Hamilton had already executed at least one history painting and several portraits in oils by this date and was being encouraged by Flaxman to paint more in this medium. Since works on paper exist of both this triple image of Emma and the portrait of Sir William, he

FIG. 98 Hugh Douglas Hamilton, *Sir William Hamilton*. Black chalk, *c.* 1789–90. Castle Howard, North Yorkshire.

may have made drawings in chalk from life in Naples and worked up versions in oil back in his studio in Rome. His ability to paint in oil is demonstrated most assuredly in his large portrait of the Earl-Bishop with his grand-daughter (National Gallery of Ireland, Dublin).

The figure of Emma on the left, with her head and hands resting on a kithara (stringed instrument) is very similar to his pastel, executed in Florence, of Lady Cowper leaning on an upright volume (exhibited Royal Academy 1787, now Firle Place, Sussex). Both she and at least one other sitter, the Countess of Erne (National Trust, Ickworth), also wear scarves wrapped around their heads like turbans.

H. D. Hamilton owned the first few volumes of *Le Antichità di Ercolano* illustrating the discoveries of Herculaneum, and the engravings after the wall-paintings are known to have influenced his work. He also employed motifs from sculpture studied in Florence and Rome, particularly on the Capitol. Paintings by fellow artists must also have exerted an influence on his depiction of Emma, and the example of Gavin Hamilton's paintings of *Poetry* and *Painting* hanging in the Palazzo Sessa was very evidently before him. The gem-engraver Nathaniel Marchant (cat. nos 113–14), the sculptor Antonio Canova and the antiquary James Byres were his closest contacts amongst the artists in Rome until his departure in 1792.

This portrait has traditionally been entitled *Emma Lady Hamilton as the Three Graces*, but the Graces seldom bear such clear attributes as here and are usually seen full-length and dancing. It is more probable that she is intended to represent the three original Muses, Meditation, Memory and Song. In his publication of Hamilton's vase collection, d'Hancarville argued that they were responsible for man's ability to recall his own history (see p. 149). Later, as nine Muses, they became known more generally as the goddesses credited with inspiration of poetry and song. Traditionally associated with Dionysus and dramatic poetry, the Muses were said to have been worshipped first by the people of Thespiae at the foot of Mount Helicon where they dwelt. In Homer's poems they 'sing the festive songs

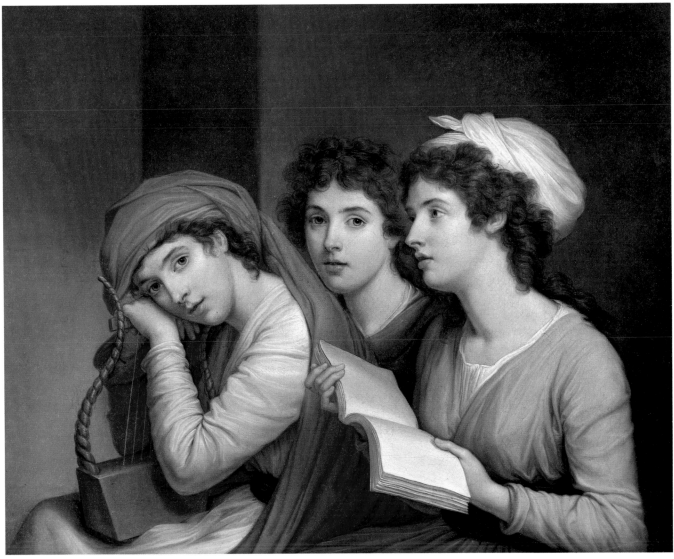

162

at the repasts of the immortals and they bring before the mind of the mortal poet the events which he has to relate and they confer upon him the gift of song' (W. Smith, *Classical Dictionary*, 1877).

By 1788, the year H. D. Hamilton first visited Naples, Emma was already well known for both her 'Attitudes' and her singing. Her portrayal as the original three Muses, better known in the eighteenth century as Terpsichore (the Muse of choral dance and song whose attribute was also the lyre), Polymnia (the Muse of sublime hymn,

without attribute but in a pensive or meditating attitude), and Calliope (the Muse of epic poetry, shown with a book) would be an entirely appropriate compliment for Hamilton's own muse. The small and intimate scale and informality of this jewel-like cabinet picture show clearly that it was a work for private contemplation rather than public consumption and display.

LITERATURE: *Angelica Kauffman und sein Zeitgenossen*, exh. cat., Bregenz, 1968, no. 281, as Kauffman; for H. D. Hamilton, see Fintan

Cullen, 'The oil paintings of Hugh Douglas Hamilton', *Wal. Soc.*, 1, 1984, pp. 165–208. We are very grateful to Dr Cullen for his kind assistance in establishing the artist of this and the following work.

163 HUGH DOUGLAS HAMILTON
(1740–1808)

Portrait of Sir William Hamilton,
c.1789–90

Oil on canvas, 26 × 21.5 cm, painted oval
Inventory label on verso: *BL 85*
Provenance: Possibly in the collection of William
 Beckford; inherited by his daughter, Susan
 Beckford, who married Alexander, 10th Duke
 of Hamilton (1767–1852); by descent to
 present owner
Part of the Hamilton Collection, Lennoxlove,
 Haddington, East Lothian, Scotland

Like the triple portrait of Emma (cat.
no. 162), this portrait of Sir William may
have belonged to William Beckford, but
unlike it or any of the other portraits of him
in this catalogue there is no attempt to
portray Sir William with any attributes – it
is not the portrait of a diplomat, connois-
seur or collector, but simply the man
himself. Also like the triple portrait of Emma,
this painting has been attributed to a
number of artists but can probably be given
to Hugh Douglas Hamilton.

Sir William Hamilton's manuscript list of
correspondents includes the record of a
letter written on 27 July 1790 to 'H. Hamil-
ton Painter' (Bodleian Library, Eng. hist.
g. 16, f. 26), the only time the artist's name
was listed between 1789 and 1791. This
painting does not appear in any of the lists
of Sir William's possessions, so must always
have been intended for a particular patron,
and as a small-scale informal portrait it was
probably intended for a friend who knew
him well. An oval black chalk drawing
related to it (fig. 98) hangs at Castle Howard,
where it has been since the late nineteenth
century and where there are other objects
with Hamilton connections. A later inscrip-
tion on the verso, 'Sir William Hamilton by
Gainsborough', can be safely discounted;
the recent attribution of the chalk drawing
to H. D. Hamilton makes more sense,
particularly considering its close relation-
ship to the oil. As a chalk drawing, the lines
of the hair and face are softer, and the lips
are slightly parted, making it a less hard
image. In the oil the artist firms the lines,
sharpens the gaze and adds gilt buttons

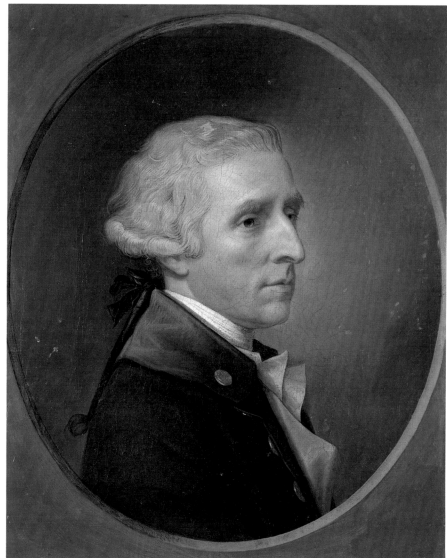

163

under the lapel and a bow to the queue.
The Irish artist's authorship of the oil is con-
firmed by the publication line on the undated
line-engraving by G. Morghen after the oil,
which clearly states 'H. Hamilton pinxit'.
(cat. no. 185). There can be little doubt that
it was painted as a pair to the triple portrait
of Emma – they both had versions in chalks
and neither painting was at the Palazzo Sessa
in 1798 when Hamilton and Clark made
their lists of its contents; neither do they
appear in the 1801 sales.

164

165

164 DAVID ALLAN (1744–1796)

A Painter of the Rue Catalana with his Wife and Child, c.1775

Oil on copper, 23.2 × 21 cm
Provenance: Robert Craig, Leith, from whom
 purchased c.1937 by Herbert Dryden,
 Bonnyrigg; purchased by present owner at
 Phillips, Edinburgh, sale 8 April 1988 (lot 118)
James Holloway

According to Sir William Hamilton's manu-script list of the paintings in the Palazzo Sessa, the room next to the library con-tained a large number of small paintings, including 'Two Bambocciati — by — of Edinburg' (British Library, Add. MS 41,200, f. 121). These were elaborated in Clark's packing list as 'Allan, Two Bambacciati Companions, One representing a Painter of the Rue Catalana with his wife and Child, & the other Two Zampognari playing before the Virgin' (Fothergill, p. 438). They were included in Hamilton's second sale at Christie's, 18 April 1801 (lot 25), as 'Two small pictures representing Neapolitan Devotions'; they were purchased by Cooper for £2.11.0. James Byres owned another version of the present painting on canvas, inscribed on the verso 'The Uncultivated

Genius drawn from the life at Naples D.A. 1775' (now National Gallery of Scotland, 2126). Allan made an etching of the subject titled *A Neapolitan Painter* (National Gallery of Scotland), which is based on both images.

Hamilton's version of this painting by David Allan shows a hack artist at work in the street outside his house with his prod-ucts, including devotional images copied from well-known originals, hanging from the doorway to attract passing customers. The painter's wife knits beside him while he works on a view of the eruption of Vesu-vius with fleeing Classical figures – a popu-lar subject with Grand Tourists, who were familiar with the story of Pliny and the eruption of AD 79. In the version in the National Gallery of Scotland titled *The Uncultivated Genius*, an image of St Januarius is added to the painter's repertoire, and his young son making a child's drawing of a man in profile in chalk on the pavement is moved to the right foreground. The parallel between the child's and the father's 'uncul-tivated genius' is thus made clearer in the National Gallery of Scotland's version and is further underlined in the etching by the addition of a small painting of Vesuvius on the easel above the painting the artist is working on, to indicate he is copying it.

LITERATURE: The image and its satirical sources are discussed at length in P. Georgel, 'Enfance et génie en 1775', *Interfaces, Image, Texte, Langage,* IV, Université de Bourgogne, 1993, pp. 241–72.

165 DAVID ALLAN (1744–96)

Two Zampognari Playing before the Virgin, 1768

Pencil, 21.3 × 21.6 cm
Inscribed in the image: *Ex Devotis Innovata AD 1768*
Provenance: Purchased from Mr Daniell
British Museum, P&D 1865–6–10–1321

The subject of this drawing indicates it was probably the study for a small oil on copper painting that formed the pair to Allan's *Painter of the Rue Catalana* (cat. no. 164). Again the costumes are carefully studied, and the subject was a popular religious custom. Like the figure of the painter, the zampognari are slightly comical figures, but they are not being satirised: the rites of the Catholic Church were followed with un-assuming piety by the people whose manners and morals Allan studied so carefully, and he

recorded them, like the costumes and amusements, in a series. His drawings of *The Seven Sacraments*, which he intended to etch, are on loan to the National Gallery of Scotland and it is in their light that the present drawing should also be seen. An aquatint etching he made of this subject in the same collection is inscribed below in ink: 'The Calabrian Shepherds playing the pastoral to the Infant Jesus at Rome'. Their instruments are the *ciaramella* or bagless pipe, which plays the melody, and the bagpipe or *zampogna*, which provides the accompaniment. It was traditional for Calabrian shepherds to come to towns to play this music during the *novena* days before Christmas and it was much admired by eighteenth-century musicians such as Handel and Bach.

LITERATURE: Errington, pp. 1–6.

166 SIR JOSHUA REYNOLDS (1723–92)

A Bacchante, 1783–4

Oil on mahogany panel, 79.4×61.5 cm
Provenance: Commissioned by Sir William
 Hamilton; his sale Christie's, 28 March 1801
 (lot 50), bought for £131.5.0 by family of
 present owners
Private collection

When he saw this painting in the Palazzo Sessa, Lord Gardenstone said it possessed 'a distinguished gaeity and spirit' (*Memorandums*, III, p. 98). Unfortunately it has suffered badly from Reynolds's over-use of wax and bitumen, a sort of tar which gives a rich and glowing effect when first applied but never completely dries. However, it was very sympathetically restored in the 1960s and much of its original loveliness and warmth remains. It was exhibited at the Royal Academy in 1784, where a mistake in the catalogue (no. 342) left it titled 'A Boy Reading', the title of the work Reynolds originally intended sending. A reviewer in the *Morning Herald* commented, 'This portrait appears to the natural eye one of the nymphs in the train of Comus, and all the aid of Mr. Storer's optics will not transform it to a Boy reading!' (Graves and Cronin, I, p. 425). The *Morning Chronicle and London Advertiser* noted, 'The eye will naturally fasten on the Bacchant of Sir Joshua, by some error omitted in the Catalogue' (19 May 1784), and the mistake was rectified in the reprint of the catalogue.

Sir William Hamilton had arrived in

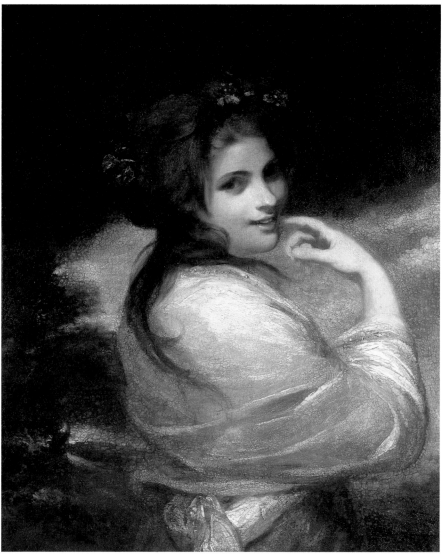

166

London in August 1783, a year after Lady Hamilton's death. He must have seen his nephew Charles Greville almost immediately and met Emma Hart, who was living in his house in Edgware Row, very shortly afterwards. Reynolds's sitters book for 1783 does not survive, but there are appointments for Sir William Hamilton for 31 March and 8, 13, 16 April 1784. Hamilton's niece Mary Hamilton, who was helping him in his negotiations with the Duchess of Portland (see cat. no. 63), attended a *Bas-Bleu* party on 12 April, where Reynolds's niece, Miss Palmer, reported to her that Sir William had been to Sir Joshua's often lately: 'he escorted my Cousin Chs Greville's Mistress, in a *Hackney coach*, & her Uncle [Sir Joshua] was painting this woman's picture for him to take to Naples. I shall

make use of this intelligence to have some entertainment in *plaguing Sir William*' (Anson, pp. 174–5). The Royal Academy exhibition opened on 26 April that year and although the sittings may have begun in 1783, the mix-up with the title in the catalogue indicates that the painting of Emma was a late entry; the flurry of sittings in April confirms this.

Reynolds was at the height of his powers in 1784 and showed sixteen paintings in that year's Royal Academy exhibition, including two of his most successful works, *Mrs Siddons as the Tragic Muse* and *Mrs Abingdon as Roxalana in 'The Sultan'*. He had portrayed another of Charles Greville's mistresses, Emily Pott, in a large history painting, depicting her as the Athenian courtesan *Thais*; her pose and costume are

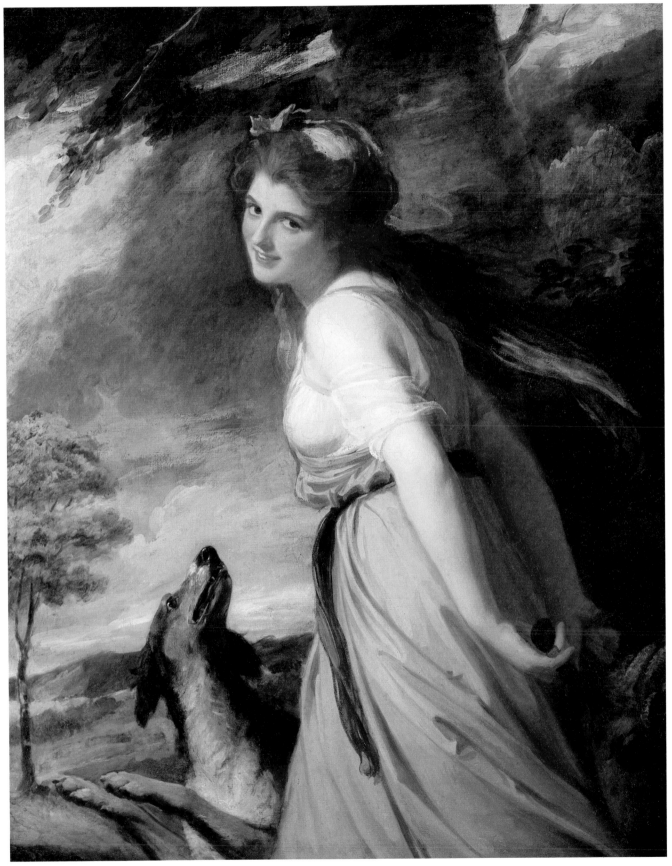

167

strongly reminiscent of other paintings by him depicting bacchantes, shown running or dancing, their hair escaping from its binding. The painting of Thais had been started by 1777, when Hamilton saw it in Reynolds's studio. Hamilton and Greville were aware of the dangers of Reynolds's experiments with media, and in his letter to Hamilton informing him that *Thais* was to be exhibited at the Academy in 1781, Greville noted: 'one additional comfort is that the head, altho' painted some years, requires no more re-painting, & promises to be one of his permanent pictures' (Morrison, no. 102). Recently bereaved, Hamilton was in no position to commission a work on a similar scale. He admired Emma's resemblance to the ideal Classical beauty found in the works of antiquity he collected. Reynolds's *Bacchante* shows a youthful, smiling Emma with an ivy wreath in her falling hair and her finger to her lips, caught in a pose indicative of imminent movement, recognised characteristics of the Muse of comedy, Thalia, an amusing conspirator in a light-hearted Classical allegory.

Hamilton settled his bill with Reynolds in September 1784 before leaving for Naples on the 11th: he paid Reynolds £52.10.0 for the *Bacchante*, £105 for the 'Museum picture' (cat. no. 51) and £36.15.0 as his contribution towards the Dilettanti picture (cat. no. 52). (Cormack, p. 155). He presumably took the *Bacchante* with him to Naples. The painting was described in Hamilton's sale catalogue as 'His Original Bacchante, painted on Pannel. This Picture has for many Years met with the universal approbation of the dilettanti in Italy, and was Engraved before it went Abroad.' The image was thus famous not only in Italy but also in Britain, the mezzotint having been published on 6 September 1784 (fig. 100) as an obvious pair to another portrait of Emma about to be sent to Naples, painted by Romney and depicting her as *Nature* (cat. no. 168). The paintings hung next to each other in the gallery at the Palazzo Sessa.

Another version of this painting, on canvas, remained in the artist's studio and was bought at his sale by James, 8th Earl of Lauderdale for £78.15.0 (Sotheby's, 12 April 1995, lot 55). Three other versions are recorded by Graves and Cronin.

LITERATURE: Graves and Cronin, I, pp. 425–7, IV, pp. 1331–2; M. Cormack, 'Ledgers of Sir Joshua Reynolds', *Wal. Soc.*, XLII, 1968–70, p. 155; for a discussion of Reynolds's allegorical portraits of women, see M. Pointon, 'Graces, Bacchantes and "plain folks": order and excess in Reynolds's female portraits', *British Journal for Eighteenth Century Studies*, 17, no. 1, Spring 1994, pp. 1–26.

167 GEORGE ROMNEY (1734–1802)

A Bacchante, 1785

Oil on canvas, 123 × 100 cm

Provenance: Sir William Hamilton; his heir, Hon. Charles Greville; his sale Christie's, 31 March 1810, lot 59 as 'Lady Hamilton as Diana, the well known engraved original picture', bought for £136.10.0 by family of present owners

Private collection

Charles Greville presented his uncle Sir William Hamilton with his portrait by Romney and had it sent to Naples sometime between 1785 and 1788 when Hamilton received four paintings by Romney. They all appear in Hamilton's 1798 manuscript list of the paintings at the Palazzo Sessa: the present painting of Emma as a *Bacchante*, which Sir William had commissioned in 1783; another portrait of Emma holding a dog, titled *Nature* (see cat. no. 168), originally commissioned by Greville himself and said to be the earliest Romney painted of her (Frick Collection, New York); a portrait of *Emma in Morning Dress*, the size of the *Bacchante*, which Emma wrote that Hamilton desired for his new apartment in 1786 (Rothschild Collection); and finally Greville's own portrait (cat. no. 49).

When Hamilton had left for Naples in 1784, the *Bacchante* was not ready, and in December Greville, who was overseeing the commission, wrote to his uncle 'Let me know how the Bacante is to be paid. I will have it packed when an opportunity offers. The dog was ugly, & I made him paint it again.' He wrote again in January: 'Emma is very grateful for your remembrance. Her picture shall be sent by the first ship – I wish Romney yet to mend the dog' (Morrison, nos 131, 134).

A review in *The World* in February 1787 described Romney's 'tender bewitching' touch in the dozens of portraits of Mrs Hart: 'They are full of captivation . . . Of these any might have gone abroad with Sir William Hamilton and answered *all his purpose* full as well as the piece he has taken with him. A piece more cumbrous and chargeable than any of the foregoing' (British Museum, P&D, Whitley Papers, X, p. 1282).

Because Sir William at first assumed, in error, that he had lost his paintings as well as his vases in the wreck of the *Colossus*, and this painting was purchased at Greville's rather than Hamilton's sale, it was for a long time assumed to be a copy of the lost original (Sichel, p. 92, n. 1). Confusion has also been caused by its being described as Lady Hamilton with a dog, as she holds one in *Nature* as well. The dog in the painting is different from the one in the later engraving after it by Charles Knight (fig. 99), and the goat is difficult to see in both the engraving and the paintings. The alternative title for the painting, *Diana*, has also caused confusion. However, the painting was listed in Hamilton's manuscript list of contents of the Palazzo Sessa, and it was included in Clark's packing list. Other paintings in the same crate appear in Hamilton's sale, so the painting was evidently not lost at sea. What

FIG. 99 C. Knight after Romney, *Lady Hamilton*. Stipple engraving, 1797. British Museum, P&D 1853–12–10–619.

has not generally been realised is that Greville was Hamilton's heir and inherited a number of paintings which were bought in at Hamilton's sale or which Hamilton chose not to sell. Although Hamilton sold his paintings of Emma by Reynolds, Vigée-Le Brun and Kauffman, he appears to have kept the two larger Romney paintings of Emma as a *Bacchante* and *In Morning Dress*, and both appear in Greville's sale after his death, where this painting was purchased (Christie's, 31 March 1810, lots 42, 59).

This early image of Lady Hamilton as a *Bacchante* was less restrained than later paint-

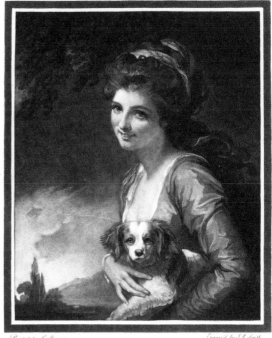

168

FIG. 100 J. R. Smith after Reynolds, *A Bacchante*. Mezzotint, 1784. British Museum, P&D 1834–2–12–18.

ings after her marriage. As a young woman who was mistress of Hamilton's nephew, it was acceptable at this time for Emma to be portrayed with all the attributes of a maenad with vine leaves in her hair, dancing herself into a frenzy for a bacchic festival. Conte di Rezzonico noted the 'certain wantonness' she displayed in this painting by Romney, who seemed 'to have excelled all his fellow artists' (p. 242). This image became a very famous one. When the painting left the studio in October 1785, a reviewer in *The Arts* expressed the wish that it had been engraved before it went abroad (Whitley Papers, x, p. 1279). It was not engraved, however, until 1797, when Charles Knight published a stipple engraving 'from the original in Sir William Hamilton's collection in Naples' (fig. 99). In fact Knight probably used as his source the copy Romney made for himself, with the original dog and with one of Emma's breasts exposed, still in the artist's studio at his death. Since Sir William's was the more

important and famous version, the engraver would naturally claim it as his source, and the print itself was copied by several engravers throughout the nineteenth century, when Emma's fame had increased even further.

LITERATURE: Ward and Roberts, pp. 180–81.

168 JOHN RAPHAEL SMITH (1752–1812) after GEORGE ROMNEY (1734–1802)

Nature, 1784

Mezzotint, 38 × 27.5 cm
Provenance: Purchased from Messrs Evans
British Museum, P&D 1853–12–10–626

The original painting (Frick Collection, New York) from which this mezzotint was engraved was the first commissioned from Romney by Charles Greville of his mistress Emma Hart. He had sat to the artist himself for a portrait in 1781 (cat. no. 49) and Emma was first taken to Romney's studio in April the following year. Wearing a rich red dress, she is depicted as a lovely young woman, lively and full of movement, as if she has been running and just picked up the dog,

whose large eyes, staring directly at the viewer, mirror her own. The pose of a young woman holding a faithful spaniel was a common motif for this size of portrait in the middle of the eighteenth century.

As the verse printed below the image makes clear, it was commonly believed that dogs were the means through which a woman's feelings for nature could be channelled into love. She innocently parades her loveliness by caressing the animal, which mirrors her own gentleness, docility and spaniel-like affection (see Shawe-Taylor).

Greville was to commission a number of other larger portraits of Emma and asked for first refusal on several large history pieces for which she was the model, but by the time they were completed he could not afford to purchase them and Emma was no longer his mistress.

In 1783–4, Sir William had commissioned a small painting of his nephew's mistress as a *Bacchante* from Reynolds (cat. no. 166). It was approximately the same size as Romney's portrait of her holding a dog, which was entitled *Nature*. In the end it was Hamilton who purchased this first small painting by Romney. It was engraved by

169

J. R. Smith and published in May 1784 before being sent to Naples, where it was joined on the walls of the Palazzo Sessa by the small *Bacchante* by Reynolds, which had also been mezzotinted by Smith in September 1784, in a similar format, with a border line in aquatint, as if to create a pair showing the two sides of Emma's character.

LITERATURE: See T. Clifford, A. Griffiths and M. Royalton-Kisch, *Gainsborough and Reynolds in the British Museum*, exh. cat., 1978, no. 147; and see D. Shawe-Taylor, *The Georgians: Eighteenth-Century Portraiture and Society*, London, 1990, pp. 137–40.

169 ELISABETH VIGÉE-LE BRUN (1755–1842)

Head of a Young Woman ('Lady Hamilton'), *c.*1790

Charcoal on panel, 26 × 33.6 cm

Inscribed: *Ce dessin fait par Madame Le Brun, avec un morceau de charbon de cuisine sur une porte d'une chambre au Casino du Chev. Hamilton, Ministre d'Angleterre à Naples a été enlevé par ordre du Chev. avide de posséder et de conserver le moindre échantillon du pinceau de cette amiable et sublime artiste*

Provenance: Sir William Hamilton; his sale Christie's, 17 April 1801 (lot 22), bt Samuel Woodburn £1.17.0; Earl of Warwick, by descent to present owner, on loan to Madame Tussaud's, Warwick Castle

Earl of Warwick

This work appeared in Hamilton's own 1798 manuscript list of his collection in the Palazzo Sessa, as 'Woman's head drawn with Charcoal – by Madme Le Brun'. It hung in the Library in the company of other small works on panel and only two items in the list away from the Mengs *Head of Christ* (cat. no. 174) (British Library, Add. MS 41,200, f. 121). It was included in the second, less important sale at Christie's in 1801, as lot 22 on the first day, 'Drawing in Charcoal from the Kitchen, on a Pannel of a Door at Pausilipo', where it was bought with lot 23 ('Spanish – Two Portraits, glazed') for £1.17.0 by Woodburn. Arguably the most discerning British dealer during the nineteenth century, Samuel Woodburn purchased a large number of other items at the sale (Brigstock, p. 477).

Unlikely as the inscription seems, its truth would seem to be verified not only by Sir William Hamilton's own description and that in the sale three years later, but also by the artist herself. In her *Memoirs*, Vigée-Le Brun mentioned she had dined a few times at Sir William's summer house on the water's edge (Villa Emma; see cat. no. 23) and added the following footnote: 'One day I sketched two small heads in charcoal upon one of the doors; I was very surprised to find

the same sketches in England at the home of Lord Warwick [she was in England 1802–5]. Sir William had had the surface of the door sawn off and had sold my sketches: I do not remember the exact sum he obtained for them' (*Memoirs*, pp. 105–6).

It is curious, however, that although this is undoubtedly one of the two original drawings Vigée-Le Brun made in charcoal on the door of the Villa Emma, neither she nor Sir William Hamilton actually states that it is a portrait of Emma. It is nevertheless close in character to the three oil paintings of Emma made by Le Brun at this time, 1790–92, when Emma was twenty-five years of age.

LITERATURE: Vigée-Le Brun, *Memoirs*, pp. 105–6.

170 After ELISABETH VIGÉE-LE BRUN (1755–1842)

Lady Hamilton, en Sibylle

Lithograph, 37.1 × 27 cm
Provenance: Purchased from Mr J. Deffet Francis
British Museum, P&D 1867–12–14–648

In Hamilton's sale at Christie's on 28 March 1801, lot 28 by Madame Le Brun was a 'Head of a Sybil painted by herself, from the large Picture which she calls her Masterpiece, and which Travels with her' (bought by Lord St Helens for £32.11.0). Vigée-Le Brun's own account is thus unfair and inaccurate: 'Later when I painted Lady Hamilton again, as a sibyl for the Duc de Brissac, I decided to make a quick copy of the head and send it as a present to Sir William, who without hesitating sold it' (*Memoirs*, p. 102). Emma sat to her at Caserta in 1790 or early 1791, while she was still Emma Hart, and Le Brun took credit for the originality of the manner in which she had arranged Emma's hair in a shawl, twisted around her head in the style of a turban so that one end fell over her shoulder; but Emma had worn one wrapped in a similar manner an earlier oil by Romney (National Portrait Gallery). In addition, beginning with A. R. Mengs's adaptation of Guercino's *Persian Sibyl* (see Roettgen, nos 23, 31), there had been a series of works by a succession of British and other artists of compositions and allegorical portraits based on, and copies of, the Guercino and Domenichino's *Cumaean Sibyl* in the Villa Borghese in Rome.

The artist's entire account of her stay in Naples and of Sir William and his patronage and hospitality is not only very ungracious

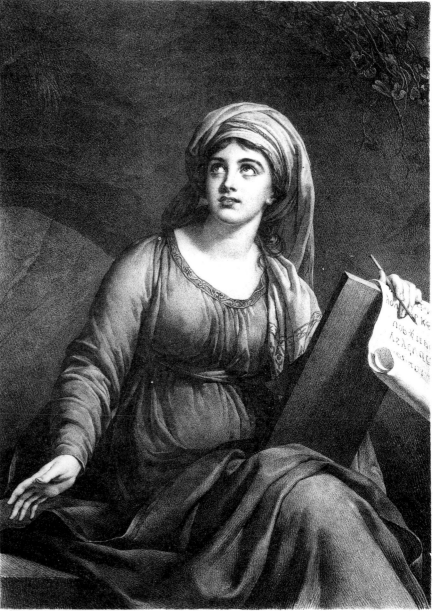

170

but also littered with one-sided accounts of later events and several other small inaccuracies. She particularly complained of Sir William trying to make money by reselling his paintings if he might benefit financially and seems to imply that he sold the work he commissioned from her (*Emma as a Reclining Bacchante*), the one she gave him as a gift, and even two drawings she had made on a door of the Villa Emma (see cat. no. 169), immediately after acquiring them. This was unjust, since it was not until he was forced to sell his entire collection that all the works he owned by her were sold. In fact, she

benefited more from his patronage – by using her painting of the famous Lady Hamilton as a sibyl to earn further commissions on her journey through Europe – than he ever earned through the sale of her works. His list of the collection at the Palazzo Sessa indicates that his bust-length version of the painting of Emma as a sibyl given to him by Le Brun hung in a bedroom with the Ducros (see cat. no. 181), Kneller's portrait of Prince Rupert and works by Gavin Hamilton, and that the large painting of *Emma as a Reclining Bacchante* held a central place in the large room he called the

Gallery. Le Brun claimed that Sir William sold the latter painting for 300 guineas. In fact, Nelson had discovered that it was to be included in Christie's March 1801 sale and purchased it beforehand so that it did not appear in the catalogue. He wrote to Emma that he had bought it because he could not bear it should be put up at auction 'if it had cost me 300 drops of Blood I would have given it with pleasure ... I desire it always to hang in my Bed chamber and if I die it is yours' (quoted in Le Brun exh. cat., Kimbell Art Museum, 1982, no. 31). It next appeared in the sale Emma held of Sir William's and Nelson's remaining effects (Christie's, 8 June 1809, lot 82), where it fetched 130 guineas.

Vigée-Le Brun saw her painting *Lady Hamilton, en Sibylle* as a history painting, and considered it to be one of her finest works. Its debt to Domenichino was not only in the subject, the turbaned Cumaean sibyl holding a scroll, but also in the emphasis placed on Emma's large eyes looking upwards, which must have found their source in Domenichino's well-known painting of *St John the Evangelist* then in the collection of the Duc d'Orléans. Vigée-Le Brun kept the original *Sibylle* with her until 1819, carrying it with her on her travels through Europe. She recorded in her *Memoirs* that one student at the Academy at Parma, who saw it in her private rooms, actually 'threw himself at my feet, his eyes full of tears ... If any among my readers should accuse me of vanity, I leave them to reflect that an artist works all his life to experience two or three moments such as the one I have just described' (p. 124). In Venice Vivant Denon exhibited the painting in his studio. In Vienna in 1793, Vigée-Le Brun exhibited it in the drawing-room of Prince de Kaunitz, where the court and town could see it for a fortnight. It was also placed on public display in Dresden at the express wish of the Elector of Saxony (see Helm). Vigée-Le Brun even sent it from St Petersburg to be shown in the Paris Salon in 1798. A version signed and dated 1792, possibly the original, was with the Hallsborough Gallery, New Bond Street in 1965 (cover, *Connoisseur*, July 1965, now private collection).

Sir William's list of correspondents includes a letter to Vigée-Le Brun written on 9 October 1792, which was presumably thanking her for the present of the smaller version (Bodleian Library, Eng. hist. g. 14). The artist had not completed the larger painting while she was still in Naples, but took it with her to Rome to finish. Anne Pitt, the daughter of Lord Camelford, sat to Vigée-Le Brun in Rome for her portrait as Hebe; on 19 January 1792 she noted in her diary that the Sibyl was finished, except for the hands. She went on to describe it as 'one of the most striking pictures I ever saw – the figure finely conceived – the attitude extremely simple with a great deal of dignity – the drapery wonderfully fine' (quotation courtesy of P. Miller of Ken Spelman Books, York, and C. Lloyd-Jacob).

Vigée-Le Brun made a fourth painting of Emma while she was in Naples. Titled *A Bacchante*, it showed her three-quarter length, her hair loose, dancing with a tambourine, and Vesuvius smoking in the distance. Once in a Parisian collection and now in the Lady Lever Art Gallery, Port Sunlight, it does not appear to have been painted for Sir William and is not mentioned in the artist's memoirs.

LITERATURE: W. H. Helm, *Vigée-Le Brun, Her Life, Works and Friendships*, London, 1916, pp. 114, 119, 121; *Elisabeth-Louise Vigée Le Brun*, exh. cat., Kimbell Art Museum, Fort Worth, Texas, 1982, no. 36; Vigée-Le Brun, *Memoirs*, pp. 102–5.

171 RAPHAEL MORGHEN (1758–1833) after ANGELICA KAUFFMAN (1741–1807)

Lady Hamilton as the Comic Muse, 1791

Engraving, 43.7 × 31.5 cm
Provenance: From Paruli's group of works by
 Morghen purchased from Messrs Colnaghi
British Museum, P&D 1843-5-13-1009

On their return to Italy after their wedding in London in September 1791, Sir William took the new Lady Hamilton to sit to

Angelica Kauffman in Rome. The painting may have been started at the beginning of the year before they left for London, as a letter from Kauffman to Sir William in May 1790 expressed her delight at his proposed trip to Rome (E. Wolf MSS, sale, Christie's, 20 June 1990, lot 272). A note in the artist's 'Memorandum of Paintings' records that the painting was completed in December and Hamilton paid 120 *zecchini*, Kauffman's usual price for a full-length portrait.

Kauffman's normal practice was to make careful preparatory drawings of the face to capture a likeness, either in chalk or in oil on a small canvas, and then to work on the large canvas; she worked hard, painted quickly, and did not use a drapery painter. It has been suggested that she may usually have offered a number of stock poses for clients to choose from, but in this case no doubt Sir William selected both the pose and allegorical association with deliberate care. Kauffman herself described this painting as

Lady Hamilton ... life size half length figure, portrayed as the character of comedy with one hand she is lifting up a curtain as if just coming out to appear before the public, and the other hand is raised and holding up a mask which she has taken off her face; she is garbed in classical style in thin and light material, her hair is partly hanging loose on her shoulders, and partly tied round the forehead; she is a very expressive and effective figure. [Manners and Williamson, p. 161]

A topos had developed in eighteenth-century portraiture in which young women, some newly married, could be depicted in the guise of the Graces, particularly the bacchante Euphrosyne who was the Grace of Mirth, or of Thalia, the Comic Muse, whose attributes were similar, but whose associations were slightly different – the bacchic Grace bore erotic overtones, while the Muse was respectably associated with the inspiration of the arts, in particular with music, comedy and theatre (see, for example, Reynolds's portrait of *Mrs Abingdon as the Comic Muse*, 1768, Waddesdon Manor). Milton's poem 'L'Allegro' was a hymn to Mirth while 'Il Penseroso' celebrated

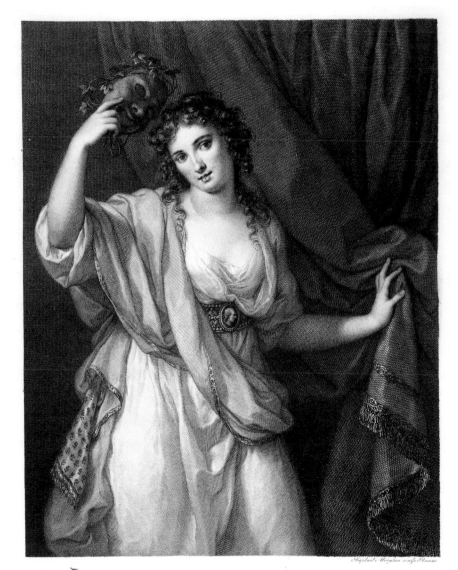

Quam veteres Graÿ pulchram expinxere Thaliam
expicta est nostro pulchrior in Latio.

171

Melancholy, the Muse of Tragedy, whom he also called the 'pensive nun'. Emma had been depicted many times as a bacchante, even specifically as Euphrosyne, before her marriage to Sir William, but in London in 1791 Thomas Lawrence was working on a grand sedate portrait of her as *La Penserosa* for the Duke of Abercorn, the head of the Hamilton family, who had supported their wedding. It would seem appropriate for Sir William Hamilton's own 'wedding portrait' of Emma to celebrate the 'Allegro' side of her character, Hamilton having supervised her thespian and musical talents as well as her ability to become a source of inspiration for artists over the previous five years. Milton's poem, however, celebrated the bacchic Euphrosyne, while Emma's identity here as Thalia, the Comic Muse, was more appropriate for a respectably married woman, and the subtle differences between the two – the one wild and abandoned and the other gently revealing herself – are carefully attended to and underlined in Kauffman's portrait. Emma wears a cameo portrait of Sir William in her belt, and the Latin inscription at the bottom of the print is a tribute to his role as creator of his own muse. Loosely translated it reads: 'The beautiful Thalia whom the Greeks painted, has been recreated more beautiful in Latium.'

The painting was engraved in Rome by Raphael Morghen before being sent on to Naples. A letter from Kauffman to Lady Hamilton in December 1793 indicates that the painting was lost at some stage, presumably *en route* to Naples: 'I was glad to hear from Sir William that your Ladyships portrait at last was found had your Ladyship made a longer stay in Rome – I should have produced a better Picture – approaching nearer to a Model inimitable – and so excellent in mind, and person –' (Manners and Williamson, p. 87). The present location of the painting is not known, but it may be the portrait of Lady Hamilton, signed and dated 1791, recorded as lot 133 in a sale at Christie's on 1 July 1921 (Manners and Williamson, p. 235); the vendor was the Marquess of Hertford, of Ragley Hall (the first Marquess was the brother of Hamilton's friend Henry Seymour Conway). It had been lot 31 on the first day of Hamilton's sale on 27 March 1801: 'This Picture is full of grace, and very harmoniously Coloured' (bt Alexander, price £31.10.0). The painting hung in the Gallery in the Palazzo Sessa next to a Giorgione portrait and Furini's *Sigismunda*, some distance from the earlier portraits of Emma by Romney and Reynolds.

LITERATURE: Manners and Williamson, pp. 87, 161.

172 RAPHAEL MORGHEN (1758–1833)
after GAVIN HAMILTON (1723–98)

a) *La Peinture*, 1780

Engraving, 43.5 × 30.5 cm
Provenance: From Paruli's group of works by
 Morghen purchased from Messrs Colnaghi
British Museum, P&D 1843–5–13–980

b) *La Poésie*, 1779

Engraving, 43.5 × 30.7 cm
Provenance: From Paruli's group of works by
 Morghen purchased from Messrs Colnaghi
British Museum, P&D 1843–5–13–982

It has often been assumed that Emma had
served as the model for Gavin Hamilton's
lost paintings of *Poetry* and *Painting* once in
Sir William Hamilton's collection. An early
catalogue raisonné of the prints of Raphael
Morghen listed his engravings after these
paintings (Maskell, 1882, nos 48, 49); dated
1779 and 1780, the prints had been exe-
cuted long before the arrival of Emma. The
existence of these prints after the lost paint-
ings was not known to scholars of Gavin
Hamilton's work and they are reproduced
here for the first time.

Sir William had known Gavin Hamilton
at least since the latter excavated the War-
wick Vase at Hadrian's Villa before 1770
and he had also bought a Palma Giovane
painting from him around this time (cat.
nos. 128, 173). But Sir William was inter-
ested in owning a painting by Gavin Hamil-
ton's own hand and had commissioned one
of the *Muse of Painting*. It was finished in
1777, but Gavin Hamilton did not send it
from Rome until the next summer, inform-
ing Sir William that he had kept it over the
winter because he did not have many of his
own finished works to show visitors to his
studio. The result was that the German
consul Johann Friedrich Reiffenstein, the
unofficial successor to Winckelmann as the
expert in Classical antiquity and modern art,
had begged to have a drawing made of it,
almost to the size of the original, 'which has
taken up a good deal of time. Besides I
somewhat regret sending you this lame
performance, being a thing unworthy of
your acceptance, but till such time as I can
send you a better I have risqued my Muse
& have delivered it' (Morrison, no. 84, 5
July 1778). No mention was made of the
painting of the *Muse of Poetry*.

Morghen's print after the *Muse of Paint-
ing* indicates that the drawing was by the

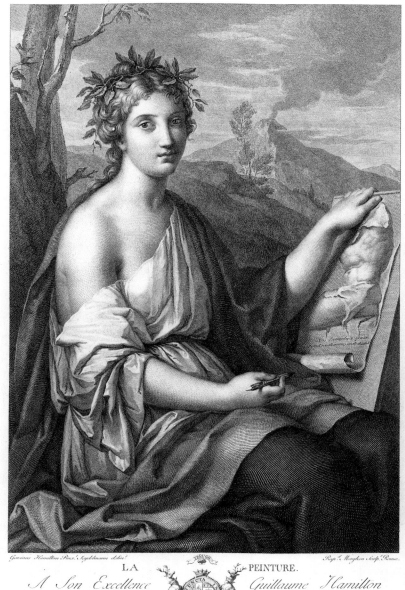

172a

young German artist Jacob Seydelmann
(1750–1829); the print, sold by Georg
Hackert in Rome, was dedicated by
Morghen to Sir William Hamilton with a
note that the painting was in his collection.
The pair to it, however, *The Muse of Poetry*,
was apparently not drawn by Seydelmann,
and when it was engraved by Morghen and
dedicated to John Acton it may not yet have
been in Sir William's collection. Gavin
Hamilton frequently painted a pair to his
compositions; although this may not have

been commissioned by Sir William, it was a
natural pair to the one he already owned
and he presumably purchased it shortly after
it was engraved. A similar pair, entitled *Love*
and *Friendship*, was offered to the Earl of
Shelburne in 1779 (Lord E. Fitzmaurice,
*Letters of Gavin Hamilton from MSS at Lans-
downe House*, Devizes, 1879, pp. 47–8).

The Muse of Painting owes much of its style
and composition to two of Sir William's
favourite artists, Guercino and Guido Reni,
and its iconography is a standard one, used

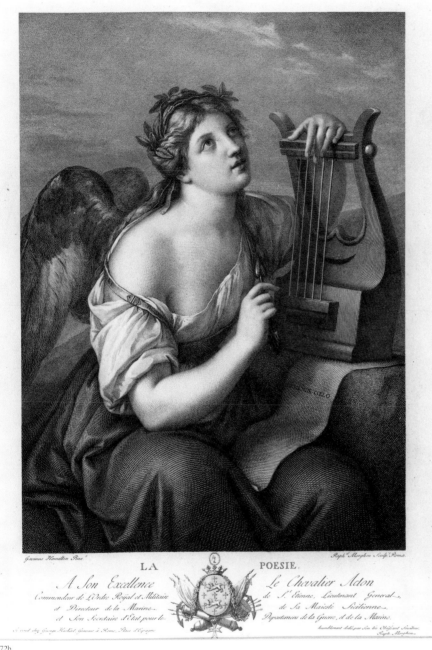

Gavinus Hamilton Pinx.

LA POESIE.

A Son Excellence

Commandeur de L'Ordre Royal et Militaire
et Directeur de la Marine
et Son Secretaire d'Etat pour le

Raph.s Morghen Sculp.t Romæ.

Le Chevalier Adon

de S.t Etienne, Lieutenant General
de Sa Majesté Sicilienne,
Departement de la Guerre, et de la Marine.

humblement dedié par Son tres Obeissant Serviteur
Raph.s Morghen.

172b

notably by Angelica Kauffman in her own self-portrait *The Artist in the Character of Design and Poetry* (1782). However, Gavin Hamilton's painting contains a personal reference to Sir William in the depiction of Vesuvius in the background, and the carefully displayed anatomical drawing of the Belvedere Torso with its clear inscription from Horace's *Ars Poetica*, 'Nos Exemplaria Graeca Nossuma versale manu versale diema' ('Place the Greek masterpieces before you, study them night and day'). The Belvedere Torso, housed in the Vatican Museum, had long been one of the paradigms of what was thought to be Greek art. According to Gavin Hamilton, 'the most valuable acquisition a man of refined taste can make is a piece of fine Greek sculpture' (Lloyd Williams, pp. 14–15). Although the *Muse of Poetry* may not have been commissioned by Hamilton,

FIG. 101 Bust of Gavin Hamilton by Christopher Hewetson, 1784. © Hunterian Art Gallery, University of Glasgow.

it is certainly appropriate that this sister art to painting is shown receiving inspiration from heaven or the gods, and that poetry is intended to accompany music, of which Sir William and the first Lady Hamilton were so fond. Apollo's lyre was to be used several times in portraits of Hamilton's second wife (cat. no. 162).

Gavin Hamilton returned to England on receiving an inheritance in 1785, and dined several times with Charles Greville, who introduced him to Emma. 'He says he has not seen anything like her in G.B., & that she reminds him of a person at Rome whom he admired much, tho she was deficient in the beauties of the mouth, & that Emma's is both beautiful & uncommon' (Morrison, no. 139). The model in Rome was no doubt the one used for the two paintings of the Muses and it is not surprising, then, that both the artist and Sir William found in Emma the embodiment of their Homeric ideal of beauty. Emma sat to Gavin Hamilton in London that year and later in Naples, and his paintings of her as a *Sibyl* (private collection) and the pendant of her as *Hebe*, the youthful cup-bearer of Zeus (Stamford, Conn.) are no doubt the result, although neither ever appears to have belonged to Sir William Hamilton as has sometimes been stated (Jaffé, 1972, no. 34).

Sir William Hamilton owned at least one other large oil painting by Gavin Hamilton of *A Sleeping Venus and Cupid with Lyre*, described in the sale of 27 March 1801, lot 59, as 'well composed, finely drawn, and better than most of that Master' (£27.6.0).

LITERATURE: J. Lloyd Williams, *Gavin Hamilton*, Edinburgh, 1994; I am grateful to Antony Griffiths for suggesting the source of the quotation as Horace.

173 JOSEPH PERINI (1748–after 1795)
after PALMA GIOVANE
(*c.*1548–1628)

Jupiter & Antiope, 1770

Plate no. 26 from Gavin Hamilton's *Schola Italica Picturae*, 1773

Engraving, 28 × 24.7 cm

Provenance: Purchased from Messrs Willis and Southerland

British Museum, P&D 1856–5–10–229

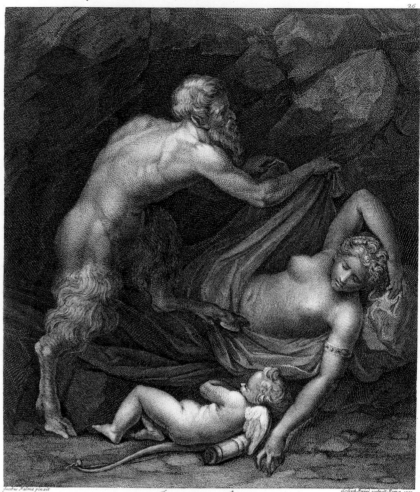

Jacobus Palma pinxit *Joseph Perini sculpsit Roma 1770*

Juppiter et Antiopa
Ex Tabula in Ædibus Principis Pio Romæ asservata.
Schola Italica.

173

In the Christie's sale of Hamilton's paintings, this work was described as 'A Satyr admiring a Sleeping Venus, Cupid presiding, in Chiaro-scuro. This Picture was in the Collection of Prince Pio, at Rome, and was engraved in the Collection of Great Italian Masters, published by Gavin Hamilton, at Rome' (Christie's, 27 March 1801, lot 55, bought for £11.11.0). Burton Fredericksen of the Getty Provenance Index has very kindly pointed out that it appeared in the inventory of Cardinal Carlo Pio di Savoia of 1 March 1689 as by Dosso Dossi, and in that of Prince Francesco Pio di Savoia of 23 March 1724 as an anonymous work. After Hamilton's sale it went through Phillips three times and was eventually sold to 'Taylor' at Christie's on 30 March 1824 for £4.4.0. It does not appear in the most recent catalogue raisonné of Palma Giovane's work (S. M. Rinaldi, Milan, 1984) and its present location is not known. The great-nephew of Palma Vecchio, this Venetian artist was greatly admired in the eighteenth century as a pupil of Titian, although this is no longer thought to be the case; his style was also reminiscent of Veronese and Tintoretto, the other two Venetians whose work was most sought after by collectors.

Gavin Hamilton published his *Schola Italica Picturae* in 1773, a gallery in print of old master paintings of consistently high quality, some of which were in important churches and collections in Rome; others Gavin Hamilton owned or had purchased as an agent. It included prints after works by Michelangelo, Raphael and Leonardo, as well as Reni's *St Jerome* and *Lot and his Daughters*, now in the National Gallery, London. The large-scale prints were made over a period of four years by a variety of the best Roman engravers, including Domenico Cunego and Giovanni Volpato. Some of them were accompanied with quotations from the Bible, Horace and other Classical authors, which served to give explanations and context to the titles. As the title page indicated, the publication could serve as a visual history of the Italian school of painting; however, by placing works he owned and had sold among some of the greatest works by Michelangelo and Raphael, Gavin Hamilton was cleverly advertising works for sale and flattering those who had bought paintings from him, such as William Beckford and the Duke of Ossory, whose names as owners were given in the letter-press. As a method of advertising, it was obviously successful in the case of Sir William Hamilton, whose name was not given on this print and who must therefore have purchased the painting after the publication of this book.

William Hamilton's association with Gavin Hamilton was close and probably dated from a time even before William arrived in Italy; it certainly lasted until Gavin's death in Rome in 1798. They had a mutual friend in James 'Athenian' Stuart, who had travelled to Naples and shared rooms with Gavin in Rome in 1748–50. He settled in Rome as a history painter in 1756. Winckelmann, who was William Hamilton's guide to Rome in 1768, was a great admirer of what was perceived as the Homeric quality of Gavin Hamilton's paintings. Sir William's notes of the artists he visited on this first trip to Rome do not mention Gavin, but he noted that the Irish statuary Christopher Hewetson was 'excellent for Portraits in Busts' and Sir William later owned Hewetson's bust of Gavin Hamilton (see Clark's list of Hamilton's collection of sculpture, case 4, no. 3 in Ramage, 1989a, p. 705). The bust of Gavin Hamilton is now in the Hunterian Collec-

tion, University of Glasgow, to which it was presented by Charles Greville who inherited it from his uncle (fig. 101). It had been exhibited at the Royal Academy in 1786, the year Gavin Hamilton accompanied Emma Hart and her mother on their journey to Sir William Hamilton in Naples. In 1797 Hewetson was in Naples making busts of Sir William and Emma, unfortunately now lost (Hodgkinson, p. 53).

LITERATURE: T. Hodgkinson, 'Christopher Hewetson, an Irish sculptor in Rome', *Wal. Soc.*, XXXIV, 1952–4, pp. 48–9, 53, pl. XVIC.

174 ANTON RAFFAEL MENGS (1728–79)
Head of Christ for 'Noli me tangere'

Oil on canvas, originally on board,
 47.2 × 37.8 cm

Label on verso inscribed: *Mengs made this Sketch for his great Picture of 'Christ in the Garden' in All Souls Chapel, Oxf, bespoken at 300 Gs . . .*

Provenance: According to label on verso, given to Sir W. Hamilton in its present rosewood frame; his sale Christie's 27 March 1801 (lot 25), bt Mr Lambert of the Temple, £10.10.0 [16 gns according to label]; bt J. W. Steers of the Temple for 23 gns; his sale Christie's 3 June 1826; bt T. C. for 40 gns, for whom outer frame purchased by Seguier July 1826 for 10 gns

Warden and Fellows of All Souls College, Oxford

Hamilton had owned a painting of *Venus* by Mengs even before he went to Italy (Prestage, 25 Jan. 1765, lot 28). On his arrival in Naples, he would have seen some of Mengs's best works, including a magnificent portrait of the young Ferdinand IV and the altarpiece in the chapel at Caserta (*Golden Age of Naples*, pp. 173–5).

In the notes he made on his tour of artists' studios on his first visit to Rome in the spring of 1768, Hamilton described 'Raphael Mengs Saxon' as the 'Best History Painter at Rome. No great natural Talents for Painting, cold in his Compositions, but a perfect Master of the Mechanism of his Art. Excellent Colourist, has a perfect knowledge of Design & the Management of the Chiaro Oscuro' (Limerick MSS, National Library of Ireland). Hamilton's *ciceroni* on this tour of Rome were James Byres and Winckelmann, both of whom had been close friends of Mengs while the artist was in Rome in the 1750s. Winckelmann's portrait had been

painted by Mengs, whom he described as the greatest artist of his time, and the two had worked together on a treatise on the taste of the ancients in art.

In fact Mengs was not in his studio in Rome in the 1760s, when he was working for Charles III in Spain. During his absence, the studio was managed by Anton von Maron (1731–1808), his most faithful pupil, who worked so much in Mengs's style that their paintings are often confused. It was Mengs's practice to make oil sketches before beginning a painting in oil on canvas, and most of these and many of his finished works were on display in his studio in Rome, which remained open to visitors and artists through the 1760s (Roettgen, p. 94). It was

on this visit to Mengs's studio that Hamilton was introduced to Maron and asked him to paint a large double portrait of himself and his wife (see p. 88).

Just before leaving Spain in 1769, Mengs received the commission to paint the altarpiece for All Souls College in Oxford. The commission had come from James Harris, the British chargé d'affaires at Madrid, and was arranged through James Byres. Mengs began making sketches in Florence on his way back and brought them with him to Rome, where Peter Beckford paid a high price for the preparatory sketch for the whole composition. The finished painting was shown to the Pope and displayed to the public at the Villa Medici, thus re-establish-

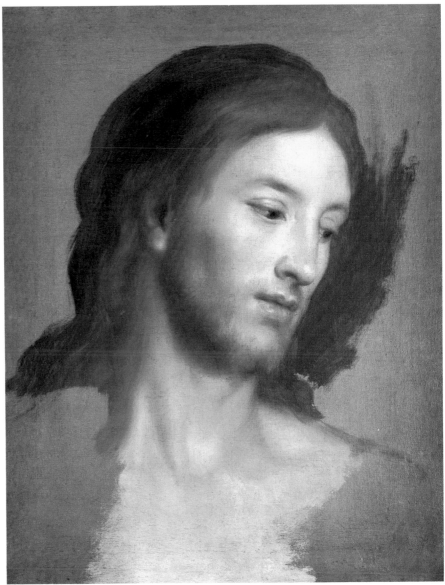

174

ing Mengs's reputation after his return to Rome. It was also exhibited in London before reaching its final destination. The pose of Christ in the final altarpiece is based on the Apollo Belvedere, a work strongly championed by Winckelmann and admired by most British visitors to Rome, whose taste Mengs stated was taken into account in this commission for a British audience.

Mengs's sketch of the *Head of Christ*, originally on panel, hung in the Library of the Palazzo Sessa with Hamilton's substantial collection of oil sketches. The painting serves here as a visual statement of this particular aspect of Hamilton's taste. Not only is the head of Christ given a delicate, almost feminine beauty, but the fresh brushwork and colours exemplify Hamilton's admiration for the spontaneity and immediacy of sketches and their ability to show not only an artist's particular skill but also the most direct part of the creative process.

Hamilton's collection also included Mengs's *Self Portrait with Pallet and Pencils*, of which there are several versions. It was sold at the second sale at Christie's, 18 April 1801 (lot 16), where it was purchased by 'Dawkins' for £1.1.0. It was not a small copy, but the same size as the slightly different self-portrait in the Walker Art Gallery, Liverpool, which shows him with a sketch of one of his works on an easel. Mengs painted many self-portraits of different types and copied each several times, often as gifts for his patrons.

LITERATURE: J. Sparrow, 'An Oxford altar-piece', *Burlington Magazine*, CII, January 1960, pp. 4–9; Roettgen, pp. 30–32, 108–9.

175 GIOVANNI BENEDETTO CASTIGLIONE (c.1610–63/5)

A Procession of Shepherds, c.1650

Drawn with brush in red-brown paint on paper with three crescents watermark, 42.5 × 57 cm

Inscribed on recto: *228* lower left; on verso, in pen and brown ink: *Gio Benedetto Castiglione./a Sua Ecc.za/Il Sig.r Cavalier Hamilton/Ministro Plenipotenz.rio di S.M.Brit.ca/alla R. Corte di Napoli/ N.P. Ant.o Piaggio di Sc.e Pie/D.D. [Dono dedit]* and with the following numbers *No.29* left side, *74* lower left, *3* upper left

Provenance: Padre Antonio Piaggio (Chierico regolare delle Scuole Pie); presented by him to Sir William Hamilton, his sale Christie's

18 April 1801 (lot 62, with a second), bt Clark £1.18.0; Roderic Ringer; Benedict Nicolson, by whom bequeathed to present owner
Private collection

Illustrated on page 86, fig. 44

Castiglione was a brilliantly inventive draughtsman who, inspired by Van Dyck's oil sketches (Hamilton owned two), evolved a technique of drawing on paper in oil in a way which produced a result somewhere between drawing and painting. This drawing is considered to be one of Castiglione's finest journey scenes, dating from a period when he was in Rome and his handling was at its most accomplished. The lovely figure of the woman on horseback appears in at least six other related drawings and in reverse in Castiglione's painting of *Rebecca Led by the Servant of Abraham*, once at Blenheim (now Barber Institute, University of Birmingham; Percy, fig. 12, p. 94). The drawing was referred to as one of a pair by Hamilton in his list of paintings in the library at the Palazzo Sessa, where they were described only as 'two drawings in red chalk by Castiglione'. There is no further description to indicate the subject of the missing drawing, although it must have been a similar brush drawing related to the animal scenes and pastoral and patriarchal journeys that the artist was working on at the time.

One of the most fascinating facts about this drawing and presumably its companion (now lost) is that they were gifts to Hamilton by Padre Piaggio, who was a Genoese like Castiglione. He had come to Naples from the Vatican court in 1753 and devised a method of reading the papyrus scrolls discovered at Pompeii. When turned out of his employment there, Hamilton gave him £20 per annum to keep a diary of the activities of Vesuvius (see pp. 72–3) and he nearly died observing the eruption of 1794, when he was in his eighties.

The beauty of the image in this work by Castiglione, and the free manner in which it is drawn, show the hallmarks of Hamilton's taste and even though he was not a great collector of old master drawings, he had a number of a this type and was a known collector of oil sketches. This drawing and its companion must have had the same effect as compositional sketches – small vivid works of art, which were capable of holding their own on a wall. Hamilton placed them in the sympathetic surroundings of his library, which was hung with several oil sketches by Mengs (cat.

no. 174), Veronese and Rubens (*Conversion of St Paul*, Ashmolean Museum, Oxford, fig. 40) as well as drawings similar in type to the Castiglione, that is, drawings which were executed not as sketches for finished compositions in oil, but were works of art in their own right. They included Vigée-Le Brun's drawing of *Emma* in charcoal (cat. no. 169), two black chalk drawings of old men's heads by Piazzetta, and two drawings in pen and brown ink of the *Prodigal Son* by Guercino. The last two drawings were further described in Clark's packing list and Hamilton's sale (17 April 1801, lot 20) as showing the Prodigal Son, first in his pride, with a woman and child begging, and then in his misery with the hogs. They were purchased at the sale for £21 by J. B. S. Morritt of Rokeby, also the purchaser of the Rubens sketch. Morritt had met Hamilton in Naples in 1795, where he was very impressed by Emma's 'attitudes' and by the attention paid to himself by the king (Marindin, *Morritt*, pp. 268–73).

LITERATURE: A. Percy, *Castiglione*, exh. cat., Philadelphia, Museum of Art, 1971, pp. 33–4, 39, 94–6; Scottish Arts Council, *Italian 17th Century Drawings from British Private Collections*, exh. cat., Edinburgh, Merchants' Hall, 1972, no. 30.

176 Attributed to CORREGGIO (c.1489–1534) by Sir William Hamilton; recently attributed to LUCA CAMBIASO (1527–85)

Venus Disarming Cupid

Oil on canvas, 148.3 × 106 cm

Provenance: Laurenzano Collection, Naples; with Sir William Hamilton by 1771; purchased by Benjamin Vandergucht, London for £1500; purchased at his posthumous sale Christie's 11 March 1796, lot 93, by family of the present owner for £600 (plus commission of £30); by descent
Private collection

Illustrated on page 83, fig. 42

A previously unpublished letter in the Krafft Bequest in the Muséum National d'Histoire Naturelle, Paris, indicates that Hamilton may have purchased his famous Correggio from the Laurenzano collection in Naples through the agency of Cesare Gaetano, Conte delle Torre. The Laurenzano collection had been formed in Rome in the seventeenth century and brought to Naples

and enlarged by later members of the family. Negotiations were delicate and the sum Hamilton paid is still not known, but the price he himself placed on it later indicated that he felt it was the most valuable painting he owned.

Hamilton must have described it fulsomely in a letter to Joshua Reynolds soon afterwards, as in Reynolds's reply of 17 June 1770 the artist mentioned that he had shown the letter to the king, on the latter's request: 'I wonder he was not tempted by your lively description of the Correggio, was I King of England I certainly would have it at all events, there is no Master that one wishes so much to see. Mr Aufrere has brought to England a Marriage of St. Catherine by Correggio and an undoubted true one, full of faults and full of Beauties' (Hilles, p. 27).

In March 1771 Hamilton wrote to Horace Walpole that he hoped to have permission to return to Britain on leave in the next few months and that Walpole would see that he had not been idle since he had been in Naples: 'the lovers of antiquity will I think be obliged to me for enriching our country with a most singular collection, and the lovers of painting for a picture of Correggio, excelled I believe by none' (Wal. Corr., XXXV, p. 409). By the following November Walpole was reporting to Horace Mann in Florence: 'Mr Hamilton's Correggio is arrived – I have seen it; it is divine, and so is the price, for nothing but a demigod or a demi-devil, that is, a nabob, can purchase it. What do you think of three thousand pounds? It has all Correggio's grace, and none of his grimace, which like Shakespeare he is too apt to blend and confound' (Wal. Corr., XXIII, p. 350).

The Correggio was offered to the British Museum with the antiquities, but the Museum argued that paintings had no place in the collection. Hamilton still felt it would do better justice to a collection in Britain than Naples, so he left it with his nephew Charles Greville to hang in his house to see if it would attract any buyers there. On his way home Hamilton wrote to Greville: 'How does my dear Venus? There is nothing like her, believe me. Do make Bartolozzi engrave it, with Cipriani's assistance, if it is still mine' (Morrison, no. 26). Both men feared there would be no British takers and it would have to go abroad, Greville writing 'poor as I am I would give £50 per annum to have it my own, for I find that I spend more than that a year, & have not

pictures I can enjoy like it ... nobody admires it as I do. I think they are so accustomed to bad & middling pictures that they are not equal to the admiration of fine ones' (Morrison, no. 27). Hamilton had arranged for a certain Patoun to make a copy for Naples, and the artist made at least two others, one for himself and one for the Earl of Warwick (Morrison, no. 29; in 1782 Hamilton also sent a copy to Catherine the Great and there are related paintings in Würzburg and Strasbourg). But, according to Hamilton, Patoun was also the reason why the Correggio did not sell, and his letters indicate that the copyist had touched it up for him and done a bad job, 'yet I do not believe that he did it maliciously'. Hamilton asked Greville to arrange to have it relined and suggested that a painter and picture cleaner called Moreland should be entrusted to touch up any missing fragments of paint: 'but mind it must be in watercolour, not oil, for that can hurt nothing, it was the method I did at Naples.' Hamilton wrote that he would not like Greville to pay even £25 per year for the Correggio and told him to enjoy it while he could: 'God knows how long, but if I ever settle in England she will be a comfort to me, as I know there is not a better picture in Europe' (Morrison, no. 37).

Hamilton's Venus remained with Greville, decorating his new home in Portman Square, until in 1785 debts forced him to give up the house and he returned Hamilton's paintings to him in Naples (by then Hamilton had resigned himself to his long-term diplomatic post). Lord Gardenstone saw it in 1788 and wrote that he 'was particularly pleased with a delightfully wanton Venus, struggling to hold Cupid's bow, which she had stolen from him; while a salacious satyr steals his arrows. It is a rare painting, by Correggio' (Travelling Memorandums, III, p. 98).

A year later, describing Hamilton's collection, the Conte di Rezzonico mentioned the famous Correggio first, saying it seemed to be the companion to the Education of Love which he knew in Paris. He described it at great length, noting that it had been restored a number of times, 'but it remains very beautiful although lacking that bloom which would have rendered it admirable, like all things by Antonio'. In passing, he wrote 'Mengs thought it by Luca Cambiaso'. A footnote stated that Rezzonico had later seen a little sketch by Cambiaso which seemed to be a preparatory sketch for the

painting (p. 239). What is not certain is whether Mengs had told Hamilton his opinion. Paintings by Cambiaso were rare in Naples, and especially in Britain in the eighteenth century, but Hamilton did know his work: in 1774, he had purchased for Greville 'a hairy Magdalen of Cambiasi in the stile of Correggio ... [which] will do well enough hung up high or over a door as the character is sweet but the picture has suffer'd a little, and was probably longer' (Morrison, no. 39). Hamilton must have been aware of the doubts, but held firmly to his attribution.

In December 1791, shortly after he had attended Hamilton's wedding to Emma, the Earl of Abercorn wrote to Hamilton with a number of requests: he wished him to send a couple of dogs, to find an Italian to serve as his maestro di cappella and also to purchase a painting for him to decorate his new house, adding 'I shall be glad to hear that you are likely to add the Correggio upon cheap terms' (Morrison, no. 203). Hamilton duly sent the dogs and Signor Giuseppe Lanza (who stayed until 1812), as well as a Parmigianino which had Abercorn in raptures, 'undoubtedly the finest thing that ever came into this country'; but Hamilton had refused to add the Correggio on cheap terms. Hamilton was by then greatly in debt and sent the painting to the dealer Benjamin Vandergucht to place it in his rooms in an attempt to sell it, still for £3,000. In April 1792, Abercorn could not forbear to give the following advice:

By the way, before I close this, let me say one word (which I am sure you will at least take in good part) upon the subject of your Correggio. Whatever idea it may naturally give you of English taste, the fact is, it has not made any stir among the amateurs, though, to do Vandergucht justice, he has placed it in his room to advantage. He has had but two offers for it, one (I think) from Sir Peter Burrell of 1000gs. & one from a person he does not name for 1200. Now, if you are determined not to part with it under the value you put upon it, of course it needs no consideration. But, if you do mean finally to sell it for the most it will bring, I am inclined to advise you to take the 1200 while you can get it, because, as well as I can judge, I rather think there is a sort of disposition or fashion to undervalue it, which will tend to make offers fall sooner than rise. All this, however, I only give as my opinion, & I do it because, though it is that of others, I am the only

friend who would venture to give it to you. [Morrison, no. 209]

In 1793 or 1794, Vandergucht appears to have come to an arrangement with Hamilton, who sold the painting to him for £1,500. However, in December 1794, the dealer accidentally drowned in the Thames while working for the Duke of Devonshire at Chiswick, and his widow, who was left with eleven children, included the Correggio as the most important item in her sale at Christies's on 11 March 1796 (lot 93), when it was purchased for one-fifth of the value Hamilton had originally placed on it.

For twenty-five years Hamilton described this painting as *his* Correggio and treated it as the greatest treasure in his collection of paintings, refusing to part with it for less than the £3,000 which he believed to be its true worth. When he first brought it to England, he thought the country would be grateful to him for bringing into it a Correggio 'excelled by none'. He only parted with it for half its worth in 1794 because he was forced to do so by the huge debt he had amassed for a new apartment in the Palazzo Sessa and his second collection of vases and their publication. Since the late 1890s, however, the attribution to Correggio has again sometimes been doubted and it has recently been attributed to Cambiaso. Today we are familiar with debates about the attribution of old masters and are used to works once considered to be by Rembrandt or Michelangelo being 'demoted' to the work of 'lesser' artists. To a handful of experts the difference between Correggio and Cambiaso is like night and day, but to the average viewer the differences are less obvious. Hamilton considered himself a connoisseur and was firm in his belief that his painting was by Correggio. How could a connoisseur, a man whose taste in painting was admired and respected throughout his life and afterwards, have been mistaken?

In the eighteenth century connoisseurship was in its infancy (Winkelmann's book of 1764 was the first to use the phrase 'history of art' in its title), and personal taste as well as the taste of the times strongly influenced which artists were well represented in collections and thus well known and which were not. Correggio was highly regarded and there were many excellent examples, but copies and works which are now clearly by other artists were hung with them and equally believed to be by his hand. The desire for works by Correggio was so strong that it gave rise to a celebrated

scandal in Rome in the 1790s when a young German artist's exercise in Correggio's manner was sold as a Correggio and was believed to be by the old master, even when the young artist insisted that it was his own work (see Griffiths and Carey, no. 46). Luca Cambiaso, a Genoese artist who was strongly influenced by Correggio, did not attract the attention of art historians until the late nineteenth century. In spite of old and new arguments about attribution, 'Sir William Hamilton's Correggio' was famous throughout Britain and Europe during his lifetime, just as he had hoped.

LITERATURE: Helen Matilda, Countess of Radnor, and William Barclay Squire, *Catalogue of the Pictures in the Collection of the Earl of Radnor*, I, privately printed 1909, pp. 61–7.

177 GUGLIELMO MORGHEN (*fl.* late eighteenth century) after CORREGGIO (*c.*1489–1534)

Venus Disarming Cupid

Engraving, 61.9 × 36.9 cm

Provenance: Part of Richard Ford's collection of prints after Correggio, purchased through Messrs Colnaghi

British Museum, P&D 1837-4-8-369

This print must have been made by Raphael Morghen's brother in the late 1780s before Hamilton's 'Correggio' returned to England for the last time. The plate was issued again later as 'Venere e Amore' with the spelling of

177

Correggio altered and a dedication to another patron (photograph in Witt Library, from *Correggio*, exh. cat., Parma, 1935, no. 32).

178 BERNARDINO LUINI (*c.*1485–1532)

Boy with a Puzzle

Oil on panel, 43.2 × 34.3 cm

Provenance: Lady Elizabeth Germain, d.1769; bequeathed to William Hamilton; his sale Christie's, 28 March 1801 (lot 75), bt Foxall for William Beckford, £1,365; purchased with Fonthill by Farquhar 1822; his sale 1823, purchased by William Beckford; by descent to his daughter, Duchess of Hamilton; Hamilton Palace sale, 17 June 1882, lot 760, bt Winckworth £2,205; the late Col. McMurdo, his sale, 13 July 1889 (lot 66), bt Davis (for 5th Earl of Carysfort) 1,670 gns (in Carysfort's list as £1,753.10); by descent to present owner

Elton Hall Collection

Great claims were made for this painting in the catalogue of Hamilton's picture sale at Christie's, 28 March 1801 (lot 75):

Nothing surely can exceed the masterly execution of this Picture; it has the Correctness of Raphael's Drawing, and the Grace and Softness of Corregio's Pencil. There are two Drawings after the same Boy in the Drawing-book of Leonardo, in the Ambrosian Library at Milan. This Picture was in the Arundell Collection, inherited by Lady Betty Germaine, who left it in her Will to the present Proprietor.

Catalogued as Leonardo da Vinci's 'Laughing Boy with a plaything in his hand', it was the last item in the sale, an honour reserved for the most important painting. William Beckford purchased it for the very high price of £1,365, over one-fifth of the amount realised by the entire sale of 150 paintings. It was engraved by Bromley as 'Boy and Tablet' in 1820 (published by William Miller, London). In 1822 Beckford sold it with the contents of Fonthill Abbey to Mr Farquhar, but bought it back again at the latter's sale and it was later inherited by Beckford's daughter, the Duchess of Hamilton. In the famous Hamilton Palace sale of 1882, it sold as a Leonardo for £2,205, although its value had dropped slightly when it was purchased seven years later by William, 5th Earl of Carysfort.

The Earl of Carysfort can be credited with recognising its correct attribution, as he included it in his list of purchases as a

Luini. In fact he probably purchased it *because* it was by this Milanese artist, one of Leonardo's most prominent followers, whose work was slightly more sentimental and thus appealed strongly to Victorian taste (see Haskell, 1976, p. 104). It was once again given prominence as an important old master when it was published as the frontispiece in the 1911 monograph on Luini by Luca Beltrami. The child is holding a 'puzzle' which consists of two blocks of wood wound with a strap: when a piece of straw or bone is placed under the straps and the toy is closed, it will have disappeared as if by magic when the blocks are opened again. The child appears in a larger composition by Luini of *Christ and John the Baptist as Children*.

When William Hamilton inherited his 'Leonardo' in 1769, it was already famous and had a very distinguished provenance. Joshua Reynolds wrote to him from London in June 1770 that he had heard that Hamilton 'had the Choice of Lady Betty Germains Pictures – I have no doubt of your chusing the best' (Hilles, p. 27). Lady Elizabeth Germain (1680–1769) was the second wife of Sir John Germain and had inherited through him the cameos and intaglios collected by Thomas Howard, Earl of Arundel, which had been bequeathed to Germain by his first wife. The gem collection was well known, as it had been offered to the British Museum for £10,000; when the Museum declined to purchase it, Lady Betty gave it to the Spencer family and it was engraved in 1780–91. The Earl of Arundel had formed his collection while at the court of Charles I and his painting collection was also famous: Walpole called him 'the father of Vertu in England'. Hamilton seems to have believed that Lady Betty had inherited part of this as well, but in fact by this date the Arundel collection was largely dispersed. Lady Betty's collections at her houses in London and Drayton, Northamptonshire, were famous and Horace Walpole included them in his 'Journals of Visits to Country Seats', but his description of Drayton does not note any paintings with Arundel provenance and the description of the house in St James consists of only two lines: the 'Leonardo' is not mentioned at all (*Wal. Soc.*, xvi, 1927–8, pp. 40, 55–8).

Hamilton owned another work which had belonged to Lady Betty Germain and which he therefore believed also had an

178

Arundel provenance: he purchased his *Sea Port with Setting Sun* by Claude from the late Earl of Bessborough, who had inherited it from Lady Betty Germain (Hamilton's sale, Christie's, 27 March 1801, lot 53).

Whether or not Hamilton's provenance or attribution of his 'Leonardo' was correct, he was entitled to be proud of this lovely painting and to promote it as one the greatest treasures of his collection. Its quality was recognised by many visitors to the Palazzo Sessa. James Smith described it as 'most capital' and 'in fine preservation' (*Tour of the Continent*, II, 1787), and in 1788 Lord Gardenstone singled it out as 'the piece which captivated me above all . . . the figure of a sweet smiling boy at his play. It is a rare painting by Leonardo da Vinci' (*Travelling Memorandums*, III, p. 98; note in Sir Brinsley Ford Archive, Paul Mellon Centre). Conte di Rezzonico admired it in 1789 'above the Correggio' and identified the 'puzzle' as a tablet game called *La scala* (the stairs) because when opened the tablets knock and unfold downwards (pp. 239–40). When Beckford purchased the painting, he hung it next to the fireplace in the Grand Drawing Room at Fonthill Abbey (see Wainwright, p. 140, fig. 120). Beckford bought it back again after letting it go with the Abbey, and it was retained by his family after his death when most of his collection was sold, underlining the fondness its owners have had for it.

LITERATURE: T. Borenius and J. V. Hodgson, *A Catalogue of the Pictures at Elton Hall*, London, 1924, pp. 11, 117.

179

179 MARIANO BOVI (1757–1813) after
PARMIGIANINO (1503–40)

Virgin and Child, 1784

Engraving, 27 × 20.8 cm

Provenance: Bequeathed by the Revd Clayton
Mordaunt Cracherode in 1799

British Museum, P&D W1–111

According to Edward Coxe, Hamilton's
Parmigianino had come from 'a most cele-
brated Collection in Spain'. Coxe's sale
catalogue (Peter Coxe, 24 March 1810, lot
72) described it in the following terms:

Parmegiano – The Infant Saviour standing
on the lap of the Virgin, and embracing her

with filial affection. Of all the Pictures in
the Collection of Sir William Hamilton,
this, (bought at his Sale) he prized above
the rest: and when we consider the
feminine sweetness and maternal regard of
the Virgin, her ineffable smile, the glow of
health and beauty on the countenances of
each, the graceful flow of the outline of the
Child, with the roundness of the Limbs,
together with the purity and warmth of the
Carnations, as well as the simplicity of the
Drapery of the Virgin, it cannot be
wondered that such a lovely assemblage
should have arrested the attention of so
great a judge, and delighted him above all

his other pictures: it is correct in all its
minuter parts, and wonderful in the general
execution – most capital – engraved. [25
March 1810, lot 66, bt Raikes £136.10.0]

The painting had hung in the Gallery in the
Palazzo Sessa, and in his own sale (28 March
1801, lot 74, bt Coxe £40.19.0) Hamilton
had given it a place of importance next to
the 'Leonardo' (cat. no. 178), stating it had
come to Naples from a celebrated collection
at Madrid. Hamilton probably acquired this
Parmigianino from the Baranello collec-
tion, part of the collection formed by the
Spaniard Diego de Ulloa, who had come to
Naples in the late seventeenth century
(Getty Provenance Index).

A number of paintings of the Madonna
and Child by Parmigianino came to
England in the eighteenth century and were
engraved with their owner's name promi-
nently displayed. The only surviving paint-
ing which matches Hamilton's was bought
by Colnaghi at the Empress Eugénie sale at
Christie's, 1 July 1927 (lot 142, 85 × 64 cm,
Witt Library photo).

The dedication on the print confirms a
tradition that Mariano Bovi was sent to
England by Ferdinand IV to study engrav-
ing. In October 1799, Bovi's brother wrote
to him from Italy describing an audience he
had with the king, to whom he explained
he was the brother of Mariano, 'whom you
sent to London under Bartolozzi, to perfect
himself in engraving and drawing, and who
has engraved your royal family' (Tuer,
p. 376). Hamilton, who knew Bartolozzi's
work well (see cat. no. 64), may have played
a role in having Bovi sent to England, subtly
acknowledged by Bovi's inclusion of the
information at the bottom of the text. Like
the work of so many of Bartolozzi's pupils,
this print has been included in the catalogue
of his works and kept with them (De Vesme
and Calabri, no. 130).

Little is known of Bovi's career, but he
was established in Piccadilly as an engraver,
print-seller and publisher, as well as a pur-
veyor of printed materials for furnishing. A
single copy of his 1802 *Catalogue of Prints*
survives in the British Library (Add. MS
33,397, ff. 183–90), but the first half (over
240 items) consists of 'Pictures and Draw-
ings by Lady Diana Beauclerk, Ang.
Kauffmann ... P. Sandby [etc.] whose
works he has collected with attention' and
which he had on view for sale at his Exhi-
bition Room. A number of the drawings
were after oils and had been made for the
engraver. No. 2, for example, was Bovi's

drawing in pen and ink of Hamilton's Parmigianino for the present print, and no. 118 was a drawing by Bartolozzi after Kauffman's portrait of the Neapolitan royal family which was also engraved by Bovi (cat. no. 12). His stock was extensive and in 1805 he went bankrupt; the three-day sale which resulted included 400 copperplates by himself, Bartolozzi and others (Tuer, p. 377).

LITERATURE: A. W. Tuer, *Bartolozzi and his Works*, 2nd edn, London, 1885.

180 SALVATOR ROSA (1615–73)

Democritus in Meditation, 1662

Etching with drypoint, 45.5 × 27.5 cm
Lettered in image, on scroll bottom left:
> *Democritus omnium derisor in omnium fine defigitur. Salvator Rosa Inv. scul*

Provenance: Bequeathed by the Revd Clayton Mordaunt Cracherode, 1799

British Museum, P&D W7–112

Rosa based his image of the philosopher Democritus on Castiglione's etching *Melancholia*, and surrounded him with Classical sculpture, symbolising former glory, and with dried bones, indicating the end of all aspirations. The inscription translates as 'Democritus the mocker of all things is here

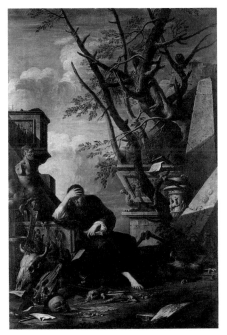

FIG. 102 After Salvator Rosa (?), *Democritus in Meditation*. Oil on canvas. New York, private collection, on loan to The Metropolitan Museum of Art.

stopped by the ending of all things' (Kitson, no. 98). The painting on which this etching is based was executed in 1650 and exhibited in the Pantheon in Rome the following year. A companion, *Diogenes Throwing away his Bowl*, was painted and both were

purchased by the Venetian ambassador Sagredo (both now Statens Museum for Kunst, Copenhagen). The paintings were in Bouchier Cleeve's collection at Foots Cray Place, Kent, from at least 1761 and were moved by his son-in-law, Sir George

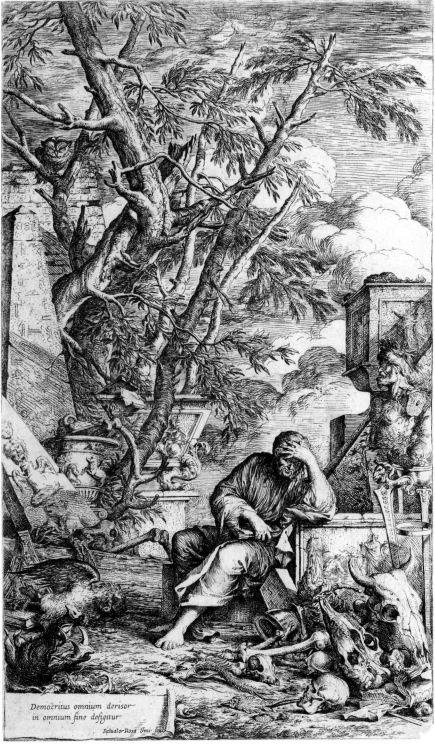

180

Young, to his house in London in 1772. They were included in at least two guides to collections around London, and William Gilpin singled them out for special praise in his *Southern Tour* (pp. 122–3) (Nicolson, I, pp. 52–3).

Sir William Hamilton included a painting by Rosa of *A Philosopher Meditating on the Effect of Time* in his manuscript list of paintings at the Palazzo Sessa, although James Clark did not recognise the subject and described it as 'A Magician with various Impliments of Sorcery' in his packing list. Hamilton provided more information for his sale, indicating that he knew the correct title and that the subject had been etched by Rosa; he also noted there was a larger version in the collection of Sir George Young. He stated that his painting had come from the 'celebrated Collection of the Duke of Laurenzano, for whose collection he had painted it' (Christie's, 27 March 1801, lot 57, bought for £65 by the Earl of Breadalbane). Hamilton could not have been mistaken about where he had purchased the painting, but what he may not have known was that the collection formed by the Dukes of Laurenzano in Rome in the seventeenth century had been added to substantially by two later members of the family who had brought the collection to Naples. The painting is listed in the Laurenzano inventories for 1710 and 1741, where it is described as a philosopher in a wood, but it does not appear in the earlier seventeenth-century inventories (Getty Provenance Index, inv. 1741/11/07).

Hamilton's smaller version of the painting was purchased by the Earl of Warwick at the Breadalbane sale on 1 June 1801. It is now on loan to the Metropolitan Museum in New York, but, on the basis of the style of painting and the colours used, it is not considered to be the work of Rosa himself and is thought to be an early copy (fig. 102). Hamilton was quite aware that it was not unknown for Italian owners consciously to sell copies as originals, but in this case, the owner's family believed it was a work painted for their ancestor. There was no reason for him to doubt that he owned a smaller but autograph version of a famous painting in London. In eighteenth-century Britain, Salvator Rosa was considered to be the finest exponent of the sublime, and the pair of paintings of philosophers which belonged to Sir George Young were among Rosa's largest, most ambitious pictures. The *Democritus* was acknowledged to be icono-

graphically complex. Rosa's etchings were also widely known, greatly admired and carefully studied throughout the century. Solitary hermits in landscapes and the theme of melancholy contemplation interested British writers and artists searching for new ways to interpret the sublime. Several of them painted variations on the theme, most significantly Joseph Wright of Derby in his *Philosopher by Lamp Light* of 1769, later known as *Democritus Studying Anatomy*, engraved as a mezzotint by Pether in 1770 (see Egerton, nos 41, 176).

A careful study of the etching, the painting in Copenhagen and Hamilton's version indicates that Hamilton's work was probably based on the etching and was not a straightforward copy of the original oil. In 1968 Hamilton's version, at Warwick Castle, had once again lost all connection with Democritus and was described as a 'A Hermit seated among classical Ruins reading a Book, surrounded by emblems of mortality' (sale Christie's, 21 June 1968, lot 68, withdrawn).

LITERATURE: Bartsch, VII, i/2; R. Wallace, 'Salvator Rosa's *Democritus* and *L'Umana Fragilità*', *Art Bulletin*, L, 1968, pp. 21–32; Nicolson, pp. 52–3; M. Kitson, *Salvator Rosa*, exh. cat., Arts Council, Hayward Gallery, London, 1973, no. 98, pl. 26, and no. 142; Egerton, nos 41, 176.

181 ABRAHAM-LOUIS-RODOLPHE DUCROS (1748–1810)

The Arch of Titus, c.1782–5

Watercolour over pen and ink and pencil,
74.2 × 52.7 cm
Provenance: Acquired in late 18th or early 19th
century, and by descent to present owner
Private collection

In the main bedroom in the Palazzo Sessa hung Gavin Hamilton's *Sleeping Venus and Cupid*, Vigée-Le Brun's *Head of Lady Hamilton as a Sibyl* (see cat. no. 170), Kneller's portrait of Prince Rupert, and a chalk drawing of Lady Hamilton in profile by Hugh Douglas Hamilton. With these important pictures hung three large watercolours by Ducros of *The Sibyl's Temple*, *The Cascatelli at Tivoli* and *The Arch of Titus at Rome*; the last of these was described by the auctioneer at the Christie's sale in March 1801 (second day, lot 22), as 'one of the best Performances of this great Master'. It was purchased by Edward Coxe for £44.2.0,

while the two views of Tivoli fetched £48.6.0 and £45.3.0. As an indication of their respective values, the H. D. Hamilton was sold for £27.6.0, the Vigée-Le Brun for £32.11.0 and the Lusieri of the eruption of Vesuvius by moonlight (see cat. no. 46) for £52.10.0. Hamilton had also owned two views of the Abruzzi region by Ducros, which hung in another room and which sold for lower sums. Unfortunately the present whereabouts of Hamilton's paintings are not known, and this watercolour of a similar view to his *Arch of Titus* has been selected to represent them.

By 1801 Ducros' work was well known and admired in England, as by then numerous travellers had seen and commissioned views by him in Rome, where he had arrived from his native Switzerland in 1776. In 1778 Ducros accompanied a group of Dutchmen to Naples and Sicily as their draughtsman; he called on the Hamiltons, dined with them at Posillipo, and made sketches around the Palazzo Sessa, including a drawing of the rope-makers in the large grotto next to the Hamilton residence (cat. no. 18, see repr. in Dibbits, p. 45). The works Hamilton owned were not produced as a result of that visit, however, but after Ducros had returned to Rome and he and Volpato had perfected their method of reproducing popular views in coloured outline etchings, begun in 1780.

C. L. Clérisseau (1722–1820), J. L. Desprez (1743–1804), G. B. Lusieri and Ducros all produced outline etchings of their most popular compositions in order to supply multiple copies and satisfy demand for 'coloured drawings' more quickly. They were individually hand-coloured and worked up by the artist, often with additional figures or foliage. The purchasers were interested in recognisable places depicted on a large scale with atmospheric effect and were less concerned with the production of an 'original' work of art than we are today. They were also unconcerned by the fact that the artist relied heavily on the camera obscura to record landscapes.

Sir Richard Colt Hoare was a particular admirer and promoter of Ducros' work. He commissioned four watercolours in 1787 and had them sent back to London, writing to his half-brother that they would be 'the admiration of the whole town & put all our English artists … to the blush' (Chessex, 1985, no. 68). Eventually thirteen watercolours and hand-coloured outline etchings by Ducros hung at Stourhead, where they

181

remain. One of the coloured etchings is of the *Arch of Titus*. It is the same size as the present work, and another watercolour of this subject, also the same size, was once owned by the Earl of Ilchester (now Fondation Custodia, Paris). The present watercolour is more delicately washed than the others, which are darker, with their details heightened in gouache and gum arabic.

A large pen and pencil drawing of the *Arch of Titus* in Ducros' studio bore a note by Sir William Hamilton dated 18 March 1791 confirming that he had given his commission to Ducros for the drawings he owned by the artist which were in his house in Naples, and that he had paid £30 sterling for them (Chessex, 1984, p. 434). From 1790, Ducros, a French-speaking Swiss, began to come under suspicion from the Roman authorities, encouraged by the artist's Italian rivals and worried about the Revolution in France. Hamilton's testimony on the back of this drawing in Ducros' studio, written while he was passing through Rome *en route* for England, was no doubt intended to serve as much as a character witness as a receipt for drawings. It failed to achieve its purpose, however, as Ducros was exiled from Rome after his enemies described him to the government as a dangerous man attached to the French Republican Party. He was in exile in Naples by June where, having been unable to remove his engraving and other equipment from his studio in Rome, he painted mostly large watercolours. A contemporary recorded that these were sold 'at very high prices in England by his protector Hamilton' (Gerning, *Neuer Teutscher Merkur*, 1798, quoted in Chessex, 1985, p. 15), but there are no surviving documents or letters to support this statement. It was at this time that he executed several large watercolours of the Abruzzi, two of which may have been those hanging in the Palazzo Sessa.

Hamilton was not Ducros' only protector in Naples: Sir John Acton commissioned six large watercolours of his villa and garden, as well as the naval shipyards and coastal fortifications at Castellammare, which reflected his position not only as Prime Minister but also General of the Neapolitan army and Minister of War. In 1799, when the Bourbons returned to Naples, Ducros was denounced as a Jacobin and was forced to leave the city.

LITERATURE: Chessex, 1984, pp. 430–37; Chessex, 1985, *passim*; Dibbits and Niemeijer, *passim*.

The English Garden
at Caserta

The gardens of the palace of the King of Naples at Caserta were as grand in scale as the palace itself, which rivalled Versailles. An aqueduct conducted a limitless supply of water to the Collina di Briano, the hill overlooking the palace to the north. The water was conveyed to the palace in a two-mile-long grand canal, punctuated by cascades, basins, and fountains adorned with sculpture, lined on either side with a broad straight walk, a narrow lawn and parallel rows of trees, broken only by terraces and stairs to accommodate the gradual descent to the level of the palace. There were more symmetrical formal gardens by the palace itself. Half-way along the east side of the long stretch of the canal were woods, on fairly level ground at first then climbing up the hill parallel to the grand cascade. It was this small rectangular area of 50 acres to the north-east of the palace that the king allocated to the queen in 1786 for the creation of an English garden (cat no. 182).

The idea of creating an English garden in a corner of the palace grounds was undoubtedly Sir William Hamilton's, and seems to have come to him on his extended leave in England in 1783–4, after the death of his first wife. On this visit he spent time with friends and relatives on their country estates and made extensive tours of Scotland and Wales with his nephew Charles Greville. The latter was keen on improving Hamilton's estate in Wales with economic schemes rather than gardening ones, but Hamilton seems to have discussed the idea of a garden at Caserta with his old friend Sir Joseph Banks, President of the Royal Society. Banks was a botanist before all else and in February 1785, shortly after his return to Naples, Hamilton wrote to him: 'The Queen of Naples has adopted my project and has given me the Commission to send for a British Gardiner & Nurseryman – I told her you had been so good as to promise to assist me in procuring one ... the Queen does me the honor to give me the superintendance of her Garden' (British Library, Add. MS 34,048, f. 22).

Carlo Knight has discussed in detail Hamilton's immersion in the project over the next ten years, thoroughly occupying himself with this new passion as part of his 'whole art of going through life tolerably' (see Chapter 1 and Knight, 1986). The land adjoined the Royal Cottage Garden, 'which is laid out in the most detestable taste', and had access to as much water as was needed to provide turf as green as any in England and enable the creation of botanic and kitchen gardens, as well as a bowling green for the king's amusement. However, since the money for the garden came directly from the queen's privy purse and was thus diverted from its usual destination – the pockets of her courtiers – Hamilton and the gardener, John Andrew Graefer, found themselves working against constant prejudice. As always, Hamilton's intentions were not for his own personal benefit, but were directed towards the honour of his native and adopted countries. He wrote to Banks in January 1788 that, in addition to the features mentioned above, he and Graefer proposed to show

a Specimen of English pleasure Garden ... and a sort of *Ferme ornée*, where experiments may be tried of different grasses to fatten Cattle – in short my idea is that this Garden at the same time that it serves to amuse the Queen, the Hereditary Prince & Princesses – will point out every sort of Culture that the nobility may, if they please, introduce upon their Estates ... but it is realy cruel to

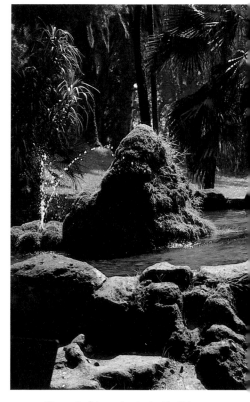

FIG. 103 'Source' of the spring in the English Garden at Caserta.

work for those who have not the least taste for improvement & comprehend nothing but the expence ... However when they will hear from Foreigners that our Garden (& which they certainly must soon) may be of infinite utility, they may give us more Encouragement. [British Library, Add. MS 34,048, ff. 43–4]

Shortly afterwards the king took over the expense of the garden from the queen, and soon he could be seen arm in arm with Graefer in 'his' garden, planning the introduction of new features including, to Hamilton's horror, a labyrinth – a feature long abandoned in the 'modern' gardens of England. The surviving accounts of the garden at Caserta mainly concern the plants, and it is more difficult to discern who was responsible for the garden 'features'. Under the king's direction, Carlo Vanvitelli designed the small 'Temple of Venus' and a large house for Graefer which included an apartment for the king. Hamilton apparently had no hand in planning the house, but was able to benefit from it, enjoying the healing qualities of the air of its elevated position while recovering from various ailments in the 1790s. Contemporary visitors do not mention the half-ruined Doric temple set into the hillside at the north end where one now enters the garden, a feature recalling the half-buried ruins of the Temple of Isis at Pompeii, of which Hamilton had witnessed the discovery in 1765. The 'aviary' arrived at next along the path in fact represented an alternative use for an enormous semicircular basin to hold water from the aqueduct in cases of emergency, a feature strongly reminiscent of the Classical amphitheatres created by William Kent in the gardens he designed at Chiswick, Stowe and elsewhere throughout Britain.

The water supply was not landscaped as a river flowing directly from the aqueduct, but was carefully channelled underground to appear as a natural spring rising from the ground and pouring over a small rocky grotto (fig. 103), then flowing underground again until it emerged in another grotto, commonly described as the 'Bath of Venus' (fig. 6). However, Diana, the goddess of the chase, was the reigning deity of this part of Campania and of the gardens at Caserta in particular (an appropriate deity for a king whose passion was hunting). A splendid sculptural group of her with Acteon featured at the base of the main cascade of the formal gardens, and here in the English Garden she was represented without her nymphs. This grotto must have been one of the first features to be completed, as it was commented upon by the earliest visitors to the garden, including the Conte di Rezzonico who was in Naples in 1789–90 (see Knight, 1986, p. 57). Approaching through a dark passage lined with huge boulders, reminiscent of Virgil's passage to the Cumaean Sibyl (the episode that inspired Kent's grottoes and Henry Hoare's recreation of the *Aeneid* at Stourhead), one emerged into an enchanting grotto, surrounded by high rocks covered with climbing plants and streaming with rivulets, sunlight dancing through the branches and sparkling on wet ferns. A crouching statue, now known to be a Venus type but described by Rezzonico as Diana, bathed in the pool and passages on the far side led into a 'cryptoporticus' lined with statues of Aesculapius, Iphigenia and other appropriate gods and goddesses.

The tour through this Classical 'Vale of Tempe' continued along a path which followed the stream from Diana's grotto as it flowed over rocky passages into larger pools with weeping willows. From there it became a river, passing under an elegant arched bridge and over cascades, eventually winding into a swans' lake with two islands graced with ruins of Classical temples. Green lawns and plantings of flowers and shrubs with Linnaean labels ran alongside, punctuated by picturesque clumps and single trees of carefully chosen shapes. In all this the contrast with the formal Italian gardens of the palace nearby, and indeed with most gardens throughout

Europe, could not have been greater; nor could any of them match the magnificent view of Vesuvius and the countryside around Naples provided by the slopes of the English Garden at Caserta (see cat. no. 182).

Hamilton's hopes, however, that the Italian nobility would profit by the king's example were to be disappointed. When the garden was finished and the plants well-grown in 1797, he wrote resignedly to Banks:

> To enjoy an English garden requires a previous education that is the case, no one can be sensible of the beauties of Homer coming to it directly from reading Tom Thumb & Jack the Giant Killer, so how many companies when they are in the Garden ask where is the English Garden? being told they are in it they say Lord! there is nothing but grass & trees that bear no fruit and often advise poor Graefer to cut out some figures on his beautiful turf. [British Library, Add. MS 34,048, f. 89]

Hamilton must have longed to place a sign over the entrance, as Henry Hoare had done in his grotto at Stourhead, quoting the Cumaean Sibyl in the *Aeneid*, crying 'Begone! you who are unitiated, Begone!'.

As Hamilton knew, however, there were others in Europe who could be numbered among the initiated. The Continental fashion for 'English gardens' started with the garden created at Wörlitz by Hamilton's friend the Prince of Dessau after his first visit to England in the early 1760s. In England gardens were not only evidence of their owners' Classical erudition but frequently also of their political inclinations, and the Prince of Dessau, like other European creators of English gardens, such as Archduke Ferdinand of Austria at Monza and Count Silva in Lombardy, was aware of his garden's status as an emblem of his admiration for what was perceived to be Britain's enlightened system of government. English gardens became particularly evocative of English enlightenment as the effects of the French Revolution and Republic advanced through Europe in the 1790s.

Hamilton was aware of the political potential of an English garden, but as a diplomat he carefully avoided any overt statements in the one he created at Caserta, concentrating instead on purely practical, botanical and visual effects. Nowhere was this more clear than in his letter to Banks after reading Richard Payne Knight and Uvedale Price's treatises on landscape in 1794:

> I think our friends Knight & Price have given a good dab at Mr Browne and the bald stile of modern Gardening. I am of the taste between what they call the Sublime & our Modern Stile of gardening for I do think that neatness & keeping adds a great beauty to Nature, especially near ones habitation unless that habitation be a Cavern or Hollow Tree. The serpentine walks, regular clumps and twisted rivers with bald banks broken here & there with a weeping willow and a chinese bridge I detest as much as they do – but I am angry with Knight for having brought in a note by head and shoulders, the politicks of the times ... (British Library, Add. MS 34,048, f. 81)

LITERATURE: Fothergill, pp. 205, 227–9; G. Venturi, 'The landscape garden in Lombardy: Utopia, politics and art at the beginning of the 19th century', *Lotus International (Quarterly Architectural Review)*, 1, 1981, pp. 39–46; Knight, 1986; C. Knight, V. Martucci *et al.*, *Il Giardino Inglese nella Reggia di Caserta: La storica e i documenti, le piante, le fabbriche*, exh. cat., Soprintendenza di Caserta e Benevento, Naples, 1987.

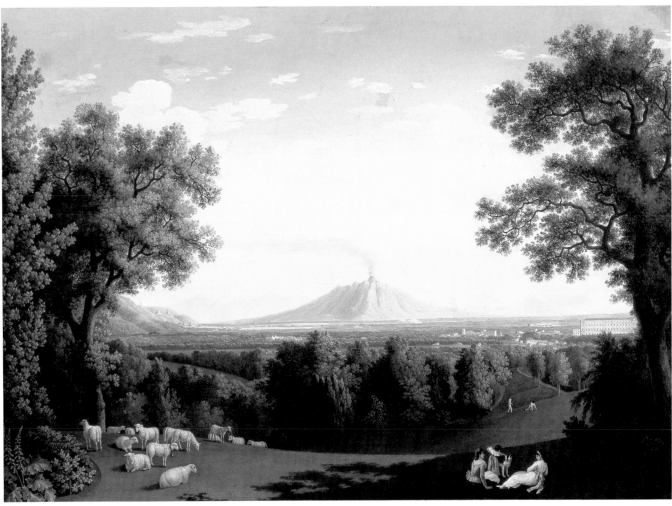

182

182 JAKOB PHILIPP HACKERT
(1737–1807)

*View of the English Garden at
Caserta,* 1793

Oil on canvas, 93 × 130 cm

Inscribed: *Veduta del Giardino Inglese a Caserta
Philippo Hackert dipinse 1793*

Provenance: Galerie Xaver Scheidwimmer,
Munich, 1982

Fundación Colección Thyssen-Bornemisza,
Madrid, 1982 46/177

Hackert's biographer, Goethe, records that
the artist first arrived in Rome with his
brother Johann in 1768; two years later they
visited Naples, carrying a letter of introduc-
tion to the British envoy, William Hamilton.
Johann painted for Hamilton two land-
scapes in gouache and a picture of Cather-
ine Hamilton's dogs, a greyhound and two
spaniels, in a landscape (sold Christie's, 1801,
lots 4 and 42 on 18 and 17 April respec-

tively). Johann travelled to England shortly
afterwards and died in Bath in 1773. On the
visit to Naples in 1770, Philipp Hackert
painted three watercolours for William
Hamilton, each 18 × 23 in (46 × 58.5 cm),
of the Monte S. Angelo and of the *monticelli*
raised by the eruption of Vesuvius of 1760.
They were purchased at the same sale (lot
23) by Charles Townley and are described
in detail in the manuscript list of 'Pictures
at Towneley' (British Museum Archives,
Townley Papers).

Philipp Hackert returned to Rome, where
with two other brothers he established a firm
of printmakers and publishers, whose prod-
ucts were based mainly on his own designs
and dominated the market in Italy from this
period. Goethe recalled that Hackert was
always surrounded by English people, lead-
ing groups of amateurs on sketching expe-
ditions and holding evening drawing lessons
around a lamplit table where everyone com-

peted in handling the lead pencil and sepia
wash while an abbé stirred their imagina-
tions with readings from Tasso (Goethe,
Hackert, pp. 51–2). English artists in Rome
and Naples were understandably jealous, and
complained of the German artist's methods
of self-advertisement and his minute atten-
tion to detail in his oil paintings and gouaches,
'which by the bye, was more congenial to
his own taste, who like most German Artists,
study more the Minutiae than the grand
principles of the Art' (Jones, *Memoirs*, p. 117).

One Englishman who was very much part
of the German artist's circle was Charles
Gore (1726–1807), who accompanied
Hackert and Payne Knight on their expedi-
tion to Sicily in 1777 and whose drawings
of this journey are in the British Museum.
Gore and his daughter Eliza were amateur
artists and learnt Hackert's gouache tech-
niques: they retired to Weimar in 1792 and
several of their drawings, especially of the

landscape around Naples and eruptions of Vesuvius, survive in the Stiftung Weimarer Klassik. Gore also painted in watercolours: one which was recently acquired by the British Museum as the work of an anonymous artist can be attributed to him on grounds of style; it is inscribed to the effect that it was painted in May 1790 in the balcony room of the Palazzo Sessa in the company of Lusieri while he was working on his *View of the Bay of Naples* (cat. no. 4). It confirms that Gore was a close member of the circle of artists who spent so much time at the Palazzo Sessa that they knew its rooms intimately (see Tischbein's description in cat. no. 4 and pp. 85–7). Gore was the source of much of Goethe's information for his biography of Hackert.

Hackert etched a remarkable series of four views drawn around Naples in 1779 and a few years later received a commission from Ferdinand IV for landscape views to decorate the palace of Caserta and the hunting lodge at Fusaro. Pietro Fabris had been the king's preferred painter of this type of landscape until his death around this time. Hackert was given the post of Royal Painter and a residence at the palace in 1785. A series of bistre wash drawings of the English Garden at Caserta record the progress of the garden from 1788 (see cat. no. 183; Hamilton owned two, purchased by Lord Northwick at his sale on 17 April 1801, lot 49).

In 1792 Hackert produced for the king's study a large gouache view of the English Garden very close in composition and style to the present painting. Sir William Hamilton also owned a large painting of this view, described in his sale as *A View of the English Garden at Caserta, with Part of the great Royal Palace, the Campagna Felice, and Mount Vesuvius and Somma*; this composition is recorded in the present painting, whose early provenance is unknown. The companion painting owned by Hamilton was described as of Hackert's own composition, but it was apparently a version of Hamilton's painting by Luca Giordano entitled *Scimmie, Pappagalli, ciucci e cornuti buoni* (Imitators, Talkative Asses and contented cuckolds) (see p. 85). These two paintings by Hackert were included in Hamilton's sale on 23 March 1801 (lots 32 and 33), where they were purchased for more than twice as much as Gavin Hamilton's pair, *Poetry* and *Painting*, or Romney's

portrait of Emma as a *Bacchante* (cat. nos 172, 167), confirming the strength of Hackert's reputation at the time.

In 1787, a Dutch visitor had already realised that the trees and lawns of the English Garden and the magnificent views its heights provided of the palace and the plains of Campania, with Vesuvius and the surrounding mountains beyond, carried the potential for the garden to become an earthly paradise (J. van Heel and M. van Oudheusden, p. 21, n. 52). In 1792, when he painted the gouache view from the English Garden for the king's study, Hackert realised that this landscape represented the arcadian ideal that eighteenth-century painters of all schools constantly sought to depict from imagination and by imitating the paintings of Claude and Poussin. His *View of the English Garden at Caserta* of 1793 was one of his earliest representations in oils of this 'ideal' landscape – which now actually existed in nature, thanks to Hamilton's and Graefer's efforts at Caserta – complete with temples, swan lakes, ruins, cascades, grottoes, extensive pastoral views capped by mountains in the distance, and above all with majestic trees which had always formed the leitmotif running through all Hackert's compositions.

During the rest of his life, particularly after he had been forced by the French invasion to flee from Naples to Florence, Hackert was to rely on various combinations of the features of the English Garden at Caserta and the views from it to provide patrons from all over Europe with his version of an ideal landscape; the combinations became increasingly fanciful and further removed from the actual garden at Caserta and became for Hackert a new genre of ideal landscape. In his *Über Landschaftsmalerei: Theoretische Fragmente*, written *c*.1795 and published in Goethe's biography of Hackert, the German artist indicated that he had looked to Claude and Dughet as others had done, admiring their composition and harmony of effect, but he also looked at them through eyes which had been trained to admire the detailed realism of Dutch seventeenth-century painters. The Dutch influence was clear in the landscapes he himself created, and he criticised the British for attempting to achieve grand effects without paying sufficient attention to the details of nature. Although Hackert and Jones criti-

cised each other's works for these respective failures, in fact both were working within the mainstream of the eighteenth-century's depiction of nature and neither manner was superior to the other.

LITERATURE: For Gore, see C. Stumpf's essay on the expedition to Sicily in Clarke and Penny, pp. 19–31; for Hackert, see Goethe, *Hackert*, Tübingen, 1811; Cheetham, 1984, p. 140, 1985, p. 141; S. Schulze, no. 277, p. 409; W. Krönig and R. Wegner, *Jakob Philipp Hackert – der Landschaftsmaler der Goethezeit*, Cologne, 1994, p. 153, fig. 146 (a version of one of Hackert's 1770 compositions for Hamilton is reproduced as fig. 138); C. Nordhoff and H. Reimer, *Jakob Philipp Hackert*, Berlin, 1994, I, pp. 77–85, II, no. 239, p. 114.

183 JAKOB PHILIPP HACKERT (1737–1807)

View of the English Garden at Caserta, 1793

Black chalk, pen and brown ink with brown wash, 63.1 × 82.4 cm
Inscribed: *al Giardino Inglese a Caserta/Filippo Hackert f.1794*
Carlo Knight

The water from the aqueduct went through a metamorphosis as it progressed downhill through the English Garden, flowing over a little cascade at the edge of 'Diana's Bath' into a gradually widening stream. This bistre view seems to be taken just before the stream passed under a bridge and then flowed over a steep cascade, widening further and entering the swan lake. The hill to which the aqueduct carried the constant supply of water is just visible in the top left of this drawing. The willow, cypress and oak trees with the type of rocks also found in the grotto, and the green lawns bordered by clearly identifiable plants give an indication here of the manner in which the 'English' effect was achieved.

Large monochrome drawings in brown wash showing landscapes and monuments were a speciality of many European artists in Italy. Both German artists such as Hackert and Kniep (see cat. no. 26) and British artists such as Jacob More and George Wallis (cat. no. 184) realised that these souvenir views could be sold for less but in higher

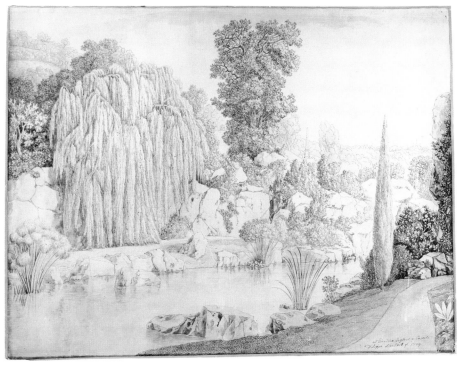

183

volume than highly coloured views and thus supply a lower, but still lucrative, end of the Grand Tour market. One of Hackert's price-lists for landscape and marine paintings survives among Hamilton's papers in the British Library, and indicates that these views were sold at prices which ranged according to size, complexity of subject, amount of finish, and medium – oils were 200 to 300 sequins, gouaches ranged from 30 to 150, and bistre drawings cost from 6 to 20 sequins (British Library, Add. MS 40,715, f. 284).

184 GEORGE AUGUSTUS WALLIS
(1770–1847)

A Classical Landscape, 1794

Black chalk, pen and brown ink with brown
 wash, 40 × 53.5 cm (drawing), 47 × 61 cm
 (with contemporary mount)
Inscribed: *G A Wallis / Rome / 1794* and on verso:
 I.J.L. Bonnet / Given by Mrs Mary [Castro?]
Provenance: I. J. L. Bonnet, according to
 inscription on verso; purchased from Abbot
 and Holder
British Museum, P&D 1993-12-11-6

In 1778 the Earl of Warwick deposited money in his uncle Sir William Hamilton's account in order that Hamilton could pay Warwick's artist, John Smith, his monthly stipend. In 1794 Hamilton found himself repeating the exercise for another of Warwick's artists, but this time the money from the earl was not forthcoming: 'It is hard that Lord Warwick will not pay me what I have advanced by his order to the painter Wallis, whose general receipt I have now sent to Ross & Olgivie' (Morrison, no. 238). This was at a time when Hamilton was heavily in debt, and six months later he complained again to Warwick's brother Charles Greville

that Warwick was not paying the money (£400) nor even answering his letter (Morrison, no. 247).

Wallis is now almost forgotten in Britain, but in 1785–6 he exhibited watercolours and drawings at the Royal Academy and in 1788 was sent by the Earl of Warwick to Rome. According to the only monograph on his work, he arrived in Naples the following year and there soon became part of the circle of German artists which included Hackert (cat. nos 182–3), Kniep (cat. no. 26) and Tischbein (cat. no. 7; and pp. 85–7). He may also have been involved in the latter's publication of Hamilton's second vase collection (Graf von Baudissin, summarised by Bailey, p. 37). The bistre drawing exhibited here certainly indicates he was part of the circle which met regularly at Hackert's studio to practise this type of landscape; his drawing style as represented in this work is perhaps closest to that of Kniep. The German artists looked to seventeenth-century Italianate painters like Claude for their own versions of the ideal Classical landscape, but they relied much more firmly on truth to nature in details than did British artists, and there was normally a great deal of rivalry between the two schools of artists working in Naples and Rome. British Grand Tourists often preferred the work of Lusieri and Ducros and these German artists to paintings by English artists, who were trained to concentrate on grand manner and effect rather than to pay minute attention to detail. At first glance Wallis seems to have adopted the German technique, but in the end he fell between the two camps, seldom satisfactorily fulfilling the demands of either.

When he first arrived in Italy, Wallis travelled to the usual sites visited by artists, and in 1792 he attracted the attention of Thomas Hope, who took him to Sicily as his draughtsman. Shortly afterwards he returned to the island in the company of Lord Berwick, and was then described as being likely to become 'the best of the English branch since the death of poor [Jacob] More' – the latter had been described by Reynolds as 'the best painter of air since Claude' (Bailey, p. 38).

Sir Joseph Banks's friend Charles Blagden visited Wallis's studio in Naples in February 1793, but was not as impressed with his work as other British Grand Tourists had been:

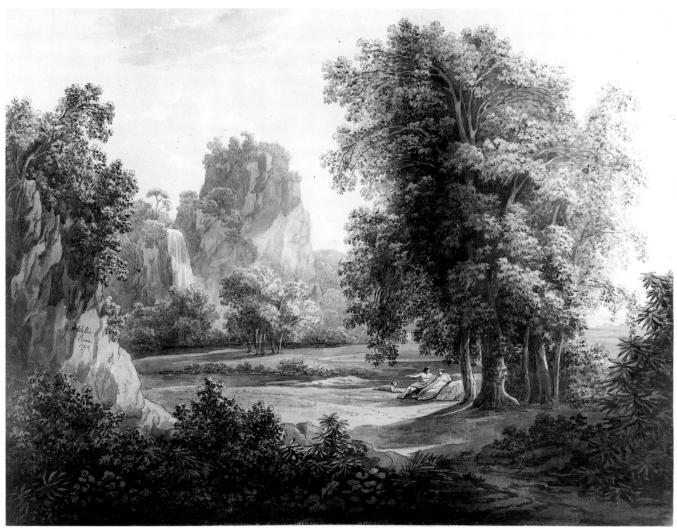

184

We then went to Mr Wallis's, an English artist, young man with keen black eyes. He has a very large picture, just finished, of the Isola di Sora in the Garigliano ... scene morning: colouring dark blues, hard, unnatural: some very fine trees, an ornament which he seems to have studied particularly. As companion to this view, he is at work on a evening view in which the ruins of Paestum ... These pictures are painted for Corbet Corbet. (Royal Society, Blagden Diary, II, f. 57).

Sir William Hamilton's 1798 manuscript list of his paintings at the Palazzo Sessa (British Library, Add. MS 41,200, ff. 121–8) included two works by Wallis: a view of the 'Posillipo Casino' which did not appear in the later sales, and a large upright landscape, possibly in oils, which did. Lot 85 on 17 April 1801 was a *View of a Cascade in Abruzzo, and on the River Liris, now called Garigliano* which had hung in the first antechamber in the Palazzo (untraced); if this painting was at all like the large *Landscape near Rome* which now hangs in the Walker Art Gallery at Liverpool, then it was a very attractive painting indeed. A large anonymous watercolour at Attingham Park, Shropshire, which hangs with the works by Hackert and Lusieri acquired by Lord Berwick, may be by Wallis, who like Hackert and Ducros sometimes relied on other artists to paint his figures; also like the others he often hand-coloured outline etchings of his compositions.

In 1794 Wallis settled in Rome, where he became part of the circle of German artists that included Joseph Anton Koch and Johann Christian Reinhart and was ostracised by British artists. In 1807, when he attempted to return to England to settle, the British artists reported to the diarist Joseph Faring-ton that Wallis had spied on them during the French occupation of Rome (Bailey, p. 50). The landscapes he exhibited that year at the Royal Academy were reviewed ecstatically by *The Times*, which claimed he was the equal of Rosa, Poussin and Claude. Later that year the dealer William Buchanan sent him to Spain to act as his agent. He spent four successful years in Heidelberg, finally settling in Florence in 1818 (Bailey, pp. 36, 53).

LITERATURE: There is further information about Wallis's 1792–3 expeditions in Charles Blagden's manuscript diary in the Royal Society; Claus Graf von Baudissin, *Georg August Wallis, Maler aus Schottland, 1768–1847*, Heidelberg, 1924; C. J. Bailey, 'The English Poussin – An introduction to the life and work of George Augustus Wallis', *Annual Report and Bulletin, Walker Art Gallery, Liverpool*, VI, 1975–6, pp. 35–54.

Last Days

In April 1797 it had been six years since Sir William Hamilton had been in England and he was extremely worried that his private concerns in Wales were suffering greatly from his long absence. He applied for and received the king's permission to return home on leave of absence in June 1797, but by then the French were advancing on Rome and he decided to wait. He was about to leave in May 1798 when he learnt that the British fleet was *en route* for Naples, where he knew Nelson would require his assistance, especially as the British consul, who would normally have taken over as chargé d'affaires, had just died. When Nelson defeated the French at the Battle of the Nile in August, events soon overtook them all. Nelson conducted the king and queen with the Hamiltons to their exile in Palermo in December 1798, and the French entered Naples. Nelson and the Hamiltons were unable to depart for England until eighteen months later, arriving there on 6 November 1800.

The flurry of satirical prints that greeted Nelson and the Hamiltons on their return to England would not have come as a surprise to them. Satirical prints were as much a part of daily life as newspapers – any public figure could expect to feature in them, and the Hamiltons and Nelson were among the most famous public figures of their day. After Hamilton's first collection of antiquities was sold to the nation, he attracted the satirical pen of 'Peter Pindar' (Dr Wolcot), who wrote:

> ... the world reports (I hope untrue),
> That half Sir William's Mugs and Gods are *new*;
> *Himself* the *baker* of the 'Etrurian Ware'
> That made our British Antiquarians stare:
> Nay, that he means ere long to cross the main,
> And at his *Naples oven* sweat again.

['Peter's Prophecy; or The President [Joseph Banks] and Poet', *Complete Works*, 1824, p. 235]

Emma Hart had been a famous beauty and her features had appeared on publicly displayed canvases by Reynolds and Romney which were frequently mentioned in the papers while she was still in London and Greville's mistress. Newspaper reviews also indicate that it was common knowledge that Greville sent her to his uncle in Naples (see cat. no. 167). In Naples she acted as Sir William's hostess at dinners for visiting Grand Tourists, and her entertainments in the form of 'attitudes' and her singing were known throughout Europe. Her marriage to Sir William aroused public comment, most notably again the pen of Peter Pindar. While there had been a note of tongue-in-cheek in his earlier verse, the one occasioned by their wedding was markedly more barbed:

> O Knight of Naples, is it come to pass,
> That thou hast left the Gods of stone and brass,
> To wed a deity of *flesh* and *blood*?
> O lock the temple with thy strongest key,
> For fear thy deity, a *comely* She,
> Should one day ramble in a frolick mood. –
> ... Yet *should* thy Grecian Goddess fly the fane,
> I think that we may catch her in Hedge-Lane.

['A Lyric Epistle to Sir William Hamilton', in *Odes to Kien Long, etc.*, Dublin, 1792, p. 42]

Horatio Nelson had been a national figure even before his 1798 victory on the Nile,

which had occasioned a number of prints by James Gillray (see George, VII, nos 9251–6, 9269). Rumours of Nelson and Emma's liaison reached England by letters, official and private, and in person via those who returned to England from Naples long before the three main protagonists.

Charles Fox had made political ground out of their mistakes in a speech in Parliament in January, and pens and tongues were sharpened and ready when the three finally arrived back in England on 6 November. A parody of the new lines of the National Anthem concerning Emma, Nelson and William appeared days later, and on 11 November Lord Nelson and Sir William, a privy councillor, were publicly snubbed by the king (Fothergill, pp. 389–90). Isaac Cruickshank's *Mansion House Treat* (cat. no. 188) appeared only one week later.

William Beckford, himself long a victim of public scandal and now living quietly at Fonthill Abbey, lent the Hamiltons a house in London until they could settle into their own at 23 Piccadilly and Sir William could organise his finances. Beckford also invited them to Fonthill with Nelson over Christmas, an event which attracted an enormous amount of public attention, not only because of the individuals involved but because it required hundreds of men working at Fonthill day and night for two months beforehand to bring the unfinished building to a condition to receive visitors. Beckford treated Emma civilly as Sir William's wife but did not admire her, calling her 'Lord Nelson's Lady Hamilton, or anybody else's Lady Hamilton'. Loyal to the memory of the first Lady Hamilton, he was extremely fond of Sir William and obviously blamed Emma for ruining his reputation. His opinion of the *ménage à trois* was that

> Nelson was infatuated. She could make him believe anything – that the profligate queen [of Naples] was a Madonna. He was her dupe. She persuaded him at last that she had a daughter – a Nelsoness. She never had a child in her life, in the opinion of those who knew something about her. She rivetted Nelson's heart by telling him it was through her means his ships were fitted and victualled. The fact was, no minister had ever such a prepondering influence at the Court of Naples as Sir William Hamilton – it was his affair. He had been all-powerful there before he saw his second wife. [Melville, pp. 231–2]

It is apparent from his own correspondence that Hamilton could ignore the public satires as long as the people whom he respected did likewise and did not alter the manner in which they dealt with him. His finances, however, were in a deeply troubled state and all efforts to obtain recompense from the government met with failure. His letters indicate that one of the most painful experiences he endured after his return was his treatment when in June 1802, as a privy councillor and foreign minister of thirty-seven years' standing, he requested an audience with the new Foreign Secretary and was kept waiting for two hours and then told to come back another time (Fothergill, p. 411).

Hamilton's remaining time in England, spent at his house in Piccadilly and at Merton, and in particular his relationships with Emma and Nelson, have been dealt with extensively in the many biographies written about these two famous figures. It is clear that Sir William wished to live quietly and enjoy the pursuits he had always enjoyed on his visits to England – seeing old friends and family, viewing their collections at their country houses and in town, and especially following his favourite role as a connoisseur. He was a member of the Royal Society and the Society of Antiquaries and a Trustee of the British Museum, whose records show that he attended every meeting when he was in town and assisted a committee specially formed to advise on the housing and display of 'the valuable Antiquities captured by the British

Army in Egypt, & deposited by the King's most gracious command'. On 20 May 1803, the committee reported that

> they have met repeatedly at the House of Charles Townley Esq where they had abundant opportunity of studying the most approved Methods of exhibiting works of Sculpture to advantage, and, with the assistance of Sir William Hamilton, unfortunately deceased, whose taste the public have always allowed to be excellent, they have been enabled to lay before the Trustees the following opinions ... [British Museum Archives, GM, p. 963].

This is a clear indication that the people whose respect Sir William Hamilton had always desired, other connoisseurs and men of taste, still valued his advice and opinions. He had no doubt enjoyed Beckford's light-hearted prediction for his reputation after his death when it was addressed to him in 1782:

> I know what you expect in Paradise, where you will certainly go, being a pure soul ... As you sweep along the milky way to the melodious jingling of St Peter's keys and behold a grand perspective of the British Museum, all Glory and Transparence like the last scene of a Pantomime, Doors wide open – Pulvinaria set in the Entry, Vases behind and a whole world of bonetty Gentlewomen and their spouses sauntering about and observing what a wonderful *larned* Gemman was Sir Wm. H—. [Melville, pp. 162–3]

185 GUGLIELMO MORGHEN (*fl.* late eighteenth century) after HUGH DOUGLAS HAMILTON (1740–1808)

Sir William Hamilton, c.1790

Engraving, 34 × 26 cm
Provenance: Presented by F. W. B. Maufe and
 Mrs G. B. Lane
British Museum, P&D 1950-5-20-290

This engraving was made from an oil painting now attributed to Hugh Douglas Hamilton (see cat. no. 163), a small intimate work, possibly painted for the sitter's young relative William Beckford. It is typical of the work of the Irish artist, who specialised in small oval portraits which captured, with only a slight amount of flattery, the likeness of the sitter and, more importantly, their character. Thus, without the attributes so clear in other portraits of Sir William – musical instruments, paintings, vases or Vesuvius – it is a portrait of the man himself, represented simply as a man of intelligence, a man of 'public and private virtues'.

The original painting does not even indicate that the sitter was a Knight of the Order of the Bath, a decoration of which Sir William was so proud that the insignia was added to David Allan's early portrait of Hamilton with his first wife (cat. no. 129), the pink sash even appearing in Progenie's watercolour of him collecting rock samples (cat. no. 44). It is therefore significant that the title 'Balnei Ordinis Eques' was added to this print by the engraver to King Ferdinand, Guglielmo Morghen, who must have engraved the painting in Naples sometime in the 1790s. To Sir William Hamilton, the Order of the Bath was his most important title, as it was a public proclamation that his diplomatic post had been applauded and rewarded by his king.

This engraving was made in Italy and probably circulated most widely in that country. However, a stipple print published in England has caused much later confusion (fig. 104). Published 27 March 1817 by T. Cadell & W. Davies, who had been Hamilton's booksellers in London, it bore the credit line 'Engraved by W. T. Fry, from an original Drawing made at Naples by C. Grignon'; this led to the long-standing attribution of the original painting to Charles Grignion, an artist whose style is

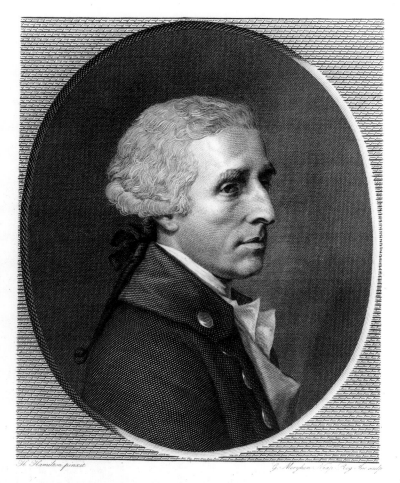

H. Hamilton pinxit. G. Morghen ...

GUGLIELMUS HAMILTON
Balnei Ordini Eques

185

'Memoir' of Sir William Hamilton to be published in the *European Magazine* in 1784, a year after the *Magazine* had printed, un-authorised, his letter to the Royal Society on the earthquake in Calabria of 1783. The profile was published with a view of an eruption of Vesuvius, but the promised 'Memoir' never arrived and the editors were forced to print their own brief account of his 'life and literary transactions':

> [Sir William Hamilton] has distinguished himself as well in the political as the polite world, and equally as a politician, a philosopher, and a man of letters … his

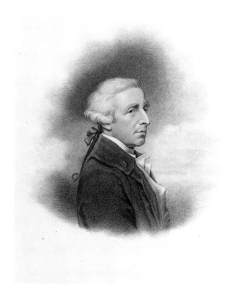

FIG. 104 W. T. Fry after C. Grignion, Sir William Hamilton, KB, FRS. Engraving, 1817. British Museum, P&D 1877–10–13–1217.

very close to that of the painting and who was active in Italy from 1782 until his death at Leghorn (Livorno) in 1804. The stipple engraving was probably based on a drawing made at Naples by Grignion after the oil painting. The painting itself, or a copy, must have hung at the Palazzo Sessa for a while before being sent or brought to England. It was then available for copying in England for some time: there is a miniature copy of it at Lennoxlove, said to be by Horace Hone; a miniature on ivory in the Victory Museum, Portsmouth, and at least two enamel versions (16.8 cm high) by William Hopkins Craft, signed and dated

1802 (one in the British Museum, MLA 1890–8–10–21, presented by A. W. Franks, and one sold at Sotheby's, 1 March 1965, lot 35).

As there are so many versions of this image – the miniatures especially must have been painted for friends – it is obviously how Sir William wished to be remembered. The Reynolds portrait (cat. no. 51) represented the founder of the 'Hamiltonian' collection, while the Romney (cat. no. 8) and the smaller Wedgwood plaque (cat. no. 59) showed Hamilton as the informal and the formal diplomat. It was the latter image which was engraved for an intended

munificence and politeness have done honour to the Sovereign he represents. Few persons of any rank, who have travelled in Italy, but have received civilities from Sir William Hamilton; and scarce any return to England but are profuse in their acknowledgments of favours conferred. With the courage of the elder Pliny, but with better fortune, he has explored the terrific scenes of devastation which Aetna and Vesuvius have of late years presented … We could enlarge on the public and private virtues of this accomplished Gentleman. [v, April 1784, p. 243]

186 (?LOUIS) MARIN (*fl.* late eighteenth century) and JEAN-JÉROME BAUGEAN (1764–1827)

Départ de Rome, du troisième Convoi de Statues et Monumens des Arts, pour le Muséum national de Paris, le 21 Floréal, An 5ème de la République, 1797

Engraving, 45 × 60.6 cm (trimmed)
Inscribed in pen and ink on verso, in Hamilton's autograph: *Lord Grenville will see by the inclosed Print just publish'd at Rome and which Sir Wm. Hamilton has the honor of presenting to His Lordship that the Soi disant Grande Nation glories in its iniquities and robberies, and is desirous of handing down to posterity the Memory of them*
Provenance: Purchased from Nils
 G. Germundson, Zurich
British Museum, P&D 1992–10–3–8

In June 1796, with the French advancing through the north of Italy and the Pope attempting to negotiate a treaty before they reached Rome, Sir William Hamilton feared the worst:

> there is no knowing what effect the flattering prospect the French wou'd naturally hold out to those needy people wou'd have upon them. I must own to you that I think that Italy is in great danger of being completely plunder'd and ruin'd unless some unforeseen accident shou'd operate in its favour, and that very soon … What a pity that Italy shou'd be so robb'd of its finest marbles, pictures & bronzes, which you see by what has happen'd at Parma will certainly be the case shou'd the French marauders advance. [Morrison, no. 282]

Hamilton resisted making preparations for the safety of his own collections in case it gave alarm in Naples, but in Rome the residents began removing as much as possible. The Treaty of Tolentino which the Pope made with Napoleon in 1797 ceded works of art to the French for the National Museum in Paris. The result by the late summer was that the city was left, as the artist William Artaud (see cat. no. 161) remarked, 'like the Sun Eclipsed, shorn of her brightest beams, her museums and churches are stripped of their choicest ornaments, Miserable copys or casts in Plaster substituted for the most exquisite originals – everything in a state of disorder' (Sewter, pp. 178–9).

The French celebrated their third convoy of treasures with the present print, 'glorying in their iniquity' as Hamilton so succinctly put it in his inscription to Lord Grenville on the verso of this graphic image which conveyed so much more than any written dispatch to the Foreign Secretary ever could.

Départ de Rome, du troisieme Convoi de Statues et Monumens des Arts pour le Museum national de Paris, le 21 Floreal An 5 de la Republique

Dedié au
DIRECTOIRE EXECUTIF DE LA RÉPUBLIQUE FRANÇAISE
Par les Citoyens Marin et Baugean

In the end the Treaty proved in vain. The French army entered Rome early in 1798 and proceeded in such a manner that even Artaud, who had grown to despise what he described as the 'corruption and depravity' of the Roman citizens, came to pity them – 'for, to use their own expression, their old Government robbed them of their garments, but their liberators will even carry off their skins' (Sewter, p. 334).

187 GEORGE KEATING (1749–1842) after HENRY SINGLETON (1766–1839)

The Right Hon. Horatio Baron Nelson of the Nile, And of Burnham Thorpe, in the County of Norfolk, Rear Admiral of the Blue… &c., 1798

Coloured mezzotint engraving, published by
G. Keating, 29 November 1798,
45.5 × 32.5 cm
Provenance: Purchased from Messrs Evans
British Museum, P&D 1861–2–9–114

This print is related to an oval drawing of 1797 now in the National Maritime Museum and an oil painting on paper laid down on canvas which was once in Nelson's family (Sotheby's, 17 December 1981, lot 120). This image of the hero is not a commonly known one, but must have been produced almost immediately after his naval victory over the French at Abū Qīr in August 1798. As the *Dictionary of National Biography* records: 'A victory so decisive, so overwhelming, was unknown in the annals of modern war. The fame of it resounded through all Europe, and congratulations, honours, and rewards were showered on Nelson.' No less spectacular were the celebrations in Naples, where he arrived badly wounded on 22 September. He was greeted on board the *Vanguard* by Sir William and Lady Hamilton, followed shortly afterwards by the King of Naples who called him 'deliverer and preserver'. Hamilton insisted that Nelson stay in the Palazzo Sessa to recover; while there, he was fêted by the British and Italians alike as the deliverer of Naples and southern Italy. He remained at the Palazzo most of the next three months, evacuating the Hamiltons and the King and Queen of Naples to Sicily in December 1798. For the next eighteen months Nelson's base was in Palermo with the Hamiltons.

In June 1800 Nelson claimed to be too ill to carry out his duties and received permis-

sion to return to England to recuperate. Sir William Hamilton had seen the arrival of his own replacement, Arthur Paget, and he and Emma accompanied Nelson to England via the courts of Vienna, Prague, Dresden and Hamburg, landing at Great Yarmouth on 6 November 1800. Immediately on landing, Nelson declared his health was recovered and he was fit to serve: on 1 January 1801 he was promoted to vice-admiral, and on 17 January was on board the Channel fleet as second in command. He sailed from Yar-

mouth for the Baltic two months later. He was able to remain in London from September 1801 until just after Sir William Hamilton's death in April 1803, and most of this time was spent in the Hamiltons' company at their house in Piccadilly or at his own house, which they had fitted out for him, at Merton.

187

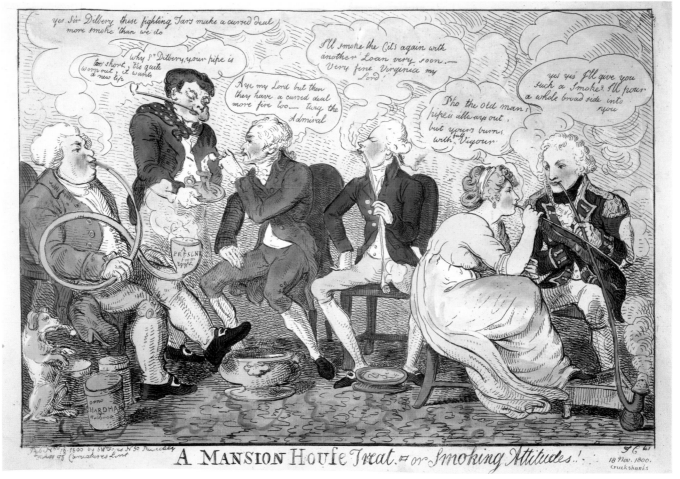

188

188 ISAAC CRUICKSHANK (1756–1810)

A Mansion House Treat – or Smoking Attitudes!, 1800

Hand-coloured etching, published by
S. W. Fores, 18 November 1800,
25.5 × 37.5 cm (trimmed)
Provenance: Edward Hawkins (Keeper of
Antiquities, British Museum) from a large
collection of personal and political satires
purchased after his death
British Museum, P&D 1868-8-8-6913

The characters in this satirical print are easily identifiable and the implications of the accompanying speeches are all too clear. The newly elected Mayor of London, Sir William Staines, noted for his plebeian manners, sits to the left, smoking Egyptian tobacco, a gift of Nelson, the hero of the Nile, seen on the far right. Sir William Hamilton lights his pipe from a candle offered by a 'Jack Tar' and the Prime Minister, William Pitt, sits next to him, preparing to 'smoke the Cits' (tax the citizens) again soon. Lady Hamilton, in one of her 'attitudes' recognisable from Rehberg's publication (cat. no. 160), smokes next to Nelson, whose pipe is by far the longest and 'burning with full Vigour' from a bowl which bears a resemblance to the *ex votos* Sir William Hamilton discovered at Isernia (cat. no. 142).

Sir William's proximity to William Pitt in this print is notable, as he was a great admirer of the prime minister. On reading Richard Payne Knight's 1794 didactic poem on landscape, he had been 'angry with Knight for having brought in a note by head and shoulders, the politicks of the times, & regretting that there was no Minister of Ability when I believe in my Conscience there never was a greater than W. Pitt' (British Library, Add. MS 34,048, f. 81).

LITERATURE: George, VII (1942), no. 9550.

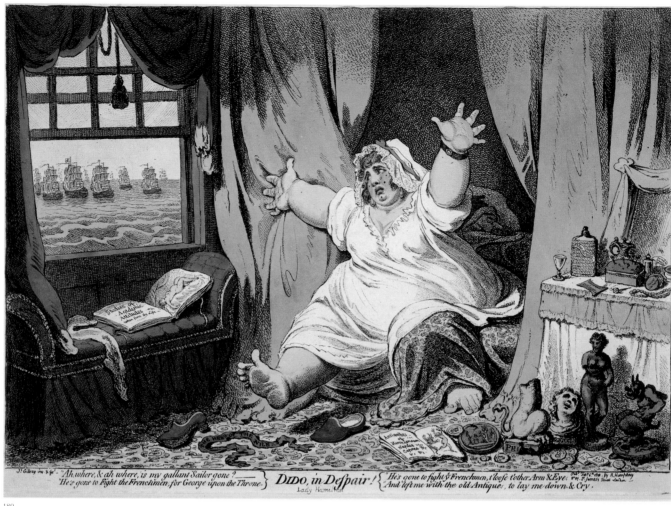

'Ah, where, & ah where, is my gallant Sailor gone? ____ | DIDO, in Despair! | 'He's gone to fight y' Frenchmen, t'loese t'other Arm & Eye,
He's gone to Fight the Frenchmen, for George upon the Throne.} | Lady Hamilton. | And left me with the old Antiques, to lay me down & Cry.

189

189 JAMES GILLRAY (1756–1815)

Dido, in Despair!, 1801

Hand-coloured etching, published by
 H. Humphrey, 6 February 1801, 25.4 × 36 cm
Inscribed: *Lady Hamilton*
Provenance: Edward Hawkins (Keeper of
 Antiquities, British Museum) from a large
 collection of personal and political satires
 purchased after his death
British Museum, P&D 1868–8–8–6927

When Lady Hamilton arrived back in London in November 1800, she was seven months pregnant. She continued to perform her 'attitudes', most notably at Christmas at Fonthill, when her performance of Agrippina with the ashes of Germanicus was witnessed by Benjamin West, who later based a painting on it, and a long account of the festivities was reported in the newspapers. Richard Cosway's drawing of her from about this time (Bignamini and Postle,

1991, no. 35) records what most people noted: that Lady Hamilton had gained weight and become 'ungainly' since her last appearance in London ten years before, but her face still retained her classic Greek beauty and her ability to take on the character of any figure from myth or history was undiminished. As unlikely as it seems, she managed to keep secret the birth of her daughter Horatia in January 1801.

Certainly there is no indication that Gillray knew of it in the series of caricatures he produced at this time. Instead he merely focused on the *ménage à trois* that was by then an international scandal. Lady Hamilton, seen here in a classic 'attitude' of despair, watches her lover's fleet in the Channel, while Sir William sleeps on in bed behind her, with caricatures of his antiquities, his own publications and Rehberg's lying scattered in the room around them. Ulrike Ittershagen has kindly pointed out that

the composition is based on a painting by G. B. Cipriani of the same title which hung in the collection of the Earl of Orford at Houghton from the time it was painted in 1783 (Christie's, 20 April 1990, lot 56).

LITERATURE: George, VIII (1947), no. 9752; Jaffé, no. 93; for the Cosway drawing see I. Bignamini and M. Postle, *The Artist's Model*, exh. cat., Nottingham University Art Gallery, 1991, and S. Lloyd, *Richard and Maria Cosway*, exh. cat., Scottish National Portrait Gallery, Edinburgh, 1995.

190 JAMES GILLRAY (1756–1815)

A Cognocenti contemplating ye Beauties of ye Antique, c.1801

a) Pencil, brown pen and ink and wash,
19.5 × 16.2 cm
Inscribed with various versions of the title and
signed lower right
Provenance: Possibly one of a group of single
drawings and sketchbooks coloured and signed
for the Revd John Sneyd by Gillray; by
descent to Col. Ralph Sneyd (Sotheby's 1927);
? purchased W. T. Spencer; Frank A. Gibson;
Andrew Edmunds, from whom purchased
British Museum, P&D 1992–5–16–14

b) Hand-coloured etching, published by
H. Humphrey, 11 February 1801,
35 × 25.4 cm (trimmed)
Provenance: Presented by the dealer William
Smith after his retirement as part of a large
collection of satires
British Museum, P&D 1851–9–1–1045

190a

The sketch for the final version of Gillray's satirical print enables us to perceive which items were the main objects of the satire from the beginning. Sir William's thin, bent figure peering through his spectacles backwards is the central feature in both versions, but the catalogue he holds in his hand in the sketch becomes a stick in the print and an expressively gesturing glove is added to his pocket. The cracked chamber-pot and small pieces of sculpture, some of them mimicking Emma's 'attitudes', were also part of the satire from the beginning. The disfigured bust Hamilton is peering at was originally conceived as Medusa but in the final version became a bust of Emma labelled 'LAIS' (a celebrated Grecian courtesan, the most beautiful woman of her age, famous also for her avarice and caprice). The single painting in the sketch was developed into a clear iconographic programme in the print: a proudly protective bust of Apis the bull guards images of Cleopatra holding a bottle of gin and a wounded Mark Antony; Vesuvius erupts over Hamilton's head, and the Emperor Claudius, his back to them and his profile mirroring Hamilton's own, is topped by the horns of a cuckold and underlined by a mummy-like figure with ass's ears labelled 'MIDAS'. The print was published just before the Christie's sales of Hamilton's painting and sculpture collections in March and April and before the sale to Thomas Hope of the remainder of Hamilton's second collection of vases.

LITERATURE: George, VIII (1947), no. 9753.

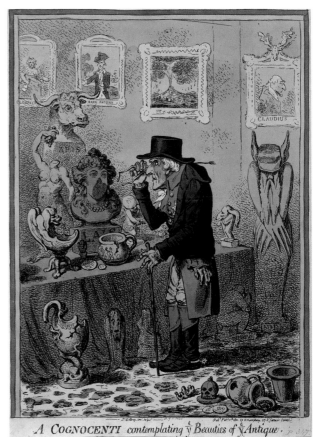

A COGNOCENTI contemplating ẙ Beauties of ẙ Antique.

190b

191 JAMES GILLRAY (1756–1815)

From Sir Willm. Hamilton's Collection, 1801

Hand-coloured etching, published by
H. Humphrey, 8 May 1801, 25.4 × 20 cm
Provenance: Edward Hawkins (Keeper of
Antiquities, British Museum) from a large
collection of personal and political satires
purchased after his death
British Museum, P&D 1868–8–8–6948

Although some of the best of Hamilton's second collection of vases had gone down with the *Colossus*, Nelson had managed to put most of Sir William's crates on board a transport which safely conveyed his paintings and a substantial number of vases to England. The month before this caricature was published, Sir William had sold all these remaining vases to Thomas Hope. Until fairly recently this print was assumed to be a caricature of Sir William himself, but in 1985 Dyfri Williams suggested that it portrays Nelson in the shape of the Meidias Hydria (see cat. no. 59), probably the best-known vase from Hamilton's collection in the Museum. Certainly if Sir William was to be portrayed as one of his vases it would have been a tall thin one. The epaulettes, wig and black bag indicate a naval figure nothing akin to Sir William in his riding coat and boots in the previous caricature by the same artist. The letters inscribed on the base are also apparently naval, although their interpretation and the exact intention of the caricaturist is still obscure. Nevertheless, when added to Gillray's individual images of Lady Hamilton and Sir William (cat. nos 189–90), this figure of Nelson completes Gillray's satirical representation of the *Tria Juncta in Uno* (three in one – the motto of the Order of the Bath).

LITERATURE: George, VIII (1947), no. 9754;
D. Williams, *Greek Vases*, London, 1985,
pp. 54–5; Ramage, 1990a, p. 479–80.

192 THOMAS ROWLANDSON
(1756–1827)

*Lady H******* Attitudes*

Etching, 23.8 × 17 cm (trimmed)
Provenance: Entered the collection before 1837
British Museum, P&D 1981–U.258

This print is most likely the source of an unsubstantiated tradition that Emma Hart

London Publish'd May 8th 1801. by H.Humphrey No 27 St. James's Street

From Sir Willm. Hamilton's Collection

191

once modelled for the life class at the Royal Academy. The caricature has been dated to *c*.1800 because that was when the other caricatures appeared, but it is possible it was produced shortly after Emma's marriage to Sir William in London in September 1791. She spent much of the previous summer modelling for Romney and other artists (including Lawrence; see cat. no. 154), and she performed her 'attitudes' frequently in London and at various country seats. In Kauffman's painting of Emma as *The Comic Muse*, engraved by R. Morghen (cat. no. 171), begun before the artist left Naples, she was shown pulling aside drapery to reveal herself holding a mask, as here, although in Kauffman's painting she was fully clothed.

Kauffman chose a sedate and respectable image of the Muse of mirth, but Rowlandson shows that he was aware of the other side of this muse's character as a bacchante, her figure echoed by the one embraced by a satyr in the background. Hamilton himself is obviously intended by the old thin man with his recognisable profile and glasses; he is shown as an elderly Pygmalion revealing his Galatea, with reminders of his collection in the busts on the floor and the vase into which the model dips her foot.

If this engraving can be dated to shortly after Hamilton's marriage to Emma, then it would have been one of a brief flurry of satirical prints published around that time. Two appeared in *Town and Country Maga-*

zine (XXII, p. 483): *Histories of the Tête à Tête… No. XXXII The Venus de Medici* and *No. XXXIII The Consular Artist*, published by A. Hamilton on 1 December 1790. This was before Sir William and Emma arrived in London in 1791. Shortly after their marriage in September that year, they were the subject of a plate in the *Bon Ton Magazine* (I. 243, 1 October 1791): *The Diplomatic Lover and the Queen of Attitudes* (see George, VI (1938), no. 7708).

LITERATURE: George, VII (1942), no. 9571.

193 TOMMASO PIROLI (1750–1824) after FRIEDRICH REHBERG (1758–1835)

a) *Drawings faithfully copied from Nature at Naples and with permission dedicated to the Right Honourable Sir William Hamilton*, 1794

Hand-coloured engraved title page, and twelve etchings, 26.9 × 20.8 cm, bound in album with

ANONYMOUS (? JAMES GILLRAY)

b) *A new edition considerably enlarged and humbly dedicated to all admirers of the grand and sublime*, 1807

Twelve etchings on blue paper, published by H. Humphrey, 26.1 × 20 cm
Plate 6, *The Muse of Dance*
Provenance: Paul Mellon Collection
Yale Center for British Art, New Haven, PN 3205+R+1802 copy 2

Although Rehberg and Piroli's set of Lady Hamilton's 'Attitudes' were not titled as such, the fame of her performances meant that purchasers knew who was depicted in the prints and several editions were issued (see cat. no. 160). No artist was named in the title page for the 'considerably enlarged' satirical set published by Mrs Hannah Humphrey in 1807. She was Gillray's publisher and printseller; their close relationship and the resemblance of these images to the figure of Emma in Gillray's *Dido, in Despair!* (cat. no. 189) would seem

to point to him as the draughtsman. Copies of the set are extremely rare – this copy lacks its title page and the British Library copy was destroyed in the Second World War.

In 1805 Lady Bessborough witnessed one of Emma's performances, noting 'Lady Hamilton did her Attitudes beautifully, notwithstanding her enormous size – at least the grave ones; she is too large for the Bacchante' (Fraser, p. 314). Emma was living in Nelson's house at Merton, although after Sir William's death in 1803 she actually saw little of her lover as he left with the fleet for the Mediterranean soon afterwards and only had one leave, in 1805, shortly before he died at the Battle of Trafalgar. After his death, Lady Hamilton remained a public figure, but continually on the move and continually in debt. Merton went into the hands of trustees in November 1808 and the remainder of Nelson's and Sir William Hamilton's libraries, antiquities and pictures were sold at Christie's on 8–10 June 1809.

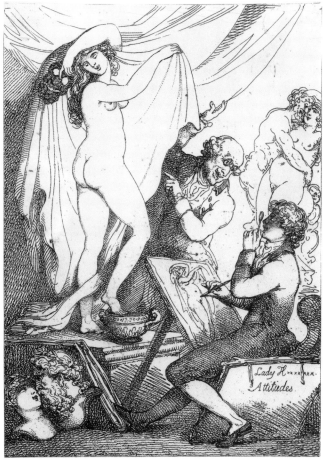

192

193

194 JAMES TASSIE (1735–99) after an
engraved gem by FILIPPO REGA
(1761–1833)

Cast glass intaglio of Emma Hamilton

L. 3.75 cm

Provenance: Presented by Sir Thomas William
 Holburne, Bath

British Museum, MLA 1867,7–8,1

The original gem by Rega may have been
carved at the same time as the one showing
Sir William in profile, which was incor-
porated into a bracelet (see fig. 55). A stip-
ple engraving was made of the original gem
of Emma by Rega, probably indicating it
was included in a published catalogue,
though this has not been discovered.
Another cast of the same intaglio is displayed
in Room 47 of the British Museum.

This cast glass intaglio by Tassie is set in
a gold fob said by the donor to have
belonged to Lord Nelson as a keepsake of
his mistress. The hair is bound and braided
in a self-conscious attempt at a Grecian
coiffure, designed to complement Emma's
famous Grecian profile. The Tassie was
probably a gift to Nelson from Emma or
even Sir William, who does not seem to
have failed in his regard for Nelson. Less
than a month before his death, Sir William
added a codicil to his Will, bequeathing his
miniature copy by Henry Bone of Vigée-
Le Brun's painting of *Emma as a Bacchante*
(now Wallace Collection) to Nelson,
whom he described as his 'dearest friend'
(Fothergill, p. 418). The miniature was pre-
sented as 'a very small token of the great
regard I have for his Lordship, the most
virtuous, loyal, and truly brave character I
ever met with. God bless him, and shame
fall on those who do not say amen.'

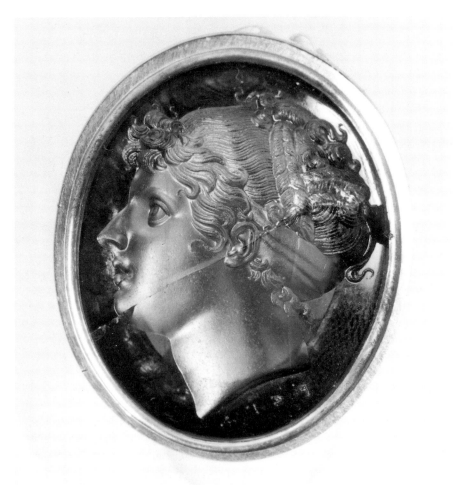

194

William Hamilton's Gifts to the British Museum

Transcribed from 'Donations', 1, Central Archive, British Museum

15 APRIL 1768: 'A large Collection of Lavas from Mount Vesuvius together with a Picture representing an Eruption of the Mountain'

21 APRIL 1769: 'A further Collection of Productions from Mount Vesuvius'

9 JUNE 1769: 'A Mushroom Stone'

27 JULY 1770: 'A large chest containing several curious Productions of the Sea about Naples'

14 JUNE 1771: 'A Curious Collection of Sea Productions'

AUGUST 1771: 'Two Scarce Italian Tracts in 4° together with a curious Specimen of Amber'

16 JANUARY 1772: 'A Chest, containing several productions of the Sea, and Some new & valuable Lavas of Mount Vesuvius'

7 MAY 1774: 'Some Specimens of dried Fish, together with Some Antiquities'

3 JUNE 1774: 'Two Torpedos from the Mediterranean…[?] Three Nautilus's two of which are imitated in Wax, and the Shell & Fish itself dried. A tripod of Bronze' (tripod and bowl, cat. no. 3)

16 JUNE 1775: 'A magnificent antique altar' (Capri altar, cat. no. 130a)

14 JULY 1775: 'A Collection of Marine Productions consisting of 21 Articles, amongst which are two curious Sea Cray Fish, a very fine piece of black Sea Palm, of the Coral kind, found at the same depth as the Corals of the Island of Caprea, a stuffed Chameleon and its Skeleton, and a Representation of its Eggs in Wax, a large Frog caught at the Lake of Agnano, near Naples, and a Sea Production like a Chinese bell flower, its animal of the vermicular kind'

3 NOVEMBER 1775: 'Three Prints of an Antique Marble Vase' (Piranesi prints of the Warwick vase, cat. no. 128)

8 NOVEMBER 1776: 'A very valuable Collection of Antiquities; "Campi Phlegraei" 2 vols fol. 1776' (see cat. no. 43)

23 JANUARY 1778: 'A Roman Glass Patera found in a Cinerary Urn at Cologne: from Sir William Hamilton by the hands of Sir John Pringle' (GR 1778.1–23.1)

2 JULY 1779: 'A collection of Marine Productions and some Scoria of the Lava of Mount Vesuvius'

26 APRIL 1782: '"Supplement to Campi Phlegraei". Naples 1779. in Folio' (see cat. no. 43)

31 JANUARY 1784: 'Six cases containing the following articles, viz No 1. Bronzes, No 2 & 3 Etruscan Vases, No 4. A Lectisternium, No 5. A Colossal Foot of an Apollo in Marble [cat. no. 133], No 6. A large piece of petrified wood'

2 MAY 1788: 'Various Productions of an Eruption of Mount Etna'

22 MAY 1789: 'A Book entitled "Codex Diplomaticus Siciliae"'

13 DECEMBER 1800: 'Two small Egyptian Idols, and a Tessera Theatralis' (old GR 1800.12–13.1 and 2)

8 OCTOBER 1802: 'A copper Medal of the Cardinal of York as Henry 9th'

11 DECEMBER 1802: 'An original Letter from the Emperor Paul, of Russia to Sir William Hamilton'

Chronology

1730

WH born at Park Place, Henley-on-Thames (13 Dec.); fourth son, sixth child of Lord Archibald Hamilton (1673–1754: RN, MP and Lord of the Admiralty, sixth son of William 3rd Duke of Hamilton) and his third wife (m. 1719), Lady Jane Abercorn (d. 1752: daughter of 6th Earl of Abercorn)

1734

Charles of Bourbon, son of Philip V of Spain, declared King of the Two Sicilies as Charles III

1736

Lady Jane Hamilton appointed Lady of the Bedchamber and Mistress of the Robes to Princess of Wales (whose London residence was Carlton House)

1738

Birth of Prince George (later George III), eldest son of Frederick Prince of Wales (4 June)

About this year Park Place sold to Prince of Wales; Lord and Lady Hamilton continue to maintain a house on estate

1739

WH to Westminster School; fellow pupils Frederick Hervey (later Earl-Bishop) and David Murray (Viscount Stormont, later Earl of Mansfield)

1742

Elizabeth Hamilton (eldest sister of WH) marries Francis, Lord Brooke (later 1st Earl of Warwick)

Commodore Martin enters Bay of Naples with squadron to persuade Charles III to cease assisting the Spaniards in Italy and to remain neutral in war of Austrian succession

1745

WH leaves Westminster School

Lady Archibald Hamilton retires from household of Prince of Wales

1746

Jacobites defeated at Culloden by English forces headed by Duke of Cumberland

1747

WH commissioned ensign, Third Regiment of Foot Guards (27 Jan.);

serving in Holland with James Wolfe under Duke of Cumberland, defeated at Lauffelt (July 1747) (order books 1747–8 in Bodleian Library)

1748

Treaty of Aix-la-Chapelle

1749

Birth of Charles Greville, nephew of WH and younger son of Earl of Warwick

1750

WH has lessons on violin from Giardini in London

'Capability' Brown lays out gardens at Warwick Castle

1751

Death of Frederick Prince of Wales

WH appointed Equerry to George Prince of Wales (to 1756)

1752

Henry Seymour Conway purchases Park Place

WH in Paris with younger sister and parents when Lady Jane Hamilton dies (3 Dec.)

1753

WH promoted to Lieutenant; styled Captain Hamilton

1754

Death of Lord Archibald Hamilton

1755

Foundation of Society of Arts

Charles III founds the Royal Herculaneum Society in Naples

1756

Commencement of Seven Years War (to 1763)

Edmund Burke, *Origins of our Ideas of the Sublime and Beautiful*

1757

WH's first sitting to Joshua Reynolds

Benjamin Franklin in London where sets up 'electrical machine'

WH made aide-de-camp to Henry Seymour Conway in Dorsetshire in summer and in ill-fated expedition against Rochefort (Sept.–Oct.)

Ferdinand Duke of Brunswick given command of allied army (Nov.)

1758

WH proposed as member of Society of Arts by James 'Athenian' Stuart; address given as Curzon Street, Mayfair (18 Jan.)

WH marries Catherine Barlow, daughter of Hugh Barlow, MP, of Lawrenny Hall, Pembrokeshire, and Clarges Street, London (25 Jan.)

WH resigns commission (May)

Birth of Horatio Nelson (29 Sept.)

1759

Charles III crowned King of Spain (6 Oct.); his third son, aged 8, becomes Ferdinand IV of Naples and III of Sicily (regency under Tanucci until age of 16)

1760

George III succeeds George II; WH now King's Equerry

Duke of Brunswick defeats French at Minden (Aug.)

General Wolfe takes Quebec (Sept.)

1761

Sale of WH's first collection of pictures, bronzes and terracottas by Messrs Prestage and Hobbs (20–21 Feb.)

WH elected representative for Midhurst, Sussex, with John Burgoyne, to support Newcastle-Bute ministry (MP to Aug. 1764)

1762

England declares war on Spain

J.-J. Rousseau, *Du Contrat Social* and *Emile*

Catherine the Great becomes Empress of Russia

1763

Sir James Gray appointed Minister Plenipotentiary to Court of Spain; WH requests his post as Envoy to Court of King of Two Sicilies at Naples (Apr.)

Treaty of Paris, end of Seven Years War, peace with France and Spain

John Wilkes arrested for issue no. 45 of *North Briton*

1764

WH appointed Groom of the Bedchamber to King George III

WH receives credentials as Envoy Extraordinary to Court of Naples (Aug.)

WH and Catherine Hamilton arrive
Naples (17 Nov.)
Edward Gibbon visits WH in Naples
J. J. Winckelmann, *History of Ancient Art*

1765
Sale of WH's second collection of
pictures, bronzes and terracottas
('brought from his House in the King's
Mews') by Mr Prestage, London
(24–25 Jan.)
Birth of Emy Lyon (later Emma Hart)
(26 Apr.)

1766
Death of James Stuart, the 'Old
Pretender', in Rome; the Pope decides
not to give title of 'Majesty' or 'King'
to his son (Jan.)
WH present during excavations of Temple
of Isis at Pompeii
WH elected Fellow of Royal Society

1767
WH receives credentials as Envoy
Extraordinary and Minister
Plenipotentiary (Feb.)
Winckelmann on fourth and final visit to
Naples (Sept.–Oct.)
Major eruption of Vesuvius (Oct.)
Publication of vol. I of *AEGR*

1768
WH's first visit to Rome with Catherine
Hamilton and Lord Stormont
(Winckelmann and Byres as *ciceroni*);
commissions portrait from Maron;
purchases collection of medals
(29 Jan.–17 Apr.)
Marriage of Ferdinand IV to Maria
Carolina of Austria
Winckelmann murdered at Trieste (8 June)
Captain Cook's first voyage
Royal Academy founded, Joshua Reynolds
president

1769
Death of Mrs Barlow (mother-in-law)
Visit of Charles Greville (Mar.)
Visit of Emperor Joseph II of Austria
(brother of Queen Maria Carolina)
(Mar.–Apr.)
WH goes with wife, Lord Fortrose and
Pietro Fabris to Sicily (18 Apr.–25 July:
Etna, Palermo, Valletta (Malta), Catania,
and Lipari Islands)
Wedgwood opens pottery works at
'Etruria', throwing six 'First Day Vases'
based on WH's publication

1770
Portrait of WH with first wife painted by
David Allan

WH requests transfer to Vienna
Mozart and his father visit Naples;
Catherine Hamilton plays for them
(May)
Charles Burney visits WH in Naples
(Oct.–Nov.)
Vol. II of *AEGR* appears

1771
Threat of war between Spain and Britain
over Falkland Islands; Spain cedes
Benjamin West exhibits *Death of Wolfe*
WH's first return to England (arr. Aug.),
taking Correggio to sell (£3,000 –
remains unsold)
WH's first collection of antiquities offered
to British Museum

1772
WH created Knight of the Bath (15 Jan.)
WH elected Fellow of Society of
Antiquaries (Feb.)
Parliament votes £8,400 for collection to
be purchased for nation and placed in
BM
WH returns to Naples, visiting *en route*
Voltaire at Ferney, Emperor Joseph II
and Lord Stormont at Vienna, and
stopping at Verona, Venice and Rome,
where he meets Charles Edward Stuart
and Pope Clement XIV
Publication of first five letters to Royal
Society as *Observations on Mount
Vesuvius, Mount Etna and other
volcanos . . .* (2nd edition 1773, 3rd
edition 1774, trans. into German 1773)

1773
WH returns to Naples (Jan.)
Pope Clement XIV abolishes Jesuit Order

1774
J. W. von Goethe, *The Sorrows of Young
Werther*
Charles Edward Stuart, the 'Young
Pretender', moves household from
Rome to Florence
Accession of Louis XVI of France

1775
War of American Independence begins (to
1783)
WH reassures Secretary of State that King
of Two Sicilies has refused to back
Spain in its support of America against
Britain
WH requests post in British embassy at
Madrid
WH offers 'Warwick Vase' to British
Museum
Death of Cecilia (possibly an adopted
daughter)

1776
Publication of *Campi Phlegraei, Observations
on the Volcanos of the Two Sicilies*
(2 vols)
WH's second return to England (dep.
May, via Paris to visit Lord Stormont
and his second wife, Hamilton's niece)
Vols III and IV of *AEGR* printed
Edward Gibbon, *Decline and Fall of the
Roman Empire* (finished 1788)

1777
WH elected member of Society of
Dilettanti (2 Mar.)
WH sits to Reynolds for portraits for
Dilettanti and British Museum
WH back in Naples (25 Nov.)
Tanucci replaced as Chief Minister in
Naples

1778
Arrival of General John Acton in Naples
to improve navy
France and Britain declare war
Joseph Banks elected President of Royal
Society (30 Nov.)

1779
WH is instrumental in King of Two
Sicilies refusing to support his father,
King Charles III of Spain, in declaring
war against Britain
Eruption of Vesuvius and publication of
supplement to *Campi Phlegraei*

1780
Gordon riots in London (June)
Visit of William Beckford to second
cousin WH in Naples (Nov.–Dec.)
Visit of Duke of Hamilton and Dr John
Moore

1781
WH announces discovery of 'Cult of
Priapus' at Isernia in Abruzzo

1782
Visit of Grand Duke Paul of Russia
(son of Catherine II)
WH acquires 'Portland Vase'
Second visit of William Beckford
(July–Aug.)
Death of Dr Drummond (13 Aug.)
Death of Catherine Lady Hamilton
(25 Aug.)

1783
WH elected Trustee of British Museum
(23 Jan.)
Thomas Jones lent room in Palazzo Sessa
while Hamilton visits scene of
earthquake in Calabria that killed 40,000
in Feb. (2–23 May)

WH departs for third return to England
(24 May)

WH attends General Meetings of British
Museum as Trustee (27 Sept., 6 Dec.)

Treaty of Versailles (Sept.)

Pitt leads Ministry in England (Dec. 1783;
in power to 1801)

1784

WH visits estates in Wales, family in
Scotland, Greville and Emma Hart at
Edgware Row; sells 'Portland vase' to
Duchess of Portland, first having it
drawn by Cipriani and copied by
Wedgwood

Two paintings commissioned by WH (by
Jones and Reynolds) exhibited at Royal
Academy

WH returns to Naples via Parma, Turin,
Florence (Nov.), Rome

1785

WH given superintendence of English
Garden to be created at Caserta; writes
to Banks for a gardener (Jan.)

1786

Arrival of John Graefer (Apr.)

Arrival of Emma Hart and her mother,
Mrs Cadogan (26 Apr.)

R. Payne Knight, *An Account of the Worship
of Priapus lately existing in Isernia*

1787

Goethe visits WH (introduced by
Tischbein); sees Emma perform
'Attitudes' (Mar.–May)

1789

WH begins to collect vases again

WH and Emma go on 32-day tour of
southern Italy (Apr.–May)

Fall of the Bastille: news of Revolution in
France reaches Naples (Aug.)

1790

WH requests leave to visit England (Nov.)

Edmund Burke, *Reflections on the Revolution
in France*

1791

Lord Grenville becomes Secretary of State
for Foreign Affairs (to 1801)

WH departs for fourth return to England,
this time with Emma, via Florence and
Venice (Apr.); arrives London (end
May)

WH member of King's Privy Council

WH visits Downton Castle (home of
R. Payne Knight) and Welsh estates;
agrees sale of second bronze collection
to Payne Knight and second collection
of gems to Sir Richard Worsley

WH obtains royal permission for wedding;
marries Emma Hart (6 Sept.), leaves for
Naples (11 Sept.); travels via Paris
where visits Lord Palmerston and Marie
Antoinette

WH advertises second vase publication,
*Collection of Engravings from Ancient
Vases*, with plates engraved under the
supervision of Tischbein (first volume
appears 1793)

WH back in Naples (Dec.)

Visit of Prince Augustus to Naples (Dec.)

1792

Riots in England

Departure of Prince Augustus (May?)

France declared a republic (22 Sept.);
French at war with Austria; French
squadron in Bay of Naples (Nov.–Dec.)

WH seriously ill (Dec.–Jan.)

1793

Execution of Louis XVI (Jan.)

France declares war on Britain (Feb.)

WH negotiates Treaty of Alliance
between Two Sicilies and Great Britain
(begun Apr., signed 12 July)

Capt. Horatio Nelson arrives in Naples
with dispatches from Lord Hood to
arrange reinforcements from Neapolitan
navy and meets WH and Emma for first
time (Sept.)

Execution of Marie Antoinette (Oct.)

Publication of vol. I of second vase
collection

1794

Nelson in campaign to capture Corsica
(Jan.–Aug.)

Major earthquake and eruption of
Vesuvius, lava destroys Torre del Greco
(June–Aug.)

Visit of Earl-Bishop, also Mrs Billington,
and Prince Augustus (Dec.)

1795

WH ill (Apr.)

Passed letter by Queen of Naples from
Spanish King stating intention to treat
for peace with France

1796

Napoleon's Italian campaign begins (Apr.);
enters Milan (May)

Naples declares neutrality

Spain declares war on Britain (5 Oct.)

WH persuades Foreign Office to allow
British fleet to remain in Mediterranean
for the moment

Attempts to sell second vase collection to
King of Prussia (May)

British refugees from Corsica evacuated to
Naples, where they are WH's
responsibility (Nov.)

Prince Augustus in Naples

Publication of vol. II of second vase
collection

1797

Nelson promoted to Rear-Admiral of the
Blue; created Knight of the Bath; loses
right arm

WH requests and receives permission for
leave in England but postpones it (June)

Death of Horace Walpole

1798

French enter Rome (Jan.) and take Malta

Earl-Bishop imprisoned by French in
Milan (Apr.–Feb. 1799)

WH sends Prince Augustus to Vienna
(May)

Davenport, British consul at Naples for
40 years, dies and WH requests new
consul as soon as possible (May?)

WH persuades Acton to permit British
fleet to be furnished with supplies in
Sicilian ports (in spite of Naples treaty
with France)

WH draws up list of paintings in his
collection (July), packed by James
Clark (Oct.–Dec.)

Nelson defeats French at Battle of the Nile
(1 Aug.)

Nelson and British fleet arrive in Bay of
Naples; Nelson guest at Palazzo Sessa
(Sept.)

Ferdinand marches on French-occupied
Rome but driven out (Nov.–Dec.)

WH evacuated with Royal Family and
other British residents to Palermo (Dec.)

Colossus with cargo of second vase
collection sinks off Scilly Isles (Dec.)

1799

WH in Villa Bastioni, then Palazzo
Palagonia, Palermo, with Nelson
(from Jan.)

Nelson orders Neapolitan navy put to
match to prevent being taken by French
(8 Jan.)

French occupy Naples (23 Jan.)

French withdraw from Naples (Apr.–May)

Arrival of Charles Lock, new British consul

WH about to depart on leave for England,
but decides to stay and help Nelson in
negotiations between King of Naples
and Neapolitan rebels (June); Nelson's
official orders only to prevent Franco-
Spanish fleet from attacking Sicily

Nelson, WH and Emma on behalf of King
of Naples declare null the terms of

Ruffo's armistice with French and rebels and direct their imprisonment and punishment

After arrival of king in Bay of Naples, WH sends long dispatch to Lord Grenville (14 July); Grenville sends George III's satisfaction with events

WH returns to Palermo with Nelson, Emma and King of Naples; showered with gifts by king and queen (said to be to value of £6,000)

Nelson created Duke of Bronte by Ferdinand IV (Aug.)

Arrival of Lord and Lady Elgin in Palermo (Oct.)

1800

WH decides finally to take leave (Jan.)

Charles James Fox, speaking on behalf of Opposition, censures Nelson's conduct in Bay of Naples the previous summer (Feb.)

Arthur Paget, WH's replacement, arrives (9 Apr.); WH refuses to present him to king or take own formal leave until day of departure (23 Apr.)

WH visits Malta with Nelson and Emma (Apr.–May); returns to Palermo (31 May)

WH gives farewell banquet in honour of George III (5 June)

WH's final departure with Nelson and Emma (10 June): return via Vienna, Prague, Dresden, Hamburg; land Great Yarmouth (6 Nov.), arr. London (9 Nov.)

WH presents himself at court, where Privy Councillor, but ignored by George III (11 Nov.)

WH presents bill for extraordinary expenses Aug. 1799–June 1800: £13,213, plus estimated losses of effects at Naples £10,000 (still negotiating at death, when account closed)

WH begins regularly to attend General Meetings of British Museum as Trustee (13 Dec.)

Christmas at Fonthill Abbey with Nelson and Emma as guests of William Beckford

Publication of vol. III of second vase collection (vol. IV published after WH's death)

1801

WH takes house at 23 Piccadilly; income from Welsh estate £1,000 p.a. plus pension £1,200 p.a., to terminate at death

Daughter born to Emma and Nelson (28 Jan.)

New ministry in government and new Secretary of State for Foreign Affairs

WH's first sale of pictures and some sculpture at Christie's (27–28 Mar.) (realised £5,025)

WH repays loan to Nelson of £2,200

British campaign against French in Egypt; Nelson second-in-command at Battle of Copenhagen (2 Apr.)

WH sells vases not on Colossus to Thomas Hope (3 Apr.): £4,000

WH's second sale of pictures and sculpture at Christie's (17, 18 Apr.; realised £716)

Nelson created viscount (22 May)

WH visits Welsh estates (Aug.)

Emma purchases Merton for Nelson (18 Sept.)

Nelson returns to England to join Hamilton and Emma at Merton (end Oct.)

1802

Treaty of Amiens (27 Mar.)

WH again presents bill for extraordinary expenses and losses (June)

Tour of west of England and Wales with Nelson and Emma, including visits to Milford Haven, to Payne Knight at Downton and to Warwick (July–Sept.)

Honorary Degree of Doctor of Civil Law conferred, Oxford (23 July)

Christmas at Merton

1803

WH attends last meeting at British Museum as Trustee (12 Feb.)

Society of Dilettanti agree to publish Antonio Piaggio's MSS and drawings documenting early excavations at Herculaneum (Mar.), but never published

WH ill (Mar.); dies (6 Apr.); interred with first wife at Slebeck Church on Milford Haven, near Haverford West

Britain resumes hostilities with France and Nelson sails on Victory (16 May)

1805

Death of Nelson in battle with Franco-Spanish fleet at Trafalgar (21 Oct.)

1813

Emma arrested for debt

1814

Emma flees to Calais

1815

Death of Emma in Calais (15 Jan.)

Abbreviations | Frequently Cited Manuscript Sources

AEGR = See Bibliography, under d'Hancarville, 1766–7
ASN = Archivio di stato, Napoli
BF Archive, PMC = Sir Brinsley Ford Archive, Paul Mellon Centre for British Art, London
BL = British Library
BM = British Museum
 Archives = Central Archives
 CM = Committee Minutes
 G&R = Department of Greek and Roman Antiquities
 GM = General Meeting Minutes
 MLA = Department of Medieval and Later Antiquities
 OL&P = Original Letters and Papers
 P&D = Department of Prints and Drawings
 WAA = Department of Western Asiatic Antiquities
HMC = Historical Manuscripts Commission
LIMC = *Lexicon Iconographicum Mythologiae Classicae*, see Bibliography
NG = National Gallery
NGI = National Gallery of Ireland
NGS = National Gallery of Scotland
NLI = National Library of Ireland
NLS = National Library of Scotland
NPG = National Portrait Gallery
PMC = Paul Mellon Centre for British Art, London
PRO = Public Record Office
RA = Royal Academy
RS = Royal Society
SNPG = Scottish National Portrait Gallery
SRO = Scottish Record Office
V&A = Victoria and Albert Museum
Wal. Corr. = *Walpole Correspondence*, see Bibliography, under Lewis
Wal. Soc. = *Walpole Society* annual volume
YCBA = Yale Center for British Art, New Haven

Add. MS (various): London, British Library, Additional Manuscripts
Blagden MS: London, Royal Society, Sir Charles Blagden diaries
Burges, James Bland, MS: Oxford, Bodleian Library, Department of Western MSS, Bland Burges deposit, B.20, C.35, C.47
Chellis Coll. MS (Bentley): Birmingham, Alabama, Birmingham Museum of Art, Dwight and Lucille Beeson Wedgwood Collection
Clark, James, packing list: in Perceval MS, Fitzwilliam Museum, Cambridge (reprinted in Fothergill, pp. 426–42)
Diario Vesuviano: London, Royal Society, diaries recording daily activities of Vesuvius, by Padre Antonio Piaggio
Eg MS (various): London, British Library, Egerton Manuscripts
Hamilton's manuscript list of his paintings collection: Add. MS 41,200, ff. 121–8
Hamilton Papers, Bodleian: Oxford, Bodleian Library, Department of Western MSS, Eng. hist. g.3–16: notebooks of Sir William Hamilton 1747–93
Hamilton Papers, Misc.: London, British Museum, Department of Greek and Roman Antiquities Library, Miscellaneous Papers of Hamilton's collections in 2 vols (1 brown binding, 1 green binding)
Hamilton Papers: Paris, Muséum National d'Histoire Naturelle, Krafft Bequest (uncalendared)
d'Hancarville, MS catalogue of Hamilton collection: London, British Museum, Greek and Roman Department Library, 2 vols, 1778
Hawkins: London, British Museum, Department of Greek and Roman Antiquities Library, E. Hawkins, manuscript 'Catalogue of Bronzes in the British Museum', 4 vols, n.d.
Knight MS: London, British Museum, Department of Greek and Roman Antiquities Library, R. Payne Knight, manuscript 'Catalogue of Bronzes', n.d.
Krafft Bequest: see Hamilton Papers, Paris
Limerick MS: see Pery MS
Payne Knight Letters: group within Wolf MSS, covering 30 June 1791 to 24 Jan. 1794
Perceval MS: Cambridge, Fitzwilliam Museum, Perceval MSS, N 5, 7, 8, 27
Pery MS: Dublin, National Library of Ireland, Limerick MSS, special list 160, no. 48, MS 16,086: Henry Pery's copy of William Hamilton's notes on a tour of Rome in company with Byres and Winckelmann (from notes in BF Archive, PMC)
Poole MS: London, British Museum, Department of Greek and Roman Antiquities Library, R. S. Poole, manuscript 'Catalogue of the Cracherode, Knight, Townley and Hamilton Gems', *c*.1850
PRO SP: London, Public Record Office, State Papers (from notes in the BF Archive, PMC)
Townley Papers: London, British Museum, Central Archives

Wedgwood MS: Barlaston, Wedgwood Museum, Wedgwood MS E 32–5365
Whitley Papers: London, British Museum, Department of Prints and Drawings, albums containing W. T. Whitley's notes on British artists
Wolf MS: sale, London, Christie's, 20 June 1990, letters of Sir William and Emma Lady Hamilton, Richard Payne Knight, etc., formerly part of Edwin Wolf collection (some now part of Krafft Bequest, see Hamilton Papers, Paris, above)
Worsley Papers: Lincoln, Lincolnshire Record Office, papers of Worsley family, later Earls of Yarborough

Bibliography

Acton, H., *The Bourbons of Naples 1734-1825*, London, 1957

Adams, E. B., *The Dwight and Lucille Beeson Wedgwood Collection at the Birmingham Museum of Art, Birmingham, Alabama*, Birmingham, Ala., 1992

AEGR, see d'Hancarville, 1766–7

Ahrens, D. (ed.), 'Zwei Werke aus dem Tischbein-Umkreis', *Räume der Geschichte: Deutsch-Römisches von 18. bis 20. Jahrhundert*, Trier, 1986

Allan, D. G. C., *William Shipley*, London, 1968

Alten, von, see Von Alten

Altick, R. D., *The Shows of London: A Panoramic History of Exhibitions, 1600-1862*, Cambridge, Mass., and London, 1978

Amyx, D. A., *Corinthian Vase Painting of the Archaic Period*, I–III, Berkeley and Los Angeles, 1988

Anson, E. and H. (eds), *Mary Hamilton: afterwards Mrs John Dickenson at Court and at Home – from Letters and Diaries, 1756 to 1816*, London, 1925

Antichità di Ercolano esposte, Le, 10 vols, Naples, 1757–92

Antiquités Etrusques, Grecques et Romaines, tirées du Cabinet de M. William Hamilton, Envoyé extraordinaire et plénipotentaire de S. M. Britannique en Cour de Naples (AEGR), see d'Hancarville, 1766–7

Babelon, E., *Catalogue des camées antiques et modernes de la Bibliothèque Nationale*, Paris, 1897

Baetjer, K., *European Paintings in the Metropolitan Museum of Art: Summary Catalogue*, 3 vols, New York, 1980

Baily, J. T. H., *The Life of Emma Lady Hamilton*, London, 1905

Barber, P., *Diplomacy: The World of the 'Honest Spy'*, exh. cat., British Library, London, 1979

Barfield, L., 'Sir William Hamilton's Chalcolithic collection', in J. Swaddling (ed.), *Italian Iron Age Artefacts in the British Museum*, London, 1986, pp. 229–33

Barocas, C., 'La storia della Collezione Egiziana del Museo', *Civiltà dell'antico Egitto in Campania* (Raccolta di studi in occasione della Mostra allestita nel Museo Archeologico Nazionale Napoli – Giugno-Settembre 1983), Naples, 1983, pp. 9–17

Barocas, C., 'Le antichità egiziane del Museo Borgiano', *La collezione egiziana del Museo Archeologico Nazionale di Napoli*, Naples, 1989, pp. 15–34

Barrell, J. (ed.), *Painting and the Politics of Culture – New Essays on British Art 1700-1850*, Oxford and New York, 1992

Bassani, E., *Cook, Polinesia a Napoli nel Settecento*, Bologna, 1982

Bassi, D., 'Il Padre Antonio Piaggio e i primi tentativi per lo svolgimento dei Papiri Ercolanesi (da documenti inediti)', *Archivo Storico per le Province Napoletane*, XXXII, 1907

Beazley, *ARV²* = J. D. Beazley, *Attic Red-figure Vase-painters*, 2, Oxford, 1963

Beckford, W., *Italy, Spain and Portugal*, London, 1840

Berghaus, P. (ed.), *Der Archäologe: Graphische Bildnisse aus dem Porträtarchiv Diepenbroick*, Münster, 1983

Bermingham, A., 'The origins of painting and the ends of art: Wright of Derby's *Corinthian Maid*', in Barrell, pp. 135–65

Bietti Sestieri, A. M., 'Italian swords and fibulae of the late Bronze and early Iron Ages', in J. Swaddling (ed.), *Italian Iron Age Artefacts in the British Museum*, London, 1986, pp. 3–23

Bivar, A. D. H., *Catalogue of Western Asiatic Seals in the British Museum, Stamp Seals II: Sassanian Dynasty*, London, 1969

Black, J., *Convergence or Divergence? Britain and the Continent*, London, 1994

Blumenbach, J. F., 'Observations on some Egyptian mummies . . .', *New Annual Register*, 1794, London, 1795, pp. 127–35

Boardman, J., 'Pyramidal stampseals in the Persian empire', *Iran*, 8, 1970, pp. 19–45

Boardman, J., *The Greeks Overseas. Their Early Colonies and Trade*, rev. edn, London, 1973

Bol, P. (ed.), *Forschungen zur Villa Albani, Katalog der antiken Bildwerke*, I, Berlin, 1989

Bologna, F., 'The rediscovery of Herculaneum and Pompeii in the artistic culture of Europe in the eighteenth century', in B. Conticello (ed.), *Rediscovering Pompeii*, exh. cat., Rome, 1990, pp. 79–91

Bonner, C., *Studies in Magical Amulets, chiefly Graeco-Egyptian*, University of Michigan, 1950

Boyle, N., *Goethe, the Poet and the Age*, I, Oxford, 1991

Briganti, G., and Spinosa, N., *All'Ombra del Vesuvio*, exh. cat., Naples, 1989

Briganti, G., Spinosa, N., and Stainton, L., *In the Shadow of Vesuvius: Views of Naples from the Baroque to Romanticism 1631-1830*, exh. cat., Accademia Italiana, London, 1990

Brigstocke, H., *William Buchanan and the Nineteenth-Century Art Trade*, London (privately printed for PMC), 1982

Brydone, P., *A Tour through Sicily and Malta*, London, 1776

Buchanan, W., *Memoirs of Painting*, 2 vols, London, 1824

Buchner, G., and Boardman, J., 'Seals from Ischia and the Lyre-player Group', *Jahrbuch des Deutschen Archäologischen Instituts*, 81, 1966, pp. 1–62

Burn, L., *The Meidias Painter*, Oxford, 1987

Burney, C., *Musical Tours in Europe*, see Scholes

Burr Litchfield, R., 'Naples under the Bourbons: an historical overview', in *Golden Age of Naples*, pp. 1–14

Caetani, Vittoria, see Sermonetta, Duchess of

Calza, R., *Antichità di Villa Doria Pamphilj*, Rome, 1977

Carabelli, G., *In the Image of Priapus*, forthcoming

Carpanetto, D., and Ricuperati, G., *Italy in the Age of Reason 1685-1789*, London, 1987

Carratelli, G.P. (ed.), *Megale Hellas*, Milan, 1983

Caylus, Comte de (Thubières de Grimoard de Pestels de Levis, A. C. P. de), *Recueil d'Antiquités Egyptiennes, Etrusques, Grecques et Romaines*, 7 vols, Paris, 1752–67

Chaney, E., and Ritchie, N. (eds), *Oxford, China and Italy: Writings in Honour of Sir Harold Acton*, London, 1984

Chatelain, J., *Dominique Vivant Denon et le Louvre de Napoléon*, Paris, 1973

Cheetham, M., 'The taste for phenomena: Mount Vesuvius and transformations in late 18th-century European landscape depiction', *Wallraf-Richartz-Jahrbuch*, XLV, Cologne 1984, pp. 131–44

Cheetham, M., 'The "Only School" of landscape revisited: German visions of Tivoli in the eighteenth century', *Idea*, Jahrbuch der Hamburger Kunsthalle, IV, Hamburg, 1985, pp. 133–46

Chessex, P., 'A Swiss painter in Rome: A. L. R. Ducros', *Apollo*, June 1984, pp. 430–37

Chessex, P., *Images of the Grand Tour, Louis Ducros*, exh. cat., Kenwood, London, 1985

Chevallier, G., 'Denon chargé d'affaires à Naples – 1782-1785', *Mémoires de la Société d'Histoire de Chalon-sur-Saône*, 2nd ser., XXXVIII, 1964, pp. 104–21

Chifflet, J., *Joannis Macarii canonici ariensis Abraxas seu Apistopistus, quae est antiquaria de gemmis basilidianis disquisito*, Antwerp, 1657

Civiltà del '700 a Napoli 1734-1799, exh. cat., 2 vols (N. Spinosa *et al.*), multi-venue, Naples, Dec. 1979–Dec. 1980 (exhibition also held in Detroit and Chicago, see *Golden Age of Naples*)

Clark, A. M. (ed. E. P. Bowron), *Pompeo Batoni, A Complete Catalogue of his Works with an Introductory Text*, Oxford, 1985

Clarke, M., and Penny, N. (eds), *The Arrogant Connoisseur: Richard Payne Knight 1751-1824*, exh. cat., Whitworth Art Gallery, Manchester, 1982

Collon, D., *First Impressions. Cylinder Seals in the Ancient Near East*, London, 1987

Connell, B., *Portrait of a Whig Peer* (2nd Viscount Palmerston), London, 1957

Constantine, D., 'Winckelmann and Sir William Hamilton', *Oxford German Studies*, 22, 1993, pp. 55–83

Constantine, D., 'Sir William Hamilton's account of a journey into the province of Abruzzo', *Oxford German Studies*, 23, 1994, pp. 104–23

Cook, B. F., *The Townley Marbles*, London, 1985

Croce, B., 'Napoli Nobilissima', *Rivista di Topografia e d'Arte Napoletana*, new series, 2, 1922

Cumberland, R., *Sanchoniatho's Phoenician History, translated from the First Book of Eusebius, De praeparatione evangelica*, London, 1720

D'Alessandro, D. A., *Mozart a Napoli: una testimonianza iconografica?*, Naples, 1991

Dalton, O. M., *Catalogue of the Engraved Gems of the Postclassical Periods . . . in the British Museum*, London, 1915

D'Arms, J., *Romans on the Bay of Naples*, Cambridge, Mass., 1970

Davenport, C., *Cameos*, London, 1900

David, F. A., *Antiquités Etrusques, Grecques et Romaines (avec leurs explications par d'Hancarville)*, 5 vols, Paris, 1785

Dawson, A., *Masterpieces of Wedgwood*, London, 1984; rev. edn London, 1995

Dawson, W. R., *The Banks Letters*, London, 1958

De Caro, S. (ed.), *Alla ricerca di Iside: Analisi, studi e restauri dell'Iseo Pompeiano*, Naples, 1992

Denison, C. D., *et al, Exploring Rome: Piranesi and his Contemporaries*, exh. cat., Montreal and Pierpont Morgan Library, New York, 1993

Deutsch, O. E., 'Sir William Hamilton's Picture Gallery', *Burlington Magazine*, LXXXII, February 1943, pp. 36–41

Dibbits, T., and Niemeijer, J. W., *Luoghi di delizia: un Grand Tour olandese nelle immagini di Louis Ducros, 1778*, exh. cat., Istituto Universitario Olandese di Storia dell'Arte, Florence, 1994

Dubois-Maisonneuve, M., *Introduction à l'étude des vases antiques, etc.*, Paris, 1817

Egerton, J., *Wright of Derby*, exh. cat., Tate Gallery, London, 1990

Elsner, J., 'A collector's model of desire: the house and museum of Sir John Soane', in J. Elsner and R. Cardinal (eds), *The Cultures of Collecting*, London, 1994, pp. 155–76

Errington, L., *David Allan: Sacraments and Bacchanals*, exh. leaflet, National Gallery of Scotland, Edinburgh, 1982

Farington *Diary*, see Garlick and Mackintyre

Ford, B., 'Thomas Jenkins: banker, dealer and unofficial English agent'; 'The Earl-Bishop: an eccentric and capricious patron of the arts'; and 'James Byres: principal antiquarian for the English visitors to Rome', *Apollo*, XCIX, June 1974, pp. 416–25, 426–34 and 446–61

Fothergill, B., *Sir William Hamilton Envoy Extraordinary*, London, 1969

Frankfort, H., *Cylinder Seals: A Documentary Essay on the Art and Religion of the Ancient Near East*, London, 1939

Fraser, F., *Beloved Emma: The Life of Emma Lady Hamilton*, London, 1986; paperback edn, 1994

Funnell, P., 'The symbolical language of antiquity', in Clarke and Penny, pp. 65–81

Furtwängler, A., 'Über die Gemmen mit Künstlerinschriften', *Jahrbuch des Deutschen Archäologischen Instituts*, 3, 1888, pp. 105ff., 193ff., 297–325

Furtwängler, A., 'Über die Gemmen mit Künstlerinschriften', *Jahrbuch des Deutschen Archäologischen Instituts*, 4, 1889, pp. 46–87

Furtwängler, AG = A. Furtwängler, *Die antiken Gemmen*, I–III, Leipzig and Berlin, 1900

Gage, J., 'Lusieri, Hamilton and the Palazzo Sessa' (letter), *Burlington Magazine*, CXXXV, November 1993, pp. 765–6

Gardenstone, Francis Garden, Lord, *Travelling Memorandums*, 3 vols, Edinburgh, 1791–5

Garlick, K., and Macintyre, A. (eds), *The Diary of Joseph Farington*, 16 vols, London, 1978–84

Gascoigne, J., *Joseph Banks and the English Enlightenment: Useful Knowledge and Polite Culture*, Cambridge, 1994

George, M. D., *Catalogue of Political and Personal Satire in the Department of Prints and Drawings in the British Museum*, VI (1784–92), VII (1793–1800), VIII (1801–10), London, 1938, 1942, 1947

Germer, R., Kischkewitz, H., and Lüning, M., 'Pseudo-Mumien der ägyptischen Sammlung Berlin', in H. Altenmüller (ed.), *Studien zur altägyptischen Kultur*, 21, 1994, pp. 81–94, pls 5–9

Gibson-Wood, C., 'Jonathan Richardson and the rationalisation of connoisseurship', *Art History*, Spring 1984, pp. 36–56

Gill, E., *Nelson and the Hamiltons on Tour*, Gloucester, 1987

Goethe, J. W. von, *Philipp Hackert*, Tübingen, 1811

Goethe, J. W. von, *Italienische Reise*, ed. H. von Einem and E. Trunz, 6th edition, 14 vols, Hamburg 1964

Goethe, J. W., *Italian Journey (1786-1788)*, trans. W. H. Auden and E. Mayer, London 1962; Penguin edn Harmondsworth, 1970

Goethe, J. W. von, *Italian Journey*, Goethe Collected Works, 6, Princeton, 1989

Goethe, J. W. von, *Römische Elegien und das Tagebuch; Roman Elegies and the Diary*, English and German parallel text, verse trans. by D. Luke, London, 1988

Golden Age of Naples, see Rossen and Caroselli

Gombrich, E., 'Reflections on the Greek revolution', in *Art and Illusion*, 4th edn, London, 1972, pp. 99–125

Gordon, T. C., *David Allan of Alloa 1744-1796, The Scottish Hogarth*, Alva, 1951

Gori, A. F., *Museum Florentinum. Gemmae Antiquae ex Thesauro Mediceo . . .*, I–II, Florence, 1731–2

Gori, A. F., *Storia antiquaria etrusca . . . dell'autore del Museo Etrusco*, Florence, 1749

Grant, M., 'Bourbon patronage and foreign involvement at Pompeii and Herculaneum', in Chaney and Ritchie, 1984, pp. 161–8

Grant, Capt. M. H., *The Makers of Black Basaltes*, London, 1910

Graves, A., and Cronin, W. V., *History of the Works of Sir Joshua Reynolds*, 4 vols, London, 1899–1901

Greifenhagen, A., 'Griechische Vasen auf Bildnissen der Zeit Winckelmanns und des Klassizismus', *Nachrichten von der Gesellschaft der Wissenschaften zu Göttingen*, 3.7, 1939, pp. 199–230

Greifenhagen, A., 'Nachklänge griechischer Vasenfunde im Klassizismus (1790–1840)', *Jahrbuch*

der Berliner Museen, new series, 5, 1, 1963, pp. 84–105

Greifenhagen, A., 'Griechische Vasen auf Bildern des 19. Jahrhunderts', *Sitzungsberichte der Heidelberger Akademie der Wissenschaften*, 1978, pp. 7–33

Griener, P., *Le Antichità Etrusche, Greche e Romane 1766-1776 di Pierre Hugues d'Hancarville. La pubblicazione delle ceramiche antiche della prima collezione Hamilton*, Rome, 1992

Griffiths, A., 'Early aquatint', *Print Quarterly*, IV, 3, 1987, pp. 255–70

Griffiths, A., and Carey, F., *German Printmaking in the Age of Goethe*, exh. cat., British Museum, London, 1994

Guasco, O., *De l'Usage des Statues Antiques chez les Anciens*, Brussels, 1768

Hall, H. R., *Catalogue of Egyptian Scarabs in the British Museum*, I, London, 1913

Hamilton, W., Several articles in the form of letters to the President of the Royal Society, mainly on volcanoes, published in *Philosophical Transactions of the Royal Society*, 57–85, London, 1768–94; partly published in *Campi Phlegraei* (1776) and *Observations . . .* (1772)

Hamilton, W., *Observations on Mount Vesuvius, Mount Etna and other volcanos: in a series of letters addressed to the Royal Society to which are added, explanatory notes by the author*, London, 1772

[Hamilton, W.?], *An Abstract of Sir William Hamilton's Collection of Antiquities*, London, ?1772

Hamilton, W., *Campi Phlegraei, Observations on the Volcanos of the Two Sicilies, As they have been communicated to the Royal Society of London*, Naples, 1776

Hamilton, W., 'Account of the discoveries at Pompeii communicated to the Society of Antiquaries of London', *Archaeologia*, IV, London, 1777

Hamilton, W., *Supplement to the Campi Phlegraei being an account of the Great Eruption of Mount Vesuvius in the month of August 1779. Communicated to the Royal Society*, Naples, 1779

Hamilton, W., *An Account of the Earthquakes in Calabria, Sicily . . .*, Colchester, 1783 (pirated from letter later published in *Philosophical Transactions of the Royal Society*, 73)

d'Hancarville (Hugues, P. F., called Baron), *Antiquités Etrusques, Grecques et Romaines, tirées du Cabinet de M. William Hamilton, Envoyé extraordinaire et plénipotentiaire de S. M. Britannique en Cour de Naples (AEGR)*, 4 vols, Naples, 1766–7 (actually 1767–76)

d'Hancarville (Hugues, P. F., called Baron), *Recherches sur l'origine, l'esprit et les progrès des arts*, 3 vols, London, 1785–6

Haskell, F., *Rediscoveries in Art: Some Aspects of Taste, Fashion and Collecting in England and France*, Oxford, 1976

Haskell, F., 'Patronage and collecting in Bourbon Naples in the 18th century', in *Golden Age of Naples*, 1981, pp. 15–22

Haskell, F., 'The Baron d'Hancarville, an adventurer and art historian in eighteenth-century Europe', in Chaney and Ritchie, 1984, pp. 177–91; reprinted in *Past and Present in Art and*

Taste. Selected Essays, New Haven and London, 1987

Haskell, F., *History and its Images. Art and the Interpretation of the Past*, New Haven and London, 1993

Hawcroft, F., *Travels in Italy 1776-1783 based on the 'Memoirs' of Thomas Jones*, exh. cat., Whitworth Art Gallery, Manchester, 1988

Hawkins, E., see Manuscript Sources (p. 310)

Haynes, D. E. L., 'The Portland vase: a reply', *Journal of Hellenic Studies*, CXV, 1995, pp. 146–52

Heel, J. van, and Oudheusden, M. van, *Brieven van Jakob Philipp Hackert aan Johan Meerman uit de jaren 1779-1804 met enkele brieven van Johann Friedrich Reiffenstein*, The Hague, 1988

Herbert, Lord (ed.), *Henry, Elizabeth and George (1734-80) – Letters and Diaries of Henry, Tenth Earl of Pembroke and his Circle*, London, 1939

Herbert, Lord (ed.), *Pembroke Papers (1780-1794) – Letters and Diaries of Henry, Tenth Earl of Pembroke and his Circle*, London, 1950

Herrmann, F., *The English as Collectors*, New York, 1972

Heydemann, H., 'Tischbein's fünfter Band der "Collection of Engravings from Ancient Vases"', *Jahrbuch des Deutschen Archäologischen Instituts*, I, 1886, pp. 308–13

Heyne, C. G., *Homer nach Antiken gezeichnet*, begun Göttingen, 1801

Hilles, F. W., *Letters of Sir Joshua Reynolds*, Cambridge, 1929

Hoffmann, H., 'Dulce et decorum est . . .', in S. Goldhill and R. Osborne, *Art and Text in Ancient Greek Culture*, Cambridge, 1994, pp. 28–51

Holloway, J., *James Tassie 1735-1799*, National Gallery of Scotland, Scottish Masters Series, 1, Edinburgh, 1986

Holmström, K. G., *Monodrama, Attitudes, Tableaux Vivants: Studies on Some Trends of Theatrical Fashion, 1770-1815*, Stockholm, 1967

Horn, D. B., *The British Diplomatic Service 1689-1789*, Oxford, 1961

Horn, D. B., *Great Britain and Europe in the Eighteenth Century*, Oxford, 1967

Houel, J. P. L. L, *Voyage pittoresque des isles de Sicile de Malte et de Lipari, etc.*, 4 vols, Paris, 1782–7

Howard, S., *Antiquity Restored. Essays on the Afterlife of the Antique*, Vienna, 1990

Hugues, P. F., see d'Hancarville

Irwin, D., *John Flaxman 1755-1826, Sculptor, Illustrator, Designer*, London, 1979

Isager, I., *Pliny on Art and Society*, London and New York, 1991

Jaffé, P., *Lady Hamilton*, exh. cat., Kenwood, London, 1972

Jahn, O., *Beischreibung der Vasensammlung König Ludwigs in der Pinakothek zu München*, Munich, 1854

Jenkins, I., 'Adam Buck and the vogue for Greek vases', *Burlington Magazine*, CXXX, June 1988, pp. 448–57

Jenkins, I., 'La vente des vases Durand (Paris 1836) et leur réception en Grande-Bretagne', in A.-F. Laurens and K. Pomian (eds), *L'anticomanie* (international colloquium, Montpellier-Lattes, 9–12 June 1988), Paris, 1992, pp. 269–78 (= 1992a)

Jenkins, I., 'Pars pro toto: a Muse from the Paper Museum', in I. Jenkins and J. Montagu (eds), *Cassiano dal Pozzo's Paper Museum*, Olivetti Quaderni Puteani, II.1 (papers of a conference held at the British Museum and Warburg Institute 14–15 Dec. 1989), Milan, 1992, pp. 49–65 (= 1992b)

Jenkins, I., *Archaeologists and Aesthetes*, London, 1992 (= 1992c)

Jenkins, I., 'Sloane's repository of time', in MacGregor, 1994, pp. 167–73

Johns, C., *Sex or Symbol?*, London, 1982

Jones, T., *Memoirs*, see Oppé

Justi, K., *Winckelmann und seine Zeitgenossen*, 3 vols, Leipzig, 1932

Kahsnitz, R., *Zeit der Staufe*, exh. cat., Stuttgart, 1977

Keynes, G., *Blake Studies*, London, 1949

Kiechler, J. A., 'The murals at Newtimber Place', *The Sussex Archaeological Society*, 113, 1976, pp. 175–81

Knight, C., 'I luoghi di delizie di William Hamilton', *Napoli Nobilissima*, XX, 1981, fasc. 5–6, pp. 180–90

Knight, C., 'Il contributo di Peter Fabris ai Campi Phlegraei di Hamilton', *Napoli Nobilissima*, XXII, 1983, pp. 107–10

Knight, C., 'Sir William Hamilton's *Campi Phlegraei* and the artistic contribution of Peter Fabris', in Chaney and Ritchie, 1984, pp. 192–208

Knight, C., 'La quadreria di Sir William Hamilton a Palazzo Sessa', *Napoli Nobilissima*, XXIV, 1985, fasc. 1–2, pp. 45–59

Knight, C., *Il Giardino Inglese di Caserta: Un'avventura settecentesca*, Naples, 1986

Knight, C., 'Un inedito di Padre Piaggio – il Diario Vesuviano (1779-1795)', *Rendiconti dell'Accademia di Archeologia, Lettere e Belle Arti di Napoli*, LXI, 1989–90, pp. 59–131

Knight, C., *Hamilton a Napoli. Cultura, svaghi, civiltà di una grande capitale europea*, Naples, 1990

Knight, C., *Les Fureurs du Vésuve: ou l'autre passion de Sir William Hamilton* (French reprint of *Campi Phlegraei*), Paris, 1992

Knight, C., 'Lusieri, Hamilton and the Palazzo Sessa', *Burlington Magazine*, CXXXV, August 1993, pp. 536–8

Knight, C., *Le Gouaches di Hamilton: Quaranta tempere del British Museum* (Italian reprint of *Campi Phlegraei*), Naples, 1994

Knight, C., *Sulle orme del Grand Tour: uomini, luoghi, società del Regno di Napoli* (collected essays), Naples, 1995

Knight, R. P., *A Discourse on the Worship of Priapus and its Connection with the Mystic Theology of the Ancients etc.*, London, 1786/7; reprinted with a foreword by O. V. Garrison, New Jersey, 1974

Knight, R. P., 'Catalogue of Bronzes', see Manuscript Sources (p. 310)

Koch, G., and Sichtermann, H., *Römische Sarkophage*, Munich, 1982

Kretschmer, P., *Die Griechischen Vaseninschriften ihrer Sprache nach Untersucht*, Gütersloh, 1894

Landsberger, F., *Wilhelm Tischbein, ein Künstlerleben des 18. Jahrhunderts*, Leipzig, 1908

Lavin, M., *Seventeenth-Century Barberini Documents and Inventories of Art*, New York, 1975

Lemburg-Ruppelt, E., 'Die berühmte Gemma Mantovana und die Antikensammlung Grimani in Venedig', *Xenia*, 1, 1981, pp. 85–108

Lemburg-Ruppelt, E., 'Der Berliner Cameo des Dioskurides und die Quellen', *Mitteilungen des Deutschen Archäologischen Instituts. Römische Abteilung*, 91, 1984, pp. 89–113

Lewis, W. S. (ed.), *The Yale Edition of Horace Walpole's Correspondence*, 48 vols, New Haven and London, 1937–83

Lexicon Iconographicum Mythologiae Classicae, Zurich and Munich, 1981 ff.

Lichtenau, Comtesse de, *Mémoires sur la Cour de Prusse*, London, 1809

Lloyd Williams, J., see Williams, J. L.

Lodge, G. H., see Winckelmann (Lodge)

Lowenthal, D., *The Past is a Foreign Country*, Cambridge, 1985

Lyons, C. L., 'The Museo Mastrilli and the culture of collecting in Naples, 1700–1755', *Journal of the History of Collections*, IV, 1, 1992, pp. 1–26

MacGregor, A., (ed.), *Sir Hans Sloane, Collector, Scientist, Antiquary*, London, 1994

Macmillan, D., *Scottish Art 1460-1990*, Edinburgh, 1990

Mancini, F., *Pietro Fabris, 'Raccolta di varii Vestimenti . . .'*, Naples, 1985

Mankowitz, W., *The Portland Vase and the Wedgwood Copies*, London, 1952

Manners, Lady V., and Williamson, G. C., *Angelica Kauffmann RA: Her Life and Works*, London, 1924

Marcarius, see Chifflet

Marchant, N., *A Catalogue of One Hundred Impressions of Gems*, London, 1792

Marindin, G. E. (ed.), *The Letters of John B. S. Morritt of Rokeby 1794-96*, London, 1914

Martin, G. T., *Egyptian Administration and Private Name Seals*, Oxford, 1971

Martyn, T., *Tour through Italy*, London, 1791

Maxtone Graham, E., *The Beautiful Mrs Graham and the Cathcart Circle*, London, 1927

Mayo, M. E., *The Art of South Italy. Vases from Magna Grecia*, Richmond, 1982

Mazzei, M., in *Annali Istituto Universitario Orientale, Dip. di Studi del Mondo Classico e del Mediterraneo Antico, Sezione di Archeologia e Storia Antica*, 12, Naples, 1990

Mazzochi, A. S., *A. S. Mazzochii commentariorum in regii Herculanensis Musei aeneas tabulas Heracleenses*, I, Naples, 1754

Megow, W.-R., *Kameen von Augustus bis Alexander Severus*, Berlin, 1987

Melville, L., *The Life and Letters of William Beckford of Fonthill*, London, 1910

Merve, P. van der (ed.), *Nelson. An Illustrated History*, London, 1995

Michaelis, A., *Ancient Marbles in Great Britain*, Cambridge, 1882

Michel, S., *Catalogue of the Magical Gems in the British Museum*, forthcoming

Mildenberger, H., *Johann Heinrich Wilhelm Tischbein, Goethes Maler und Freund*, exh. cat., Landesmuseum Oldenburg, Schleswig-Holsteinisches Landesmuseum and Frankfurter Goethe-Museum, 1987–8 (published 1986)

Miller, A., *Letters from Italy*, London, 1775

Mitter, P., *Much Maligned Monsters: The History of European Reaction to Indian Art*, Oxford, 1977

Mocchetti, F. (ed.), *Opere del Cavaliere Carlo Gastone, Conte della Torre Rezzonico, VII: Giornale del Viaggio di Napoli negli Anni 1789 e 1790*, Como, 1819

Momigliano, A., 'Ancient history and the antiquarian', *Journal of the Warburg and Courtauld Institutes*, 13, 1950, pp. 285–315

Moore, D. T., 'Sir William Hamilton's volcanology and his involvement in the *Campi Phlegraei*', *Archives of Natural History*, 21, 2, 1994, pp. 169–93

Moreno, P., *Scultura ellenistica*, 2 vols, Rome, 1994

Morris, R., *HMS Colossus*, London, 1979

Morrison, A., *Catalogue of the collection of autograph letters and historical documents formed between 1865 and 1882 by A. Morrison. The Hamilton and Nelson Papers*, I: nos 1–301; II: nos 302–1067, combined and annotated under direction of A. W. Thibideau, London, 1893–4

Morritt, J. B. S., see Marindin

Münter, F., *Nachrichten von Neapel und Sicilien auf einer Reise in den Jahren 1785 und 1786 gesammelt*, Copenhagen, 1790

Münter, F., *Religionen der Karthager*, Copenhagen, 1821

Museum Worsleyanum, or a Collection of Antique Basso Relievos, Bustos, Statues and Gems, with Views of Places in the Levant taken on the Spot in the years 1785-7, 2 vols, London 1796–after 1803; see also Visconti, 1834

Nagler, G. K., *Neues Allgemeines Künstler-Lexicon*, Munich, 1840

Namier, L. B., and Brooke, J. (eds), *The History of Parliament: The House of Commons 1754-1790*, II, London, 1964

Newton, I., *The Chronology of Ancient Kingdoms Amended*, London, 1728

Nicolson, B., *Joseph Wright of Derby*, 2 vols, London, 1968

Nordhoff, C., and Reimer, H., *Jakob Philipp Hackert 1737-1807: Verzeichnis seiner Werke*, 2 vols, Berlin, 1994

Oppé, A. P., 'The Memoirs of Thomas Jones', *Walpole Society*, XXXII, 1946–8

Oppel, M., *J. H. W. Tischbein: Zeichnungen aus Goethes Kunstsammlung*, Weimar, 1991

Overbeck, J., *Die antiken Schriftquellen zur Geschichte der bildenden Künste bei den Griechen*, Leipzig, 1868

Painter K., and Whitehouse, D., various essays in *Journal of Glass Studies*, 32, Corning Museum of Glass, 1990

Palmerini, N., *Opere d'intaglio del cav. Raffaello Morghen*, Florence, 1824

Passeri, J. B., *Picturae Etruscorum in Vasculis*, I, Rome, 1767; II, 1770; III, 1775

Payne Knight, R., see Knight, R. P.

Pears, I., *The Discovery of Painting: The Growth of Interest in the Arts in England, 1680-1768*, London and New Haven, 1988

Penny, N. (ed.), *Reynolds*, exh. cat., Royal Academy, London, 1986

Penzer, N. M., 'The Warwick Vase', part I, *Apollo*, LXII, December 1955, pp. 183–8; part II, *Apollo*, LXIII, January 1956, pp. 18–22

Piaggio, Antonio, *Diario Vesuviano*, see Knight, 1989–90, and Manuscript Sources (p. 310)

Piranesi, G. B., *Vasi, candelabri, cippi, sarcofagi*, etc., 2 vols, Rome, 1778. See also Wilton Ely, 1994

Piranesi, exh. cat., Pierpont Morgan Library, New York, 1994, see Denison

Polignac, F. de, 'La "fortune" du columbarium. L'archéologie sub-urbaine et l'ébauche d'un nouveau modèle culturel', *Eutopia* (commentarii novi de antiquitatibus totius Europae), II, 1, 1993, pp. 41–63

Poole, P. S., see Manuscript Sources (p. 310)

Potts, A., *Flesh and the Ideal*, London, 1994

Ramage, N., 'The initial letters in Sir William Hamilton's collection of antiquities', *Burlington Magazine*, CXXIX, July 1987, pp. 446–56

Ramage, N., 'A list of Sir William Hamilton's property', *Burlington Magazine*, XCCCI, October 1989, pp. 704–6 (= 1989a)

Ramage, N., 'Owed to a Grecian urn: the debt of Flaxman and Wedgwood to Hamilton', *Ars Ceramica*, 6, 1989, cover and pp. 8–12 (= 1989b)

Ramage, N., 'Sir William Hamilton as collector, exporter and dealer: the acquisition and dispersal of his collections', *American Journal of Archaeology*, 94, 1990, pp. 469–80 (= 1990a)

Ramage, N., 'Wedgwood and Sir William Hamilton: their personal and artistic relationship', *Proceedings of the Thirty-fifth Annual Wedgwood International Seminar*, 1990, pp. 71–90 (= 1990b)

Ramage, N., 'Piranesi's decorative friezes: a source for neoclassical border patterns', *Ars Ceramica*, 8, 1991, pp. 14–19 (= 1991a)

Ramage, N., 'The dating of the four volumes of Sir William Hamilton', *Ars Ceramica*, 8, 1991, p. 35 (= 1991b)

Ramage, N., 'Sir William Hamilton: the diplomat as archaeologist', *American Journal of Archaeology*, 96, 1992, pp. 372–3 (= 1992a)

Ramage, N., 'Goods, graves, and scholars: 18th century archaeologists in Britain and in Italy', *American Journal of Archaeology*, 96, 1992, pp. 653–61 (= 1992b)

Ramage, N., 'The Warwick Vase and the issue of reproduction', *Proceedings of the 39th International Wedgwood International Seminar*, forthcoming 1995

Raspe, R. E., *A descriptive catalogue of a general collection of ancient and modern engraved gems, cameos as well as intaglios, taken from the most celebrated cabinets in Europe; and cast in coloured pastes, white enamel and sulphur by James Tassie, modeller, arranged and described by R. E. Raspe*, I–II, London, 1791

Redford, G., *Art Sales: A History of Sales of Pictures and other Works of Art*, 2 vols, London, 1888

Reilly, R., *Wedgwood*, 2 vols, London and New York, 1989

Reilly, R., and Savage, G., *Wedgwood. The Portrait Medallions*, London, 1973

Rezzonico, see Mocchetti

Richardson, J., *A Discourse on the Dignity, Certainty, Pleasure and Advantage of the Science of a Connoisseur*, London, 1719

Richardson, M., 'Model architecture', *Country Life*, September 1989, pp. 224–7

Richter, G. M. A., *The Engraved Gems of the Greeks, Etruscans and Romans, Part I, Engraved Gems of the Greeks and the Etruscans*, London, 1968; *Part II, Engraved Gems of the Romans*, London, 1971

Ridgway, D., 'James Byres and the ancient state of Italy', *Proceedings of the 2nd International Congress of Etruscan Studies (26 May–2 June 1985)*, Suppl. to *Studi Etruschi*, Rome, 1989, pp. 213–29

Roettgen, S., *Anton Raphael Mengs 1728-1779 and his British Patrons*, exh. cat., Kenwood, English Heritage, London, 1993

Rom über die Alpen tragen. Fürsten sammeln antike Architektur: Die Aischaffenburger Korkmodelle, exh. cat., Bayerische Verwaltung der staalichen Schlösser, Gärten und Seen, Munich, 1993

Romanelli, D. (ed.), *Isola di Capri. Manoscritti inediti del Conte della Torre Rezzonico, del Professore Breislak, e del Generale Pommereul*, Naples, 1816

Romney, J., *Memoirs of the Life and Works of George Romney*, London, 1830

Rossen, S. F., and Caroselli, S. L. (eds), *The Golden Age of Naples: Art and Civilization under the Bourbons 1734-1805*, exh. cat., 2 vols, Detroit Institute of Arts with Art Institute of Chicago, Detroit, 1981

Rossetti, D. de, *Il Sepulcro di Winckelmann in Trieste*, Venice, 1823

Rudoe, J., 'The faking of gems in the eighteenth century', in M. Jones (ed.), *Why Fakes Matter: Essays on Problems of Authenticity*, London, 1992, pp. 23–31

Rumpf, A., *Chalkidische Vasen*, Berlin and Leipzig, 1927

Russell, F., 'Under Vesuvius: British patrons and Neapolitan view painters – II', *Country Life*, May 1985

Russell, F., *John, 3rd Earl of Bute, Patron and Collector*, forthcoming

Rymsdyk, J. and A. van, *Museum Britannicum, being an exhibition of a great variety of antiquities and natural curiosities, belonging to . . .the British Museum etc.*, London, 1778

Schiller, C. G. W. (ed.), *Aus meinem Leben von J. H. W. Tischbein*, 2 vols, Brunswick, 1861

Schnapp, A., 'La pratique de la collection et ses conséquences sur l'histoire de l'Antiquité. Le chevalier d'Hancarville', in A.-F. Laurens and K. Pomian (eds), *L'anticomanie* (international colloquium, Montpellier-Lattes, 9–12 June 1988), Paris, 1992, pp. 209–18

Schnapp, A., *La conquête du passé. Aux origines de l'archéologie*, Paris, 1993

Scholes, P. A. (ed.), *Dr. Burney's Musical Tours in*

Europe, I: An Eighteenth Century Musical Tour in France and Italy, London, 1959

Schulze, S., *Goethe und die Kunst*, exh. cat., Schirn Kunsthalle, Frankfurt, 1994

Seidmann, G., 'Nathaniel Marchant, gem-engraver 1739–1816', *Walpole Society*, LIII, London, 1989, pp. 1–105

Sermonetta, Duchess of (Caetani, Vittoria), *The Locks of Norbury*, London, 1940

Sewter, A. C., 'The life, work and letters of William Artaud 1763–1823', unpublished MA thesis, University of Manchester, 1951 (containing transcriptions of MS letters now in John Rylands Library, University of Manchester)

Shadow of Vesuvius, see Briganti et al., 1990

Shawe-Taylor, D., *The Georgians: Eighteenth Century Portraiture and Society*, London, 1990

Sichel, W., *Emma, Lady Hamilton*, London, 1905

Skinner, B., *The Indefatigable Mr Allan*, exh. cat., Scottish Arts Council, Edinburgh, Glasgow, etc., 1973

Smith, A. H., *A Catalogue of Antiquities in the Collection of the Earl of Yarborough at Brocklesby Park*, London, 1897

Smith, A. H., 'Gavin Hamilton's letters to Townley', *Journal of Hellenic Studies*, 21, 1901, pp. 306–21

Smith, J. P., *James Tassie 1735-1799*, London, 1995

Smith, J. T., *Nollekens and his Times*, 2 vols, London, 1828

Smith, W., *A Classical Dictionary of Biography, Mythology and Geography*, various edns, including London, 1877

Sörrensen, W., *Johann Heinrich Wilhelm Tischbein, sein Leben und seine Kunst*, Berlin and Stuttgart, 1910

Sparkes, B. A., *Greek Pottery. An Introduction*, Manchester, 1991

Sparkes, B. A., and Talcott, L., 'Black and plain pottery of the 6th, 5th and 4th centuries BC', *The Athenian Agora*, XII, Princeton, 1970

Spinosa, N., et al., see *Civiltà del '700 a Napoli*

Strazzullo, F., *Settecento Napoletano, Documenti*, 2 vols, Naples, 1982–4

Swaddling, J., *Corpus Speculorum Etruscorum*, Great Britain I, fasc. 1, forthcoming

Tait, H. (ed.), *Seven Thousand Years of Jewellery*, London, 1986

Tait, H., *Catalogue of the Waddesdon Bequest in the British Museum, 3: The Curiosities*, London, 1991

Tassie, see Raspe

Thibideau, A. W., see Morrison

Thiersch, H., 'Ludwig I von Bayern und die Gorgia Augusta', *Abhandlungen der Gesellschaft der Wissenschaften zu Göttingen*, XXI, 1, 1927, pp. 77ff.

Thompson, J. R. F., 'David Allan and the Hamilton portraits', *The Connoisseur*, April 1970, pp. 250–53

Thorpe, W. A., 'The social history of the Portland Vase: II, Barberini into Portland', The Glass Circle, Lectures and Papers 137 (manuscript), London, n.d.

Thubières, A. C. P. de, see Caylus, Comte de

Tillyard, E. M. W., *The Hope Vases*, Cambridge, 1923

Tischbein, J. H. W., *Collection of Engravings from Ancient Vases Discovered in the Kingdom of the Two Sicilies between 1789-90*, I–V, Naples, 1793–after 1803

Tischbein, J. H. W., *Aus Meinem Leben*, see Schiller

Trendall, *LCS* = A. D. Trendall, *The Red-figured Vases of Lucania, Campania and Sicily*, Oxford, 1967

Trendall/Cambitoglou, *RVAp* = A. D. Trendall and A. Cambitoglou, *The Red-figured Vases of Apulia, Part I: Early and Middle Apulian*, Oxford, 1978; *Part II: Late Apulian*, Oxford, 1982

Tuer, A. W., *Bartolozzi and his Works*, 2nd edn, London, 1885

Vermeule, C., and von Bothmer, D., 'Notes on a new edition of Michaelis: Ancient Marbles', part II, *American Journal of Archaeology*, 60, 1956, pp. 321–50, pls 104–16

Vesme, A. de, and Calabri, A., *Francesco Bartolozzi, Catalogue des Estampes*, Milan, 1928

Vickers, M., 'Imaginary Etruscans: changing perceptions of Etruria since the fifteenth century', *Hephaistos*, 7/8, 1985–6, pp. 153–67

Vickers, M., 'Value and simplicity: a historical case', in M. Vickers and D. Gill, *Artful Crafts. Ancient Greek Silverware and Pottery*, Oxford, 1994; rev. version of 'Value and simplicity: eighteenth century taste and the study of Greek vases', *Past and Present*, 116, 1987, pp. 98–137

Vigée-Le Brun, E., *Memoirs of Elisabeth Vigée-Le Brun*, trans. S. Evans, London, 1989

Visconti, E. Q., *Musée Pie Clementin*, 6, Milan, 1821

Visconti, E. Q., 'Osservazioni sopra un antico cameo etc.', in G. Labus (ed.), *Opere Varie*, I, Milan, 1827

Visconti, E. Q., *Museo Worslejano* (small version of Museum Worsleyanum), Milan, 1834

Vollenweider, M. L., *Die Steinschneidekunst und ihre Künstler in Spätrepublikanischer und Augusteischer Zeit*, Baden-Baden, 1966

Von Alten, F. (ed.), *Aus Tischbein's Leben und Briefwechsel*, Leipzig, 1872

Wainwright, C., *The Romantic Interior – The British Collector at Home 1750-1850*, New Haven and London, 1989

Wal. Corr., see Lewis

Ward, T. H., and Roberts, W., *Romney: A Biographical and Critical Essay with a Catalogue Raisonné of his Works*, 2 vols, London, 1904

Ward-Perkins, J., and Claridge, A., *Pompeii AD 79. Treasures from the National Archaeological Museum, Naples and the Pompeii Antiquarium, Italy*, Sydney, 1980

Watkin, D., *Thomas Hope 1769-1831 and the Neo-Classical Idea*, London, 1968

Watkins, T., *Travels through Swisserland [sic], Italy, Sicily, the Greek Islands, to Constantinople in a series of letters to P. Watkins in the year 1787, 1788, 1789*, 2 vols, London, 1792

Waywell, G. B., *The Lever and Hope Sculptures. Ancient Sculptures in the Lady Lever Art Gallery, Port*

Sunlight and a Catalogue of the Ancient Sculpture formerly in the Hope Collection, London and Deepdene, 1986

Weege, F., 'Oskische Grabmalerei', in *Jahrbuch des Deutschen Archäologischen Instituts*, XXIV, 1909, pp. 99–140

Wendorf, R., *Emma Hamilton's Attitudes by Frederick Rehberg*, exh. cat., Houghton Library, Cambridge, Mass., 1990

Wentzel, H., 'Die Kamee mit dem ägyptischen Joseph in Leningrad', in *Festschrift Hans Kaufmann*, Berlin, 1956, pp. 85–105, illus. I–11

Wentzel, H., 'Staatkameen im Mittelalter', *Jahrbuch der Berliner Museen*, 1962, pp. 42–77

Wester, U., 'Die Reliefmedaillons im Hofe des Palazzo Medici zu Florenz', *Jahrbuch der Berliner Museen*, 7, 1965, pp. 15–91

Williams, C. I. M., 'Lusieri's surviving works', *Burlington Magazine*, CXXIV, August 1982, pp. 492–6

Williams, C. I. M., 'Lusieri's masterpiece?', *Burlington Magazine*, CXXIX, July 1987, pp. 457–8

Williams, D., *Greek Vases*, London, 1985

Williams, J. L., *Gavin Hamilton 1723-1798*, National Galleries of Scotland, Scottish Masters Series, 18, Edinburgh, 1994

Wills, G., 'Sir William Hamilton and the Portland Vase', *Apollo*, CX, September 1979, pp. 195–201

Wilton, A., 'William Pars and his work in Asia Minor', in E. Clay (ed.), *Richard Chandler, Travels in Asia Minor 1764-1765*, London, 1971, pp. xix–xxxvi

Wilton-Ely, J., *Piranesi as Architect and Designer*, Pierpont Morgan Library, New York, 1993; New Haven and London, 1994

Wilton-Ely, J., *G. B. Piranesi: The Complete Etchings*, 2 vols, San Francisco, 1994

Winckelmann, J. J., *Description des pierres gravées du feu Baron de Stosch*, Florence, 1760

Winckelmann, J. J., *Geschichte der Kunst des Alterthums*, 2 vols, Dresden, 1764

Winckelmann, J. J., *Monumenti Antichi Inediti*, 2 vols, Rome, 1767

Winckelmann, J. J., *Briefe...*, ed. W. Rehm, 4 vols, Rome, 1952–7

Winckelmann (Lodge) = Winckelmann, J. J., *The History of Ancient Art*, trans. G. Henry Lodge, 2 vols, Boston, 1856 and several other edns

Woolf, S. J., *A History of Italy 1700-1860*, London, 1979

Woolley, A. R., and Moore, D. T., 'The British Museum collection of rocks from Vesuvius made by William Hamilton and his observations on the volcano between 1764 and 1800', Session 5, History of ideas and men in volcanology, *International Conference on Active Volcanoes and Risk Mitigation*, Naples, 1991

Young, H., (ed.), *The Genius of Wedgwood*, exh. cat., Victoria and Albert Museum, London, 1995

Zazoff, P., *Die antiken Gemmen*, Munich, 1983

Zwierlein-Diehl, E., *Antike Gemmen in Deutschen Sammlungen*, II (Staatliche Museen Preussischer Kulturbesitz Antikenabteilung. Berlin), Berlin, 1969

Index